D1530984

Studies in the History of Art VOLUME 10

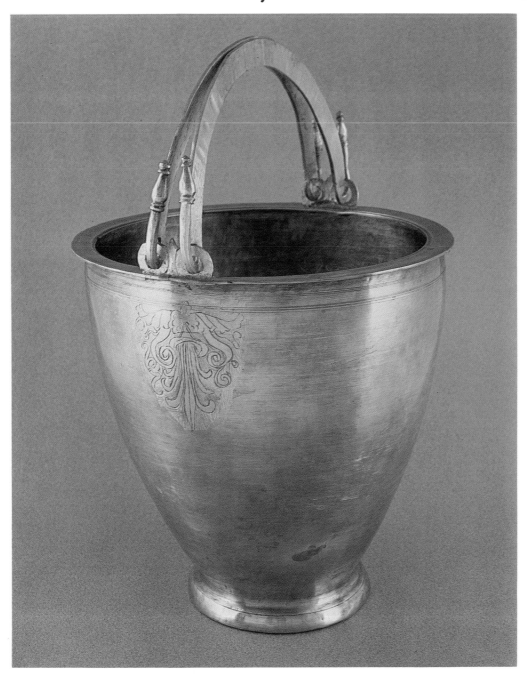

SYMPOSIUM SERIES I

*Macedonia and Greece in Late Classical
and Early Hellenistic Times*

EDITED BY BERYL BARR-SHARRAR
AND EUGENE N. BORZA

National Gallery of Art, Washington

This publication was produced by the Editors Office, National Gallery of Art, Washington.
Printed by Eastern Press, New Haven, Connecticut.
The type is Bembo, set by Composition Systems Incorporated, Arlington, Virginia.
The text paper is LOE Dull and the cover is Mead Moistrite Matte.
Unless otherwise noted, all photographs have been supplied by the authors.

Cover and *Frontispiece:*
Pl. 2. Silver situla from Tomb III, Vergina; Archaeological Museum of Thessalonike, no. 13 (photo: Time Incorporated).

The Library of Congress Cataloged this Serial as Follows:
Studies in the history of art. 1971/72 [Washington] National Gallery of Art.
With Annual report, issued by the National Gallery of Art, supersedes the gallery's Report and studies in the history of art.
1. Art—Historiography—Periodicals. I. United States. National Gallery of Art.
N386.U5S78 709 72-600309
ISBN 0-89468-005-6
ISSN 0091-7338 MARC-S
Library of Congress 73 [2]

Past issues of *Studies in the History of Art*
1967 *Report and Studies in the History of Art* [Vol. 1] (unnumbered)
1968 *Report and Studies in the History of Art* [Vol. 2] (unnumbered)
1969 *Report and Studies in the History of Art* [Vol. 3] (unnumbered)
1971/1972 *Studies in the History of Art* [Vol. 4] (unnumbered)
1973 *Studies in the History of Art* [Vol. 5] (unnumbered)
1974 *Studies in the History of Art* Vol. 6
1975 *Studies in the History of Art* Vol. 7
1978 *Studies in the History of Art* Vol. 8
1980 *Studies in the History of Art* Vol. 9
The volumes for 1967-1969 included the National Gallery of Art's annual report, which became a separate publication in 1970.

TABLE OF CONTENTS

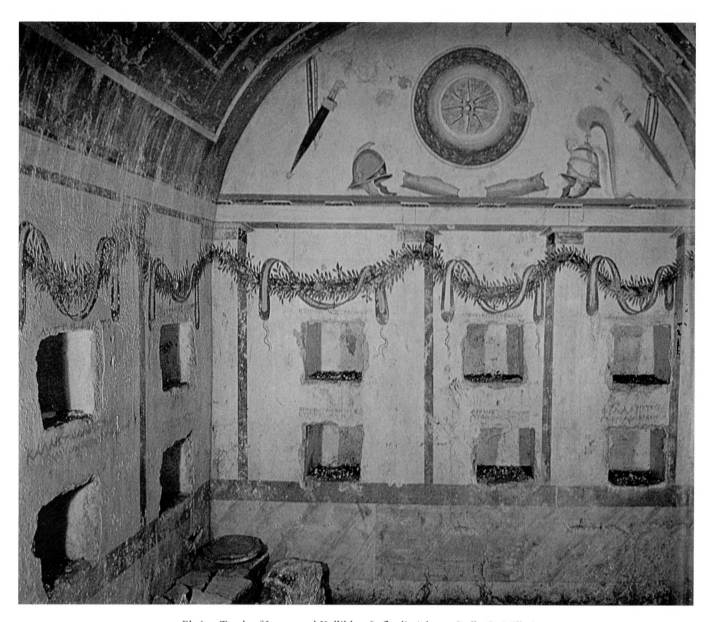

Pl. 1. Tomb of Lyson and Kallikles, Lefkadia (photo: Stella G. Miller).

PREFACE

FOREWORD

WITH THIS VOLUME, THE NATIONAL GALLERY OF ART expands the scope of its *Studies in the History of Art*. It will now publish three series under this title: symposia, monographs, and collected articles. The first will be devoted to papers presented at scholarly meetings sponsored principally by the Gallery's Center for Advanced Study in the Visual Arts. The second will be dedicated to extended considerations of single topics or themes related to this institution's collections or activities. The third will continue the tradition established through ten years of *Studies*, publishing volumes containing articles which focus on objects in the collection, but will now also include articles on works beyond the holdings of the Gallery.

This issue is the first in the symposium series. The papers contained herein were presented at the first major symposium sponsored by the Center. It was timed so that the participants could study the original material assembled for the exhibition *The Search for Alexander*, coordinated by the Gallery, which began its North American tour in Washington in November 1980.

We look forward, with this expanded format, to a wider range and an increased number of scholarly investigations relating to the collections, exhibitions, programs, and fields of inquiry pursued at the National Gallery of Art.

J. CARTER BROWN
Director

THE CENTER FOR ADVANCED STUDY IN THE VISUAL ARTS, the sponsor of the symposium that resulted in the papers here assembled, was founded in 1979, as part of the National Gallery of Art, to promote the study of history, theory, and criticism of art, architecture, and urbanism through the formation of a community of scholars. The activities of the Center include a fellowship program, meetings, research, and publication.

The symposium, "Art and Architecture in the Late Fourth Century and Hellenistic Period in Macedonia and the Rest of Greece," was the first large meeting of scholars sponsored by the Center. It coincided with the opening of the exhibition *The Search for Alexander* at the National Gallery. The symposium program was planned in consultation with Professors Phyllis Williams Lehmann, James McCredie, and Nicholas Yalouris and with advice from Professors Martha Leeb Hadzi, Miranda Marvin, David Mitten, and Cornelius Vermeule. The Kress Foundation generously provided support for the symposium. The Center plans to hold periodic symposia on a variety of topics, some related to exhibitions at the National Gallery.

The publication program includes a series within *Studies in the History of Art* for papers presented at scholarly meetings sponsored by the Center. Publication is intended to record the events, to make the papers available, and to encourage further research.

Professor Eugene Borza agreed to edit the history papers of the symposium; Professor Beryl Barr-Sharrar those on art history. The Editors Office of the National Gallery prepared the volume for publication.

HENRY A. MILLON
Dean

INTRODUCTION

ONE OF THE MOST IMPORTANT RECENT DEVELOPMENTS in ancient Mediterranean studies has been the discovery and exploration of numerous archaeological sites in Macedonia. Traditional accounts of a dynamic and colorful period of famous kings and daring exploits can now be supplemented with an array of goods, dazzling in their richness and workmanship, from tombs excavated in northern Greece. Not only the contents, but the tombs themselves and the remarkable paintings found on their walls and façades add significantly to an understanding of the ancient Macedonians, whose impact on succeeding generations of Mediterranean peoples was profound.

This volume of the journal *Studies in the History of Art* contains eighteen papers presented at the National Gallery of Art in Washington on 14-15 November 1980. The occasion was a symposium on "Art and Architecture in the Late Fourth Century and Hellenistic Period in Macedonia and the Rest of Greece" sponsored by the National Gallery's Center for Advanced Study in the Visual Arts. The symposium was scheduled to coincide with the opening of *The Search for Alexander* exhibition at the National Gallery.

The focus of these collected papers is ancient Macedonia. Five discuss problems or aspects of Macedonian history. Others present Macedonian tomb architecture and its painted decoration—including the friezes from Vergina—as well as the jewelry, metal vessels, and arms found within the tombs. Also examined are mosaics from the palaces at Pella and the coinage of Philip II and Alexander. These artifacts demonstrate the sophisticated high culture of the ancient Macedonians, one which was clearly influenced by traditional Greece—especially Athens—but which developed significant regional characteristics of its own. Such distinctions arose easily in an atmosphere of wealth and luxury which allowed experimentation with forms; another important factor was the alertness and receptivity of the Macedonian court to external stimuli and artistic innovation.

In addition to the art, architecture, and history of the fourth-century kingdom of Macedon, its cultural and material influence on the succeeding periods, including—in the area of wall painting—the early Roman, is discussed. The collapse of the independent city-state before the notion of empire brought political and social changes during the Hellenistic centuries that allowed the Greeks to settle all over the inhabited world. The successors of Alexander returned to the tradition of Macedonian kings Archelaus and Philip II to become patrons and promoters of Hellenic art and culture.

By and large these papers suggest the authors' recognition of the need to combine traditional historical analysis of primary sources with a study of the newly discovered material remains of Macedonian culture. One result of the National Gallery's symposium and the publication of these papers may well be the establishment of other efforts among ancient historians, archaeologists, art historians, literary historians, epigraphists, anthropologists, numismatists, and others to engage in cooperative scholarship.

For this opportunity, and on behalf of all the scholars who participated, we wish to thank Henry A. Millon, dean of the Center for Advanced Study in the Visual Arts, and J. Carter Brown, director of the National Gallery of Art, who understood the value of such a symposium. We especially appreciate the good will with which the symposium was carried out and the warm hospitality of our hosts.

We are very grateful also to one of the participants among us, Nicholas Yalouris, inspector general of antiquities of Greece, for his help in obtaining photographs and his willingness that they be published in this volume. Manolis Andronikos, professor of archaeology at the University of Thessalonike and excavator of Vergina, is also to be particularly warmly thanked for his generosity in allowing the publication of material which he himself was the first to see and about which he has not had time to write at length.

For struggling with numerous problems of consistency and style, we thank Cathy Gebhard and Mei Su Teng of the editors office, National Gallery of Art, whose skill and patience have guided these papers into print.

BERYL BARR-SHARRAR
EUGENE N. BORZA

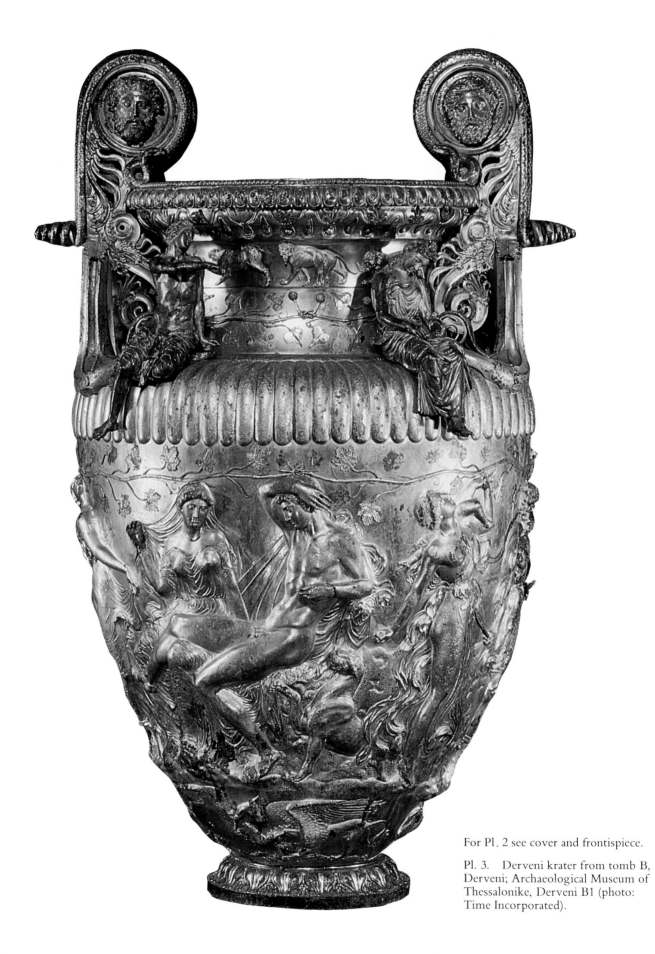

For Pl. 2 see cover and frontispiece.

Pl. 3. Derveni krater from tomb B, Derveni; Archaeological Museum of Thessalonike, Derveni B1 (photo: Time Incorporated).

10

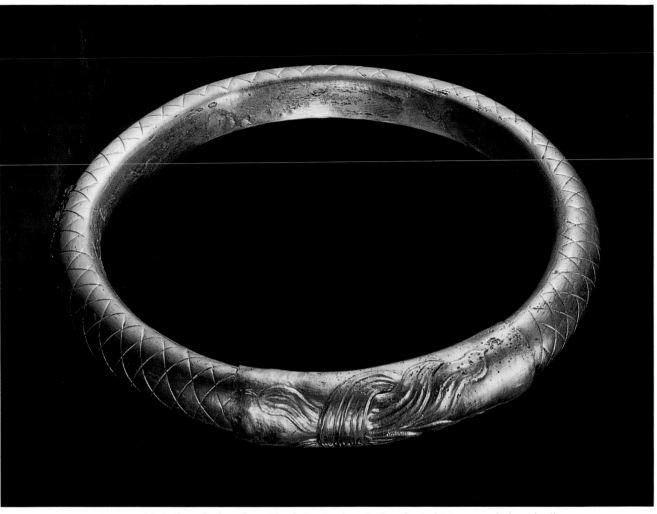

Pl. 4. Gilded silver diadem from Tomb II, Vergina; Archaeological Museum of Thessalonike
(photo: Time Incorporated).

ABBREVIATIONS

BOOKS AND JOURNALS

AA	Archäologischer Anzeiger
AAA	Athens Annals of Archaeology
AbhBerl	Abhandlungen Berlin
ABV	J. D. Beazley, Attic Black-Figure Vase-Painters (Oxford 1956)
ActaA	Acta Archaeologica
ADelt	Archaiologikon Deltion
AJA	American Journal of Archaeology
ANSMN	American Numismatic Society Museum Notes
AntK	Antike Kunst
ArchEph	Archaiologike Ephemeris
ArchRep	Archaeological Reports
ARV	J. D. Beazley, Attic Red-Figure Vase-Painters (Oxford 1963)
ASAtene	Annuario della R. Scuola Archeologica di Atene
AthMitt	Mitteilungen des deutschen archäologischen Instituts, Athenische Abteilung
AthMitt-BH	Athenische Mitteilungen, Beiheft
AUMLA	Australian Universities Language and Literary Association
BABesch	Bulletin van de Vereeniging tot Bevordering der Kennis van de Antike Beschaving
BCH	Bulletin de correspondance hellénique
BerlWinckProg	Winkelmannsprogramm der Archäologischen Gesellschaft zu Berlin
BICS	Bulletin of the Institute of Classical Studies of the University of London
BMMA	Bulletin of the Metropolitan Museum of Art, New York
BMQ	British Museum Quarterly
BonnJbb	Bonner Jahrbücher
BSA	British School at Athens, Annual
BullComm	Bullettino della Commissione Archeologica Comunale di Roma
BullEpigr	L'Année philologique bulletin épigraphique
CP	Classical Philology
CQ	Classical Quarterly
CRAI	Comptes rendus de l'Académie des inscriptions et belles lettres
CSCA	California Studies in Classical Antiquity
CSIR	Corpus Signorum Imperii Romani
CVA	Corpus Vasorum Antiquorum

CW	Classical Weekly
EAA	Enciclopedia dell'arte antica, classica e orientale
FGrHist	F. Jacoby, Fragmente der griechischen Historiker (Berlin 1923–)
GRBS	Greek, Roman and Byzantine Studies
IG	Inscriptiones Graecae
IstMitt	Mitteilungen des deutschen archäologischen Instituts, Abteilung Istanbul
JdI	Jahrbuch des (k.) deutschen archäologischen Instituts
JdI-EH	Jahrbuch des (k.) deutschen archäologischen Instituts, Ergänzungsheft
JHS	Journal of Hellenic Studies
JOAI	Jahreshefte des oesterreichischen archäologischen Instituts
JRS	Journal of Roman Studies
JSav	Journal des savants
JWarb	Journal of the Warburg and Courtauld Institutes
Meded	Mededeelingen van het Nederl. Historisch Institut te Rome
MélRome	Mélanges d'archéologie et d'histoire de l'Ecole française de Rome
MémAcInscr	Mémoires présentés par divers savants à l'Académie des inscriptions et belles lettres
MMJ	Metropolitan Museum Journal
MonAnt	Monumenti Antichi
NC	Numismatic Chronicle
OJhBeibl	Jahreshefte des oesterreichischen archäologischen Instituts, Beiblatt
Paralipomena	J. D. Beazley, Paralipomena (Oxford 1971)
POxy	B. P. Grenfell and A. S. Hunt, Papyri Oxyrhynchus (London 1898–)
PSI	Papiri Greci e Latini
RA	Revue archéologique
RE	Pauly-Wissowa, Real-Encyclopädie der klassischen Altertumswissenschaft (Stuttgart 1894–)
REA	Revue des études anciennes
REG	Revue des études grecques
RhM	Rheinisches Museum für Philologie
RivIstArch	Rivista del R. Istituto d'Archeologia e Storia dell'Arte
RömMitt	Mitteilungen des deutschen archäologischen Instituts, Römische Abteilung
SBBerl	Sitzungsberichte Berlin
SIG	Dittenberger, Sylloge Inscriptionum Graecarum
SIMA	Studies in Mediterranean Archaeology
TAM	Tituli Asiae Minoris
TAPA	Transactions of the American Philological Association
YCS	Yale Classical Studies
ZPE	Zeitschrift für Papyrologie und Epigraphik

CLASSICAL REFERENCES

Aelian	*VH*	*Varia Historia*
Andocides	*Alc.*	*Against Alcibiades*
Aristotle	*Pol.*	*Politics*
	Rh.	*Rhetoric*
Arrian	Unless otherwise noted all references are to the *Anabasis*	

Arrian	*Tact.*	*Tactica*
Asclepiodotus	*Tact.*	*Tacticus*
Didymus	*in Dem.*	*Commentary on Demosthenes*
Plato	*Grg.*	*Gorgias*
	Prt.	*Protagoras*
	Symp.	*Symposium*
Pliny	*NH*	*Natural History*
Plutarch	*Ages.*	*Agesilaus*
	Alc.	*Alcibiades*
	Alex.	*Alexander*
	Arat.	*Aratus*
	De Alex. fort.	*On the Fortune or Virtue of Alexander*
	De glor. Ath.	*De gloria Atheniensium*
	Them.	*Themistocles*
Polyaenus	*Strat.*	*Stratagems*
Vitruvius	*De Arch.*	*On Architecture*
Xenophon	*Ages.*	*Agesilaus*
	Hell.	*Hellenica*
	Hippik.	*Peri Hippikēs*
	Mem.	*Memorabilia*

Right: Pl. 5. Pluto and Persephone, Tomb I, Vergina (photo: Time Incorporated).

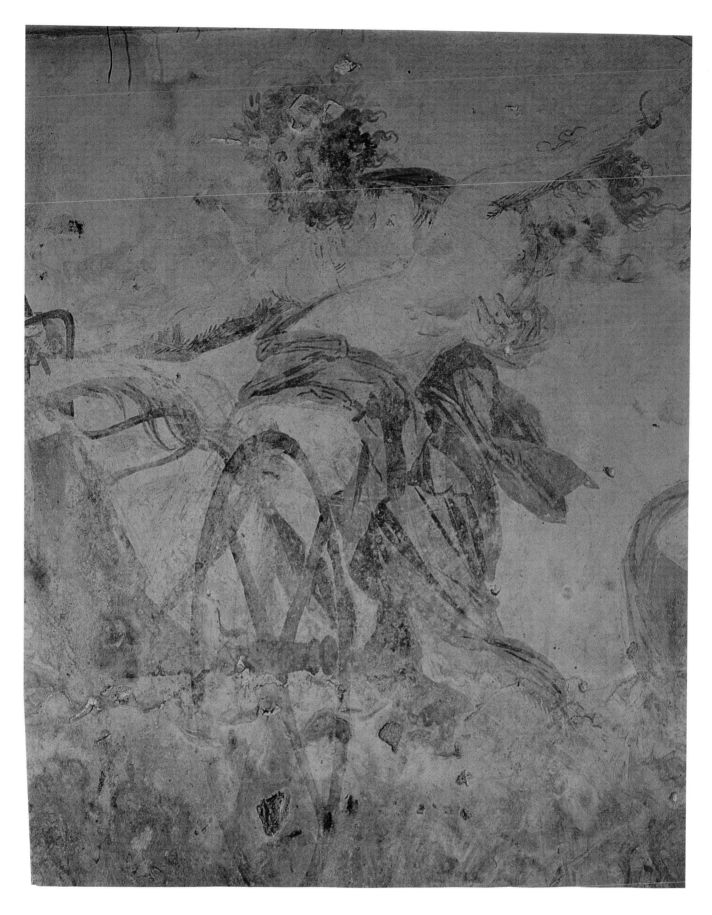

The History and Archaeology of Macedonia: Retrospect and Prospect

EUGENE N. BORZA

Department of History,
The Pennsylvania State University

UNTIL RECENTLY RATHER LITTLE attention has been paid to the peripheral areas of the Greek world. Scholarship—and indeed public interest—has been focused on the great centers of classical Greece: Athens, Corinth, Olympia, and Delphi, to name a few, or on the interesting sites of the Greek Bronze Age: Crete, Mycenae, Tiryns, and Thera, among others. This phenomenon is due in part to the central themes of a rich ancient literature, much of it produced in Athens. and to the remarkable series of excavations conducted by Greek and foreign archaeologists in the central, southern, and Aegean districts of the country. It is perhaps not a coincidence that the development of these archaeological sites corresponds with the growth of tourism—a major source of revenue for the modern Greek nation—and that most of these sites lie within a few hours' journey from Athens by road or by sea.[1]

A perusal of the shelves of any well-stocked classics library reveals the enormous amount of space taken up by the excavation reports of the famous sites.[2] If one adds the popular and scholarly general accounts of the classical period, the often lavish and very beautiful picture books, and the guide books and histories, one might come away with the impression that ancient Greek civilization consisted mainly of such places. Barely noticed tucked away amidst these magisterial volumes would be a few works with titles like *Macedonia, Thrace and Illyria; Epirus; Early Civilization in Thessaly; Archaia Makedonia;* and *Altthrakien.* For these areas were the marches of the Greek world, peopled with "half-Greeks," as L. H. Jeffery called them. These are regions until recently not much exploited archaeologically. It is almost as if the northern and western regions of the Greek peninsula were to be eternally committed to the half-light of the barbarian world.[3]

Yet it is an encouraging trend in classical scholarship that these remote areas are beginning to receive notice. Several factors may account for this emergence. We may have nearly reached a stage of exhaustion in mining the traditional sources for Greek history. How much more historical material can be squeezed from Thucydides? What new authors are about to come to light? It is sobering to reflect that, a half dozen or so recent major finds excepted, virtually all the Greek literature we now possess has been known since the Italian Renaissance. Indeed, it may be the simple passage of time, during which we have worked carefully through the literary evidence from antiquity, that now forces us to seek fresh materials. As these seem not to be forthcoming for classical Greece, we are forced to turn increasingly to nonclassical periods (to wit, the recent surge of interest in the Dark Ages and the archaic period) and to regions heretofore thought to be outside the mainstream of Greek history.

Moreover, most of the important classical sites in the south have been dug, and, while much material undoubtedly remains, increasing urbanization, industrial development, and large-scale agriculture will make it economically undesirable and technically difficult to explore virgin archaeological zones. Major Bronze Age excavation will probably continue apace. Interest in the period is high, many of the sites are in sparsely populated areas, and the Greek government looks to such regions as a means of development for the tourist industry. Thus virtually by default at-

tention shifts to the peripheral areas, many of which are not yet densely peopled and industrialized, and where one may still walk unhindered over fields and slopes gathering shards from the surface and identifying natural landmarks. As we turn to less familiar and mainly unworked regions, we do so with a sound base of traditional Greek history and an increasing skill in the integration of literary evidence with material finds. We also have learned much from social and behavioral studies which enable us to join to the critical core of humanistic endeavor the insights of economics, cultural anthropology, and political science. The last decades of this century may yet prove to be an age of progress in Macedonian studies.[4]

I. Ancient Macedonia: The Nineteenth-Century View

The course of Macedonian studies in the modern era has been fitful. Neglect of Macedonia has occurred partly for the reasons stated above: funds for excavation have usually been directed toward the more accessible, famous, and tourist-oriented sites in the southern lands and islands of Greece, places with direct links to a literature and history which once formed the core of traditional education in the West, and which continue to permeate the popular consciousness everywhere. Ironically the ancient Macedonians themselves, however unwittingly, are partly responsible for their own relative obscurity. For in their own time they produced a commander of unrivaled reputation. The fame of Alexander the Great's achievement—part conquest and part romance—has overwhelmed the lit-

erature on Macedonia, and clouded the society from which he sprang. Moreover, Alexander and especially his father Philip had incurred the enmity of the greatest of Athenian orators. Demosthenes' castigations of the Macedonian kings have echoed through the centuries. Whatever the character of Macedon's conquest of Greece, Demosthenes has had his revenge, for the Demosthenean view of the Macedonians has affected our understanding of fourth-century Greek politics. That view has produced a drama in which the "civilized" cities of Greece, led by Demosthenes and the Athenians, struggled against domination by the northern "barbarians." Only recently have we begun to clarify these muddy waters by revealing the Demosthenean corpus for what it is: oratory designed to sway public opinion and thereby to formulate public policy. That elusive creature, Truth, is everywhere subordinate to Rhetoric; Demosthenes' pronouncements are no more the true history of the period than are the public statements of politicians in any age.[5] The Demosthenean view, encased in rich language and elegant style, has colored the reconstruction of events. Few persons spoke in behalf of the Macedonians in their day, and those who did were regarded as fools or traitors. Macedon spoke with her spears. But Macedonian spears, so effective against Demosthenes in life, have been powerless against him since.

Moreover, the ancient Macedonians had inhabited an area which has been a hinterland of modern Greece. At the very moment when Schliemann, Dörpfeld, and Evans were revealing the riches of Bronze Age culture in the Pelo-

ponnesus and Crete, Macedonia still lay uneasily under Turkish control. Most of ancient Macedonia was incorporated into the modern Greek state only in 1913, and has been a politically sensitive region ever since, both in its relationship with the Athens-dominated government in the south and with its non-Hellenic neighbors to the north.[6]

Comprehensive studies of Macedonia are thus a mark of recent twentieth-century scholarship. The nineteenth century saw Macedonia largely in terms of political biography and "missionary history." In the view prevalent in German scholarship, it was Philip and Alexander's destiny to propagate Hellenic unity and to spread the higher culture of the Greeks among the less fortunate peoples of the world. It was a civilizing mission; it had little to do with Macedon or Macedonian history except insofar as that northern race had produced two men whose historical impact was undeniable. Philip, after all, was the conqueror and unifier of Greek states traditionally torn by internecine conflict. Thus freed from the burden of dissipating their energies in continual strife, the Greeks might at last release their culture upon the world, with the Macedonians acting as the vehicle for its spread. The impetuous, brilliant young Alexander, tutored by Aristotle, fond of Homer and Euripides, was the suitable instrument for the mission.

It was a dynamic concern in the minds of nineteenth-century scholars, made no less important by the fact that many German intellectuals and politicians felt witness to the same phenomenon occurring in their own day: the

unification of the German states and the consequent spread of their own *Kultur*. This vision has remained a feature of German scholarship on the subject: the emergence of the world figure as a stabilizing force and the articulator of the dynamic energies of a creative people. Until the Hohenzollern collapse the modern analogue was the adoration of the Prussian dynasty; in the twentieth century it was transformed into a more generalized messianic *Führerprinzip*.[7] Whatever the value of this concept as a reflection of contemporary moods in historiography and political ideology, it has dealt mainly with the dramatic external features of Macedonian history, such as the conquests of famous kings. Serious study of the infrastructure of Macedonian society and history still lay in the shadow of Argead imperialism and Prussian diplomacy.

One of the inescapable dilemmas faced especially by German scholars was the recognition that Philip, the embodiment of national will and the unifier of Greece, was also regarded as a threat to the higher civilization of an Athens widely admired among educated persons in the Western world. Even the staunchest advocates of Philip's apparent single-minded resolve were forced to retreat before Demosthenes' ringing cries for freedom from tyranny. Few saw through the rhetoric. When the English historian-archaeologist D. G. Hogarth attempted in 1897 to present a view of Philip which emphasized Philip's *Macedonian* outlook, echoed Diodorus Siculus' encomium to Philip's statesmanship,[8] hinted at some duplicity in Demosthenes' activities, and questioned the orator's ethics,

the result was greeted with mixed reviews.[9] Western philhellenism and pro-Athenian sentiment were too strong to permit a serious attempt to acquit Philip of the charge of hurting civilization by warring with Athens. Hogarth's work had little effect on subsequent scholarship. Early twentieth-century historians continued both the occasional writing of political biographies of the preeminent fourth-century kings and the consideration of Macedonian history only in the context of general Greek history.[10] What was required for a deeper understanding of Macedon and her kings were serious source studies and archaeology. The latter was to wait for decades, as early twentieth-century interest in Macedonia sprang from modern politics rather than from the study of antiquity.

II. Macedonian Studies and the "Macedonian Question"

It is safe to say that in modern times "Macedonia" has meant mainly *to Makedonikon zētēma,* the infamous "Macedonian Question." At least as early as the 1880s both the Great Powers and local irredentists were anticipating the prospect of allocating portions of the decaying Ottoman Empire in Europe. No part of European Turkey was more complex than Macedonia, with its roiling mix of nationalities and its great prize, the port of Salonika, Aegean gateway to the Balkans. One visitor to Salonika could describe it thus: "there congregates a confusion of nationalities and of dirt unsurpassed at least in Europe all around such a confusion of high-pitched voices as can only be fitly compared to the

parrot-house in the Regent's Park." And another: "Salonica has the moral squalor of Europe with the physical squalor of the East."[11] Perhaps nowhere else in Europe had the centuries left such a multiethnic residue as in Macedonia. The region abounded in enclaves and admixtures of Greeks, Bulgarians, Serbs, Jews, Turks, Albanians, Vlachs, other minority groups, those of mixed ancestry, and those of uncertain or even capricious nationality. The very definition of nationality varied. Was one an ethnic Bulgarian or Serb or Greek if he spoke a particular language, practiced a certain religion, adhered to some local faction, or identified with some distant independent state? Not only could the western European observers not agree, but in a region where some Jews practiced Islam and some Bulgarian native-speakers regarded themselves as Greek, it was apparent that even many of the local residents were uncertain what the basis of nationality should be.

As Turkish authority in the region waned, several trends appeared. Albania took form as a separate modern state. Serbs, Bulgarians, and Greeks fought first against the Turks and then against one another for control of Macedonia. The result of two Balkan Wars (1912–1913) and World War I was the success of the Serbian claim to the northwestern regions of Macedonia, the cession to Greece of Epirus, central and western Macedonia, and the eastern portions up to the Nestos River (including Salonika), and the granting to Bulgaria of the remainder.

Two main historical movements may be observed in this period. One is the desire for the Ottoman

overthrow and the reconciliation of Great Power interests with local independence movements. The second is the attempt by Bulgaria, a state facing the Black Sea, to gain a Mediterranean seaboard by establishing a claim along the Aegean in Macedonia and Thrace. In direct opposition to Bulgarian aspirations was Greece, which claimed both regions on the basis of a historical continuity going back to antiquity. The situation was exacerbated by the inextricable mixture of Greeks and Bulgarians in many of the disputed areas.[12] The Greeks seized Salonika early in the first Balkan War against the Turks,[13] and the Bulgarians were deprived of their Thracian littoral by the Treaty of Lausanne (1923).[14] The Bulgarian-Greek bitterness which smoldered in the region throughout the interwar period broke out openly during World War II when nearly all of eastern Macedonia was given by Germany to the Bulgarians to administer as occupied territory. The Bulgarians proceeded to incorporate the region into their state, thus temporarily regaining an Aegean outlet.[15] Moreover, the lure of Salonika for Balkan Slavs was still strong. There is evidence to suggest that Germany offered Salonika to *both* Yugoslavia and Bulgaria (at different moments) as an enticement to cooperate with German policy in Greece in 1940-1941; the ancient Slavic dream of an Aegean port was thus exploited by Germany with the utmost insincerity.[16]

As World War II was transformed into a period of civil strife inside Greece herself, the new Yugoslav and Bulgarian socialist states continued to press the Macedonian Question. The Communist insurrection in Greece eventually failed for a number of reasons fully described in the literature on the period. One of the principal features of this civil war is that Greek communists were supported at various times by Yugoslavia, Bulgaria, and the USSR. But Yugoslav and Bulgarian interests in Macedonia were clearly incompatible with the ethnocentricity of most members of the Greek Communist Party (KKE). And when the Comintern eventually ordered the KKE to conform to Bulgaria's view of the Macedonian Question, Greek communists found themselves in an intolerable position, caught between Comintern policy and their own Hellenic identity, itself reinforced by ideological principles based on Lenin's doctrines about self-determination. When at one point, bowing to Comintern policy, the KKE announced its support for the detachment of Macedonia from Greece, an uproar was created at home.[17] The military defeat of the Greek communists in 1949 apparently settled the Macedonian Question for the Greek side. But it was clear that the Hellenic-Slav conflict over Macedonia would be replaced by a Yugoslav-Bulgarian dispute over the matter, a hostility which has soured relations between the two socialist states ever since.[18] The Yugoslavs eventually abandoned their territorial claims outside the Macedonian republic of the Yugoslav federation, although the Bulgarian position on the question of extranational "Macedonians" is still unclear. Only the passage of time will tell if the Macedonian Question has become another relic of Balkan history.

Against this modern backdrop it may be seen that studies of ancient Macedonia were subordinated not only to the intense interest in famous southern classical sites, but also to the continuing drama of contemporary Macedonian politics. Almost certainly the very precarious position of modern Macedonia has until recently discouraged intensive studies of the region. Once the political status of Macedonia was determined by the treaties settling World War I, a period of relative stability settled on the countryside. The main problems for the region related to the establishment of Greek administration and the settlement of large numbers of refugees, most of them from the population exchange following the birth of the modern Turkish state and the collapse of Greek ambitions in Asia Minor.[19] This influx of Anatolian refugees resulted in the establishment of scores of new farming villages, a draining of marshes, the building of roads, and the conversion of an area which had often been described by early travelers as largely barren and depressed into one of the richest agricultural regions of Greece. In the Mediterranean world one of the most common consequences of man's effort to change the face of the landscape for the purpose of economic development is to uncover (literally) the past. There is no way to measure this trend precisely in Macedonia except to gain some general impressions by scanning the annual reports issued by the Greek Archaeological Service and by foreign journals. Archaeological "rescue" operations in the face of modern construction have now become nearly as commonplace in northern Greece as they have been for decades in the central and southern areas.

III. Macedonian Archaeology

We have already seen that the reconstruction of an ancient Macedonian history depends upon the analysis of both literary sources and material remains. First, the archaeology of the region. Long under Ottoman rule, and beyond the common travelers' routes of the eastern Mediterranean, Macedonia was virtually unknown to the West save for the reputation of its ancient kings. It never attracted the dilettante visitors who came to Athens and the islands to gaze in awe at ruined temples and to meditate over battered sculpture. When the West discovered the northern parts of Greece, it was for military purposes.

It was with France in mind that the British government dispatched Capt. (later Lt. Col.) William Martin Leake to Greece in 1804, charging him with the responsibility of surveying the countryside to provide detailed information about topography, fortresses and naval stations, and "the political and military dispositions of the inhabitants." Leake was also required to render assistance to the Turks in the event of a French invasion.[20] In several Greek journeys in 1805-1810, Leake conducted his mission with such precision and competence that he was cited by his government and attracted the attention of Nelson, Wellington, and Byron. He also noted enough detailed information about the countryside in the Peloponnesus as well as central and northern Greece to publish during his years of retirement a number of volumes recounting his journeys.[21] Leake made several visits to Epirus, Macedonia, and adjacent regions.[22] His keen eye for details, antiquities, customs, and topography not only immediately made his life's work a historical handbook for Greek archaeology, but also continues to provide the modern historian with one of the sharpest available pictures of early nineteenth-century Greece.

In 1861 Léon Heuzey was dispatched to northern Greece under an imperial commission of Napoleon III, the purpose of which was to study the remains of antiquity. Heuzey's lavish report describes in detail the region around Philippi in eastern Macedonia, the Hellenistic palace complex at Palatitsa (near modern Vergina), other central Macedonian sites, and an archaeological reconnaissance in western Macedonia and along the Albanian coast.[23] But even with the work of Leake, Heuzey, and others, Macedonia remained remote from the European consciousness. One eminent German classical scholar failed even to include Macedonia in his otherwise comprehensive geographical survey of Greece.[24] As late as 1912, the British scholar A. J. B. Wace could write, ". . . the whole region [upper Macedonia] is still archaeologically a *terra incognita* and since the existing literary sources give us little information about its geography we must look to archaeology for the solution of some existing problems."[25] And the British Admiralty *Handbook of Macedonia* (1920) described it as "a region which has been for the last forty years less traversed by Western Europeans than any other part of Europe south of the Arctic regions." At that very moment barely 200 miles to the south, the Athenian Acropolis had already undergone several restorations, and the American School at Athens was only a decade away from commencing excavation of the Agora.

In fact the opening up of Macedonia in the twentieth century was due largely to Wace and others associated with the British School of Archaeology at Athens. Early in its history the school had expressed an interest in northern Greece, publishing an article on contemporary folk customs.[26] Wace himself made several journeys into the region in the period from 1906 to 1912, and published continuously in the *Annual* of the school on what he had observed there.[27] In 1912 he wrote, "Now that [Macedonia's] political status has been changed only recently it would be premature to attempt here any full discussion of its ancient geography, since we may expect fresh discoveries."[28] Wace himself would help create interest in "fresh discoveries." Among the most interesting relics of antiquity were the large tumuli which dotted the central Macedonian plain and surrounding slopes. Leake had commented on them, and in 1914 Wace described some seventy tumuli, many of which subsequently were found to contain prehistoric remains.[29]

World War I proved to be an unanticipated boon for Macedonian studies. Macedonia was occupied by British and French armies (reinforced by Serbian and Greek units) in 1915-1918 so as to hold an Allied-Balkan flank against the enemy. The front was on the whole static (the British having pushed their lines forward only 20 to 30 miles in the period 1916-1918), and the fighting desultory. Although strategically important to protect Salonika and to thwart Bulgarian and Central Powers ambitions in the Balkans, this Allied

zone served mainly as a buffer between disputing Greek factions until the single great northern offensive in 1918. It was fortunate that among British officers were former students of the British School at Athens, and that the French army had attached to it a Service archéologique. For two years reports were gathered on prehistoric tumuli and historical sites, material finds were conserved and studied, archaeological survey maps were drawn, and plans were laid for postwar excavation and museum construction. In a happy display of Anglo-French cooperation these studies were coordinated and published in British and French journals in the immediate postwar period.[30] These wartime researches may have produced more enthusiasm and interest than actual knowledge. One of the leading British scholar-soldiers recognized the mixed results of the military survey: "From the various discoveries of Greek and Roman date above described no very coherent idea of Macedonia in historical times emerges [on the question of town sites]." Yet he notes: "The exigencies of war rendered methodical exploration for the most part impossible, but from the occasional discoveries made it has been possible to piece together a certain limited idea of classical culture in that part of Macedonia occupied by troops of the British Salonika Force."[31]

Perhaps the most important result of the wartime activity was its direct influence on Macedonian archaeology in the 1920s. For their part the French, whose interest in the area dates from Heuzey's time, began to excavate along the eastern Macedonian littoral. Their exploratory prewar and wartime surveys

gave way to systematic excavations at Thasos and in the region of Philippi.[32] But it was the British, having demonstrated a commitment to Macedonian studies before the war, and having collected information during their military occupation of north-central Macedonia, who opened the region to archaeology. In 1915 Wace, who had earlier written on the subject, identified and explored the site of the great Chalcidic center, Olynthus. This was a preliminary survey; he expressed hope that "the British School at Athens will before long be able to begin excavation here."[33] It was not to be, at least not for Wace and the British. For in 1920, Wace, now director of the school, was called south to begin those remarkable excavations at Mycenae which revealed so much of the language and culture of Bronze Age Greece. Olynthus would have to await the spade of the American, David M. Robinson, who uncovered it in a series of campaigns from 1928 to 1938, in which he recovered a large number of items illuminating the culture of northern Greece before the city's destruction by Philip II of Macedon in 348 B.C.[34]

Wace's Macedonian efforts, however, found worthy successors. Stanley Casson, who had been active with the British Salonika Force, dug at Chauchitsa in the middle Axius valley in 1921-1922. In 1926 Casson published his *Macedonia, Thrace and Illyria,* based on his own archaeological field work representing the British School and on a number of journeys in these areas in the period 1913-1925. It was the first serious attempt to reconstruct the early history of these northern Greek regions down to the time of

Philip II. A pioneering work, it suffered from the fact that systematic archaeology was just beginning in Macedonia and Thrace, and that Illyria was yet virtually unknown archaeologically. About the time that Casson's book appeared, another member of the British School, W. A. Heurtley, was commencing a series of studies of tumuli that would establish him as the father of Macedonian prehistory. Although the main activities of the British School were elsewhere, a small Macedonian Exploration Fund was available to Heurtley. Throughout the 1920s Heurtley excavated judiciously at several sites in central and western Macedonia, slowly establishing a chronology and describing the connection between early Macedonia and the rest of Greece. In 1931, however, the British School was given an opportunity to excavate at Ithaca, and Heurtley, like Wace before him, was called away from Macedonia, the lure of Homer being irresistible. Because of the Ithacan campaigns and other interruptions, Heurtley did not produce his great work on prehistoric Macedonia until the eve of the Second World War.[35]

In December 1929 Heurtley led some young British School students, fresh from Cambridge, on a walk up the Haliacmon gorge and then taught them something of Macedonian pottery. One of the students, Nicholas Hammond, commenced a series of walks in 1930-1933 upon which was based a study of the passes over the Pindus from Epirus into Macedonia and Thessaly.[36] This work established Hammond as a leading topographer of northwestern Greece. Hammond spent much of World War II as a British liaison officer

working with the Greek Resistance in Thessaly and Macedonia, and came to know parts of the country thoroughly. This autoptic experience, joined by a considerable amount of postwar research, resulted in the publication in 1967 of *Epirus,* the most comprehensive Greek regional study done up to that time. Its thorough review of geography, historical topography, and antiquities established a model for such studies, and would be matched only by Hammond's own *A History of Macedonia.*[37] The latter work, encyclopedic in scope, attempted to include virtually everything known about Macedonia. Hammond laid heavy emphasis on geographical factors as historical determinants, a method the soundness of which will appeal to anyone with experience in Greece. The unique aspect of Hammond's method, however, was his attempt to synthesize the work of Bulgarian, Albanian, Yugoslav, and Greek archaeologists on the prehistory of the region (heretofore they might just as well have been excavating on separate planets).[38] Moreover, Hammond unified topography, archaeology, and history based on literary sources in a grand manner which few generalists and no specialists would have attempted. It is a highly personal work because of its evidence-gathering procedures. It is also a work some of whose methods and conclusions have not satisfied all readers. But, taken together with *Epirus,* it serves as a useful model of regional studies development for other parts of Greece.

The Second World War and ensuing civil strife virtually halted archaeological investigation in Greece except for some small-scale continuing German and French excavations. With the renewal of scientific activity in the 1950s the situation might be described thus: the foreign institutes of archaeology, in particular the British, American, French, and German schools, continued to dominate the excavation of most major classical and some Bronze Age sites; with a few exceptions most of these were located in the central, southern, and Aegean regions of Greece. The Greeks themselves, though skillful and enthusiastic, lacked funds and had not appeared to match the foreigners in producing major results. The rudimentary level of Macedonian archaeology was such as to show only Heurtley's basic prehistoric classifications, the excavation of a few sites, a series of explorations, and a general understanding of topography. Pella, Edessa, and Verria were hardly known, and many famous ancient places were either unexcavated or their sites not yet identified: Mende, Acanthus, Torone, Methone, Pydna, and Aegae, to mention a few.

Two developments characterize Macedonian archaeology since World War II. The first is the increasing intensity with which the countryside is being investigated. Many renowned ancient places from the historical period have been identified and surveyed, and the excavation of others has commenced. Second, most of this archaeological activity has been in Greek hands. The prewar period saw some Greek work, notably by Pelikides and Romaios, but the postwar era is dominated by the excavations of the Greek Archaeological Service. A short list would include Verria, Derveni, Dion, Edessa, Kavalla, Kozani, Lefkadia, Naoussa, Pella, Potidaea, Servia, Torone, and Vergina. A short list of excavators' names includes: M. Andronikos, G. Bakalakis, D. Lazarides, Ch. I. Makaronas, D. Pandermalis, Ph. Petsas, and K. Rhomiopoulou. These scholars and their associates have until recently labored in relative obscurity in the north. But their accomplishments have contributed to the reconstruction of a Macedonian history. Parts of Philip and Alexander's capital at Pella have been unearthed. A series of fine fourth-century B.C. and later tombs at Derveni and near Lefkadia show something of the material wealth and artistic sophistication of the Macedonian gentry. Hellenistic, Roman, and Byzantine materials have been uncovered at Verria, the fortifications of ancient Edessa are coming to light, a continuous occupation from the Greek Bronze Age to Roman times has been revealed at Kozani, the Naoussa region has been identified with ancient Mieza, extensive prehistoric sites have been studied at Servia and elsewhere, the rich Chalcidian city of Torone has been identified and excavation begun, and what appears to be a royal cemetery has been discovered at Vergina.[39] A continuous culture is being revealed more sophisticated in the later periods than we had heretofore suspected. It would now appear that the obscurity of Macedonia has come to an end.

IV. The Writing of Macedonian History

If archaeology were one of the factors wanting for the production of Macedonian history, research based on literary sources was the other. We have already seen that nineteenth-century historical scholarship had produced some

general accounts of Greek history in which Macedonia was mentioned only peripherally to the mainstream of Greek history until the time of Philip and Alexander. Moreover, some biographical studies of both Philip and Alexander resulted from the intense interest in Philip's quarrels with Athens, in his unification of Greece, and in the spread of Hellenism through Alexander's conquests. In nearly every respect these events were seen as external to the Macedonian national experience, itself a concept not yet formulated in the modern mind. In brief, the Macedonians were viewed as an adjunct to Greek history. It may not go too far to suggest that Macedon seemed important only insofar as she catalyzed certain movements in Greek history and later served as a resistance to Roman expansion in the East. If there was anything like an independent Macedonian history it was part of the general *Hellenismus,* that broad conception of Greek culture framed by J. G. Broysen[40] and others in the mid-nineteenth century, which included as well the Greek city-states, Ptolemaic Egypt, and the Seleucid areas of western Asia. Macedon and her sister kingdoms were described mainly as the decayed residue of classical Greek culture and as the background for Roman conquest.[41] It is a fact that even today in most English-speaking universities virtually no Hellenistic history is taught after Alexander's conquests and before Roman expansion. Some independent Hellenistic histories appeared early in the twentieth century, notably of the Ptolemaic and Seleucid monarchies for which material evidence (especially papy-

rus documents for Egypt) seemed available.[42] But it is indicative of the state of Macedonian studies that Macedonia's history on a large scale had to wait seventy years more for the pen of Hammond.

That is not to say that scholarship on Macedonia has been lacking, only that it took the form of monographs and journal articles on limited subjects. A veritable cottage industry on Alexander the Great has arisen in the modern period. The biographies of Macedon's most famous king alone number in the scores, and now a whole volume has appeared concerned only with modern bibliography on the subject.[43] Studies of Philip II have not been so numerous, and until recently have been mainly the product of German scholarship.[44] The guidelines laid down in the nineteenth century for the study of these preeminent Macedonian monarchs continued almost without exception to dominate twentieth-century studies. Students of Philip were still forced to reconcile their sympathies for the unifier of Greece with their misgivings about the man who ended the independence of Athens. Whatever the resolution, it was always the Greek context that prevailed. As far as Alexander is concerned, manifold interpretations have been propounded concerning the king's motives, designs for good or evil, degree of civility or barbarism, and military competence—interpretations as often as not reflecting the psychological predilections of the authors themselves. Whatever personal ideologies and systems of source analysis lay under these portraits of Alexander, nearly all have shared the late nineteenth-century conception of a world figure writ

larger than life. The minimalist position has not been popular.

Some biographical studies of prominent Hellenistic Macedonian figures have appeared[45] as well as accounts of special periods and topics,[46] and collections and commentaries on several categories of evidence.[47] The great general histories of Greece have barely touched Macedonia before the eve of Philip II's rise to power. A survey of several of the famous *Griechischen Geschichten* and of the *Cambridge Ancient History* reveals scant attention to Macedonian affairs in volumes focused on the development of the Greek city-states. This is not to condemn the general-history approach; there are horrendous problems associated with the organization of materials in large-scale history, and the peripheral areas will always seem to be shunted aside in favor of the mainstream.[48] The effect is to fragment the history of a region or a people. Such has been the case of Macedonia.

We have seen thus far that several circumstances hindered the development of a synthetic Macedonian history: intense interest in the literature and archaeology of classical Greece, the remoteness and political upheavals of northern Greece in modern times, the fragmentation of Macedonian scholarship into studies of limited subject matter, and the delay in the development of Macedonian archaeology. To these factors one must add an additional burden. In attempting to construct a framework for a national history of Macedonia, the historian is faced with the uninviting prospect of writing about a people who are virtually silent about themselves. Egyptians, Jews, Sumerians, Athenians, Ro-

mans, and others have left rich legacies of literature, folk epic, architecture, inscriptions, and other material finds. But the Macedonians remain one of the mute peoples of antiquity, joining the Spartans, Etruscans, and Carthaginians. This would appear to be a cruel fate for a people who served as a shield to protect Greece from barbarian invasions, produced the most famous conqueror of all time, and represented one of the few serious obstacles to the foreign policy objectives of the Roman Republic.[49]

Any reconstruction of Macedonian history rests on three main categories of evidence: the first is our general knowledge of historical topography in the southern Balkans, with special reference to the movement of peoples, the effects of climate, and the relationship between human beings and the lands they inhabit.[50] The second is the growing body of material finds from the historical period, including tombs, coins, and inscriptions. While archaeological activity exists in high degree, the publication and analysis of these discoveries is slow. Third, and for the traditional historian the most comfortable material with which to work, are the literary sources. Yet it remains an obstacle to the writing of Macedonian history that we have no truly Macedonian source. Few persons who ever visited the region wrote about it, and only a handful of authors, however foreign, were even marginally contemporary with the Macedonian events they describe. What survives from the early period are fifth- and fourth-century writers whose attitudes about Macedonia range from the mildly curious (e.g., Thucydides 2.99 is written as

if describing a tribe living in some Asian or African limbo) to the contemptuous. A few writers like Isocrates and Aeschines avoided the prevalent hostility, but their views are as shaded as those of Demosthenes. Our best narrative account of Philip II was written by Diodorus three centuries after the king's death and was based mainly on non-Macedonian sources. Likewise the evidence for Alexander's career is late and derivative, ranging in time from the late first century B.C. (Diodorus) to the mid-second century A.D. (Arrian). It is the continuing occupation of those interested in Alexander to recover the earliest and most contemporaneous sources underlying these late histories, and there is reason to believe that some internal Macedonian materials may survive, however encrusted, in these later accounts. Most of what we know about Macedonia in the Hellenistic era comes from fragments scattered through a number of later writers, from Polybius' narrative account of Roman imperialism, and from the traditions imbedded in the writings of Rome's national historian, Livy. It is clear that many of these sources are biased, making one hope that historical topography and archaeology will come to the historian's aid, speaking as they do (to paraphrase Mommsen) without love or hate.

V. Prospect and Prelude

The recent archaeological discoveries and their interpretations (some of which are described elsewhere in this volume) have begun to make an impact on historians. First, we are no longer writing about a people known only from a hostile or distant literature. The

material finds have given us a texture for some periods of Macedonian history. It has, for example, now become impossible to think about the Macedonian monarchy and gentry of the fourth century B.C. without a vision of these splendid objects.

Second, ecological studies have provided a fresh picture of a central plain in which all known prehistoric and historical sites rest on the crescent-shaped piedmont above a sea inlet and marshland. The abundance of timber on the mountains throughout the region and the precious-metal resources of eastern Macedonia make us think anew about the economic importance of the region in antiquity.[51]

Third, the many inscriptions of the fourth century and early Hellenistic period—only a few of which have been published—give us names and, perhaps, even regional and familial identities.[52] A larger corpus may shed more light on the problem of the Macedonian language.[53]

Fourth, continuing excavation in the Chalcidice and along the Pierian coast will add to our knowledge of the relations between Macedon and the Greek cities in northern Greece through a study of the items of exchange.[54]

Next, we know now that we are dealing with a culture which, at least in its upper strata, was both wealthy and sophisticated, especially in the use of metals, wall painting, and tomb architecture. This information drives the final nail into the coffin lid of Demosthenes' argument about Macedonian barbarism, a people, he snorted, not even fit to make good slaves.[55] Moreover, by the fourth century the culture appears to have a common identity, having been

influenced by the southern Greeks, yet retaining a regional cast.[56] We suspect that the Macedonians were an *ethnos*.

We have learned more—much more—and yet there is so much that still puzzles us, especially about the organization of the Macedonian kingdom for administrative purposes, and about the internal dynamics of political and economic life. But what does the future hold for Macedonian studies?

Clearly Macedonia is an archaeological treasure house. There is almost no area which lacks the potential for yielding important information for all prehistoric and historical periods. If one must choose regions, this historian assigns priority to the Pierian foothills and coastal plain and to the Chalcidice. There one hopes to learn much about the early Macedonian heartland and about the Macedonian contacts with the Greek settlements of the northern Aegean.

But archaeology requires patience and perseverance; it is by nature an expensive and slow-paced activity. Yet we historians are impatient, knowing how much we stand to gain from continued excavation and that we are for the first time on the verge of understanding an internal Macedonian history. Thus, I would like to make some observations on enhancing the spirit of cooperation between excavator and writer of history.

Urbanization and industrialization spread quickly in Macedonia nowadays, increasing the possibility that sites may be covered over or disturbed (rescue or salvage archaeology is the least preferable form of art). Is it possible to identify and set aside for future excava-

tion potentially rich sites? As one example I think of the areas on the periphery of Vergina, especially on the south. There are presumably important historical monuments in this region, including the early Macedonian capital and perhaps even the theater where Philip II was assassinated. I am happy to report that large tracts of this area have been surveyed and the land set aside in controlled zones for future excavation.[57] It is a procedure to be admired, and one hopes that it will be extended to other areas.

We must give credit to our Greek colleagues for their important discoveries of recent years. They have worked under difficult circumstances, often lacking sufficient funds for excavation and sufficient freedom from numerous other duties. Publication of their discoveries has often been slow, and this has provoked a major dilemma. Should an excavator wait until a study of finds is completed before releasing information, as has occurred in the case of the Tomb of the Palmettes at Lefkadia or at Dion, thereby delaying the dissemination of knowledge to serious scholars for years, even decades? Or should one announce finds as they occur, releasing information for the press and articles for popular journals, as has been the case with the royal cemetery at Vergina? Professor Andronikos' procedure has benefited the cause of Macedonian studies, gaining funds and attention. But by releasing information early, the excavator risks the criticism of those who make judgments about the finds without the benefit of a scholarly publication. These are difficult choices. Those of us who do not dig, but who depend heavily on the results of excavation, must be

understanding of this plight.

I would, however, risk the suggestion that in two areas publication need not be delayed until the final interpretations of a complex site are concluded. There is little reason to delay the publication of inscriptions, which are so important to historians. Dozens of Macedonian inscriptions exist in storerooms and workshops in nearly perfect states of preservation. There is little or no need to verify or restore texts, and I would hope that every effort would be made to release these quickly. Second, reports of scientific specialists can be published as they are completed. As a number of human remains have been recovered, especially from the Vergina area, they have been subjected to the analysis of physical anthropologists. There is little need to delay the publication of anthropologists' reports; to subject scientific reports to independent scrutiny in no way threatens the integrity of the excavator's interpretations of the site, and it provides an immediate benefit by increasing our general knowledge of the physical conditions under which the ancients lived and died.

I offer a further comment as an admirer of antiquities. We are grateful to those excavators who have released objects for display and photographic reproduction even prior to their scholarly publication. Our aesthetic experience is enhanced by the opportunity to admire and study these beautiful and interesting objects, even as we await the definitive interpretation which the excavator is empowered to make. We are in the debt of those who have provided this service, even while not obligated to do so, and we encourage others to follow suit.

In one sense we stand where Schliemann and Evans and Marinatos stood, confronted by an abundance of fascinating remains from an ancient culture. We share their sense of awe, and their frustration at the difficulty of understanding what we possess. But it is an exciting prospect for those of us who will be part of the process of discovery and interpretation. We extend a hand of congratulations to our Greek colleagues for their achievement, and include as well a wish for increased international cooperation and consultation. In this spirit one may predict that an age of fulfillment in Macedonian studies is about to begin.[58]

Notes

I am indebted to the following persons for assistance in the preparation of this manuscript: A. E. Healey, librarian of the Institute of Classical Studies, London, where most of the research was done; Louisa Laourdas of the Institute for Balkan Studies, Thessalonike, for helping me see things from the Greek side; Jan Shoemaker, Department of History of The Pennsylvania State University, for carefully and cheerfully typing the manuscript; and my wife, Kathleen Pavelko, for saving me from some of the more egregious lapses of style.

1. It has always struck me as significant that magnificent northern sites such as Philippi, Thasos, and Olynthus are unknown to most visitors, while the remains of Roman (!) Corinth are among the most popular tourist attractions in Greece, though I daresay from personal observation that visitors to Corinth are generally disappointed in what they see. Corinth's popularity lies in part in her location, an hour by road from Athens and enroute to Mycenae, Epidaurus, Olympia, and other Peloponnesian sites.

2. An informal shelf count reveals 30 separate volumes for Corinth, 33 for Delos, 27 for Delphi, 20 for the Athenian Agora, and 18 for Olympia.

3. It is to be regretted, for example, that we have almost no internal evidence for two important and wealthy Chalcidic cities. Mende (never destroyed in antiquity) has not been systematically excavated, and the site of Torone is only now being explored for the first time.

4. This last sentence was originally written in the summer of 1977 as part of my review article of J. R. Ellis, *Philip II and Macedonian Imperialism,* (London, 1976), in *CP 73* (1978), 239. In another part of the same essay (238) I wrote: "Few regions of modern Greece hold so much promise for excavation as Macedonia." Within three months M. Andronikos had uncovered the royal cemetery at Vergina, and within a year a number of important contributions to Macedonian studies, long in preparation, reached print.

5. This is made clear everywhere in Ellis (note 4). Of course *everything* said by Demosthenes is part of the history of the period because it reveals something of Demosthenes' views and the politics of Athens. Nevertheless the Demosthenean corpus can hardly be regarded as an entirely accurate record of what was actually going on.

6. During World War I there was widespread opposition to the government's policy of accommodation with the Central Powers. In 1916 a national movement was formed under the leadership of E. Venizelos which established a provisional government at Salonika. By June 1917 the Salonika-based movement had succeeded in gaining the recognition of the Allies and in overthrowing the regime at Athens. As late as the 1950s and 1960s there continued to exist among right-wing politicians and military officers at Athens a deep suspicion of and hostility toward left-wing politicians and university students in Salonika. Fear of left-wing trends in the north may have led indirectly to the coup d'état of the "Colonels' Junta" of 1967-1974.

7. The phrase is E. Badian's from his "Some Recent Interpretations of Alexander," *Alexandre le Grand. Image et réalité,* Fondation Hardt, Entretiens 22 (Vaudoeuvres-Geneva, 1976), 281. Although polemical and dogmatic in its conclusions, Badian's paper is an excellent review of German attitudes toward Alexander, with special reference to the National Socialist and post-World War II period. Other useful summaries may be found in Peter Green, *Alexander of Macedon* (Harmondsworth, 1974), 482ff., and E. N. Borza (ed.), U. Wilcken, *Alexander the Great* (New York, 1967), xii-xxi.

8. Diodorus 16.95.1-4.

9. Hogarth, *Philip and Alexander of Macedon* (London, 1897). For more detail on Hogarth's place in Macedonian historiography see Borza, "Philip II and the Greeks" (note 4), 236-238, and "David George Hogarth: Eighty Years After," *Ancient World 1* (1978), 97-101.

10. Some examples of the former: U. Wilcken, "Philipp II von Makedonien und die panhellenische Idee," *Sitz. preuss. Akad. Wiss. zu Berlin,* Philos.-hist. Kl. (1929), 291-316; A. Momigliano, *Filippo il Macedone* (Florence, 1934); F. R. Wüst, *Philipp II von Makedonien und Griechenland in den Jahren 346 bis 338* (Munich, 1938); P. Cloché, *Un fondateur d'empire: Philippe II, roi de Macédoine* (St. Etienne, 1955), and *Histoire de la Macédoine jusqu'à l'avènement d'Alexandre le Grand* (Paris, 1960). Of the latter: a cursory survey of the influential modern histories of Greece (Beloch, Berve, Bengtson, Busolt, Holm, Bury, and the *Cambridge Ancient History*) reveals only casual references to the Macedonians before the reign of Philip II. Even N. G. L. Hammond, *Hist. of Greece²*, has rather little on early Macedonia. Only E. Curtius in his *Griechische Geschichte⁶*, 3 vols. (Berlin, 1887-1889), deals with Macedonia at length in a separate section on northern lands; Curtius' regional organization has much merit.

11. The first quotation is from D. G. Hogarth, "In Macedonia," *Macmillans Magazine* (August, 1889), 282; the second is from H. N. Brailsford, *Macedonia. Its Races and Their Future* (London, 1906), 83. The latter's sympathies are with the Bulgarians in the Macedonian Question, while Hogarth's view is more balanced even while slightly philhellenic. Salonika's population at the time was estimated at 110,000, of whom about 70,000 were Sephardic Jews. Virtually the entire Jewish community was exterminated by the Nazis during World War II.

12. In 1902 the Greek prime minister, Alexander Zaïmis, openly admitted that the chief threat to Hellenism in Macedonia came from the Bulgarians, not the Turks; see F. R. Bridge, ed., *Austro-Hungarian Documents Relating to the Macedonian Struggle, 1896-1912* (Thessalonike, 1976), doc. no. 50 (report of the Austr.-Hung. legation in Athens).

13. On 9 November 1912 a Greek army raced into the city just hours before the arrival of the Bulgarian force. The Bulgarians were outraged at having been deprived of their prize; only frantic diplomatic efforts kept the two armies apart. Salonika has been Greek from that day, except for its German occupation during World War II.

14. The eventual Thracian settlement established by the Treaty of Lausanne fixed the Greek-Turkish frontier at the Maritza River, where it remains today.

15. Discussed at length by Evangelos Kofos, *Nationalism and Communism in Macedonia* (Thessalonike, 1964), 100-110; this is an objective and well-documented work, given the provenance of its publication.

16. Kofos (note 15), 96-97, evidence cited. It is significant that the Germans, while permitting virtually all of the surrounding areas in Macedonia up to the Axius to be controlled by the Bulgarians, never relinquished authority over Salonika itself.

17. Kofos (note 15), 128-135, 179ff., with evidence cited.

18. In outline see Kofos (note 15), 188ff.

19. The 1928 census put the population of Macedonia at 1,412,477, of whom more than 638,000 were refugees; see Charles B. Eddy, *Greece and the Greek Refugees* (London, 1931), 134 and 145. Eddy was chairman of the Greek Refugee Settlement Commission appointed by the League of Nations.

20. Leake's instructions from Lord Harrowly and other relevant documents from the Leake family papers are quoted in John H. Marsden, *A Brief Memoir of the Life & Writings of the Late Lt.-Col. William Martin Leake* (London, 1864).

21. Among others, *Topography of Athens* (1821), *Travels in the Morea* (1830), *Travels in Northern Greece* (1835), supplements to the Athenian and Peloponnesian volumes, and one of the first systematic studies of Greek coins, *Numismata Hellenica* (1854-1859).

22. Described in *Travels in Northern Greece* (note 21).

23. Léon Heuzey and Honoré Daumet, *Mission archéologique de Macédoine,* 2 vols. (Paris, 1876).

24. Conrad Bursian, *Geographie von Griechenland,* 2 vols. (Leipzig, 1862-1872). Although Bursian included Epirus, for him Greece ended at the northern border of Thessaly thereby excluding Macedonia and Thrace. In his comprehensive *The Geographical Background of Greek and Roman History* (Oxford, 1949), M. Cary includes Macedonia and Thrace in his section on the Balkans, not the one on Greece; see 290-291 and 302-305.

25. A. J. B. Wace, "Inscriptions from Upper Macedonia," *BSA 18* (1911-1912), 167, based on the author's 1911 and 1912 journeys in the region.

26. H. Triantaphyllides, "Macedonian Customs," *BSA 3* (1896-1897), 207-214. In an editorial note the school's director, Cecil Smith, expressed a wish that modern Greek customs and folklore would "usefully occupy the attention of the foreign schools at Athens."

27. A. J. B. Wace, "North Greek Festivals and the Worship of Dionysus," *BSA 16* (1909-1910), 232-253; "Inscriptions from Upper Macedonia" (note 25); "The Mounds of Macedonia," *BSA 20* (1913-1914), 123-132; "The Site of Olynthus," *BSA 21* (1914-1915; 1915-1916), 11-15.

28. Wace (note 25), 167.

29. Leake, *Travels in Northern Greece,* III (note 21), 260; Wace, "The Mounds of Macedonia" (note 27), 123-132.

30. Summaries by Ch. Picard, "Les recherches archéologiques de l'armée française en Macédoine, 1916-19," *BSA 23* (1918-1919), 1-9; S. Casson, "Note on the Ancient Sites in the Area Occupied by the British Salonika Force during the Campaign 1916-1918," *BCH 40* (1916), 293-297; and G. Mendel, "Les travaux du Service archéologique de l'armée française d'orient," *Académie des inscriptions et belles-lettres, comptes rendus* (1918), 9-17. The main reports (with excellent maps) are Léon Rey, "Observations sur les sites préhistoriques et protohistoriques de la Macédoine," *BCH 40* (1916), 257-292, and "Observations sur les premiers habitats de la Macédoine. Recueilles par le Service archéologique de l'armée d'orient, 1916-1919," *BCH 41-43* (1917-1919), published as a monograph (Paris, 1921); and E. A. Gardner and S. Casson, "Macedonia. Antiquities Found in the British Zone, 1915-1919," *BSA 23* (1918-1919), 10-43. Much of the rest of this issue of *BSA* was given over to reports of the British Salonika Force on special mat-

ters, e.g., prehistory, pottery, inscriptions, mounds, etc. At least a dozen British school students saw Macedonian military service, among whom were E. A. Gardner, M. N. Tod, A. M. Woodward, M. S. Thompson, S. Casson, and A. W. Gomme.

31. Casson, *BSA 23* (note 30), 40-41.

32. For bibliography see the *Guide de Thasos* published by the French School at Athens (Paris, 1967), 193-198, and Paul Lemerle, *Philippes et la Macédoine orientale à l'époque chrétienne et byzantine* (Paris, 1945). Preliminary excavation reports can be read at large in *BCH* and since World War II in the Greek archaeological journals, as the Greeks themselves have become more involved in digging.

33. Wace, *BSA 21* (note 27), 11-12.

34. D. M. Robinson et al., *Excavations at Olynthus*, 14 vols. (Baltimore, 1929-1952).

35. *Prehistoric Macedonia* (Cambridge, 1939).

36. N. G. L. Hammond, "Prehistoric Epirus and the Dorian Invasion," *BSA 32* (1931-1932), 131-179.

37. *Epirus* (Oxford, 1967); *A History of Macedonia.* I: *Historical Geography and Prehistory* (Oxford, 1972) and (with G. T. Griffith) II: *550-336 B.C.* (Oxford, 1979).

38. The phrase is Hammond's own (note 37), I, viii.

39. Anyone interested in following the continuing progress of archaeology in Macedonia (and other regions of Greece) can do so conveniently by reading the annual *Archaeological Reports* published jointly by the Society for the Promotion of Hellenic Studies and the British School at Athens.

40. Fullest expression in his *Geschichte des Hellenismus²* (Gotha, 1877-1878).

41. There were, of course, exceptions to the trend. In addition to Droysen there were among others Julius Kaerst, *Geschichte des Hellenismus*, I³, II² (Berlin and Leipzig, 1927 and 1926), and H. Bengtson, *Die Strategie in der hellenistischen Zeit*, 3 vols. (Munich, 1937-1952), plus a small number of recent works on Hellenistic culture.

42. E. R. Bevan, *The House of Seleucus*, 2 vols. (London, 1902); A. Bouché-Leclerq, *Histoire des Séleucides*, 2 vols. (Paris, 1913), and *Histoire des Lagides*, 4 vols. (Paris, 1903-1907).

43. Jakob Seibert, *Alexander der Grosse*, Erträge der Forschung, 10 (Darmstadt, 1972). Useful shorter bibliographies have been compiled by E. N. Borza (note 7), E. Badian, "Alexander the Great, 1948-1967," *CW 65* (1971), 37-56, 77-83, and can also be found in the most useful and comprehensive of recent biographies, Peter Green (note 7). A provocative discussion of some modern trends in Alexander historiography is Badian's "Some Recent Interpretations of Alexander" (note 7).

44. Review of scholarship on Philip in E. N. Borza, "Philip II and the Greeks" (note 4). In addition to Ellis' work on Philip, recent studies include G. C. Cawkwell, *Philip of Macedon* (London, 1978), and M. B. Hatzopoulos and L. D. Loukopoulos, eds., *Philip of Macedon* (Athens, 1980).

45. Among which: M. Fontina, *Cassandro, re di Macedonia* (Turin, 1965); E. Manni, *Demetrio Poliorcete* (Rome, 1962); O. Mueller, *Antigonus Monophthalmus und "Das Jahr der Könige,"* Saarbr. Beitr. z. Altertumskunde, 11 (Bonn, 1973); Cl. Wehrli, *Antigone et Démétrios* (Geneva, 1968); W. W. Tarn, *Antigonus Gonatas* (Oxford, 1918); F. W. Walbank, *Philip V of Macedon* (Cambridge, 1940); and Pierre Briant, *Antigone le Borgne. Les débuts de sa carrière et les problèmes de l'assemblée macédonienne* (Paris, 1973), in which is a very useful bibliography of materials on the Hellenistic period.

46. E.g., F. Geyer, *Makedonien bis zur Thronbesteigung Philipps II* (Munich and Berlin, 1930); F. Hampl, *Der König der Makedonen* (Weida, 1934); C. F. Edson, "Early Macedonia," *Archaia Makedonia*, I (Thessalonike, 1970), 17-44; F. Granier, *Die makedonische Heeresversammlung* (Munich, 1931); A. Aymard, "Sur l'assemblée macédonienne," *REA 52* (1950), 115-137; and D. W. Engels, *Alexander the Great and the Logistics of the Macedonian Army* (Berkeley and Los Angeles, 1978).

47. Inscriptions: the first volume of Macedonian inscriptions is edited by C. F. Edson, *IG* 10.2, fasc. 1, including only the Salonika region and no inscriptions earlier than the early third century B.C. Literary sources: F. W. Walbank, *A Historical Commentary of Polybius*, I-III (Oxford, 1957-1979), indispensable for the career of Philip V; plus commentaries on Herodotus (How and Wells), Thucydides (Gomme et al.), and Plutarch, *Alexander* (Hamilton) for earlier periods. Coins: as usual, commentaries are mainly in the numismatic journals. Useful summary in Martin Price, *Coins of the Macedonians*, British Museum Publications (London, 1974). Basic work on the early coins can be found in J. Svoronos, *L'hellénisme primitif de la Macédoine* (Paris, 1919), and Doris Raymond, *Macedonian Regal Coinage to 413 B.C.*, American Numismatic Society, Numismatic Notes and Monographs, 126 (New York, 1953). Philip II's coinage is treated by Georges LeRider, *Le monnayage d'argent et d'or de Philippe II frappé en Macédoine de 359 à 294* (Paris, 1977); also see a summary of early Macedonian coinage through Philip's reign in Colin Kraay, *Archaic and Classical Greek Coins* (London, 1976), chap. 8. The complex coinage of Alexander the Great has yet to be thoroughly discussed; the best existing account is by A. R. Bellinger, *Essays on the Coinage of Alexander the Great*, American Numismatic Society, Numismatic Studies, 11 (New York, 1963). Inevitably one must turn to the major descriptions and catalogues of coin types, e.g., B. V. Head, *Historia Numorum²* (Oxford, 1911), 192-239, for an excellent basic historical classification of Macedonian coins. Also B. V. Head and R. S. Poole, *A Catalogue of the Greek Coins in the British Museum. Macedonia, etc.* (London, 1879), although a much-needed new catalogue is in preparation; and *Sylloge Nummorum Graecorum*, V.3 (London, 1976), for an excellent illustrated description of the Macedonian coins in the Ashmolean Museum, Oxford.

48. The historian's age-old bane, e.g., Diodorus 1.3.5-8, 5.1.4, 16.1.1-3, and 17.1.2.

49. See Edson (note 46), 17-18, and Harry J. Dell, "The Western Frontier of the Macedonian Monarchy," *Archaia Makedonia*, I (Thessalonike, 1970), 115-116.

50. It is here that Hammond's work will likely have its greatest impact as laid out not only in *Epirus* and *A History of Macedonia* (note 37), but most recently in *Migrations and Invasions in Greece and Adjacent Areas* (Park Ridge, N.J., 1977).

51. An analysis of ecological and resource studies (with bibliography) can be found in E.N. Borza, "Some Observations on Malaria and the Ecology of Central

Macedonia in Antiquity," *American Journal of Ancient History 4* (1979), 102-124.

52. E.g., the grave stelae inscriptions pictured in Hatzopoulos and Loukopoulos (note 44), plates 81, 109, and 110.

53. We know very little about the Macedonian language, as has been emphasized by E. Badian, "Greeks and Macedonians" (in this volume). The reader interested in this question should see J. N. Kalleris, *Les anciens Macédoniens,* I and II.1 (Athens, 1954 and 1976).

54. Little work has been done on this question, but my own cursory survey of the photographic archives of wine amphora stamps in the Pella museum revealed that the Macedonians at Pella imported wine from Thasos, Mende, and Torone. The classification and enumeration of these stamps have yet to be accomplished.

55. Demosthenes *Third Philippic* 9.31.

56. For examples see the paper of Beryl Barr-Sharrar, "Macedonian Metal Vases in Perspective: Some Observations on Context and Tradition" (in this volume).

57. I am indebted to M. Andronikos and K. Rhomiopoulou for sharing this information with me. To show how quickly things move in Macedonian studies nowadays, as this contribution was being readied for the editor, Greek newspapers were reporting that an archaeological survey had revealed the walls and acropolis of Aegae.

58. The final section of this paper was originally written to provide a sanguine conclusion for the symposium (November 1980) at the National Gallery of Art. My intention was not to include it in this extended published version of my paper. I have, however, been encouraged by several fellow symposiasts to retain these sentiments, and I am happy to present them here virtually as read in their original form.

Greeks and Macedonians

E. BADIAN

*Department of History,
Harvard University*

THIS PAPER DOES NOT PROPOSE to bring up the much-debated old question of whether the ancient Macedonians "were Greeks." From the anthropological point of view, if suitably reworded, it could no doubt be answered; I suspect that, to the anthropologist, remains found in the areas of ancient Greece, Macedonia, and surrounding parts would not show significant differences. However, this is of no historical importance: no more so than it would have been to point out in the 1930s (as I am told is the fact) that there is little anthropological difference between Jewish communities and the non-Jewish populations among whom they happen to live. From the linguistic point of view, again, if suitably reworded (i.e., "Did the ancient Macedonians speak a form of ancient Greek?"), the question seems to me at present unanswerable for the period down to Alexander the Great. We so far have no real evidence on the structure of the ancient Macedonian language; only on proper names and (to a small extent) on general vocabulary, chiefly nouns. This is not a basis on which to judge linguistic affinities, especially in the context of the ancient Balkan area and its popula-

tions.[1] Let us again look at the Jews—those who in the 1930s were living in Eastern Europe. Their names were Hebrew with a slight admixture of German and Slav elements; their alphabet and their sacred writings were Hebrew. Yet their vocabulary was largely, and the structure of their vernacular language almost entirely, that of a German dialect. As a precious survival of a prenationalist world, they are of special interest in such comparisons. One wonders what scholars would have made of them, if they had been known only through tombstones and sacred objects.

In any case, interesting though the precise affinities of ancient Macedonian must be to the linguistic specialist, they are again of very limited interest to the historian. Linguistic facts as such, just like archaeological finds as such, are only some of the pieces in the puzzle that the historian tries to fit together. In this case, unfortunately, as every treatment of the problem nowadays seems to show, discussion has become bedeviled by politics and modern linguistic nationalism:[2] the idea that a nation is essentially defined by a language and that, conversely, a common

language means a common nationhood—which is patently untrue for the greater part of human history and to a large extent even today. The *Kultursprache* of ancient Macedonians, as soon as they felt the need for one, was inevitably Greek, as it was in the case of various other ancient peoples. There was no feasible alternative. But as N. G. L. Hammond remarked, in the memorable closing words of volume I of his *History of Macedonia,* "a means of communication is very far from assuring peaceful relations between two peoples, as we know from our experience of the modern world."[3] It is equally far (we might add) from betokening any consciousness of a common interest.

What is of greater historical interest is the question of how Greeks and Macedonians were *perceived* by each other. We have now become accustomed to regarding Macedonians as "northern Greeks" and, in extreme cases, to hearing Alexander's conquests described as in essence Greek conquests. The former certainly became true, in Greek consciousness, in the course of the Hellenistic age; the latter may be argued to be true *ex post facto*. But it is an important

BADIAN *33*

question whether these assertions should properly be made in a fourth-century B.C. context. Not that Greeks abstained from ruthless fighting among themselves. But as is well known, there was —in the classical period and above all since the great Persian Wars—a consciousness of a common Hellenism that transcended fragmentation and mutual hostility: of a bond that linked those who were "Hellenes" as opposed to those who were "barbarians," and (by the fourth century at any rate) of certain standards of behavior deemed to apply among the former that did not apply between them and the latter.[4] The question of whether the Macedonians, in the fourth century B.C., were regarded as Greeks or as barbarians —a question which, as I have indicated, is not closely connected with the real affinities that a modern scholar might find—is therefore of considerable historical interest. Of course, any answer we might tentatively give must be one-sided at best. The average Macedonian (as distinct from the royal family and the highest nobility) has left us little evidence of what he thought—or indeed, whether he cared. But on the Greek side, fortunately, there are far more records. An answer can and should be attempted.

There is no evidence whatsoever of any Macedonian claim to a Greek connection before the Persian War of 480-479 B.C. Amyntas I had long before this recognized the suzerainty of Darius I; his daughter had married an Iranian nobleman, and his son Alexander I loyally served his suzerain, continuing to profit by Persian favor and protection, as his father had done.[5] However, being a shrewd politi-

cian, Alexander I took care to build bridges toward the Greeks, giving them good advice that would not harm his overlord;[6] and when at Plataea it became clear to anyone who would look that a decisive Greek victory could not be long delayed, he came out in full support of the victors, rendering them services that were appreciated. In fourth-century Athens a record of this appears to have survived—and it is of a certain interest that this great Macedonian king, the first of his line to have serious dealings with the Greeks and a friend of Athens in particular, was confused with his successor Perdiccas.[7]

In any case, with Persian overlordship gone for good, cooperation with his southern neighbors became an essential aim of policy. It was no doubt at this time, and in connection with his claim to have been a benefactor of the Greeks from the beginning, that he invented the story (in its details a common type of myth) of how he had fought against his father's Persian connection by having the Persian ambassadors murdered, and that it was only in order to hush this up and save the royal family's lives that the marriage of his sister to a Persian had been arranged.[8] It was also at this time that he took the culminating step of presenting himself at the Olympic Games and demanding admission as a competitor. (The date is not attested, but 476, the first opportunity after the war, seems a reasonable guess.) In support, he submitted a claim to descent from the Temenids of Argos, which would make him a Greek, and one of the highest extraction. With the claim, inevitably, went a royal genealogy going back for six generations, which (again) we first encounter on this

occasion. We have no way of judging the authenticity of either the claim or the evidence that went with it, but it is clear that at the time the decision was not easy. There were outraged protests from the other competitors, who rejected Alexander I as a barbarian—which proves, at the least, that the Temenid descent and the royal genealogy had hiterto been an esoteric item of knowledge. However, the *Hellanodikai* decided to accept it—whether moved by the evidence or by political considerations, we again cannot tell.[9] In view of the time and circumstances in which the claim first appears, and the objections it encountered, modern scholars have often suspected that it was largely spun out of the fortuitous resemblance of the name of the Argead clan to the city of Argos:[10] with this given, the descent (of course) could not be less than royal, i.e., Temenid.

However that may be, Alexander had clearly made a major breakthrough. He seems to have appreciated the Argive connection and cultivated it. Professor Andronikos has suggested that the tripod found in Tomb II at Vergina, which bears an Argive inscription of the middle of the fifth century, was awarded to Alexander I at the Argive Heraea, to which the inscription refers.[11] Moreover, the official decision by the *Hellanodikai* won wide recognition. We find it recorded in Herodotus, as proof of the Macedonian kings' Argive descent, and Thucydides accepts the latter as canonical. As might be expected, it was by no means the only version. Flatterers accepting the king's hospitality might extend the pedigree to Temenus himself;[12] and by the fourth century we find that a version extending the royal

line by several generations, to make it contemporary with Midas (a known historical figure of considerable importance), had won general acceptance, indeed seems to be official:[13] the first king's name is now the very suitable Caranus (Lord).[14]

By the time Herodotus picked up the story of the verdict by the *Hellanodikai,* a graphic detail about Alexander's participation had been added. Unfortunately the meaning of his words is not perfectly clear, but the most plausible interpretation is that Alexander in fact tied for first place in the race.[15] In any case, it is clear that Herodotus' version comes, directly or ultimately, from the Macedonian court. One might have thought that the historic decision would have encouraged other Macedonian kings to follow Alexander's example. His successors, Perdiccas and Archelaus, certainly continued to be involved in the international relations of the Greek states and patronized Greek culture. Yet we have no evidence of any participation by Perdiccas and only a late and unreliable record of an Olympic victory by Archelaus, which is difficult to accept.[16] With the exception of that single item, no Macedonian king between Alexander I and Philip II is in any way connected with the Olympic or indeed with any other Greek games. There is not (so far, at any rate; though this may change) even another Argive tripod.

Another item deserves comment in this connection. It is said to have been Archelaus (and here the evidence is more reliable) who founded peculiarly Macedonian Olympics at Dium. We might call them counter-Olympics, for everyone knew where the real

Olympic Games were celebrated. It is possible that Archelaus, trying to revive Alexander's claim at Olympia (and Euripides' development of his lineage perhaps was intended as further support), either had difficulties in gaining acceptance or was even rejected, despite the precedent. Such decisions might change with political expediency, and there were certain to be *some* Greeks who would challenge his qualifications and provide a reason for a new investigation. The suggestion is not based only on the establishment of the counter-Olympics. As it happens, even Euripides' manufacture of an older and unimpeachable Temenid descent did not convince everyone. When Archelaus attacked Thessalian Larisa, Thrasymachus wrote what was to become a model oration *On Behalf of the Larisaeans.* Only one sentence happens to survive: "Shall we be slaves to Archelaus, we, being Greeks, to a barbarian?"[17] Ironically, it is based on a line by Euripides.

Now, that is an odd piece of rhetoric, as applied to Archelaus. Its significance is not merely to demonstrate that as late as c. 400 B.C. the official myth of the Temenid descent of the Argead kings could be derided. What makes it really surprising is that Archelaus seems to have done more than any predecessor to attract representatives of Greek culture and to win their approval—which, like representatives of culture at all times, they seem, on the whole, to have willingly given to their paymaster, even though he had won power and ruled by murder and terror.[18] As we have already noted, Euripides wrote for him and produced a myth of immediate descent from Temenos; a host of other poets are

attested in connection with him; and Zeuxis painted his palace (giving rise to a suitable witticism ascribed to Socrates) and gave him a painting of Pan as a gift. It is really remarkable that this king, of all Macedonian kings, should be described as—not a tyrant, which would be intelligible, but a barbarian. It may add up to a declaration at Olympia that either reversed the judgment of Alexander's day or, at least, confirmed it against strong opposition: our decision on these alternatives might be influenced by whether or not we regard the late report of Archelaus' Olympic victory as authentic. In any case, Thrasymachus' description of Archelaus should be seen in close connection with the counter-Olympics founded by him and (in whatever way) with that report of his Olympic victory.

As a matter of fact, there is reason to think that at least some even among Alexander I's friends and supporters had regarded the Olympic decision as political rather than factual—as a reward for services to the Hellenic cause rather than as prompted by genuine belief in the evidence he had adduced. We find him described in the lexicographers, who go back to fourth-century sources, as "Philhellen"—surely not an appellation that could be given to an actual Greek. No king recognized as Greek, to my knowledge, was ever referred to by that epithet. On the other hand, the epithet cannot come from his enemies; *they* (surely) would have had other tales to tell: of what he had done when the Mede came and before, perhaps. It may be, therefore, that we can trace a tradition that interpreted the decision on his Temenid descent as a political gesture back

to at least some of Alexander's own Greek friends. Once we notice this, it becomes even less surprising that, as far as we know, his successor Perdiccas did not tempt fate and the judges again, and that the next king, Archelaus, may have run into trouble when he did.

Of course, as is well known, the claim to Hellenic descent is, as such, neither isolated nor even uncommon. It is perhaps the earliest we know of. And no other monarch had the imaginative boldness of Alexander I in having it authenticated, at the right political moment, by the most competent authority in Hellas. (Perhaps no other monarch ever found such an opportunity.) But by the fourth century, certainly, the rulers of Macedonian Lyncestis prided themselves on descent from the Corinthian Bacchiads—a royal dynasty fully comparable with the Temenid claims of their rivals at Aegae. The kings of the Molossi (another people not regarded as fully Hellenic) were descended from Achilles himself, via Pyrrhus son of Neoptolemus: their very names proved it. And if not fully Hellenic, then at least equally ancient and connected with Greek myth. The distant Enchelei in Illyria were ruled by descendants of Cadmus and Harmonia, not unknown in the heart of Greece itself.[19]

Whether aristocratic families in Italy and Sicily were at this time also claiming descent from Greek heroes—or if not Greek, at least Trojan—does not at present seem possible to discover. We have no literature or "family" art going back to such an early period. On the other hand, it is known and uncontested that, long before the fifth century, Sicilian and Italian tribes and peoples were linked by Greek speculation, and had learned to link themselves, to Greeks or Trojans. The two were by no means clearly distinguished at the time, but conferred common legitimacy and antiquity as properly Homeric. Odysseus as *ktistes* seems in fact to have preceded Aeneas, at least in central Italy.[20] This makes it very likely (one would think) that the ruling families of the peoples concerned took their own descent back to the mythical ancestor, thus legitimizing their rule. If so, they would precede Alexander I by several generations.

This, as I have had to admit, remains speculation, since relevant evidence is simply unknown. But what we do thus attain is a certain and extensive cultural background to the claim of the Greek origin of the Macedonian people (as distinct from the kings). That claim, too, first appears in Herodotus. It makes the original Macedonians identical with the original Dorians.[21] When it first arose, we cannot tell. It is almost certainly later than the royal family's Temenid pedigree: had Alexander I known of this assertion, he would presumably have advanced it, like the details of the royal lineage, in support of his own contention. Yet in Herodotus it appears as a separate issue, and it is clear that (by his day, at any rate) it had never been submitted to the judgment of the *Hellanodikai,* presumably because supporting material could not be found and (as we have seen) Macedonian influence at Olympia was never again such as to make acceptance of this much wider claim probable. Certainly, no Macedonian appears on the lists of Olympic victors that have survived (a fair proportion of the whole) until well into the reign of Alexander the Great. Yet one would have thought that Macedonian barons, who thought highly of physical prowess and who certainly had the resources needed, would have been able to win one of the personal contests, or at least a chariot race—a feat that, by some time early in the fourth century, even a Spartan lady could perform.[22] As we have seen, by the end of the fifth century counter-Olympics had been established in Macedon, and Macedonians were free to indulge their competitive ambitions without undergoing the scrutiny of the *Hellanodikai.* We may confidently assert that the claim to Hellenic descent, as far as the Macedonians as a whole were concerned, was not officially adjudicated for generations after Herodotus and Thucydides.

The origin of this claim (as an unofficial myth) can be dated to some time between the admission of Alexander I and the middle of the century (when Herodotus must have picked it up: i.e., it presumably does still go back to Alexander I himself) and, as I have already implied, may be looked for in the search for further support for the authenticity of the king's own Hellenism, which was (as scrutiny of the scant evidence has suggested) not entirely undebated. Like the principal issue itself, it soon developed further. By the time of the Caranus myth (noted above) it had been supplemented by an actual migration of Peloponnesians. This was clearly a more specific event than a claim (to identity with the Dorians) that might arouse both disbelief and even opposition; and it fits in well with the way in which "ancient history" was conceived of in the case of most peoples in the Graeco-

Roman world—all but the few who, like the Athenians, laid claim to being (within limits that had to be recognized) "autochthonous." The claim to Greek origin of the Macedonians as a people, therefore, can be seen arising and developing within the fifth and possibly early fourth centuries, at a time when similar claims were familiar and indeed commonplace in the West. In fact, the historian Hellanicus, at some time late in the fifth century, seems to be the earliest literary source that makes Aeneas the founder of Rome.[23]

The first half (approximately) of the fourth century was a sorry time for Macedonia.[24] Between the assassination of Archelaus about 400 B.C. and the accession of Philip II, the gains of the able and long-lived kings of the fifth century seem to have been largely lost, and Macedon was weakened by civil war and foreign invasion to the point where, by 359, the kingdom seemed close to disintegration. Philip's mother and her intrigues (whatever the truth about that obscure and much-expanded topic) had not improved matters.[25] When Philip's brother and predecessor Perdiccas III was killed in a military disaster in Illyria, Philip (who took over, whether or not as protector of Perdiccas' young son[26]) was faced by several pretenders, each supported by a foreign power.[27] That had been the pattern in several changes of monarch in the Argead kingdom. In this as in other respects, Philip's achievement deserves to receive full justice.

During the long-drawn-out anarchy and regression, the Macedonian claim to "Hellenism" cannot be expected to have made much progress. As we have seen, no Macedonian (king, baron, or commoner) appears in the Olympic victor lists. Nor do we find the Macedonian people ever regarded as a political entity, transacting business with Greek states. It is the kings that make alliances and (at least on one attested occasion) take part in panhellenic congresses.[28] The Macedonians as such do not appear, any more than, for example, the Persians or the Thracians do. We have to wait until the time of Antigonus Doson, it seems, before the Macedonians are attested as a people in the political sense.[29] This in itself, of course, may not be relevant to the issue of their presumed "Hellenism," any more than the king's presence at a congress was to his. For obvious reasons, congresses were political meetings, and attendance at them would be ruled by political needs and convenience. The king of Macedon would be asked to send representatives, just as the king of Persia did, when the Greek states thought this desirable or even when he himself did. There is no record of tests by *Hellanodikai* at such meetings. It does, however, show that for political purposes no difference was seen between Macedonians and (say) Thracians and Persians, i.e., other nations under monarchical rule. This may have been a contributing factor in unwillingness to recognize Macedonians as Greek. Whatever the truth (and I repeat that I am not concerned with the issue of fact), they would easily be *assimilated* to barbarians, and it seems that indeed they were. It is well known that, when Philip II, after winning the Sacred War, was rewarded by Apollo with the places of the defeated Phocians on the Amphictyonic Council, the seats went to him personally. His representatives are Philip's men; they have nothing to do with the Macedonians.[30] There is no question here, as there might be in the case of international relations, of his acting as the empowered ruler of his people. He is acting in his own behalf, just as 130 years earlier Alexander I had acted at Olympia. A claim for admission of "the Macedonians" to the Amphictyony would have been much harder to enforce. Philip was far too good a diplomat to advance it.

We have seen that earlier Macedonian kings had been "philhellenic" and had attracted and patronized Greek culture. The precise results of this within Macedonia cannot at present be documented. It is to be supposed that such outstanding works as Zeuxis' paintings on the walls of the royal palace had some effect on the tradition (obviously a long one) that we have now seen exemplified in the Macedonian tomb paintings. But the missing links have not yet been found. It is to be hoped that they will be. However, if there ever was any really deep penetration even into the circle of the court and the nobility, that presumably regressed in the first half of the fourth century. It is only with Perdiccas III that we for the first time find a demonstrably genuine attachment to an aspect of Greek culture: in this instance, philosophy. We are told extravagant tales of his expecting his nobles to share those interests, and of his excluding from his company (and that may mean from the very title of *hetairoi*) any that did not conform.[31] At any rate, he had links with the Academy and appointed what appears to have been a court philosopher from that school, Euphraeus of Oreos. The stories we have about

him and his influence are overlaid with later amplification, and the facts in any case do not matter here.[32] But as has been rightly observed, the demonstrably false and tendentious account of his death as due to the nobles' revenge may be taken as attesting their hatred for him and his influence.[33]

Philip himself learned his lesson —if he needed to: he cannot be shown to have had any cultural interests himself, as his brother (and later his son) did. But he certainly lost no time in reinstating the Macedonian king's claim to Temenid descent as a practical matter. We have no Herodotus to tell the details. (Perhaps Theopompus did, but his account is unfortunately lost.) What is certain—and it cannot be accident—is that for the first time since Archelaus, and for the first time ever reliably, we hear of a Macedonian victory at Olympia: needless to say, the king's own. And it comes, significantly, at the very first games (356 B.C.) after his accession to power. The story of his victory in the chariot race, which was announced to him at the same time as the birth of a son and one or two military successes, must in its essentials be believed.[34] And since such victories did not come easily or spontaneously, we can see that he had considered what in modern terms we may call the image of the Macedonian monarchy in Greece as important, and as *immediately* important, as the restoration of Macedonian military power. This, of course, does not mean that he at once developed his plans for winning hegemony over Greece. We have no good evidence on when and how those plans developed, and it would be unrealistic to put them as early as this. But it clearly shows that he

had ambitious plans for his relations with the Greek international community: he knew that those relations would be based on actual military strength (of course), but greatly assisted by recognition of his standing as a Temenid and (now) an Olympic victor. Philip was never one to underestimate propaganda and the importance of his image. In the light of our investigation so far, we can trace this trait back to his accession.

In due course, as we know, he did see the opportunities presented by the apparently incurable mutual wars and hatreds of the Greek states. The response of some Greek intellectuals to this (it cannot be shown to have had much effect on practicing politicians, or any at all on ordinary Greeks) had been a call for a Hellenic crusade against the Barbarian in the East. As the hope of having a city-state (Sparta or Athens) lead it faded, they were willing to accept even a monarch as leader in this crusade.[35] Jason of Pherae had been cut off before he could attempt the task.[36] By the time Philip was ready to consider it, the Persian empire was tearing itself to pieces in satrapal rebellions: if one could only overcome the first hurdle, the union of the Greek states, the rest seemed almost easy. After his victory in the Sacred War, at the latest, his plans seem to have been ready. By 342, he took the first step toward the military goal by invading Thrace in order to make the invasion of Asia strategically possible.[37] About the same time he invited Aristotle to become the teacher of his son and designated heir Alexander.

Apart from all else, the invitation was a political masterstroke. As was brilliantly recognized by Werner Jaeger, it secured for Philip

an alliance (secret for the time being, of course) with the philosopher-tyrant Hermias of Atarneus, Aristotle's patron and relative by marriage, who could provide both a bridgehead and connections with other potentially disloyal subjects of the King.[38] It also resumed, after a necessary interruption, the Macedonian king's connection with the Academy; but this time cautiously. The Greeks who mattered would obviously be impressed, but the Macedonian barons need fear no repetition of the Euphraeus episode. For one thing, Aristotle was the son of a man who had been court physician to Philip's father.[39] This not only ensured personal loyalty: it meant that he knew the Macedonian court and (we might say) he would know his place. Moreover, it was at once made clear that he was not coming as a court philosopher. He was installed with the young prince in a rustic retreat at a safe distance from the court and the capital. It is to be presumed that Aristotle was as happy to be at Mieza as the courtiers were to see him settled there.

At Philip's court, Greeks and Macedonians seem to have been completely integrated: there is no observable social difference among the *hetairoi*. But as contemporary observers noted, the social tone was far from lofty, as it had been under Perdiccas. Indeed, Theopompus has left us his famous satirical description, culminating in the epigram that the *hetairoi* might more suitably have been called *hetairai*: not courtiers but courtesans.[40] The satirist should not be taken too literally. Philip's court was no Bacchic *thiasos*, nor a collection of runaway criminals. His own success and (under his direction) that of his

commanders and diplomats suffices to prove it. But it is clear that it was better for Aristotle to be at Mieza.

Alexander, in fact, was to be the living symbol of the integration of Greeks and Macedonians, embodying its perfection. Unlike any of his predecessors, Philip seems to have planned far ahead. The integration of his court was a sample of what would some day come, led (he hoped) by his son—who, we ought perhaps to remember, had been born at the very time of Philip's Olympic victory. *What* Aristotle taught Alexander, we do not know and probably never shall. The facts were soon overlaid with historical romance, as it turned out (and it could certainly not be foreseen at the time) that the greatest philosopher of the ancient world had taught its greatest king. Romantic speculation must be resisted. In fact, were it not attested, there would be nothing in the future career of either man to enable us to guess the association, although it would be clear enough that Alexander had had an excellent Greek teacher.[41] They must have read the classics, like Herodotus and Xenophon.[42] Above all, however, Aristotle inspired the prince with a love of Greek literature, especially poetry, and with the ideal of emulating the Homeric heroes. Aristotle or Aristotle's relative Callisthenes presented him with a text of Homer, which (we are told) Alexander later put in a valuable casket found among the spoils of Darius. Characteristically, he is said to have kept it under his pillow at night, next to his dagger.[43]

Characteristically: for Alexander, despite his thorough Greek education and obviously genuine interest in Greek literature, was nevertheless a Macedonian king. Romance about the "Idyll of Mieza" (in Wilcken's famous phrase) has tended to obscure the obvious fact that Alexander's contact with Aristotle was not the sole educational experience he had between the ages of thirteen and fifteen. It must inevitably have been during that time that he acquired the more obvious skills essential to a Macedonian king: skills physical, administrative, and political. It was presumably only to a small extent Aristotle's political theory (if he got so far as to study it) that enabled Alexander, at the age of fifteen to sixteen, to act as regent of Macedon in Philip's absence and (necessarily with the help of experienced advisers, but nonetheless in his own name) to win a major victory;[44] though when, with Philip's permission, he founded a colony and named it after himself, his teacher wrote a treatise for him on how to do it.[45] Throughout, Greek culture and Macedonian reality must have proceeded alongside each other. That, indeed, was the point.

Alexander grew up in a circle that included Greek and Macedonian friends. Our best evidence on his early friends comes in the list of those exiled after the Pixodarus affair.[46] We have the names of two Macedonian nobles and of three Greeks who had settled in Philip's refounded Amphipolis. The point is variously noteworthy.

First, although (as we have seen) Philip seems to have made no social distinction between Greeks and Macedonians among his *hetairoi,* Greeks never commanded his armies. As we shall see, it would have involved technical difficulties and might have caused resentment among the Macedonian soldiers.[47] Alexander, right from the start, entrusted commands to his Greek friends. Indeed, Erigyius received an important cavalry command in the first winter of the expedition and, when he died in 327 after a distinguished career, is described by Curtius as "one of the renowned commanders." Nearchus, another of these Greeks, ultimately rose to even greater fame, enhanced by the fact that he could also write.[48] Promotion, though naturally helped by personal contact with Alexander and services to him, depended more on talent than on nationality.[49]

What is also worth noting is that these Greeks, of various origins, had become "Macedonians from Amphipolis."[50] We have no detailed knowledge of Philip's administration, but it is clear that annexed Greek cities, including those founded by himself, counted as parts of the Macedonian kingdom, not (like those of the Hellenic League) as allies. That, indeed, was why they had not become members of the Hellenic League.[51] Yet, while Macedonian subjects of the king, they nonetheless retained some sort of civic identity which put them on a level with (most obviously) the districts of Orestis or Eordaea within old Macedonia. Whatever it was, it was a political masterstroke, for which Philip should receive due credit. There is no trace of it among any of his predecessors, and it foreshadows what was to become characteristic, centuries later, of the cities of the Roman Empire. It is also clear that these cities had attracted able and adventurous Greeks from the less prosperous parts of the Greek world as settlers. And some of them (a very select body) moved

on to Pella, to become royal *hetairoi*.[52] To these Greeks, the question of whether to regard Macedonians as Greeks or as barbarians would have been simply irrelevant.

It was perhaps far more relevant to a rather important class of Greeks who must not be omitted in any discussion such as this: Greek mercenaries. At the beginning of his campaign, Alexander had very few Greek mercenaries: he could not afford many and, at that point, did not need many. The Persian King, on the other hand, seems to have had a large number.[53] Alexander's first contact with them was at the Granicus: those who were captured were sent to forced labor in the Macedonian mines, as traitors to the cause of Hellas.[54] Clearly, this piece of terrorism, comparable with the destruction of Thebes, was intended *pour encourager les autres*. It turned out to be a mistake. Not only did Greek cities ask to have their citizens back (not, it seems, frightened into acquiescence by the implication that they were supporting or condoning treason),[55] but the effect on the King's mercenary forces was the opposite of what had been intended. Seeing no hope in surrender, they prepared to fight to the death—as Alexander soon found out. Once he did, the policy was as quietly dropped as it had been flamboyantly started. To obtain their surrender, he was happy to promise them safety.[56]

Once the new policy had been established, fear for their own fate no longer guided the mercenaries' actions. Their true feelings can now be seen and assessed. After the battle of Issus, eight thousand of them refused to surrender, made their way down to the coast, and escaped by sea. We are not con-cerned with the details of their later fate, conflictingly related in our poor sources, except to note that they all fought against Macedon again when they had the chance. But the mercenaries (not many of them) who fought in the Persian ranks at Gaugamela seem to have escaped and remained with Darius. In fact, they remained loyal almost to the end, and when Bessus could not be stopped, joined Artabazus in preparations to continue the war in the mountains. It was only when Artabazus himself surrendered, in exchange for very honorable treatment, that they had to give up. Alexander seems to have used the occasion for another resounding sermon on collaboration with the national enemy, but when they surrendered, he in fact treated them well, releasing those who had been in the Persian service since before war was declared on Persia and merely taking those who had joined the Persians since (i.e., the real "traitors") into his own service.[57]

Of course, it must by no means be thought that all Greek mercenaries hated Alexander: by the time these events were concluded, he himself had enrolled far more Greek mercenaries himself than were by now fighting against him. But the loyalty of those Greeks to Darius is nonetheless striking, both because it illustrates the persistent division of opinion among Greeks about the Macedonian conquest and the fact that some continued to prefer Persian barbarians to acquiescence in that conquest, and (although this is not relevant to us here) because it throws unexpected light on the character of Darius III, as at least some men saw it. As for Alexander, now that he was the only possible employer for their labor, his relations with Greek mercenaries continued to be uneasy. We shall come back to them.

As we have seen, it was Alexander who in himself symbolized, and who ultimately inherited, Philip's policy of integrating Greeks and Macedonians. Indeed, it is probably not fanciful to suggest that this may be remotely connected with his own later policy of attempting a limited integration of Greeks *and* Macedonians with Iranians: the famous "policy of fusion." That policy, as is well known, aroused anger and resistance among the Macedonian forces near the end of Alexander's life.[58] Yet after politic concessions he persisted, and at the very end of his life he is even reported to have initiated a rather mysterious military reform, which combined Macedonians and Persians in small tactical units on a permanent basis.[59] In the light of this it is particularly interesting to notice that he never—either before or at that time—tried to integrate Greeks into the Macedonian infantry.[60] We cannot really tell why. Presumably, during most of the campaign he simply did not want to upset the well-trained Macedonian units that were his best military asset, either in the tactical or in the emotional sphere; while at the very end, both for tactical and for political reasons, integration of Macedonians and Iranians was important, while integration of Greeks with either was not.

The fact as such, however, seems quite certain and has really been known for a long time, although it has not always been adequately noted. It is worth documenting once more, without reference to various late sources on the history

of Alexander, where the evidence on the point is not worth much. Unfortunately these sources have at times been irresponsibly used in this context, and this has obscured the issue and the facts.[61]

Alexander himself, as we have seen, like any first-generation product of integration, in a way stood between two worlds not yet perfectly merged, rather than in a world that could be regarded as unified and Greek. Conflicts between the Greek and the Macedonian elements occasionally emerge, especially where, in our sources, conflicts between actual Greeks and Macedonians are allowed to appear: thus, most prominently, at the banquet that led to the death of Clitus, where Alexander, according to our tradition, sided with his Greek courtiers against his Macedonian officers and denigrated Macedonians as such in comparison with Greeks.[62] At least the outline of that story must be believed, since the killing of Clitus did occur, as a result of a drunken altercation: that part is made clear by the official account, which used the fact to ascribe the event to the wrath of an accidentally neglected god.[63] Although the end is variously told, and at least one of the versions is clearly distorted in the interests of exculpation, in the development of the quarrel we not only do not get alternatives, but it is hard to conceive of it as having been essentially different from what is described. However, although the whole of the argument had turned to a comparison of Greeks and Macedonians, with Alexander favoring the former, at the end he is said to have called for his guards in Macedonian (Μακεδονιστί) when he felt his life threatened. It

has often been argued that this was a reversion to a more primitive part of his psyche, under stress. This could be taken as overpowering his expressed intellectual preference for the Greeks, i.e., the Greek part of his own nature.[64]

But the answer is probably simpler than that. He used the only language in which his guards could be addressed. An interesting papyrus fragment, known for some time, seems to be the only good source to reveal the fact.[65] It tells of a battle, early in 321 B.C., in which the Greek Eumenes, with cavalry and light arms only, faced the Macedonian noble Neoptolemus with his Macedonian phalanx. Wanting to avoid battle and, if possible, to take over the opposing infantry rather than fight them, he set out to convince them of the hopelessness of their position—successfully, as we can gather elsewhere, though our fragment breaks off before we see the outcome. I quote the part that is of interest for our problem:

> When Eumenes saw the close-locked formation of the Macedonian phalanx . . ., he sent Xennias once more, a man whose speech was Macedonian, bidding him declare that he would not fight them frontally but would follow them with his cavalry and units of light troops and bar them from provisions.

Now, Xennias' name at once shows him to be a Macedonian. Since he was in Eumenes' entourage, he was presumably a Macedonian of superior status, who spoke both standard Greek and his native language. He was the man who could be trusted to transmit Eumenes' message. This clearly shows that the phalanx had to be addressed in Macedonian, if one wanted to be sure (as Eumenes certainly did) that they would understand. And—almost equally inter-

esting—he did not address them himself, as he and other commanders normally addressed soldiers who understood them, nor did he send a Greek. The suggestion is surely that Macedonian was the language of the infantry and that Greek was a difficult, indeed a foreign, tongue to them. We may thus take it as certain that, when Alexander used Macedonian in addressing his guards, that too was because it was their normal language, and because (like Eumenes) he had to be sure he would be understood. We may also take it as certain that educated Greeks did not speak the language, unless (presumably) they had grown up with Macedonians and had learned it, as some of Alexander's Greek companions clearly must have.

That these facts (fortunately for us) can be documented, for the period just after Alexander's death, by a late but reliable source is variously helpful to the historian. First, it throws much-needed light on the difficulties that Greeks had in commanding Macedonian infantry. Philip II, we remember, is not known to have employed any. Presumably, the first-generation Greek immigrants into his cities had not learned the language. Eumenes, however, is notorious for the trouble he repeatedly had in getting Macedonian infantry to fight for him, even though he was one of the ablest of the Successors. We can now see that his disability was not only his Greek birth, as has always been realized, but the simple fact that he could not directly communicate with Macedonian soldiers. His alien culture and provenance were not only obvious in an accent: it was a matter of language.[66] In the end, he therefore lost his bid for power and his life.[67]

We also learn—and this is where this discussion started— that although Alexander's Greek companions (or at least some of them) did know the language, having come to Macedonia at an early age, Alexander never tried to impose Greek on his Macedonian infantry or to integrate it with Greek units or Greek "foreign" individuals.

Above all, however, this helps to explain how, half a generation after Philip's revival of the Macedonian king's claim to eminent Greek descent had been accepted at Olympia and his efforts to integrate his court had been bearing fruit, Greek opponents could still call not only the Macedonian people, but the king himself, "barbarian." In this respect, nothing had changed since the days of Archelaus. The term is in fact more than once used of Philip by Demosthenes, most notably in two passages. In one, in the *Third Olynthiac* (3.24), he claims that a century ago "the king then in power in that country was the subject [of our ancestors], as a barbarian ought to be to Greeks." In the second, a long tirade in the *Third Philippic* (9.30 f.), he claims that suffering inflicted on Greeks by Greeks is at least easier to bear than that now inflicted by Philip, "who is not only not a Greek and has nothing to do with Greeks, but is not even a *barbarian* from a place it would be honorable to name—a cursed Macedonian, who comes from where it used to be impossible even to buy a decent slave." This, of course, is simple abuse. It may have nothing to do with historical fact, any more than the orators' tirades against their personal enemies usually have. But as I have tried to make clear, we are not concerned with historical fact as such; we are con-

cerned only with *sentiment,* which is itself historical fact and must be taken seriously as such. In these tirades we find not only the Hellenic descent of the Macedonian people (which few seriously accepted) totally denied, but even that of the king. It is not even mentioned merely in order to be rejected: the rejection is taken as a matter of course. Now, the orator clearly could not do this, if his audience was likely to regard his claim as plain nonsense: it could not be said of a Theban, or even of a Thessalian. The polite acceptance of the Macedonian kings as Hellenes ruling a barbarian nation was still not totally secure: one would presumably divide over it on irrational grounds, according to party and personal sentiment—as so many of us still divide, over issues that are inherently more amenable to rational treatment.[68]

As regards the Macedonian nation as a whole, there was (as far as we can see) no division. They were regarded as clearly barbarian, despite the various myths that had at various times issued from the court and its Greek adherents, perhaps ever since the time of Alexander I, and demonstrably ever since the time of Perdiccas II. This comes out most clearly in a well-known passage by one of Philip's main supporters, that apostle of panhellenism, Isocrates. The passage is so important that it must be quoted in full in a note.[69] Some time not long after the Peace of Philocrates, the orator congratulates Philip on the fact that his ancestor, having ambitions to become a ruler, had not attempted to become a tyrant in his native city (i.e., Argos), but "leaving the area of Greece entirely," had decided to seize the kingship over Macedon.

This, explains Isocrates, shows that he understood the essential difference between Greeks and non-Greeks: that Greeks cannot submit to the rule of a monarch, while non-Greeks actually cannot live without it. It was this peculiar insight that enabled Philip's ancestor to found a firmly established dynasty over a "people of non-kindred race." He is described (with pardonable exaggeration, for it is unlikely that Isocrates was deliberately contradicting similar claims by other dynasties that had by then arisen: see above) as the only Greek who had ever done so.

Whether Philip was entirely happy about this, we cannot know. As we have seen, he had made every effort to reconcile and integrate Greeks and Macedonians. But the passage provides the necessary background to the fact that even Philip had not tried to pass off his Macedonians as Greeks and had been perfectly content to accept membership of the Delphic Amphictyony as a personal gift, just as, in due course, he never tried to make his Macedonians members of the Hellenic League. Meanwhile, he was hoping to leave the final settlement of the problem to the future: Alexander was to prepare the way for fuller integration than could at present be attempted or claimed.[70]

We have no idea of what Macedonians, on the other side of this fence, thought of this whole issue: no Macedonian oratory survives, since the language was never a literary one. But that the feeling of a major difference (obviously, the Macedonians would not cast it in terms of "Greeks" *versus* "barbarians"), of their being "peoples of non-kindred race," existed on both sides is very probable. For one

thing, the language barrier would keep it alive, even though the literary language of educated Macedonians could only be Greek. That fact was as irrelevant to ordinary people (and perhaps even to those above the ordinary level) as was the Hellenic cultural polish of the Macedonian upper class that has been revealed to us in recent years. The artistic and cultural *koinē* of much of eighteenth-century Europe was French; indeed, upper-class German ladies might confess that it was the only language they could write.[71] Yet not all of them, by any means, were even Francophile, and none of them felt that they *were* French. The reaction to a Greek "court philosopher," or perhaps—if we can believe at least the outline of the story—the anger of Clitus: these help to document feelings in the very class that, as we now know, was culturally conspicuous for Hellenism. But like many prejudices, these feelings of antagonism are most clearly seen among ordinary people—whether the Athenians who applauded Demosthenes' tirades or ordinary Macedonian soldiers; and not only those who deserted Eumenes.[72]

Alexander himself, with that basic tact that (at times surprisingly) links him to his father, had not tried to force military integration on his Greeks and Macedonians. Both were useful to him as they were. Having monopolized the market in Greek mercenaries, he forced them to settle in the northeastern frontier region of the empire, in a ring of colonies that was to ensure its military safety.[73] Even before his death, when he had disappeared into India and there were apparently rumors circulating that he would never re-turn, some of the conscripts in those colonies started on the long migration home, and at least some of those who did were successful.[74] As soon as he was safely dead, many thousands of them banded together for the long march back, through areas held by hostile Macedonians and inhabited by natives perhaps equally hostile to both. Of course, this movement had little to do with national antagonism on the mercenaries' side. It was a revolt against Alexander's despotism, which in this instance had happened to be aimed at Greeks. The fact that in the final battle a large contingent betrayed their comrades and deserted to the Macedonians shows that (as centuries before in the battle of Lade[75]) national antagonism was by no means pervasive, and was perhaps not at all prominent. However, a Macedonian army under Pithon did defeat the rebels. Pithon, no doubt recognizing their immense value for the empire as a whole, persuaded them to go back to their posts, assuring them personal safety in return. Yet, contrary to his oath, seventeen thousand Greeks were cut down, after surrendering their arms, by the enraged Macedonians, and Pithon could not stop them.[76] The patent needs of the empire and the oath of their commander were swallowed up in the explosion of what we can only regard as the men's irrational hatred for their Greek enemies. The effect of the massacre on the later history of the region cannot be assessed; but it must have been considerable.

The rebellion at the eastern extreme of the empire thus helps us document Macedonian antagonism toward Greeks. Correspondingly, rebellion at the other end documents Greek feeling about the Macedonians. Perhaps rebellion had been brewing even before.[77] But it was in any case the immediate result of Alexander's disappearance. Once more Athens rallied the Greeks to freedom, and once more she found many followers. The war, known to us (and to some ancient sources) as the Lamian War, was described by its protagonists as "the Hellenic War." The term speaks for itself, at least concerning the feelings of those who used it.[78] In a wider Greek theater, where love of Greek freedom was not easily given up, and where (just as in the days of Isocrates, a generation earlier) despotism was still equated with barbarian rule, the spirit we find in Demosthenes' oratory is thus confirmed.

In fact, these two rebellions at the two extremes of the empire were the only ones for a long time. It was (significantly) *only* Greeks, whether professional soldiers or mere Greek citizens, who showed enough spirit to challenge what they felt to be the foreign domination. But that they in fact did so shows that at this time the gap between Greeks and Macedonians was by no means bridged. The work of the Argead kings who had long tried to work toward bridging it, and the work of Alexander who was himself the result of that long process (though, as we saw, he did not try to force it on beyond what was acceptable), was to take perhaps another century to reach fruition. Perhaps it was not *fully* completed until both parties became conscious of their unity, as it had by then developed, in contrast to a conqueror from the barbarian West.[79]

1. The most thorough study by a trained linguist is by J. N. Kalleris: *Les anciens Macédoniens,* I (Athens, 1954); II 1 (Athens, 1976). Unfortunately it is not yet completed, though the linguistic portions probably are. It clearly shows the nature of the evidence. Discussion of individual words, especially the ancient glosses, takes up a large part of the work (I, 57–288). It constantly shows the difficulty of studying words in isolation from structure. Many of the words Kalleris regards as dialectal Greek have been taken by eminent predecessors as non-Greek; and this is not to be refuted by his repeated imputations of anti-Greek prejudice (an idea that would never have occurred to most of them). His success, much of the time, in finding Greek dialect forms that may be related only points up the difficulty of placing an isolated word firmly in the context of one Indo-European language rather than another—especially when those languages were in constant contact, in an age totally devoid of linguistic nationalism or exclusiveness. In most cases, even the distinction between *centum* and *satem* languages will not help. All that can usually be offered is an alternative explanation. Where this is not possible, Kalleris tends to resort to emendation of the text—in most cases legitimately, perhaps: emendation is often needed in difficult texts. But it again helps to underline the uncertainty of the whole business in the present state of our knowledge.

2. It is the one advantage of the foreigner that he can more easily avoid this distraction—though (alas) not the imputation of it by those themselves affected (see notes 66 and 68).

3. N. G. L. Hammond, *A History of Macedonia.* I: *Historical Geography and Prehistory* (Oxford, 1972), 441.

4. The basic survey is still by J. Jüthner, *Hellenen und Barbaren,* "Das Erbe der Alten," n.s. 8 (Leipzig, 1923). Indeed, on the problem here discussed Jüthner is brief, decisive, and (within his set limits) unsurpassed (see 28–32).

5. See Hammond in N. G. L. Hammond and G. T. Griffith, *A History of Macedonia.* II: *550–336 B.C.* (Oxford, 1979), 58–60, 61–65, 99–101, documenting Alexander's trimming.

6. See Hammond (note 5). The advice to the Greeks to withdraw from Tempe (Herodotus 7.173) was obviously very welcome to Xerxes, as was Alexander's advice to the Athenians to give up the struggle and accept Xerxes' offer (Hdt. 8.140–141): this account no doubt came to Herodotus from an Athenian source (cf. Hdt. 8.143, ad fin., with its frank assessment of Alexander's role), not from the Macedonian source at Alexander's court. The advice at Plataea (Hdt. 9.44–45) was certainly useful to the Greeks, but if they were even moderately alert, they would not have failed to notice Mardonius' preparations for battle, which took place only after dawn; it therefore made little effective difference. Still, this service was remembered in his favor (see note 7).

7. Hammond notes that there is no evidence in Herodotus of any attacks by Alexander on the retreating Persians after Plataea (see note 5, 101). But Herodotus simply does not mention Alexander. As Alexander could not have got back to Macedonia in time to attack the main retreating forces under Artabazus, who naturally made all possible speed (Hdt. 9.89), he may well have harried the rear of the army and cut off stragglers. (He did not stay behind for the council of the Greeks, which is reported in detail.) He would have been foolish not to do so, at this stage. In the fourth century, there was a (confused) tradition of his doing a great deal at this juncture (see paragraph below). But though that cannot be used as real evidence, it seems to follow from the Greeks' later gratitude to him, and the fact (see note 6) that he had not done much for them during the war itself, that some services were rendered at this stage. As we have seen, Herodotus does not seem to have had Alexander's own account of the war, though he had a report going back to Alexander on other matters.

The fourth-century version appears in Demosthenes 23.200: there "Perdiccas" (carefully described as the Macedonian king at the time of the Persian invasion) is said to have received Athenian citizenship as a reward for "having destroyed the retreating barbarians and completed the disaster to the King." The confusion with Perdiccas is startling, and the suggestion that he received Athenian citizenship does not fit in with anything we know about Athenian practices at the time. The passage follows one (Dem. 23.199) detailing an award of citizenship to a Meno of Pharsalus, "when [he] had given us twelve talents of silver for the war at Eion near Amphipolis and had come to our assistance with three hundred cavalry of his own *penestae*." There is a slight complication: the two examples are repeated, almost verbatim, in [Demosthenes] 13.23–24, except that there it is explicitly claimed that not citizenship but *ateleia* was granted. However, it may be regarded as certain that the author of that compilation of uncertain date had no source other than Demosthenes, whom he adapted to his own purposes. We must treat Demosthenes 23.199–200 as we find it.

The Meno episode could conceivably belong to the Peloponnesian War, where a Meno of Pharsalus did aid Athens at one time (Thucydides 2.22.3). But it is not conceivable that Thucydides, of all men, would not have mentioned his aid at Eion *suo loco.* Moreover, Demosthenes seems to assign the two grants to the same general period: the time of the Persian Wars. Hence Meno belongs to the capture of Eion in the 470s. The precise specification of the benefits conferred, in return for which the grants were made, suggests an actual document as a source; they would be thus detailed in the ἐπειδή clause introducing the resolution. And the error about the person of the Macedonian king (and perhaps also the specification of Eion as, anachronistically, "near Amphipolis") would

suggest composition in the fourth century, when fifth-century history was much more appealed to by the orators than known. We should at least consider whether we may here have specimens of a further class of documents (citizenship awards) that belong within the context of what Christian Habicht noted twenty years ago: the engraving, in fourth-century Athens, of fictitious documents allegedly reproducing fifth-century originals of the age of the Persian Wars. See C. Habicht, "Falsche Urkunden zur Geschichte Athens im Zeitalter der Perserkriege," *Hermes 89* (1961), 1-36.

8. For the story of the assassins disguised as female companions, see Herodotus 5.19-21. It is rightly disbelieved by Hammond (note 5), 98 f., and must be later apologetic invention.

9. Herodotus 5.22 tells the story in detail, with a reference to his later account of the genealogy of the Macedonian kings (8.137-139). Oddly enough Hammond, rightly critical of Herodotus' "Macedonian" interpretation of Alexander's part in the war (note 5, 98 f. et. al.), accepts the story of the Argive descent and its associated king-list without hesitation (ibid., 3 ff.), as he seems to accept the wording of Herodotean speeches as precise and reliable historical evidence (101, note 4, not citing the actual source). It is in those speeches and nowhere else that we get Alexander's claim, already at the time of the war, to be of Greek descent and a benefactor of the Greeks, and that the Athenians (Hdt. 8.143, ad fin.) confirm that he is their friend and benefactor.

It is perhaps worth pointing out that it was precisely in 476 that Themistocles received an ovation at the Olympic Games (Plutarch *Them.* 17.4); also that at another panhellenic center, soon after the war, Themistocles propounded a policy of forgiving Medizers and keeping them within the Greek community—as an insurance against Spartan domination (Plut. *Them.* 20.3; cf. perhaps Pausanias 10.14.5-6: heavily encrusted with legend, but presumably built on a true report of a Delphic embassy). It was most probably in 476 that Sparta showed Thessalian ambitions (Hdt. 6.72; cf. Paus. 3.7.9). That date for Leotychidas' expedition has been argued by many, best perhaps by K. J. Beloch, *Griechische Geschichte* II2 2 (Berlin, 1916), 191-192 (though his argument for a two-

year campaign, 477-476, is not convincing). It might be comforting, in that year, to have that benefactor of Athens, Alexander I, within the Greek community. It was from Alexander's territory that Themistocles later sailed to Asia (Thucydides 1.137.1-2).

10. The ancients had two strictly etiological etymologies for the Argeads: from Orestian Argos or from a putative Argeos, son of Makedon: see Hammond (note 3), 431, for the references. Hammond's elaborate story of the migrations of the Argead Macedonian tribe (430-440 and passim), remote from ancient literary sources, forces him to reject the Argead name as the royal dynasty's (433, giving some of the evidence for this and adding: "But the dynasty was a foreign one. . . ."). His justification for his acceptance of the (to our knowledge) relatively late claim to descent from the Temenids, in this context, must be quoted (cf. also note 15): ". . . the fact that the claim was accepted without question by Herodotus and Thucydides alike makes its authenticity practically certain." (That it was *not* accepted by the competitors at Olympia when they first heard it, nor—as this paper will try to show—by many Greeks after, is perhaps relevant.) *That* argument would authenticate the hegemony of Agamemnon, the return of the Heraclids, and much more that is not (like the Argead story) merely common to Herodotus and Thucydides, but agreed on by many other sources as well, indeed never questioned by Greeks of the classical age.

11. The Argive tripod, displayed in the exhibition at Thessalonike (1978), was not shown in the exhibition in Washington (1980-1981). Professor Andronikos' suggestion was made in a lecture in Washington. Professor Habicht has drawn my attention to *REG 64* (1951), 173, no. 137: a silver phiale originally dedicated at Megara, but found in a third-century Macedonian tomb, and perhaps brought to Macedonia as booty. The Argive tripod could be a recently captured item, deposited in the royal tomb because of its obvious sentimental value to an Argead king.

12. This was done by Euripides: see Hyginus *Fabulae* 219 and, for the papyrus and the right interpretation, Hammond (note 5), 5, 11.

13. On the Caranus story, known in several variants, see the extensive discussion by Hammond (note 5), 5-14 (Justin's version translated, 12); for the meaning of the name, 11-12. Hammond does not regard the story as authentic.

14. The Caranus story, of course, reinforces the claim to Dorian affinity by turning the Dorian element into an actual band of invaders from Peloponnesus. As such, it might well fit the time of Archelaus, whose attempt to reinforce and confirm the decision obtained by Alexander (possibly with mixed success) will occupy us below. Hammond suggests that time for its invention, since he believes that its connection with the founding of Aegae places it before the capital was moved to Pella ([note 5], 5-6, concluding: "most probably within the years *c.* 407-*c.* 400"). The time of Archelaus remains possible and suitable, but his argument is weak. Aegae was never forgotten as the original capital; and the condition that the first king and all his line must dwell there could be deemed to be perfectly satisfied by its remaining the ritual capital and containing the royal burial places.

15. Herodotus, after reporting the decision, continues with a phrase that has been debated ad infinitum (5.22): καὶ ἀγωνιζόμενος στάδιον συνεξέπιπτε τῷ πρώτῳ. There can be no irrefutable interpretation, since Herodotus nowhere else uses the verb in anything like a comparable phrase. However, the translation ". . . and ran a dead heat for the first place" (Godley in the Loeb edition), despite objections that were raised (against its models) in the last century and have at times been raised since, seems the only acceptable one. It is based on the fact that Plutarch *Moralia* 1045d quotes Chrysippus' propounding a hypothetical case in a contest for the judge to decide and discussing the way the decision should be reached. The case is described as follows: ὑποθέμενος δύο δρομεῖς ὁμοῦ συνεκπίπτειν ἀλλήλοις. Although this was written two centuries after Herodotus, technical language tends to survive; and it is clear that, at any rate by Chrysippus' time, the verb was a technical term of the agonistic vocabulary. Since Herodotus uses it in an agonistic context, it should therefore be taken to have the same meaning. This would also explain why it is nowhere else used in a comparable sense: Herodotus had no similar scene to describe,

and the occasions for its use were naturally very limited.

However, it is inconceivable that a king, attaining that position, should be denied the verdict by the judges. On the other hand, it is a fact that Alexander's name does not occur in the list of victors for the *stadion*, which survives complete well beyond the relevant period. This has considerable bearing on the veracity of the whole of the "Macedonian" tradition transmitted by Herodotus. Strangely enough, Hammond seems to be ignorant of the fact that the victor list survives in the first book of Eusebius. See his comment (note 5), 3, note 1, in giving reasons why the Macedonian kings' claim to Temenid descent should be accepted: "The Hellanodicae were convinced; Herodotus and Thucydides had no doubts in the matter; *and it was easy to check in the list of Olympic victors that Alexander won the stadion . . . in a particular year*" (italics mine). On the first two points see note 10 with text. The third can be taken as decisive *against* Hammond, who, however, failed to perform the "easy check" for himself.

16. Solinus 9.16 is the only attestation, some time between c. A.D. 250 and 390. (See H. Walter, *Die "Collectanea Rerum Memorabilium" des C. Iulius Solinus,* Hermes Einzelschriften Heft 22 [Wiesbaden, 1969], 73-74.) The passage on Archelaus is so extraordinary that the whole of it must be quoted if the reader is to appreciate it.

> ab hoc Archelaus regnum excepit, prudens rei bellicae, navalium etiam commentor proeliorum. hic Archelaus in tantum litterarum mire amator fuit, ut Euripidi tragico consiliorum summam concrederet: cuius suprema non contentus prosequi sumptu funeris, crinem tonsus est et maerorem quem animo conceperat vultu publicavit. idem Pythias et Olympiacas palmas quadrigis adeptus, Graeco potius animo quam regali gloriam illam prae se tulit.

The creation (apparently) of the Macedonian navy; the love of literature that made him appoint Euripides his chief adviser and mourn the poet's death by shaving his head; finally the Pythian and Olympic victories displayed as befitted a Greek rather than a king—one can only wonder as much where all this stuff came from as what, in detail, some of the language means. There is a modicum of known fact: his *prudentia rei bellicae* comes, remotely, from Thucydi-

des' famous characterization; his patronage of Euripides was common knowledge. Whether this suffices to make the otherwise unattested two panhellenic victories credible, each reader must decide for himself. It should perhaps be added that in what precedes, the succession of Macedonian kings is explicitly listed as Caranus-Perdiccas-Alexander-Archelaus. Hammond (note 5), 150, accepts the victories without discussing the context.

17. Thrasymachus F 2 (H. Diels, ed., *Die Fragmente der Vorsokratiker,* 6th ed., by W. Kranz [Dublin-Zurich, 1951]). For the Macedonian "Olympics" see Diodorus 17.16. 3-4, putting the sacrifice and the contest to Zeus and the Muses at Dium; Arrian 1.11.1 says that the games to Zeus were held at Aegae and seems to put the sacrifice in the same place; the games to the Muses are added as a *logos.* Dium, the traditional sanctuary of Zeus, seems the more likely site, and Arrian may be mistaken; but until the site of the games is found, we cannot be certain.

18. On Archelaus see also the two preceding notes. For his technical achievements, the *locus classicus* is Thucydides 2.100.2. On his character, see especially Plato *Grg.* 471 and passim: Socrates makes him the type of person who has become rich and powerful through crimes and is therefore wrongly regarded as happy by the ignorant; but after his wicked life he will be punished by the judges of the underworld (ibid. 525). It is a neat touch that he is among those judged by Rhadamanthus, who judges "those from Asia" (524a and e), like the Great King; not by Aeacus, who is in charge of Europeans (524a). That Plato was, at any rate, not misrepresenting Socrates' opinion of Archelaus is shown by an anecdote in Aristotle *Rh.* 2.1398a, where Socrates explains why he refuses to visit Archelaus: he implies that he does not want to risk finding himself helpless in the king's power. Aelian *VH* (we do not know from what source) reports a witticism by Socrates against Archelaus in connection with his having his palace painted by Zeuxis. (Socrates says that people will now go to see the palace, though not Archelaus.)

For Zeuxis and the various poets at the court, the references are assembled in *RE,* II (1895), 447 (cf. 445); add Zeuxis' making

the king a gift of his painting of Pan (Pliny *NH* 35.62).

19. Alexander "Philhellen": see the evidence assembled by Hammond (note 5), 101, note 3. As he says, it is all late; but as it includes Harpocration, there is good reason to think that the term was found in fourth-century sources. Further than that we cannot trace it, and it is possible that it was in fact coined in the fourth century and does not derive from any contemporary source. Hammond's idea that the term was coined "to distinguish Alexander from his greater successor of the same name" is unlikely, unless we assume that it came from circles that wanted to ascribe anti-Hellenism to the latter. Kalleris has promised a treatment of this matter, which will no doubt appear in the second part of his vol. II (see note 1).

For the Lyncestians, Molossians, and Enchelei, see Strabo 7.7.8.326. The original date of these claims is unknown, but Neoptolemus I, an early member of the Second Athenian Confederacy, was certainly born and named in the fifth century. It is likely that the Lyncestians and Molossians were in fact imitating their Argead neighbors.

20. The evidence on this is complex and cannot be discussed at length here. See G. Karl Galinsky, *Aeneas, Sicily, and Rome* (Princeton, 1969), chaps. II-III. Galinsky shows that Odysseus actually precedes Aeneas, both in Sicily and among the Etruscans. Even apart from the Aristonothos krater, of the seventh century, Aeneas is demonstrable c. 525 (p. 121). See also P. J. Riis, in *Entretiens sur l'antiquité classique* 13 (1967), 70-71 (Aeneas at Vulci c. 520), 83 (Aeneas at Veii in second quarter of fifth century).

21. Herodotus 1.56, 8.43: the Lacedaemonians, Corinthians, Sicyonians, Epidaurians, and Troezenians are of "Dorian and Macedonian" stock. (1.56 repeats the idea.) There is no reason to think that Thucydides accepted it: he resolutely puts Macedonian contingents among barbarians, e.g., 2.81.6; 4.124.1. It is difficult to follow Hammond (note 5), 45, in claiming that this referred to a stage of culture: "The question of language was entirely separate." (He also applies this to Thrasymachus' remark, quoted in note 17 and text.) He does not attempt to prove that Thucydides, or Greeks of his generation, used the

term barbarian to indicate people whom they considered speakers of a Greek dialect; while we know from the very etymology of the word that "barbarians" were people whom Greeks could not understand. For those who accept their testimony, Aristophanes confirms it.

22. Cynisca (see Plutarch *Ages.* 20.1; Xenophon *Ages.* 9.6). On Archelaus' reported victory, see note 16.

23. Hellanicus, *FGrHist* 4 F 84. But the story, current in Italy even earlier, may well have appeared in earlier Greek writers, as the Odysseus myth quite probably did. (See note 20.) It was essentially the Greeks who furnished ambitious barbarian peoples with the materials of their "ancient history," especially as they had long been given to mythological speculation linking peoples by common descent. For one such, the common origin of Aeolians, Ionians, and Dorians—i.e., confined to Greeks—see the discussion by Hammond (note 3), 271 f. He believes that the "names indicate the common origin in Thessaly of three tribally and dialectically distinct groups of the Greek-speaking people." (He has to admit that the story is not quite adequate: we have to add the northwest Greeks, not put into the family as a separate line by the ancients.) The speculations that derive the Persians from Perseus and relate them to the Spartan kings and the Egyptians (via Acrisius) are detailed for us in Herodotus (6.53). They give us the measure of the worth of the information we find on the kinship of nations in the Greek myths.

24. Hammond (note 5) rightly calls the period covered by his chapter IV (167-200) "A Period of Instability." The chapter covers the years from the death of Archelaus to the accession of Philip II (399-359).
A very unfortunate typographical error in the exhibition catalogue *The Search for Alexander* (Yalouris, Andronikos, and Rhomiopoulou; Boston, 1980) has accidentally suppressed this period and thereby not only distorted the whole development of Macedonian history, but cheated Philip of the credit he deserves. On page 23 of the catalogue, in the list of Macedonian kings, the date of Archelaus' death appears as 359 instead of 399, so that Philip becomes his immediate successor. It is to be hoped that this error will be corrected in any new edition. Rarely has a misprint

conveyed so much misinformation!

25. See the royal soap opera narrated in Justin 7.4.7, 7.5.4-8; cf. scholia on Aeschines 2.29. Obviously, the story has been embroidered by Hellenistic fiction. But it cannot be treated as cavalierly as it is by Hammond (note 5), 183, who writes the whole of it off as "poppycock," for the reason that "it bears no relation to the procedure in the Assembly of the Macedones against those who were detected in a treasonable plot." Fortunately this kind of *staatsrechtliche* fundamentalism has now been dealt two blows from which it will not soon recover. See R. A. Lock, "The Macedonian Army Assembly in the Time of Alexander the Great," *CP 72* (1977), 91-107, and R. M. Errington, "The Nature of the Macedonian State under the Monarchy," *Chiron 8* (1978), 77-133. (Neither of these articles could yet be known to Hammond.)

26. Justin 7.5.9-10 says that Philip was for a time the guardian of young Amyntas, son of Perdiccas. Diodorus (16.1.3) calls him king from the start and gives him twenty-four years on the throne, which is certainly false. Neither of these sources, on its record, inspires much confidence. But since Justin has an explicit statement, difficult to regard as later fiction, it has usually been believed. J. R. Ellis ("Amyntas Perdikka, Philip II and Alexander the Great," *JHS 91* [1971], 15-24) has argued against it, proposing (very implausibly, in view of the political circumstances) that *IG* VII. 3055 (Lebadeia), calling Amyntas king, belongs in the context of a conspiracy against Alexander after Philip's death. I suspect the argument may be misconceived. It is quite possible that Philip was from the start entitled to be called king, but was originally expected to let Amyntas come to the throne (perhaps only as his successor) in due course. I do not want to give the impression that I believe Macedonian *Staatsrecht* provided for such cases, but there may have been an expectation of what was appropriate (a νόμος); and we might compare the case of Antigonus Doson and Philip V (the only parallel I know of, though later). I still find it difficult to believe that Justin's statement is pure fiction. He does not exploit it as a weapon against Philip, as one would expect if it were—far from it: it contributes to Philip's glory. Yet it is unlikely to have been invented for that purpose.

27. For a summary and discussion see Griffith (note 5), 210-211.

28. Aeschines 2.32, claiming documentary evidence, therefore probably to be believed. Of course there is no reason why a Macedonian king should not be represented by an envoy at an international congress. It is only Aeschines, in 343, who gives the impression that it was an exclusively *Greek* congress. The date of the particular meeting has been difficult to establish. It may even be that Amyntas was represented as a member of the Second Athenian Confederacy, if (as is the most common view) the congress was the one of 371. (See Hammond, note 5, 179.) In any case, the incident has no bearing on the kings' claim to "Hellenism," let alone the Macedonians'.

29. Under Antigonus Doson: see F. W. Walbank, *A Historical Commentary on Polybius,* I (Oxford, 1957), 256.

30. See Griffith (note 5), 453-454: "There was no question of the Macedonian *ethnos* achieving membership now in place of the Phocians. . . . It was on Philip personally and on his descendants that membership was conferred." The whole context is to be highly recommended for an excellent discussion of some of the problems treated in this paper.

31. See Griffith (note 5), 206 ff. The story about the restriction imposed for admission to hetairic status comes from the anecdotalist Carystius of Pergamum, one of Athenaeus' favorite sources. The term used, at any rate, is that Euphraeus συνέταξε τὴν ἑταιρείαν in such a way as to forbid participation at the king's meals to those who did not know geometry and philosophy.

32. Carystius is a mere gossip, though he must have had good sources. The "letter of Speusippus" has for fifty years been recognized as genuine, almost alone in the corpus of philosophers' letters, ever since the eloquent defence and analysis by E. J. Bickermann and J. Sykutris, *Speusipps Brief an König Philipp,* Ber. über die Verh. der Sächsischen Akad. der Wiss., Phil.-hist. Klasse 80.3 (Leipzig, 1928). The case is by no means decided, and most of the learned editors' arguments were irrelevant. As Bickermann himself put it (31): "Zum grösseren Teil sind die im Briefe enthaltenen Nachrichten und Notizen für die Echt-

heitsfrage nichtssagend." The same applies, even more strongly, to the linguistic analysis. Fortunately the letter makes little contribution to our present purpose. (But it does elsewhere: e.g., Griffith, note 31.)

33. Griffith (note 31).

34. The story is a favorite of anecdotalists; see (best) Justin 12.16.6 and Plutarch *Alex.* 3.5 (adding, to the Illyrian success, the fact that he had at that moment just taken Potidaea). The chronology is difficult to check in detail, and for Parmenio's Illyrian campaign we have no controls at all. But Alexander was probably born on 6 Hecatombaeon, whereas the Olympic victory was about July 26: see S. G. Miller, "The Date of Olympic Festivals," *AthMitt* 90 (1975), 229-230. This makes the approximate coincidence of the items credible. I do not want to digress into discussion of the well-known problems of the Athenian calendar. But it is generally agreed that Hecatombaeon was the first lunar month that began after the summer solstice. (See, in general, A. E. Samuel, *Greek and Roman Chronology: Calendars and Years in Classical Antiquity.* Hd. d. Alt. I.7 [1972], 64, with note 1.) In 356, the new moon phased in Athens about 7:30 p.m. on July 14. (For the precise time, see E. J. Bickerman, *Chronology of the Ancient World* [Ithaca, N.Y., 1968], 115, given, of course, in GMT.) If that day was 1 Hecatombaeon, Alexander was born on July 19. The difference, in any case, will not be more than a day or two.

All of this, incidentally, decisively proves that these were not the Macedonian "Olympics," but the real ones. The Macedonian festival was between campaigning seasons, not in summer (see the sources cited in note 17: we do not know even an approximate date, but the season as such is certain).

35. This vast topic has been interminably discussed. For a good survey, see G. Dobesch, *Der panhellenische Gedanke im 4. Jh. v. Chr. und der "Philippos" des Isokrates* (Vienna, 1968).

36. Xenophon *Hell.* 6.1.

37. The invasion is discussed in all the standard works, most recently by Harry J. Dell in *Philip of Macedon,* eds. M. B. Hatzopoulos and L. D. Loukopoulos (Athens, 1980), 98-99 (unfortunately without notes). For more detailed discussion of the facts (not of the purpose), see Griffith

(note 5), 554-566 and continuing, in part, to 584. I have discussed this in an article, "Philip II and Thrace," forthcoming in *Pulpudeva 4.*

38. See W. Jaeger, *Aristotle²* (Oxford, 1948), 112-120, on Hermias and Aristotle's appointment to Macedon. (On the political nature of the appointment, especially 120.) Whether Aristotle was still a member of the Academy at the time, or whether his departure from Athens went along with "secession," cannot be discussed here. But as Chroust has pointed out, it is likely that his departure was caused by political events; and there is a late tradition, in a well-informed source, that Speusippus later invited him to become head of the Academy. On this, see A. H. Chroust's collection of essays, *Aristotle* (London, 1973), 117-124.

39. Nicomachus (Diogenes Laertius 5.1), who traced his ancestry to Asclepius himself (Dionysius Halicarnassensis, *Epistula ad Ammaeum* 1.5; D.L. 5.1; and various late biographies). Aristotle, born in 384/3 (ibid.), must have spent much of his youth at the court of Pella, but we do not know when Nicomachus went from Stagira to Pella, nor when he died.

40. *FGrHist* 115 F 224-225. (For the Thessalians, see F 162.)

41. But it probably goes too far to deny the association altogether. (Thus Chroust [note 38], 125-132.) Along with some rather poor arguments, Chroust does make it clear that most of the attestation is late and heavily embroidered, and that contemporary sources do not mention it where we might expect them to. But the various forged Hellenistic letters dealing with the association were no doubt based on a tradition that it had existed, and the treatises *On Kingship* and *On Colonists,* recorded as addressed to Alexander, are no doubt genuine. (On the latter see note 45.)

42. These would be required reading, especially in view of Philip's Persian campaign, but also in view of Alexander's practical interests: see the anecdote in Plutarch *Alex.* 5.1 (perhaps not wholly credible as it stands). For Herodotus we have better evidence, not usually noticed. There can be little doubt that Alexander's plan for crossing the Danube (Arrian 1.3.3—mistranslated in the second Loeb edition), involving ships sent from Byzan-

tium up the Danube, must be inspired by Darius' famous crossing (Hdt.4.89, 4.97). Of course, he may have read this with Lysimachus.

43. On his emulation of Homeric heroes, see, e.g., L. Edmunds, "The Religiosity of Alexander," *GRBS* 12 (1971), 363-391, esp. 372-374. (Page 368: "He slept with the Greek language and a Macedonian weapon under his pillow.") For the Homer of the casket, see especially Plutarch *Alex.* 8.2; cf. 26.1-2. The other sources are collected by J. R. Hamilton, *Plutarch Alexander. A Commentary* (Oxford, 1969), 20-21. Plutarch assigns the "recension" to Aristotle, and the details vary. Note Edmunds' conclusion (370): "If Alexander gained anything from his study with Aristotle besides an admiration of Pindar and Homer, not a trace of it is reflected in his life." (Cf. note 41 with text.)

44. Plutarch *Alex.* 9.1. The regency must include the time of the siege of Perinthus, earlier in 340, although it is not mentioned in Plutarch (who is not concerned with historical *akribeia,* as he tells us): Philip did not return home between the two sieges, which followed closely upon each other, and cannot have made new provisions.

45. Plutarch (note 44). The site of Alexandropolis has not been identified. On the foundation, see Hamilton (note 43), 22-23; add (on Aristotle's treatise) my note in "Alexander the Great and the Unity of Mankind," *Historia* 7 (1958), 442.

46. Arrian 3.6.5; Plutarch *Alex.* 10.4 (omitting Laomedon, even though he tells the story in great detail). The surprising omission in both sources is that of Hephaestion. We should probably conclude from this that Hephaestion was not among Alexander's earliest friends, despite the attested intensity of the friendship later on. (See W. W. Tarn, *Alexander the Great* [Cambridge, 1948], 2.78.) In fact, the only source (apart from the *Romance*) that makes them childhood friends is Curtius (3.12.16), in an elaborately written introduction to the scene with Darius' mother (cf. the *logos* in Arrian 2.12.6). Apart from this *logos,* the earliest mention of Hephaestion in Arrian is in another *logos,* regarding Alexander and Hephaestion at Troy (1.12.1).

47. See below. Professor Mylonas suggested in the discussion after my paper at the symposium in Washington (Novem-

ber 1980) that Philip perhaps refrained from employing Greeks because he had good reason to distrust them, since they had so often betrayed him. This does not seem to me a likely motive. Philip did use Greeks on various diplomatic missions (e.g., various Athenians to carry messages to Athens and, best known, Python of Byzantium in 344/3). However, embassies sent from the court on official state business, e.g., the one to Athens in 346 (see Theopompus, *FGrHist* 115 F 165), consisted of prominent Macedonians.

48. On Erigyius see H. Berve, *Das Alexanderreich auf prosopographischer Grundlage* (Munich, 1926), 2.151-152; on Nearchus, ibid. 269-272, and cf. my article, "Nearchus the Cretan," *YCS 24* (1975), 147-170.

49. Laomedon, Erigyius' brother, obviously lacked military ability, but had linguistic talents unusual in a Greek of his day. See Berve (note 48), 231-232. These young men, who had grown up in Philip's kingdom and were described as "Macedonians," will have acquired an adequate knowledge of the Macedonian language (see below).

50. Note particularly the arrangement of the list of trierarchs in Arrian *Indica* 8.18: Amphipolitans are put among Macedonians and contrasted with "Greeks." On all this, see the complicated speculations on the Macedonian "law of citizenship" by Hammond (note 5), 647-652, rightly describing the result of his system as a "complex state." As in other respects (see note 25), such schematic elaborations of fourth-century Macedonian *Staatsrecht* are entirely modern and academic. Hammond makes many useful points and collects the main sources (though he nowhere warns us that reference to autonomous Macedonian "cities" is not found before Philip II; indeed, he implies the opposite). But we should not picture Philip's state as provided with a Department of Immigration and Naturalization, or its citizens as carrying identity cards.

51. On Hellenistic Macedonian cities, where the evidence is better, see A. Giovannini, *Untersuchungen über die Natur und die Anfänge der bundesstaatlichen Sympolitie in Griechenland,* Hypomnemata 33 (Göttingen, 1971), 76-83 (see 80 on the "gradual

Hellenization" of the country and its administrative consequences).

52. It is possible, of course, that some of the men whom we know as courtiers had come to Pella straight from Greece and had been given estates elsewhere that gave them *polis* citizenship. Thus Nearchus was "a Cretan by birth, but resident at Amphipolis on the Strymon" (Arrian *Indica* 18.10). Hammond (note 5), 648, rightly connects citizenship with a grant of land, but does not notice that Nearchus was exiled from Pella as early as 336 (sources, note 46). He cannot have "resided" at Amphipolis at any time after this, and presumably not for some time before.

53. For Alexander's mercenaries, see Diodorus 17.17.3 (probably to be accepted). The number serving under the Persian King is (as with all such figures) never reliably stated. Pausanias' figure of 50,000 (11.25.5) shows us what to expect, as does the figure of "nearly 20,000" (Arrian 1.14.4) at the Granicus. (They take no part in the fighting, and all but 2,000 are later massacred!) At Issus 30,000 are reported (Arrian 2.8.5); there is no way of reasonably conjecturing the true figure. On the other hand, the 8,000 said to have escaped from Issus (see note 57 with text), presumably a fair proportion of all who fought there, may be accepted, as their story is unconnected with battle figures and is given in detail (though not without its own contradictions). Since there must have been mercenaries in other parts of the empire, the King certainly had many more—probably several times more—than Alexander.

54. Arrian 1.16.6. Whether he had a *right* to do so, as *hegemon,* without consulting the Council of the Greeks (cf., e.g., Plutarch *Alex.* 55.9), was not a question that would greatly trouble him.

55. Thus the Athenians got their citizens back in the spring of 331 (Arrian 3.6.2)—precisely when Alexander first heard about the beginning of a rebellion in Peloponnesus (Arr. 3.6.3). The two events cannot be unconnected.

56. First at Miletus (Arrian 1.19.6): "But when he saw that those on the island were prepared to fight to the end, he was seized with pity for the men, because they seemed noble and loyal men to him, and he

made an agreement with them on condition that they should fight on his side."

57. Issus: I have discussed these 8,000 in "Harpalus," *JHS 51* (1961), 26, with source references. Gaugamela: Arrian 3.16.2 mentions the escape of 2,000 mercenaries (Curtius has a different figure), but we have no figures for those who took part in the battle. Their final departure from Darius: Arr. 3.21.4. (They were unsuccessfully pursued by Craterus: Arr. 3.23.6.) Their surrender after being deserted by Artabazus and his sons: Arr. 3.23.7-9. (By that time there were about 1,500 left.) Terms: Arr. 3.24.5.

58. References to the ample modern treatments are unnecessary. The main sources: Arrian 7.6 and 8; parallel treatments in the inferior sources.

59. Arrian 7.23.3-4. Though the details are very specific and must be accepted, Arrian does not tell us (and presumably did not know) how many men and units were involved in the reform. Berve (note 48), 1.121, takes it as a reform embracing the whole army. But in view of the highly experimental nature of the proposed combination of different armaments and mobility in small units, it is almost inconceivable that Alexander was intending to dismantle the whole of the Macedonian phalanx (the best infantry in the world) in order to change over to this completely untried system on the eve of a major campaign. Were there solid evidence for such a plan, there would be no escape from concluding that Alexander was by then insane.

60. As far as I can see, we have no information about cavalry. What will henceforth be said about separation of Greeks and Macedonians in the army should be taken as applying to infantry, even where this is not explicitly repeated.

61. Kalleris (note 1), II 1, 473-478, quite rightly insists that the rhetoric of Curtius cannot be regarded as evidence, though his quotation of Tarn at his worst (477, note 1) and a serious methodological confusion over Polybius do not help his case. As regards Polybius, he insists on the authority of Polybius as superior to that of Curtius, ignoring the fact that Polybius' testimony refers to his own time, more than a century after the events described in Curtius. In the same way, Plutarch cannot be used as a reliable source on this point.

62. We cannot here analyze the complicated tradition on the death of Clitus. See Hamilton (note 43), 139-145, with references to earlier discussion. Nothing particularly useful has been added since.

63. Arrian 4.9.5. (Cf. 4.8.1-2, preparing for it.)

64. The word is used in Plutarch *Alex.* 51.6. It is not in Arrian, who has (no doubt by design) a much abbreviated and less flamboyant account based (in this part) on the same source. See Kalleris (note 1), II 1, 478-479; 485-486 (with long discussion of the verb μακεδονίζειν in between). He explains it as "un signe que le roi se trouvait dans une situation extrêmement critique" (486), quoting Plutarch's own interpretation as evidence. He forgets what he himself rightly had to say about the opinions of late authors as evidence. In fact, but for the evidence of the papyrus (see note 65 with text), the word in Plutarch would have been impossible to interpret accurately, as is shown by attempts made before 1950 and by some since. Hammond carries the basic error to extremes: "The use of the Macedonian language was an indication of a civil commotion for which military intervention was needed" (note 5, 46, note 2). Plutarch would have been as surprised as the original actors by this overinterpretation. In his discussion of this passage Hammond shows no awareness of the papyrus.

65. *Editio princeps* by Bartoletti in *PSI,* XII 2 (1951), no. 1284. It was at once recognized as a fragment of Arrian's *Successors* by K. Latte; see (now) *Kleine Schriften* (Munich, 1968), 595-599. Recently, A. B. Bosworth has republished it and put it in its proper historical setting: "Eumenes, Neoptolemus, and *PSI* XII 1284," *GRBS* 19 (1978), 227-237.

66. Kalleris (note 1), II 1, 486-487, has a brief comment on the papyrus, apparently added after he had completed his main treatment. He describes the speaker as "un Grec nommé Xénias" and "capable d'imiter parfaitement la prononciation et les idiotismes du macédonien" and, on this basis, tries to explain why the man was used by Eumenes. For this interpretation he cites the support of Jacoby. The whole interpretation is unfortunately invalidated by a piece of carelessness. The man's name (actually copied correctly by Kalleris in his

transcription of the Greek text, 487, note 2) is Xennias, not Xenias. Now, Jacoby did not know, but Kalleris himself did and indeed amply illustrates (I, 293), the fact that consonantal gemination is a characteristic of ancient Macedonian, though it is found sporadically in various Greek dialects. In our particular context, the *obvious* interpretation must be accepted.

In view of the defined purpose of this paper, I am not concerned with the argument (again of interest to linguistic specialists, but not to historians) as to whether Macedonian was a "dialect" or a "language"—not that we know enough about it to be able to discuss the point. I have been told by native speakers of various Slav languages (including some rather distantly related) that they can understand each other's native language for many ordinary purposes. Yet these are rated as separate languages. The decision in such cases often depends on political factors; as, e.g., when Afrikaans became a separate language after being regarded for generations as a despised dialect of Dutch. In antiquity, where there is no linguistic nationalism, Greek became the *Kultursprache* of many tribes, especially in the Hellenistic age, without their being closely related to Greeks. What is important in our context, at any rate, is not this rather abstract question, but the much simpler (although, of course, more subjective) one of mutual intelligibility.

67. On Eumenes we have the biased, but nonetheless valuable, account of his kinsman Hieronymus of Cardia, transmitted in various degrees by Diodorus and Plutarch. His difficulties can therefore be followed in some detail. Note that he never became a "Macedonian" (Arrian *Indica* 18.7).

68. Kalleris' work, scientifically of high quality, is often made unacceptable in its conclusions by precisely this intrusion of nonacademic motives and methods—oddly enough, after he has charged various eminent German-speaking scholars with (of all things) the political motive of "pan-Illyrianism." Political sentiments based on the survival of nineteenth-century nationalism ought to have no place in academic discussion. We are all guilty of enough errors without them.

69. Isocrates 5 (*Philip*) 106-108:
ὅ τε κτησάμενος τὴν ἀρχήν, μεῖζον
φρονήσας τῶν αὑτοῦ πολιτῶν καὶ
μοναρχίας ἐπιθυμήσας, οὐχ ὁμοίως
ἐβουλεύσατο τοῖς πρὸς τὰς τοιαύτας
φιλοτιμίας ὁρμωμένοις. Οἱ μὲν γὰρ
ἐν ταῖς αὑτῶν πόλεσι στάσεις καὶ
ταραχὰς καὶ σφαγὰς ἐμποιοῦντες
ἐκτῶντο τὴν τιμὴν ταύτην, ὁ δὲ τὸν
μὲν τόπον τὸν Ἑλληνικὸν ὅλως εἴα-
σεν, τὴν δ' ἐν Μακεδονίᾳ βασιλείαν
κατασχεῖν ἐπεθύμησεν· ἠπίστατο
γὰρ τοὺς μὲν Ἕλληνας οὐκ εἰθισμέ-
νους ὑπομένειν τὰς μοναρχίας, τοὺς δ'
ἄλλους οὐ δυναμένους ἄνευ τῆς
τοιαύτης δυναστείας διοικεῖν τὸν βίον
τὸν σφέτερον αὐτῶν. Καὶ γάρ τοι συν-
έβη διὰ τὸ γνῶναι περὶ τούτων αὐτὸν
ἰδίως καὶ τὴν βασιλείαν γεγενῆ-
σθαι πολὺ τῶν ἄλλων ἐξηλλαγ-
μένην· μόνος γὰρ τῶν Ἑλλήνων οὐχ
ὁμοφύλου γένους ἄρχειν ἀξιώσας,
μόνος καὶ διαφυγεῖν ἠδυνήθη τοὺς
κινδύνους τοὺς περὶ τὰς μοναρχίας
γιγνομένους. Τοὺς μὲν γὰρ ἐν τοῖς
Ἕλλησι τοιοῦτόν τι διαπεπραγμέ-
νους εὕροιμεν ἂν οὐ μόνον αὐτοὺς
διεφθαρμένους, ἀλλὰ καὶ τὸ γένος
αὐτῶν ἐξ ἀνθρώπων ἠφανισμένον,
ἐκεῖνον δ' αὐτόν τ' ἐν εὐδαιμονίᾳ
τὸν βίον διαγαγόντα τῷ τε γένει
καταλιπόντα τὰς αὐτὰς τιμὰς ἅσπερ
αὐτὸς εἶχεν.
On this, see also Griffith (note 5), 453, following and explaining the natural implication of the passage. Indeed, this seems to be the only major point of interpretation on which Griffith differs from Hammond.

70. We have seen that Alexander himself marks an as yet imperfect fusion of Greek and Macedonian. It is legitimate to suggest that it was Philip's policy, as embodied in himself, that gave Alexander the idea for his own extension of it to Iranians when he had conquered them—particularly since in the end, as the Susa marriages and the adoption of the children of the Macedonian soldiers' children show, he too seems to have settled for the next generation to solve the problem that for the present had turned out insoluble.

71. Thus in the salons of the German aristocracy at the court of Copenhagen, French was the language spoken, as is amply attested. The Schimmelmanns, who presided over the most resplendent of the salons, took a serious interest in Ger-

man literature; yet in a letter to the count's young secretary, Barthold Georg Niebuhr, who had just announced his engagement, the countess, writing in German, complains that she has no practice in doing so. (I copied the letter in the Royal Archive in Copenhagen.) Indeed, her German (known also from some other letters) is awkward and full of mistakes, unlike her French. The count himself frequently wrote in German. An interesting correspondence with Niebuhr (which I also copied there) survives, as yet unpublished. His German, though better, is also far from perfect. In fact, when, as a young man, he had tried his hand at literature, he wrote in (excellent and classical) French. We tend to look at ancient problems in artificial isolation.

72. Not surprisingly, Arrian had great difficulty in dealing with this antagonism or, even at the best, felt difference between Greeks and Macedonians that he found in his sources. P. A. Brunt has usefully collected the relevant passages (in his Loeb edition of Arrian, I. xxxvii, note 33). If we consider the ones in the *Anabasis* (the ones in the *Indica* are of a different nature: see note 51) we shall find that nearly all are in speeches, clearly written by Arrian himself. One that is not (2.10.7) describes the fighting between the Macedonian phalanx and Darius' Greek mercenaries at Issus: καί τι καὶ τοῖς γένεσι τῷ τε Ἑλληνικῷ καὶ τῷ Μακεδονικῷ φιλοτιμίας ἐνέπεσεν ἐς ἀλλήλους. Closely following his source (it is at once followed by the almost "lapidary" prose recording the death of Ptolemy son of Seleucus and about 120 eminent Macedonians), the passage illustrates the kind of thing that must have given Arrian the inspiration for the speeches. In the speeches he solves his problem (for, as Brunt rightly points out, an ethnic difference between Greeks and Macedonians was in Arrian's own day so remote as to be practically beyond understanding) by making the Macedonians into a kind of *tertium corpus*, distinct from both Greeks and barbarians. (See, most clearly, 2.7.4-5; 4.11.8—not successful!) It should perhaps be added that where Brunt sees an inconsistent view (2.14.4: εἰς Μακεδονίαν καὶ εἰς τὴν ἄλλην Ἑλλάδα), including Macedonia in Greece, there is no need to do so. There is a well-known Greek idiomatic use of ἄλλος in which it means (roughly) "as

well." See R. Kühner, *Ausführliche Grammatik der griechischen Sprache,* 3rd ed. by B. Gerth, II.1 (Hannover-Leipzig, 1898), 275, note 1, citing (i.a.) Thucydides 7.61 and, perhaps more important in assessing Arrian, Xenophon *Hell.* 2.4.9, as well as numerous other passages, starting with Homer. (They refer to a similar use of *alius* in Latin and parallels in some modern languages.) In view of the unanimous testimony of the other passages collected by Brunt, this one must surely be taken in the same way, as "pleonastisch zur Hervorhebung des Gegensatzes."

73. See my discussion (note 57), 26-27 (with sources and the principal modern references).

74. See note 73. The main account is in Curtius 9.7. Diodorus (17.99.5-6), as so often, is guilty of confusion.

75. Herodotus 6.13-14.

76. Diodorus 18.7. The elaborate story that Perdiccas had ordered the massacre, out of fear that Pithon would form the rebels into a private army, is absurd on its face. Perdiccas, more than anyone, must (as regent) have been concerned about the safety of the frontier, which these men guaranteed. Their promise to return to their stations must have been precisely what Perdiccas would want. One can only presume that this tale of Perdiccas' responsibility for the slaughter is part of the anti-Perdiccan propaganda that is so prominent through large sections of our sources on the time between the death of Alexander and the death of Perdiccas. It may be relevant to recall that Pithon, who had most explaining to do in this connection, was later the leading conspirator in the assassination of Perdiccas. (See Diodorus 18.36.5.)

77. See note 57, 36-40.

78. *IG* II² 448, lines 43-45; 505, line 17; 506, line 9. In view of occasional attempts to interpret the phrase "the Hellenic War" in a politically neutral sense, the explicit statement of the first of these documents (the nearest in time: honors for Euphron of Sicyon, 318/7) should be quoted in full: [ἐπὶ τοῦ πολέμο]υ τοῦ Ἑλληνικοῦ ὅν ἐ[ν]ε[στήσατο ὁ δῆμος ὁ Ἀθηναίων ὑ]πὲρ τῶν Ἑλλήνων. Cf. also Hyperides 6 (*Epitaphios*), full of references to Athens' defense of the freedom of the Greeks. Note especially the parallels between the defense

of Greece against the Persians in 480 and against Antipater and the Macedonians now:

6.12 Ἐντεῦθεν δ' ἐλθὼν εἰς Πύλας, καὶ καταλαβὼν τὰς [παρ]όδους δι' ὧν καὶ πρότερον ἐπὶ τοὺς Ἕλληνας οἱ βάρβαροι ἐπορεύθησαν, τῆς μὲν ἐπὶ τὴν Ἑλλάδα πορείας Ἀντίπατρον ἐκώλυσεν, . . .

6.37 Λέγω δ(ὲ) τοὺς περὶ Μιλτιάδην καὶ Θεμιστοκλέα καὶ τοὺς ἄλ|λους, οἵ, τὴν Ἑλλάδα ἐλευθερώσαντες, ἔντιμον μὲν τὴν πατρίδα κατέστησαν, ἔνδοξον ⟨δὲ⟩ τὸν αὑτῶν βίον ἐποίησαν· 38 ὧν οὗτος τοσοῦτον ὑπερέσχεν ἀνδρείᾳ καὶ φρονήσει, ὅσον οἱ μὲν ἐπελθοῦσαν τὴ⟨ν⟩ τῶν βαρβάρων δύναμιν ἠμύναντο, ὁ δὲ μηδ' ἐπελθεῖν ἐποίησεν.

79. Cf. Polyaenus 5.104 (speech of Agelaus of Naupactus). I should like to express my thanks to the Institute for Advanced Study, where this paper, both in its original version as delivered at the symposium in Washington, D.C., and in its full version for publication, was written during my stay as a visiting member; also to Professor Christian Habicht, who read the final version and gave me some useful bibliographical references.

The Alexandrian Age: Alexandrian Literature with Special Reference to Alexandrian Poetry

C. A. TRYPANIS

Athens

AT ALEXANDER'S DEATH in June 323 B.C., Greece, united for the first time since Mycenaean days, stretched her rule to the Indus in the East, and from South Russia to Egypt in the North and South. Only in the West was Greek influence contained by the power of Carthage and Rome.

But as we all know, after Alexander's death his empire shrank and split, and Greece proper was no longer the only or even the main center of influence and wealth. We need not go into the violent wars of Alexander's Successors. It will suffice to say that with the battle of Ipsus (301 B.C.), the dream of Antigonus I to reassemble the whole of Alexander's conquests under his own rule was shattered, and that it was the battle of Corupedion (281 B.C.) which fixed the main political boundaries of the Hellenistic world for the next hundred years.

Our historians in this symposium will no doubt deal not only with Alexander and his immediate Successors, but also with the Roman conquest of the Greek world —Egypt, the last Hellenistic kingdom, fell to the Romans, as you may remember, in 30 B.C.—so I need not go into that. I should like,

however, to stop for a moment at an important event in the East: the defeat of Antiochus III near Sipylus in 190 B.C., which enabled the small state of Pergamon to become a large power over all of Asia Minor. This became possible, of course, only because of Roman support.

Perhaps the most important political and cultural phenomenon of the Alexandrian era is that the city-state gave way to the notion of empire, a notion severely attacked by classical theorists and tyranny-fearing democracies. The narrow limits of the classical polis were overthrown, and the *oecumene*, the inhabited world, was opened up for the Greeks to settle in and to spread their civilization. Thus we see the vast Hellenistic monarchies emerging with their mixed populations, their crowded capitals, their great increase in wealth and luxury, and their endowed institutions of learning.

The endeavor of Alexander to fuse Greek and Persian elements into a new cultural unit, which had caused such a violent reaction from his Macedonian soldiers, was abandoned by his Successors, who, following in the footsteps of the old Macedonian kings—the

tradition of Archelaus and Philip II—became the supporters and patrons of Hellenic art and culture, even though the real end of "classical culture" was already evident before the Macedonian Greeks came on the scene. The result of this, which also protected Alexandrian literature from any direct Oriental influence, was evident chiefly within the walls of the many newly founded cities that sprang up along the great trading routes to the East; for, outside, the vast "barbaric" populations— Egyptians, Persians, Syrians, Jews, etc.—retained their languages, their religions, and their cultures.

Together with the end of the independent city-state we also see the traditional religion of the Olympian gods deeply shaken among those Greeks who witnessed the power of the gods pale before the human "saviors" and "benefactors," who could undoubtedly help and rescue their friends. The skepticism and the doubt which had already challenged all accepted views since the fifth century was now triumphant. Hellenistic man felt abandoned and alone with royal patronage and protection as his one hope, and the goddess

TRYPANIS *53*

Tyche—Fortune—as the only deity in whom he came to believe.

These political and social changes had naturally enough a deep and lasting effect upon the Alexandrian men of letters. For whereas classical Greece recited, sang, and discussed through the medium of the city-state—poet, architect, and sculptor felt the same responsibility towards the state that the legislator and the statesman felt—the Hellenistic men of letters withdrew from their fellow men and avoided the multitude. Poets, scholars, and scientists wrote and worked as specialized individuals, secure in their libraries and studies, totally uninterested in public life, in fact often feeling a deep contempt for the *profanum volgus*. Their works were directed to a limited public of appreciative connoisseurs—an audience of specialists—and all they asked for was a powerful patron and peace in which to classify and study the new material the conquest of the East had provided and the vast literary output of classical Greece, which was amassed in the Hellenistic libraries and which like a *damnosa hereditas* absorbed and oppressed their lives.

Athens, the capital of the Greek classical world, was still a significant center of learning and culture—after all it was then that she gave the world New Comedy —and her major philosophic schools were in full action; but every day shrouded her deeper in the silence of a capital in decline, a city where the past was more significant than the present and contemplation more appropriate than action. The real center of the economic and cultural life of the Greeks had shifted to Alexandria, the city founded by Alexander in

332-331 B.C. to be the capital of the Universe, a role Fate denied her. However, under the Ptolemies Alexandria achieved great cultural and artistic excellence when they chose her to be the capital of their own Egyptian kingdom. She became the undisputed literary and scholarly capital of the Greek-speaking world, and in the early Alexandrian centuries consciously moved away from the direct influence of Attic literature, which for centuries had dominated the literary scene.

Ptolemy I, at the instigation of Demetrius of Phaleron, the peripatetic philosopher and statesman who had taken refuge in Egypt, established in the grounds of his palace in Alexandria the museum with its great library, which became the true center of learning and culture of the entire Hellenistic world. This was organized on the pattern of an Athenian philosophic school and housed a band of scholars—all worshippers of the Muses—exempt from taxation and supported by a generous salary granted by the Ptolemies, who appointed a president, an *Epistates* or *Hiereus*, as head of the institution. The office of the *Epistates* was an important one—the holder was also responsible for the education of the Crown Prince—and men of great excellence held it. The buildings, splendidly furnished, included a great library, a communal dining hall, an *exedra* for discussions and lectures, and a *peripatos* with trees.

How strange state-supported scholars and poets appeared to the Greeks can also be seen by the spiteful lampoon of Timon of Phleious, which compares the museum with a coop in which, instead of wild animals and exotic birds,

the king feeds for his pleasure scholars and poets who, as opposed to the animals, "keep up their endless fights."

The Ptolemies spared themselves no pains to concentrate in the libraries of Alexandria the vast literary inheritance of classical Greece. Thus the great library of the museum had amassed in the reign of Ptolemy II the huge number of 490,000 books—later the number rose to 700,000—and the daughter library of the Sarapeion, which was probably founded in the reign of Ptolemy III, numbered 42,800 volumes.

Initially, the Ptolemies entrusted the arduous task of classifying this vast literary material to three poets, because only poets could find their way about in that mass of mythological and dialectal texts. Thus Zenodotus of Ephesus undertook to classify epic and lyric poetry, Alexander Aetolus, tragic, and Lycophron of Chalcis, comic verse.

To Callimachus later fell the hard task of preparing a catalogue of the books of the Alexandrian Library. This, known as *The Tables*, the *Pinakes*, filled 120 volumes and contained the name and biography of every author, a list of his works —even if not extant—the first line of every extant work, as well as the number of verses, if it were a poem. This huge enterprise—all books from Homer to the last cookery-book in the library were catalogued—was, of course, of unique significance in the history of Greek literature.

The classification, copying, and emendation of that formidable body of classical authors not only gave birth to the new science of scholarship, but also influenced the course of Greek poetry. For the

first Alexandrian scholars were, and considered themselves primarily, professional poets—literature had become a profession—and their acquaintance with that great corpus of literary material had a tremendous influence upon their art. It proved an insupportable burden—as "classics" in any language often are—which suffocated nearly all attempts at creative originality. At one level, they were naturally spellbound by the linguistic wealth and the perfection of form Greek literature displayed from Homer to Menander; but at another they realized they were incapable of breaking free and creating new types of poetry as the Ionians had created the epic and the Athenians, drama. In their search for novelty the furthest they dared to venture was to mix and to mingle the old, clearly defined forms of poetry, which gave them the sense that they were creating and yet not shattering the spell of tradition. This resulted in the same man trying his hand at a variety of poetic genres, a practice almost unknown in the classical world, and in the breaking down of the old traditional division of poetry into epic, lyric, and dramatic.

The tradition of the scholar-poet, which began with Antimachus of Colophon in the fourth century B.C., was followed by his successors almost as a matter of course. Thus we have poets of the Golden Age of Alexandrian poetry, like Aratus who believed he was versed in astronomy; Eratosthenes who was a mathematician; Nicias, the doctor friend of Theocritus, and Nicander, who were versed in medicine; Callimachus, Lycophron, Alexander the Aetolian, Apollonius Rhodius, and Rhianus, who were grammarians,

lexicographers, literary critics, and literary historians, to mention only some of the leading figures of those days. Although very little of their work survives, it appears that Philetas and Simias and their contemporaries experimented in most of the poetical forms which the next generation of Alexandrians favored, i.e., narrative elegy, epyllion, catalogue poetry, hymn, iambus, didactic poem, epigram, and paignion. To these the poets of the Golden Age of Alexandrian poetry (c. 290-c. 240 B.C.), who continued to compose epics in the grand manner and to experiment in tragedy, added the pastoral. Unfortunately, little can be established of Alexandrian tragedy, though its seven most famous poets were known as the Tragic Pleiad.

In their search for novelty—the spirit of "exploration" is characteristic of that period—the highbrow Alexandrian poets turned to scholarly and highly polished verse, which became the criterion of great art, and which for Callimachus and his followers was valid only if employed in poems of a limited length; for them "a long book is a great evil." This attitude often led to an artificial and fastidious style, delighting in the use of archaic words, scholarly allusions, literary dialects, and a number of intricate and varied meters known by the names of the poets who had used them. The effect of many of those poems is decidedly bizarre and pedantic, and by no means in keeping with the grand and sweeping lines of the rest of Hellenistic art, the great temples and palaces, the grand mosaics representing the battles of Alexander, or the majestic pathos of the sculptures of the altar of Pergamon or the statues of Laocoon and the dying Gaul.

Moreover, as true religious feeling had declined in the Hellenistic world the ancient gods and heroes were humanized and often reduced to mere aesthetic figures, and the traditional panhellenic myths were avoided as having been too often used in the past and therefore no longer exciting. Fresh sensational episodes from mythology and especially local myths with an etiological content—those that gave cause for the establishment of a cult or the foundation of a city—were now sought after, for the object of poetry, even of Alexandrian didactic poetry, was not *prodesse*, but *delectare*.

At the same time, traditional patriotism gave way to court flattery—and often revolting court flattery like the praises sung for the hair of Queen Stratonice who was bald—and love, both ideal and sensual, came to take a central position in all poetry, a development due to the Euripidean legacy and the realism and individualism which were prevalent in the Hellenistic world. In fact, the portrayal of all kinds of love is achieved with astonishing insight and detail: from the ideal passion of Medea for Jason in the Argonautics of Apollonius Rhodius to the low prostitute practices in the mimes of Herodas and the homosexual love of the epigram. Later—in the days of Parthenius—this culminated in a morbid interest in unnatural passion and erotic crime realistically portrayed. All this, together with the rest of Alexandrian pornographic literature, was transferred to Rome and continued there until the exile and the death of Ovid.

Moreover, big-city life, which developed in the Hellenistic world, brought about a yearning for the tranquillity of country life and the

lost peace of humanity, such as we find in the bucolic poets, the true precursors of the Roman *ruris amatores*. This turn to the simple and the rustic brought children, slaves, animals, and landscape into Alexandrian verse, subjects on the whole beyond the scope of classical poetry.

But it should be remembered that in spite of their limitations and the fury of bigoted pedantry with which they waged their war against the followers of the big traditional epic, it was Callimachus and his school who embarked in the only serious endeavor to renew and revitalize the Greek poetic tradition even if, as it appears, they finally did not win the day. Through the classical centuries no such attempt had been made.

Unfortunately, we cannot follow today the details of the literary battle among whose protagonists were Callimachus and his pupil Apollonius Rhodius. It is quite possible that personal and even political differences became involved in this embittered dispute that obliged Apollonius to withdraw to Rhodes. At the same time it should be born in mind that side by side with the scholarly, pedantic, and aristocratic atmosphere of the museum, the library, and the court, which to a certain extent determined the more stately forms of Alexandrian literature, the "cyclic" poetry of the traditionalists and the new style championed by Callimachus and all scientific writing, there existed the great and varied population of the capital of the Ptolemies, indeed of every Hellenistic city, for whose taste "lower" literary forms were cultivated. Recent discoveries of papyri have revealed to us the existence of a popular satiric and moralizing literature which—in spirit at least—is quite alien from the products of the highbrow Alexandrians. Along with this we should take into account what may be called the popular amusement literature of the age, a mass of writing for which it is hard to find a comprehensive name, but which may be loosely denominated as "The Mime and Its By-Products," whose farcical and humorous and frankly sensual features entertained the lower classes. And together with this the papyri have brought to light the existence of a lower popular medicine.

Strange as it may appear, the highbrow aristocratic and the low literary trends, no matter how opposed to one another, interacted and exercised a mutual influence; and continuous commerce of scholarly and realistic elements clearly took place between them. In fact, the clearest connecting link between them is to be found in such writers as Theocritus and Herodas, who handled the popular material according to the principles of Alexandrian art.

The example of the Ptolemies was followed by other Hellenistic kings who fostered art and letters. In Pella, the Macedonian capital, Antigonos Gonatas gathered about him a circle of distinguished poets and philosophers; in Antioch, Antiochus Soter built a great library which was to influence profoundly the later development of Greco-Syrian literature; and most important of all, the Attalids of Pergamon attempted to develop a center of learning around a library that would compete with the Alexandrian Museum. And Alexandrian literature did not flourish only in these courts, but spread along the shores of Asia Minor and onto some of the adjacent islands such as Samos, Cos, and Rhodes, penetrated into the Peloponnesos and reached Southern Italy and Sicily, and up to Armenia in the East.

What is striking is that although Alexandrian literature flourished in so many centers and its poets were born in towns as far apart as Syracuse and Soloi or Tarentum and Naucratis, it has strikingly common features and a common literary atmosphere. This is greatly due to the important foundations of learning like the Museum of Alexandria or the Library of Pergamon, that in a sense set the fashion in the literary life of their day. It is also due to the great development of the book trade, the common curricula of many schools of rhetoric and grammar that had spread across the Hellenistic world, the great festivals organized by the Hellenistic kings— festivals like the Alexandria, the Ptolemaia, the Seleucia, the Demetria, the Eumenia, etc.—and the various professional troupes or guilds of poets, actors, singers, instrumentalists, trainers of choruses, etc.—all fashioned on the pattern of the Athenian *synodos* of the third century that journeyed from city to city performing in theaters or taking part in various competitions on the stage or in the orchestra. At the same time a great number of smaller shows (*epideixeis*) were organized in which poets and orators competed before wide audiences. So there was no lack of opportunity for the new Alexandrian trends to become known and plenty of incentive for poets to compose new works. Nor should the works on agriculture, medicine, astrology, mathematics, or natural science go unmentioned.

It is true that the study of Alex-

andrian literature is hampered by our ignorance of its true relationship to the literature of the fourth century B.C. For we know a great deal about Attic prose of that century, but very little about Attic or indeed Greek poetry of those years. However that may be, it was not until Atticism set in, in the first century B.C., that the Greeks reacted against Alexandrianism and Alexandrian poetry, a reaction due to moral, aesthetic, anti-Eastern, and pedagogical reasons. It was then that the Alexandrian writers, especially the poets, with very few exceptions, ceased to be copied and read and were thus consigned to an oblivion from which only very few things have been rescued. We must try to piece together everything else from scanty ancient quotations and the papyrus scraps retrieved in the last and present century from the sands of Egypt.

But no matter how important for the history of Greek literature and the culture of the Western world and how interesting as poetry and philosophy the writings of the Alexandrian age may be, it should be born in mind that all the conditions of those days tended to foster science rather than literature. Hence the third and the second centuries B.C. are the great years of Greek natural science, medicine, mathematics, and scholarship, and not of creative literature. To a certain extent, this accounts for the short duration of the Golden Age of Alexandrian letters, extending only from about 290 to 240 B.C. After that, with the exception of a few *epigonoi* like Euphorion, Eratosthenes, Rhianos, Moschos, Bion, and some epigrammatists, poetry seems to have been at a discount. It was not until Parthenius brought the Alexandrian theory of poetry to Rome in the age of Sulla that Callimachus again became influential, even though his teachings were expressed in a new language and addressed to a different society and to people gifted with other qualities than those of the Greeks.

A Reconsideration of the Pixodaros Affair

MILTIADES B. HATZOPOULOS
The National Hellenic Research Foundation, Athens

PLUTARCH'S NARRATIVE of the events that preceded Alexander's accession to the throne presents the most explicit and detailed surviving evidence of the young prince's complicity in his father's assassination. At the same time, it preserves the unique account of the Pixodaros affair.[1] This is no mere coincidence. Indeed, it has long been recognized that in Plutarch's narrative Philip's marriage with Kleopatra, the violent incident at the wedding banquet, Alexander's and Olympias' flight from Macedonia, and the young prince's return and new conflict with his father, on account of the abortive marriage plans with Pixodaros' daughter and the banishment of Alexander's closest companions, form a fatal concatenation of events and constitute the indispensable logical and historical premise for the understanding of the momentous step, taken by the heir apparent, to instigate a frustrated and perhaps mentally deranged young man to slay his father, his stepmother, and her uncle.[2] However, it has been E. Badian's particular merit to draw attention to the conclusive importance of the Pixodaros affair, which provides definitive proof of the precariousness of Alexander's

reconciliation with his father and of his unmitigated sense of insecurity.[3]

That this is indeed the impression that Plutarch, or rather his source, meant to convey is a fact that nobody can or has challenged. What has more and more come under question recently is whether this highly dramatic version of the events that led to Philip's assassination should be accepted as a reliable historical document.[4] My contention is that a decisive test is readily provided by the crucial Pixodaros affair: if it could be reasonably argued that Plutarch's account is chronologically impossible as it stands, and if even with the help of the other narratives of the same events no likely story can be reconstructed in which Alexander's exhortations to Philip's assassin-to-be can actually be placed *after* the new estrangement due to the Carian marriage fiasco, a case could be made that we are in fact dealing with a literary creation which has adroitly, but misleadingly, rearranged the actual sequence of events in order to make up a good story and, at the same time, to prove a moral point.

* * *

In Plutarch's narrative, after Al-

exander's self-inflicted exile and his return to Macedonia, and after the Pixodaros affair, the following events succeed in close logical and chronological sequence: the outrage suffered by Pausanias at the instigation of Attalos and Kleopatra, the unfortunate young man's frustration at not obtaining justice from the king, and, finally, Olympias' exhortations and especially Alexander's unambiguous incitation to kill τὸν δόντα καὶ γήμαντα καὶ γαμουμένην ("the giver of the bride, the bridegroom, and the bride").[5] Although, as a rule, no precise chronological references are given, the order of presentation and the implicit logic of the story leave no doubt that the reader is meant to believe that the events described in these paragraphs happened in that order after the Pixodaros affair. This impression is strengthened by the only explicit indication about the relative date of Alexander's fatal decision to become an accomplice before the fact in his father's assassination. The encounter between the young prince and the assassin-to-be, who was "bewailing his fate," is described as having taken place μετὰ τὴν ὕβριν ("after the outrage"), which in plain Greek can only

mean soon after and not several years later.[6] Now, we know that this cannot be so. Although recent attempts have again been made to postulate an Illyrian campaign for the year 337,[7] it has been rightly established since the beginning of this century that this campaign has existed mostly—and then again merely by implication—in the imagination of later and not wholly trustworthy writers.[8] As I argue elsewhere, the Illyrian war that saw Philip's wounding (in the collarbone), as well as the wounding of 150 Companions, and the death of not some otherwise unknown second Pausanias but Kleopatra's own brother Hippostratos took place in the sixteenth year of Philip's reign, i.e., probably during the campaign season of 345.[9]

The references to Olympias' parallel exhortations, instead of clarifying, complicate matters further.[10] On top of the chronological problem just mentioned—which applies to her case as well, since we are meant to believe that her action also followed closely Pausanias' outrage and the king's denial of justice—we do know that she had left Macedonia the day of Philip's wedding with Kleopatra, not to return before her husband's assassination.[11] It needs some stretching of the imagination to believe that her efforts to secure her husband's assassin can date before her rival's definitive victory, or alternatively, to envision the exiled queen organizing regicide by correspondence, or—even more far-fetched—secret meetings with the future murderer on some deserted crest of Mount Pindos.[12]

It can be argued that it is unfair to submit a late summary or paraphrase, written nearly half a millennium after the event, to such a close scrutiny. Therefore if, with the help of other surviving sources, a less absurd dating could be established of the decision by Pausanias to kill Philip—at Alexander's instigation or not—it should be readily taken into consideration, despite all the internal inconsistencies and contradictions of Plutarch's relevant paragraphs.[13]

Now, thanks to Justin and Diodorus, we happen to know the "precise" events that provoked Pausanias' decision to kill Philip. Although recent attempts[14] to date Pausanias' humiliation to February 336 must probably be dismissed as too contrived, it is true that all the other ancient sources correlate Pausanias' explosion of indignation (at least several months and probably several years after the outrage itself) with Attalos' nomination as one of the commanders of the Asian expedition and with his imminent departure, an event which would now frustrate all hopes of justice or revenge.[15] This is explicitly stated by Justin[16] and is equally implied by Diodorus' narrative, according to which Philip's reluctance to punish Attalos was not only due to the king's recent marriage with Kleopatra, but also to the fact that his new relative "had been selected as a general of the advanced [sic] force being sent to Asia."[17] Thus, the two other surviving detailed accounts date—if not the actual humiliation—the reactivation of Pausanias' grudge and his resolve to take justice into his own hands to the period between Philip's decision to send an advance force to Asia and its actual departure, that is between winter 337/336 and early spring 336, and in no case later than that.[18] This is implicitly also confirmed by Alexander's alleged ex-

hortation to Pausanias to kill "the giver of the bride, the bridegroom, and the bride,"[19] which, in order to make sense, requires a date not long after the marriage and, at the same time, Attalos' presence in Macedonia, where he would still be within Pausanias' reach.[20] This is the most we can do to put some order and reason into a narrative that is cruelly lacking in both.

I shall now try to establish that the Pixodaros affair cannot have occurred when we are meant to believe it did, that is sometime between Alexander's return from Illyria and his conspiracy with Pausanias. As already stated, according to the logic of Plutarch's narrative, in the same way that the violent scene of the wedding banquet marks the beginning of Alexander's estrangement from his father, the episode of the abortive alliance with Pixodaros constitutes the decisive proof that the attempted reconciliation between father and son through the good offices of Demaratos was neither thorough nor definitive. Both incidents are equally necessary in the perspective of the (rightly or wrongly) suspected complicity of Alexander in his father's assassination.

The story is well known. Pixodaros the satrap of Caria approached Philip through a certain Aristokritos,[21] probably an actor, proposing to him the marriage of his eldest daughter[22] with Arrhidaios, Philip's eldest, but mentally deficient son from Philinna, an obvious way of entering into a Macedonian alliance. Alexander's mother and friends had no difficulty in persuading the young prince that the dynastic marriage was but the first step in his father's plan to replace him as successor by

his elder and idiotic brother. Alexander, in order to thwart this (imaginary or real) danger, sent his favorite actor Thessalos[23] to convince Pixodaros that "he ought to ignore the bastard brother who was a fool" and instead to marry his daughter to Alexander himself. This new and better prospect delighted Pixodaros, but Philip, on being informed of his son's untimely initiative, went with Philotas to Alexander's room and reprimanded him "in that he desired to become the son-in-law of a man who was a Carian and a slave to a barbarian King." Philip not only humiliated Alexander before his friend Philotas, but also enjoined the Corinthians to deliver Thessalos to him bound in chains and banished his son's closest companions from Macedonia. Thus, we are led to believe that Alexander was still smarting from such a humiliation when he took the fatal step of using Pausanias as the tool for his revenge.

As one can readily see, Plutarch's account is fraught with difficulties. Some improbabilities, such as the highly unlikely terms of Alexander's castigation by Philip, have been pointed out by several modern scholars.[24] To these more could be added, e.g., the absurd characterization of Arrhidaios as a bastard[25] or the alleged order to the Corinthians for Thessalos' arrest, which was never carried out[26] notwithstanding the presence of a strong Macedonian garrison at Corinth.[27] More serious doubts about the historicity of the Pixodaros affair stem from the fact, repeatedly discussed in recent years,[28] that neither Arrian[29] nor Strabo[30]—both of whom preserve a fairly detailed account of Carian history during this period, and

particularly of the relations of the last Hekatomnids with the Macedonians—know anything about such an incident.[31] Moreover, Arrian, in a different passage,[32] explicitly correlates the banishment of Alexander's companions not with the Pixodaros affair but with the initial estrangement between father and son because of Philip's marriage with Kleopatra. Yet all these improbabilities, inconsistencies, and contradictions, which separately taken might be explained away, are eclipsed by—or rather become merely subsidiary sources of corroborative evidence before—the utter impossibility of fitting this episode into Plutarch's chronological and logical framework, that is to say, placing it any time before the alleged conspiratorial conversation between Alexander and Pausanias.

The Pixodaros affair is generally dated, usually without further discussion, toward the end of 337 or the beginning of 336.[33] If, however, we examine the matter a little more closely, it is very difficult not to come to the conclusion that, for reasons pertaining to pure chronology as well as to historical context, it simply could not have taken place before the end of spring 336.[34]

First, the chronological reasons. The Pixodaros affair reputedly occurred sometime after Alexander's return from his self-imposed exile, following the violent altercation with Attalos and his father at Philip and Kleopatra's wedding. This wedding actually constitutes our first chronological landmark.[35] The *terminus ante quem* of the marriage is at least nine months before Philip's death;[36] in other words, the end of the year 337 at the latest, since meanwhile Kleo-

patra had given birth to a child "a few days" before Philip's assassination.[37] It is however the *terminus post quem* which narrows down the possible date of the marriage and creates the greatest difficulties for the credibility of the Pixodaros affair. Indeed, unless we should ignore our one and only piece of ancient evidence[38] and invent an *ad hoc* visit of Philip to the Macedonian court—unlikely in itself and nowhere attested, as J. R. Ellis has recently stressed[39]—this marriage took place after Philip's return to Macedonia as the elected captain general of the Hellenes for the war against the Persians.[40]

Now, G. Cawkwell[41] has rightly pointed out that our two sources, which are the only ancient evidence we possess, categorically date this event in the Athenian year 337/336.[42] Moreover, this same English scholar's masterly study of the chronological problems concerning the events that followed the battle of Chaironeia has established, with minuteness carrying conviction, that according to all the available data the conclusion of Philip's activities in Greece must be dated well on in 337.[43] Therefore, the *terminus post quem* of Philip's marriage cannot be placed before July 337, at the earliest, and should probably be situated several months later, perhaps not earlier than October, if we are to believe the only, though perhaps not wholly reliable, indication at our disposal.[44] Accordingly, Alexander's flight, his visit to Epeiros, his stay in Illyria, Demaratos' mediation, and the return of the exiled prince must have extended at least to the end of the campaign and navigation season of 337.[45] In any case, these events do not leave the necessary time for the arrival of

Aristokritos at the Macedonian court, the negotiations with Philip, the exchange of letters between Alexander and his mother, the mission of Thessalos to Pixodaros, the return of the actor from Caria with the satrap's positive answer, and finally, the discovery of Alexander's intrigues by Philip. Therefore, there is no doubt that on purely chronological grounds the conclusion of the Pixodaros affair cannot be dated before well on in the spring of 336 and probably toward the end of that season, if its beginning should be placed at the commencement of the navigation season of 336.

Now, this is precisely the dating required by the analysis of the political situation. A. Olmstead[46] had already seen that Pixodaros' initiative cannot be understood unless we take into consideration the new element of the landing of the Macedonian expeditionary force in Asia Minor at the very beginning of the sailing season (probably March 336).[47] It is very likely indeed that Pixodaros' attempt to defect from the Great King was provoked by the extremely serious events that, after a year and one-half of relative calm since Arses' accession to the throne, were shaking again the fabric of the Persian empire.[48] These events might reasonably include the Great King's assassination in May or June 336[49] and at least the landing and the progress, since the beginning of spring 336,[50] of the Macedonian expeditionary corps along the western coast of Asia Minor down to the valley of the Meander to the very borders of Pixodaros' satrapy.[51]

A. Olmstead's thesis has now found an indirect but valuable confirmation in a recent epigraphical discovery, the trilingual stele of Xanthos.[52] Without ignoring the difficulties that Badian was, after all, the first to stress, it must be admitted that his solution[53] compels recognition by its elegance, its simplicity, and particularly its fidelity to the historical context, which it respects without attempting any "arbitrary remodelling."[54] Thus, it was not Artaxerxes Ochos' death and the difficulties of Arses' accession to the throne (wrongly dated in 337) that provoked Pixodaros' betrayal of the Persian cause and his attempted *rapprochement* with Philip.[55] In all probability, in June/July 337[56] Pixodaros was still the loyal satrap of the Persian king, respectfully dating with the king's name the decrees that he inscribed on stone,[57] and considering himself well compensated for his fidelity. After all—if my interpretation of the epigraphic evidence is correct[58]—the king, soon after his accession, had again extended the Hekatomnid rule into the neighboring province of Lycia, and the satrapal place of Xanthos had become once more the second residence of the rulers of Caria.[59] It takes considerable imagination to believe, in the absence of all evidence, that Pixodaros was with one hand reorganizing his newly acquired province while with the other instructing Aristokritos to engage in treasonable negotiations with the king of the Macedonians against the ruler who had treated him so generously. From the beginning of the following spring, however, an understanding with Philip, whose generals were already encroaching on Pixodaros' insular sphere of influence[60] and were swiftly approaching the Carian dynast's frontiers,[61] was evidently a question of life and death.

If this dating is accepted, Pixoda-ros' reluctance, a few months later, to pursue his plans of alliance with Macedonia, far from being hard to explain[62] or providing evidence of the very poor relations between Alexander and his father,[63] finds a ready and obvious explanation in the reversal of fortunes which was to take place soon after,[64] when Philip's assassination threw Macedonia and the whole of Greece into confusion and stirred up uncertainties, soon to be followed by unexpected setbacks, among the expeditionary corps in Asia.[65] Pixodaros from then on had every interest not only in abandoning his unfortunate attempt, but in burying it in oblivion.

* * *

Such are the only possible (but also perfectly likely) dates of the Pixodaros affair, if it really happened. For it is largely incompatible with the chronology as well as the logic of Plutarch's account. Indeed, even with the greatest conjurer's skill it is impossible to fit that account between the conclusion of the Pixodaros affair, well on in spring 336 at the earliest, and Attalos' departure for Asia in the very beginning of the same spring. Attalos was simply not there any longer. Whether Plutarch's inability to make correct use of his source or, more probably, his source's indifference to historical accuracy is to be blamed, one must inescapably conclude that the Pixodaros affair, if not simply invented, was completely different from what Plutarch's account would have us believe, and could in no case have the significance which is usually attributed to it. Alexander may still have had reasons to instigate his father's murder, but his action was not decided

by an abortive marriage with a Carian princess. The search for the personality and the motives of the great historian and moralist (none other than Theopompos himself, in my opinion)—who first re-moulded the whole account of Philip's murder in order to prove that the king's moral disorders, intemperance, infatuation with women, and "marriages and amours"[66] brought about his ruin and that of the Temenid house —would carry us beyond the present subject and make us anticipate the conclusions of an investigation which is still continuing.[67]

Proposed Chronological Table of Major Events Referred to in the Discussion of the Pixodaros Affair

340/339	Pixodaros expels Ada and becomes dynast of Caria.
August-September 338	Battle of Chaironeia.
November 338	Murder of Artaxerxes Ochos, accession of Arses to the Persian throne.
June-July 337	Pixodaros also satrap of Lycia, loyal to the Great King, reorganizes his (newly acquired?) province.
After mid-summer 337	Return of Philip and Alexander to Macedonia after two years' absence.
Fall 337	Philip's marriage to Kleopatra, estrangement from Olympias and Alexander.
Winter 337/336	Preparations for the Asian expedition. Appointment of Attalos as one of the leaders of the advance force.
March 336	Landing of the advance force in Asia.
May-June 336	Assassination of Arses. Spectacular successes of the advance force.
Fall 336	Assassination of Philip.[1]

1. The references justifying most of these datings are to be found in the text and the notes of the article. My preference for a late dating of Philip's assassination is developed in my study on the Oleveni inscription (note 9).

Notes

I should like to thank Professor E. Badian for reading and improving this article while I was his guest at Princeton for a few days. He is not, of course, responsible for the opinions expressed. I also wish to thank Dr. J. R. Ellis who, having heard about the subject of my communication, brought me a manuscript of his (yet unpublished) exhaustive study of Philip's assassination. We had the great pleasure to realize that we had independently reached the same or similar opinions on many points. Unfortunately, I finished reading this manuscript only when I had already delivered my Washington communication, and so it was too late to take it into account in my text. All I have been able to do is to draw attention in my notes to some of the most important points, where our reasoning or our conclusions have followed a parallel course.

1. Plutarch *Alex.* 10.1-5.

2. U. Köhler, "Uber das Verhältniss Alexander's des Grossen zu seinem Vater Philipp," *SBBerl* (1892), 507, note 1; cf. J. R. Ellis, *Philip II and Macedonian Imperialism* (London, 1976), 227, and N.G.L. Hammond, "The End of Philip," in M. B. Hatzopoulos and L. D. Loukopoulos, eds., *Philip of Macedon* (Athens, 1980), 168.

3. E. Badian, "The Death of Philip II," *Phoenix 17* (1963), 245; cf. Badian, "Konrad Kraft, Der 'Rationale' Alexander," *Gnomon 47* (1975), 54-55: ". . . all hinges on the interpretation of this incident, after his return from exile in Illyria"; also J. R. Hamilton, "Alexander's Early Life," *Greece and Rome 12* (1965), 121; G. T. Griffith in N. G. L. Hammond and G. T. Grif-

fith, *A History of Macedonia,* II (Oxford, 1979), 679-680. Professor Badian was kind enough to make clear to me that he does not accept all the dramatic details of this tradition, as, for instance, Alexander's conversation with Pausanias.

4. K. Kraft, *Der "Rationale" Alexander,* Frankfurter Althistorische Studien, 5 (Kallmünz, Lassleben, 1971), 11-42; Ellis (note 2), 211-234 and 301-308 (cf. his contribution "The Assassination of Philip II," *Ancient Macedonian Studies in Honour of Charles F. Edson* [Thessalonike, forthcoming]); Hammond (note 2), 166-175.

5. Plutarch *Alex.* 10. 6-7; the English version of the famous verse (289) from the *Medea,* as all other quotations in English from Plutarch's *Life of Alexander,* are given after Bernadotte Perrin's translation in the Loeb Classical Library edition.

6. Cf. J. R. Hamilton, *Plutarch, Alexander, a Commentary* (Oxford, 1969), 27; J. Rufus Fears, "Pausanias, the Assassin of Philip II," *Athenaeum* (1975), 120-121; Ellis (note 2), 302, note 3.

7. The hypothesis originated with A. Schaefer, *Demosthenes und seine Zeit,* III (Leipzig, 1858), 58 (III² [Leipzig, 1887], 63-64), but at the beginning of this century it was abandoned after an important papyrological discovery (note 8). Its recent revival is due to N. G. L. Hammond, "The Kingdoms in Illyria *circa* 400-167 B.C.," *BSA 61* (1966), 245, note 27, who has been followed by R. L. Fox, *Alexander the Great* (London, 1973), 504 (Omega edition); Ellis (note 2), 216; 262, note 2; 302, note 3; Griffith (note 3), 473, 684-685 (in the chronological table on page 726, the year 336 is suggested, which is even harder to accept); and H. Dell, "Philip and Macedonia's Northern Neighbours" in *Philip of Macedon* (note 2), 95. It is not clear whether the readoption of this hypothesis by K. Kraft (note 4), 34-36, was influenced by Hammond's arguments or not. The revisionist trend has been resisted by E. Badian (note 3, *Gnomon),* 53-54, and G. Cawkwell, *Philip of Macedon* (London, 1978), 192, note 27.

8. F. Stähelin, "Die griechischen Historikerfragmente bei Didymos," *Klio 5* (1905), 150-151, followed by P. Foucart, "Etudes sur Didymos," *MémAcInscr 38,* 1 (1909), 118-121 [142-145]; E. Meyer, "Isokrates' zweiter Brief an Philipp und Demosthenes' zweite Philippika," *SBBerl* (1909), 758-779; and K. J. Beloch, *Griechische Geschichte,* III², 1 (Berlin, 1922), 600, note 2, making use of a recent papyrological discovery; Diels-Schubart, ed., *Didymi de Demosthene commenta* (Leipzig, 1904), cols. 12-13. For subsequent discussions of the subject until 1966, cf. Fanoula Papazoglou, "Les origines et la destinée de l'état illyrien: Illyrii proprie dicti," *Historia 14* (1965), 156-158, and Hammond (note 7), 245, note 27.

9. The chronology of this campaign is discussed in my paper "The Oleveni Inscription and Some Chronological Problems Concerning the Reign of Philip II," which will be included in a forthcoming volume of Macedonian essays in honor of Harry Dell.

10. Plutarch *Alex.* 10.6.

11. Justin 9.7.10; latest thorough discussion of Olympias' whereabouts at that crucial period, Badian (note 3, *Gnomon),* 53. His conclusions are accepted by Griffith (note 3), 685-686, and Cawkwell (note 7), 179, but apparently not by Ellis (note 2), 217; cf. 305, note 36.

12. Cf. Griffith (note 3), 686.

13. Plutarch *Alex.* 10.6-7.

14. Fears (note 6), 122; cf. Kraft (note 4), 34.

15. Fears (note 6), 123; Ellis (note 2), 224-227; 307, note 63; and now (note 4), 8-9 and 48 of the manuscript.

16. Justin 9.6.8.

17. Diodorus 16.93.9 (the English translation of this passage, as all other quotations from Diodorus, is given after C. Bradford Welles' translation in the Loeb Classical Library edition); cf. Kraft (note 4), 34. The Greek wording (ἐπὶ δὲ τῆς προαπεσταλμένης δυνάμεως εἰς τὴν Ἀσίαν στρατηγὸς προκεχειρισμένος) is not unambiguous. It is the context that requires the full etymological rendering of προ- in the verb προχειρίζω (cf. M.A.

Bailly, *Dictionnaire Grec-Français*, s.v.: "4 élire d'avance à main levée désigner d'avance, choisir auparavant."). Even if it is true that Diodorus' narrative is not lacking in absurdities, one simply cannot accept that he wants us to believe that Pausanias waited patiently until Attalos was safely away in Asia before airing his grievances to the king. This is why I consider Welles' translation as well as the other scholars' (cited in this and the next note) understanding of the passage as the only proper one.

18. The date of Attalos' departure is fixed by Justin, 9.5.8; cf. Kraft (note 4), 34-35, and especially Fears (note 6), 122, who rightly places Pausanias' complaints "in the period shortly before spring 336."

19. Plutarch *Alex.* 10.7.

20. Fears (note 6), 121.

21. Cf. H. Berve, *Das Alexanderreich auf prosopographischer Grundlage*, II (Munich, 1926), 67, no. 125, Ἀριστόκριτος.

22. Probably named Ada; cf. Berve (note 21), 12, no. 21, Ἄδα.

23. Cf. Berve (note 21), 180, no. 371, Θέσσαλος.

24. E. Badian (note 3, *Phoenix*), 245; Fears (note 6), 127-128; Ellis (note 2), 227, and (note 4), 49-51 of the manuscript; Griffith (note 3), 679, note 6; Hammond (note 2), 168.

25. Cf. now Ellis (note 4), 25 of the manuscript.

26. Berve (note 21), 180, no. 371, Θέσσαλος, with references; cf. Fears (note 6), 128; Ellis (note 2), 219; and R. Flacelière and E. Chambry, *Plutarque, Vies*, IX, Collection des Universités de France (Paris, 1975), 228.

27. Ellis (note 2), 203; Griffith (note 3), 612, with references. Ellis (note 4), 50 of the manuscript, now draws attention to the same fact.

28. Badian (note 3, *Phoenix*), 246, note 12. Cf. Hamilton (note 3), 121, note 5, and (note 6), 27; Kraft (note 4), 26-27, and note 1; Badian (note 3, *Gnomon*), 54-55; Fears (note 6), 128, note 5; Ellis (note 2), 303, note 22; and W. Heckel, "Kleopatra or Eurydike?" *Phoenix 32* (1978), 155.

29. Arrian 1.23.7-8.

30. Strabo 14.2.17 (C 656-657).

31. Badian has kindly pointed out to me that this was only to be expected in our accounts of Carian history, which were not written, as was Plutarch's narrative, from the viewpoint of Pella. This can perhaps be argued about Diodorus' (16.74.2) short notice and Strabo's longer account but—in my opinion, at least—not about that of Arrian (note 29), who is writing precisely from the Macedonian point of view. One is naturally always left with the possibility of contending—as Badian has done on a similar occasion (note 28; cf. note 32)—that Arrian's silence may be deliberate in this case also.

32. Arrian 3.6.5.

33. K. J. Beloch, *Griechische Geschichte*, III², 2 (Berlin, 1923), 143; Berve (note 21), 320, no. 640, Πιξώδαρος (cf. 12, no. 21, Ἄδα, and 295, no. 594, Ὀροντοπάτης); and more recently Badian (note 3, *Phoenix*), 245; Fears (note 6), 27; Ellis (note 2), 303, note 22; and Griffith (note 3), 679-680. The dating of this affair to 340, as suggested by Gabriele Bockisch, "Karer und ihre Dynasten," *Klio 51* (1969), 168-169, is unwarranted, to say the least.

34. Cf. A. Olmstead, *A History of the Persian Empire* (Chicago, 1948), 490; Fox (note 7), 507 and 504.

35. Only Gabriele Bockisch (note 33) seems to disregard it.

36. The old hypothesis about Kleopatra's two children, which was recently revived by Fox (note 7), 18, 504, should be shelved, as demonstrated by Ellis (note 2), 301-302, notes 1 and 4; 306, note 54 (cf. his unpublished study [note 4], 20 of the manuscript), and Griffith (note 3), 681, note 1.

37. Diodorus 17.2.3; cf. Fears (note 6), 120-121, note 27.

38. Diodorus 16.89.3.

39. Cf. Ellis (note 2), 301-302, note 1.

40. Accordingly, the dating of this marriage is not affected by the *vexata quaestio* whether the foundation of the Hellenic League and the Persian War were decided in one and the same or in two distinct meetings.

41. Cawkwell, "The Crowning of Demosthenes," *CQ 19* (1969), 167, note 5.

42. Diodorus 16.89.3; *FGrHist* 255 (= *POxy.* 12) 5. 24-25. I do not know why Ellis (note 2), 20, and Griffith (note 3), 726, in their chronological tables, date the (last) meeting of the Hellenic League at the very beginning of 337 (respectively "Winter-Spring" and "Early") and Philip's return to Macedonia and his marriage with Kleopatra in spring or summer 337. Ellis (note 2), 297, note 106; 302, note 2, does not mention the Oxyrhynchos papyrus; instead he challenges Diodorus' dates on the authority of Beloch (note 33), 299. Beloch, however, does not object to the date of 337/336 for the final meeting at which it was decided (during the winter, in his view) to make war against Persia, but wishes simply to distinguish this meeting from the meeting (late autumn or winter 338, according to his chronology) that considered the foundation of the Hellenic League. Consequently, Beloch's argumentation does not authorize someone who rejects the hypothesis of Philip's return to Macedonia between the two meetings (cf. Ellis [note 2], 302, note 1) to date Philip's return to Macedonia and marriage with Kleopatra to spring-summer 337. Equally hard to understand are Griffith's arguments; he does not discuss the date of the unique, (in his opinion) meeting at Corinth. Yet he (note 3), 681, note 1, seems not to exclude the possibility of Philip's return and marriage any time after the end of the year 338.

43. Cawkwell (note 41), 166-169; cf. Cawkwell (note 7), 176.

44. Dio Chrysostomus 2.2: cf. Cawkwell (note 7), 178.

45. It can naturally be argued, as Hammond (note 2), 168, and Ellis (note 4), 49 of the manuscript, have recently, that the episodes of Alexander's quarrel with his father and Attalos and his Illyrian self-imposed exile are not historical. This may well be so, but in such a case the Pixodaros affair, which ultimately stems from the same common source, has even less chance of being related to historical reality.

46. Olmstead (note 34), 490; cf. Beloch (note 8), 604, followed by Fox (note 7), 507.

47. Justin, 9.5.8: *initio veris*.

48. Cf. J. Pritchard, *Ancient Near Eastern Texts*[3] (Princeton, 1969), 566, with Mesopotamian evidence of a more or less successful attempt of a certain Nidin-ᵈBel to establish himself as Great King in 336/335, i.e., sometime between the reigns of Arses and Darius. I owe this information to Professor A. B. Bosworth, whom I wish to thank for his kind interest.

49. H. Swoboda, s.v. "Darius," *RE 4* (1901), 2205; Olmstead (note 34), 490.

50. Justin (note 47).

51. Cf. Beloch (note 33), 133, unless the Magnesia mentioned by Polyaenus *Strat.* 5.44.4 is not the well-known city on the Meander, but its less famous homonym on Sipylus, as Badian contends in his thorough study of Parmenio's Asian campaign: "Alexander the Great and the Greeks of Asia," *Ancient Society and Institutions, Studies Presented to Victor Ehrenberg on His 75th Birthday* (Oxford, 1966), 39-42 and particularly 63 with note 20.

52. It was discovered in August 1973 and published for the first time in "La stèle trilingue récemment découverte au Lêtôon de Xanthos," *CRAI* (1974), 89-93, 115-125, and 132-149, by H. Metzger, E. Laroche, and A. Dupont-Sommer, who presented the Greek, the Lycian, and the Aramaic text respectively (cf. J. and L. Robert, *BullEpigr.* [1974], 553). Its definitive publication by the same scholars forms now a separate volume of the *Fouilles de Xanthos, VI: La stèle trilingue du Létôon* (Paris, 1979).

53. E. Badian, "A Document of Artaxerxes IV?" in K. H. Kinzl (ed.), *Greece and the Eastern Mediterranean in Ancient History and Prehistory, Studies Presented to Fritz Schachermeyr on the Occasion of His Eightieth Birthday* (Berlin-New York, 1977), 40-50.

54. J. and L. Robert, *BullEpigr.* (1977), 472: "C'est la solution élégante, qui évite d'avoir à remodeler arbitrairement les règnes satrapiques' . . . de Mausole, d'Idrieus et de Pixôdaros." L. Robert has reiterated his adhesion to Badian's hypothesis in his article, "Les conquêtes du dynaste Lycien Arbinas," *JSav* (1978), 22, note 44. It is significant that in their definitive publication, the editors of the inscription find nothing to counterpoise Badian's arguments, except certain reservations that he himself had stressed in his own article. Naturally, it does not follow that in some instances there exist no other possible interpretations of the text than those proposed by Badian. For example, it is perhaps possible to save the traditional chronology of Pixodaros' accession to power in 340/339 (cf. Badian [note 53], 41-42, 46-47), without rejecting the obvious interpretation of the Greek text—questioned by Badian (note 53), 44-45, but maintained in the definitive publication—that Pixodaros' nomination as satrap of Lycia and subsequent appointment to other positions took place in the first regnal year of King Arses (starting in April 337). A likely hypothesis could be that the new event, as clearly stated in the epigraphic text, is not Pixodaros' accession to power in *Caria*—which is what Diodorus actually dates in 340/339—but just the restoration of the Hekatomnid rule in *Lycia*, that may well have been enacted by the new king Arses, soon after his accession in November 338 (Olmstead [note 34], 490).

55. Thus W. Judeich, *Kleinasiatische Studien* (Marburg, 1892), 252-253.

56. Cf. *Fouilles de Xanthos*, VI (note 52), 161.

57. Cf. *Fouilles de Xanthos*, VI (note 52), 167; Badian (note 53), 44.

58. See note 54. For the Hekatomnid position in Lycia, cf. Judeich (note 55), 252-253; Bockisch (note 33), 166. In this connection the importance of *TAM*, 45, recently reread by E. Laroche, *Fouilles de Xanthos*, VI (note 52), 111-112, cannot be overestimated.

59. *Fouilles de Xanthos*, VI (note 52), 161.

60. Judeich (note 55), 252; cf. 244; Bockisch (note 33), 168; cf. M. N. Tod, *Greek Historical Inscriptions*, II (Oxford, 1948), 265 (no. 192), and now A. J. Heisserer, *Alexander the Great and the Greeks, the Epigraphic Evidence* (Norman, Oklahoma, 1980), 79-95.

61. Cf. Polyaenus *Strat.* 5.44.4; cf. note 51. Even if Badian (note 51), 63, is correct and the Macedonian expeditionary force did not advance beyond Ephesos, the overall picture would hardly be affected; cf. Badian (note 51), 40: "It was not only a few islands that went over to the Macedonians, but considerable cities on the mainland. There was almost certainly far more, especially on the stretch of coast between Lesbos and Samos, than our haphazard evidence enables us to recover."

62. Cf. Ellis (note 2), 305, note 40. Ellis (note 4), 51 of the manuscript, has now independently proposed the same dates and the same explanation of Pixodaros' behavior.

63. Cf. Badian (note 3, *Phoenix*), 245; cf. Griffith (note 3), 680 and note 2.

64. Cf. Fox (note 6), 507.

65. Cf. Ellis (note 2), 219-222 and 305, note 48.

66. Plutarch *Alex.* 9.5.

67. A study on fourth-century Macedonian historiography in which I am currently engaged.

The First Months of Alexander's Reign

J . R . E L L I S
*Department of Classical Studies,
Monash University, Australia*

"AT THE AGE OF TWENTY YEARS," declares Plutarch in his biography, "Alexander received a kingdom exposed to great jealousies, dire hatreds and dangers on every hand."[1] Dealing more specifically with internal matters, the same author, in his reverential essay *On the Fortune or the Virtue of Alexander,* says "all Macedonia was in ferment, looking to Amyntas and the sons of Aeropos."[2] (Amyntas was the new king's cousin, around thirty years of age, the sons of Aeropos members of the upper Macedonian royalty or nobility of Lynkos, in the northwest of the kingdom. Very shortly afterwards, two of the sons of Aeropos were dead, executed as accessories in the regicide, and a little later Amyntas, son of Perdiccas III, was also killed, for high treason against Alexander.)[3]

The sources for Philip's assassination are of very dubious value —most of them, in my view, late, tendentious, and nearly worthless for their ostensible subject, though they shed valuable light on the propaganda of later years and decades. Those for Alexander, although of course copious, are, on top of their other deficiencies, not very knowledgeable on the details

of the earliest days of the reign, the immediate aftermath of Philip's death. It is not my purpose here to examine the assassination. My own view, currently awaiting publication,[4] is that from the material accessible to us it is impossible to go beyond, fundamentally, either the explanation of Aristotle, that the assassin was driven by personal motives, or his implication, that Philip's murderer acted on behalf of no identifiable other person or persons.[5] My intention, rather, is to see what may be reconstructed of the atmosphere of Alexander's first weeks and months as king.

This was a period heavy with significance, I think, for the young monarch's relationships with those about him and for his style of leadership. People may become locked by force of circumstances, especially by their response to particularly onerous circumstances, into a pattern of behavior from which it may be difficult to escape even when conditions change. I think Alexander found himself king prematurely and unexpectedly at a moment that can hardly have been more formidable for him.[6] His responses to the immense challenges then facing him go some distance toward ex-

plaining the kind of king he became.

I begin with the alleged treason of Attalos, uncle and guardian of one of Alexander's father's wives and one of the commanding officers of the advance force sent to prepare the way in Asia Minor for Philip's projected Eastern campaign.[7] In the sources for this affair there are serious problems of detail and chronology. Diodorus, after brief allusions to the opening of the reign, refers to Attalos as a possible rival for the throne and to Alexander's resolution on that account to kill him, fearing that he might turn for support to those southerly Greek states at that moment threatening to rise in revolt against Macedonia.[8] In the course of his account of the Hellenic defections Diodorus refers to a secret communication sent by the Athenian Demosthenes to Attalos, offering his cooperation toward the overthrow of the king. According to this account, by that time Alexander had already ordered an agent, Hekataios, to join the command in Asia Minor and to await his chance either to arrest or to kill Attalos.[9] If we accept Diodorus' narrative, Alexander appears to have reason from the very beginning to rid

himself of this commander, though he lacked an actual charge to use as instrument. Continuing with Alexander's successful move into Greece to secure for himself the panhellenic positions Philip had held, this account then has Attalos thinking better of his treacherous designs—which are assumed, never specified—and dispatching to his king Demosthenes' letter together with affirmations of his own loyalty. But this does not save him and he falls to Hekataios.[10] Diodorus then turns to events of 335.[11]

Now it has been commonly assumed that the death of Attalos occurred quite shortly, within two months or so, after Philip's death in about July 336.[12] But that is not an inference one would be justified in drawing from Diodorus' narrative, in view of both his sloppy chronographic practices and the fact that he is at this point seeking to combine two sequences of events occurring in different places, a feat he rarely accomplishes without some injury to the chronology of the originals. The best that we may infer is that his source for the Attalos story appears to place its beginning just after Philip's death. The date of its finale may be a different matter.

Plutarch, in his *Life of Demosthenes,* refers to the letter (or letters, in this case), which Demosthenes had addressed to the generals (plural) in Asia Minor, and he places these communications, again, shortly after the assassination.[13] (If he is right that all or several commanders were canvassed, it implies something much more indiscriminate than does Diodorus' account, which singles out Attalos. But we have no way of being sure.) No other author mentions the inci-

dent, though Justin may have had its context in mind when he wrote that Alexander "put to death all of his stepmother's relatives whom Philip had promoted to positions of dignity or military command."[14] He also says that this occurred "when Alexander set out for Asia"—which is especially interesting because it implies (little though it may be worth on its own) that, although the Athenian overtures may have been made in the first days of the new reign, the king's move against Attalos was not made, or at least completed, until late 335 or even early 334. In fact a date of this order is clinched by indirect testimony in Polyaenus that Attalos was still in his command after the middle of 335.[15] If, as it seems, Attalos made his declaration of loyalty a year or more after Philip's death, then it is likely that what induced him to do so was the suppression of the mutinous movements in central and southern Greece during the capture and suppression of Thebes. That was in the autumn of 335.

The matter of the alleged treason needs careful treatment. In the ructions following Philip's death, the two pieces of literary evidence which we have already noticed suggest there was evidently a concern felt among prominent Macedonians that the difficulties were too great to be overcome by the mere twenty-year-old now on the throne. In Plutarch's *Life of Alexander* we are told that he was even advised to abandon Hellenic concerns altogether so as to concentrate all efforts on holding the Macedonian frontiers.[16] This was the country to which, shortly before, emissaries from the cities of the Greek world had come bearing gifts and honors and to which

news of early military successes in Asia Minor had begun to return.[17] Now it could be recommended that all that had implied should be relinquished in desperate self-preservation. In such circumstances, when it seemed possible, even likely, that the great gains made through the long, painstaking efforts of King Philip would be lost through Alexander's inexperience, it is not surprising that some Macedonians turned to thoughts of treason.

But—if we can imagine, thus, why he might have been tempted —how could Attalos have been so fatally mistaken as to believe that his protestations of loyalty would reassure Alexander? By about that time other Macedonians, afflicted at first perhaps by the same fears and committing themselves too openly to opposition, were already escaping retribution, or so they thought, by defecting to the Persian king.[18] But Attalos did not follow them, although in Asia Minor he was well placed to do so. Instead he threw himself on Alexander's mercy. He misjudged; that is clear. But it must have seemed likely, from his vantage point, that his assertions would be believed and accepted. And that implies that he had committed no technically treasonous act; when Diodorus says he had actually "turned his hand to treason," he must be wrong.[19] Again it is no more than inference. Attalos could not hope to be forgiven treason, and his only salvation would have lain in flight. His crime cannot have been one of commission—and accordingly no source can name any concrete transgression. Rather, in the first place he had too long delayed his disclosure, presumably, it seems, for a year or more. Secondly, he

had failed to allow for Alexander's own sense of insecurity at this critical time, on the eve of the Eastern expedition.

But there ought to be further consequences of his declaration of loyalty. I have argued in my paper on the assassination of Philip that the story of the treasonous insult hurled by Attalos at Alexander a year or so before Philip's death seems more likely to be the invention of a later time.[20] Late 335 is perhaps that time. For Attalos is less than likely to have staked his life on the king's tolerance if, even before the accession, he had been conspicuously guilty of *lèse majesté* against him. On the other hand, such a libel would have been a most useful fiction for Alexander, or an apologist like Kallisthenes, to circulate to justify the king's harsh response to a respected officer who had not, by the letter of any law, actually committed treason but had been eliminated nevertheless.

Stories are recorded in several sources referring to the death of Attalos' niece and ward Kleopatra, the seventh and (as it turned out) last wife of Philip, along with that of her baby daughter Europe.[21] In them the most horrific and frankly incredible charges are made against Olympias, mother of Alexander.[22] The murder of Kleopatra too is often dated soon after Philip's assassination;[23] in that setting it may be explained as the vengeful act of the older wife with all restraint removed by her husband's death. But I would argue the more convincing context for Kleopatra's death is that in which her uncle Attalos died. For, again, Attalos is not very likely to have hoped for mercy from a king who had already ordered or condoned the murder of his close relatives.

Rather, I suggest, when Justin speaks of the deaths of all Alexander's stepmother's relatives just before the Asian campaign began he is preserving the essence of the information that at that time Attalos and his niece and others were eliminated.[24]

By the time of this purge Alexander's stock was rising, the result of his lengthening string of successes in dealing with the domestic and foreign problems caused by Philip's death. Macedonian faith in him must have been increasing, and he could now afford to take some steps that would have been too risky a year earlier. His supreme test was yet to be faced: to demonstrate to enemies and assure friends that he could lead the coming expedition with something at least approaching the success expected of his father. As it happened, so he did. But in prospect no one could know. There was always the likelihood of setback or defeat and, in that case, a repetition of the reactions of late 336 in Macedonia and beyond. There was only one guarantee against that: to continue the string of victories already begun. But at least as insurance he might remove the potential nuclei of opposition at home. It was for that second reason, I suggest, that he refused to soften before Attalos' assurances, that he wiped out the rest of that man's family as well as (for this was probably about the same time) his own cousin Amyntas.[25] This was no time, as his major trial approached, to leave the kinsmen of Philip to exploit any failure. Nor was it a time for such people, if they recognized their vulnerability and found the opportunity to escape, to dally within his reach.

My reason for dwelling at some length on a sequence of events that occurred at least a year after Alexander's accession to the throne is an indirect one. My real aim is to concentrate attention, by contrast, on the very earliest months. That was a time, so our sources say (this is the sort of thing in which they are interested), of frenetic military and diplomatic activity. But (and we learn less of this, for the sources find it difficult to conceive of an Alexander who was not—or not yet—"the Great") it was also a period of extreme delicacy for the young king in his dealings with his own Macedonians. There was no time for reflection, no time for carefully building a personal power base, no time for beginning the task of tactfully easing the powerful men of Philip's court and militia—at least one of whom had commanded Philip's army before Philip's Alexander was born—into less influential positions. Those appointments of his own men he did make were to junior posts; even when the campaign army crossed the Hellespont it was still dominated, as was the royal court at home, by Philip's men.[26] The compulsions of the circumstances had rendered Alexander immediately and heavily dependent upon such as these, and that was a bad beginning for a man who would have to establish his credentials to lead in his own right. It was a beginning that he would not be able to undo for some years. One thing required—and as it happened this young man had it in plenty—was a winning combination of military audacity and skill. The problems susceptible of that kind of solution were rarely insuperable to him. But some of the early wounds had gone deep and would continue to make solutions to equally serious

matters difficult to achieve.

In a series of enormously and deservedly influential articles on Philip's assassination and its consequences for Alexander, Professor Badian has portrayed a young man in some fundamental ways dependent on others.[27] To him—if I read him aright—Alexander's progressive attempts to lift himself by his own puppet strings into a position of real power represent an essential basis for the assessment of his aims and motivations. In general, I follow him in this. But I have argued elsewhere for a different interpretation of the evidence for the assassination. To me, Alexander was not "a youth *raised to power by* a clique of nobles who . . . expected to rule through him."[28] Instead, I am suggesting a slightly different setting for the crucible in which some of the ruling characteristics of Alexander the Great's reign were formed.

I have proposed by implication in this paper that Alexander's rule did not "open . . . with a reign of terror," but that the purge, when it came a year or more later, was the *consequence* of the king's own difficulties in the earliest months, of a practical need to prevent a recurrence of them should events prove troublesome during his absence in Asia.[29] I would be the last to deny the importance to the understanding of Alexander's career of the young king's early dependence on the experienced senior men of Philip's command. Its consequences are clearly seen, for example, in his deteriorating relationships with Parmenion and Antipatros—though in the case of the latter the process was slower because distance eased some of the discomfort. They are seen too, I

think, in Alexander's assiduous cultivation of the common soldiers' loyalty. What may appear at times, given his responsibilities as leader, a foolhardy level of personal risk taking is better explained, I believe, in terms of his pressing need for mass support —exactly what carried him unscathed, for example, through the potentially dangerous consequences of his decision to murder Parmenion in 330. But what I am proposing is that the roots of this dependence are to be found not in the circumstances preceding Philip's death but in those precipitated by it. What drove men like Attalos close to treason (and some to the act), what induced even the feeling that Philip's hard-won gains might be abandoned, was what also drove Alexander into an unwilling reliance upon Philip's men, whose resistance to new ideas, the product of their years, their status, and their success, would be a lasting deadweight on him in circumstances that were constantly to face him with unfamiliar problems demanding novel solutions.

In conclusion, and mostly as a speculative footnote, I point out that if, as still seems more likely than not, Tomb II at Vergina is Philip's, then that structure was erected, filled, and sealed in just that period with which we have been concerned.[30] I have not heard, nor can I see, any very compelling explanation of its apparently hasty completion; the interior of the main chamber (however magnificent its contents) is only partly finished. But if we appreciate the degree of instability approaching desperation in Alexander's first days, then we may be approaching

an explanation. Of course it takes only a limited number of workmen to build even a royal tomb, and it is hard to imagine that such a handful could not be spared for long enough to finish the task properly. But it may have been a question of priorities: in particular, whether it was possible to delay the final religious rites (in which Alexander, as chief priest, would certainly officiate) for those extra days when the king's presence must have been urgently needed in Pella. I do not pretend to have found the answer; I merely note that some special explanation seems necessary and that the stormy conditions of Alexander's accession seem likelier to provide it than most.

Notes

well, *Philip of Macedon* (London, 1978), 180, and N. G. L. Hammond and G. T. Griffith, *A History of Macedonia*. II: *550-336 B.C.* (Oxford, 1979), 688.

13. Plutarch *Demosthenes* 23.2.

14. Justin 11.5.1.

15. Polyaenus *Strat.* 5.44.4.

16. Plutarch *Alex.* 11.2.

17. I drew attention, in *Philip II and Macedonian Imperialism* (London, 1976), 220-223, to the synchronism of the celebrations at Aegae and the early news of success from northwest Asia Minor.

18. Arrian 1.13.2, 1.17.9, Diodorus 17.48.2, Curtius 3.11.18, Plutarch *Alex.* 20.

19. Diodorus 17.5.1.

20. See note 4.

21. For the wives and children of Philip see Athenaeus 13.557 b-d.

22. Justin 9.7, Pausanias 8.7.7, Plutarch *Alex.* 10.4.

23. For example, Beloch (note 12), 613; Cawkwell (note 12), 180.

24. Justin 11.5.1.

25. "Amyntas Perdikka, Philip II and Alexander the Great," *JHS 91* (1971), 15-24.

26. Justin 11.6.4-7. The imbalance is stressed by E. Badian, "The Death of Parmenio," *TAPA 91* (1960), 327-328, and P. Green, *Alexander of Macedon* (Harmondsworth, 1974), 120, 160.

27. See in particular Badian (note 26), 324-338; "Alexander the Great and the Loneliness of Power," *AUMLA 17* (1962), 80-91 (reprinted in, E. Badian, *Studies in Greek and Roman History* [Oxford, 1964], 192-205); "The Death of Philip," *Phoenix 17* (1963), 244-250.

28. *AUMLA* (note 27), 81 (*Studies*, 193); italics mine.

29. Badian (note 26), 325.

30. M. Andronikos, "Vergina: The Royal Graves in the Great Tumulus," *AAA 10* (1977), 1-72; W. L. Adams, "The Royal Macedonian Tomb at Vergina: An Historical Interpretation," *The Ancient World 3* (1980), 67-72; and now P. W. Lehmann, "The So-Called Tomb of Philip II:

A Different Interpretation," *AJA 84* (1980), 527-531, have suggested that it is the tomb of Philip III (Arrhidaios). There are prima facie difficulties in both attributions (though a third is hard to imagine), and publication is not yet complete, but the pottery dates seem difficult to overlook. The question however is still open.

1. Plutarch *Alex.* 11.1.

2. Plutarch *De Alex. fort.* 1.3.

3. Amyntas: Plutarch *De Alex. fort.* 1.3., Curtius 6.9.17, 6.10.24, Justin 12.6.14. The sons of Aeropos: Arrian 1.25.1, Justin 11.2.1, Diodorus 17.2.1, Plutarch *Alex.* 10.4.

4. "The Assassination of Philip II," *Ancient Macedonian Studies in Honour of Charles F. Edson* (Thessalonike, forthcoming).

5. Aristotle *Pol.* 5.8.10 (1311 b2).

6. Such an interpretation follows from my conclusion (in the paper cited in note 4) that our evidence does not indicate that either Alexander or those supporting him procured Philip's assassination.

7. Diodorus 16.93.9, Justin 9.6.8. Collected references to Attalos in H. Berve, *Das Alexanderreich aus prosopographischer Grundlage, II* (Munich, 1926), no. 213, note 4.

8. Diodorus 17.2-3. I should add that I can see no literal sense in which Attalos, who was not a member of the royal line, could be taken by Alexander for a "rival for the throne." I take this to be a mistaken inference, by Diodorus or his source, from the fact of Attalos' murder—the cause of which, I shall argue, was quite different.

9. Diodorus 17.3.

10. Diodorus 17.4, 17.5.1-2.

11. Diodorus 17.5.3-17.6.3.

12. For example, see K. J. Beloch, *Griechische Geschichte* III,1 (Berlin and Leipzig, 1923), 613; more recently, G. C. Cawk-

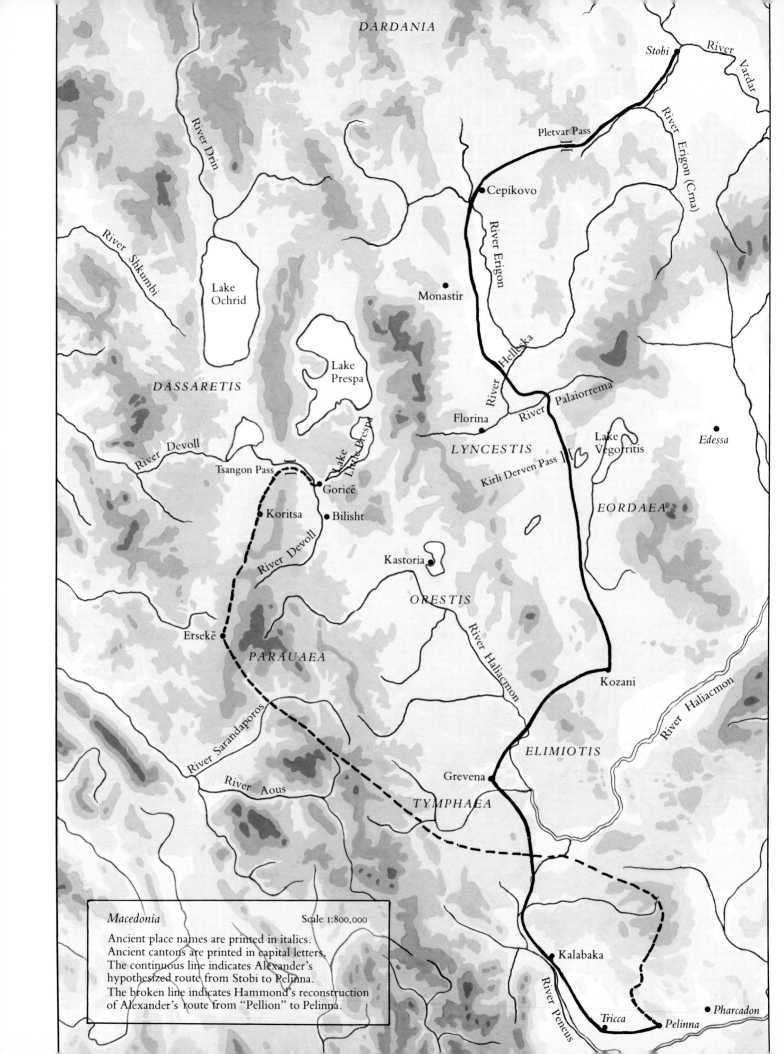

DARDANIA

Stobi

River Vardar

Pletvar Pass

River Erigon (Crna)

Cepikovo

River Erigon

River Drin

Lake Ochrid

Monastir

River Shkumbi

DASSARETIS

Lake Prespa

River Helleska

River Palaiorrema

Florina

Edessa

LYNCESTIS

River Devoll

Lake Little Prespa

Tsangon Pass

Goricë

Lake Vegorritis

Kirli Derven Pass

EORDAEA

Koritsa

Bilisht

River Devoll

Kastoria

ORESTIS

Ersekë

PARAUAEA

River Haliacmon

Kozani

River Haliacmon

River Sarandaporos

ELIMIOTIS

River Aous

Grevena

TYMPHAEA

Kalabaka

River Peneus

Tricca

Pelinna

Pharcadon

Macedonia Scale 1:800,000

Ancient place names are printed in italics.
Ancient cantons are printed in capital letters.
The continuous line indicates Alexander's
hypothesized route from Stobi to Pelinna.
The broken line indicates Hammond's reconstruction
of Alexander's route from "Pellion" to Pelinna.

The Location of Alexander's Campaign against the Illyrians in 335 B.C.

A. B. BOSWORTH

Department of Classics and Ancient History,
The University of Western Australia

THE SEARCH FOR ALEXANDER is all too often the fate of the military historian. His professional interest is to plot with the greatest possible exactitude the route taken during the campaign of conquest, but time and time again he is at the mercy of sources whose last concern is to give accurate geographical pointers. The most detailed source is usually Arrian, who occasionally reproduces from Ptolemy quite specific information about routes and marching times. Unfortunately for us, Arrian includes such material with gay and random insouciance. His primary intention is to do justice to the magnitude of Alexander's achievements, and to that end he concentrates his narrative upon the more colorful and sensational material provided by his sources. When the king apparently covers fifteen hundred stades from Khodzhend to Samarkand in three days of forced marching, it is undeniably an epic achievement, and the time and distance is duly set on record for the astonishment or incredulity of posterity.[1] For the most part, however, Arrian sprinkles names haphazardly as little more than embellishments to his narrative. There can be alarming gaps. The very first campaign against the Triballians begins with a detailed itinerary from Amphipolis to the crossing of the Nestos (1.1.5), precisely the portion of the route least interesting to the modern historian. Then comes a ten-day march to the passes of Mount Haemus. There is no hint what route was taken. Arrian is solely interested in Alexander's stratagem against the autonomous Thracians defending the pass (1.1.7-13), and he is content to give the vaguest of locations on the Haemus.[2] How Alexander arrived at the scene of his triumph is a matter of indifference. Next we are taken from the unnamed pass to the Danube with only one geographical reference point mentioned. The river Lyginus, three days' march from the Danube, comes into the narrative as the site of another victory, glorious and effortless (1.2.1; cf. no. 4 and 6). The Lyginus is not mentioned elsewhere, and the details Arrian gives are quite useless because of their vagueness. It is clear that the geographical material is primarily determined by the character of the narrative and its distribution is totally capricious. Arrian may be detailed and precise, as when he gives a fairly full account of Alexander's march from Amphipolis to Sestos in the spring of 334 (1.11.3-5); but he can leave his readers floundering in the desert, as when he takes Alexander from Thapsacus to the Tigris without naming a single intermediate point or specifying where on the Tigris Alexander made his crossing (3.7.3-5).

In most cases the reconstruction of Alexander's campaign routes involves a considerable element of doubt and uncertainty. The historian can only work within the parameters provided by the sources, point out the areas of doubt and the geographical possibilities, and wait for some archaeological miracle to provide an exact location. What I must emphasize is the necessity to view the whole of the evidence in its historical context. One must not be preoccupied with a single piece of evidence to the exclusion of the rest of the pattern. One instructive example concerns the history of 328 B.C. Scholars have agonized for centuries over a passage of Curtius Rufus which apparently states that Alexander undertook a march to the oasis of Margiana (Merv),[3] a wholly inexplicable journey of some 350 kilometers through the desert steppes which left the heartland of Bactria

in the grip of insurrection and war. But Margiana comes into the story only through a traditional "correction" in Curtius.[4] The manuscripts refer only to a city of *Margania,* and the description of the area is quite incompatible with the flat desert around the oasis of Merv. It is evident that Curtius is referring to a location (otherwise unknown) inside Bactria/Sogdiana, and the false emendation makes nonsense of the strategic narrative of 328. There is a stark lesson. In all such investigations one must first construct the general lines of the campaign and then attempt greater precision within that framework. One must not pursue some seductive will o' the wisp outside the limits of the wider source context. What I wish to examine in this paper is one particular *ignis fatuus* which has stubbornly diverted attention from the geographical context of Arrian's account of Alexander's Illyrian campaign. The issue is important methodologically; and, if my conclusions are correct, some light is shed on the turbulent politics of Macedon at the time of Alexander's accession.

In the summer of 335 B.C. Alexander was in Agrianian territory, by the headwaters of the river Strymon, when news arrived of defection in Illyria. Alexander accordingly left the Agrianian king and cut southwest through Paeonian territory. His route is not given. Arrian merely states that Alexander marched along the river Erigon and made for the city of Pellion which the Illyrian king Cleitus had occupied as the strongest point in the country. Alexander encamped by the river Eordaicus, intending to attack the city the next day (1.5.5). It was surrounded by wooded mountains (1.5.6) and,

when Alexander withdrew, he was forced to make a river crossing at a point where the mountain side came down precipitately to within a few feet of the water's edge (1.5.12; cf. 1.6.5-6). That is all Arrian tells us, and it is pretty unpromising material. The only feature which can be positively identified is the river Erigon, the present day Crna, which joins the Axios (Vardar) just south of ancient Stobi. Now it is most improbable that Alexander led his army through the rugged gorges which mark the southward course of the Crna from its confluence with the Vardar.[5] He would have cut across the upper reaches of the river, where he could follow its course southward to its confluence with the Helleska, which provides the gateway to the Upper Macedonian canton of Lyncestis. It seems that Arrian gives geographical reference points only for the last stage of the march and ignores the entire sector from the upper Strymon to the Crna. Apart from the identifiable Erigon there is nothing to focus upon except the fact that the river near the occupied city of Pellion is named Eordaicus. This river does not recur in any other context, but the name suggests some connection with the Macedonian canton of Eordaea, the area around the lakes of Petres and Vegorritis.[6] A small link, it is true, but the link is taken up in the immediate sequel, when Arrian first takes Alexander's march on Thebes through Eordaea before plunging south through Elimiotis (1.7.5). The context of Arrian's narrative, then, is the general northwest area of Macedon. Alexander approached the Illyrian base by way of the Crna and left it through Eordaea. It is distressingly imprecise, but a clear

direction seems to emerge. No other source says anything of substance. Diodorus speaks in the most general terms of Alexander "passing over Paeonia, Illyris, and the lands bordering on them," [7] and his vague statement is at least compatible with the line of march from Agrianian territory indicated by Arrian, that is, through Paeonia to the territories north of Macedon in the region of the Erigon and finally down to Macedon proper. Other sources refer perfunctorily to the Illyrians as Alexander's enemies but give no hint of the location of the campaign.[8]

It is now that the *ignis fatuus* beckons intriguingly away from the context provided by Arrian. The city occupied by the Illyrians is named Pellion, and one is tempted to look in other sources for a city of the same name. A candidate is soon to hand. As early as 1596 Abraham Ortelius of Antwerp included in his *Thesaurus Geographicus* a note arguing that Arrian's Pellion is the same as the fortress of Pelion in Dassaretis, which figures in Livy's campaign narrative of 199 B.C. (Livy 31.40.4).[9] This fortress lay between the Orestian city of Celetrum (Kastoria) and the Roman base at Apollonia, and is usually and plausibly located on the upper reaches of the river Devoll, near the frontier of modern Albania.[10] Ortelius' suggestion was endorsed by Johannes Freinsheim in a marginal note to his prestigious supplements to Curtius, published in 1687, and hallowed by Gronovius in his classic 1704 edition of Arrian. Gronovius indeed identified Arrian's river Eordaicus as the Apsus, the modern Devoll. The damage was done and done brilliantly. In subsequent editions of Arrian,

Pellion was spelled Πήλιον as a matter of course, and it was almost inevitable that nineteenth-century travelers looked for the site of the Illyrian campaign in the valley of the Devoll. Colonel William Leake accepted the equation of sites as axiomatic, and having correctly located Dassaretis in the upper Devoll valley, he was able to hit upon the narrow Tsangon Pass as the strait through which Alexander made his retreat. Pelion therefore was below the pass in the vicinity of Pliassa.[11] George Grote immediately enshrined the location in his *History of Greece,* as did Droysen a few years later, unlike Grote referring not to Leake but to the work of the French antiquarian, Barbié du Bocage.[12] There were occasional skeptics in later years, but the identification had achieved canonical status. It has recently provided the basis for Professor Hammond's reconstruction of the campaign of 335. Hammond places Pelion further upstream than did Leake, at Goricë in the plain of Poloske, immediately southwest of Lake Ventrok, but the identification of Arrian's Pellion and Livy's Pelion is the central unquestioned assumption.[13]

If Pellion is located on the river Devoll it lies considerably to the southwest of the Erigon. One must assume that Alexander left it far behind and traversed the bulk of Upper Macedonia before meeting the Illyrian forces.[14] A narrative gap of this nature, as we have seen, would be far from unique in Arrian and is quite feasible. What is not feasible, however, is the dislocation of the battle site from Eordaea and Alexander's itinerary to Thebes as recorded by Arrian. Leake frankly admitted the problem and suggested rather lamely

that Alexander returned to Pella before marching on Thebes. Why Alexander then made a protracted diversion into Upper Macedonia instead of simply following the coast road south, he left an unsolved and unasked question. More recent scholars have had an advantage over Leake. Since Oberhummer's early work in Pauly-Wissowa it has been orthodoxy to claim that there existed a second Eordaea. It existed moreover in the upper reaches of the Devoll and provided the upper waters of the river with its ancient name of Eordaicus.[15] What is more, Stephanus of Byzantium states that there were no less than four territories named Eordaea, two of which lay outside Macedonia, in Ἰβυρία and in Thrace.[16] Let us concede that Ἰβυρία is a corruption of Illyria and let us look for more explicit evidence. That evidence comes from the *Geographia* of Claudius Ptolemaeus. Here there is a tribal heading for the Eordetae or Eordaei, and three towns are listed under it: Scampeis, Deboma, and Daulia (Ptolemy 3.13.26 Nobbe). None has any connection with the known cities of Macedonian Eordaea, and the group as a whole is located far to the west, extending toward the Epirote coast. Scampeis moveover looks suspiciously like the Scampis mentioned in the *Itinerarium Antonini* as a staging post along the Via Egnatia, a little to the east of modern Elbasan.[17] In that case a second Eordaea has providentially appeared in the vicinity of Pelion in Dassaretis, and the will o' the wisp is beginning to look disturbingly like the beacon fire of truth.

The Eordaei of the west retain their solid and substantial appearance only as long as they are taken

out of their context in Ptolemy. When we examine that context there emerges an unpurged Augean stable of error and omission. If his locations are taken collectively, they suggest a westward migration almost unparalleled before the covered wagons of American folklore. The city of Garescus in Orbelia, otherwise firmly attested in the upper Strymon district, is dislocated three degrees west from the longitude of Amphipolis and placed in the central Pindus.[18] But the confusion is much worse than simple misplacement of coordinates. Let us take the canton of Orestis, known from all other sources to be located on the western border of Macedon and to have boasted the sites of Celetrum (Kastoria) and Argos Oresticum. Neither city appears in Ptolemy. Instead Orestis is credited with the inland and coastal cities of Amantia and the mouth of the river Celydnus, well-known areas of Epirus.[19] In the same way the Macedonian mountain canton of Elimiotis, is given the Epirote community of Byllis; and Elyma, which does seem to be a settlement of Elimiotis, is pushed impossibly far to the west, between inland Amantia and the coast.[20] I do not pretend to understand how the errors have occurred, but it seems undeniable that Ptolemy's list has tribal names moved forcibly west and foisted upon demonstrably alien communities. Now the cities otherwise attested in Macedonian Eordaea are Arnisa, Cellis, and Boceria. Like the cities of Orestis they are omitted in Ptolemy's survey of Macedonia. An "Arnissa" does indeed occur, but it is placed in the hinterland of Dyrrhachium and attributed to the Taulantii.[21] By contrast the area of Eordaea proper,

between Edessa and the canton of Lyncestis, is a melancholy blank on Ptolemy's map. Given that the tribal areas of Orestis and Elimiotis have demonstrably and erroneously been applied to localities on the Epirote coast, it seems more than likely that the same has happened with Eordaea. Scampeis, Deboma, and Daulia may indeed have been located near the Devoll, but their attribution to the Eordaei is uncertain in the extreme.

Even if it is accepted for the sake of argument that the upper reaches of the Devoll contained a district called Eordaea, there remains the problem of the route back to Thebes. Arrian says that Alexander led his army παρὰ τὴν Ἐορδαίαν τε καὶ τὴν Ἐλιμιῶτιν καὶ παρὰ τὰ τῆς Στυμφαίας καὶ Παρ⟨α⟩ναίας ἄκρα. Now the principal route from the Devoll leads directly back through Bilisht to Kastoria and central Orestis, then directly to Tricca in northwest Thessaly. If Alexander were moving directly and rapidly to crush the Theban rebellion, it is hard to see how Orestis could have been omitted from his itinerary or Elimiotis included. Professor Hammond has made a heroic effort to solve the difficulty in a recently published article which he most generously made available to me in manuscript. Faced with the unpalatable fact of Arrian's itinerary, he makes Alexander bypass Orestis completely and take an extended march over the central spine of the Pindus by routes favored in more recent years by goats, shepherds, and fugitive guerrillas.[22] I do not deny that such a march was possible, but I do deny that it was necessary. Hammond believes that Alexander was being deliberately secretive, keeping the news of his advance from the Thebans until the last possible moment. The route across the mountains, however, would have impeded his progress unnecessarily at a time when speed was vital. No one could predict how long the Macedonian garrison could hold the Cadmeia, and it was immensely more important to reach Thebes quickly than to reach it secretly. Indeed neither Arrian nor any other source suggests any secrecy in Alexander's movements. His worry was that the Thebans might be joined by other insurgents, and his ends were best achieved by publicity—by displaying to prospective rebels that the young king was descending like an avenging angel, his army intact and victorious. As it happened, his speed was sufficient to forestall the rumor of his advance,[23] and the shock of his arrival effectively deterred any active intervention from outside; but the secrecy was a secondary and unplanned factor. Alexander would therefore have chosen the route which produced maximum speed with the minimum strain on his troops. Hammond's hypothesized route also involves a degree of violence to Arrian's text. Arrian implies that Alexander went from Eordaea directly to Elimiotis, which is irreconcilable with the route along the western spine of the Pindus.[24] Hammond accordingly assumes that the districts in the itinerary are listed in a "paratactical" not a geographical order, with the lowlands first and then the highlands.[25] I cannot find any parallel for this remarkable procedure, nor can I believe that Arrian had the geographical knowledge or interest to distinguish so sharply between mountain and lowland. Indeed Elimiotis is a very strange area to categorize as lowland, given that it contained peaks of the magnitude of Mount Bourinos, with spot heights up to 1866 meters. Finally Elimiotis fits very uneasily into Hammond's itinerary. Alexander's hypothesized route is taken down the Pindus spine to Kranea, in the south of ancient Tymphaea. This site lies just above the headwaters of the Peneus, and the road drops southeast to Kalabaka and then to Tricca at the edge of the Thessalian plain. It was the direct route south, yet Hammond ignores it and takes Alexander on a mountainous detour due east to Karperon and Dheskati before moving south to Pelinna. The only reason I can see is that Elimiotis is included in Arrian's itinerary, and whatever the losses in speed and convenience Alexander's route must be taken there.

I hope that it may now be admitted that Livy's Pelion in Dassaretis cannot be identified with Arrian's city of Pellion without disregarding the wider geographical context he provides. Skepticism may perhaps be taken further. Arrian's name for the occupied city is Πέλλιον and three lines above comes a reference to the Macedonian capital of Pella. The similarity of form may be mere coincidence, but there is also the possibility of manuscript corruption. The familiar name Pella may have persisted in the mind of a scribe (or even of Arrian himself) and displaced the less familiar name of the occupied city. Such corruptions occur elsewhere in Arrian's text and are a fairly familiar phenomenon in manuscript tradition. It is possible to argue that an original spelling Πήλιον was

corrupted by its proximity to Πέλλαν, but that is only one possibility.[26] The original form may have been totally different as at 3.5.5, where the name Balacrus is repeated from the context and displaces the original Arrhybas.[27] In that case the original identification with Livy's Pelion was not only fallacious but based on a textual corruption pure and simple.

Let us return to the wider context of Arrian. The two details which are clear are that Alexander approached the occupied city by way of the river Erigon and that when he left the campaign area his route took him through Eordaea and Elimiotis. These indicators point to the general area of Lyncestis. A route along the Erigon leads directly into the plain of Florina, the heart of Lyncestis, and on the eastern side of that plain is the Kirli Derven pass, which was the main access point for Eordaea. Lyncestis proper lay between Alexander's approach march and his line of departure; and it is reasonable to look for the site of "Pellion" in that general area. Other factors can now be taken into account. Alexander's campaign was fought against two Illyrian kings, Cleitus and Glaucias. Glaucias ruled the Taulantii who were domiciled in the hinterland of Dyrrhachium, on the Epirote coast.[28] Cleitus' nationality is not stated explicitly, but he was the son of the formidable Bardylis and clearly ruled one of the major Illyrian nations.[29] Since the Taulantii and Autariatae are accounted for in Arrian's narrative, one may assume that his people were the third great tribe, the Dardani. Their territory lay due north of Macedonia, in the wild country between the Drin and the Crna.[30] To reach Lyncestis Cleitus needed merely to

drive south through the Monastir gap. The Taulantii also had an easy access route along the future Via Egnatia, rounding the north of Lake Ochrid and passing into Lyncestis via Monastir. It was an ideal meeting place, slightly closer to Cleitus' domains; and it was Cleitus who took the initiative and occupied "Pellion" in anticipation of Glaucias' arrival.

Lyncestis was not only geographically salient; its occupation was politically opportune. During its existence as an independent kingdom there had been intermittent periods of friendship with the Illyrians; and most notably the Lyncestian Arrhabaeus had allied himself with the Illyrian dynast Irrhas to make war upon Archelaus of Macedon.[31] Admittedly Lyncestis had been annexed by Philip early in his reign and absorbed into the fabric of Macedon proper, but in his last years there was increasing tension. The head of the leading family of Lyncestis, Aeropus, appears to have been exiled immediately before Chaeronea. Polyaenus alone gives us the story (Strat. 4.2.3), and it is brief and sensational: two generals exiled for insinuating a girl musician into camp. But the names of the culprits (Aeropus and Damisippus) are plain and unambiguous, and the only Aeropus known at this period was the Lyncestian dynast.[32] Not surprisingly the exile precipitated unrest. Plutarch in a famous passage of rhetoric speaks of Macedon at Alexander's accession as "festering and looking towards Amyntas and the sons of Aeropus";[33] and, when Philip met his tragic end at Aegae in the autumn of 336, two of the sons of Aeropus were executed as privy to the conspiracy.[34] Whatever the

truth of that dark episode there is no doubt that the leading nobility of Lyncestis were deeply estranged from the Argead house of Pella, and the discontent may have extended to the more humble populace. There is no hint in the sources that they sided with the invaders, and indeed they may well have provided the human sacrifices, whose carcasses Alexander's army encountered on its arrival (Arrian 1.5.7). But on the other hand there is no suggestion that Alexander received any help from the locals. Ptolemy and Aristobulus would have laid emphasis on the stirring picture of a loyal peasantry flocking to the standards of their king, but they would have had little taste for recording the populace watching the campaign with sullen indifference. Lyncestis in 335 was a troubled and volatile area. It is not surprising that Alexander was galvanized into immediate action by reports of Illyrian movements in that direction.

We must now ask whether there is anything intrinsically implausible in a campaign fought in Lyncestis. The sole objection appears to be the difficulty of finding a settlement which could be properly described as a city. Hammond has stressed the absence of reports in ancient writers and the fact that the site excavated near Florina was a village with no circuit of walls.[35] But the ancient reports of Lyncestis are very slender during the fourth century and the early Hellenistic period. There is virtually nothing between the campaign of Brasidas in 424 and Polybius' campaign narrative of the Second Macedonian War. The history of the area in the reigns of Philip, Alexander, and the Successors is totally lost. Now it would

be hard to believe that Philip left Lyncestis untouched. The territory had certainly been occupied by the Illyrian forces of Bardylis at the traumatic period of his accession; and once it was cleared after his decisive victory of 358 B.C. Philip must have taken measures to protect it against future invasions. In Thrace at least he was to consolidate his victory by founding a network of cities with military colonists.[36] Many evade location and may not have survived long after his death, but their existence is certain. The same process presumably took place elsewhere, and Justin at least speaks in appallingly vague terms of the transplantation of cities and populations inside Macedonia proper. His account is presented with the most banal and wretched rhetoric, but it does tell of whole populations set at the borders facing the enemy, with the addition of prisoners-of-war divided out *in supplementa urbium*.[37] The project resembles Alexander's system of military foundations in the northeast of his empire, with the ruling nucleus of discharged Hellenic soldiers supplemented by a subject population of ex-rebels.[38] As so often, the model may have been Philip's. If, then, Philip established defensive outposts on the frontiers of Macedon, Lyncestis will have had its share of them.[39] Indeed Arrian's city of "Pellion" may well have been an alien implant by Philip, a fortress with a military population recruited outside the area. The Lyncestians would have continued to live in their tribal villages, coexisting willingly or unwillingly with the defensive foundations. "Pellion" itself need not have had a long life. It was burned by the Illyrian king Cleitus before his withdrawal in

335 (Arrian 1.6.11) and may not have been rebuilt. If so, any surviving traces will be meager.

There is no valid *a priori* objection to the hypothesis that Philip established a city fortress in Lyncestis. Its existence can be proved or disproved only by extensive archaeological investigation, but Arrian's narrative gives some indications. In the first place it nestled against a circuit of mountains, at the edge of the plain of Florina. Secondly it was close to a river, a river called the Eordaicus. The name suggests a connection with the canton of Eordaea, and I would argue that it rose in the eastern mountains, the range separating Lyncestis from Eordaea. It was probably one of the tributaries of the Helleska which intersect the plain, and because it rose in the vicinity of Eordaea it was called the Eordaean tributary. Finally the site of "Pellion" was close to a river crossing where the mountains came sharply down to within a few feet of the river. I must emphasise that Arrian does not speak of a pass proper, merely of a passage shut off on the one side by the river and on the other by a cliff.[40] The problem was not to force a pass but to cross the river under harrassment from troops on the mountainside. I should myself be inclined to try first the northeast corner of the plain, where the Palaiorrema, now the main tributary of the Helleska, comes very close to the mountain wall.[41] But such conjecture is largely unprofitable. Arrian's description gives only the most sketchy picture of the theater of operations, and there is a wide theoretical field for investigation. If a defensive foundation of the period of Philip is discovered, sited at the edge of the Lyncestian plain

and showing traces of destruction by fire, we will finally have a fixed site. Until then the general location suggested by Arrian will have to suffice.

The conclusion is tentative but necessarily tentative. What I hope I have done is to dissipate an illusion and to have brought the siting of the Illyrian campaign back into the general context provided by Arrian and the wider political context of 335 B.C. That context was truly dramatic. Alexander was in the far northeast of his kingdom when news came of an Illyrian movement on his northwest frontier, affecting a region which was politically sensitive. If a hostile base was established at "Pellion," unrest could easily spread and the Illyrians could create havoc in the loyal areas of the kingdom. It was an emergency which required Alexander's presence and Alexander's army. In effect the king arrived quickly enough to split the invading forces (Arrian 1.5.8); but he could not maintain the siege of "Pellion" after the Taulantian army occupied the surrounding heights, and he had to extricate himself, forcing the passage of the Eordaicus under pressure but without loss. It was the Illyrians' cavalier disregard for defensive precautions which then enabled Alexander to make his surprise night attack and crush the majority of the Illyrian army. They had allowed Alexander to "steal his victory" (cf. Arrian 3.10.2) and threw away the advantages of their position. Had they stood firm until news arrived of the Theban rebellion they would have placed the king in an excruciating dilemma. If he abandoned the garrison on the Cadmeia, there was the danger of the Thebans raising a major war in

southern Greece. If he withdrew to deal with the Thebans, the Illyrians were left entrenched in Lyncestis, in an excellent position to convulse the western part of his kingdom. He was only saved from the agony by a matter of a few days. The Illyrians were careless and paid the penalty of defeat, when a little more attention to camp discipline might have rewritten the history of Alexander's reign.

ADDENDUM

Alexander's retreat to Thessaly (Arrian 1.7.5)

After the rout of the Illyrians Alexander regrouped his army for the renewed siege of "Pellion," but was diverted by the news of the Theban revolt. Cleitus was therefore able to burn the city and effect his retreat (Arrian 1.6.11). The fact that he was able to do so indicates that Alexander had raised the siege and withdrawn to cope with the Thebans. Alexander's route took him first into Eordaea, presumably following the course of the Via Egnatia over the Kirli Derven pass.[42] Once in Eordaea he moved south to the area of modern Kozani and southwest through ancient Elimiotis to the middle reaches of the Haliacmon, probably via the Siatista gap. From there he went towards Grevena (in eastern Tymphaea) and from Grevena to the Peneus valley, more or less directly.[43] On this reconstruction he did not pass through Parauaea, but Arrian does not say that he did, merely that he went "across the peaks of Tymphaea and Parauaea." Arrian here uses παρά in the sense of "across" (not "along"), just as he does when he describes Darius' passage of the Zagros—παρὰ τὰ ὄρη τὰ Ἀρμενίων ἤλαυνεν ἐπὶ Μηδίας (3.16.1). Parauaea and Tymphaea are grouped together as a single entity (as, it seems, they are by Plutarch, *Pyrrhus* 6.4), and since they straddled the central spine of the Pindus, the watershed could be defined by them. What Arrian is saying, then, is that Alexander went from Elimiotis to the central Pindus. The outliers of this range he crossed between Grevena and Kalabaka, and he finally plunged down to Thessaly by way of the Peneus valley and Tricca. It was a direct route through central Macedon which Alexander could cover at maximum speed and still conserve the fighting strength of his troops.

1. Arrian 4.6.4. The report has been widely accepted (cf. W. W. Tarn, *Alexander the Great* [Cambridge, 1948], I, 69-70; D. W. Engels, *Alexander the Great and the Logistics of the Macedonian Army* [Berkeley, 1978], 104); but justified skepticism has been expressed by E. N. Borza, in U. Wilcken, *Alexander the Great* (New York, 1967), 338, note 159. P. A. Brunt, *Arrian I* (Cambridge, Mass., 1976), 505-506, has noted that Curtius 7.9.21 also mentions a march of four days, *from* Maracanda to the scene of the disaster on the Zeravshan, and he suggests that Arrian has conflated two different marches.

2. δεκαταῖος ἀφίκετο ἐπὶ τὸ ὄρος τὸν Αἷμον (1.1.5). Because of Arrian's vagueness (and the unsatisfactory evidence for the location of the Triballians) Alexander's crossing of the Haemus has become a battleground of scholarship. See further A. B. Bosworth, *A Historical Commentary on Arrian's History of Alexander,* I (Oxford, 1980), 51-55.

3. Curtius 7.10.15; cf. *Metz Epitome* 14. I discuss the history of this problem in a forthcoming article, "A Missing Year in the History of Alexander the Great," to be published in *JHS* 101 (1981).

4. The history of this emendation is very similar to the history of the emendation of Arrian's "Pellion" (cf. notes 9 and 10). It originated in Ortelius' *Thesaurus Geographicus* (Antwerp, 1596), s.v. MARGINIA (*Pro* ANTIOCHIA *Margiana habeo in Margiana regione &* MARGIANAM *restituo*). Freinsheim then adopted it in his definitive edition of Curtius, and it was almost universally ac-

cepted in subsequent editions. Even when the manuscript reading was retained, the location was still held to be in Margiana. The lone exception appears to be the Paris edition of Le Tellier (1678), in which it is argued that "Margania" is an otherwise unattested location in Sogdiana.

5. Cf. L. Heuzey and H. Daumet, *Mission archéologique de Macédoine* (Paris, 1876), 321-323, followed by N. G. L. Hammond, *A History of Macedonia,* I (Oxford, 1972), 65. The main road from Stobi in antiquity went via the Pletvar pass and modern Prilep and reached the upper Crna in the vicinity of Cepikovo (cf. Hammond, 66 with map 9; L. Heuzey, "Reconnaissance archéologique d'une partie du cours de l'Erigone," *RA* [1873], 18-22, 37-44).

6. For the geography of Eordaea see most conveniently Hammond (note 5), 106-110.

7. ἐπῆλθεν δὲ καὶ τὴν Παιονίαν καὶ τὴν Ἰλλυρίδα καὶ τὰς ὁμόρους ταύταις χώρας (Diodorus 17.8.1). Alexander's route from the Agrianian heartland to the Erigon took him strictly through Paeonia and Pelagonia, not impinging on Illyris proper. But the context of Diodorus is very vague. He describes the Danubian campaign merely as a campaign against Thrace and Thracians and speaks in the most general terms of subjugation of all the neighboring barbarians. I cannot believe that Diodorus is attempting to reconstruct Alexander's itinerary. Rather he is condensing in the briefest possible compass Alexander's dealings with Thracians, Paeonians, and Illyrians; and his skimpy and unilluminating narrative cannot be pressed to provide precise details of the itinerary.

8. Plutarch (*Alex.* 11.6) speaks of Alexander ἐν Ἰλλυριοῖς καὶ Τριβαλλοῖς, as does the Athenian decree mentioned by Arrian 1.10.3 (σῶος ἐξ Ἰλλυριῶν καὶ Τριβαλλῶν). Curtius 3.10.6 and 5.1.1 (adduced by Hammond [note 13], 76, note 20) have nothing to do with the campaign of 335.

9. Ortelius (note 4), s.v. PELION . . . *Illyridis oppidum quoque Stephano. Est & Dassaritiorum urbs in Macedonia, Livio 31. forte Pellium, geminato LL, apud Arrianum in Alexandro, ad Erigonem fluvium, & eandem cum Stephani puto, ut qui Illyricum hucusque extendat.*

10. Livy's Pelion is presumably the same

as Πήλιον Ἰλλυρίας πόλις, which Stephanus adduces from the work of Asinius Quadratus (*FGrHist* 97 F 24). The city *may* be identical with the fortress Peleon in Epirus Nova which was later restored by Justinian (Procopius *De Aedificiis* 4.4 [p.117.28, ed. Haury]).

11. W. M. Leake, *Travels in Northern Greece* (London, 1835), III, 322-325.

12. G. Grote, *History of Greece* (London, 1856), XII, 36; J. G. Droysen, *Geschichte des Hellenismus* (Gotha, 1877), I², 1.128.

13. N. G. L. Hammond, "Alexander's Campaign in Illyria," *JHS* 94 (1974), 66-87, esp. 76. At roughly the same time Albanian archaeologists proposed a somewhat different identification, with the site of Lower Selce, in the upper Shkumbi valley, west of Lake Ochrid and northwest of Pogradec, where there is an impressive group of rock tombs; cf. N. Ceka, "La ville Illyrienne de la Basse-Selce," *Iliria* 2 (1972), 167-215, esp. 198-199; N. Ceka and L. Papajani, *Studia Albanica* 9 (1972), 92-94, tentatively accepted by P. Cabanes, *L' Epire de la mort de Pyrrhos à la conquête romaine* (Besançon / Paris, 1976), 320, note 232. Once more the location rests on the identification with Pelion in Dassaretis, which became totally inevitable once the Albanians took Freinsheim's supplement to Curtius, with its explicit reference to Dassaretis, as an independent ancient source cognate to Arrian ("ces deux auteurs ont utilisé, sans nul doute, la même source . . . peut-être Ptolémée").

14. For a conjectural route via Vatochorion and Bilisht see Hammond (note 13), 78.

15. Oberhummer, s.v. "Eordaia" (2), *RE* 5 (1905), 2656-2657, following Müller's annotations to Ptolemy. See also Hammond (note 5), 95-96; (note 13), 76.

16. Stephanus of Byzantium, s.v. Ἐορδαῖαι δύο χῶραι, Μυγδονίας ⟨καὶ Μακεδονίας⟩ (cf. Thucydides 2.99.5) εἰσὶ καὶ ἄλλαι δύο, ἡ μὲν Ἰβυρίας ἡ δὲ Θράκης. Herodian I, ed. A. Lenz (Leipzig, 1867), 282.35 quotes the passage, making the necessary supplement and reading Ἰβηρίας for Ἰβυρίας. Even though he accepts the correction Ἰλλυρίας, Meineke is unwilling to believe in four separate areas named Eordaea, supposing instead that Stephanus' sources referred to the same district in differing geographical contexts: *epitomator*

autem, quod centies factum ab eo vidimus, distinxit quae non distinguenda erant.

17. *Itineraria Romana,* ed. O. Cunz (Leipzig, 1929), I, 48, 318.2; 49, 329.8. For a precise location see Hammond, "The Western Part of the Via Egnatia," *JRS 64* (1974), 188.

18. Ptolemy 3.13.25. For the location in the upper Strymon see Strabo 7 F21, 36; Pliny *NH* 4.35.

19. Ptolemy 3.13.5, 22. Amantia is generally identified with the ruins in the modern village of Ploçe; cf. S. Anamali, "Amantie," *Iliria 2* (1972), 72-77; Cabanes (note 13), 384-385. See, however, N. G. L. Hammond, *Epirus* (Oxford, 1967), 224-225, who opts for Klos.

20. Ptolemy 3.13.4, 21. For the site of Byllis, which is epigraphically fixed, see Hammond (note 19), 225-227; Cabanes (note 13), 395, note 183.

21. Ptolemy 3.13.20. Müller and Tomaschek (s.v. ARNISSA, *RE 2* [1896], 1206) argued that Arnissa should be identified with the Eordaean city, displaced by Ptolemy into Taulantian territory. In view of the considerable geographical dislocation in the passage I am not as sure as Hammond (note 5), 108, note 4, that the argument is "totally misplaced."

22. Cf. N. G. L. Hammond, "The March of Alexander the Great on Thebes in 335 B.C.," in Μέγας Ἀλέξανδρος: 2300 χρόνια ἀπὸ τὸν θάνατο τοῦ (Ἑταιρεία Μακεδονικῶν Σπουδῶν: Μακεδονικὴ Βιβλιοθήκη ἀρ. 57: Thessalonike, 1980), 171-181 (sketch map attached). His hypothesized route (179-180), takes Alexander from the plain of Koritsa to Erseke (cf. Hammond [note 19], 275) and from there across the flank of Mt. Grammos to the Sarandaporos valley. Next he goes via Fourka and Samarina and crosses the dividing range to Smixi on the east side of Mt. Vasilitsa (see the outline map in Hammond [note 19], 259). From Smixi the itinerary is by way of Avdhella and Kranea, and then it branches sharply east to Karperon and Dheskati before plunging sharply south to Mavreli and finally to Pelinna.

23. Arrian 1.7.5-6; Diodorus 17.8.3 (ἧκεν . . . ἄφνω). The surprise of his advance was increased by the rumor that he had been killed in the Triballian campaign (Justin 11.2.7-8).

24. See the discussion in the addendum above.

25. Hammond unnecessarily complicates the problem by insisting that the sense of παρά in Arrian 1.7.5 can only be "alongside"; and Alexander's route is accordingly taken along the borders of the provinces in question. But Arrian uses παρά with the accusative to describe simple motion towards or through an area. Compare the instructions to Parmenion, παρὰ τὴν χώραν τὴν Καδουσίων ἐλαύνειν ἐς Ὑρκανίαν (3.19.7), where the objective is clearly to drive through, not alongside, Cadusian territory. See also 3.16.1, quoted in the addendum.

26. 1.5.4 ἐς Πέλλαν ἀφικομένῳ: 1.5.5 ἐς Πέλλιον πόλιν ἐστέλλετο. Indeed the word πόλιν immediately following provided another inducement to assimilation.

27. Compare 2.20.5, where Alexander replaces Cleander, and 4.7.2, where the name Bessus intrudes from the immediate context and displaces the original name of the satrap of Syria (cf. Bosworth, "The Government of Syria under Alexander the Great," *CQ 24* [1974], 60-63).

28. Arrian 1.5.1, 8.

29. Bardylis was defeated by Philip II around 358 B.C. (Diodorus 16.4.4), and he was clearly one of the principal Illyrian dynasts. The only two tribes which seriously come into question are the Ardiaei and the Dardanians. Of these the Ardiaei were ruled by the house of Pleuratus, who was defeated by Philip around 344-343 (Didymus, *in Dem.* col.12.64-65; cf. Hammond, "The Kingdoms of Illyria *circa* 400-167 B.C.," *BSA 61* [1966], 245). The Dardanians seem the only alternative. Their subjugation is vaguely attested by Justin 8.6.3 shortly after the Peace of Philocrates. I cannot accept the arguments of Fanoula Papazoglou, "Les origènes et la destinée de l'état illyrien: Illyrii propie dicti," *Historia 14* (1965), 143-179 (now accepted in principle by F. W. Walbank, *A Historical Commentary on Polybius,* III [Oxford, 1979], 694), that there was a separate Illyrian state on the northwest borders of Macedon, whose population was described as "Illyrians" or *Illyrii proprie dicti.*

30. Strabo 7.5.7 (316). See further Hammond (note 29), 250.

31. Aristotle *Pol.* 5.1311 b 12-14. For this

interpretation see Bosworth, "Philip II and Upper Macedonia," *CQ 21* (1971), 99. Hammond (note 29), 244, argues that Irrhas belonged to the Lyncestian royal house; but he is forced to discard the explicit evidence that Eurydice (mother of Philip II and daughter of Irrhas) was of Illyrian extraction.

32. Polyaenus' story has in fact been noted and accepted as historical; cf. A. Schäfer, *Demosthenes und seine Zeit,* II, 2nd ed. (Leipzig, 1886), 556; Kirchner, s.v. AEROPOS (6), *RE 1* (1893), 679. There has not to my knowledge been any suggestion that the general exiled was the same man as the Lyncestian dynast, but given the rarity of the name and the high status of the culprit, the identification must be viewed as highly probable.

33. Plutarch *De Alex. fort.* 1.3 (327 C).

34. Arrian 1.25.1-2 (cf. Diodorus 17.2.1; Justin 11.2.1; Plutarch *Alex.* 10.7). On this passage see now Bosworth (note 2), 159-160.

35. See, most recently, N. G. L. Hammond and G. T. Griffith, *A History of Macedonia,* II (Oxford, 1979), 143.

36. For details and sources see Hammond and Griffith (note 35), 557-559; 673.

37. Justin 8.6.1. On this passage see J. R. Ellis, "Population-Transplants by Philip II," Μακεδονικά 9 (1969), 9-17; Hammond and Griffith (note 35), 661-662. I would retract an earlier remark ("Ἀσθέταιροι," *CQ 23* [1973], 250) that Justin refers solely to movements of population within existing settlements.

38. Cf. Justin 12.5.12; Curtius 7.6.27; Arrian 4.4.1. On Alexander's colonizing policy see P. Briant, "Colonisation hellénistique et population indigènes," *Klio 60* (1978), 74-77.

39. Hammond and Griffith (note 35), 660-661, argue plausibly that Philip founded Heraclea Lyncestis in 358 and speculate on the probable blend of population.

40. Arrian 1.5.12 τῇ μὲν πρὸς τοῦ ποταμοῦ ἀπειργόμενα, τῇ δὲ ὄρος ὑπερύψηλον ἦν καὶ χρημνοὶ πρὸς τοῦ ὄρους. Leake (note 11), 323, insisted that this description refers to a "remarkable pass," as does Hammond (note 13), 81-82.

41. The names of the watercourses in the plain of Florina vary according to the age of the map. I have taken my information here from the Defense Department 1:500,000 map of the Thessalonike region (Series 1404, Sheet 322D), supplemented from the old German 1:100,000 staff map of Florina-Ptolemais (Sheet no. 5/C).

42. For the route see C. F. Edson, "The Location of Cellae and the Route of the Via Engatia in Western Macedonia," *CP 46* (1951), 1-16; Hammond (note 5), 51-52.

43. The fact that Alexander broke his march at Pelinna does not imply that Pelinna was the first place he reached in Thessaly (as Hammond repeatedly assumes). Rather Pelinna was the principal Macedonian bastion in the area, the sole city to remain loyal in the Lamian War (Diodorus 18.11.1), and it was an ideal place to pause briefly before plunging south to Boeotia. Nothing excludes his having reached Pelinna via Tricca and the Peneus valley. Cf. Hammond (note 5), 118: "if he had aimed to enter Thessaly at Kalabaka and go on to Tricca, he would have taken the direct route from Grevena to Khani Murgani in some twelve hours." That is what I believe actually happened.

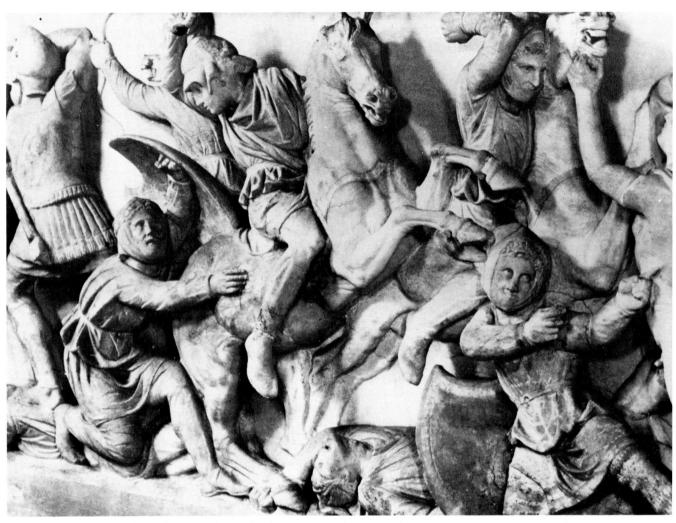

Fig. 22. Alexander Sarcophagus, battle scene, Macedonian cavalryman, Archaeological Museum, Istanbul.

Macedonian Arms and Tactics under Alexander the Great

MINOR M. MARKLE III

Department of Classics and Ancient History,
The University of New England, Australia

Abstract

DURING THE REIGNS OF Alexander the Great and the early Successors the Macedonian sarissa varied in length from 4.5 to 5.5 m. and in weight from 3.3 to 6.2 kg. The longer sarissa, perhaps without a butt-spike, was held by Alexander's Foot Companions so that the points of the weapons of the first five ranks would project beyond the front line. These troops did not wear corselets, and apart from helmets and greaves, their only special armor was small, relatively flat shields 62 cm. in diameter suspended from their left shoulders by a strap. The larger Macedonian shields were hoplite in type and were carried along with the spear and hoplite armor by the Macedonians from the time of Philip II through the Hellenistic period. From the reign of Antigonus Gonatas the larger Macedonian shield became more convex in outer profile than the traditional Greek hoplite shield with flat curvature and offset rim, and it became distinguished by a characteristic decoration of its outer surface. Under Alexander the hypaspists seem to have been armed with the hoplite panoply, while the six brigades of Foot Companions employed the sarissa. Polybius' criticism of the sarissa-armed phalanx demonstrates both its advantages and weaknesses. Alexander did not waste manpower, and whenever the sarissa would not have contributed to the attainment of his military objective he armed the brigades of the phalanx with other weapons. The shorter Macedonian sarissa, 4.5 m., was employed frequently in battle by cavalry. The cavalry sarissa itself is not described in the written sources but is clearly illustrated by the archaeological evidence. Both the mounted lancers (*sarissophoroi*) and the Companion Cavalry used the traditional javelins when their assignments called for pursuit, harassment, or reconnaissance, and they employed the cavalry sarissa when they engaged in direct assault. The cavalry sarissa was always held in the middle with one hand by the Macedonians, and its forward point was always counterbalanced by an iron butt-spike. No evidence suggests that the Macedonians ever carried the long cavalry lance with both hands as was done later by the Sarmatians and Roman *contarii*. Asclepiodotus attests that the advantage of a cavalry sarissa was that it enabled riders so armed to outreach their opponents in close combat. Philip II adopted the wedge formation for his sarissa-armed horsemen so that he might be able to cut through every hostile formation, and he probably learned from Epaminondas at the battle of Mantinea in 362 that such tactics were most effective with the use of *hamippoi*. That Alexander and later Macedonian kings employed hoplites paired with sarissa-armed horsemen as a tactical unit is indicated both by the literary and archaeological sources.

Preliminary Remarks

In an earlier article entitled "The Macedonian Sarissa, Spear and Related Armor" it was not possible, because of lack of space, to supplement the arguments with photographs of the relevant archaeological evidence.[1] Some of this material was contained in books and journals which could be found only in large research libraries, and thus most readers would have been unable to look up these illustrations in order to evaluate for themselves my interpretations. Moreover, since the publication of this article, I have continued research on Macedonian arms and armor,

and much additional archaeological material has been found and published which supports my views.[2] I am most grateful for the opportunity to present in this article photographs of most of the relevant archaeological evidence. In addition, I intend to examine in much greater detail a subject which I introduced in another article, "Use of the Sarissa by Philip and Alexander of Macedon": the flexibility of the Macedonian army.[3] With regard to this matter, I argued that the sarissa had a limited use, which depended on the terrain and military objective, and that when the sarissa was not appropriate the Macedonian soldiers employed other arms. In this article, I intend to omit the great set battles of Alexander, which I have already discussed, and concentrate on the arms employed by his infantry and cavalry for forced marches, surprise attacks, sieges, and skirmishes. Such military activity was far more common than the great battles, and in these frequent actions the flexibility of the Macedonian army can be observed at its best. Finally, only recently have I come to recognize the importance of *hamippoi* to close-order cavalry combat in the army of Alexander. Some difficult problems in interpreting the literary sources are solved by the assumption that these troops are being employed.

Specifications of the Macedonian Sarissa

Since the size and weight of the sarissa determined its use in battle and what arms and armor must be carried or worn in combination with it, the evidence for the specifications of the sarissa and its concomitant small telamon shield

Fig. 1. Ancient Cemetery of Mounds at Vergina.

must be examined. Both archaeological finds and the ancient writers suggest that the sarissa varied within certain limits in length and weight. Only the literary sources provide information about the length, since up to the present time no sarissa-head and butt-spike have been published which were found in place at the original distance apart with fragments of the wooden shaft in between them.[4] On the other hand, variations in weight are shown by various sizes of sarissa-heads, most of which were not found with any butt-spikes.[5] The best examples of the metal remains of sarissae have been excavated from the Ancient Cemetery of Mounds at Vergina by Manolis Andronikos and Photios Petsas and from the Royal Tombs, also at Vergina, discovered and excavated by Professor Andronikos, the latter not yet published. These mounds, or tumuli, at Vergina were constructed for burials of the early Iron Age, but parts of this burial site were employed again in the early Hellenistic period (Fig. 1).

There can now be no doubt about the date of the sarissa-head, butt-spike, sleeve, and spearhead

Fig. 2. Sarissa-head, spearhead, butt-spike, and sleeve from Vergina (photo: M. Andronikos).

published by Andronikos in 1970 (Fig. 2). Though they were not found actually within a Hellenistic burial, they were discovered close beside such a tomb which had been plundered by grave robbers, and Andronikos argues convincingly that these weapons were discarded by the plunderers as being without value.[6] This argument is now confirmed by his discovery of a butt-

spike belonging to a sarissa in the late fourth-century B.C. Tomb II at Vergina, attributed by him to Philip II. This butt-spike was displayed in the exhibition *Treasures of Ancient Macedonia* which opened in August 1978 at the Archaeological Museum in Thessalonike (but is not shown in the catalogue), and it resembles the previously discovered butt-spike in its size and unusual design: both have a middle part formed by four fins. Though the one on exhibition had a more elaborately decorated socket, I would conclude that both these weapons must be closely contemporary. This conclusion, however, is based merely on my personal observation and is contingent on Andronikos' publication of this important find. In contrast, two much lighter sarissa-heads (LXIX-LXXI I 32 and K 38) from the excavations of Petsas at Vergina can be firmly dated to the Hellenistic period, and they were found without butt-spikes (Fig. 3).[7] The earth-fill of tumuli LXIX-LXXI contained "an exceptionally large amount of plain Hellenistic pottery." Moreover, within these tumuli, in addition to Hellenistic vases, burials E and M contained one bronze coin of Cassander each (E 4 and M 44), and in burial H was discovered a bronze coin of Alexander the Great (H 23).[8] Although the tags on which the excavation numbers of these two weapons had been noted have been lost, I have been able to identify them by comparison of the entire collection with figures in the publication. Unfortunately, none of the other weapon points identified as sarissa-heads by size and weight was found in place and undisturbed in firmly dated Hellenistic burials (Fig. 4). Instead, they were found either in the earth-fill

Fig. 3. Hellenistic sarissa-heads from Vergina; top: LXIX-LXXI K 38, bottom: LXIX-LXXI I 32 (photo: Ph. Petsas).

of tumuli sometimes containing both prehistoric and Hellenistic pottery and sometimes containing exclusively prehistoric sherds, or in prehistoric burials disturbed by later burials, some of which could be dated to the Hellenistic period, others not.[9] Nevertheless, it seems probable that some of these sarissa-heads, if not all, are Hellenistic in date, and together with the two firmly dated Hellenistic sarissae, they provide evidence for a lighter Macedonian sarissa than the one published by Andronikos in 1970. First, the evidence for the heavier sarissae will be presented, and then that for the lighter weapons.

To begin with, it must be accepted as axiomatic in the absence of evidence to the contrary, that the Macedonian sarissa in the time of Alexander the Great varied in length only between about four and a half and five and a half meters. The maximum length of the sarissa at this time was twelve cubits, or about five and a half meters, according to Theophrastus, a good contemporary source, and the shortest sarissa was ten cubits, or about four and a half meters, according to Asclepiodotus, whose

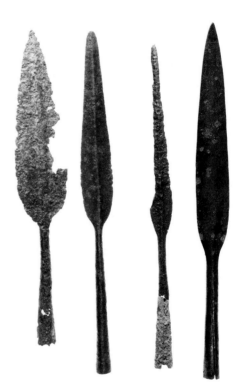

Fig. 4. Sarissa-heads from Vergina of doubtful date (photo: Ph. Petsas).

testimony must relate to the late fourth century B.C.[10] It must be stated now, what will become clearly evident in the following discussion: that the length of the sarissa, to a much larger extent than its weight, made it extremely cumbersome and difficult to handle. Nevertheless, the lighter the sarissa, the less tiring it would be to carry and employ over an extensive amount of time. Of course its weight would depend partly on the length and thickness of the wooden shaft: thus, the 5.5 m. sarissa would be heavier than the 4.5 m. weapon. The total weight, however, given these limits in length, would be affected even more by the weight of the iron tips and by the presence or absence of the butt-spike, because in order to avoid unwanted vibration, the heavier iron points require a wooden shaft thicker along its entire length. Such a heavy sarissa is best exemplified by the finds of Andronikos (Fig. 2). This weapon consisted of a sarissa-head, butt-spike, and iron sleeve. The purpose of the metal sleeve is unknown, but the close correspondence of its diameter with those of the sockets of both the sarissa-head and butt-spike indicates that it fitted on the wooden shaft of the sarissa. Though it was tentatively identified by Andronikos as a coupling sleeve, it is much too short to support the weight of two halves of a sarissa: its length is only about 16 cm. Perhaps it was placed in the middle of the shaft as a handle, a convenient balance mark for the cavalryman who had to grasp the sarissa precisely at midpoint with his right hand: such a sleeve can be discerned on the sarissa of the Macedonian noble on horseback charging a barbarian on foot from

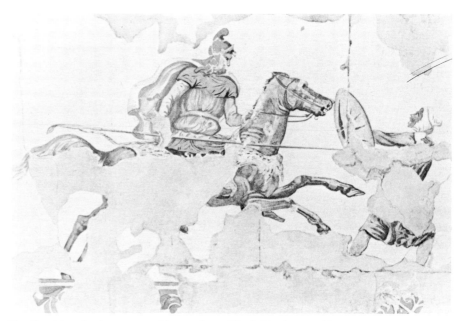

Fig. 5. Macedonian mounted lancer from Kinch Tomb, near Naousa.

the Kinch Tomb near Naousa (Fig. 5). In this case the sleeve is just forward of his right hand with which he holds the weapon: he no longer needs to be concerned with balance since the point of his lance seems embedded in, and hence supported by, his adversary's shield.

The butt-spike, corresponding closely in weight to the sarissa-head, served as a counterweight to the heavy forward point in order that the weapon might be balanced. Such a counterweight was more useful when the forward point was heavy. Consequently, the lighter sarissa-heads are found without butt-spikes. These lighter sarissae were, I believe, carried by infantry: in the tightly packed formations of foot soldiers the danger was great that men in the rear ranks would be jabbed in their stomachs by the back parts of the sarissae held by the men standing in front of them, and this experience would tend to be less damag-

ing if the lance butts were not tipped with sharp iron points. For cavalry, however, which charged in less dense formations, the butt-spike, besides being a counterweight, had two other functions. It served both as a support by which the lance could be implanted against the ground so that a charging horse could be transfixed by falling upon the point without the rider holding the lance being unseated and as a spare point in the

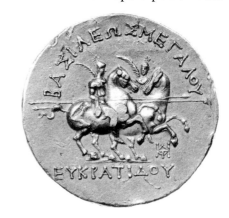

Fig. 6. Coin of Eucratides of Bactria, mounted lancers, Bibliothèque Nationale, Paris.

event that the sarissa-head should be broken off. That the butt-spike was a feature of the cavalry sarissa during the late fourth century B.C. is shown by the painting from the Kinch Tomb near Naousa, dated about 300 B.C.: the rear portion of the Macedonian rider's sarissa clearly is tipped with a butt-spike (Fig. 5). That the cavalry sarissa continued to be armed with a butt-spike until the middle of the second century B.C. is demonstrated by a coin of Eucratides of Bactria (156 B.C.). On the reverse, the two cavalrymen hold sarissae with butt-spikes equal in size to the sarissa-heads (Fig. 6).[11]

For computation of the weight of the heavy sarissa armed with the iron points published by Andronikos, the following information and measurements are necessary: the sarissa-head is 0.51 m. in length, the diameter of the socket into which the upper end of the shaft is inserted is 0.036 m., and its weight is 1.235 kg.; the butt-spike has a length of 0.45 m., a socket diameter of 0.034 m., and a weight of 1.070 kg.; the weight of Macedonian cornelian cherry (cornus mas, L. κράνεια) is about 0.76 g. per cu. cm. The sockets indicate a shaft of about 35 mm. in diameter, but it would need to be a bit thicker to avoid excessive vibration, about 38 mm.[12] The longest sarissa of 550 cm. minus the length of the point and butt-spike (51 cm. plus 45 cm.) 96 cm. would equal 454 cm., excluding the cones of wood inserted into the sockets of the head and butt. The volume of this shaft (π r² h: 3.14 x 3.61 x 454) would be 5,146 cu. cm., and its weight would be this figure times 0.76 g. per cu. cm., which would be 3.911 kg. The addition of the weights of the butt-spike and sarissa-head would give

a total weight of 6.216 kg. for the longest Macedonian sarissa armed with the heavy points. In the same manner, the weight of the shortest, 4.5 m., sarissa can be computed: on the assumption that the shaft was the same diameter as that of the longest sarissa and tipped with the same heavy head and butt-spike, it would weigh 5.355 kg. This computation has been confirmed by a facsimile of the 4.5 m. sarissa which I have had constructed. Thomas Latané of Baltimore, Maryland, a skilled metalworker, forged a sarissa-head and butt-spike which are exact copies of the ones published by Andronikos and accurate in weight to within 50 grams. The shaft, on which I fitted these metal points, was made of oak, a wood similar in weight to cornel. James Beard of Free Union, Virginia, made the shaft; he determined that the diameter would need to be about 39 mm. to avoid undue vibration with points of such weight. The total weight of this 4.5 m. sarissa is 5.50 kg.

The lighter Macedonian sarissae were armed with forward points almost equal in length to that of the sarissa-head found by Andronikos, but were far less heavy (Fig. 3). Sarissa-head LXIX-LXXI K 38, for example, being 47 cm. in length, is only 4 cm. shorter than Andronikos' sarissa-head, but it weighs only 235 g., slightly more than one-fifth of the 1,235 g. weight of Andronikos' sarissa-head. Again, sarissa-head LXIX-LXXI I 32 is 50 cm. in length, yet weighs only 297 g., about one-fourth of the weight of Andronikos' sarissa-head. Neither LXIX-LXXI K 38 nor I 32 is as well preserved as Andronikos' sarissa-head, and so they would have been somewhat heavier in their original condition. Neverthe-

less, their comparative lightness has resulted, for the most part, from a difference in design. Their blades are slenderer and thinner than those of the heavy sarissa-head published by Andronikos. Moreover, their necks are much less thick, and their sockets have thinner walls and smaller diameters.[13] Nevertheless, they could be firmly attached to shafts of about 4.5 to 5.5 m. in length on the condition that the shaft tapered toward the forward end. Since these sarissa-heads are only about one-fifth to one-fourth the weight of Andronikos' and were not paired with butt-spikes, they would not require as thick a shaft to support them.

Sarissa-head LXIX-LXXI K 38, for example, with no accompanying butt-spike could be supported by a shaft of 0.034 m. in diameter. The longest sarissa of 5.5 m. in length minus the length of the sarissa-head, 0.47 m., would have a wooden shaft of 5.03 m., excluding the cone of wood to be inserted into the socket of the point. The volume of this shaft (π r² h: 3.14 x 2.89 x 503) would be 4,565 cu. cm., and its weight would be this amount times 0.76 g. per cu. cm., the approximate weight of cornel wood, which would equal 3.469 kg. The weight of the sarissa-head is 0.235 kg., and thus the total weight of a five and a half meter sarissa would be 3.704 kg. (about 8.14 lbs.). By the same method of computation, the shortest, or 4.5 m., sarissa armed with this point would have a shaft with a volume (π r² h: 3.14 x 2.89 x 403) equaling 3,647 cu. cm., and this figure times 0.76 g. per cu. cm. would give a weight of 2.772 kg. The sarissa-head weighing 0.235 kg. added to the shaft would result in a weight

of 3.007 kg. (6.6 lbs.) for the shortest sarissa armed with this lighter point alone.

To appreciate the significance of the greater length and weight of the Macedonian sarissa, it is necessary to compare it with the hoplite spear, which was held in the right hand by infantry and used for thrusting. A typical hoplite spearhead of the early Hellenistic period among the many found by Petsas at the ancient cemetery at Vergina is VII A Iα (Fig. 7): its length is 0.277 m., the diameter of its socket 0.026 m., and its weight 270 g. The total length of a spear tipped with this point would have been about 2.20 m.[14] The full length of the spear minus the length of the spearhead would give a wooden shaft 1.923 m. in length, exclusive of the cone of wood inserted into the socket of the spearhead. The volume of this shaft ($\pi\ r^2$ h: 3.14 x 1.69 x 192.3) would be 1,005 cu. cm., and its weight would be this figure times 0.76 g. per cu. cm. which would equal 0.763 kg. The spearhead weighing 0.270 kg. added to this shaft would make the total weight of this hoplite spear 1.034 kg. (2.3 lbs.). It is, therefore, clear that the shortest and lightest Macedonian sarissa is almost three times heavier than the average hoplite spear, and that the longest and heaviest Macedonian sarissa is about six times heavier than the average hoplite spear.

The Small Macedonian Telamon Shield

A Foot Companion of the Macedonian king had to hold his five and a half meter sarissa with both hands, and thus he was able to carry only a small shield suspended by a strap from his left

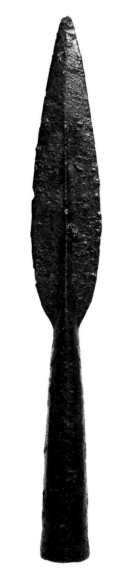

Fig. 7. Hellenistic hoplite spearhead from Vergina (photo: Ph. Petsas).

shoulder.[15] Asclepiodotus (*Tact.* 5) describes this shield: "Of the shields of the phalanx the best is the Macedonian of bronze which is eight palms in width and not too hollow." The Greek palm equaled three inches (7.687 cm.): Herodotus (2.149) writes that a foot equals four palms and a cubit six palms.[16] Thus, the diameter of this shield was 24 inches, or about 62 cm., considerably smaller than that of the hoplite shield which averaged about 34 inches, or 87 cm., in diam-

eter.[17] Asclepiodotus also states that the small shield must be "not too hollow." From the time of early Greek lyric poetry the epithet κοῖλος was applied to a hoplite shield because its offset rim produced a hollow space much greater than that produced by a single-grip shield. Asclepiodotus, therefore, may be implying that the small Macedonian shield did not have an offset rim. Moreover, many of the larger Macedonian shields display a strikingly convex shape in profile: this characteristic is clearly shown on the Monument of Aemilius Paullus at Delphi (Fig. 8). Thus, Asclepiodotus must also mean that the small shields must not be so convex in their outer faces as the large Macedonian shields.

Such shields as those described by Asclepiodotus are represented in relief sculpture at Veroia in Macedonia (Fig. 9). The drawing represents an approximate reconstruction of only a part of the remains of these shields which are found in two different places: some are built into the old wall of Veroia (Fig. 10), and others lie in the sculpture garden of the Archaeological Museum of Veroia (no photograph available). These shields were carved in the exact size of originals: the hoplite shields with flat curvature and offset rims are 87 cm. in diameter, and the smaller and flatter rimless shields have a diameter of 62 cm. One half of each shield seems to have been carved in advance on the face of one block of stone, and the complete shield would have been assembled only with the construction of the wall. Blocks in the sculpture garden lie properly matched but are not joined together. The blocks measure about 0.94 m. long by 0.48 m.

Fig. 9. Relief sculpture of shields from Veroia, scale: 0.001-0.01m.

Fig. 10. Relief sculpture of shields in old city wall of Veroia, Archaeological Museum, Veroia.

Fig. 8. Fallen Macedonian hoplite, Monument of Aemilius Paullus, Archaeological Museum, Delphi.

high by 0.15 m. deep (excluding the depth of the shields). The smaller shields are about 0.045 m. in depth at center, and the larger 0.08 m. in depth at center. However, I must stress that all these measurements are approximations, and that I hope to prepare a definitive publication of these sculptures at a later date. Not all of the shields extant from this architectural decoration are shown in the illustration, but I believe that originally each hoplite shield would alternate with a pair of small "sarissa" shields. A pair of these small shields (one of them incomplete) is found incorporated into the old wall of Veroia (Fig. 10).

Careful study must precede any announcement of firm conclusions, but certain observations can be made. First, it is very unlikely that these sculptures constituted part of a trophy representing the captured armor of Macedonia's enemies: by comparison of the literary testimony and archaeological remains only the Macedonian infantry is shown to have employed both these types of shields. Instead, they seem to have been intended as architectural decoration representing the two types of shields which were most characteristic of the Macedonian infantry: the large hoplite shield resembles precisely those carried by the Macedonian hoplites on the Alexander Sarcophagus (Fig. 11), and the smaller shields resemble those attributed to the Macedonian phalanx by Asclepiodotus not only in exact size but even in shape (they lack a rim and are not so "hollow" as the hoplite shields). Second, the com-

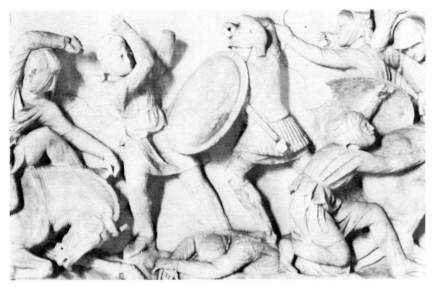

Fig. 11. Alexander Sarcophagus, battle scene, Macedonian hoplite, Archaeological Museum, Istanbul.

parison of the larger shield with those on the Alexander Sarcophagus suggests that the sculpture is from late fourth century B.C., since, as will be shown below, the larger Macedonian shield became even more convex and took on a characteristic decoration at the beginning of the third century B.C.

In addition to the small telamon shield, Macedonian sarissa-armed foot soldiers wore only the chiton with helmet and greaves and carried either a dagger or sword. That they did not wear the corselet is indicated by the omission of the ϑώραξ as necessary equipment for sarissa-armed infantry when they were being trained by Philip II (Polyaenus *Strat.* 4.2.10) and by its absence in an inscription found in the Strymon river recording military regulations on required arms and armor in the time of Philip V.[18] The sarissa itself was so heavy and cumbersome that it may have been deemed best to relieve such infantry from the obligation to wear the heavy corselet. Moreover, Polybius stresses the density of sarissa-

armed formations and states that the ranks behind the fifth ranks carried their sarissae "slanting upwards over the shoulders of those ahead of them in order to make secure the area directly above the battle array, excluding by the density of their sarissae as many of the missiles as flying over the heads of the leading men could fall on the rear ranks" (18. 30). Such a formation made the corselet less important as protective armor. If the sarissa-armed phalanx was penetrated by the enemy, the telamon shield could be shifted to a soldier's chest or back and thus serve the purpose of a corselet.

The Macedonian Hoplite Panoply

The larger Macedonian shields were hoplite in type and were carried along with the spear and hoplite armor by the Macedonians from the time of Philip II through the Hellenistic period. The earliest datable evidence for such shields is a gilded bronze shield cover contained in the important tomb at

Vergina discovered by Andronikos in autumn 1977.[19] The shape and size of this shield cover is of the traditional Greek hoplite type with flat curvature and offset rim, and I would estimate its diameter to be about 92 cm., equal to that of a large hoplite shield. According to Lorimer, "the diameters (of hoplite shields excavated at Olympia) . . . ranged from 80 to 100 centimeters —roughly 31 to 39.3 inches."[20] Moreover, the inner fittings of the shield over which this cover was placed included the central arm-ring (πόρπαξ) and handle inside the rim (ἀντιλαβή), both attached to a metal strip which extended across the horizontal diameter of the inside of the shield.[21] The central arm-ring, through which the hoplite thrust his left forearm up to the elbow, and the handgrip especially distinguish the hoplite shield from the single-grip or telamon shield, the latter being the type of the smaller Macedonian "sarissa" shield. Because of gold, silver, and ivory inlay this shield cover has been identified by Professor Andronikos as parade equipment, but it is unlikely that parade armor would differ in design from that actually employed in battle, although it might differ in ornamentation. Above all, it is significant that this shield cover with its flat curvature and offset rim resembles the shields carried by the Macedonian infantry represented on the Alexander Sarcophagus (Fig. 11).

The earliest representations in art of the larger Macedonian shields and their concomitant hoplite panoply are found on the Alexander Sarcophagus, which has been most recently and convincingly dated to 312 B.C.[22] Evidence from the Alexander Sarcophagus cannot be dismissed by insisting

that details of arms and armor are anachronistic due to artistic license and heroizing tendencies in commemorative sculpture. Although the artist has observed the tradition of heroic nudity in the case of some figures, he has paid close attention to details of contemporary armor in his representation of fully armed combatants. Comparison of the bronze infantry helmet, the Thracian or Phrygian type found at Vitsa in Epirus,[23] with those worn by Macedonian infantry on the sarcophagus (Fig. 11) will demonstrate the sculptor's attention to accurate detail: except for its missing cheekpieces, it resembles precisely the Macedonian infantry helmets in the sculpture. The Macedonian shields represented on the sarcophagus are not the convex and ornate types in later wall paintings and monuments; instead, they are ordinary round shields of traditional Greek design with flat curvature and offset rim. Inner fittings— arm rings and handles, painted and in relief—are visible. Moreover, these hoplite shields are carried by infantry who wear the full hoplite panoply: helmet, greaves, and, most important of all, corselets. Lorimer writes: "Most vital of all after the shield is the plate corselet, an indispensable compensation for the manoeuvrability of the telamon shield and for the protection it afforded in retreat."[24] The hoplite shield, held by the left forearm and hand, afforded protection only to the left side of the torso, and thus the corselet was needed to cover the unprotected part of the upper body.

Coinage provides evidence for the development of the convex and ornately decorated shield, which is regarded as the Macedonian type, from the traditional Greek hoplite shield. A coin of Ptolemy I Soter, dated 315/314 B.C., represents on the reverse Athena Alkidemos, the Macedonian goddess whose statue was at Pella, carrying the traditional Greek hoplite shield with flat curvature and offset rim. In her raised right hand she carries a spear, not a sarissa (Fig. 12).[25] The shape of this shield in profile resembles both those represented on the Alexander Sarcophagus and the bronze shield cover found by Andronikos in the royal tomb at Vergina. These similarities would indicate that the shield held by the goddess must represent the type used by the Macedonians at this time. The earliest stage of development from this type into the more characteristic Macedonian shield is shown by a coin of Seleucus I, struck at Persepolis in Persia 303-300 B.C. (Fig. 13).[26] The reverse of this coin represents the winged goddess Victory crowning a trophy with a wreath. The shield on this trophy has a much more convex shape in profile than do the earlier shields, and even its offset rim is bent inward to make it much more hollow within. The Macedonian star in relief, serving as a boss, decorates the center of the outer face of this shield. The shield is appropriately represented with the rest of the hoplite panoply on the tree trunk, including helmet, sword, and, most important, the corselet with fitted apron of leather straps. The scene portrays the victory of one Macedonian over another, a grim characteristic of the struggle among the Successors, probably the victory of Seleucus, Ptolemy, and Lysimachus over Antigonus and Demetrius at Ipsus in 301 B.C.

A coin of Lysimachus, dated 300-298 B.C., confirms this devel-

Fig. 12. Silver tetradrachm of Ptolemy I Soter, reverse Athena Alkidemos, The American Numismatic Society, New York.

Fig. 13. Silver tetradrachm of Seleucus I, reverse Victory crowning a trophy, Museum of Fine Arts, Boston.

Fig. 14. Silver tetradrachm of Lysimachus, reverse Athena Nikephoros, Museum of Fine Arts, Boston.

Fig. 15. Silver tetradrachm of Antigonus Gonatas: obverse Macedonian shield, reverse Athena Alkidemos; The American Numismatic Society, New York.

opment of the Macedonian shield (Fig. 14).[27] The reverse shows a seated Athena Nikephoros with hoplite shield and spear. The convex shield, with an elaborate relief decoration as a boss, rests against the chair beneath her left arm, and the spear with its point fixed into the ground in front of her feet extends diagonally behind her. Finally, Antigonus Gonatas celebrated his victory over the Gauls in 277 B.C. by an issue of the Athena Alkidemos type coinage (Fig. 15). On the reverse, Athena Alkidemos carries on her left arm a convex-type hoplite shield with offset rim, its center decorated with a face of Pan in relief, and the obverse side occupied by an entire shield, for the first time showing the full development of the crowded Macedonian decoration.[28]

Wall paintings in the mid-Hellenistic Tomb of Lyson and Kallikles provide additional evidence that the Macedonian infantry continued to fight as traditional Greek hoplites. On the north wall is a large shield with offset rim decorated with the Macedonian star in the center surrounded by a laurel wreath in the outer band (Fig. 16, Pl. 1); this decoration is similar to the star forming the boss of the shield on the coin of Seleucus I (Fig. 13). Also on the north wall (Fig. 16) are represented swords, greaves, and infantry helmets with cheekpieces, all of which closely resemble those represented on the Alexander Sarcophagus (Fig. 11), especially the helmet on the left with its forward-turned crest. On the south wall (Fig. 17) is painted a hoplite shield with a banded offset rim enclosing a broad band of eight incomplete banded circular reserves, each centering three beads and each separated by a styl-

ized thunderbolt; next, a band of beads encircles a banded circular central reserve left empty. The decoration on this shield is very similar to that of the obverse side of the coin of Antigonus Gonatas (Fig. 15). In addition to the shield are a pair of swords and a pair of infantry helmets with cheekpieces, surmounting a pair of composite corselets fitted at the waist with a skirt of double rows of long and short straps. These corselets are similar to those worn by Macedonian infantry on the Alexander Sarcophagus (Fig. 11), to that worn by Alexander himself on the Alexander Mosaic (Fig. 18), and to one found by Andronikos in the royal Tomb II at Vergina but not yet published. Just as do the contents of the royal tomb, the paintings in the Tomb of Lyson and Kallikles give us control of the monumental evidence. The arms and armor must be represented precisely as those employed by the occupant; there would be no purpose in heroic conventions.

The Monument of Aemilius Paullus at Delphi commemorating the Roman victory over King Perseus of Macedonia at Pydna in 168 B.C. confirms the argument that the large round shields in the Tomb of Lyson and Kallikles are hoplite in type (Figs. 8 and 19-21). The Macedonian shields on the monument can be clearly distinguished from the Roman shields by ornament, size, and shape (Fig. 19). The Roman ones are oval-shaped (not shown in the figure) or large body-shields (*scuta*) extending from ankles to face, both types supported by a single, central handle. The Macedonian shields are round with convex outer faces decorated in the distinctive manner (Fig. 20). One example covers a fallen infan-

tryman almost like a large bowl (Fig. 8). The decoration of these shields varies only in very slight details: for example, the outer rim, not offset, in some cases consists of concentric circular bands (Fig. 20), in others it is a plain circular band surrounding two concentric circles of beading (Fig. 8). In all cases, these outer circular bands encircle six half-circular beaded and banded reserves which surround a central circular reserve enclosing the Macedonian star. The decoration is similar in conception to that on the obverse side of the coin of Antigonus Gonatas (Fig. 15), and resembles even more closely the shield on the south wall of the Tomb of Lyson and Kallikles (Fig. 17). Moreover, like the shield on the north wall of this tomb (Fig. 16) and like the shield on the trophy depicted by the coin of Seleucus I (Fig. 13), the centers of these shields on the Monument of Aemilius Paullus are decorated with the Macedonian star. In view of these distinguishing marks of size, shape, and decoration, the single round infantry shield whose inside is shown must be Macedonian (Fig. 21), and it has the central armring (πόρπαξ) and handle (ἀντιλαβή) which are the special features of the hoplite shield.

Apart from the evidence of the continued use of the hoplite shield and other armor until the end of the Macedonian monarchy, other archaeological remains attest to the importance of hoplite arms in the Macedonian army. In the cemetery at Vergina the number of hoplite spearheads which can be dated to the early Hellenistic period is considerably greater than the number of sarissa-heads: the ratio is almost three to one. Since these are the burials of quite ordinary Macedo-

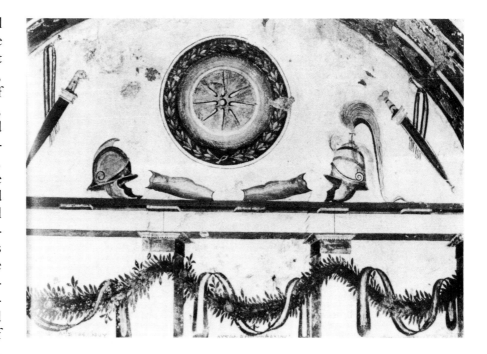

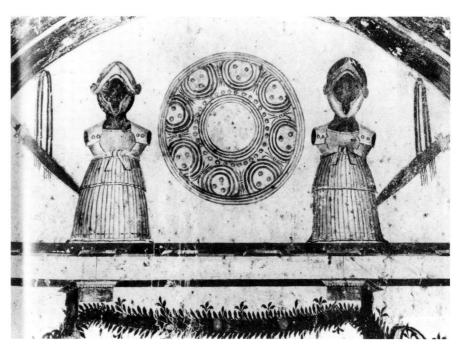

Top: Fig. 16. Tomb of Lyson and Kallikles, north wall, hoplite shield, greaves, helmets, and swords (photo: Sp. Tsavdaroglou, courtesy of S. G. Miller).

Bottom: Fig. 17. Tomb of Lyson and Kallikles, south wall, hoplite shield, corselets, helmets, and swords (photo: Sp. Tsavdaroglou, courtesy of S. G. Miller).

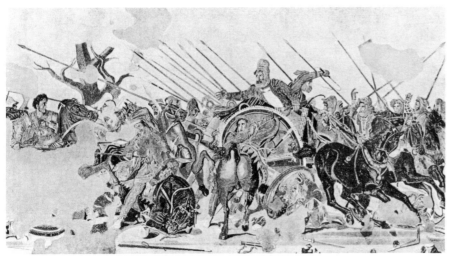

Fig. 18. Alexander Mosaic, National Archaeological Museum, Naples.

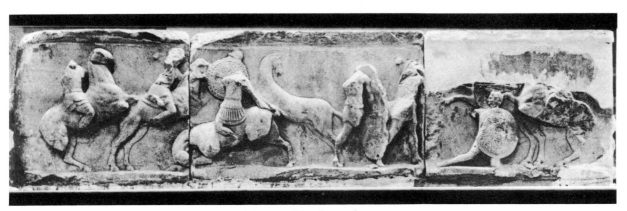

Fig. 19. Monument of Aemilius Paullus at Delphi, initial battle panel.

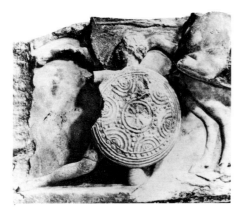

Fig. 20. Monument of Aemilius Paullus at Delphi, Macedonian shield, exterior.

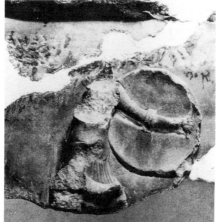

Fig. 21. Monument of Aemilius Paullus at Delphi, Macedonian shield, interior.

nian soldiers, the weapons confirm what we learn from other sources, that the army of Alexander continued to make greater use of the spear than the sarissa.[29] The finds of Andronikos in the royal tombs at Vergina included both spearheads and sarissa-heads, and this would indicate that in military practice the kings set the example for the common soldier by training themselves in the use of both weapons.[30]

I have argued elsewhere in detail that the part of the Macedonian infantry under Alexander the Great *normally* armed with the hoplite panoply were the hypaspists and that the Macedonian phalanx, con-

sisting of the six brigades of Foot Companions, employed the five and a half meter sarissa whenever that weapon was appropriate.[31] Both hands of the foot soldier were required to wield such a weapon, since he had to grasp it sufficiently close to its butt to permit the sarissae of the first five ranks to project beyond the first rank. The sarissa was useless outside the tight formation, and the phalanx armed with it had both advantages and limitations. Polybius (18.29-30) states that nothing could withstand its frontal charge and that it was impossible for the front ranks to face about in the mass forward movement so interwoven would men and lances become that no flanking movements, turns, or strategic retreats would be possible. Polybius is categorical in his definition of the only kind of ground on which sarissa-armed infantry could be employed. He writes (18.31.5): "And again it is agreed that the phalanx has need of flat and open places (τόπων ἐπιπέδων καὶ ψιλῶν) which, in addition, have no obstacle, and I mean ditches, ravines, junctures of glens, crags, river-beds. For all of the aforesaid are sufficient to hinder and break up such a formation." Study of the performance of sarissa-armed infantry in various battles illustrates more precisely what Polybius means by "flat and open places." The obvious meaning of the phrase would be plains, but it does not exclude rising ground provided that the slope was fairly even. At Cynoscephalae the Macedonian phalanx on the right wing performed well because it seems to have been descending a smooth and unbroken slope, but the left wing of the sarissa-armed phalanx, still on the

march, was unable to go into formation, partly because of "the difficulty of the terrain" (Polybius 18. 24-25). Ultimately, it was the ground that defeated the Macedonians at Cynoscephalae, since the smooth slope seems to have been only broad enough to permit the right wing to descend against the Romans; the left wing, unable to go into formation because of the difficulty of the ground and so put to flight, rendered the right wing vulnerable in the flanks and rear.[32] Polybius' judgment about the kind of terrain on which the infantry sarissa could be employed must not be dismissed: he commanded the cavalry in the army of the Achaean Confederacy in 170/169, and that army employed both cavalry and infantry sarissae.[33] Moreover, his statement applies just as much to the late fourth century as to the early second century, since the infantry sarissa of his time was substantially the same weapon as the earlier model.[34] Alexander did not waste manpower, and whenever the sarissa would not have contributed to his military objective he armed the brigades of the phalanx with other weapons.

The Flexibility of the Macedonian Army

I have considered in another article the weapons employed by the Foot Companions of the phalanx in the great set battles of Alexander and have argued that at the Granicus River and at Issus they employed hoplite spears, at Gaugamela sarissae, and at the Hydaspes both sarissae and javelins.[35] I will now concentrate on the use of the six brigades of Foot Companions for forced marches, surprise attacks, sieges, and skirmishes and consider whether the ancient accounts

suggest what weapons this infantry employed. However, before attention is directed to the Foot Companions, an accurate perspective must be gained on Macedonian arms. What weapon could be used in the greatest variety of situations? It is assumed that the sarissa, being uniquely a Macedonian weapon, was most commonly used, but not only the sarissa but even the spear frequently had to be abandoned in its first victim, leaving its owner to fight on with his sword. Plutarch (Alex. 32.5-6) states, in his description of the arming of Alexander before the battle of Gaugamela, that the Macedonian king had trained himself most frequently to use a sword in his battles (ἠσκημένος τὰ πολλὰ χρῆσθαι μαχαίρᾳ παρὰ τὰς μάχας). Even without this valuable testimony, common sense would suggest the importance of the sword to both infantry and cavalry. Soldiers pressing forward and pushed by those arrayed behind them, whether on foot or on horseback, once they had thrust the points of their sarissae into the bodies of their adversaries often would be unable to withdraw their weapons and thus would be compelled to drop them and fight their way forward with the sword. The lighter and shorter spear could present a similar problem: it was more easily broken and also could be difficult to extract. The Alexander Sarcophagus illustrates this situation (Fig. 11). The position of the Macedonian hoplite's arm, which once held a weapon perpendicular to the plane of the relief, above and across his shield and forehead, shows that the weapon was a sword, not a spear. He was about to slash forward with the blade at the Persian who has raised both

arms to ward off the blow. This hoplite has lost his spear and fights with a sword. Moreover, in another part of the battle scene (Fig. 22) a Macedonian cavalryman on a rearing horse turns around with his right arm raised above his head so as to swing a weapon downward against a Persian kneeling on one knee and cowering beneath a shield to the rear of the horse. Again, the position of his raised right arm shows that the metal weapon which it once held was a sword, not a spear or sarissa. In this case, the rider has already left his sarissa in the body of a Persian and now must continue fighting with his sword.

The sword was a much more effective weapon than either the sarissa or spear in numerous situations. Unlike the latter weapons which could only be thrust in one direction at a time, the slashing sword could be swung through a broad arc in one movement harmful or fatal to any enemy who stood within that space. This weapon was especially useful after formations had broken up and combat took place between individuals or among small groups. This kind of fighting commonly occurred in sieges of cities, and the ancient accounts single out the sword as the weapon most effectively employed by Alexander in the storming of fortified cities.[36] The sources provide much more specific information about the weapons employed by Alexander, but they also show that the soldiers followed his example. Diodorus (17.11.3–4), writing concerning a battle between the Macedonians and Thebans on the occasion of Alexander's siege of Thebes in 335, relates that both armies first threw their light missiles at each other,

and then "all joined in hand to hand combat with the sword." Citing the superior weight of the Macedonian phalanx as a factor in this battle, Diodorus shows that he includes them among those who employed the sword, and he says nothing about the use of the sarissa in this battle.[37] His account is only intelligible if one assumes that initially all the phalangites, and not merely contingents of light-armed infantry, were armed with javelins. They could not have carried both sarissae and javelins. Thus, once these missiles were expended (τούτων ἐξαναλωθέντων καὶ πάντων), they fell to close-order combat with swords.[38]

The accounts of the campaigns of Alexander suggest that he and his soldiers were trained in the use of various weapons and that the arms which they employed depended solely on the occasion. The principal question asked by Alexander when he considered how his troops should be armed was what weapons and armor would be most effective in winning the particular military objective. Alexander in his attack on the citadel of the Malli wore a corselet and carried a hoplite shield.[39] The small Macedonian telamon shield would have been useless to Alexander in his assault on the citadel, and it was not used with the corselet. Moreover, Arrian's description of Alexander being covered by his shield (εἰληθεὶς ὑπὸ τῇ ἀσπίδι) as he mounted the wall on the ladder (6.9.3) would indicate the use of the large Macedonian hoplite shield. Again, at the siege of Tyre, Alexander fought as a hoplite with spear, shield, and sword (Diodorus 17.46.2). That he could kill some of the enemy by striking them with the rim of his

shield (. . . τύπτων ἀπέκτεινεν, ἐνίους δ' αὐτῇ τῇ περιφερείᾳ τῆς ἀσπίδος . . .) shows that he carried the large Macedonian shield with its offset rim, not the rimless small telamon shield. On the other hand, at the battles of the Granicus and of Gaugamela Alexander fought on horseback with the cavalry sarissa, or xyston.[40]

The ancient writers also attest that individual soldiers were trained in the use of diverse weapons. In a duel between Coragus and Dioxippus, the Macedonian Coragus fought with a javelin or spear, a sarissa, and a sword, which are termed his "usual weapons" by Curtius.[41] At the siege of the rock of Aornus in India, Charus, one of Alexander's Companions, fought with both spear and sword, and since he was a Companion, at other times he would frequently have fought on horseback with either sarissa or javelin.[42] Charus is not the sole example. Others among Alexander's Companion Cavalry and bodyguards were trained to fight on horseback with javelins and sarissae and on foot as hoplites with shields and spears.[43] Moreover, considerable numbers of Alexander's infantry were trained to ride horses and carry their usual infantry arms.[44]

Finds from the Ancient Cemetery of Mounds at Vergina also indicate that the individual Macedonian soldier was trained in the use of various weapons.[45] These burials of ordinary infantry soldiers are not nearly so rich in arms and armor as the royal tombs. The surviving sons could not afford to bury with their fathers the costly hoplite panoply or the other armor used with the sarissa. Nevertheless, sufficient arms were placed with the dead to corroborate the

literary evidence for the flexibility of Alexander's army. I have already published a catalogue of the arms found in individual burials in this cemetery both in the early Iron Age and the Hellenistic period. Most of the weapons in this catalogue were fully described and illustrated in the article itself, and the rest will be definitively published in an article forthcoming in *Makedonika*. At the time I wrote the article for the commemorative volume on Alexander the Great I had not yet completed my study of the collection. The group of weapons found in the Hellenistic tumulus LXIX-LXXI burial 1, which I listed in that article (pp. 266–267) under "Doubtful Cases" (VII. D.) "spearhead," knife, and sword, can now be identified as sarissahead, knife, and sword. This sarissa-head has already been described above and illustrated (fig. 3, LXIX-LXXI I 32). The sword (LXIX-LXXI I 29) is a double-edged, slashing, and thrusting sword (Fig. 23). The hilt except for the hand-guard is broken off, but the blade is well preserved: total length 0.55 m., weight 300 g., width of handguard 0.11 m. Some fragments of iron have been identified by Petsas as remains of the hilt, but they are so reduced by rust as to be unidentifiable except for the "swallowtail" top of the hilt (Figs. 23 and 24). The third weapon found in this burial was the knife (LXIX-LXXI I 33). It is single-edged and small, almost a long crescent in shape (Fig. 24): length 0.181 m., weight 35 g.

Therefore, both the written sources and archaeological evidence suggest that the individual Macedonian soldier was trained in the use of various weapons and that the sword was employed

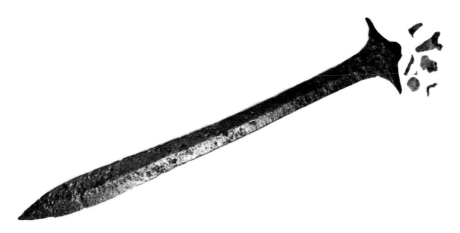

Fig. 23. Macedonian Hellenistic sword LXIX-LXXI I 29 (photo: Ph. Petsas).

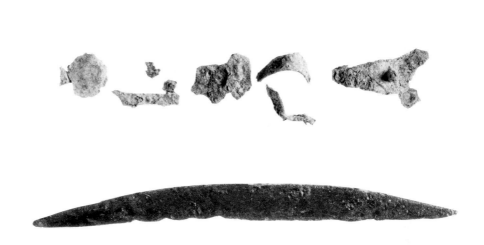

Fig. 24. Fragments from hilt of sword and Macedonian Hellenistic knife LXIX-LXXI I 33 (photo: Ph. Petsas).

more frequently by the Macedonian cavalry and infantry than any other weapon. With these circumstances in mind, we must consider what weapons were employed by the Foot Companions of the Macedonian phalanx when they were involved in sieges, forced marches, and skirmishes. Let us first observe their use in siege warfare.[46]

Arrian (1.8.1-5), describing the siege of Thebes, writes: "Ptolemy son of Lagos says that Perdiccas was placed in charge of the guard of the camp with his own brigade, and since the palisade of the enemy was not very far away, he did not await Alexander's signal for battle but himself first attacked the palisade and tearing it apart rushed among the advanced guards of the Thebans. Amyntas son of Andromenes, following him, himself led on his own brigade. . . ." Polybius (18.31.2-6), as has been shown, stressed that sarissae were suitable

for use in battle only on "flat and open places which . . . have no obstacle. . . ." Sarissae were utterly unsuitable for attacking a palisade and storming over into a besieged city. Moreover, Diodorus (17.11.3-4) attests that the Macedonians during this siege fought with javelins and swords in a battle before the city, and these Macedonians would surely include the brigades of Foot Companions.[47] Accordingly, the brigades of Perdiccas and Amyntas would have been armed with spears and swords, the weapons employed by Alexander himself when he mounted the walls of a besieged city.

Diodorus, to be sure, gives a variant account of Perdiccas' penetration of the palisade. He states (17.12.3) that Alexander took note of a small unguarded gate and "sent Perdiccas with a sufficient number of soldiers to seize it and enter the city."[48] The account of Ptolemy with its precise detail is much more probable than that of Cleitarchus, preserved by Diodorus, with its conventional motif of the unguarded gate. Nevertheless, for the thesis maintained here it does not really matter which version is accepted: Perdiccas' soldiers would not have been armed with five and a half meter sarissae for fighting their way either through palisades or in the enclosed areas of a city which include narrow, crooked streets, buildings, and fences. Diodorus himself (17.12.5) states that when the Thebans were driven back into their city "they perished in the narrow streets and trenches by falling upon their own weapons." In such circumstances, their Macedonian assailants would have fought with spears and swords.

Space does not allow a detailed study of the use of the Foot Companions in each of the sieges of Alexander, but in none would the sarissa have been employed. Only a brief summary of the evidence can be given here, and I will give only the most essential commentary. During the siege of Halicarnassus in 334 Alexander hoped to capture Myndus either by treachery from within or by a sudden raid on a weak part of the wall. In addition to the other forces which Alexander selected for this purpose, he took along the brigades of Amyntas, Perdiccas, and Meleager (Arrian 1.20.5). Since Alexander took half of the Foot Companions, they formed the largest part of his forces, and he would have armed them with weapons useful both for battles outside the city and for storming the wall. Sarissae could have been employed in the former eventuality but not in the latter. Second, during the siege of Halicarnassus, two infantrymen from the brigade of Perdiccas in drunken rivalry armed themselves with javelins and attacked the wall, and due to the opposition from the defenders which they provoked, more of Perdiccas' men joined in (Arrian 1.21.1-3; cf. Diodorus 17.25.5). For this attack, these Foot Companions took javelins, and probably also swords; sarissae would have been useless. Third, in 332 at the siege of Tyre, the Foot Companion brigade of Coenus was assigned the task of rushing over a drawbridge from a ship to assault a breach in the city wall defended by the enemy (Arrian 2.23).[49] Such an assignment could not have been carried out with sarissae; instead of these arms the brigade of Coenus would have carried spears and swords just as did the hypaspists with whom they shared this mission. Indeed, on this occasion Alexander himself, who led one of the charges across a drawbridge from a tower constructed on ships lashed together, was armed as a hoplite, and fought with spear, sword, and large hoplite shield with offset rim (Diodorus 17.46.1-2).[50] Surely, Alexander would not require his Foot Companions to employ weapons less appropriate than his own for this assault.

Gaza, the fourth case, poses a different problem. Use of the Foot Companions at this siege is not attested by the naming of specific brigades, but it seems most improbable that they remained idle during the action. When Arrian states that Alexander brought up the "phalanx" on all sides of the wall, he would have intended the term to include the Foot Companions and not merely the hypaspists, archers, and other light-armed foot soldiers (Arrian 2.27.5-6). Everyone was in the action: ladders were placed against the wall and Neoptolemos, one of the Companions, was the first to mount. Apparently, he and other members of the Companion Cavalry were fighting on foot, surely in hoplite equipment. They would not have fought without shields as they did on horseback. Arrian's next statement: ἐπὶ δὲ αὐτῷ (Νεοπτολέμῳ) ἄλλαι καὶ ἄλλαι τάξεις ὁμοῦ τοῖς ἡγεμόσιν ἀνέβαινον would include more than τάξεις of the hypaspists and light-armed soldiers with their commanders. Since there was ἔρις πολλή among the Macedonians who made some claim to valor as to who first would mount the wall, I would expect that ἄλλαι καὶ ἄλλαι τάξεις would include the six τάξεις of Foot Compan-

ions. They would not have stood aside to allow archers and javelin-throwers to take pride of place, and for this combat they would have employed spears and swords rather than sarissae. Moreover, if the Companion Cavalry was fighting on foot armed with infantry shields, it seems likely that the Foot Companions would also employ arms and armor suitable for the occasion.

At the siege of Massaga in winter 327/326, Alexander sent "Alcetas with his brigade" up to the wall "to recover the wounded and to recall to the camp as many as were still fighting" (Arrian 4.27.1). These Foot Companions would have worn corselets and probably would have carried hoplite shields to protect themselves from missiles discharged from the wall. Perhaps they would have been armed with javelins and swords, since after throwing their javelins they would have an arm free to help the wounded. In any case, sarissae would have been only a hindrance on such an assignment. Among the troops which Alexander took against the rock of Aornus was the brigade of Coenus (Arrian 4.28.8), and on such terrain these Foot Companions would have had no use for sarissae. Moreover, Arrian (4.29.2) informs us that when Alexander was leading the rest of the army, which would include the brigade of Coenus, to the stockade constructed by Ptolemy, he was stopped when the tribesmen opposed him due to the difficulty of the ground. Alexander had foreseen this problem by sending Ptolemy ahead, and he would not have compounded his troubles by arming the brigade of Coenus with sarissae.

At the siege of Sangala the brigades of ἀσθέταιροι could not have been armed with sarissae (Arrian 5.22-24). The defenses of the enemy were such that spears and swords would have been the appropriate weapons. The Cathaeans ". . . were drawn up in front of the city on a hill which was not precipitous on all sides. They had placed their wagons around the hill and were encamped inside of them so that the wagons formed a triple palisade" (5.22.4). Arrian in his description of the order in which Alexander drew up his troops states that the brigades of Foot Companions were stationed somewhat to the left of the middle of the line (5.22.6). When the cavalry assault on the wagons failed, Alexander "leapt down from his horse and led on the phalanx of foot" (5.23.1). This phrase clearly includes the brigade of "asthetairoi" toward the left as well as the hypaspists and Agrianes stationed on the right wing. Finally, in 326/325 Peithon commanded one of the brigades of Foot Companions (Arrian 6.6.1), and took them, along with two squadrons of the cavalry, against the Malli "who had taken refuge in a strong and fortified place" (Arrian 6.7.2-3). In attacking and capturing this fortress the brigade of Peithon would not have been armed with sarissae.

I would also maintain that sarissae would not have been carried by the Foot Companions on expeditions involving fast and long marches during which skirmishes and battles might occur in unexpected places, often on rugged terrain. Arrian (2.5.6) reports that Alexander took three brigades of the Macedonian infantry, all the archers, and the Agrianes and marched against the Cilicians who were occupying the mountains. If

these three brigades of foot soldiers had been armed with sarissae, they might have been able to fight with advantage in the valleys between mountains. On the other hand, if they had carried swords, spears, and javelins they would have been serviceable throughout the mission. Alexander would not have wanted so many infantry merely to sit down and wait while the Agrianes and archers fought on the slopes. Moreover, armed with sarissae they would have had difficulty in defending themselves if attacked on rugged ground.

In the march to seize the Persian Gates Alexander took not only the hypaspists but all six brigades of Foot Companions (Arrian 3.18.1-10): they are all named in the course of this expedition—the brigades of Craterus, Meleager, Perdiccas, Amyntas, Coenus, and Ptolemy (son of Seleucus). It is difficult to identify the more heavily armed troops sent with Parmenion by the main road into Persia, although the soldiers taken by Alexander are contrasted with these men (3.18.1). The fact that the contrast was made would indicate that all the troops who accompanied Alexander were lightly armed, and this would mean that the Foot Companions would not have carried the heavy five and a half meter sarissa. All these troops Alexander led on a fast march through the mountains, and they found the Persian Gates blocked by a wall and a large Persian army. When Alexander was unable to capture the wall by assault because of the difficulty of the terrain and because his troops were being pelted with missiles thrown by the Persians from the heights, he left the brigades of Craterus and Meleager and other forces with orders

to coordinate their attack on the wall with his assault on the Persian army from the other side. He then took the brigades of Perdiccas, Amyntas, Coenus, and Ptolemy by night over a rough and narrow road. After advancing about eleven miles, he turned back toward the Gates, and detaching the Foot Companion brigades of Amyntas and Coenus with orders to descend to the plain and bridge the river, he continued by a difficult and rough track with the rest of his forces at a run (δρομῷ) against the Persians. His forces still included the brigades of Perdiccas and Ptolemy, and they attacked the first and second Persian guards before dawn and at dawn assaulted the trenched Persian camp. Sarissae would have been utterly unsuitable weapons for this kind of mission and for combat on such uncertain terrain. Moreover, the brigade of Craterus would have used spears and swords in assaulting the wall, which was ἄπορον διὰ τὴν δυσχωρίαν. It is possible that the brigade of Ptolemy, which had been left near the Persian side of the wall to cut down any of the enemy attempting to escape, was armed with sarissae. But this would depend on the terrain, and sarissae would have been extremely awkward to carry over the difficult and narrow tracks by night. So I think that Craterus' brigade was also armed with spears and swords.[51]

Space does not permit a discussion of the many other occasions on which brigades of Foot Companions were used on long and fast marches through rugged terrain. I will only enumerate the cases with little or no comment. The Macedonian phalanx which was taken in

pursuit of Darius would have included brigades of Foot Companions (Arrian 3.20.1-2). The bulk of the forces sent against the Tapurians consisted of the brigades of Craterus and Amyntas (Arrian 3.23.1-5). The brigades of Coenus and Amyntas were taken on an expedition against the Mardi who dwelt in country so difficult to enter because of its natural defences that it had not been invaded for a long time (Arrian 3.24.1-3). In addition to other forces Alexander took the brigades of Amyntas and Coenus on a fast march against Satibarzanes and the Areians and traversed 600 stades (68 miles) in two days. Curtius (6.6.20-36) describes this expedition and refers briefly (21) to the forces which Alexander led out as "levem armaturam et equestres copias." The "light-armed" would include the brigades of Amyntas and Coenus, and so they would not have been armed with the heavy sarissae. The brigades of Craterus, Polyperchon, Attalus, and Alcetas were sent by Alexander on a long campaign against Catanes and Austanes (Arrian 4.22.1).[52] On such a mission it was impossible to predict on what kind of terrain the battle with Catanes and Austanes would ultimately be fought. Since no hypaspists were sent, the Foot Companions would have needed arms and armor which would serve them in the most varied circumstances: hence, not sarissae. Finally, the brigades of Coenus and Attalus and the hypaspists were taken on a long march through difficult country against the Aspasians (Arrian 4.24.1). This case concludes my argument that the varied use made of the brigades of Foot Companions suggests that they were variously armed. I will

now consider whether the same argument applies to the Companion Cavalry and *sarissophoroi* cavalry.

The Macedonian Cavalry Sarissa

The shorter Macedonian sarissa, 4.5 m. (15 ft.), was frequently employed in battle by Alexander's cavalry. It was usually called *xyston* by the ancient writers. Both the *sarissophoroi* and Companion Cavalry probably often used the traditional javelins when their assignments called for harassment, pursuit, or reconnaissance, and they employed the cavalry sarissa when they engaged in direct assault. The ancient sources seldom designate what weapons were used by cavalry for particular assignments, but some perspective on the matter can be gained by trying to see the cavalry in its historical context. Coinage shows that from the reign of Alexander I (493-454) through that of Archelaus I (413-399) Macedonian riders carried two javelins.[53] Moreover, Xenophon in his *Cavalry Commander,* written probably about 365 B.C., stresses that the main object in the training of a horseman was to teach him to throw the javelin; spears were to be used in parades and in arming grooms to deceive the enemy as to the size of the force.[54] In his essay *On Horsemanship,* written soon after *Cavalry Commander,* Xenophon rejects the long spear as an offensive weapon and recommends the javelin (12.12): "Instead of the spear made of cane, which is weak and difficult to carry, we recommend two cornel wood javelins. For it is possible for the skillful man to throw the one and to use the other in front or on the sides or behind. And it is, at the same time, stronger than the

spear and easier to carry." In addition to the two javelins, Xenophon advocates the slashing sword rather than the thrusting sword for cavalry (*Hippik.* 12.11). The advice of Xenophon reflects the traditional Greek use of cavalry for harassment, pursuit, defense, and reconnaissance.

Philip II, following Epaminondas and the Thebans, perceived the effectiveness of cavalry as an assault force for breaking through an opposing phalanx in hand-to-hand combat.[55] For this purpose, he introduced the sarissa as a cavalry weapon. Asclepiodotus (*Tact.* 1.3) writes: "Cavalry which fights at close quarters uses long spears, for which reason it is called *xystophoron*. . . ." On the other hand, Macedonian cavalry did not cease to use the javelin, simply because the sarissa had been introduced. When the *sarissophoroi-prodromoi* and squadrons of Companion Cavalry were sent ahead of the army as observers and were meant to report back the dispositions of the enemy, they were probably not armed with sarissae (Arrian 1.12.7, 1.13.1, 3.7.7). Cavalry sent on reconnaissance would do anything possible to avoid fighting at close quarters; indeed, if they were so unfortunate as to be seen, they would flee back at a gallop to make their report. Two javelins and a sword would be more useful arms for such missions.

It is more difficult to decide how the *sarissophoroi* and Companion Cavalry would be armed for pursuits and for long and fast marches (Arrian 3.8.1-2, 3.18.2, 3.20.1-2, 3.25.6). The object of a pursuit or forced march was, of course, to come to battle with the enemy as quickly as possible. The heavy and cumbersome sarissa would be a hindrance en route, but might prove advantageous in the end.

In major battles Alexander did not always arm the Companion Cavalry with sarissae. At least some of these horsemen were armed with javelins for the battle against the Triballians. According to Ptolemy (Arrian 1.2.5-7), Alexander "ordered Philotas to take the cavalry of upper Macedonia and charge their right wing . . . Heracleides and Sopolis he assigned to lead the cavalry from Bottiaea and Amphipolis against their left wing. The phalanx of foot and the remaining cavalry, which he extended in front of the phalanx, he led against the middle. And so long as there was a discharge of missiles from each of the two sides (καὶ ἔστε μὲν ἀκρο-βολισμὸς παρ' ἑκατέρων ἦν), the Triballians stood their ground. When, however, the phalanx in dense order charged them stoutly, and the cavalry, no longer throwing their javelins (οὐκ ἀκοντισμῷ ἔτι) but pushing with their horses themselves, began to fall on them here and there, they turned" The "remaining cavalry" which Alexander places in front of the phalanx probably should be identified as the other squadrons of Companion Cavalry. There is no evidence that Alexander employed any allied cavalry in these critical battles by which he secured his succession.

On the other hand, both at the Granicus and at Gaugamela the Companion Cavalry fought with sarissae. Arrian (1.15.5) says that at the Granicus the Companion Cavalry (οἱ σὺν Ἀλεξάνδρῳ) began to prevail ". . . because they fought with cornel wood lances (ξυστοῖς κρανείνοις) against javelins (πρὸς πάλτα)." And later he states (1.16.1): "And the Persians on all sides, both themselves and their horses, were now being struck in the faces with lances (τοῖς ξυστοῖς) and were being pushed off in front of the cavalry. . . ."[56] Later, narrating the battle at Gaugamela, Arrian (3.14.3) describes the Companion Cavalry (οἵ τε ἱππεῖς ἀμφ' Ἀλέξανδρον) and Alexander himself "cutting the faces of the Persians with their lances (τοῖς ξυστοῖς τὰ πρόσωπα τῶν Περσῶν κόπτοντες)."

The cavalry sarissa itself is not described in the literary sources. To learn about this weapon, we must turn to the archaeological evidence. The Alexander Mosaic shows that the cavalry sarissa was only about one meter shorter than the infantry sarissa (Fig. 18). Though the rear portion of Alexander's lance is not shown due to damage to the mosaic, it would have been equal in length to the forward part and have been counterbalanced with a butt-spike. By carefully comparing the length of the forward part of Alexander's sarissa with the probable size of the horses and height of the Persian standing before the wheel of Darius' chariot, who would be between 170 and 180 cm. in height and who holds a spear of slightly greater length than his height (about two meters), one can conclude that the length of the forward part of Alexander's lance equals about two and a quarter meters, and this doubled would produce a lance of four and a half meters.

The Alexander Sarcophagus also provides early evidence of the length of the Macedonian cavalry sarissa (Figs. 25 and 26). The metal weapons, reins, and bridles, which once were attached to these sculp-

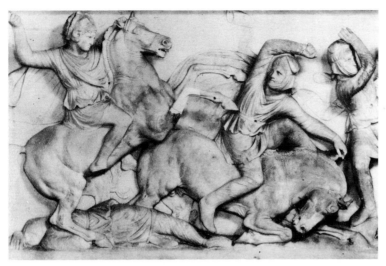

Fig. 25. Alexander Sarcophagus, "Alexander Battle," Alexander on horse, Archaeological Museum, Istanbul.

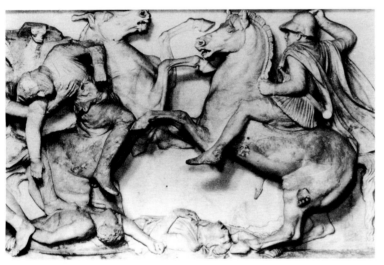

Fig. 26. Alexander Sarcophagus, "Alexander Battle," Macedonian Companion Cavalryman, Archaeological Museum, Istanbul.

tures, are now missing, but the holes in which they were attached indicate something of their character and most particularly prove the great length of the Macedonian cavalry lances. In the representation of the "Alexander Battle" only the forward half of Alexander's sarissa would have been displayed, since he is the first figure in the panel on the left and his raised right hand is in the upper left corner of the frame (Fig. 25). The bronze shaft of his lance was once held in this closed right hand, and the hole which supported the forward half of this weapon is just above the right front fetlock of his horse; thus his lancehead was at the waist of his Persian adversary. Comparison with the other figures in the relief suggests that the forward half of his sarissa was about two and a quarter meters in length. Another sarissa-armed Macedonian horseman enters the battle at the right end of the panel (Fig. 26), and he has planted his lance in the stomach of his Persian opponent. The forward part of his lance can be measured from his raised right fist to the hole at the waist of his dying enemy, and the length is approximately the same as that of the forward half of Alexander's lance. The rear half of his lance would have projected beyond the limits of the panel and would have been omitted.

Armed with such a weapon, the horseman must have had difficulty in maintaining his seat when he struck an enemy with his sarissa. No stirrups were used by the Greeks, though they were at this time employed by the Scythians.[57] Once the rider had stuck his lance into the body of an opponent, he could not normally withdraw it if his horse continued to move forward, and he was compelled to drop the weapon to avoid being unseated and to hack his way through the enemy with his sword. The sarissa could be carried on march by resting it against the shoulder (Fig. 27) or by letting it rest diagonally across the back of the horse (Fig. 6). The latter method followed by the Bactrian cavalrymen would be easier for the rider. In battle the lance could not be shifted from the lower to upper position without the use of both hands (Figs. 28, 29, and 30). So the cavalryman had to decide in advance how to use the weapon. There is no evidence that the Macedonians ever carried the cavalry sarissa with both hands as did the Sarmatians and the Roman *contarii*.

Finally, how did Philip II and Alexander the Great employ cavalry for close, hand-to-hand combat? Arrian (*Tact.* 16.6-7) writes that Philip trained the Macedonians to use the wedge formation, and he adds the observation: "And this formation itself is thought use-

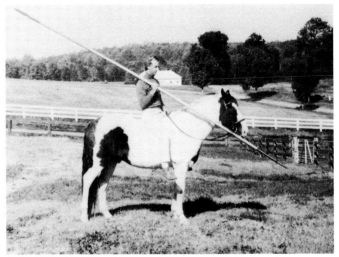

Fig. 27. The cavalry sarissa held at rest.

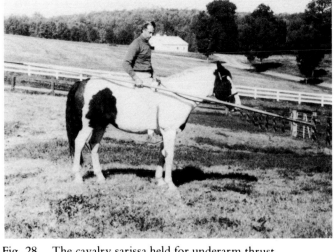

Fig. 28. The cavalry sarissa held for underarm thrust.

Fig. 29. Changing the position of the cavalry sarissa.

Fig. 30. The cavalry sarissa held for overarm thrust.

ful because the commanders are stationed on all sides (ἐν κύκλῳ), and the front tapering into a point makes it possible easily to cut through every hostile formation . . ." Cavalry assaulting infantry could employ the wedge formation either with the aid of or without the aid of *hamippoi,* a term used by historians and writers on tactics to designate infantrymen, each of whom fought paired with a horseman. The Pajawa Sarcophagus from Xanthus in Lycia, dated to the early fourth century B.C., rep-

Fig. 31. Pajawa Sarcophagus, horsemen in wedge charging light infantry.

Fig. 32. Attic black-figured neck-amphora by the Antimenes painter, *hamippos* fallen on knee, Walters Art Gallery, Baltimore.

resents horsemen charging in a wedge formation against light infantry drawn up in a phalanx (Fig. 31). No *hamippoi* are employed.

To appreciate the importance of *hamippoi* one must examine briefly some of the evidence for their history. Hoplites occasionally seem to have fought paired with cavalry in late sixth-century B.C. Athens. An Attic black-figured, red-bodied neck-amphora by the Antimenes painter, dated 530-520 B.C., in the Walters Art Gallery, Baltimore, illustrates this practice (Fig. 32): two cavalrymen wearing helmets, corselets, and greaves and armed with both lances and javelins attack each other, their horses rearing up face to face. A hoplite in full panoply and armed with a spear accompanies the cavalryman on the left. He has fallen on his right knee and looks backward and upward apprehensively at his mounted comrade as if he fears for his friend's safety. Moreover, *hamippoi* were also used by the Co-

rinthians earlier in the sixth century B.C. On the Hector Krater (late Corinthian, second quarter of the sixth century) two heavily armed horsemen are each paired with a hoplite in full panoply.[58] It is not known whether cavalry and *hamippoi* in sixth-century Athens and Corinth succeeded against hoplites. The combination was probably not very effective without well-trained horses, extensive drilling and practice combined with skilled generalship; otherwise, it would have been more widely employed in the classical period.[59] Thucydides (5.57.2) records that among the Boeotian forces who came to the Peloponnesus in 418 to defend Argos against Sparta were 500 cavalry and an equal number of *hamippoi,* but no account is given of them in action. The first recorded successful employment of this tactical formation is that of Epaminondas at the battle of Mantinea in 362. Xenophon writes (*Hell.* 7.5.23-25): "He [Epa-

minondas] advanced his army prow forward like a trireme in the belief that wherever he rammed and cut through he would destroy the entire army of the enemies. . . . The enemy, on the one hand, had drawn up their cavalry like a phalanx of hoplites, six in depth and without *hamippoi*. Epaminondas, on the other, made a strong wedge (ἔμβολον) of his cavalry and positioned *hamippoi* among them in the belief that the cavalry, when it cut through, would defeat the entire opposing army." Xenophon goes on to report the success of these tactics. I have no doubt that Philip was very much influenced by the tactics of Epaminondas, but the sources have preserved no account of his use of *hamippoi*.

Alexander made considerable use of these troops in his battles. In his campaign against the Taulantians in 335, after he had forced them to withdraw into their city, he "noticed some few of them occupying a ridge along the side of which he intended to march, he ordered his bodyguards and the Companions with him to take up their shields, mount their horses, and charge the ridge; when they had arrived, if those occupying the ridge should stand their ground, half were to dismount from their horses, mingle with the cavalry and fight on foot. The enemy observing Alexander's initiative abandoned the ridge." At the battle of Granicus, Alexander employed light infantry as *hamippoi*. Arrian reports (1.16.1) ". . . and they [the Persians] suffered much harm at the hands of the light infantry which was mixed with the cavalry." Pollux (1.132) states that the combination of a heavily armed cavalryman with a light-armed hoplite was an invention of

Alexander. Finally, Alexander also employed *hamippoi* at Gaugamela. Arrian (3.14.2) writes: "And making a wedge of the Companion Cavalry and of the infantry phalanx stationed beside them, he led them at a run . . . towards Darius himself. . . ." The infantry stationed beside the Companions at Gaugamela were the *agema* of the hypaspists and the other hypaspists (3.11.8-9), and these foot soldiers were armed as hoplites. There is also archaeological evidence for the use of *hamippoi* during the reign of Alexander and afterwards: it is thus that I would interpret the Macedonian hoplites fighting mingled with the cavalry on the Alexander Sarcophagus (Fig. 11) and the Macedonian hoplites paired with Macedonian horsemen on the Monument of Aemilius Paullus which commemorates his victory over Perseus at Pydna in 168 B.C. (Fig. 19).

That mounted lancers assaulted both opposing cavalry and infantry in formation is attested for later periods of history. Machiavelli in his *Art of War*, published in 1520, writes that the Swiss infantry adopted a formation similar to the Macedonian phalanx, arming themselves with pikes five meters in length. He states that their reason for so equipping themselves was protection from the assaults of the German cavalry. It is a striking demonstration of the paucity of the ancient sources that we must go to the Italian Renaissance to learn the full genius of the Macedonian kings who devised sarissa-armed cavalry and infantry. That tactician is greatest who designs the best defense against his own offense. The best means to oppose sarissa-armed cavalry was by similarly armed foot soldiers.

Notes

1. M. M. Markle, "The Macedonian Sarissa, Spear, and Related Armor," *AJA 81* (1977), 323-339.

2. Photios M. Petsas has generously allowed me to study and publish the weapons which he excavated from the cemetery of mounds at Vergina, and I have published one article based on these finds: M. M. Markle, "Weapons from the Cemetery at Vergina and Alexander's Army," Μέγας Ἀλέξανδρος 2300 Χρόνια ἀπό τόν θανατόν του *(Alexander the Great: The 2300th Anniversary of His Death)*, Society for Macedonian Studies (Thessalonike, 1980), 243-267. I will publish the entire collection of weapons in an article forthcoming in *Makedonika*. In addition, Manolis Andronikos has published photographs and preliminary reports of his views on his important finds from the royal tombs at Vergina: see, for example, "Vergina. The Royal Graves in the Great Tumulus," *AAA 10* (1977), 1-72; "Regal Treasures from a Macedonian Tomb," *National Geographic 154* (July 1978), 54-77; and "The Royal Tomb of Philip II," *Archaeology 31* (September-October 1978), 33-41.

3. M. M. Markle, "Use of the Sarissa by Philip and Alexander of Macedon," *AJA 82* (1978), 483-497.

4. Professor Andronikos told me that he has found a sarissa-head embedded high on the wall of one of the royal tombs with its butt-spike at a position on the floor which suggests that the two pieces may be at their original distance apart, but we must await his publication for definite measurements.

5. For examples, see Markle (note 2), pl. 5.

6. For the original publication of Τύμβος Ψ, see M. Andronikos, *Vergina* (Athens, 1969), 58; then M. Andronikos, "Sarissa," *BCH 94* (1970), 91-107; for the argument cited, see 95-96.

7. Ph. M. Petsas, "Ἀνασκαφή Ἀρχαίου Νεκροταφείου Βεργίνης," *Archaiologikon Deltion 18B* (1963), 217-232 on 225-227.

8. Petsas (note 7), 223-224, 226. My translation of Petsas' Greek.

9. I am now less certain about the dates of these sarissa-heads than I was when I wrote the article (note 2), and I hope to have the opportunity later this year to have a look at some of the relevant pottery before completing a definitive study of the weapons excavated by Petsas from Vergina.

10. For a detailed argument on the reliability of these testimonia, see Markle (note 1), 323.

11. For additional evidence that the cavalry sarissa normally was equipped with a butt-spike, see Markle (note 2), 258-259. For uses of the butt-spike, see Markle (note 1), 323-324.

12. For a detailed discussion of these factors with documentation, see Markle (note 1), 324, where the computations are made in avoirdupois.

13. LXIX-LXXI K 38 lacks about two-thirds the perimeter of the end of its socket, but the arc of the surviving part permits a reconstruction of its original perimeter, from which a diameter can be obtained: external diameter 0.029-0.030 m.; thickness of socket walls 0.002-0.0025 m.; internal diameter about 0.025 m. LXIX-LXXI I 32 has an unusually short socket, and rust has taken a large toll: external diameter 0.022-0.0225 m.; thickness of socket walls 0.001-0.0015 m.; internal diameter 0.020 m.

14. For the total length, see Markle (note 2), 252-253.

15. For references, see Markle (note 1), 326, note 19. For a different view of these shields, see J. K. Anderson, "Shields of Eight Palms' Width," *CSCA 9* (1976), 1-6.

16. For other evidence, see Markle (note 1), 326 and note 20.

17. H. L. Lorimer, "The Hoplite Phalanx,"

BSA 42 (1947), 76-138 on 122.

18. See Markle (note 1), 328 and note 30.

19. Photographs of this shield cover can be seen in the articles of Andronikos (note 2), and in N. and J. Gage, "Treasures from a Golden Tomb," *The New York Times Magazine,* 25 December 1977, 14-19, and in N. Yalouris, M. Andronikos, and K. Rhomiopoulou, *The Search for Alexander,* exh. cat. (Boston, 1980), 32.

20. Lorimer (note 17), 122.

21. The inner fittings of the shield were described and illustrated with a slide by Professor Andronikos in his lecture at the National Gallery of Art, Washington, D.C., 16 November 1980.

22. Volkmar von Graeve, *Der Alexandersarkophag und seine Werkstatt* (Berlin, 1970), 13, 118–133.

23. For a photograph of this helmet, see *The Search for Alexander* (note 19), no. 103, p. 155.

24. Lorimer (note 17), 79.

25. A. B. Brett, "Athena Alkidemos," *ANSMN 4* (1950), 55-72, and Markle (note 1), 326-327.

26. *The Search for Alexander* (note 19), 110, no. 23.

27. *The Search for Alexander* (note 19), 107, no. 17.

28. Brett (note 25), 63 and pl. XII, 14.

29. Markle (note 2).

30. In the exhibition *Treasures of Ancient Macedonia* which opened at the Archaeological Museum of Thessalonike in August 1978, I counted three sarissa-heads, one accompanied by a large butt-spike, and three spearheads from the royal tombs. There was also another iron sarissa-head from tomb D at Derveni. These identifications are based only on my own observations: the weapon points did not have labels, and only from Andronikos' publication will we obtain total numbers.

31. Markle (note 1), 329-333.

32. I want to express my gratitude to Dr. John Morgan of Princeton University who contributed his thoughts and research on this matter, though he does not agree with me on this battle. For his view, see J. D. Morgan, "Sellasia Revisited," *AJA 85* (1981), 328-330, on 330.

33. For Polybius' position, see F. W. Walbank, *Polybius* (Berkeley, 1972), 7. Polybius' judgment is confirmed by studies of the five and a half meter Swiss pike; see Sir Charles Oman, *A History of the Art of War in the Sixteenth Century* (New York, 1937), 70. The battle of Morat is not good evidence that the pike-armed Swiss phalanx could normally storm a palisade, since in this case 25,000 pikemen went over "the entrenched position" defended only by a "few thousand men." Duke Charles, unaware of the approach of the Swiss, had sent back his main body to camp and left the position relatively undefended (Sir Charles Oman, *A History of the Art of War in the Middle Ages,* II [London, 1924], 268-270). Thus, the defenders would have been overwhelmed by the sheer numbers of pikemen, and so would have been unable to take advantage of the gaps that inevitably would have opened in the Swiss phalanx.

34. The longest sarissa in actual use in Polybius' time was fourteen cubits in length, two cubits longer than the maximum sarissa of Alexander's day (Polybius 18.29.2). This difference of less than a meter would not have affected the handling of the weapon.

35. Markle (note 3), 493-496. John Morgan in a letter to me raised objections to my argument that some of the Foot Companions were armed with javelins in the battle against Porus. He pointed out that Curtius (8.14.24-25) wrote that "Agriani et Thracae leviter armati" were sent by Alexander against the elephants and these troops threw their javelins against the beasts. In reply to this objection, I would point out that Arrian (5.13.4) states that the Agrianes and javelin-throwers were stationed κατὰ τὰ ἄκρα τῆς φάλαγγος, while Porus stationed his 200 elephants about 100 feet apart "so that they should be stationed before all the phalanx of foot" (5.15.4-7). I maintain that the "Agriani et Thracae leviter armati" could not have thrown their javelins at all these elephants across the entire phalanx and that some of the Foot Companions were armed with javelins with which they opposed the beasts opposite themselves, as Arrian indicates (5.17.3).

36. In a siege of a citadel of the Malli, Alexander uses only his sword, according to Ptolemy (Arrian 6.9.4-6, 6.10.1) and Curtius 9.4.26-5.20. At the siege of Tyre, Alexander employs both spear and sword, according to Diodorus 17.46.2 and Curtius 4.4.11; at the siege of Gaza, Alexander kills an assassin with his sword, according to Hegesias of Magnesia, *FGrH* 142 F 5 and Curtius 4.6.16.

37. Of course, caution must be exercised in the use of Diodorus for any battle account. He frequently abbreviates his source, and it is possible that he has omitted an earlier stage of the battle in which sarissae were employed. On the other hand, there is nothing implausible in the notion that both sides relied on swords if the battlefield was so broken up by obstacles that neither traditional hoplite tactics nor the sarissa-armed phalanx could be employed.

38. John Morgan suggested to me that τὰ κοῦφα τῶν βελῶν ἐπὶ τοὺς πολεμίους ἔβαλον "may refer only to the *psiloi* who traditionally opened a battle," but this explanation fails to account for the fact that Diodorus has *all* troops falling to close combat with swords.

39. Arrian 6.9.3-4, 6.10.2, 6.11.1. The shield carried by Alexander is clearly distinguished from the "sacred shield . . . taken from the temple of Athena of Ilium" which was carried before him in battle.

40. For Granicus, Arrian 1.15.5 ξυστοῖς κρανεΐνοις; 8 τῷ ξυστῷ; termed less precisely, 6-7 τὸ δόρυ; Diodorus 17.20.4 τὸ ξυστόν. For Gaugamela: Arrian 3.14.3 τοῖς ξυστοῖς; Plutarch *Alex.* 33.1 τὸ ξυστόν.

41. Diodorus 17.100-101; cf. Curtius 9.7.16-26, a less accurate account; for a discussion of this anecdote, Markle (note 3), 491 and note 43.

42. Curtius 8.11.1-19; cf. Arrian 4.28.1-30.4; Diodorus 17.85-86.1. I take Curtius' statement that Alexander chose Charus "ex sua cohorte" to mean that Charus was one of his Companions: no part of the Macedonian army was the "cohors" of Alexander in the Roman sense of the term.

43. Arrian 1.6.5. τοῖς σωματοφύλαξι does not refer to the seven royal bodyguards who were the most trusted and chief officers in the army but to a larger group of Alexander's elite guards. τοῖς ἀμφ᾽ αὐτὸν ἑταίροις refers probably to a small number of Companion Cavalry around him, but the occasion demanded only a small number: only a few (οὐ πολλοὺς) of the enemy occupied the ridge which blocked Alexander's passage.

44. Arrian 3.21.7 names 500; and 4.23.2 "up to 800."

45. See Markle (note 2), 264-267.

46. These six brigades of the Foot Companions are identified by the names of their commanders. At the battle of the Granicus (Arrian 1.14.2) they were the brigades of Perdiccas son of Orontes, Coenus son of Polemocrates, Amyntas son of Andromenes, Philip son of Amyntas, Craterus son of Alexander, and Meleager son of Neoptolemos. By the time of the battle of Issus, Ptolemy son of Seleucus replaced Philip son of Amyntas (Arrian 2.8.4), and at the battle of Gaugamela, Polyperchon son of Simmias has replaced Ptolemy son of Seleucus.

47. This passage is discussed above and in notes 37 and 38.

48. Cf. Polyaenus Strat. 4.3.12. A. B. Bosworth, "Arrian and the Alexander Vulgate," Alexandre le Grand: Image et réalité, Entretiens sur l'antiquité classique, 22 (Geneva, 1976), 1-33, on page 14 maintains that Ptolemy has distorted the actual events of this battle to show his future enemy Perdiccas to be responsible for a military reverse, but I am unable to agree with him. The picture of Perdiccas is not unfavorable: he is represented as a rather impetuous commander who by his boldness succeeds in breaking through the first palisade. The temporary reverse mentioned by Bosworth does not occur until after Perdiccas was wounded while forcing his way through a second palisade. Ptolemy does not imply that Perdiccas' tactics were responsible for the reverse, but rather credits the Thebans' sudden resistance after they had already begun to retreat. I am in full agreement with Jacoby's commentary on this fragment of Ptolemy; see FGrH 138 F 3.

49. The text of Arrian 2.23.2 identifies the brigade of Coenus as one of the ἀσθέτεροι, but Bosworth, "Ἀσθέται-ροι," CQ 23 (1973), 245-252, has shown that this term denotes those brigades of the Foot Companions which came from Upper Macedonia.

50. In spite of W. W. Tarn, Alexander the Great, II (Cambridge, 1948), 120, there is no reason to believe that this tower was not constructed on the triremes which had been lashed together: towers were included among μηχαναί. In this case, there would be no substantial conflict with the account of Arrian, at least with regard to this matter.

51. Curtius 5.3.17-4.34 provides an account lengthened by the usual embroidery and rhetoric but without the specific information about what parts of the army were employed where.

52. H. Berve, Das Alexanderreich, II (Munich, 1926), 22, points out that this mission must have taken a long time, since Alexander felt obliged to write to Craterus, Attalus, and Alcetas about the conspiracy of the pages (Plutarch Alex. 55).

53. B. V. Head, ed., R. S. Poole, British Museum, Department of Coins and Medals: Catalogue of the Greek Coins. Macedonia, etc. (London, 1879), 156,163.

54. Hipparchicus 1.6, 1.21, 1.25; 3.3; 5.6. For the date of this manual, E. C. Marchant, trans., Xenophon, Scripta Minora (London, 1962), xxviii.

55. Markle (note 3), 486-487. For objections to my view, see P. A. Rahe, "The Annihilation of the Sacred Band at Chaeronea," AJA 85 (1981), 84-87. Rahe argues that the Macedonian cavalry could not have cut through the hoplite phalanx of the Sacred Band, and his argument depends upon his conception of the nature of the horse. He writes: ". . . no horse that has not gone berserk will gallop into a solid mass of men, charge into a nest of spears, or smash through a wall of shields." Neither the testimony of experienced cavalry commanders nor cavalry training manuals support his contention: see, e.g., Capt. Louis E. Nolan, Cavalry: Its History and Tactics (London, 1853), 292-314; Lt.-Col. George T. Denison, Jr., Modern Cavalry (London, 1868), 162-184; Great Britain, War Office, Cavalry Training (London, 1907), 129 and 225-229. Nolan writes (292): "I will not affirm, with Colonel Mitchell, and some other military writers, that cavalry, if properly armed, mounted, and led, will under every circumstance or combination of circumstances, break an infantry square —I will only say that it may frequently do so." Nolan follows his judgment by adducing numerous examples of cavalry successfully charging and breaking infantry squares which stood their ground. It is worth remembering that in these cases cavalry were obliged to charge in the face of missiles discharged from firearms, much more formidable than the short hoplite spears held by the Thebans at Chaeronea. As to Waterloo, a classic example put forward by Rahe, Denison (164-165) maintains that it ". . . is not a fair case." A successful cavalry charge depends largely upon speed, but the French cuirassiers were forced to charge "down one hill, across a muddy heavy valley, up another hill . . ." so that by the time they reached the British squares they were slowed to "a trot with their horses blown."

56. For the battle at the Granicus, see Arrian's full account (1.14.1-1.16.4; Plutarch Alex. 16.1-5).

57. A. Alföldi, "Die Herrschaft der Reiterei in Griechenland und Rom nach dem Sturz der Könige," Gestalt und Geschichte (Festschrift Karl Schefold), AntK, Beiheft 4 (Bern, 1967), 17-18 and pl. 6, 1 and 9, 9.10.

58. H. Payne, Necrocorinthia (Oxford, 1931), fig. 37 and pl. 40, 3; date, p. 104.

59. Alföldi (note 57), 19-20, makes an important contribution in his discussion of the hamippos, and I agree with his argument that the infantrymen in such pairs must have been fully armed. But the horseman also must have been in full armor for close combat with the phalanx, and none of Alföldi's evidence indicates heavy cavalry except for the Corinthian Krater (note 58); in other cases an unarmed squire is mounted and leads by the reins alongside his own horse a second horse which clearly belongs to the heavily armed infantryman who stands, advances on foot, or fights near him (see fig. 1 on p. 14; pl. 1; 2.1; 4.2,3). This difficulty cannot be explained away by stating, as Alföldi does, ". . . oft hat der Vasenmaler auch versäumt, ihnen Waffen zu geben" (p. 21).

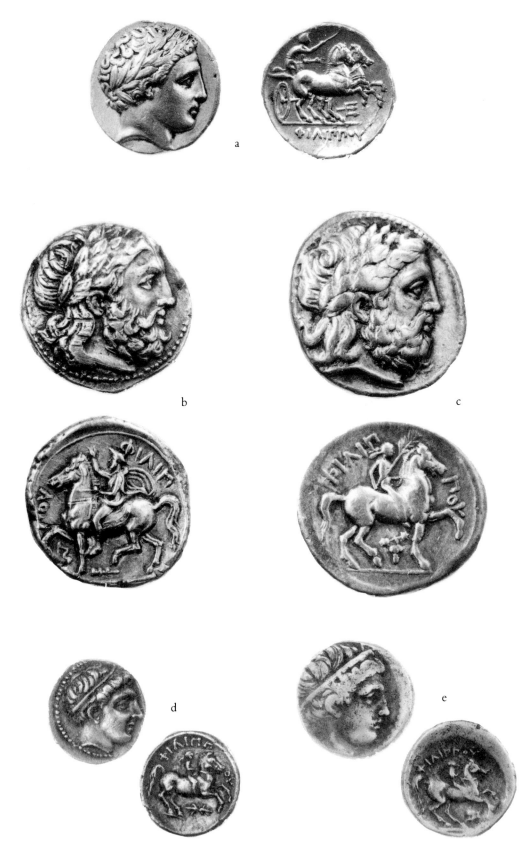

Fig. 1. Coins of Philip II: a. gold stater, b-c. silver tetradrachms, d. silver tetrobol, e. bronze unit.

The Coinage of Philip II and Alexander III

MARGARET THOMPSON

The American Numismatic Society (Emeritus)

CONSIDERING THE WEALTH OF beautiful and spectacular objects uncovered at Vergina, it seems ungrateful to point to one notable omission. There are no coins. It is not likely that the coins, had they been found, would have altered the existing numismatic record, but they might have provided important, even crucial, evidence for the chronology of the tomb. As it is, this paper can only offer a glimpse of what might have been.[1]

In 359 B.C. Philip II came to power, first as regent for the infant Amyntas and then as ruler in his own right. Philip's ambition, his qualities of leadership, and the devoted discipline of his army enabled him in a short period of time to establish control not only over Macedon but over most of mainland Greece as well. It was certainly no handicap that Philip also possessed the rich Pangaean gold and silver mines, said to have yielded an annual revenue of one thousand talents. This he used to produce an impressive and extensive coinage, the first major bimetallic coinage of the Greek West (Fig. 1). For the gold staters he chose a laureate head of Apollo as obverse type, possibly inspired by the beautiful coins of the Chalcid-ian League or by Philip's connections with Delphi. The reverses display a racing chariot, with reference to an Olympic victory in which Philip seems to have taken great pride. On the tetradrachms the head of Zeus is coupled first with a figure on horseback, wearing cloak and causia and thought to represent the king himself, and then with a mounted jockey holding a palm branch, again apparently an allusion to an Olympic triumph. Small silver and bronze coins carry the Apollo head of the gold and, on the reverse, usually a horseman. Judging by the coinage, Philippos was well named.

With the resources of the Pangaean mines and a stable currency behind him, with Macedonia strengthened and the rest of Greece submissive, Philip was turning his thoughts to the invasion of Asia Minor when an assassin put an end to his planning in 336 B.C.

Alexander was twenty at the time. A few years to consolidate his position in Greece and he was ready in 334 to cross the straits and embark on that fabulous career of conquest which would lead him through Asia Minor and Phoenicia, into Egypt, and as far east as the banks of the Hyphasis. Eleven years later he was dead, leaving behind as perhaps his most enduring monument the great international coinage which had financed his triumphs.

From the beginning, Alexander thought of himself as the champion of the Greeks against the Persians and his choice of coin types (Fig. 2) was apparently influenced by this concept. The magnificent staters and double staters carry the head of the warring Athena, combined with the highly appropriate type of Victory. Silver tetradrachms and fractions reproduce the head of the hero Heracles, from whom Alexander claimed descent, and on the reverse a seated Zeus. Down to the right, the legend reads simply ΑΛΕΞΑΝΔΡΟΥ —money of Alexander. On the bronze there is again a Heracles head and the weapons of the hero.

This coinage poured in profusion from a number of mints. With some degree of certainty we can identify twenty-three of them (Fig. 3): the home bases of Pella and Amphipolis, the Hellespont centers of Lampsacus and Abydus, a cluster of Ionian mints (Colophon, Magnesia, Miletus and possibly Teos), inland Sardes, Side, and Tarsus in southern Anatolia, at least

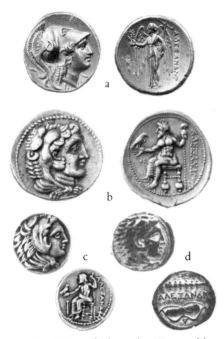

Fig. 2. Coins of Alexander III: a. gold distater, b. silver tetradrachm, c. silver drachm, d. bronze unit.

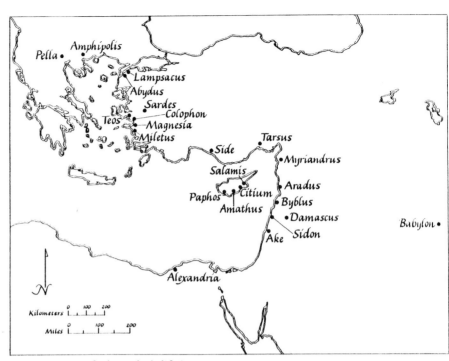

Fig. 3. Mints of Alexander's lifetime.

four Cypriote cities, Damascus, and then along the Syrian-Phoenician coast the workshops of Myriandrus, Aradus, Byblus, Sidon, and Ake. In Egypt there was the new foundation of Alexandria and in the East, most remote of all, the mint of Babylon.[2]

With few exceptions these cities had long records of coinage. The mints and the workmen were at hand, but now instead of diversified local issues they were required to produce a uniform royal coinage. The gains are obvious but, as always with standardization, at the expense of individuality and variety. The gold staters of Lampsacus, the darics and sigloi of Sardes, the staters of the satraps of Cilicia, the shekels of Sidon—all these and other local coinages were replaced by the unchanging and somewhat monotonous types of Alexander. This was the first stage of the Alexander coinage.

By 323 B.C. Alexander was dead in Babylon and the vast empire he had had no time to consolidate began to show signs of weakness. Our only concern with the struggles of the Successors is in their effect on the coinage and this is almost imperceptible. Philip III, Alexander's half brother, during his brief reign did place his name on his money. The types remain constant but ΦΙΛΙΠΠΟΥ replaces ΑΛΕΞΑΝΔΡΟΥ, and this is a great boon to numismatists. One could wish that the other Successors had been equally explicit. Unfortunately this is not the case. Old Antigonus the One-Eyed never changed the coinage. From beginning to end it is the royal coinage of Alexander, preserved intact as a symbol of the undivided empire which Antigonus hoped to inherit. Seleucus and Lysimachus did eventually produce their own money but not until late in the century.

Only Ptolemy, secure in distant Egypt, showed greater initiative, and it is interesting to see how the coinage reflects his growing boldness (Fig. 4). For a few years after Alexander's death there is no alteration. Then the obverse is modified. The Heracles head is replaced by that of the deified Alexander in elephant-skin headdress, perhaps in reference to the Indian victories in which Ptolemy had distinguished himself or perhaps as a reminder that Egypt possessed Alexander's body. Later still, the reverse is altered as a striking representation of the fighting Athena takes the place of the seated Zeus, but the legend remains that of Alexander. By the end of the century the coinage is Ptolemy's own: his portrait appears on the obverse, his eagle and name on the reverse. This then is the second phase of the Alexander coinage: the money of the Successors, for the most part

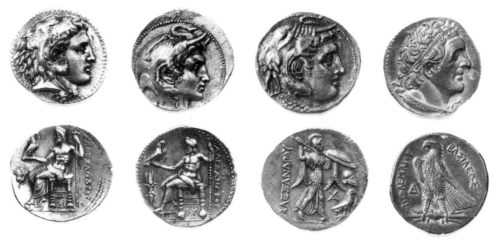

Fig. 4. Coins of Ptolemy I.

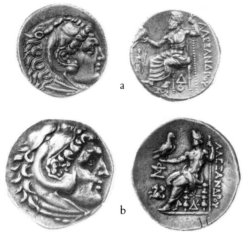

Fig. 5. Tetradrachms of Lampsacus: a. time of Alexander, b. civic issue.

identical with the lifetime coinage and covering roughly the last quarter of the fourth century.

The third phase was to last much longer and to involve strikings of a quite different character. The fourth-century Alexanders had been royal or quasi-royal coins; the third- and second-century Alexanders were civic issues, struck by independent or semi-independent cities at various periods for varying lengths of time, and usually commemorative of newly acquired freedom. During the reign of Antiochus II, Lampsacus, for example, seems to have gained a measure of autonomy and to have celebrated this by striking a series of Alexanders. The two coins illustrated (Fig. 5) are from Lampsacus: at the top a lifetime Alexander and below a civic issue of the third century. Although very different in style, they have in common the basic types and the Alexander leg-

end. The lifetime coin has no indication of the issuing authority; the civic piece has as a symbol in the left field the badge of Lampsacus, the forepart of Pegasus. After the fall of Antiochus Hierax in 229-228 B.C., a number of other cities struck Alexanders as coinages of liberation. For the most part such strikings ended with the battle of Magnesia in 190; after that date the free cities tended to put out issues with local ethnics and types. But on the periphery of the Greek world the coining of Alexanders continued even longer. One such issue, from Odessus on the Black

Sea, was minted in the early first century, over two hundred years after Alexander's death; the head on the obverse is very similar to representations of Mithradates VI of Pontus.[3]

The longevity of the Alexander coinage and its revival as an autonomous coinage at so many places are, on the surface, somewhat puzzling phenomena. It was certainly no matter of sentiment or devotion to the memory of the great Macedonian. It was simply good common sense from a commercial point of view. The original staters and tetradrachms had formed a truly international coinage. They had traveled widely throughout the ancient world, penetrating areas that had known no other coinage. They were acceptable everywhere, often in preference to any other kind of money. When they were not available from outside, they were copied locally (Fig.

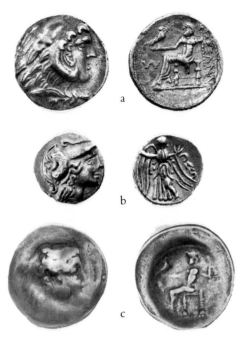

Fig. 6. Alexander imitations: a. tetra-drachm from Gerrha, b-c. Danubian stater and tetradrachm.

6). Hoard evidence proves that Arabian imitations were struck toward the end of the third century, probably at Gerrha near the island of Bahrain in the Persian Gulf.[4] What looks like a "W" in front of the seated Zeus has been identified as the Arabic letter *shin*, indicating that the Zeus of Alexander had been transformed into the Arabian sun god Shamas. Thousands of miles to the northwest, mints in the Danubian region were producing other crude and barbaric travesties, again derived from the money of Alexander.

To a lesser degree the coinage of Philip II had an impact that extended well beyond the relatively brief period of the king's reign. One of the most interesting results of a recent analysis of Philip's money is the discovery that much of both the gold and silver, hitherto attributed to Philip's lifetime, was actually minted by Alexander, side by side with his own coinage.[5] As LeRider says, the motivation may

have been in part an economic response to the popularity the original Philips had enjoyed, especially in areas to the north of Macedonia, but the political implications cannot be disregarded. Alexander's accession was not an untroubled transfer of power. Conspiracies against him are recorded, and it is evident that at the outset he needed the support of his father's close associates. What better way to insure their loyalty than by continuing Philip's coinage as a manifestation of fidelity to Philip's memory? Posthumous Philips were struck between 336 and 328 B.C., by which time Alexander was all-powerful and political expediency was no longer an issue. From then until Alexander's death there were no Philips but production was again resumed in 322 or thereabouts and then in mints of Asia Minor as well as Macedonia. These issues would seem to be connected with the joint kingship of Philip III and may have been intended originally to stress the legitimacy of his succession. Philips ceased to be coined officially shortly after 300 B.C. at the latest and in some mints c. 317 when Arrhidaeus was assassinated, but they were then imitated with varying degrees of success in areas where the prototypes had circulated widely. Much of the coinage of Celtic Europe is modeled on the gold and silver of Philip II, as witness the staters of various Gallic tribes and tetradrachms of local Dacian origin (Fig. 7).

With the publication of LeRider's monumental volume, we have at long last a definitive study of the coinage of Alexander's father. We do not have, and probably never shall have, anything comparable for the coinage of Alexander himself. Philip's issues were in truth

substantial but minting was limited for the most part to the two Macedonian workshops of Pella and Amphipolis over a period of roughly sixty years if one includes the posthumous strikings. The Alexander coinage in its entirety was a tremendous outpouring of currency, emanating over the course of several centuries from scores of mints scattered throughout the Hellenistic world. The complications are manifold.

In essence the problem is to divide the plethora of issues into series of coins assignable to individual mints. For this task the signposts are few and the pitfalls many. Ludwig Müller, the Danish scholar, made the first attempt in 1855, ascribing the strikings to well over one hundred different mints on the basis of style and the association of symbols and monograms with particular cities.[6] His publication is still the sole comprehensive listing of the Alexander issues and many of Müller's attributions are as valid today as when he made them, but the past century has brought to light much new material and further research has substantially modified his conclusions. The only other survey of a large cross-section of the Alexander coinage, published by Edward

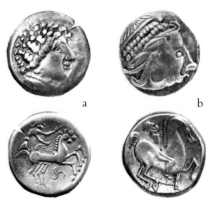

Fig. 7. Philip imitations: a. Celtic stater, b. Dacian tetradrachm.

T. Newell in 1912, was based on an analysis of a tremendous hoard of coins found at Demanhur in Egypt.[7] In this brilliant study Newell employed the scientific tool of die identities, invalidating many of Müller's mint groupings by showing that reverses supposedly produced by different cities were in reality linked by a common obverse die. Newell's work dealt chiefly with the strikings found in the Demanhur Hoard, buried about 318 B.C., and even for the early period between 336 and 318 many questions as to exact provenance were left unanswered. Subsequent studies of particular mints by Newell and others have helped to clarify the picture but much remains to be done.[8]

In identifying the mints we are on safer ground in the third and second centuries than in the fourth. When the free cities struck Alexanders, they generally indicated the source of the money by the use of a distinctive badge or monogram. A walking lion with star above and the MI monogram below is commonly found on autonomous issues of Miletus; the same symbol and monogram on an Alexander series tells us where the coinage was struck (Fig. 8). The sphinx and the amphora were traditional types of Chios; when we find Alexanders with the symbol of a sphinx seated on an amphora, it is not hard to decide where they were minted.

When one goes back to the fourth century, the problems multiply. A few, a very few, of the royal mints carefully labeled their output: Ake with the first two letters of its name in Phoenician, Sidon with ΣΙ and Aradus with an AP monogram. Occasionally the symbol on an isolated issue pro-

vides a clue, but by and large the symbols of the fourth century are not civic badges but moneyers' marks, and bringing together issues on which the same symbol occurs is dangerous unless there is supporting evidence for the association. The monograms of the fourth century are equally treacherous. They are usually the abbreviated versions of moneyers' names and not abbreviated ethnics, and with a coinage as extensive as this, it stands to reason that men of the same or similar names could well have been connected with different mints.

One would expect the hoards to be helpful in identifying the mints, at least by district, but here we are defeated by the nature of the coinage. Gold and silver traveled freely throughout the empire and what we find in the large hoards is a record of the most productive mints rather than of local or regional workshops. The Demanhur Hoard is an excellent example of this.[9] The mint closest to the findspot is Alexandria, which was opened around 325 B.C. Its coinage between 325 and 318, the burial date of the hoard, is represented by

216 tetradrachms. Ake, the next closest mint, provided seventy-nine tetradrachms covering the same eight-year period. Distant Babylon on the other hand contributed 267 and Amphipolis, almost equally remote, provided 688. The same situation prevailed with the drachm coinage. Certain Anatolian mints apparently concentrated on putting out the small change for the entire empire, and their issues form the bulk of the material in hoards, not only from Anatolia but from sites as distant as Attica and Mesopotamia. Actually it is the bronze hoards which will

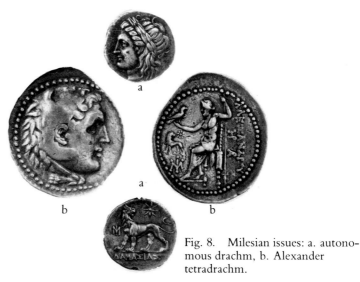

Fig. 8. Milesian issues: a. autonomous drachm, b. Alexander tetradrachm.

prove most useful, once we have enough of them. Bronze, being a local currency, did not travel far from its place of origin, and we should eventually be able to rely on the hoards for definite information as to the sources of the various bronze issues.

A second major problem is the arrangement in sequence of a particular group of associated issues. Occasionally we have a dated coinage; we may not always know what the era is but we do have an order of emission. At Ake, for example, a common obverse die

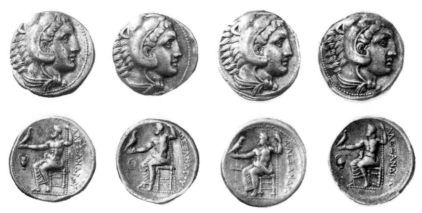

Fig. 9. Alexanders of Amphipolis.

often links reverses with successive Phoenician numerals, establishing a straightforward series of annual issues at that mint.

For the most part, however, the strikings are undated; all that we have are changing monograms or symbols, sometimes both. By analogy with the dated coinage one might assume that a change in marking indicates the end of one annual issue and the beginning of another. This is surely true in some cases. Aradus became a royal mint in 332. In the Demanhur Hoard with its burial date of 318 there are fifteen distinct strikings from the mint of Aradus, as listed by Newell. The exact correspondence of the number of issues and the number of years available for their emission points to a regular annual output at Aradus with no complicating factors.

This is definitely not the case at other mints. The same obverse die is used for four coins of Amphipolis (Fig. 9). Upon turning them over, one finds four different symbols on the reverses: a vase, a wreath, a stylis, and a helmet. In a coinage as large as that of Amphipolis, it is quite impossible to suppose that an obverse die survived for four years, or for two full years and a part of two others. With ex-

tensive use the average obverse wore out after a few months. What we have here clearly is a record of several symbols in simultaneous production.

At Babylon the situation is infinitely worse. Newell's tickets in the ANS trays record eighty-five obverse dies for the lifetime coinage, covering a period of eight years from the fall of Babylon in October of 331 to the death of Alexander in June of 323. The earliest obverses are coupled with reverses marked only with two Greek letters. Then secondary controls appear and these present a pattern of utter chaos. Thirty-one symbols and four monograms are employed. The disconcerting factor is their distribution. One would logically expect a group of symbols used concurrently, then abandoned and replaced by others, as seems to have been the case at Amphipolis. Nothing of the sort happens. The majority of the symbols continue to be used throughout the entire lifetime coinage in combination with early, middle, and late obverses. One obverse is coupled with fifteen different symbols; others with ten or eleven. It looks as though every reverse cut for these obverses was given a different marking, and this

raises the possibility that if we had a complete record of all reverses originally in use, we might find all thirty-five symbols and monograms more or less simultaneously employed on the lifetime issues of Alexander at Babylon.

What was the purpose of this gallimaufry of markings? If this were a huge coinage, one might better understand the need for an elaborate system of differentiation, but the surprising fact is that it is not a truly huge coinage. Newell knew eight-five obverse dies. In all probability the record is incomplete but it cannot be seriously deficient. Let us assume, however, that originally there were 120 to 130 obverses in use, and this would seem a generous margin of error. Eight years of coinage with 120 to 130 dies gives 15 or 16 dies per year. Yet the mint of Athens at one period used over fifty, and possibly as many as one hundred, obverse dies in a single year of production.[10] The lifetime coinage of Babylon is by no means enormous, and it is difficult to see why it needed thirty-five of anything. The devices on other coinages have been interpreted in various ways: moneyers' marks, workshops within the mint, bookkeeping records to tally the amount of bullion received by the mint with the number of coins struck. No one of these hypotheses makes any sense as applied to this Babylonian coinage, given its size.

Some day, although it will not be soon, the Alexander coinage as a whole will be ordered and dated, and we can move beyond this rather tedious task of establishing die-linkages and chronological sequences to evaluate the contribution of the coinage to our knowledge of Alexander himself. One

thing that can be said even now is that the lifetime coinage does not provide a reliable lifetime portrait. Various attempts have been made to single out individual obverse dies in the long Heracles sequence as realistic representations of the great Macedonian, but the arguments are not convincing.[11] The only early coins that undoubtedly portray Alexander are some rare decadrachms or medallions, issued at Babylon during Alexander's reign or shortly thereafter.[12] These commemorate a notable Eastern victory and show Alexander on horseback attacking the Indian king, Porus, who rides an elephant. On the reverses there is a standing figure of Alexander with elaborate Oriental headdress, holding the thunderbolt of Zeus. But, as in the case of the tetradrachms of Philip II with mounted king, the scale of the rendering is too small to provide any clear indication of Alexander's features, even assuming that the die-cutter was concerned with an accurate likeness. Only on coins of the Successors, those of Ptolemy and Lysimachus, do we have a head that is intended aᶜ a representation of Alexander—but Alexander the god, not the man, and therefore to some extent idealized.

With respect to Alexander's fiscal policies, we have more evidence. Quite obviously his basic intention was to provide a standard currency for lands under his control, at least as far east as Mesopotamia. For this purpose he made use of existing Persian mints. These were now royal mints and over them there must have been a measure of royal supervision.

One question which arises is the extent to which Alexander or his financial ministers controlled and correlated the output of the various mints. Some, like Babylon and Amphipolis, produced substantial to enormous coinages; others were comparatively inactive. Babylon, it might be assumed, was a key mint since this was Alexander's base of operations in the East. Distant Amphipolis in the 320s must have had a different function. Was its tetradrachm coinage so huge because it was destined to meet the needs not only of the Greek homeland but of most of Asia Minor as well? We find in studying the output of the individual mints that there was a difference in the kind of coinage turned out by the various regions. Macedonia, Cilicia, and mints further south and east produced tetradrachms in quantity but very few drachms; Asia Minor produced drachms in quantity but comparatively few tetradrachms. Both types of coinage circulated freely throughout the empire but the basic difference between tetradrachm and drachm mints persisted down to the end of the fourth century. Is this evidence of a concession to regional preferences? Before the coming of Alexander, the familiar medium of exchange for most of Asia Minor was a small silver coin, the siglos or the autonomous drachm; in other areas it was a large silver coin, the tetradrachm or the shekel, that provided the basic unit of trade. It seems possible at least that Alexander took these local traditions into consideration.

The appearance of some local coinages side by side with the royal Alexanders certainly points to a flexible financial policy on Alexander's part. In 331 B.C. Mazaeus, governor of Babylon under Alexander, began to strike a series of lion staters, which continued to be

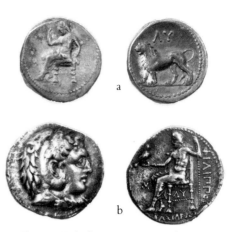

Fig. 10. Babylonian issues: a. lion stater, b. tetradrachm of Philip III.

produced into the reign of Seleucus I. At the outset the coins carried the name of Mazaeus but that was soon abandoned. The tetradrachm illustrated (Fig. 10) belongs to the time of Philip III and has the control marks M and ΛY. The lion stater above bears the same controls and must be contemporary. In one of his studies Newell made the passing suggestion that the lion staters might represent a temple currency, which would place them in a special category and explain their appearance and survival during a period when the royal mint was turning out a quantity of royal coins.[13]

It is doubtful that Newell would have maintained this theory in any final publication of the series, but in any case the explanation will not suffice for the satrapal and royal issues of Tarsus (Fig. 11). On the coins illustrated the renderings of the Zeus and Baaltars figures are so close in style that Newell felt they were the work of the same die-cutter.[14] Both pieces are marked with a *beta,* which can be associated with Balacrus, satrap of Cilicia under Alexander.[15] The coinages are clearly contemporary and dated by Newell c. 327 B.C. The

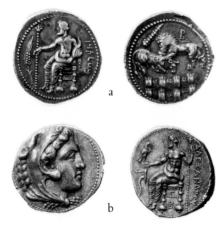

Fig. 11. Tarsiote issues: a. satrapal stater, b. tetradrachm of Alexander.

Baaltars coin is a direct imitation of satrapal issues being struck in Cilicia before the arrival of Alexander. The types are identical except for the omission of the name of the satrap. Furthermore the Baaltars issue is on the Persic weight standard. A reversion to the old Persic types is strange enough; a reversion to the old Persic weight standard is astonishing. The explanation must surely be what Newell suggested: a deference on Alexander's part to local customs and preferences. Realizing that the new money could not be forced abruptly or wholesale onto conservative trading centers, Alexander permitted an occasional issue of the old kind of coinage.

It will be interesting, once the chronologies of the Alexanders and the civic coinages have been more carefully defined and related, to see how far this policy of tolerance extended. The striking of municipal coinage in large denominations must have been exceptional but municipal small change may have been a fairly common phenomenon. Were the minting cities expected to produce a certain amount of royal money and then permitted to put out, at their own expense of course, autonomous issues of small silver and bronze for local and regional use? One assumes that this would have involved complications in equation when different standards were used. The Attic and Persic standards are not easily related, yet we have hoards combining Attic weight drachms of Alexander and Persic weight hemidrachms of several Asia Minor mints.[16] The two types of coinage apparently did circulate together to some extent. Was it simply by weight or was there some accepted formula for relating their values?

There are many such questions still unanswered, but each problem resolved brings us that much further along in our search for Alexander.

Notes

1. All coins illustrated are in the collection of the American Numismatic Society (ANS) and were photographed by Michael Di Biase. The map is the work of Kathleen Borowik.

2. The coinages of most, but not all, of these mints are identified by E. T. Newell, *Alexander Hoards, II: Demanhur, 1905,* American Numismatic Society, Numismatic Notes and Monographs, 19 (New York, 1923), 26-64. Other series are discussed by M. Thompson and A. R. Bellinger, "Greek Coins in the Yale Collection, IV: A Hoard of Alexander Drachms," *YCS 14* (1955), 3-45.

3. M. J. Price, "Mithradates VI Eupator, Dionysus, and the Coinages of the Black Sea," *Numismatic Chronicle* (1968), 6-7.

4. O. Mørkholm, "New Coin Finds from Failaka," *Kuml* (1979), 219-236.

5. G. LeRider, *Le monnayage d'argent et d'or de Philippe II* (Paris, 1977), esp. 400, 433-438.

6. *Numismatique d'Alexandre le Grand* (Copenhagen, 1855).

7. *Reattribution of Certain Tetradrachms of Alexander the Great* (New York, 1912).

8. The bibliography down to 1963 has been conveniently assembled by mints in A. R. Bellinger, *Essays on the Coinage of Alexander the Great,* American Numismatic Society, Numismatic Studies, 11 (New York, 1963), 114-130. The record is somewhat confused by the fact that Bellinger has listed all of Müller's attributions regardless of validity.

9. Note 2. The mint totals given in the text here are based on Newell's chronology.

10. M. Thompson, *The New Style Silver Coinage of Athens,* American Numismatic Society, Numismatic Studies, 10 (New York, 1961), 653, 709-713.

11. They are summarized by A. R. Bellinger (note 8), 14-21.

12. An example in the ANS collection is illustrated in *Sylloge Nummorum Graecorum, The Burton Y. Berry Collection* (New York, 1961), 295.

13. E. T. Newell, *The Coinage of the Eastern Seleucid Mints,* American Numismatic Society, Numismatic Studies, 1 (New York, 1938), 106.

14. E. T. Newell, *Tarsos under Alexander* (New York, 1919), 16-21.

15. Uncertainty as to the meaning of the *beta* on various Cilician issues has been removed by the discovery of a stater on which the name of Balacrus is written in full behind the seated Baaltars. The coin, now in the ANS cabinet, has been published by its former owner. H. von Aulock, "Die Prägung des Balakros in Kilikien," *Jahrbuch für Numismatik und Geldgeschichte* (1964), 79-82.

16. E.g. nos. 1365 and 1444 in M. Thompson, O. Mørkholm, C. M. Kraay, eds., *An Inventory of Greek Coin Hoards* (New York, 1973).

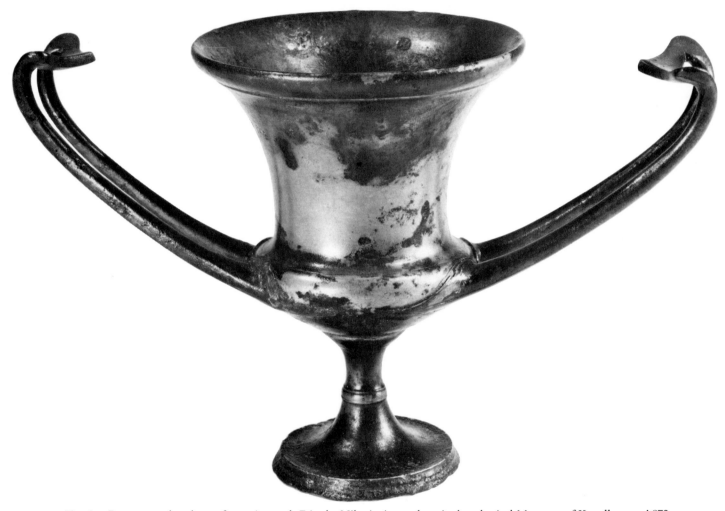

Fig. 6. Bronze cup-kantharos from cist tomb E in the Nikesiani tumulus, Archaeological Museum of Kavalla, no. A872
(photo: Time Incorporated).

Macedonian Metal Vases in Perspective: Some Observations on Context and Tradition

BERYL BARR-SHARRAR
New York City

DOMINATING THE INVENTORY OF the often spectacular Macedonian fourth-century burials are the bronze and silver utensils and vessels—made for use and often showing signs of wear—placed in the tomb for the funeral banquet of the dead.[1] The richness of this material is a circumstance of the funeral customs of the Macedonians and their beliefs in the afterlife, which seem to have differed substantially from those held by the Athenians and other contemporaries. Even graves marked with elaborately carved stones in the Keramaikos, for example, have only terra-cotta offerings.[2]

Opulence was the style of the Macedonian court, and magnificent celebrations with silver cups and golden spoons became the stuff of legend.[3] Noble funerals and concomitant offerings to the dead, under the autocratic rule of the Macedonian dynasty, were from all evidence entirely in accord with the luxury to which these people were accustomed in life.

Confronted with the extraordinary array of objects executed in precious and base metals found in tombs in Macedonia during the last twenty years, one might ask what information there would be concerning Greek metal vases without this northern Greek material. Little is known from other existing metalware, as finds from areas outside Macedonia and ancient Thrace (which includes modern Bulgaria) are few.

Some information can be obtained, however, from pottery of high quality created in Athens during the fifth and most particularly during the fourth century. Black-glazed vases are assumed to reproduce metal prototypes—including some with lavish decoration—with a high degree of exactness, at least to the extent that pottery can do this. From a study of the repertoire of this Athenian black-glazed ware, one observation is clear. Highly creative contributions were made by Athenian metalsmiths, who may have been foremost in the field, to the invention and development of classical metal vase shapes. Based to some extent, but not only, on knowledge of the close political and cultural interaction between Athens and Macedonia from the late fifth century on, one may go a step further and suggest that the taste cultivated at the Macedonian court—and taste in this case means preference for shape and decoration—was essentially Athenian.

Macedonian preferences were by no means exclusively Athenian, however. The recognition of a less than complete dependence on Athens is critical because some other elements must have been in effect to explain the fact that the splendid shape of the Athenian calyx-krater, well documented by examples in Attic black-glazed ware, is not represented, at least not yet, in the Macedonian repertoire of metal vases. This is all the more surprising as an elegant imported pottery example was found in one of the tombs at Derveni.[4]

Also, without this reservation one could not account for the fact that an equally classical shape—which in this case was not attempted in pottery reproduction by the Athenians but was surely in use in metal form in Athens, Thebes, and Corinth in the middle of the fourth century, that is, the spectacular volute krater—is represented in Macedonia only twice. One is an example that may well be an Athenian or Corinthian import,[5] and the second is a version elaborated so far beyond all ordinary standards that one suspects behind its production a conscious

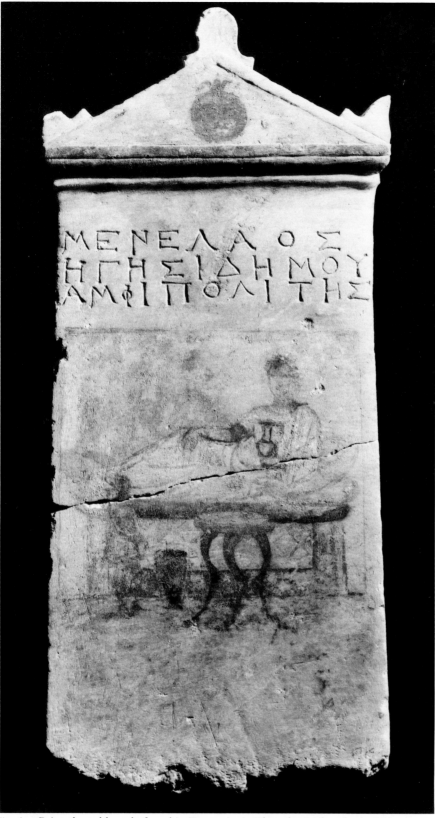

Fig. 1. Painted marble stele found in Demetrias in Thessaly, Archaeological Museum of Thessalonike. Volos, no. *Lambda* 356 (photo: courtesy of Time Incorporated).

allegiance to a distinctly non-Attic predilection or interest. The reference in the second case is, of course, to the Derveni krater.[6]

Disregarding the wider range of metal vase production—which includes a good many shapes too peripheral in terms of everyday needs to invite the potter's attention, like the pierced vessel on a tripod described by Professor Andronikos as a lamp box[7]—it may be seen that the Macedonian repertoire—while always influenced and guided by quite specifically Athenian taste—in its choice of shapes often, and surprisingly, follows what one must suppose are local traditions and preferences. I will discuss in this paper both the Athenian basis or direction of Macedonian taste in metal vessels and the local currents—perhaps indigenous, perhaps imported from the East—which give the vases found in the Macedonian tombs their special character.

As a starting point one may consider a fairly simple work of the third century, a painted marble funerary stele from Demetrias in Thessaly (Fig. 1).[8] It may be called a Macedonian work, because the inscription tells us that the dead man is from Amphipolis. He is shown reclining, feasting in the realm of the dead, a long-stemmed drinking vessel in his hand. The light gray color of the cup is undoubtedly meant to indicate that it is made of silver. The same shape exists in an actual drinking vessel found in Kersch and now in Leningrad (Fig. 2).[9] The painted version is rimless and plain-bodied while the actual silver vessel has a molded rim and a ribbed body, but they are essentially the same type of cup.

Under the couch, or *kline,*

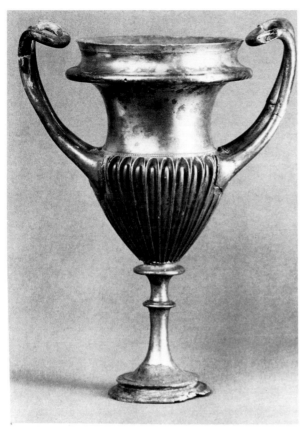

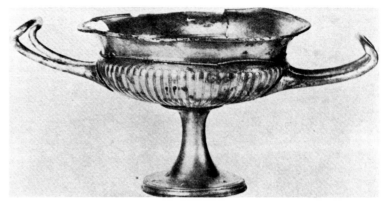

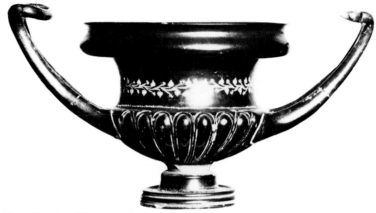

Fig. 2. Silver krateriskos from Kersch, The Hermitage.

Top: Fig. 3. Silver cup from Tschmyrew, Bulgaria; The Hermitage.
Bottom: Fig. 4. Attic black-glazed krateriskos, Skulpturensammlung, Dresden.

stands a bucket-shaped vessel painted a yellow color—a dark ochre—which must indicate that it is made of polished bronze. This vessel presumably contains the wine or ritual mixture which is intended to be ladled into the pitcher held by the serving boy who stands nearby, and then poured by him into the dead man's cup. The vessels reproduced on this stele must be characteristic of what was actually used in Macedonia at the time of the artist's execution of the painting. The drinking cup and the bucket are both clearly enough preserved in outline to study; the pitcher is indistinct.

The shape of the drinking cup identifies it as a krateriskos. In all likelihood this vessel's form—with its high stem and flaring han-dles which do not join the upper wall—is one of the shapes that Macedonian metalsmiths bor-rowed from the Athenian reper-toire. A broad yet high-stemmed silver Attic cup with looping, turned-back handles, an import to Thrace, was found in a fifth-century context in a tomb in Tschmyrew, Bulgaria (Fig. 3).[10] By at least the middle of the fourth century, in the black-glazed reper-toire a more compact version ap-pears with a molded lip and low foot, such as an example now in Dresden (Fig. 4).[11] This shape may be compared to that of metal cups from the second half of the fourth century found in Macedonia, for example the two identical silver cups among the group of silver vessels from grave B at Derveni, one of which is illustrated here (Fig. 5).[12] The Attic black-glazed cup in Dresden (Fig. 4) has a molded rim and ribbed body, but the Derveni vessel is otherwise similar in conception, size, and dis-tribution of weight.

All of the silver and bronze cups from Macedonian tombs so far dis-covered have plain rims and no vertical ribbing on the body. The Macedonian material thus argues strongly for a preference for rim-less cups with plain bodies in later fourth-century metalware, at least in that region. It may be that pot-ters chose to reproduce variations which were not as popular in silver as one would have thought. Possi-bly, once potters had learned to copy the originally metallic lip-molding and ribbing, they found a

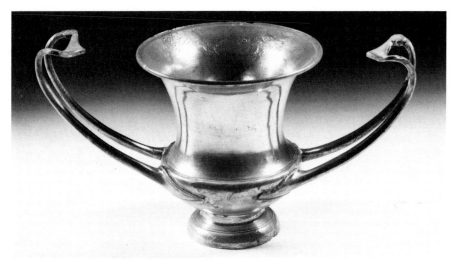

Fig. 5. Silver cup-kantharos from grave B at Derveni, Archaeological Museum of Thessalonike, Derveni B5 (photo: Time Incorporated).

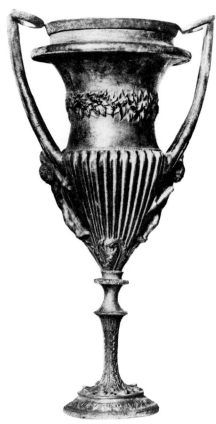

Fig. 7. Silver krateriskos from Tarento, Louvre.

greater market for this more elaborate variety of black-glazed clay cup.[13]

A more attenuated version of the shape exemplified by the Derveni cup (Fig. 5) existed in metal in Macedonia, as attested by several examples, among them a bronze cup from cist tomb E in Nikesiani (Fig. 6).[14] The narrower proportions of this bronze vessel with the shrinking of its foot—which grows a stem—represent a later development of the sturdier proportions of the Derveni silver cup.

Athenaeus credits the fourth-century writer Epigenes with a complaint that drinking cups were no longer fat but "small and dainty as if one were intended to drink the cup and not the wine" (11. 472a). Yet it is easy to see why these cups were popular. High-walled with flaring rim and handles which spring upward from ivy-leaf forms on calyx-shaped bowls and then turn inward at the top toward the lip, they are both elegant and flashy. Until the pottery from these tombs is published one cannot really date these metal cups

more accurately within the second half of the fourth century than to recognize a chronological progression from lower shape (Derveni cup) to higher shape (Nikesiani cup), acknowledging the gradual reduction in horizontal proportions to lighten the form and accentuate the vertical axis. This tendency for shapes to become thinner and more refined led by about the turn of the fourth to the third century to a complete restructuring of this vessel—resulting in the elegant, highly refined version exemplified by the krateriskos found in South Russia (Fig. 2).

That the reevaluation of this shape may have occurred in Athens would be probable in any case, but it is further confirmed by terra-cotta black-glazed versions of the high-stemmed cup found among a group of black-glazed vessels from an Athenian or Atticizing workshop on Kalymnos.[15] An immigrant Athenian potter was probably responsible for the production of these clay krateriskoi, which are more or less identical in

shape to the Leningrad silver one. This elongated shape with high stem—with or without molded rim and ribbing—has so far failed to appear in Macedonian tombs.[16]

The actual production of this high-stemmed krateriskos continued in Greek centers throughout the third, and perhaps well into the second century. Still associated with burial ritual, the shape appeared on grave monuments throughout the third and into the second half of the second century, in shallow, carved relief.[17] The famous silver krateriskos from Tarento is an elaborated version with relief ornament under the handles and around the neck, and a mark-

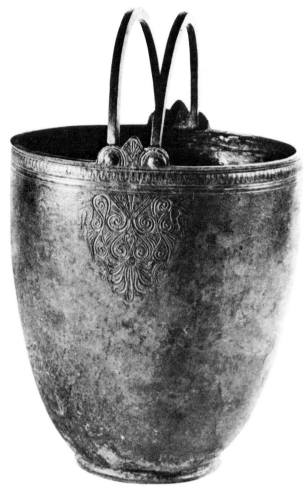

Fig. 8. Bronze situla from a tomb in Kalamaria, Thessalonike; Archaeological Museum of Thessalonike.

edly exaggerated verticality (Fig. 7). From its original assignment to the first quarter of the third century, the date of this cup has with good reason been moved forward.[18] The use of this drinking cup in Hellenistic times is attested by the Macedonian painted stele (Fig. 1) and, further, by one of the famous Dioskourides mosaics from Pompeii (the original painting of which is usually dated to the second half of the third century B.C.) in which the krateriskos may be clearly seen in the hand of one of the comedy characters.[19]

Considering how little is known of monarchic third-century Macedonian material in contrast to what

remains from the fourth century, it is important to remember that remarkable achievements apparently continued, as suggested by such finds as the tomb at Naoussa, near Lefkadia, tentatively dated to the second half of the third century.[20] It is unexplained why, so far, so little material that might be recognizably of third-century date has been uncovered in Macedonia. With the krateriskos, in any case, we have the development of a late classical vessel type where little may be said about Macedonian input. Unlike some other shapes, that of the krateriskos did not survive into the Roman Imperial repertoire.

The case for a Macedonian con-

tribution is very different with the pail-shaped vessel, or situla, like the one on the painted stele from Thessaly (Fig. 1). A late fifth-century situla found in a tomb in Salonika illustrates the appearance of this type of vessel at the time when Euripides was at the Macedonian court and perhaps somewhat later (Fig. 8).[21] The graceful contour, together with the palmette and scroll design cast into the wall under the handle, immediately betrays classical traditions which did not originate in Macedonia. However, the shape as such —somewhat plumb, but practical —is one found frequently in northern Greece and ancient Thrace, and it may be that migrant metalsmiths from Athens or elsewhere—lured to the court by prospects of gain—took an indigenous shape and transformed it by providing the genius for elegance which was initially alien to that region. The presence of such immigrant craftsmen in neighboring areas is strongly suggested by a find from ancient Thrace—the pail situla from Păsătrovo in Bulgaria. The added relief on the walls clearly indicates Athenian taste (Figs. 9 and 10). This may be a provincial work by artisans actually trained in Athens, migrant or colonized Athenians who developed their own atelier and style.[22]

The fourth century—the period of the highest quality bronze and silver vessels in terms of elegance of profile and balance of proportions—brought subtle changes to the pail situla. Fourth-century situlae are marked by somewhat more graceful contours and discreet ornamentation, both qualities seen in a silver situla from Tomb III in Vergina (Fig. 10a, Pl. 2).[23] Such limited ornament underscores the fact that

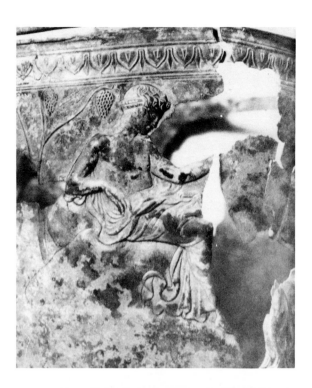

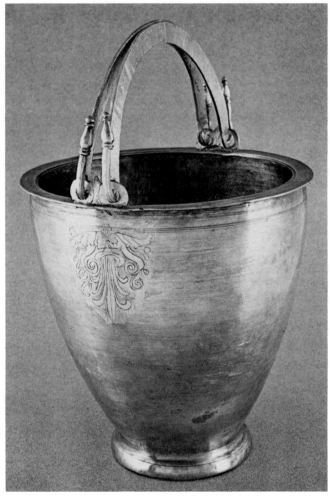

Top left: Fig. 9. Bronze situla from Pă-
sătrovo, Archaeological Museum of
Plovdiv, Bulgaria.

Top right: Fig. 10. Detail of the situla
from Păsătrovo.

Bottom right: Fig. 10a. Silver situla
from Tomb III, Vergina; Archaeological
Museum of Thessalonike, no. 13.

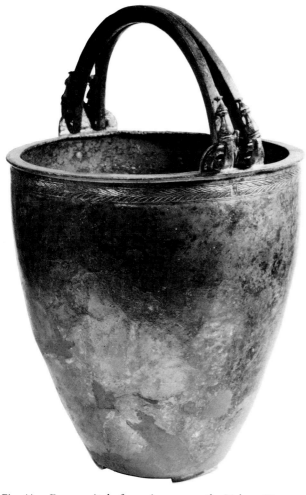

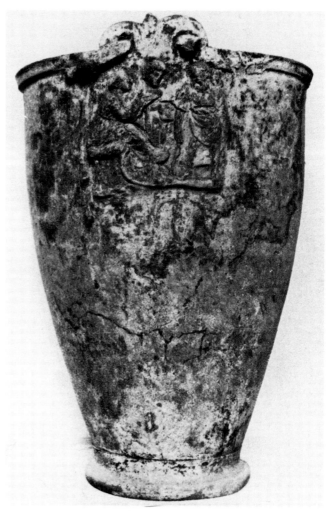

Fig. 11. Bronze situla from Arzos near the Hebros River, Archaeological Museum of Komotini, no. 1894 (photo: Time Incorporated).

Fig. 12. Terra-cotta situla from Orvieto.

these vessels were made for use. On the Vergina pail, inverted palmettes—engraved in surprisingly unfinished, sketchy lines and washed with gold—decorate the walls under the handle attachments. By the end of the fourth century, this situla shape was at the height of its elegance, as exemplified by a bronze vessel from a tumulus dated to that time in Arzos in the Hebros River area in the eastern reaches of ancient Macedonia (Fig. 11).[24]

At this time and later, with the expansion of Macedonian power, the more refined shape gained wider currency. A terra-cotta ver-sion of late third-century date from Orvieto in Italy is testimony to that (Fig. 12).[25] Its proportions correspond well with those of the situla on the Macedonian painted stele (Fig. 1).

Undoubtedly indigenous to the north, certainly practical, and apparently much in demand, the situla form invited inventive changes and elaboration. Versions of this bucket with its double handles were fashioned to serve as pitchers. An unadorned, probably late fifth- or early fourth-century example from the classical cemetery in Kozani in western Macedonia has secondary handles in the form of swans' heads (Fig. 13).[26] Another, from Nikesiani in eastern Macedonia, datable to the forties of the fourth century, shows a marked development over the earlier one in the conversion of the simple spout into a lion's-head spout, a sophisticated elaboration which probably again reveals the influence of Athenian taste in a northern atelier (Fig. 14).[27]

The asymmetry of the areas under the handles necessitated by the imposition of the pitcher concept upon the bucket was probably adopted from an Eastern prototype,[28] and the earliest development of the vessel may have oc-

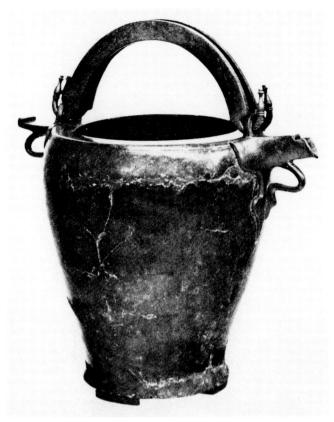

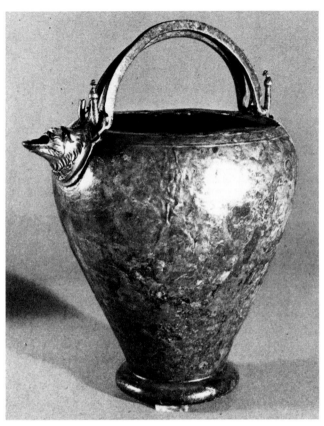

Fig. 13. Bronze situla from the classical cemetery in Kozani, Archaeological Museum of Pella.

Fig. 14. Bronze situla with lion's-head spout from cist tomb E in the Nikesiani tumulus, Archaeological Museum of Kavalla, no. A 1403.

curred in Greek colonies in the Propontis areas or in Thrace, where there are many examples of this type of situla, but where its shape changes very little, if at all.[29] It is almost certain, however, that the final, rather subtle refinement of this concept to what might be considered its consummate form took place during the second half of the fourth century in Macedonia, at or near the court.

Bronze situla of this type—with a surprising number of variations in profile—were discovered in abundance in the Derveni group of tombs. More were found in other tombs in northern Greece. These include at least two silver examples: one from the main chamber of Tomb II at Vergina,[30] another at Pilaf-Tepé (Fig. 15).[31] There are many others from ancient Thrace, where the type is possibly the oldest and certainly the most frequent of all situlae, the several shapes of which compose the largest classification of bronze vessels in that region.[32] Those many spouted situlae in Thrace, some preserved in fragments only, seem to have been produced by local artisans for local markets and do not show the inventiveness, variation of profile, and diversity of ornament revealed by the Derveni material, nor the tendency toward opulence exemplified by the silver situla from Pilaf-Tepé. The Nikesiani and Pilaf-Tepé vessels demonstrate the progressive development of the shape toward greater elegance (Figs. 14 and 15).

Behind the spout, in the wall of this vessel type, is a sieve for straining the wine. Some literary sources suggest that the Macedonians —and presumably other "barbarians"—drank their wine unmixed with water.[33] If true, this strengthens the argument for the invention of this vessel in the north and explains the certain popularity and probable development of the shape at the Macedonian court. Unlike the pail situla, this type does not seem to have continued beyond the middle of the third century B.C. Terra-cotta reproductions were made of its ultimate shape at least into the third century.[34] Nothing remotely like it exists in the Roman repertoire.

Buckets found in Macedonia of yet another conformation, such as one from grave B at Derveni (Fig.

16),[35] have concave walls, moldings on the lip and base, three low feet, and—like the bell situla and the pitcher variety with lion spout—two swinging handles which are designed to lie flat on the lip. Red-figured Apulian copies of this shape, such as an example in the Metropolitan Museum,[36] demonstrate how in the atmosphere of international exchange that existed in the second half of the fourth century B.C. the shape could be adopted for local needs in another part of the world. Its inappropriateness in clay is obvious; the prototype of this vase is certainly the metal shape developed, if not initially generated, in Macedonia.[37]

In the case of the bucket or situla, then, one may conclude that the allegiance of Macedonian metalsmiths to centers of longstanding productivity such as Athens and Corinth is far from slavish. While one may still hold that the best Macedonian taste is Athenian—most noticeably from the time of Philip II and afterward—selective shapes tied to indigenous customs are by no means abandoned, but persist.

A good example of the ease with which Macedonian craftsmen accepted and promoted shapes which were not Greek in origin, but in this case borrowed from Persian neighbors—apparently at a time when Persia was not yet conquered—is the creative adaptation of a small footless silver cup (Fig. 17).[38] Parading figures in fifth-century reliefs from Persepolis hold cups somewhat squatter, but similar in design to the numerous examples from fourth-century Macedonia.[39] Macedonian metalsmiths—educated and inspired by Attic and Corinthian traditions—took this shape in hand and made of it something which emerges as a tribute to the liberal spirit of their culture. A close look at the interior medallions which still survive in many of these cups reveals the playfulness, grace, and beauty with which a vessel shape from a foreign culture has been imbued.

The cup from a grave in Stavroupolis in Salonika (Fig. 17) is decorated with the medallion of a woman's head gracefully turned in three-quarter view (Fig. 18). Another, from Tomb II at Vergina, bears a similarly oriented head of Dionysus; a third—also from Ver-

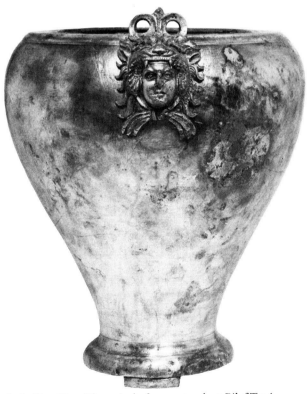

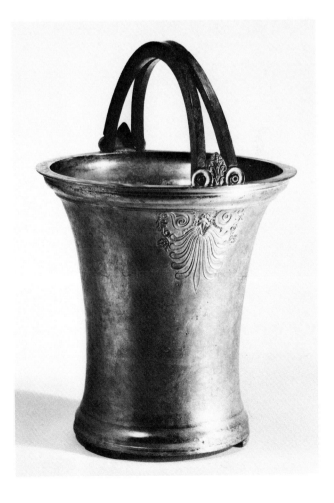

Left: Fig. 15. Silver situla from a tomb at Pilaf-Tepé, Velestino; National Museum, Athens, inv. no. 12079.

Right: Fig. 16. Bronze situla from grave B at Derveni, Archaeological Museum of Thessalonike, Derveni B28 (photo: Time Incorporated).

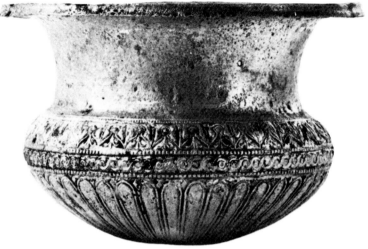

Fig. 17. Silver kalyx cup from a cist grave in Stavroupolis, Thessalonike; Archaeological Museum of Thessalonike.

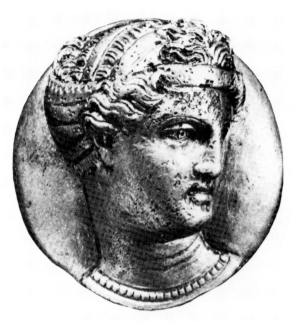

Fig. 18. Detail from the center of the kalyx cup from Stavroupolis, Thessalonike.

gina—is decorated with the mask of a drunken Silenus. Other Silenus masks from such cups exist (one from Derveni), as do female heads,[40] and there is at least one gorgon mask (also from Derveni). All of these heads and masks have gilded details, and some seem to be from the same workshop. The preponderance of female heads within the cups may suggest that these were drinking vessels made specifically for women.

This concept may be called a Macedonian creation, for it was, after all, the taste and demand of the customer which made the inventive elaboration of these cups by the metalsmith possible. The placing of a high-relief figural image on the elevated boss or omphalos of these cups suggests a particular taste for the luxury of visually pleasing embellishment of a highly refined nature,[41] and—in this respect—it is hardly of consequence whether the metalsmith himself was a Macedonian or was trained somewhere else.

The quality of the noble, pristine faces of the miniature heads of women in these cups contrasts radically to what Macedonian relief would have been—despite the extravagance of the court and the riches invested in artifacts—had the barbarousness of the Macedonians as argued by Demosthenes and Theopompos been based on truth. One has only to study details of the relief on the gold vessels found in Panagurischte in Bulgaria to understand what truly barbarian taste embraced.[42] These vessels demonstrate quite dramatically the fact that Macedonian wealth alone could have been no safeguard against failures of taste. What may perhaps be termed barbaric about this Macedonian material is its quantity. One is reminded of nomads and their inclination to hoard portables. Indeed, this allusion becomes more pertinent as one contemplates the early, still pastoral, and unsettled stages of the Macedonian community.

Concerning Macedonian spon-

sorship of the arts, then, one may tentatively say at this point—and for various reasons the full picture is not yet available—that it appears to have been much in accord with mainstream Greek developments, at the same time demonstrating freshness and vitality toward the satisfaction of local needs. Thus, it is quite possible that generous commissions allowed artistic ideas to reach fruition in Macedonia, which in other and more restricted circumstances might not have developed for lack of an openminded environment conducive to invention.

The simple clay pyxis of third- to second-century date from tombs in Macedonia, as recently published by Stella Drougou and Iannis Toratsouglou, is a common product which may reflect such an important invention (Fig. 19).[43] Sculptural lion's-claw feet and a decorative bust medallion on the lids of many of these clay pyxides point to a metal prototype. The terra-cotta versions are only a

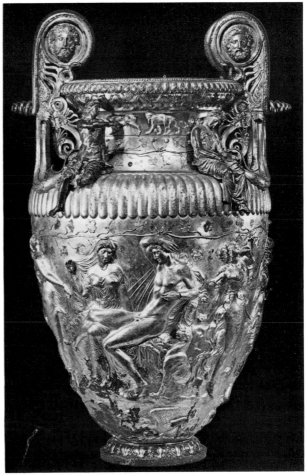

Fig. 19. Terra-cotta pyxis from a rock-cut tomb in Veroia, Archaeological Museum of Veroia.

Fig. 19a. Side A of the Derveni krater, from tomb B at Derveni; Archaeological Museum of Thessalonike, Derveni B1.

modest reflection of the original products, which may have been made of gold and silver. One must look beyond these surrogates to visualize the original reliefs on the lids as small repoussé master-pieces, and the lion's-claw feet as they may have been, forged in sil-ver or gold with engraved details. The invention-as-conception is of such quality and character that, to-gether with other evidence like the giant black-glazed pyxides of fourth-century date, the possibility of the original invention of such a vessel in a fourth-century Macedo-nian court atelier becomes almost a certainty.

It may be that the Macedonian contribution involved the possibil-ity of pushing beyond a certain democratic modesty or reticence to which other centers like Athens or Corinth were sworn. Autocratic rulership, enriched and otherwise fortified by recent and massive conquests—the allusion is to Philip II—would necessarily feel the need to assert its increase of authority in ways generally understood, such as significant artifacts.

A prime example of this kind of significant artifact is the Derveni krater (Fig. 19a, Pl. 3). As I have ex-pressed elsewhere,[44] I believe on stylistic grounds that the Derveni krater is not South Italian, nor Co-rinthian, nor Attic, but exemplifies the particular style and flair devel-oped at the Macedonian court spe-cifically for the Macedonian rulers. The Pella mosaics show the same expansiveness and rhythm.[45] Nothing in tomb B at Derveni, where the krater was found, con-tradicts a date for the krater in the thirties of the fourth century B.C.

It is from such a work—and the krater may not even have ranked among the most conspicuous of its time—that we proceed to some un-derstanding of the concepts and ef-fort behind the creation of similar objects which had almost no func-tional purpose, such as those de-scribed by Athenaeus as among what must have been a breathtak-

ing display of metalwork in the early third-century procession of Ptolemeus Philadelphus in Alexandria.[46] The daring of the relief of these now lost vessels, and the extravagance of the added plastic figures as they are described by Athenaeus, far exceeded those aspects of the Derveni krater. Yet even the krater seems to us excessive when measured against the better-known and more common classical product.

Evidence for a precedent of more modest ambition than the Derveni krater exists in the form of fragments of a black-glazed relief krater found in Olympia—probably of Corinthian fabric—on which the figures are only half as large as the Derveni figures, and their distribution on the vessel much less extensive (Fig. 20). Despite the obvious differences between these two relief vessels in terms of ambition, if such metal vessels as lie behind these fragments existed in the fourth century in the Peloponnesus we have the possibility of influence into Macedonia from yet another source.[47]

The only evidence that is at all comparable in size and quality to the Derveni krater relief from the later, Hellenistic period is a terracotta mold impression taken from a finished metal product of perhaps the middle of the third century. The plaster cast of this mold, showing the positive relief as it appeared on the metal vessel (Fig. 21),[48] demonstrates adequately enough the kind of relief to which the monarchic style of the Derveni krater led. It is as a continuation of this tradition of lavish, decorative high relief that the so-called neo-Attic kraters of the second and first centuries B.C. must be considered. The Derveni krater clearly stands

Fig. 20. Fragments of a black-glazed relief krater found in Olympia (photo: Deutsches Archäologisches Institut, Athens).

at the beginning of this tradition, and in its very isolation may indicate the extent to which—especially in the development of a particular taste—the Macedonian sponsorship was indeed providential.

In conclusion, three impressions emerge from an initial study of the metal vessels from these Macedonian tombs. The first is the purity of the Greek taste which they reveal. It is perfectly clear that the Macedonian court cultivated and developed on a high level the taste characteristic of the major city-states of the time, mainly Athens. The second is the variety and independence of the Macedonian repertoire of metal vessels. That repertoire, as one can see it so far, comprises many shapes which demonstrate both the persistence of perhaps long-established local traditions and the willingness to receive stimuli from centers even outside the Greek world. When these factors are taken into consideration, together with the probable new forms of lavish display well

suited to the particular autocratic environment of Macedonia, it is apparent that the resources of this new empire are to be understood not only in terms of great financial support for the arts, but in terms of a rich inventiveness operating on a very considerable scale.

The third and last impression is the importance of the rule of Philip II, whose Hellenism provided the atmosphere in which this high level of creativity flourished. What must be understood as Philip's taste—the style or styles which he encouraged in the arts—seems somehow consistent with his political aspirations. His appreciation of Greek culture in all probability will prove to have been considerably more profound than the criticisms of conservative Athenian citizens like Demosthenes have led us to believe.[49]

As for the period immediately after Alexander the Great—the two Hellenistic centuries properly speaking—and the manifestations of that period, a strange fact emerges from the metal vessel

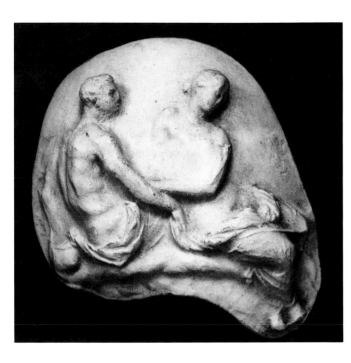

Fig. 21. Plaster cast of an ancient mold taken from a metal relief vessel, National Museum, Athens.

shapes represented in the Macedonian tombs so far discovered. All seem to be classical; that is, most all seem to be within the repertoire which we have so far considered to be from the fourth century. Is this because Hellenistic tombs were plundered? Were these tombs differently equipped? Or, must we rethink our ideas about shape evolution with regard to metal vessels? Continuing excavations should provide the answer.

Notes

Research and travel necessary for the successful completion of this paper were made possible by a grant from the American Philosophical Society, to whom I wish to express my gratitude.

I also wish to thank the following colleagues and friends for the permission necessary for the reproduction of photographs: N. Yalouris, M. Andronikos, K. Rhomiopoulou, S. Drougou, and I. Toratsouglou of Greece; H. Protzman of Dresden; I. I. Saverkina of the Hermitage; and G. Hübner of the German Archaeological Institute in Athens.

1. The earliest evidence for this custom in Greece is in Corinthian vase painting of the early sixth century. A depiction of the dead hero's banquet was actually painted on the wall of a tomb in Lycia at the beginning of the fifth century. The style of this painting shows both Greek and Persian influence. See M. Mellink, "Excavations at Karatas-Semayük and Elmalı, Lycia, 1970," *AJA* 75 (1971), 250-255. According to J. M. Dentzer ("Le motif du banquet couché dans le Proche Orient et le monde grec du VII⁰ au IV⁰ siècle," *RA* [1971], 215-258) the theme of the funeral banquet on independent carved marble relief stelae developed during the course of the fourth century, and its appearance was set into a more or less predictable formula by the end of the century. R. A. Tomlinson suggests that the architecture of the Macedonian tombs, with their painted façades and stucco pilasters which are decorative rather than functional, represents the *Hestiatoria* of the dead and derives its character from actual tents erected for feasting. See Tomlinson, *Thracia*, Symposium 3, Sofia

1972 (Sofia, 1974); I owe this reference to Stella Miller. The most famous tent known from antiquity is that of Ptolemy Philadelphus at Alexandria, described in Athenaeus (5.196-197). See the reconstruction by F. Studniczka in *Das Symposion Ptolemaios II* (Leipzig, 1914), pl. 1.

The appearance of the Macedonian tombs, in any case, suggests real architecture, and that fact together with the actual burial within them of quantities of gold, silver, and bronze vessels suggests—like the mood of the Anatolian tomb painting and East Greek marble grave stelae—the naive belief that indications of power and material possession, both real and symbolic, somehow counteracted the threat of death.

2. For a recently excavated fourth-century burial in the Kerameikos, see Ursula Knigge, "Die Gesandtenstelen im Kerameikos," *AAA* 5 (1972), 258-265.

3. Numerous passages in Athenaeus attest to this. For the golden spoons, 3.126.

4. In the Archaeological Museum of Thessalonike. It has a highly elegant ivy design painted around the neck in gold leaf.

5. *Treasures of Ancient Macedonia,* exh. cat. (Thessalonike, 1980), no. 157, p. 59 and pl. 25.

6. Eugenia Youris, *O Krateros ton Derveni,* Biblioth. Ath. Arch. Etair., no. 89 (Athens, 1980).

7. N. Yalouris, M. Andronikos, and K. Rhomiopoulou, *The Search for Alexander,* exh. cat. (Boston, 1980), no. 166, p. 185 and pl. 33.

8. *The Search for Alexander* (note 7), no. 48, p. 124 and pl. 8. For its antecedents, see note 1.

9. In the Hermitage Museum, inv. no. 171836.21. Height, 22 cm.

10. Published in "Archäologische Funde im Jahre 1909," *AA* (1910), cols. 219-220 and fig. 18.

11. In the Staatliche Kunstsammlungen, Dresden, inv. no. 1417. Dated by G. Kopcke to 330-320 on the basis of the ornament: "Golddekorlerte Attische Schwarzfirniskeramik des vierten Jahrhunderts v. Chr.," *AthMitt* 79 (1964), no. 243, p. 48; pl. 38, 2.

12. *The Search for Alexander* (note 7), nos. 131 and 132, p. 169; illustrated on p. 168. These cups are 9 cm. high. A coin of Philip II was found in Derveni tomb B among the ashes found in the Derveni krater. Cf. a similar but slightly smaller silver cup found in Tomb III in Vergina: *The Search for Alexander* (note 7), no. 156, p. 181 and pl. 26. Tomb III is now dated by Professor Andronikos to the third quarter of the fourth century: "The Royal Tomb of Vergina and the Problem of the Dead," *AAA* 13 (1980), 168-178. Cf. also what may be a somewhat earlier silver cup: *Treasures of Ancient Macedonia* (note 5), no. 283, p. 75 and pl. 41.

13. The rimless variety did exist in black-glazed ware at this time, however, although it does not seem to have been the most prevalent. There are examples from the Agora. See B. A. Sparkes and L. Talcott, *The Athenian Agora,* XII: *Black and Plain Pottery* (Princeton, 1970), nos. 671-678, pp. 119-120, pl. 28 and fig. 7. An Attic import was found in a tomb in Langaza, not far from Derveni: Th. Macridy, "Un tumulus Macédonien à Langaza," *JdI* 26 (1911), 198, fig. 7.

14. *The Search for Alexander* (note 7), no. 121, p. 161. For its counterpart, found with it, see *Treasures of Ancient Macedonia* (note 5), no. 410, p. 97 and pl. 57. These cups are almost 2 cm. higher than the Derveni cups: 10.8 cm. A coin of Alexander was found in cist tomb E in Nikesiani. A similar bronze cup said to be from Amphipolis is in the Staatliche Antikensammlungen und Glyptothek in Munich (Inv. Br. 3766). See J. Mertons, "A Hellenistic Find in New York," *MMJ* 11 (1976), 83, fig. 21. Two more bronze cups which are similar if not identical to the Nikesiani examples were found in grave D at Derveni: *Treasures of Ancient Macedonia* (note 5), 70, nos. 246 and 247; for 246, pl. 33.

15. *CVA* Brussels, III L and III N, pls. 3, 20. In the Musées Royaux. Lower-stemmed krateriskoi from the group may be dated to the first decade of the third century. See Kopcke (note 11), 48-49, and compare similar material from the Agora dated to that time: Sparkes and Talcott (note 13), 120, note 47.

16. Even lower-stemmed examples of either variety have apparently appeared infrequently. One of each, Attic imports found in a tomb in Amphipolis, are in the Archaeological Museum in Kavalla. They appear to be examples from the early third century. Publication of the black-glazed pottery from Pella is being undertaken by Stella Drougou.

17. A marble stele from Mesembria on the Black Sea, now in the Sofia Museum, with the relief of an attenuated krateriskos similar in proportion to the Leningrad vessel, was dated by E. Pfuhl and H. Möbius to the middle of the third century: Pfuhl and Möbius, *Die ostgriechischen Grabreliefs,* (Mainz, 1977), no. 2260, pl. 319. Similar stelae exist with what may be later forms of the krateriskos; at least one is dated by Pfuhl and Möbius to as late as the second half of the second century (no. 1511, pl. 373).

18. To the last quarter of the third century by L. Byvanck-Quarles van Ufford: "Le Trésor de Tarente," *BABesch* 33 (1958), 51; to 100 B.C. by H. Kuthmann: *Untersuchungen zur Toreutik des zweiten une ersten Jahrhunderts vor Christus* (Hannover, 1959), 26-28. Originally dated by Pierre Wuilleumier: *Le Trésor de Tarente* (Paris, 1930), 41-47. That the type of full garland on the neck of the Tarentine krateriskos did not exist before the middle of the second century in Pergamon, as Kuthmann points out, may suggest a mid-second-century date, but it is probably not later.

19. For the Dioskourides mosaic, see Alfonso de Franciscis, *Il Museo Nazionale di Napoli* (Naples, 1963), pl. xx. He dates the mosaic itself to the second to first century.

20. By Katerina Rhomiopoulou: "A New Monumental Chamber Tomb with Paintings of the Hellenistic Period near Lefkadia (West Macedonia)," *AAA* 5 (1973), 87-92.

21. *Treasures of Ancient Macedonia* (note 5), no. 332, p. 81 and pl. 47. Height, 24.8 cm. The shape appeared in nearby ancient Thrace as early as the last quarter of the fifth century and was well established there by the end of the century or the first decades of the fourth century. See I. Venedikov, *Thracia,* 4 (Sofia, 1977), 85-89. At least nineteen buckets of this general type

have been found in Thrace, where, according to Venedikov, finds can be documented until the end of the first quarter of the third century. The development of the shape during this time is demonstrated by Thracian finds as well as by the Macedonian examples. In Thrace decorative motifs (not the figurative reliefs) and sometimes the handle attachments were cast separately and soldered onto the walls. In the Macedonian workshops—with what must have been more sophisticated casting techniques as well as a desire for refinement of the bucket shape—both handle attachments and the low-relief palmettes under the handles were incorporated into the wax model before casting, as in this example from Thessalonike. For a list of situlae of this general type, see the helpful compendium by R. J. Riis in "The Danish Bronze Vessels of Greek, Early Campanian, and Etruscan Manufacture," *ActaA 30* (1959), 18-21. See also L. Byvanck-Quarles van Ufford, "Remarques sur les relations entre l'Ionie grecque, la Thrace et l'Italie," *BABesch 41* (1966), 42-49, who adds a few vessels to the list, notably one in Istanbul, said to be from Thessalonike (Istanbul Museum inv. 2212; height, 24 cm.). According to Venedikov, the shape existed in the Propontis area before it existed in Thrace (88-89). The earliest examples of this shape in bronze found in Southern Italy are dated by context to the end of the fourth century (M.-V. G. Pomes, "Cronologia delle situle rinvenute in Etruria," *Studi Etrusci 25* [1947], 66-76). But see note 25 below.

22. This bucket is in the Archaeological Museum in Plovdiv, Bulgaria. First published in 1909, it was published recently by Ivan Venedikov (note 21, 81-89) and dated there by him to the first quarter of the fourth century. It is one of a group of four of the same shape with a discrete area of relief on the walls (not a frieze) for which W. Züchner suggested a common workshop in Cyzicus: Züchner, *Der Berliner Mänadenkrater, 98. BerlWinckProg* (Berlin, 1938). One other was said to have an Eastern provenience (Bithynia); another was said to have been found in Dodona; the provenience of the remaining one was unknown. It is possible to add another situla to this group (of which two are now lost). Venedikov publishes a situla from Vasiljovo with a relief image of a seated Dionysus with some stylistic resemblance to

these (84, figs. 37-38). The provenience helps support the argument for a northern workshop. Also related to this group, similar in the outlining of the figures and the graphic representation of rocky terrain (as well as other landscape elements: the Dodona fragment also has a leafless tree) but with less judicious use of line in the drapery, is the repoussé bronze plaque, now in two pieces, from Olynthos (*Treasures of Ancient Macedonia* [note 5], no. 358, p. 85 and pl. 49). Mrs. Byvanck-Quarles van Ufford has seen this resemblance also (note 21). The assignment of these reliefs to the north can in some measure be taken as confirmation of a northern tradition of metal relief ware which led up to the court style of which the frieze on the Derveni krater is so far our prime example. It must be remembered that the frieze on the Maenad Krater in Berlin, which Züchner identified with the figuration on these relief situlae and assigned with them to Cyzicus—as well as most (to my knowledge, all) of the situlae reliefs—were cast, not repoussé like the frieze on the Derveni krater. In considering this question, one should not overlook the local style of Thessalian grave reliefs—with their distinct flatness and emphasis on line—which appeared by the early fifth century. See S. Casson, *Macedonia, Thrace and Illyria* (Groningen, 1968), 253, and especially H. Biesantz, *Die thessalischen Grabreliefs* (Mainz, 1965), passim. The bronze plaque from Olynthos, from a harness decoration, may in some way be a link between the proposed northern situla workshop and an atelier nearer the Macedonian court. And see note 45 below.

23. Tomb III is now dated by Professor Andronikos to the third quarter of the fourth century (note 12). For the situla: *The Search for Alexander* (note 7), no. 157, p. 181 and pl. 26. Height, 32.5 cm. Although it has a foot and more narrow base, the Vergina situla is otherwise quite similar in profile—with its distinct lip and wide mouth—to the bronze situla from the Thracian site of Mal-Tepé, which is cast, not forged like the silver bucket, and dated to about 350 by Venedikov (note 21, 88, fig. 44). (Also see B. Filow, *Bulletin of the Bulgarian Archaeological Institute* [1937], 59,

fig. 60.) In both vessels, the handles, which end in bud forms, protrude up and through their attachments. Under the handle attachments, the Mal-Tepé situla has large inverted palmette and scroll designs which were cast separately and soldered onto the walls. By contrast, the engraved and gold-washed palmettes on the Macedonian silver situla are elegant counterparts in intaglio technique to the low-relief palmettes cast into the walls of Macedonian bronze situlae. (See note 21.)

24. *The Search for Alexander* (note 7), no. 107, p. 156 and pl.17. Height, 21 cm. A parallel from Bulgaria of similar shape and handle structure, but with handle attachments cast separately and soldered on, comes from the region of Goce Delčev and is dated by Venedikov to no earlier than the end of the fourth century or the beginning of the third (note 21), 89 and fig. 46. Compare a derivative Campanian bronze example: Pomes (note 21), 75, fig. 38.

25. Published in E. Pernice, *Hellenistische Tische, Zisternenmündungen, Beckenuntersätze, Altare und Truhen: Die Hellenistische Kunst in Pompeji,* 5 (Berlin and Leipzig, 1932), pl. 48, 1. There are examples in terra cotta painted in the Apulian red-figure style: B. Schroder, *Griechische Bronzeeimer in Berliner Antiquarium,* 74. *BerlWinckProg* (Berlin, 1914), 10-11, figs. 6-7; and see J. B. Beazley, *Etruscan Vase Painting* (Oxford, 1947), 61. This is the earliest known version of this bucket shape in Southern Italy according to Pomes (note 21), which suggests that although there was apparently no local production in metal at that time, the shape was known there at the end of the fifth century or the beginning of the fourth. Many examples exist in black-glazed ware, frequently but not always with figural reliefs under the handle areas. See Sparkes and Talcott (note 13), 201, note 5, and Beazley, 250-252 and 288-289. Also G. Schneider-Herrmann, "Tarentiner Situla in Leiden," *BABesch 39* (1964), 115–121 for a black-glazed relief situla in Leiden.

26. *Treasures of Ancient Macedonia* (note 5), no. 36, p. 41 and pl. 8. Height, 16.8 cm.

27. *The Search for Alexander* (note 7), no. 122, p. 161 and pl. 18. Height, 21.5 cm. The prevalence of this type of situla in ancient Thrace also suggests a northern origin. See note 32. Coins of Alexander were found in cist tomb E in Nikesiani with this situla.

28. See a vessel carried by a figure in the tribute procession of the Medes in a frieze on the Apadana at Persepolis: E. F. Schmidt, *Persepolis,* 1 (Chicago, 1953-1957), pl. 27. For an ancient amphora from ancient Iran in forged sheet metal bronze, see P. R. S. Moorey, *Ancient Persian Bronzes in the Adam Collection* (London, 1974), no. 139.

29. Venedikov (note 21), 79, thinks the origin was Thrace, and refers to this shape as the characteristic "Thracian" situla type.

30. *The Search for Alexander* (note 7), no. 157, p. 181 and pl. 26. Height, 21.6 cm.

31. *Alexander the Great,* exh cat. (Thessalonike, 1980), pl. 67; also C. D. Edmonds, "The Tumulus of Pilaf-Tepe," *JHS 20* (1900), pl. v. Height, 25 cm.

32. Venedikov (note 21), 63 and 65-80. In Greece the shape was not really well known until the recent excavations in Macedonia. This situla type has been found in areas of South Russia and Bulgaria; for an example now in Kiev, see *From the Land of the Scythians,* exh. cat. (New York, n.d.), 127, no. 179. Later derivatives have been found in Southern Italy: see Riis (note 21), 15, fig. 12, for an example in the Vatican museum; there are others in the Villa Julia, the Louvre, the British Museum, etc.

33. Diodorus Siculus (16.87) recounts that Philip drank wine undiluted, and Athenaeus that Alexander pledged toasts with unmixed wine (12.537). The discovery in Macedonia of so few kraters—in which wine was mixed with water—suggests the possibility that such vessels were used in the north only ceremonially. Certainly this might well have been the case with the Derveni krater.

34. See an example in black-glazed ware in the Archaeological Institute of the University of Zurich: G. Kopcke, "Ein Siebgefäss in Zurich," *Antike Kunst 9* (1973), 70 and pl. 26, 2; another from Crete: "Chronique des fouilles en 1975," *BCH 100* (1976), pt. 2, 729, fig. 348. Unglazed varia-

tions with relief decoration, probably painted, have been found in Italy: National Museum of Copenhagen, inv. no. 2048.

35. *The Search for Alexander* (note 7), no. 135, p. 170 and pl. 19. Height, 20 cm.

36. The Metropolitan Museum of Art, New York, inv. no. 56.171.64, Fletcher Fund, 1956. Dated to the third quarter of the fourth century. Apulian vase painters apparently knew the shape in polished bronze. See the depictions of such vessels on an Apulian volute krater in the Metropolitan Museum: inv. no. 69.11.7, Mrs. J. J. Rorimer Gift, 1969.

37. It is Professor Venedikov's opinion that the origin of the shape of this situla was a goblet well known in Asia Minor and Thrace at the end of the sixth and throughout the fifth century, and that the handles were adapted to it in Thrace from other forms of the situla: Venedikov (note 21), 80. A goblet of similar shape appears in the procession of the Medes on the Apadana at Persepolis: Schmidt (note 28), pl. 27. Refinement of the shape, however, surely took place at or near the royal Macedonian workshops.

38. This one is from a cist grave in Stavroupolis, Thessalonike: *Treasures of Ancient Macedonia* (note 5), no. 280, p. 74 and pl. 41. Height, 6 cm. Compare the exterior of the cup to that of one from Tomb II at Vergina with a Silenus mask in the interior: *The Search for Alexander* (note 7), no. 164, p. 184 and pl. 33; another from tomb A in Nikesiani: ibid., no. 120, p. 160; and a third from Sedes in Thessalonike: *Treasures,* no. 317, pp. 79-80 and pl. 45.

39. The Babylonians in the tribute procession on the stairway of the Apadana: Schmidt (note 28), 31. Some Persian examples have been found recently in Asia Minor. See A. Oliver, *Silver for the Gods* (Toledo, 1977), 40, with bibliography.

40. From various Macedonian graves. These cups have been found throughout the north of Greece as well as in Bulgaria. A silver medallion with a miniature woman's head turned in three-quarter pose found in South Russia and now in the Hermitage is certainly contemporary to the Macedonian examples and may well have

been in a cup imported from a Macedonian workshop: B. Segall, "Alexandria und Tarent; eine tarentinische Fundgruppe," *AA* (1965), suppl., col. 567, fig. 11. It is similar to a female head in a cup found in tomb D at Nikesiani, dated by a coin of Cassander to the beginning of the third century. See *The Search for Alexander* (note 7), no. 118, p. 160, for the outside of the bowl only.

41. This type of decorative representation continued into the Hellenistic period with the embellishment of the omphalos phiale with heads and busts, most of them of women. The type survives in Hellenistic hammered silver phiali and in the so-called Calena bowls of third- and second-century date. See B. Barr-Sharrar, "The Hellenistic and Early Imperial Decorative Bust" (Ph.D. diss., Institute of Fine Arts, New York University, 1980), 21-26 and 423-482.

42. For relief details of the Panagurischte vessels, see I. Venedikov, *Panagurischte Gold* (Sofia, 1961), passim, or A. Rhodes, *Art Treasures of Eastern Europe* (New York, 1972), 234-235.

43. S. Drougou and I. Toratsouglou, Ἑλληνίστικοι λαξεύτοι τάφοι Βέροιας (Athens, 1980). See also Barr-Sharrar (note 41), 16-21 and 363-423.

44. B. Barr-Sharrar, "Towards an Interpretation of the Frieze on the Derveni Krater," *Bronzes hellénistiques et romains: Tradition et renouveau: Actes du V^e Colloque international sur les bronzes antiques* (Lausanne, 1979), 55-59.

45. In stylistic affinities, the krater frieze seems to lie somewhere between the languid figure of Dionysus on his panther with the elegant drawing of silhouettes and lightness of touch in modeling, and the Gnosis stag-hunt mosaic with its greater spatial orientation of figures on a rocky ground and stronger modeling. What makes the Derveni frieze figures seem so baroque are the swirls and sweeps of drapery which move around them as if in some ethereal breeze. The rhythm is in the same spirit as that of the decorative motif of scrolls and tendrils which border the Gnosis mosaic and elements of which decorate the krater, where no gesture ends without a flourish. See the detail of a protruding curl over the left shoulder of the cast sleeping Ariadne figure on the Derveni krater.

46. Athenaeus 5. 196-200. One huge vessel had metal figures sitting on the rim and relief figures around the neck and body.

47. S. Karousou suggests the antecedents of the elaborate terra-cotta volute kraters from South Italy are Corinthian or Laconian: S. Karousou, "Technourgoi Krateron," *AthMitt 94* (1979), 88-91.

48. Both mold impression and plaster cast are in the National Museum, Athens. The cast was published by A. Brückner, *Anacalyptera, 46. BerlWinck Prog* (1904), 12.

49. For a discussion of Philip's personality, including his interest in Greek culture, see P. Lévêque, "Philip's Personality," in *Philip of Macedon,* eds. M. Hatzopoulos and L. Loukopoulos (Athens, 1980), 176–187.

Fig. 3. Gold oak wreath found in the larnax in Tomb II at Vergina, Archaeological Museum of Thessalonike, no. 17.

Macedonian Royal Jewelry

REYNOLD A. HIGGINS

British Museum (Emeritus)

IT MUST BE CONFESSED at the outset that, from the mid-fourth century B.C., in reality there is no such thing as Macedonian jewelry, only Greek jewelry. Moreover, very little surviving material could actually be called royal. Nevertheless, by combining all the available evidence, it should be possible to obtain an idea of what jewelry would have been worn at the Macedonian court from the fourth to the second century B.C., and to trace its origins. For the sake of brevity, two categories will perforce be ignored: the closely related field of signet rings and ordinary, run-of-the-mill material which would have been more appropriate to commoners than to royalty.

This investigation, which would not have been possible without the pioneer work of Pierre Amandry, Herbert Hoffmann, Stella Miller, and Berta Segall,[1] will be divided into five stages: the later fifth and early fourth centuries (the formative period), the second and third quarters of the fourth century, the late fourth and early third centuries, the full third century, and the second century.

The later fifth and early fourth centuries

The middle of the fifth century is a suitable starting point because this is when the regular production of jewelry began again in Greek lands after an unexplained lull—in actual surviving jewelry though not in artistic representations—between approximately 600 and 450 B.C. The material comes principally from Eretria in Euboea and from the Greek and Scythian communities in South Russia, where gold was plentiful; it is not yet recorded from Macedonia.

Typical of this period is a pair of earrings in London from a tomb at Eretria of the later fifth century (Fig. 1).[2] The basic boat-shape is decorated with filigree and enameled rosettes; a miniature siren sits on it and cockle shells hang from it by chains. The whole complex hangs from a large enameled rosette which would have been worn in the lobe. Filigree and enamel replace the granulation of the seventh century, the purpose of this minute decoration being to reflect the strong Mediterranean sunlight when the earrings were worn.

Two necklaces of the same date from graves at Nymphaeum in the

Fig. 1. Earring from a pair from a tomb in Eretria, British Museum.

Crimea, now in Oxford, show the shape of things to come (Fig. 2).[3] One is composed of ribbed discs with rosettes and bud-pendants; the other, more complicated, has rosettes with acorn pendants, separated by honeysuckle dividers. This elaborate interlocking arrangement has almost the precision of a work of engineering.

Animal-headed hoop bracelets, last seen in seventh-century Rhodes and probably of Persian inspiration, now reappear and are recorded from Nymphaeum and Cyprus.[4] Finally, a finger ring with a bezel in the form of a Boeotian shield is recorded from graves at

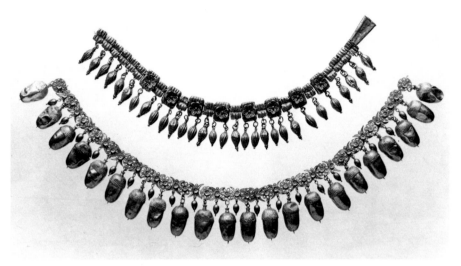

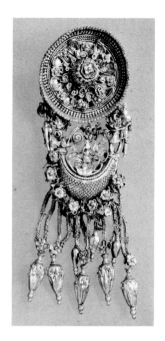

Left: Fig. 2. Necklaces from graves at Nymphaeum in the Crimea, Ashmolean Museum, Oxford.
Right: Fig. 4. Earring from Madytos in the Troad, The Metropolitan Museum of Art, inv. no. 06.1217.3.

Eretria, from Thespiae, Perachora, and (allegedly) Kavalla.[5]

The mid-fourth century

Our second group covers the second and third quarters of the fourth century. Thanks to the efforts of Philip II in exploiting the gold mines in his territory, gold jewelry is now found in Macedonia and neighboring Thessaly. The two recently excavated royal tombs at Vergina belong to this period. The bulk of material surviving from this time, however, still comes from South Russia. In addition, the Thracians were now showing an interest in Greek jewelry.[6]

A gilded silver adjustable diadem from Tomb II at Vergina (Pl. 4) is apparently unique.[7] It is a large-scale reproduction in precious metals of the *diadema,* the ribbon habitually worn around the forehead by Hellenistic rulers, and it proves beyond any doubt that this was a royal tomb. At the back of it is a representation of the reef-knot, sacred to Heracles, which se-

cured the ribbon at the back of the wearer's head. It has been suggested that this oversize metal example was worn by the king around his helmet.[8]

Gold wreaths are frequently found in Greek tombs from the fourth century B.C. onwards. Most were probably made purely for funerary use, but some are stouter and better made, and were evidently worn in the owner's lifetime. Three were found in the Vergina tombs. A splendid oak wreath (Fig. 3) was found in the gold larnax of the main chamber of Tomb II and must surely have been worn by the king in his lifetime.[9] An equally splendid gold wreath of myrtle was found in the antechamber of Tomb II and a plainer oak wreath in Tomb III.[10] The gold larnax from the antechamber of Tomb II contained a diadem which is a masterpiece of openwork decoration with its floral ornament, palmettes, figures of bees gathering nectar, and discrete touches of enamel.[11] A later version of this type of object is shown here (Fig. 12).

Earrings are now plentiful. The late fifth-century boat earring (Fig. 1) has evolved into a longer and more elaborate type, represented by many examples from the Black Sea coast and elsewhere. One example comes from Madytos in the Troad (Fig. 4).[12] A pair comes from tomb Z at Derveni,[13] and another one is said to have been found at Trebizond.[14] Necklaces, too, evolve from earlier types. An example from Homolion in Thessaly clearly derives from the Nymphaeum varieties like those in Fig. 2.[15] An even finer example comes from Tarentum at the other end of the Greek world (Fig. 5).[16]

Two pretty swivel-rings, one from Homolion and one from the Pavlovsky Barrow on the Taman Peninsula, date to about the middle of the fourth century. A similar ring, in Berlin, is said to come from Tarentum and there are others.[17] The bezels of these rings usually incorporate scenes in gold leaf set against a deep blue background and protected by a covering of crystal: a surprising degree of elaboration at this early date.

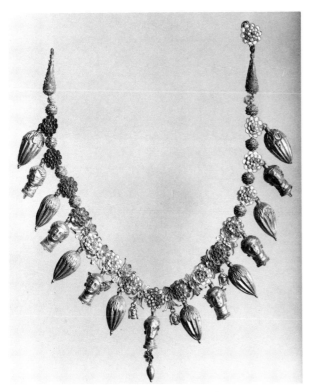

Fig. 5. Necklace from Tarentum, British Museum.

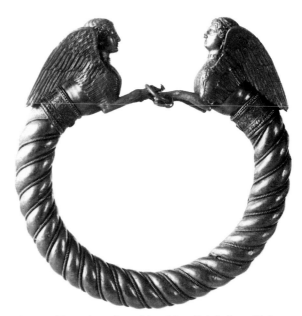

Fig. 6. Hoop bracelet with sphinx finials from Kul-Oba, The Hermitage.

The animal-headed hoop bracelet continues and is represented by a fine pair in Leningrad from Kul Oba. The finials are in the form of sphinx-protomes (Fig. 6).[18]

The late fourth and early third centuries

The third group is extremely rich in surviving material, which surely reflects the actual state of affairs at the time. For in addition to the output of the Macedonian and Thracian gold mines exploited by Philip II, there was also the vast quantity of Persian gold put into circulation in the Greek world as a result of Alexander's conquests in the East. Our sources in Macedonia are the rich cemeteries in and near Salonika. The contents of these cemeteries are, in general, unlikely to antedate by much the foundation of Thessalonike by Kassander about 316 B.C., although Lete, modern Derveni (which has already been mentioned), was probably in existence by at least 330. Other fruitful sources include Kyme in Aeolis, for a group, most of which is in London, of the late fourth and early third centuries,[19] and a set in Pforzheim of much the same date, said to come from Sardis.[20] And there are some well-dated groups from the West. South Russia is not so rich.

A love of polychromy—derived from Persia or, less probably, from Egypt—began to take effect about 325 B.C. The approach was at first cautious, but by the full third century, our next period, the effect was truly lavish. It was achieved by the use of colored glass and stones. Popular stones were chalcedonies, carnelians, and above all garnets. The latter, in the variety of almandine garnets, were used to great effect, cut *en cabochon*. They were introduced from India, and not, as Pliny believed, from Alabanda, although they may well have been worked at Alabanda.[21] Finally, enamel was used to a limited extent, as before.

Of the forms of the jewelry, wreaths continue in greater numbers than in the previous period. Temple inventories from Delos for 279 B.C. and subsequent years refer to gold wreaths of laurel, myrtle, ivy, olive, oak, and vine.[22] Numbers of such wreaths have been found in burials of this period. Examples from Macedonia are one from Sedes (Salonika) (Fig. 7),[23] another from Stavroupolis (Salonika), and a third from Amphipolis.[24] Floral diadems continue, after the example of the diadem from the antechamber of Tomb II at Vergina. An example, from Stavroupolis (Salonika) is a particularly

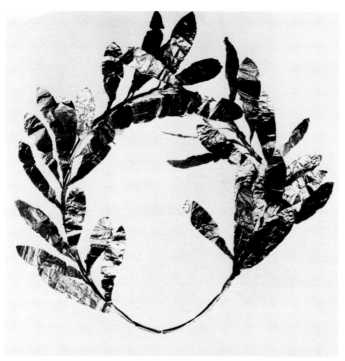

Fig. 7. Gold olive wreath from a grave in Sedes, Thessalonike, Archaeological Museum of Thessalonike, no. 5408.

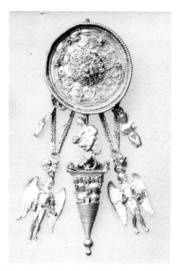

Fig. 8. Earring from a tomb in Kyme in Aeolis, British Museum.

good one.[25] So is one from Sedes (Salonika).[26]

A new type of earring appears in the richer burials of the late fourth century, based on the pendant cone or pyramid which is also occasionally found around the middle of the fourth century.[27] The pyramid is suspended from a disc. A number of such earrings were found in a tomb or tombs at Kyme in Aeolis. On one example sits a minute figure of a woman playing knucklebones (Fig. 8.)[28] From the disc hang two doll-like figures and, on chains, two flying Victories. Everything is decorated with exquisite filigree and, somewhat surprisingly, rather coarse granulation.

Some idea of the contents of the jewel box of a well-to-do Macedonian lady of 330–300 B.C. will be gained from a study of a set of jewelry in New York, believed to come from Thessalonike (Fig. 9).[29] It consists of a pair of earrings, a necklace, a pair of bracelets, a finger ring, and two pairs of fibulae—all, of course, in gold. The earrings are among the finest of their kind. A representation of Ganymede carried off by the eagle hangs from an elaborate honeysuckle ornament. The necklace is a strap, hung with tiny spearheads. Temple inscriptions from Delos for 279 B.C. and subsequent years mention necklaces with spears and amphorae.[30] This, then, is a spear necklace. Amphora necklaces are also known; one in London is allegedly from Melos (Fig. 10).[31]

Her animal-headed hoop bracelets were a conservative element in the lady's jewelry; but these are very splendid ones, of rock-crystal, with ram-headed gold finials. Her finger ring is of interest because it is set with an Indian emer-ald, which could only have reached the Greek world after Alexander's conquests. The four gold fibulae would have secured her dress. Fibulae like these, usually of silver, are found throughout Greece but are commoner in the north, as they are of Thracian origin. A similar set of gold fibulae was found in a tomb in Veroia.[32]

The lady's husband would have had very little jewelry in his tomb: probably a wreath and possibly a signet ring. In addition, his garment might well have been fastened by a gold double-shanked pin of the kind sometimes known as the Illyrian pin. Such pins evolved in Illyria (modern Yugoslavia) about the sixth century B.C. and spread to Macedonia. Most extant examples are in bronze, a few in silver, and a very few in gold. Two of the rare gold examples were found in Macedonia;[33] one is

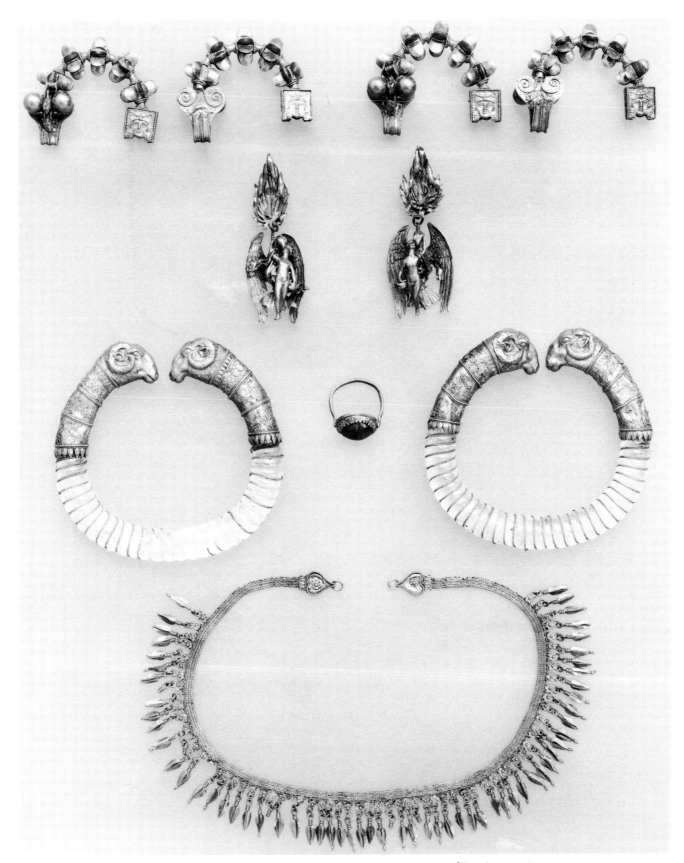

Fig. 9. Set of jewelry thought to be from Thessalonike, The Metropolitan Museum of Art, inv. no. 37.11.8-17.

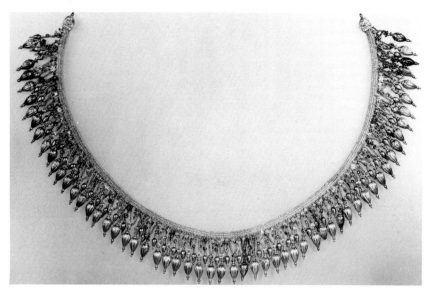

Fig. 10. Amphora necklace thought to be from Melos, British Museum.

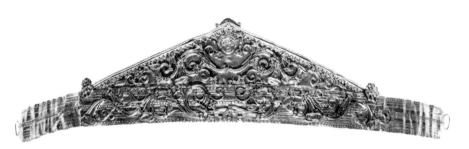

Fig. 11. Gable-shaped diadem from Santa Eufemia in Calabria, British Museum.

equipped with a gold sheath to cover the points.[34]

Jewelry specifically of the early third century B.C. is seldom easy to identify, but two groups from the West, well dated by coins, help to fill this gap. A beautiful gable-shaped diadem (Fig. 11) comes from Santa Eufemia, the ancient Terina, in Calabria.[35] With its fine floral scrolls and its low-relief decoration, it is a more splendid version of the diadems from Kyme in Aeolis, which it serves to date. The other group was found at Gela in Sicily in 1888.[36] Its present whereabouts is not known, but the associated coins prove that the hoard was buried in 280 B.C., when Gela was destroyed and abandoned for-ever. The jewelry consists of a Heracles knot with tassels (from a diadem?), a cord necklace with lion-head finials, two finger rings, etc. Adumbrations of the elaborate late Hellenistic style are already apparent.

The full third century

As bad luck would have it, firmly dated evidence for the full third century is scarce, although it must have been a very rich period for jewelry. The Tomb of the Erotes at Eretria, whose contents are in Boston, certainly belonged to this pe-riod.[37] In the West, the "Tomb of the Gold Ornaments" at Canosa in Apulia is dated to the second half of the third century.[38] This century sees the further development of the polychrome style, of which good examples are provided by the elaborate floral diadem from Ca-nosa (Fig. 12)[39] and the one from Eretria.[40] The opulent decoration of applied ornament, inset stones, and enamel follows the trend set a century earlier by such master-pieces as the diadem from the ante-chamber of Tomb II at Vergina. Strap necklaces continued un-changed throughout this period.

The second century

Unlike the third century, the sec-ond century is well documented. One of the key groups, recently published by Stella Miller, is a pair of graves at Pelinna in Thessaly, the contents of which give a good idea of the jewelry of a rich Mace-donian lady of this period.[41] Another group, further afield, consists of the contents of three contemporary graves in a tumulus near Phanagoria in the Taman Pe-ninsula, just east of the Crimea, known as Artjukhov's Barrow. This very rich material was for-merly dated to the third century, but it has recently been restudied, and it is now given a date around the middle of the second century, which makes much more sense.[42] This suggests a date, on stylistic grounds, in the first half of the sec-ond century for a set of jewelry be-lieved to come from Carpenisi in Thessaly and now divided be-tween two museums in Athens, the National Museum (Stathatos Collection) and the Benaki Mu-seum.[43] Finally, a *terminus ante quem* is provided by a hoard of coins and jewelry from a house on Delos, buried in all probability during the sack of 88 B.C.[44]

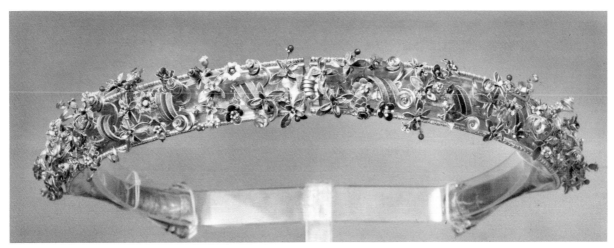

Fig. 12. Floral diadem from Canosa, Staatliche Antikensammlungen und Glyptothek, Munich.

The hallmark of second-century jewelry is the extremely rich polychromy provided by the lavish use of colored glass and stones. In addition to the stones employed previously, we now see pearls from the Persian Gulf and emeralds from the newly discovered mines in the Egyptian eastern desert.[45]

A typical second-century diadem comes from the Carpenisi Group and belongs now to the Benaki Museum (Fig. 13).[46] The center is a richly decorated Heracles knot, inlaid with cabochon garnets, and enameled at the edges; to this is attached a double strap of gold. From various points hang gold and garnet tassels; there are now nine, and were originally ten. An even more elaborate example comes from Artjukhov's Barrow, and more are recorded from North Greece and South Russia.[47] A terracotta figure of about 100 B.C. shows such a diadem in use (Fig. 14).[48]

Earrings, too, become more elaborate. A pair from Pelinna, in the Macedonian kingdom, takes the form of a Victory driving a two-horse chariot over the prow of a ship.[49] The group is sur-

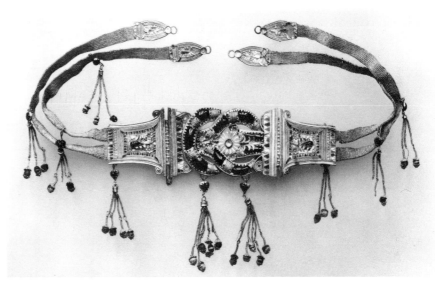

Fig. 13. Diadem from the Carpenisi Group, Benaki Museum, Athens.

mounted by two garnets in gold settings. Fig. 15 shows an even more elaborate creation from Artjukhov's Barrow.[50] A white glass dove with green wings hangs from a rosette, above which is a representation of the disc and feathers of the Egyptian goddess Isis; feathers and disc are inlaid with carnelian. Two gold tassels, threaded with garnets, also hang from the rosette.

A necklace from Pelinna contains a curious mixture of pen-

dants, set with garnets, useful to students if not very decorative. They comprise two crescents, a flask, two Victories, four Erotes, a royal star of Macedonia, an eagle, and two medallions with busts of Artemis and Helios.[51] A more decorative necklace comes from Artjukhov's Barrow (Fig. 16). A cord with lynx-head ends is equipped with bezel-set garnets and emeralds in a striking ensemble.[52] Strap necklaces continue down to about 150 B.C. (Carpenisi Group).

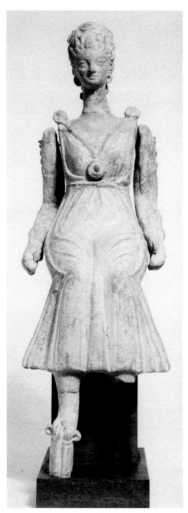

16

Fig. 14. Terra-cotta figure, British Museum.

Fig. 15. Earring from Artju-khov's Barrow, The Hermitage.

Fig. 16. Necklace from Artju-khov's Barrow, The Hermitage.

14

15

Reference to the terra-cotta figure (Fig. 14) reveals that, in addition to the diadem on her head, she wears a medallion on her breast to gather two cross-straps and her girdle. Such a medallion, the *periamma,* is reproduced in Fig. 17.[53] Similar in style to this medallion, but evidently different in function, are four medallions of the Carpenisi Group, which are surrounded by a network of gold chains (Fig. 18).[54] The purpose of these articles has never been clearly demonstrated, but the suggestion that they are hairnets gains credence from the existence of a similar medallion in a German private collection from Tarentum, which is incorporated in a rigid caplike network.[55] A fifth medallion with a net of chains was excavated in a tomb belonging to the Greek colony of Kallatis on the western coast of the Black Sea.[56]

Fancy bracelets are also found in the second century. The coiled

Fig. 17. Gold medallion, Museum of Historic Art, Princeton University.

snake is a popular form.[57] In an elaboration of this type in the Metropolitan Museum in New York, the finials are composed, not of snakes' heads, but of the torsos of a triton and tritoness respectively.[58] A second type of bracelet is composed of a circlet of gold, usually of openwork filigree, with inset stones. A good example in Chicago is believed to have come from a second-century burial in Syria.[59]

Finger rings were made in the same style. One from Amphipolis is made of openwork filigree, with an inset garnet.[60] Another type of ring is known from many examples, and may be dated by comparison to one from Pelinna. It has a cabochon-cut stone projecting from an elaborately molded bezel-setting.[61]

This brings us to the end of free Macedonia, and almost to the end of Hellenistic jewelry. What follows is Roman rather than Greek, and that is a different story.

Fig. 18. Gold medallion, Benaki Museum, Athens, no. 1556.

Notes

I am indebted to the following persons and institutions for supplying photos and for granting me permission to publish them: Professor M. Andronikos and the Greek Ministry of Culture and Sciences (Figs. 3 and 7 and Pl. 4); the Museum of the History of Art, Princeton University (Fig. 17); the Ashmolean Museum, Oxford University (Fig. 2); the Benaki Museum, Athens (Figs. 13 and 18); the British Museum, London (Figs. 1, 5, 8, 10, 11, and 14); the Hermitage Museum, Leningrad (Figs. 6, 15, and 16); Dr. Max Hirmer (Fig. 12); Messrs. Methuen and Co. (Figs. 2, 4, 6, 12, 13, 15, 16, and 18 [from R. Higgins, *Greek and Roman Jewelry*²]); the Metropolitan Museum of Art, New York (Figs. 4 and 9).

1. P. Amandry, *Collection Hélène Stathatos, vol. I: Les bijoux antiques* (Strasbourg, 1953) and *Collection Hélène Stathatos, vol. III: Objets antiques et byzantins* (Strasbourg, 1963); P. Davidson and H. Hoffmann, *Greek Gold: Jewelry from the Age of Alexander* (Mainz, 1965); S. G. Miller, *Two Groups of Thessalian Gold*, University of California Classical Studies, vol. 18 (Berkeley, 1979); B. Segall, *Museum Benaki, Katalog der Goldschmiede-Arbeiten* (Athens, 1938).

2. F. H. Marshall, *Catalogue of the Jewelry in the Departments of Antiquities of the British Museum* (London, 1907; photolithographic reprint, 1969), nos. 1653-1654; R. A. Higgins, *Greek and Roman Jewelry,* second ed. (London, 1981), pl. 24E. Height, 6 cm.

3. M. Vickers, *Scythian Treasures in Oxford* (Oxford, 1979), pls. xa and xia; Higgins (note 2), pl. 27. Lengths, 25 cm. and 31 cm.

4. Vickers (note 3), pl. xviiie; Marshall (note 2), nos. 1985-1986, pl. xxxix; Higgins (note 2), pl. 30A.

5. *Treasures of Ancient Macedonia,* exh. cat. (Athens, 1979), no. 399, p. 96 and pl. 50; Higgins (note 2), 132.

6. R. F. Hoddinott, *Bulgaria in Antiquity* (London, 1975), 33-108 passim.

7. Nicholas Yalouris, Manolis Andronikos, and Katerina Rhomiopoulou, *The Search for Alexander,* exh. cat. (Boston, 1980), no. 162, p. 183 and pl. 30.

8. The suggestion was originally made by Professor M. Andronikos and drawn to my attention by Professor Andrew Stewart.

9. *The Search for Alexander* (note 7), no. 173, p. 187 and pl. 36.

10. Professor Andronikos describes them in *The Search for Alexander* (note 7), 35 (the myrtle wreath) and 38 (the oak wreath).

11. See Andronikos in *The Search for Alexander* (note 7), 37.

12. The Metropolitan Museum of Art, New York, inv. no. 06.1217.3; Rogers Fund 1906. Higgins (note 2), pl. 25A. Height, 7.5 cm.

13. *The Search for Alexander* (note 7), no. 138, p. 171 and pl. 11.

14. *The Search for Alexander* (note 7), no. 61, p. 133 and pl. 14.

15. Miller (note 1), pl. 4.

16. Marshall (note 2), no. 1952, pl. xxxv; Higgins (note 2), pl. 28. Length, 30.6 cm.

17. See Miller (note 1), 18.

18. Higgins (note 2), pl. 30B. Diameter, 11.5 cm.

19. Marshall (note 2), pl. xxxviii.

20. B. Segall, *Zur griechischen Goldschmiedekunst des vierten Jahrhunderts v. Chr.* (Wiesbaden, 1966). Mentioned in Davidson and Hoffmann (note 1), 64, 123, and 162, in relation to their nos. 4, 41, and 57.

21. This important discovery was recently made by Mavis Bimson of the British Museum Research Laboratory. It was made public in a lecture to the Society of Antiquaries of London on November 6, 1975.

22. Th. Homolle, "Comptes des hiéropés du temple d'Apollon délien," *BCH 6* (1882), 1-167.

23. *The Search for Alexander* (note 7), no. 60, p. 132 and pl. 11.

24. *Treasures of Ancient Macedonia* (note 5), no. 293, p. 76 and pl. 38; and no. 395, p. 96 and pl. 55.

25. *The Search for Alexander* (note 7), no. 114, p. 159 and pl. 11. (There it is called a gold ornament.)

26. *Treasures of Ancient Macedonia* (note 5), no. 318, p. 80 and pl. 46.

27. *The Search for Alexander* (note 7), no. 89, p. 148 and pl. 12.

28. Marshall (note 2), nos. 1670-1671. Height, 6.1 cm. There is another pair said to be from Kyme in the Antikenmuseum in Berlin: *The Search for Alexander* (note 7), no. 64, p. 135.

29. The Metropolitan Museum of Art, New York, inv. no. 37.11.8-17; Harris Brisbane Dick Fund 1937. G. M. A. Richter, "The Ganymede Jewelry," *BMMA 32* (1937), 290. Height of earrings, 5.5 cm. Height of bracelets, 7.7 cm.

30. See note 22.

31. Marshall (note 2), no. 1947, pl. xxxv; Higgins (note 2), pl. 49B. Length, 33.6 cm.

32. *The Search for Alexander* (note 7), no. 55, p. 130 and pl. 12

33. *The Search for Alexander* (note 7), no. 67, pp. 136-137; and no. 137, pp. 170-171.

34. *The Search for Alexander* (note 7), no. 137. See P. Jacobsthal, *Greek Pins* (Oxford, 1956), 137 ff.; Amandry, *Collection Hélène Stathatos,* vol. I (note 1), no. 146, and vol. III (note 1), nos. 42-43; *Germania 34* (1956), 68.

35. Marshall (note 2), no. 2113, pl. xli. Greatest height, 4.2 cm.

36. *MonAnt 17* (1906), 539, fig. 371.

37. *The Search for Alexander* (note 7), nos. 91-99, pp. 149-153 and pl. 13 (no. 92).

38. *Iapigia 6* (1935), 225-262.

39. Higgins (note 2), pl. 45B. Length, 45 cm.

40. From the Tomb of Erotes. *The Search for Alexander* (note 7), no. 92, p. 150 and pl. 13.

41. Miller (note 1), 25-48.

42. E. H. Minns, *Scythians and Greeks* (Cambridge, 1913), 433; *Jahrbuch des römische-germanischen Zentralmuseum, Mainz 5* (1958), 94; *Sovietskaya Arkheologiya* (Leningrad, 1960), 46-58; summary in German, *Bibliotheca Classica Orientalis 6* (1961), 306.

43. Amandry, *Collection Hélène Stathatos,* vol. I (note 1), nos. 232-266; vol. III (note 1), 247-255; Segall, *Museum Benaki* (note 1), nos. 28-36.

44. "Trésor hellénistique trouvé à Délos en 1964," *BCH 89* (1965), 503-566.

45. Higgins (note 2), 38.

46. *The Search for Alexander* (note 7), no. 79A, p. 143 and pl. 15.

47. Higgins (note 2), 158.

48. *Catalogue of Terracottas in the British Museum* (London, 1903), no. C521.

49. *The Search for Alexander* (note 7), no. 72A, p. 139. Stella Miller suggests the subject may have been copied from a grandiose sculptural group set up by a Macedonian king (Miller, note 1, 43).

50. Higgins (note 2), pl. 48B. Height, 6.5 cm.

51. Miller (note 1), pl. 15; *Treasures of Macedonia* (note 5), no. 10, p. 34, and pl. 6.

52. Higgins (note 2), pl. 50A. Length, c. 30 cm. See also Minns (note 42), 431, fig. 321.

53. Most recent bibliography: *The Search for Alexander* (note 7), no. 78, pp. 142-143 and pl. 13; also Higgins (note 2), 167 and pl. 52A.

54. The one illustrated is in the Benaki Museum, inv. no. 1556. See Higgins (note 2), pl. 52B; Segall (note 1), no. 36. Diameter, 11.1 cm.

55. Davidson and Hoffmann (note 1), no. 124, pp. 266-270, pl. VII and figs. 124a-c.

56. V. Canarache, *The Archaeological Museum of Constantza* (Constanta, 1967), 39.

57. For example, *The Search for Alexander* (note 7), no. 66, p. 136 and pl. 10.

58. See "Review of the Year 1958-1959," *BMMA 18* (1959), 30, 34-36; and "Greek, Roman, and Etruscan Jewelry," *BMMA 24* (1965-1966), 279.

59. Higgins (note 2), pl. 50B; Davidson and Hoffmann (note 1), 159. Length, 6.8 cm.

60. *The Search for Alexander* (note 7), no. 90, p. 149 and pl. 13.

61. Miller (note 1), pl. 26.

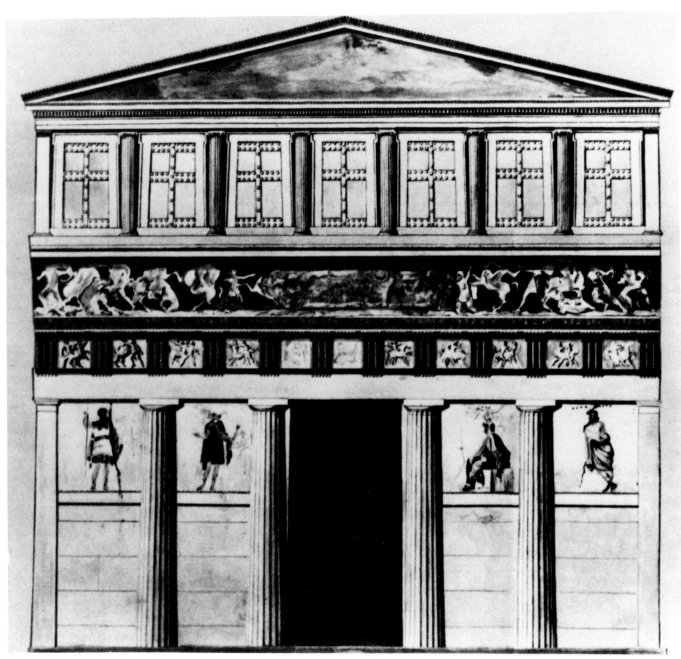

Fig. 3. Lefkadia Great Tomb, reconstruction of façade (photo: Ph. M. Petsas).

Macedonian Tombs:
Their Architecture and Architectural Decoration

STELLA G. MILLER

Department of Classics, Stanford University

A MACEDONIAN TOMB BY DEFINI-
TION is a built chamber tomb with a
barrel-vaulted roof. This structure,
which was sometimes built par-
tially underground, was subse-
quently covered by an artificial
earth tumulus.[1] The Macedonian
type of tomb makes its first ap-
pearance sometime well along in
the course of the fourth century
B.C.[2] Although it is most probably
indebted to Near Eastern proto-
types, the final product, the Mace-
donian tomb as we know it, was
surely the creation entirely of Mac-
edonian architects.[3] Once intro-
duced, the Macedonian tomb co-
existed with other forms of burial
structures such as cist graves and
rock-cut tombs of various sorts.[4]

Of the fifty or so known Mace-
donian tombs (a number which is
steadily increasing) fewer than
twenty percent can be dated to the
fourth century.[5] The majority ap-
pear to date to the third and second
centuries although it must be
noted that dating with any degree
of precision is only rarely possi-
ble.[6] Whatever the date, this type of
tomb must at all times have been
reserved for only the wealthiest of
the Macedonian aristocracy.

Among Macedonian tombs
there are many variations. In plan,

the burial chamber can be square
or rectangular with dimensions
running from a small scale of un-
der two meters by nearly three
meters on a side, up to a large scale
of approximately four and a third
by nearly four and three-quarter
meters.[7] The burial chamber is
often, but not always, accompa-
nied by a smaller forechamber
whose dimensions and scale with
regard to the burial chamber fol-
low no set pattern.[8] Examples of
the relationship of these two cham-
bers can be seen in Figures 1 and 2,
which reproduce cross sections
through two tombs which will be
of further interest below: an early
third-century Ionic tomb found at
Vergina in 1938 (Fig. 1)[9] and the so-
called Great Tomb at Lefkadia of
later fourth-century date (Fig. 2).[10]
Finally in terms of plan, a passage-
way or dromos was sometimes
built to serve as an approach to the
tomb.[11]

Interior walls may be decorated
in one of several different ways.
Usually they have painted and
sometimes incised zones which are
occasionally interrupted by deco-
rated bands. The interior decora-
tion of the Ionic tomb at Vergina,
visible in the section in Figure 1, is
typical.[12] However, much more

elaborate interior decoration is also
known, most notably in the fore-
chamber of a tomb at Dion dating
perhaps as early as the late fourth
century[13] and in the burial chamber
of the roughly contemporary
Great Tomb at Lefkadia.[14] The
former has a thus far unique ar-
rangement consisting of an en-
gaged Ionic order in stone with
heart-shaped columns in the cor-
ners (a capital appears in Fig. 10).[15]
The walls of the burial chamber of
the Lefkadia Tomb, on the other
hand, are provided with an Ionic
order rendered in stucco: pro-
jecting pilasters with Ionic capitals
and entablature placed above a
plain stuccoed wall, an arrange-
ment clearly visible in Figures 2
and 4.[16]

The burial chamber is some-
times furnished with one or more
funerary couches, in a few in-
stances with thrones (one in the
Vergina Tomb appears in Figs. 1
and 9), and occasionally with
chests or stands for them.[17] Most
Macedonian tombs discovered in
the past have been pillaged either
entirely or in part. In the relatively
few instances in which small finds
have been discovered associated
with their burials, the objects have
been of familiar but modest types:

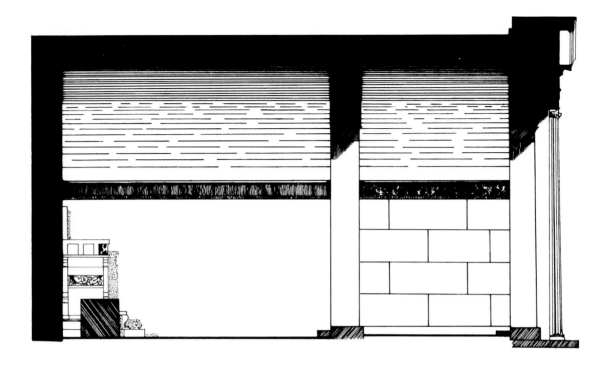

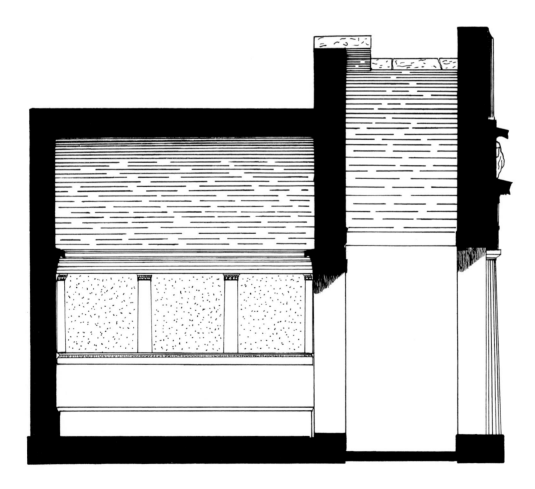

Top: Fig. 1. Vergina Tomb,
cross section (after K. A.
Rhomaios, Ὁ Μακεδονικὸς
Τάφος τῆς Βεργίνας
[Athens, 1951], fig. 6).

Bottom: Fig. 2. Lefkadia
Great Tomb, cross section
(after Ph. M. Petsas, Ὁ
Τάφος τῶν Λευκαδίων
[Athens, 1966], fig. 3).

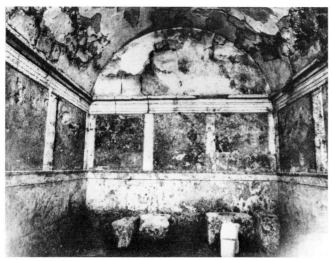

Fig. 4. Lefkadia Great Tomb, view into burial chamber (after Ph. M. Petsas, Ὁ Τάφος τῶν Λευκαδίων [Athens, 1966], pl. 21).

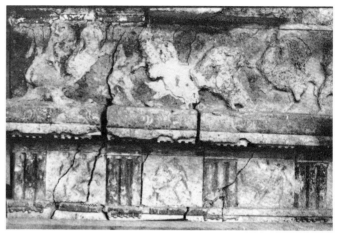

Fig. 5. Lefkadia Great Tomb, detail of façade (after Ph. M. Petsas, Ὁ Τάφος τῶν Λευκαδίων [Athens, 1966], pl. 29a).

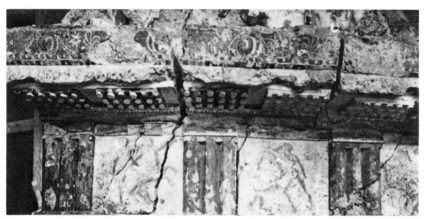

Fig. 6. Lefkadia Great Tomb, detail of façade (after Ph. M. Petsas, Ὁ Τάφος τῶν Λευκαδίων [Athens, 1966], pl. I'1).

pottery, jewelry, weapons, terracotta figurines, and the like.[18] The extraordinarily rich (and unlooted) tombs of the Great Tumulus at Vergina have now brought to light an assortment of lavish outfittings which are unique both in quality and in quantity.[19]

After this brief introduction to Macedonian tombs in general we can now consider one aspect of this type of tomb, namely the decorative (as opposed to the functional) character of its architecture.

The simplest kind of Macedonian tomb façade is unarticulated and plain, pierced only by a doorway with its lintel. An example is a tomb near Lefkadia dating to the second half of the third century, the so-called Tomb of Lyson and Kallikles (Fig. 25, Pl. 1) which will be discussed in greater detail below. This variety of Macedonian tomb had a long life throughout the Hellenistic period. Standing in sharp contrast to this austerity are those tombs which will now be of concern: tombs which have an engaged architectural order carved in stone and applied across their façades.[20] One such is the Ionic tomb

at Vergina which, as noted above, probably dates to the beginning of the third century.[21] The tomb when viewed from straight ahead, as in Figures 7 and 8, gives the impression of being a small tetrastyle prostyle temple, complete from its column bases to the pediment. The architect of the Vergina Tomb, like his colleagues working on other tombs of similar type, produced a monument which gave the illusion (but only the illusion) of being a freestanding architectural entity.[22] This illusion of a real building is, however, spoiled from any view but a directly frontal one. The cross section of the tomb (Fig. 1) clearly shows that the façade is just that; a façade applied in a decorative manner to a wall.

The Doric order is employed in the same manner as the Ionic tomb façades. An example is a tomb discovered at Haghios Athanasios, a monument which probably dates to the beginning of the third century (Figs. 12 and 13).[23] No Macedonian tombs of Corinthian order are known[24] but a striking combination of Doric and Ionic used together appears on the Great Tomb

Fig. 7. Vergina Tomb, reconstruction of façade (after K. A. Rhomaios, Ὁ Μακεδονικὸς Τάφος τῆς Βεργίνας [Athens, 1951]).

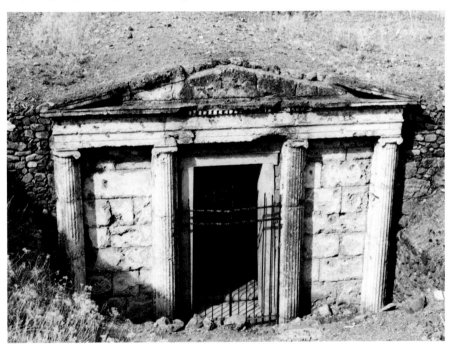

Fig. 8. Vergina Tomb, façade.

at Lefkadia the date of construction of which must lie in the later fourth century (Fig. 3).[25] On it the Doric order in the lower half of the façade is separated by means of a large frieze with stuccoed relief figures from the Ionic order which forms its second story. The series of what may be either doors or windows in the Ionic intercolumniations are nonfunctional and purely decorative, a fact which becomes immediately apparent in a cross section (Fig. 2). This, then, is part of a fundamental and pervasive characteristic of Macedonian tombs: the façade (as a whole as well as in many of its details) serves an ornamental rather than a tectonic function.[26] We realize that the façade is applied without reference to the structural elements which lie behind, and indeed, the ingenious barrel-vaulted roofing system is completely and intentionally masked by this means.[27] Furthermore, as we have seen, this façade deliberately misleads the viewer into thinking of the structure as something other than what it really is. In other words, it creates an illusion.[28]

What I intend to show in the next few pages is the kind of development which takes place within Macedonia once the principle of the use of architectural decoration to create an illusion has been established, as it clearly has by the late fourth century. Once such a principle has been accepted, it is only logical to exploit its decorative character. In order to trace this development, we must first briefly note certain characteristics of the Macedonian architectural style.

We know remarkably little about pre-Hellenistic Macedonian architecture[29] but in about the middle of the fourth century Macedo-

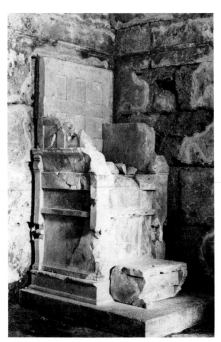

Fig. 9. Vergina Tomb, throne in burial chamber.

nia appears to have been the recipient of a new wave of architectural influence.[30] The resulting style which permeates Macedonia in the Hellenistic period seems clearly to derive from the great architectural centers of Greece, especially Athens and the Peloponnesus. This style, moreover, owes its character not only to sources of different geographical origin[31] but also to various chronological stages within those several sources.[32] Such eclecticism in itself implies a lack of tradition in the canonically accepted system of architectural principles from which it borrowed so freely. To be sure, experimentation and innovation were standard practices in the major Greek architectural centers, but there the approach was still bound by a framework of traditional principles; proportions might be altered and embellishments added or omitted, but such modifications never jeopardized the conventions

of a fundamentally structural approach. The Macedonians, however, evidently unfamiliar with these particular traditions, recognized few constraints. It is this factor, I believe, which is at the root of the Macedonian approach to architecture, which tends to emphasize the decorative at the expense of those established and canonical principles derived from an ultimately functional concept of architecture and its ornamentation. We must now examine a few specific ways in which these characteristics manifest themselves.

It is typical of Macedonian architecture to dispense with a number of the basic rules or guidelines which seem normally to have governed Greek architecture elsewhere. Among these rules are those dealing with proportions, distribution and placement of the different architectural members, and the profiles and decoration of those members.

Space permits only a few examples to illustrate. We have already seen that full, canonical engaged colonnades can appear on tomb façades. Columns are often placed in such a way as to suggest a prostyle arrangement (as on the Vergina Tomb, Figs. 7 and 8) or sometimes, when the outermost columns are replaced by pilasters, they are supposed to suggest a building in antis (as on the Lefkadia Great Tomb, Fig. 3). These arrangements may be constrasted with the situation on certain tombs which reduce the colonnade to a pair of columns (as on the Haghios Athanasios Tomb, Figs. 12 and 13) or a pair of pilasters (as on a tomb in Thessalonike, Fig. 14)[33] placed at the outer edges of the façade. In each instance the door jambs are made to stand for the missing central columns. The

reflective viewer will realize that this represents a structural impossibility: the frieze above could never have been physically supported if this were a freestanding order in the round rather than an engaged façade. This kind of treatment is further abbreviated on certain tombs where the colonnade is reduced to a pair of engaged pilasters which flank the doorway. Examples are a Doric tomb dating well into the third century at the Haliakmon Dam (Figs. 15 and 16)[34] and the so-called Kinch Tomb near Lefkadia of late third- to early second-century date (Figs. 17 and 18).[35] With this sort of treatment of the architectural order we are departing from the appearance of structural reality. The eye of the viewer is supposed to gain the *impression* of real architecture, but he is not supposed to think things through to their logical conclusion.

A radical step further away from reality is taken on another Ionic tomb at Vergina, the so-called Palatitsa Tomb. It is now completely destroyed but was fortunately recorded in a series of drawings made by the nineteenth-century travelers L. Heuzey and H. Daumet.[36] One of these is reproduced in Figure 24. I suspect on the basis of their drawings of mouldings that the tomb may date to the later third century.[37] What is so striking here (Fig. 24) is that although the superstructure of the façade looks normal (with epistyle, dentils, and geison) something is distinctly lacking below: in the drawing the pilaster capitals are shown as being fully carved in relief, but the area beneath—where relief pilasters should appear—must have been simply painted on the flat stuccoed surface so indicated on the draw-

Fig. 10. Dion Tomb, detail in corner of forechamber.

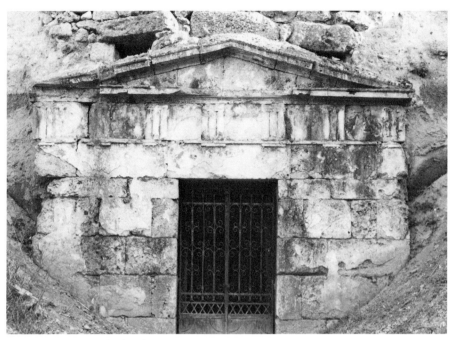

Fig. 11. Dion Tomb, façade.

ing. This is a kind of illusionism, a mixture of real and imitative, of plastic three-dimensionality and trompe l'oeil.

A different treatment of the architectural order appears on a number of Doric tombs which simply employ the entablature and omit any suggestion of columns or pilasters altogether. An example is the late fourth-century tomb at Dion (Fig. 11).[38] In these instances the entablature serves merely to crown a plain wall interrupted only by the entrance door.

A rather more casual use of the entablature appears on another group of tombs which, like the last group, omits columns beneath the upper order. Here, however, instead of tailoring the triglyph-metope frieze to end properly with a triglyph at each side (as on the Dion Tomb, Fig. 11), the architect allows the frieze to end abruptly in a truncated metope. Illustrations include the Kinch Tomb (Figs. 17

and 18) and the roughly contemporary Pydna Tomb of which we see a drawing by Heuzey and Daumet (Fig. 19) as well as a detail of the much-defaced upper right corner (Fig. 20).[39] This sort of arrangement is, of course, completely heretical to Greek architecture.[40] The frieze is further abbreviated on the Tomb at the Haliakmon Dam where it is cropped to such a degree as to act simply as an exaggerated lintel above the wide doorway (Figs. 15 and 16). The architectural order is being treated like a kind of prefabricated repeating border motif, of which any desired length can be extracted to crown a wall or part of it.

Yet another indication of the essentially decorative character of this type of architecture concerns the mouldings which set off and embellish major architectural divisions. The rules governing mouldings and their usage are, of course, fairly precise and well established

by tradition within the classical period.[41] Both the type of moulding to be used in a particular spot and the ornamentation on it (carved or painted) are regulated by tradition. Another of the basic tenets of mouldings, it will be remembered, is that their frontal decorative surface should echo the three-dimensional profile.

These traditional architectural principles are regularly violated in Macedonia. A few examples will illustrate. On the Doric order of the Great Tomb at Lefkadia the bed moulding of the geison is painted with a Lesbian leaf, very properly for a Doric moulding in this position (Fig. 6). But the profile, instead of taking the form of the normal double-curved cyma reversa, is a single-curved ovolo (Fig. 22).[42] A related use of paint to suggest something not substantiated by the profile it covers is even more radical: on the Pydna Tomb (according to the drawing of Heuzey and

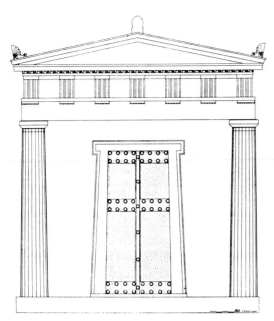

Fig. 12. Haghios Athanasios Tomb, reconstruction of façade (after *Makedonika 15* [1975], 179, fig. 25).

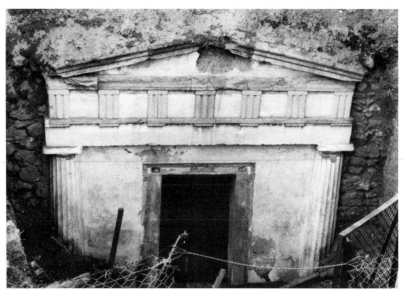

Fig. 13. Haghios Athanasios Tomb, façade.

Daumet, Fig. 21) a bead-and-reel motif was painted on the fascia at the top of the triglyph. Yet the surface on which this motif appears is not the proper half-round demanded by the implied curve of the painted motif, but simply a flat surface. Furthermore, the location of this painted motif (and hence the implied location of the moulding) halfway down the fascia indicates that its architectural significance as a defining element has not been grasped; it is employed solely for its decorative effect. The correct location and morphology of the moulding in question can be seen on a detail of the triglyph-metope frieze of the Vergina Palace (Fig. 23).[43] Another example of the use of paint to suggest the third dimension is found on the dentil course in the burial chamber of the Lefkadia Great Tomb. Here, in place of the proper individually cut dentils (seen correctly rendered on the façade of the Vergina Tomb, Fig. 8),

there is simply a series of painted dentils on a continuous straight fascia (Figs. 2 and 4).[44] This treatment illustrates the development of another kind of trompe l'oeil which tends to substitute paint on a simplified or even a flat surface for a canonical or three-dimensional element.

A curious and very telling example involving such substitution, but in quite a different way, is again on the Great Tomb at Lefkadia. The large frieze which separates the two architectural orders on the façade features a battle scene rendered in relief stucco, therefore projecting forward (Fig. 3 and detail, Fig. 5). But just below in the metopes are flat, two-dimensional painted representations of a centauromachy, representations which are provided with ample shading to suggest projection in relief. That is to say, the metopes are supposed to create the illusion of relief sculpture by means of paint.

Here then, is a striking combination of plastic reality and painted illusion on one and the same building.[45]

The preceding has involved a somewhat detailed examination of minutiae whose purpose, however, was to establish a pervasive tendency in Macedonian architecture. Now it will be useful briefly to introduce a few examples of freestanding architecture, public monuments with close Macedonian associations. These will, I believe, help document those tendencies in a broader spectrum of the Macedonian architectural style since it is obvious that the tombs discussed so far were not readily (if at all) accessible to the public eye.

First we may note the decorative use of engaged columns or pilasters above a podium or high wall. An outstanding example is the Philippeion at Olympia built by Philip II after the Battle of Chaeronea in 338 B.C. and, at least in my

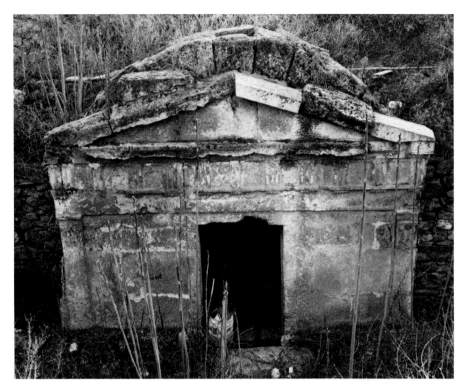

Fig. 14. Thessalonike Tomb, façade.

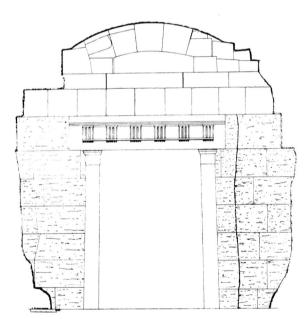

Left: Fig. 15. Haliakmon Dam Tomb, reconstruction of façade (after *Makedonika 15* [1975], 295, fig. 62).

Right: Fig. 16. Haliakmon Dam Tomb, façade.

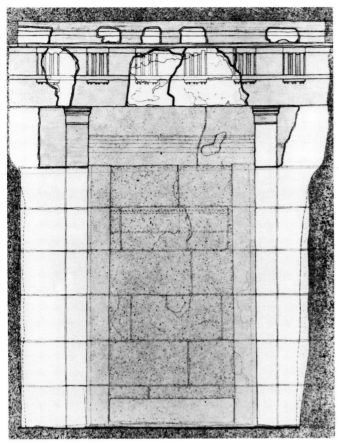

Fig. 17. Kinch Tomb, reconstruction of façade (after *ArchEph* [1971], 152, fig. 4).

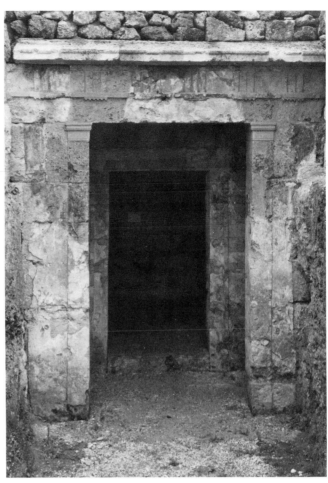

Fig. 18. Kinch Tomb, façade.

opinion, almost certainly the work of a Macedonian architect.[46] On its interior, which housed portrait statues of Philip and his family, there was a strictly decorative use of engaged Corinthian half-columns resting on a podium; these columns support nothing at all.[47] We see a similar arrangement on the Arsinoeion dedicated in the 280s at the Sanctuary of the Great Gods on Samothrace by Arsinoe while she was still wife of King Lysimachus. It features a decorative order of pilasters high up on the outside and an equally decorative but nonfunctional row of Corinthian half-

columns in the same position on the inside.[48]

Next we can note the stuccoed version of the same kind of arrangement inside the late fourth-century Hieron also on Samothrace.[49] Here a stuccoed engaged architectural order is placed high up on the wall in much the same manner as that in the interior of the Great Tomb at Lefkadia.[50] Finally, there is a structure nearly contemporary with both the Samothracian Hieron and the Lefkadia Great Tomb which provides a striking illustration of a truly decorative façade standing in open air.

This is the Gateway of Zeus and Hera on Thasos in its remodeled phase dating to the last quarter of the fourth century.[51] This remodeling provided the gateway with a stone-built façade of two superimposed orders, Ionic above Doric, which was applied to the surface of the city wall.[52] It thus bears an arresting similarity to the façade of the Lefkadia Great Tomb (cf. Fig. 3), a relationship whose significance has been discussed by R. Martin.[53] This type of essentially ornamental architecture is the ancestor of a long line of such façades in the Hellenistic period.[54]

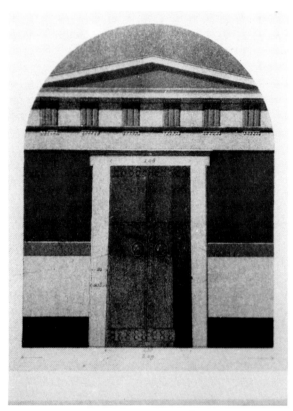

Fig. 20. Pydna Tomb, detail of upper right corner of façade.

Fig. 19. Pydna Tomb, reconstruction of façade (after L. Heuzey and H. Daumet, *Mission archéologique de Macédoine* [Paris, 1876], pl. 18).

Fig. 21. Pydna Tomb, drawing of detail of triglyph-metope frieze (after L. Heuzey and H. Daumet, *Mission archéologique de Macédoine* [Paris, 1876], pl. 18).

We can summarize some of the tendencies outlined above. The Macedonians had a predilection for funerary façades intended to create an illusion of being something other than what they are. Secondly, their architects tended to treat individual elements within these façades like optional motifs to be applied, abbreviated, or omitted altogether. And thirdly, architects experimented and interchanged combinations of real stone architectural members with stuccoed elements and their imitations in paint to such an extent that the line between architecture and painting began to blur. The next logical step in such an architectural idiom is what we know in the Roman world as the Second Style of wall painting.[55] By that we refer to the basically illusionistic kind of painting which seeks by means of an architectural framework to suggest a three-dimensionality or an opening up of space on what in reality is a flat wall surface.

That this perfectly logical next step was, in fact, taken in Macedonia is shown by the Tomb of Lyson and Kallikles near Lefkadia.[56] Although discovered in 1942, this tomb has only recently become widely enough known through still preliminary reports to enter into serious discussions of ancient architecture and architectural painting.[57] The tomb takes its name from the first two deceased members of a family headed by an otherwise unknown man by the name of Aristophanes. The two brothers Lyson and Kallikles must have died sometime in the second half of the third century as is suggested by ceramic evidence and the style of lettering which produced

Fig. 22. Lefkadia Great Tomb, profile of Doric geison (after Ph. M. Petsas, ʿΟ Τάφος τῶν Λευκαδίων [Athens, 1966], fig. 21).

Fig. 23. Vergina Palace, detail of triglyph-metope frieze.

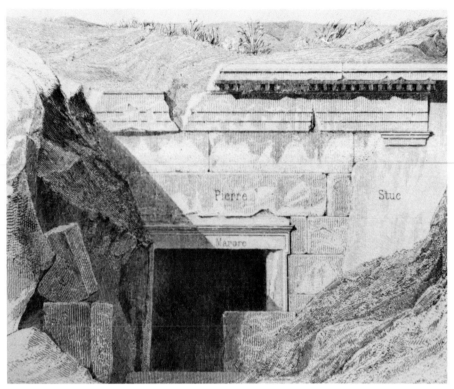

Fig. 24. Palatitsa Tomb, reconstruction of façade (after L. Heuzey and H. Daumet, *Mission archéologique de Macédoine* [Paris, 1876], pl. 15).

their painted names.[58] The ashes of the two brothers, along with those of a third brother who presumably died later, were placed in niches along the wall opposite the doorway (Fig. 28). Their respective wives were buried below them and remains of their descendants were placed in appropriate niches along the two side walls (Figs. 29 and 30). The military gear painted in the lunettes suggests the family must have distinguished itself in a military capacity. Historically, however, nothing is otherwise known of any of them.

We turn to details. The orthostates are incised in the plaster and painted to resemble veined marble ashlar masonry (cf. Figs. 27 and 28). The square pilasters and capitals, painted in three-quarter view, take the doorway as a focal point and rotate in perspective with re-

gard to it (Fig. 27). Depth is indicated on the pilasters and on the underside of the architrave and mutules by shading and perspective lines.

A continuous garland appears to swing freely from pilaster to pilaster. On the walls behind them there is no indication of any termination of depth (there being no "coursed masonry" at this level) so one's eye is not focused on any particular plane in space. In the lunettes, on the other hand, a very specific plane in space is indicated (Figs. 27 and 28). The armor, of course, demands an implied depth equal to its own size, but the hanging gear (the shields and swords) suggests the existence of a solid wall recessed something like a meter or so (our mind tells us) from the front edge of the architrave.

The interest of our architect-

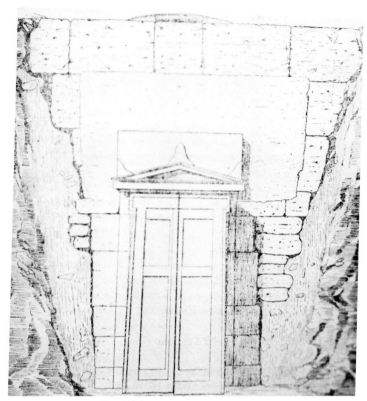

Fig. 25. Lyson and Kallikles Tomb, reconstruction of façade (after *Makedonika 2* [1941-1952], 635, fig. 12).

Fig. 26. Lyson and Kallikles Tomb, detail of altar on west wall of forechamber (photo: Sp. Tsavdaroglou).

painter in creating a spatial illusion is nowhere more clearly evident than in the tiny forechamber which is so narrow a person can only barely pass through.[59] On entering this forechamber, one sees on the walls to the left and right, respectively, an altar and a perirrhanterion.[60] We may note particularly the radical perspective rendering of the altar (Fig. 26) which is supposed to suggest much greater space than actually exists in these confined quarters.

The principle of creating an illusion of spatial recession by means of an architectural order treated in perspective is thus firmly fixed in Hellenistic Macedonia. I think it need hardly seem surprising that such a style of architectural painting should have evolved as a sub-

stitute for real architecture in this particular area. Indeed, I think it is precisely in such a region as Macedonia which placed such emphasis on domestic and funerary display that we should actually *expect* a development of this nature.

We must, of course, ask what relation this material bears to wall painting of the Roman era. No aspect of the complex study of Roman wall painting has caused more controversy than the question of the origin of the Second Style, as is witnessed by the steady stream of scholarly writings on the subject.[61] Macedonia is now rightly entering into the realm of possible candidates for the source of this style with the recognition of the significance of the Tomb of Lyson and Kallikles. The role, direct or indi-

rect, it may play in this matter goes beyond the scope of this paper[62] but a few general observations on the subject are, I believe, appropriate in this context.

It is evident that there exists an awkward gap of well over a century between the construction of the Lyson and Kallikles Tomb and the earliest known appearance of the Second Style in the Roman world.[63] The seriousness of this problem cannot be glossed over despite certain obvious parallels which can be drawn between specific Roman paintings on the one hand and Hellenistic Macedonian façades and wall paintings on the other.[64] However, it is almost inevitable that other pertinent monuments dating to the chronologically vital middle Hellenistic era

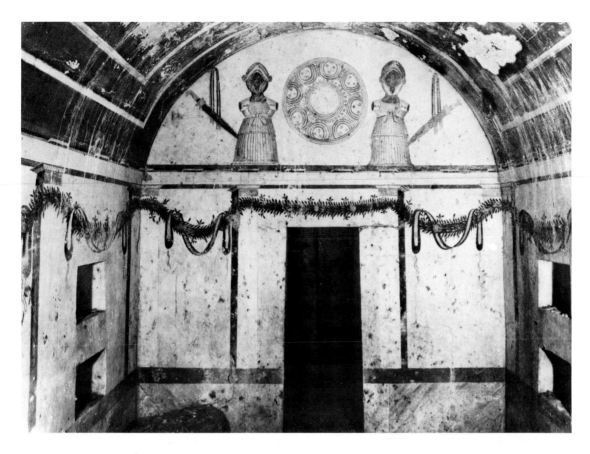

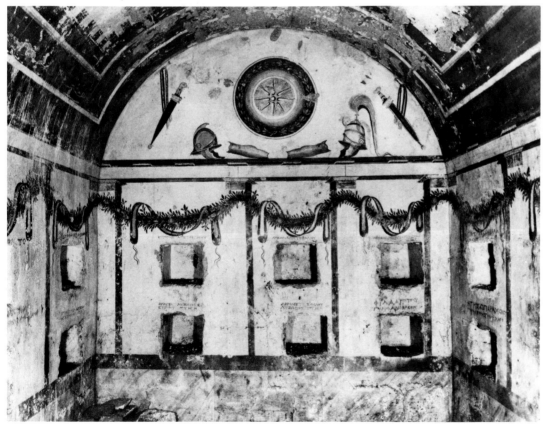

Top: Fig. 27. Lyson and Kallikles Tomb, south wall of burial chamber (photo: Sp. Tsavdaroglou).

Bottom: Fig. 28. Lyson and Kallikles Tomb, north wall of burial chamber (photo: Sp. Tsavdaroglou).

Fig. 29. Lyson and Kallikles Tomb, west wall of burial chamber (photo: Sp. Tsavdaroglou).

Fig. 30. Lyson and Kallikles Tomb, east wall of burial chamber (photo: Sp. Tsavdaroglou).

will yet be discovered not only in Macedonia but also in Alexandria, Rome, and elsewhere, which will substantially increase our understanding of the character of the period and perhaps help fill in the chronological void. On the other hand, I also believe that we must recognize the significant role played by readily portable but ephemeral vehicles in the form of easel paintings and copy books.[65] Such media surely circulated widely in the Hellenistic period and will have performed an important function in the widespread stylistic *koinē* which ultimately found an outlet on Roman walls in the multitude of foreign elements (Greek, Egyptian, and otherwise) which seem so at home in that context. Thus, although I suspect new discoveries may well shed new light on the problem of the sources of painting styles, I also believe that we have to think in terms of a highly sophisticated and clearly interrelated later Hellenistic world in which the old sharply defined regional lines no longer existed. Therefore, although innovators of

trends and styles may sometimes be suspected (and certainly at present the Tomb of Lyson and Kallikles stands out as the earliest dated monument with its particular kind of decoration) many aspects concerning the subject of origin and transmission of motifs from one region to another may perhaps never be fully understood.

With regard to Macedonia's role in all of this, two conclusions can validly be drawn at this point: first, the illusionistic style of architectural painting evidently did actually develop independently in that region; and second, given Macedonia's historical role, this style, once developed, *could* easily enough have diffused from there. What I have attempted to demonstrate in the preceding pages is simply how this style of painting evolved in Macedonia and, most especially, why it was the direct (and, I would maintain, almost inevitable) outcome of certain tendencies characteristic of Macedonian architecture and particularly of Macedonian funerary architecture.

Notes

It is a pleasure to express gratitude and indebtedness to the Greek Archaeological Service and to the numerous colleagues who have helped me in many different ways over the years in studying Macedonian architecture. I mention particularly the following: M. Andronikos, G. Bakalakis, the late Ch. I. Makaronas, L. T. S. Meritt, Stephen G. Miller, D. Pandermalis, Ph. M. Petsas, K. Rhomiopoulou, B. S. Ridgway, M. K. Siganidou, I. Touratsoglou, and C. K. Williams II.

Photographs, where not otherwise credited, are the author's. Special recognition should go to the late Sp. Tsavdaroglou for his superb photographs of the Lyson and Kallikles Tomb, Figures 26-30.

1. An excellent illustration of the appearance of the Macedonian tomb with its tumulus has been made readily available by M. Andronikos in "Vergina: The Royal Graves in the Great Tumulus," *AAA 10* (1977), 55, fig. 22, and in Nicholas Yalouris, Manolis Andronikos, and Katerina Rhomiopoulou, *The Search for Alexander,* exh. cat. (Boston, 1980), 29, fig. 12. On Macedonian tombs in general see D. C. Kurtz and J. Boardman, *Greek Burial Customs* (London, 1971), 273-282; A. K. Orlandos, Τὰ Ὑλικὰ Δομῆς τῶν Ἀρχαίων Ἑλλήνων (Athens, 1958), I, ii, figs. 372-396; S. G. Miller, "Hellenistic Macedonian Architecture: Its Style and Painted Ornamentation" (Ph.D. diss., Bryn Mawr, 1971); D. Pandermalis, "Ὁ Νέος Μακεδονικὸς Τάφος τῆς Βεργίνας," *Makedonika 12* (1972), 147-182, especially 176-182; and, most recently, B. Gossel, *Makedonische Kammergräber* (Ph.D. diss., Munich, 1979; published Berlin, 1980).

2. The new excavations being undertaken by Professor Andronikos and his associates at the Great Tumulus of Vergina may provide the earliest datable Macedonian tombs. Mr. Andronikos, who has so generously shared his discoveries in preliminary stages of study, dates Tomb II to the third quarter of the fourth century (summarized in *AAA 10* [1977], 70-72). He is currently dating Tomb III to the same period, probably a little after Tomb II (information gratefully received by letter of 4 May 1981). On Tomb III see his preliminary report in *The Search for Alexander* (note 1), 37-38.

3. Asia Minor and Anatolia apparently played an important role in the development of the tomb type. Cf. most recently Pandermalis (note 1), 177; Kurtz and Boardman (note 1), 277-297; and Gossel (note 1), 10-12, 29, 69-73, on the problem. The recent suggestion by several scholars that Alexander's engineers brought the vaulting technique to Greece from the Near East will have to be reconsidered in light of the new discoveries at Vergina (cf. T. D. Boyd, "The Arch and the Vault in Greek Architecture," *AJA 82* [1978], 83-100, and R. A. Tomlinson, "Vaulting Techniques of the Macedonian Tombs," *Archaia Makedonia*, II [Thessalonike, 1977], 473-479). See recent comments on this issue by E. A. Fredricksmeyer, "Again the So-called Tomb of Philip II," *AJA 85* (1981), 333-334, and W. M. Calder III, "Diadem and Barrel-Vault: A Note," *AJA 85* (1981), 334-335. Finally, see M. Andronikos, "The Royal Tomb at Vergina and the Problem of the Dead," *AAA 13* (1980), esp. 173-177.

4. Outstanding cist graves include those of Sedes (N. Ch. Kotzias, "Ὁ παρὰ τὸ ἀεροδρόμιον τῆς Θεσσαλονίκης [Σέδες] Γ΄. Τάφος," *ArchEph* [1937], 866-895); Derveni (Ch. I. Makaronas, "Τάφοι παρὰ τὸ Δερβένι Θεσσαλονίκη, *Deltion 18*, B2 [1963], chron. 193-196, pls. 223-234); and Vergina (M. Andronikos, *AAA 10* [1977], 4-5, figs. 1-2). On rock-cut tombs see an outstanding group at Beroia (S. Drougou and I. Touratsoglou, Ἑλληνιστικοὶ Λαξευτοὶ Τάφοι Βεροίας [Athens, 1980], especially 107-114). There is also a special type of rock-cut tomb in Macedonia with architectural façade known from examples

at Siderokastro (*Deltion 22*, B2 [1967], chron. 427, pl. 313 c,d, and "Archaeological Reports," *JHS 89* [1969], 25, fig. 26) and an unpublished tomb at Marina, discovered by M. K. Siganidou as noted by Drougou and Touratsoglou, 114.

5. For catalogues of Macedonian tombs see Pandermalis (note 1), 177-182 (including dimensions and plans of many tombs in three foldout plates), and Gossel (note 1), 77-272 (with a more detailed discussion of each tomb). Several more recently discovered but still unpublished tombs must now be added to the list.

6. The pillaging of most tombs has left few criteria for dating them other than stylistic grounds. Pandermalis (note 1), 176, has attempted a chronological sequence for certain of the tombs. I differ with some of his datings (as will emerge in subsequent footnotes) but agree with him concerning the weakness of Rhomaios' theory of dating on the basis of the position of the circle inscribed by the vault within the chamber (K. A. Rhomaios, Ὁ Μακεδονικὸς Τάφος τῆς Βεργίνας [Athens, 1951], 18). My own basis for dating relies on the proportions and morphologies of architectural elements with only a few exceptions where independent evidence could be brought to bear. The methodology was undertaken with great awareness of its limitations and pitfalls. Gossel, who has more recently synthesized the evidence of material and scholarship, provides a chronological outline (not always adequately argued) which tends, with a few notable exceptions, to agree with my own as will be seen below.

7. See Pandermalis (note 1), 177-182.

8. See plans in Pandermalis (note 1), between pp. 176-177 and discussion by Gossel (note 1), 30-37.

9. The Vergina Tomb was published by K. A. Rhomaios (note 6), who dated it to the first half of the third century (48-49). Pandermalis (note 1), 176, suggests around 300; Gossel (note 1), 259, suggests late fourth century. For my dating in the early third century see Miller (note 1), 104-107.

10. Published by Ph. M. Petsas, Ὁ Τάφος τῶν Λευκαδίων (Athens, 1966), who dated it after 300 (179) but in verbal discussion now agrees with a late fourth-century dating; Pandermalis (note 1), 176,

suggests around 300; Gossel (note 1), 169, places it in the late fourth or very early third century; for my dating in the late fourth century see Miller (note 1), 102-104.

The paintings of this tomb have recently been discussed by M. Robertson, *A History of Greek Art* (Cambridge, 1975), 568-571; V. J. Bruno, *Form and Color in Greek Painting* (New York, 1977), 23-30 (and see critique by V. von Graeve, "Zum Zeugniswert der bemalten Grabstelen von Demetrias für die griechische Malerei," *La Thessalie,* Symposium Lyon 1975, Collection de la maison de l'orient méditerranéen 6, *Arch.* 5 [Lyon, 1979], 126-128); and V. J. Bruno, "The Painted Metopes at Lefkadia and the Problem of Color in Doric Sculptured Metopes," *AJA 85* (1981), 3-11.

11. E.g., a fourth-century tomb at Eretria (K. G. Vollmoeller, "Uber zwei euböische Kammergräber mit Totenbetten," *AthMitt 26* [1901], 339, fig. 2) and a late third- to early second-century tomb at Pydna (L. Heuzey and H. Daumet, *Mission archéologique de Macédoine* [Paris, 1876], pl. 18). The Pydna Tomb is exceptional in that it includes an additional small antechamber between the dromos and the façade, as can be seen on the plan of Heuzey and Daumet. On the Pydna Tomb see also note 39.

12. For a color reproduction of the decorative band in the forechamber of the Vergina Tomb see Rhomaios (note 6), pl. 2 bottom. Cf. also Tomb II at Vergina (*AAA 10* [1977], 55, fig. 22). A summary chart of painted wall decoration (on monuments known up to 1970) appears in Miller (note 1), 169-174; see now also discussion by Gossel (note 1), 39-50

13. G. Soteriades, "Ἀνασκαφαὶ ἐν Δίῳ. Ὁ Καμαρωτὸς Τάφος," *Πανεπισ. Θεσσ. Φιλοσοφ. Σχολ. Ἐπισ. Ἐπετ.* 2 (1932), 5-19 (see also plan in Pandermalis [note 1], foldout plan 3). Soteriades dated the tomb to 300 or earlier (p. 7). Ch. I. Makaronas dated it no earlier than the mid-third century ("Ἀνασκαφὴ 'Μακεδονικοῦ' Τάφου Καρύτσας," *Praktika* [1955], 158-159); Pandermalis (note 1), 176, indicates the third century; Gossel (note 1), 124, and Miller (note 1), 99-101, suggest the end of the fourth century. See also comments by J. Boardman who, in connection with discussion of a painted border motif in the tomb, accepts the third century as a *terminus ante quem* ("Travelling Rugs," *Antiquity 44* [1970], 143-144).

14. On the dating of the Great Tomb see note 10.

15. See plan in Pandermalis (note 1), foldout plan 3; for the upper wall see illustrations of a corner of the forechamber in Soteriades (note 13), 6, fig. 1, and S. G. Miller, "The Philippeion and Macedonian Hellenistic Architecture," *AthMitt 88* (1973), pl. 86,3. On heart-shaped columns (or piers) see J. J. Coulton, "The Treatment of Reentrant Angles," *BSA 61* (1966), 137-141. Coulton (137) attributes the invention of the heart-shaped pier to Ionia.

16. See Petsas (note 10), 45-54, on the interior chamber.

17. See Gossel (note 1), 55-63, on tomb furniture. On the Vergina throne see H. Kyrieleis, *Throne und Klinen, JdI-EH 24* (1969), 156, no. 41.

18. On grave gifts see most recently Gossel (note 1), 64-68.

19. See Andronikos, *AAA 10* (1977), 1-72; *Treasures of Ancient Macedonia,* exh. cat. (Thessalonike, 1978), 48-57; and *The Search for Alexander* (note 1) with appropriate catalogue entries.

20. On tomb façades see Gossel (note 1), 22-29; H. H. Büsing, *Die griechische Halbsäule* (Wiesbaden, 1970), 23-25; and D. Pandermalis, "Beobachtungen zur Fassadenarchitektur und Aussichtsveranda im hellenistischen Makedonien," *Hellenismus in Mittelitalien* (Kolloquium in Göttingen, June 1974), *Abhandlungen der Akademie der Wissenschaften in Göttingen,* Philologisch-Historische Klasse, folio 3, 97 (1976), 387-395.

21. On the chronology of this tomb see note 9.

22. The question of the relationship of architectural façades of Macedonian tombs to freestanding architecture has been discussed with no unity of opinion. The resemblance of these façades to temples has been noted by Rhomiopoulou (*The Search for Alexander* [note 1], 25) and Rhomaios (note 6), 20. Petsas has emphasized the relationship of the façade of the Great Tomb at Lefkadia to domestic architecture (Petsas [note 10], 87ff.), and Pandermalis (note 20), 391-394, compared that tomb with the Vergina Palace. In this regard see also discussion by Gossel (note 1), 28-29. R. A.

Tomlinson, on the other hand ("Thracian and Macedonian Tombs Compared," *Thracia,* Symposium III, Sofia 1972 [Sofia, 1974], 247-250), suggests that the Macedonian tombs represent the "hestiatoria" of the dead and derive from the literarily attested tents erected for feasting, such as that of Ptolemy II in Alexandria (described by Callixenus, quoted by Athenaeus *Deipnosophistae* 5.196a-197c). Since I believe that the concept of the Macedonian tomb is an outcome of the pervasive syncretistic tendencies of the Macedonians, I think it is extremely difficult to draw valid conclusions with regard to the intended significance of these façades.

23. Cf. Ph. M. Petsas, "Ἅγιος Ἀθανάσιος-Γέφυρα," *Makedonika 15* (1975), 174-180. I am deeply indebted to Professor Petsas for permission to publish a photograph of the tomb and to reproduce his drawing of the façade. It is his intent to present a full publication of the tomb. For my dating in the early third century see Miller (note 1), 108-109; Gossel (note 1), 85, places it in the second half of the third century.

24. On the subject of the Corinthian order in Macedonia see Miller (note 15), 212-213. It may in this context be worth noting an unusual tomb discovered near Kassope which employs the Corinthian order (S. I. Dakaris, "Ἀνασκαφαὶ εἰς Κασσώπην-Πρεβέζης," *Praktika* [1952], 327-328, figs. 2-3).

25. On the dating of this tomb see note 10.

26. Pandermalis (note 20), 387-388, refers to a "Blendfassade." Cf. comments on the decorative monumental façade by R. Martin, "Sculpture et peinture dans les façades monumentales au IVe siècle av. J.-C.," *RA* (1968), 171-184, and additional references in note 20.

27. A notable exception to the masking of the vault on the façade view is a tomb at Toumba (Ph. M. Petsas, "Ὁ Μακεδονικὸς Τάφος παρὰ τὸ Χωρίον Τούμπα ίῆς Παιονίας," *Χαριστήριον εἰ Ἀ. Κ. Ὀρλάνδον* [Athens, 1966], III, 233-243; see comments on this tomb by Tomlinson [note 3], 479, and Pandermalis [note 20], 388, note 4).

28. It is, of course, obvious that tombs with architectural façades are not unique to Macedonia. Tombs with rock-cut façades resembling temples or house fronts have a

long history in the Near East, including tombs of Achaemenid Persia and the many Lycian and Carian tombs, the latter dating probably to the fourth century and later. They are well represented in the Hellenistic cemeteries of Alexandria and Cyprus (earlier examples also exist on Cyprus) and in the West there are rock-cut and built chamber tombs with engaged architectural façades, some of which may be contemporary with the first of the Macedonian examples (see Kurtz and Boardman [note 1], especially 283-297, with pertinent bibliography to which one can add P. Roos, *The Rock-Tombs of Caunus, SIMA* 34:1,2 [1972, 1974]; J. P. Oleson, "Technical Aspects of Etruscan Rock-Cut Tomb Architecture," *RömMitt* 85 [1978], 283-314; Miller [note 1], 149-155; and Gossel [note 1], 10-12, 29, 69-73). Whether these tombs derive ultimately from a single source (which might most logically be sought in the Near East) is not certain but possible (see references in note 3). However, their interrelationship goes far beyond the scope of this paper and indeed is a subject which awaits a major study of its own once the necessary regional studies have been undertaken.

29. What, for example, may have been the appearance of the Palace of Archelaus at Pella with its paintings by Zeuxis (as described by Aelian *VH* 14.17)? Our very limited knowledge of pre-Hellenistic Macedonian architecture is heavily dependent on the remains of only two known Archaic temples, both of Ionic order, one at Neapolis-Kavalla (D. I. Lazaridis, Νεάπολις, Χριστούπολις, Καβάλα, Ὁδηγὸς Μουσείου Καβάλας [Athens, 1969], 17-20 with references, pls. 32-33) and the other at Therme-Thessalonike (G. Bakalakis, "Therme-Thessaloniki," *Neue Ausgrabungen in Griechenland. AntK.* Beiheft 1 [1963], 30-34 with references, pls. 17-18). It would appear from these remains that Asiatic influence was very strong in Macedonia during this period.

30. This new wave is perhaps to be connected with the political aims of Philip and Alexander in their desire to underscore kinship and legitimacy among the rest of the Greeks. A conscious effort, therefore, may have been made to imitate (and surpass?) the style of the great mainland cultural centers (cf. Miller [note 1], 231-232, on this subject).

31. An example concerns the treatment of the Ionic columns. Normal Attic bases and capitals are frequently, very properly, used together (e.g., at Pella on the peristyle of North House in Section I, Block 1, Ph. M. Petsas, "Ten Years at Pella," *Archaeology* 17 [1964], 76, 82, fig. 15, 83, fig. 16) as are Peloponnesian bases and capitals (e.g., on the large Ionic order of the Vergina Palace, M. Andronikos, Ch. I. Makaronas, N. Moutsopoulos, G. Bakalakis, Τὸ Ἀνάκτορο τῆς Βεργίνας, [Athens, 1961], pls. 22, 23, fig. 1). But there is uncanonical usage as well in which elements of two different types are combined (e.g., in the forechamber of the Dion Tomb a Peloponnesian capital, visible in Figure 10, is paired with an Attic base, not illustrated). Conversely, one also finds an Attic capital combined with a Peloponnesian base (as on the façade of the Great Tomb at Lefkadia, Fig. 3). See also my comments on this subject (Miller [note 1], 228-230).

32. Anachronisms include the frequent (but not invariable) use of the hawksbeak of ovolo variety (used for raking geison crowns on the Dion and Haghios Athanasios Tombs, cf. Miller [note 1], 83) at a period well after it had been supplanted elsewhere by the cyma reversa type (cf. L. T. Shoe, *Profiles of Greek Mouldings* [Cambridge, Mass., 1936], 106); and the use of a Doric frieze crown, ovolo or half-round (used on the frieze of the Vergina Palace, Fig. 23, and imitated on the Pydna Tomb, Fig. 21; cf. Miller [note 1], 74-75 and below), which otherwise is found on a limited series of buildings in Greece in the sixth and fifth centuries (Shoe, 169).

33. Cf. Ch. I. Makaronas, "Λευκάδια," *Makedonika* 2 (1941-1952), 599-601, and "Archäeologische Funde / Makedonien," *AA* (1942), 162, fig. 30; the latter illustration shows the façade only partially cleared. I previously stated that the tomb is no longer visible and, equally mistakenly, said that it had no columns or pilasters (Miller [note 1], 66). Figure 14 (photograph taken in 1980) speaks for itself in this regard. Makaronas, the discoverer, proposed a date of around 200 for the tomb, a dating with which Gossel (note 1), 239, agrees. Since I have never studied and measured its façade in detail, I offer no precise date although it is obviously not one of the earlier tombs.

34. Ph. M. Petsas, "'Ἁλιάκμων, φράγμα," *Makedonika* 15 (1975), 293-296. I am deeply grateful to Professor Petsas for permission to illustrate this tomb with a photograph and his drawing of the façade. It is his intent to publish this tomb at some date in the future. For my third century dating see Miller (note 1), 109; Gossel (note 1), 216, suggests a date probably in the second half of the third century.

35. This tomb is named for the nineteenth-century traveler K. F. Kinch who published the first report of it ("Le tombeau de Niausta, tombeau macédonien," *Danske Vidensk. Selskab. 7 R., Hist.-Filos. Skrifter,* Afd. IV, 3 [Copenhagen, 1920]). See most recently K. Rhomiopoulou and I. Touratsoglou, "Ὁ Μακεδονικὸς Τάφος τῆς Νιάουστας," *ArchEph* (1971), 146-164. They suggest (164) a dating around the middle of the third century; Pandermalis (note 1), 176, dates it in the third century; Gossel (note 1), 177, suggests it is not likely before the mid-third century; for my dating of late third to early second century see Miller (note 1), 111-113.

The famous painting from the back wall of this tomb, now almost totally destroyed, is most recently reproduced in the Ἱστορία τοῦ Ἑλληνικοῦ Ἔθνους (Athens, 1973), IV 186. It has been frequently cited elsewhere (e.g., J. Six, "Nikomachos et la peinture d'un hypogée macédonien de Niausta," *BCH* 49 [1925], 263-280, and M. H. Swindler, *Ancient Painting* [New Haven, 1929], 300, who discusses it in her section on preserved paintings of the fourth and third centuries).

36. Heuzey and Daumet [note 11], pls. 15-16.

37. For my dating in the later third century see Miller (note 1), 107-108; Pandermalis (note 1), 176, dates the tomb to around 300; Gossel (note 1), 208, suggests maybe the beginning of the second century.

38. Cf. note 13. The accompanying photograph was taken in 1968. More recently, following damage of winter rains to the tomb, the earth was removed from around it and a much-needed protective shed built over it at the instigation of D. Pandermalis. I am indebted to Professor Pandermalis for permitting me to revisit the tomb in the fall of 1980.

39. Cf. Heuzey and Daumet (note 11), pl. 18. Pandermalis (note 1), 176, dates the tomb to the third century; P. W. Lehmann agrees with a third-century date in connection with the wall decoration (*Samothrace III, 1: The Hieron* [Princeton, 1969], 207); G. M. A. Richter implied a dating in the fourth to third century by her dating of the couch from the tomb to that period (*The Furniture of the Greeks, Etruscans, and Romans* [London, 1966], 60, fig. 322); for my dating toward the end of the third or into the second century see Miller (note 1), 110-111; similarly, Gossel (note 1), 224, places it in the late third or early second century. With regard to the frieze, the Pydna Tomb is a somewhat special case in that a vaulted dromos, ending in a small vaulted antechamber, approaches the tomb proper; the curved vault thus intersects the rectilinear façade (see Heuzey and Daumet [note 11], pl. 18 bottom, for section).

40. The use of half-metopes is advocated by Vitruvius (*De Arch.* 4.3.1-2) as a means to avoid the inevitable problems of spacing with regard to columns and the triglyph-metope frieze above. (On the problem see D. S. Robertson, *Greek and Roman Architecture* [Cambridge, 1969], 106-111, and Coulton [note 15], 132-146.) Since neither the Kinch Tomb nor the Pydna Tomb is provided with columns, the justification for using half-metopes cannot, of course, derive from any such consideration (although the Pydna Tomb remains a special case, as stated in note 39).

41. The standard work on mouldings remains Shoe's *Profiles of Greek Mouldings*, note 32.

42. In fact, the architect consistently formed mouldings of ovolo profile for the façade of the Lefkadia Great Tomb and then painted them to suggest cyma reversas or hawksbeaks; a true cyma reversa does, however, appear on the toichobate of the interior (cf. Fig. 2). At Pydna, too, the crown moulding of the horizontal geison

is an ovolo painted with a Doric leaf to suggest a hawksbeak (Heuzey and Daumet [note 11], pl. 18 upper right).

43. On this moulding see note 32. Note also the painted egg-and-dart which appears beneath each of the four painted figures on the façade of the Lefkadia Great Tomb, Fig. 3; the surface on which the band appears is entirely flat.

44. For the painted dentils see the artist's rendering in Petsas (note 10), pl. E^I, 1, fig. 13, pp. 50-51, 99. Trompe l'oeil dentils also appear on a painted cist grave from Sedes (Kotzias [note 4], 874, figs. 7-8, dated 320-305 B.C. on the basis of finds, p. 895). See similarly painted dentils and other architectural details in the well-known Thracian tomb near Kazanlak in Bulgaria, a provincial work dating most likely to the reign of Seuthes III (see most recently L. Zhivkova, *Das Grabmal von Kazanlak* [Recklinghausen, 1973], pl. 12).

45. Cf. Robertson's astute comments on the relationship of sculptural and pictorial elements on the Great Tomb (note 10, 568-571).

46. Miller, note 15.

47. Ibid., section, 215, fig. 5. Engaged columns have strong Peloponnesian affinities. For a discussion of the decorative use of engaged columns, see ibid., 213-217. See also Büsing (note 20) and for a differing viewpoint R. Martin, "Valeur et emploi fonctionnel des colonnes d'applique dans l'architecture hellénistico-romaine," *Mélanges d'histoire ancienne et d'archéologie offerts à Paul Collart*, Cahiers d'archéologie romande, 5 (Lausanne, 1976), 285-294.

48. K. Lehmann, *Samothrace—A Guide to the Excavations and the Museum* (Locust Valley, N.Y., 1975), 54-58. This building is undergoing intensive study in preparation for definitive publication. Although fundamental changes in the reconstruction will be necessitated, the use of interior and exterior engaged colonnades on a high podium remains an established fact. I am indebted to Professor Phyllis Lehmann for discussing the new study of this building with me.

49. P. W. Lehmann (note 39), 138-142, 204-212, and plate vol. pl. 106.

50. Recent discoveries, as yet unpublished, made by M. K. Siganidou at Pella provide additional evidence for the widespread use of this sort of interior decoration in fourth-century Macedonia (cf. the restored segment of wall from Pella currently, 1981, on exhibition in the Archaeological Museum of Thessalonike). This type of arrangement is, of course, the fully developed equivalent of what in the West is called the First Style of Roman wall painting (which, for clarity's sake, I would prefer to call the "Relief Architectural Style" when applied to Greek walls; see Miller [note 1], 140-149).

51. Cf. Martin (note 26), 171-184, and C. Picard, *Etudes thasiennes*, VIII,1: *Les murailles, les portes sculptées à images divines* (Paris, 1962), 149-176.

52. Cf. Martin (note 26), 173, fig. 1.

53. Ibid., 177-180. Cf. also comments by Gossel (note 1), note 828.

54. Cf. comments by Martin in J. Charbonneaux, R. Martin, F. Villard, *Hellenistic Art* (New York, 1973), 56, 61, and Pandermalis (note 20), 387.

55. On the Second Style see, for example, A. Maiuri, *Roman Painting* (Geneva, 1953), 38-44, and R. Bianchi Bandinelli, *Rome the Center of Power 500 B.C. to A.D. 200* (New York, 1970), 117-129.

56. For the sake of clarity, I would prefer to call this type of painting in Greece the "Painted Architectural Style," reserving the already confusing term "Second Style" for Italian painting (see Miller [note 1], 149-168).

57. Originally reported briefly by Ch. I. Makaronas, "Λευκάδια," *Makedonika 2* (1941-1952), 634-636; an expanded illustrated preliminary report was published by Makaronas and S. G. Miller, "The Tomb of Lyson and Kallikles, A Painted Hellenistic Tomb," *Archaeology 27* (1974), 248-259. See also I. Touratsoglou, *Lefkadia* (Keramos Guides, Athens, 1973), 21-26; K. Fittschen, "Zur Herkunft und Entstehung des 2. Stils—Probleme und Argumente," *Hellenismus in Mittelitalien* (note 20), 541, cf. 558; P. W. Lehmann, "Lefkadia and the Second Style," *Studies in Classical Art and Archaeology, A Tribute to P. H. von Blanckenhagen*, G. Kopcke and M. B. Moore, eds. (Locust Valley, N.Y., 1979), 225-229; Gos-

sel (note 1), 178-189. My publication of the tomb is in preparation.

58. Full evidence will be in the forthcoming publication. One of the pyxides is illustrated in Makaronas and Miller (note 57), 251.

59. See plan, ibid., 248.

60. The perirrhanterion is illustrated, ibid., 253.

61. The bibliography is vast. I cite only a few of the most recent discussions: Fittschen, note 57; Lehmann, note 57; J. Engemann, *Architekturdarstellungen des frühen zweiten Stils, RömMitt*, Ergh. *12* (1967), especially 15-146; M. Lyttelton, *Baroque Architecture in Classical Antiquity* (Ithaca, 1974), 18-25; G.-C. Picard, "Origine et signification des fresques architectoniques romano-campaniennes dites de second style," *RA* (1977), 231-252; K. Schefold, "Der zweite Stil als Zeugnis alexandrinischer Architektur," *Neue Forschungen in Pompeji,* ed. B. Andrae and H. Kyrieleis (Recklinghausen, 1975), 53-70.

62. P. W. Lehmann (note 57) sees it as the direct source for the Roman style.

63. The earliest known example of Second Style painting in the Roman world is in the House of the Griffins on the Palatine, a house usually dated to around 100 B.C. (see Bianchi Bandinelli [note 55], 117-118, fig. 120).

64. E.g., P. W. Lehmann (note 57), 227. See comments on this subject by Robertson (note 10), 571-573. Note also the thoughtful discussion by von Graeve (note 10), 111-137, concerning painted Hellenistic grave stelae from Thessalian Demetrias and certain Roman wall paintings as reflections of classical Greek painting.

65. See comments on the transmission of paintings by Robertson (note 10), 574-575; also K. Weitzmann, *Illustrations in Roll and Codex. A Study in the Origin and Method of Text Illustration* (Princeton, 1947), and idem, *Ancient Book Illumination, Martin Classical Lectures,* 16 (Cambridge, Mass., 1959).

Fig. 8. Athens, Temple of Olympian Zeus (photo: Alison Frantz).

Architecture as a Medium of Public Relations among the Successors of Alexander

HOMER A. THOMPSON

School of Historical Studies,
Institute for Advanced Study

FROM VERY EARLY TIMES a fine building was regarded by the Greeks as a gift worthy of a god. Miniature models of temples have been found among the earliest votive offerings in Greek sanctuaries.[1] In the archaic period kings and tyrants vied with one another in the creation of magnificent temples for their divinities.[2] The archaic period also witnessed lively rivalry among the city-states in the design of treasuries, those charming little buildings with the basic scheme of temples that were dedicated in the major sanctuaries.[3] Although scale and format appear to have been fixed by convention within fairly narrow limits, there was room for competition in the choice of location and material, in ornamental detail, and in quality of workmanship. As was common in Greek affairs, competition brought out the best in the architectural profession. Some of the treasuries are to be rated among the finest gems of early Greek architecture.

The fashion for treasuries died out in the early fifth century B.C., and we know of few gift buildings of the later fifth or early fourth centuries. But in the time of Philip and Alexander there begins another series of architectural dedications which has not a little in common with the earlier series. These later dedications with which we shall be concerned were all made by members of royal families who were concerned with improving their images or projecting their personalities abroad. First-rate architects and engineers were engaged. The finest available materials were employed. New techniques were devised or developed. The result was a goodly number of the most interesting and finest buildings of the period. As to the effectiveness of this form of public relations one can only say that the long continuation of the practice suggests some degree of success.

To illustrate these general observations I propose to bring together a number of the best documented of such royal dedications. I shall choose some that stood in the great sanctuaries, and others from a couple of the old Greek cities. The chronological range will be the two centuries following the death of Philip II in 336 B.C.

We may begin with an early and familiar example, the Philippeion at Olympia (Fig. 1).[4] This is referred to by Pausanias (5.20.9-10), our only literary source, as a "round structure" built for Philip after the collapse of Hellas at Chaironeia. The building stood, according to Pausanias, within the Altis at the exit by the Prytaneion, on the left-hand side. Within the building were statues of Philip, his parents, Amyntas and Eurydike, his first wife, Olympias, and his son, Alexander; all were made of gold and ivory by Leochares.

I shall leave it to others to deal with the architecture and sculpture of the Philippeion, but I wish to say something about its function. In the first place the monument had a personal quality: according to Pausanias it was built for Philip, not for Zeus. This may account in part for the location of the Philippeion, so different from that of the old treasuries which, as dedications to Zeus, were placed in full view of the façade of Zeus' temple. Although the choice of location may seem unexpectedly modest for one who was seldom modest by nature, I suspect that at the time of construction the entrance by the Prytaneion may have been much used; this would have assured high visibility—something, as we shall see, that greatly concerned our royal benefactors. We do not know in which direction the Philippeion

Fig. 1. Olympia, the Altis, model seen from the southeast (photo: Deutsches Archäologisches Institut, Athens).

faced. If, as seems most probable, it looked eastward, the building was brought into close relationship with the Pelopion, the shrine of the founder of the Olympic Games who was the great-grandfather of Herakles, a reputed ancestor of the Macedonian royal family.[5] The use of gold and ivory for the statues of that royal family also smacks strongly of divinity, especially in a place within a stone's throw of Pheidias' chryselephantine Zeus. Already before Chaironeia, Philip, like his father Amyntas, had enjoyed divine honors,[6] and it seems probable that Alexander received similar honors, at least in some places, as early as his liberation of the Greek cities of Asia Minor, i.e. 334-333 B.C.[7] Since the installation of the statues in the Philippeion was probably done at the order of Alexander, the family group may be thought of not merely as royal but as divine.[8] One will recall Philip's claim, recorded by Diodoros (16.92.5; 16.95.1), to be rated as a thirteenth god alongside the ca-

nonical twelve.[9] Hence the Philippeion is probably to be regarded not as a treasury nor yet as an heroon but as something very like a temple.

As to the motivation behind the establishment of the Philippeion, the emphasis on Chaironeia in Pausanias' reference leaves little doubt that Philip, who undoubtedly initiated the project, wished to have a physical reminder of his mastery of Greece in the greatest and most frequented of all the national sanctuaries. But such political considerations must have been reinforced by nostalgic memories of his personal triumphs in the Olympic Games, once in the horse race, twice in the chariot race, as proudly memorialized on his coins.[10]

At Delphi (Fig. 2) as at Olympia there had been a splendid efflorescence of treasuries in the sixth and early fifth centuries.[11] Here, as at Olympia, these buildings were dedicated to the presiding divinity by various city-states. In Delphi

there appears to have been more freedom and so more rivalry in the placing and in the design of the little buildings. National pride is manifested in various ways. The Athenians for instance gave prominence to their patron goddess Athena and to their national hero Theseus in the sculptural adornment of their treasury.

But we must concentrate on a couple of much later monuments, the two stoas that project so prominently from the east and the west sides of the sanctuary proper. A few years ago Professor Pierre Amandry observed on the back wall of the West Stoa (No. 56 on Fig. 2) remnants of an inscription, tantalizingly incomplete, but well enough preserved to attest the dedication by the Aetolians of arms taken from the Gauls.[12] These arms must have been trophies captured in 279 B.C. when the Aetolians played a leading role in saving the sanctuary from the Gauls.[13] A set of cuttings in the walls of the stoa were interpreted by Amandry as for the fastening of the arms, especially the Gallic shields. Pending the definitive examination of the building one may nevertheless ask whether some of the cuttings may not have been intended for securing wooden panels for paintings commemorating the victory. Delphi was an appropriate place for an Aetolian dedication since in the third century the sanctuary was under the protection of the Aetolian Confederacy.

I mention the Aetolian dedication by way of preface to the stoa on the east side of the sanctuary (No. 33 on Fig. 2).[14] Despite the disparity in size the two buildings look like pendants, and this indeed was in all likelihood the case. The smaller East Stoa has been attrib-

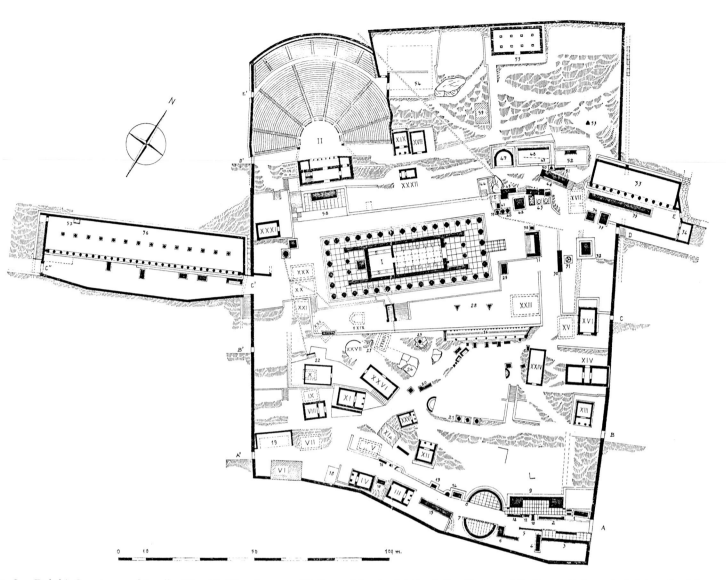

g. 2. Delphi, Sanctuary of Apollo. No. 56: West Stoa; no. 33: Stoa of Attalos I (after J. Pouilloux and G. Roux, *Enigmes à Delphes,* fig. 34).

uted on good evidence to Attalos I, King of Pergamon, 241-197 B.C. In view of its position overlooking the forecourt of Apollo's temple, the East Stoa is undoubtedly to be regarded as a dedication to the god. The capacious West Stoa may be supposed to have been designed in the first place to serve a practical use as a shelter for people attending the nearby theater. The small scale of the East Stoa, on the other hand, suggests that it was intended pri-

marily for some other purpose. This purpose was established some years ago by Professor Georges Roux who interpreted a set of cuttings in the back wall of the building as for the attachment of wooden panels of the kind referred to above. One may confidently conjecture that these panels carried murals relating to Attalos' greatest achievement, the crushing defeat of the Gauls after they had crossed into Asia Minor. The same theme

was probably commemorated sculpturally in an enormous monument that rose in front of the stoa and was inscribed with a dedication by Attalos to Apollo.

Since we know that Attalos I in the years between 220 and 207 B.C. had supported the Aetolians in their struggle against Philip V of Macedon, I would venture to suggest that Attalos was prompted to make his dedication in friendly emulation of the Aetolians as fel-

low saviors of Greece against invaders from the north.[15]

The great importance of the Pergamene dedication lies of course in its demonstration of the desire of one of the new kingdoms of the East to make its presence felt in one of the greatest sanctuaries of old Greece. Of interest at the technical level is the skill shown by the architect in handling a very rugged site, a skill developed to a high level by Pergamene architects in their homeland.[16] Significant also is the great technical competence shown in the vaulting of an exhedra below the level of the stoa terrace, a branch of architecture in which the Pergamenes were at this time playing a creative role.[17]

From Delphi we take ship to Apollo's other great sanctuary, Delos (Fig. 3). Here too we find ourselves in an age-old sanctuary with many treasuries and other dedications of an architectural nature from the archaic and classical periods.[18] But the Hellenistic period also saw much building activity on the island, particularly in the years of independence c. 314-166 B.C. Its central location in the Aegean made Delos a natural focal point of the rivalries among the Hellenistic powers. Early in the period Delos became a member of the Island Confederacy. When at the beginning of the third century the confederacy fell under the domination of Ptolemy I of Egypt, Delos became its religious center. The Ptolemaic presence is documented by the inscriptions, but little of an architectural nature remains, and that little is modest (the Philadelpheion on Mount Kynthos?). About the middle of the third century the Ptolemies were supplanted in the Aegean by the Macedonians, who made a truly monu-

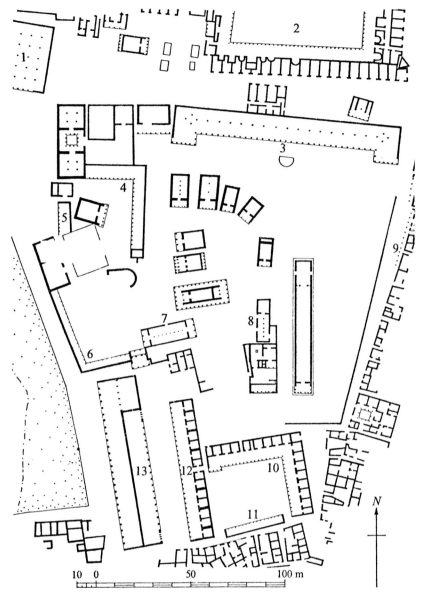

Fig. 3. Delos, Sanctuary of Apollo. No. 3: Stoa of Antigonos; no. 12: South Stoa (of Attalos I?); no. 13: Stoa of Philip V (after J. J. Coulton, *The Architectural Development of the Greek Stoa*, fig. 60).

mental impact on the sanctuary.

We will look at only two Macedonian dedications on Delos, both of which can be attributed to specific monarchs. First, the enormous two-winged stoa erected by Antigonos Gonatas, probably in the third quarter of the third century B.C., to close most of the north side of the main sanctuary of Apollo (No. 3 on Fig. 3).[19] Second,

the smaller but still substantial stoa built by Philip V toward the end of the third century to border the west side of the avenue that led to the entrance at the southwest corner of the sanctuary (No. 13 on Fig. 3).[20] Both buildings were not only large in scale but located in very prominent positions. Both served the physical comfort of very large numbers of people who came

from all parts of the Greek and later also of the Roman world. On the façade of each stoa the name of the donor was engraved in large letters. By now the kings had come to realize that for the purpose of public relations the stoa gave best value: i.e., a maximum of exposure and of public service for a minimum of outlay. We may assume that Antigonos Gonatas and Philip V, like Philip II long before, were desirous of establishing a seemly Macedonian presence near the center of the Hellenic world. They rightly chose Delos, for the center had shifted far to the east since the time of Philip II.

Antigonos' building belongs to that type of two-aisled, one-storied stoa, the two ends of which were bent forward at right angles and treated like temple façades. This type began in Athens in the late Periklean period with the Stoa of Zeus Eleutherios.[21] The plan was subsequently copied or adapted in many parts of the Greek world, usually, as here, on a much larger scale. The tremendous expansion represented by the Delian example may be regarded as typical of the Macedonian temperament. The architrave of the marble façade carried the dedicatory inscription, fragmentary but plausibly restored to read: "King Antigonos, son of King Demetrios, a Macedonian, to Apollo."[22]

In front of his stoa Antigonos displayed his family. The French excavators came on the remains of a long pedestal on which had stood twenty-one bronze statues. A centrally placed inscription labeled the group as the ancestors of the king; below each figure was its proper name.[23] Hence the dedication was stamped with a dynastic quality.

Philip's stoa had a traditional plan: a long rectangle with a Doric façade and no interior columns. The entablature resembled that of Antigonos' building in its material, workmanship, and massive proportions. Similar too was the dedicatory inscription on the architrave: "Philip, King of the Macedonians, son of King Demetrios, to Apollo."[24] Philip's original building, the one-aisled colonnade, bordered the west side of the broad avenue leading to the entrance of the Sanctuary. It was later to be enlarged by the addition of a second aisle facing outward across the harbor. But even the original stoa, though the same length as the earlier building on the east side of the avenue, overshadowed that structure through its greater depth, wider column spacing, and larger columns. There is reason to believe that the earlier, more modest stoa had been built with the aid of a rival royal family, that of Pergamon. It has been suggested, and the suggestion is plausible, that this is an example of "one-upmanship" between the two dynasties.[25]

We may look into one more sanctuary, that of the Great Gods on Samothrace (Fig. 4).[26] Although it may seem remote to the scholar preoccupied with the classical period of Greek history, this rocky island at the very top of the Aegean Sea documents in an extraordinarily vivid way the interplay of dynastic forces in the third and second centuries B.C.[27] The existence of the sanctuary is well attested by the authors of the classical period (Herodotos, Aristophanes, Plato), but it is doubtful if any of the substantial buildings in the sanctuary antedates the fourth century. Hence there was both need and room for much new construction in the Hellenistic period.

Why the leading powers of the time should have vied with one another in meeting these needs is a matter of conjecture. At no period in its history could the island have been of great importance to any power for strategic or commercial reasons. A more plausible explanation is the growing attraction of the cult of the Great Gods, a mystery religion which appealed to an age whose faith in the old Olympian gods had become jaded. The island sanctuary became a fashionable resort, and the fashion was stimulated by royal patronage.

The long years of strenuous effort on the part of the Institute of Fine Arts, New York University, have made of Samothrace a remarkably illuminating museum for the study of the history of both architecture and religion, and no less of international relations. The royal families of Macedonia and of Ptolemaic Egypt are each represented by two well-documented buildings, and other royal dedications may be unrecognizable only because of the lack of inscriptions. The certainly royal buildings are all of striking design, and they have been situated with a view to maximum visibility, evidently in rivalry one with another. There are so many of them, however, that we can do no more than take a very hasty "Swan's Tour."

The visitor coming from the ancient city entered the Sanctuary through its east side. The propylon, the Ptolemaion, was given monumental form by a building which served also as a bridge over a torrent and which offered generous shelter for visitors in its two deep porches (No. 26 on Fig. 4, and Fig. 5).[28] More is said about the architectural design of this attractive building in this publication by Pro-

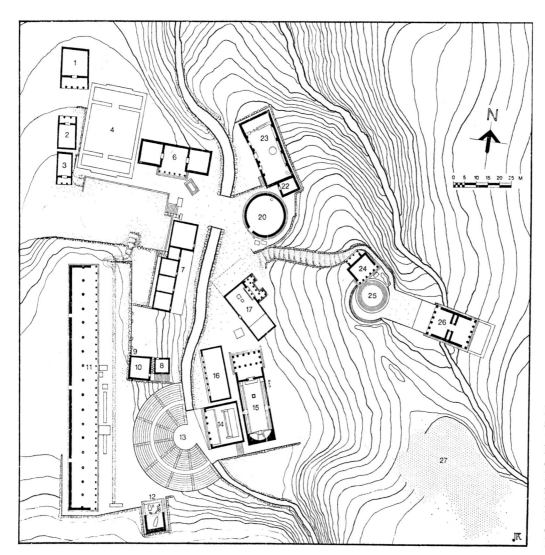

Fig. 4. Samothrace, Sanctuary of the Great Gods. No. 14: Altar Court; no. 26: Ptolemaion; no. 24: Dedication of Philip III and Alexander IV; no. 25: Theatral Area; no. 20: Rotunda of Arsinoe II (after *Samothrace, Guide,*[4] Plan III [J. Kurtich]; courtesy of the Institute of Fine Arts, New York University).

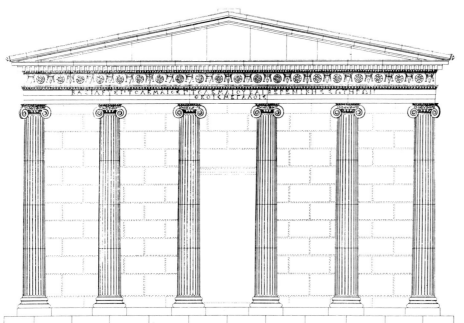

Fig. 5. Samothrace, east façade of the Ptolemaion, restored (after *Untersuchungen auf Samothrake,* II, pl. xlvii).

fessor Alfred Frazer in his paper "Macedonia and Samothrace: Two Architectural Late Bloomers." At this point I would like to emphasize the innovative combination of the Ionic and Corinthian orders, one in the outer and one in the inner porch, the skillful construction of the vaulted passage for the torrent, and the exquisite carving of the ornament on the entablature. In both design and execution the building was of outstanding quality. The visitor was left in no doubt about the identity of the benefactor. On the architrave at either end of the building was engraved the name of the donor: Ptolemy II Philadelphos. The inscription ran "King Ptolemy, son of Ptolemy and of Berenike, Saviors, to the Great Gods." The date must be between 285 and 280 B.C., and the dedication is a vivid reminder that at this time the Ptolemies were indeed the dominant power in the Aegean. The portraits of Ptolemy II and his redoubtable second wife, Arsinoe II, reveal much of the secret of that dominance.[29]

Continuing into the Sanctuary we pass a curious circular paved area surrounded by steps and with an altar at its center, clearly a place for religious rites (No. 25 on Fig. 4).[30] A rectangular exhedra or alcove, presumably for the shelter of spectators, overlooked the "orchestra" from the northwest (No. 24 on Fig. 4). Its hexastyle Doric façade was of fine, white, probably Pentelic marble, and the architrave bore the names of the donors in large and beautiful lettering: King Philip III Arrhidaios, half-brother of Alexander the Great, and Alexander IV, the posthumous son of Alexander. The text read "Kings Philip (and) Alexander to the Great Gods." The date must fall between

323 and 316 B.C. We may assume that the young rulers were aware of their family's long connection with Samothrace. It is here that Philip II, while still a youth and undergoing initiation into the mysteries, met and fell in love with the Molossian princess Olympias, who was to become his consort.

The west porch of the Ptolemaic propylon has much the same shape as the exhedra of Philip and Alexander, and it could well have served, like that building, as a shelter for spectators. But Ptolemy chose different architectural orders and an appreciably larger scale for his building.

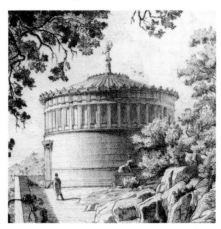

Fig. 6. Samothrace, Rotunda of Arsinoe II, restored (after *Untersuchungen auf Samothrake,* I, pl. liv).

As we descend the steep path that leads down into the middle of the Sanctuary we have on our right the great round building that bore the dedicatory inscription: "Queen Arsinoe, daughter of King Ptolemy, wife of King . . . dedicated . . . to the Great Gods" (No. 20 on Fig. 4, and Fig. 6).[31] Once again the letter forms are beautiful. The purpose of the structure is obscure, but its central location and the prominence of boukrania and phialae in the decoration show that

it was closely connected with the cult. It is scarcely a beautiful building, and the parts are more attractive than the whole, but with a diameter of about 20 meters it has the distinction of being the largest of all the known roofed round buildings of Greece. Roofing such a space without interior supports called for engineering ability of a high order. The unprejudiced observer is likely to feel that the designer was intent on creating the most impressive structure in the Sanctuary. In this he succeeded, and in doing so doubtless gratified the donor. The dedication was probably made by Arsinoe after her marriage, c.276 B.C., to her brother, Ptolemy II Philadelphos, and in gratitude for the refuge she had found in the Sanctuary when pursued by her savage earlier husband, Ptolemy Keraunos, her half-brother.

Finally, we come to the rectangular structure designated by the excavators the "Altar Court" (No. 14 on Fig. 4).[32] Its columnar marble façade looked toward the Theater, and it seems in fact to have served as the scene building. A very fragmentary inscription on the architrave is most plausibly interpreted as a dedication by that Arrhidaios, half-brother of Alexander the Great, whom we have already met as a joint donor of the alcove above the round ceremonial area. This second contribution reinforces the assumption of a lively Macedonian interest in the Sanctuary, and the fact that the donor's name was in full view of the spectators in the Theater accords with the general practice of our royal donors.

So much for sanctuaries. Let us turn now to consider benefactions made by Hellenistic kings to a couple of the old city-states. We may

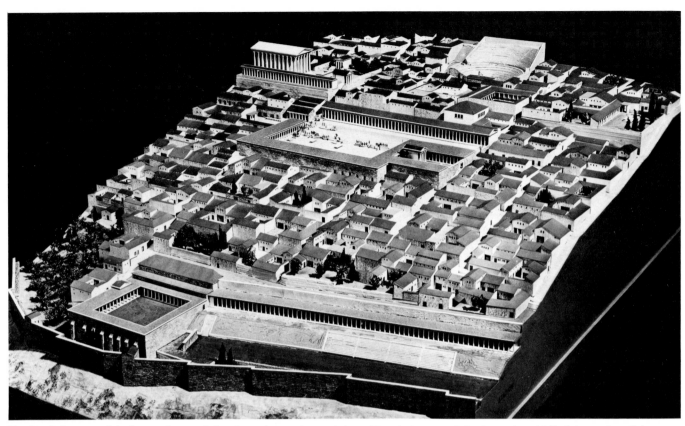

Fig. 7. Priene, model of central part of city, from the southeast; Athena Temple in upper left, Agora in middle (photo: Staatliche Museen, East Berlin).

start with Priene (Fig. 7).[33] We think of Priene as a small town, but it was in fact an old city, a respected member of the Ionian League and the birthplace of Bias, one of the universally recognized seven sages. When Alexander was engaged in his campaign to free the Greek cities of Asia Minor (334-333 B.C.) Priene had recently embarked on the development of a new town-site. A splendid Ionic temple for Athena, the patron goddess of the city, had been designed by the distinguished architect Pytheos, and its construction was well under way. Alexander showed personal interest presumably by making a contribution toward the cost. This was recorded in beautiful lettering engraved in the topmost block of

the southern anta of the temple: "King Alexander dedicated the temple to Athena Polias."[34] The marble is now in the British Museum. Alexander's name must have added still more to the fame of Pytheos' building.

From a letter of Alexander engraved on the anta just below the dedicatory inscription we learn of other benefactions such as autonomy and exemption from payment of "the contribution" *(syntaxis)*.[35] It is not surprising that a shrine of Alexander was established in the city. The date of its foundation is unknown, but in the second half of the second century B.C. it was still sufficiently respected to merit rehabilitation.[36]

Despite the royal contribution,

construction on the Temple of Athena lagged, and the building was not completed until at least the middle of the second century B.C. The installation of the cult statue of Athena also falls in the second century. It may have been paid for by Orophernes, a prince of Cappadocia and pretender to the throne (159-157 B.C.). So much has been inferred from the discovery within the pedestal of the statue of a half-dozen silver coins of Orophernes.[37] This may seem an unusually self-effacing way for a Hellenistic prince to record a benefaction, but the "foundation deposit" does appear to imply Orophernes' participation.

The Agora of Priene, like the temple, developed stage by stage

over a period of a couple of centuries. The crowning touch came with the erection of the great two-aisled colonnade, officially known, at least in its later history, as the Sacred Stoa, on the north side of the square.[38] It was an impressive and splendidly situated building, reminiscent of the Stoa Poikile in the Athenian Agora in its southward exposure and in the multiple roles which it played in the life of the community. A very fragmentary inscription from the architrave indicates that the city owed the stoa also to a princely benefactor, probably again a member of the royal family of Cappadocia; most likely Ariarathes VI, 130-c.116 B.C.[39]

The experience of Priene illustrates how the ruler of one of the new Hellenistic states, even one of the second rank, might have at his disposal resources for carrying out a civic project that was quite beyond the capability of an ancient city-state.

Priene looked to Athens as her mother city. In religious, cultural, and constitutional matters this was indeed the case. It is little wonder therefore that Athens received even more attention than Priene from the Hellenistic princes. Throughout most of our period Athens still counted for something in military and commercial terms, but on the whole it seems safe to suppose that the donors were motivated primarily by gratitude toward the city which they regarded as the chief source of their own culture. Nor were the Athenians disposed to discourage this attitude. Certainly they profited from it.[40]

From a great number and variety of benefactions space will permit only a very limited selection. I should like to speak of just three

well-documented examples: the resumption of work on the Temple of Olympian Zeus (Fig. 8) by Antiochos IV of Syria, and the erection of stoas by kings of Pergamon alongside the Theater of Dionysos (Fig. 9) and the Agora (Fig. 11). But mention must be made of another great royal benefaction which augmented the civic facilities of Athens, the Gymnasium named after its founder, the Ptolemaion (Pausanias 1.17.2).[41] From the sequence of Pausanias' account this establishment appears to have been located a little to the east of the Agora. But the actual site has not yet been found, nor is the date likely to become certain until the site can be explored. The foundation has been attributed variously by scholars to Ptolemy II (308-246 B.C.), Ptolemy III (246-221 B.C.), and Ptolemy VI Philometor (180-145 B.C.). One of the few certainties about the Ptolemaion is its possession of a library, something appropriate to a Ptolemaic foundation. Nor should we pass over in silence the valuable contribution made by Ariobarzanes II Philopator, King of Cappadocia (63/62-52/51 B.C.), in rebuilding the Odeion of Perikles which had been burned by the Athenians themselves to prevent its timber falling into the hands of Sulla's troops in 86 B.C.[42] To be associated even with the repair of such a monument from the great days of Athens may have brought as much prestige as the construction of a new building.

A visitor to Athens may be forgiven for finding the Temple of Olympian Zeus (Fig. 8) the most impressive of the ancient remains in the city.[43] Most of us, in thinking of the temple, recall its beginnings under the Peisistratids in the late sixth century B.C. and its trium-

phal completion by the Emperor Hadrian over seven centuries later. We are likely to be less conscious of an intermediate phase datable to the second quarter of the second century B.C. At this time construction on the temple was resumed on the initiative of Antiochos IV Epiphanes, King of Syria (175-164 B.C.).[44] The undertaking came out of a remarkable conjunction of circumstances. Antiochos, on his return from a lengthy detention in Rome, had spent some time in Athens and had received Athenian citizenship. He was enamored of all things Greek, and he looked to Athens in particular for models in shaping the governance and society of his kingdom. Like Philip II he was a great worshiper of Olympian Zeus, and this was probably the immediate incentive for his interest in the Athenian temple. In Rome he had witnessed a great spate of construction — temples and civic buildings — and it is characteristic of Antiochos' cosmopolitan outlook that he should have chosen a Roman architect, Decimus Cossutius, to supervise the project in Athens.

The Peisistratids had left the building with little if anything in place above ground level, although many colossal drums had been shaped in poros for Doric columns. Antiochos and Cossutius updated the design by changing the order from Doric to Corinthian and the building material from poros to marble. But the shortness of Antiochos' reign and his preoccupations in the East prevented the completion of the work. Even in its half-finished state, however, the Olympieion aroused the wonder of visitors, and Livy (41.20.8) referred to the Temple of Jupiter Olympius at

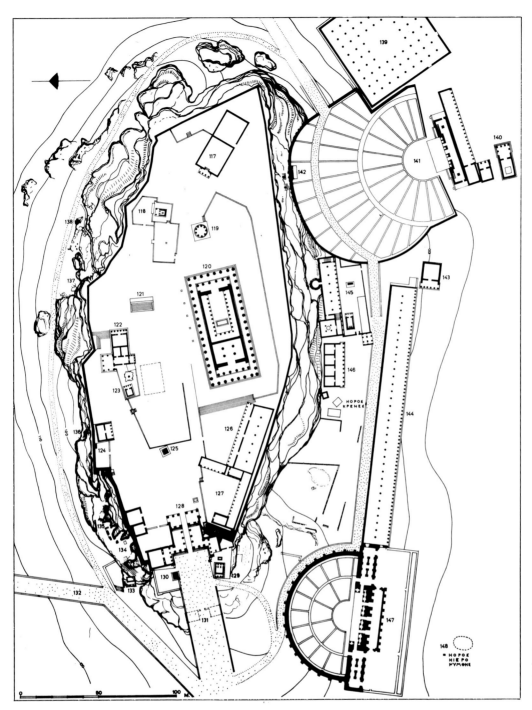

Fig. 9. Athens, Acropolis and Theater District (after J. Travlos, *Pictorial Dictionary of Ancient Athens,* fig. 91).

Athens as "the only one in the world begun on a scale worthy of the greatness of the god."

Now let us turn to the Pergamene benefactions. The Theater of Dionysos at the southeast foot of the Acropolis seated fourteen thousand or more spectators.[45] In case of a sudden rainstorm or in the interludes between plays on a hot summer day, where were so many people to find shelter? Before the Hellenistic period the available space was very inadequate. It comprised the Odeion of Perikles, a small one-aisled stoa directly below the Theater, and a two-storied stoa in the adjacent Sanctuary of Asklepios. But their combined capacity was in the hundreds rather than the thousands.

A more adequate solution had been worked out at Pergamon in the early years of the reign of Eu-

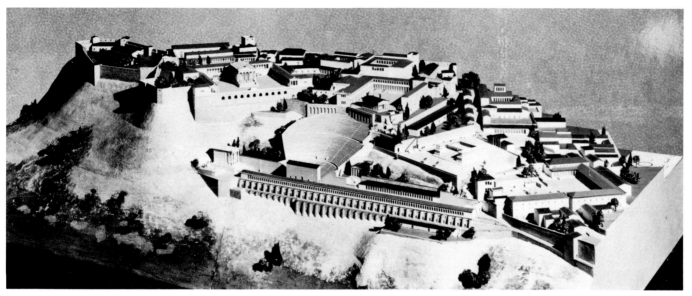

Fig. 10. Pergamon, model of the Acropolis, from the southwest (photo: Staatliche Museen, East Berlin).

menes II (197-159 B.C.).[46] Despite a very difficult terrain tremendous colonnades were erected both below and to one side of the Theater, shelters commensurate in scale with the audience (Fig. 10). A similar solution was now applied in Athens. Westward of the Theater of Dionysos, close in at the foot of the Acropolis, a colossal stoa was built (No. 44 on Fig. 9).[47] It was two aisles wide and two stories in height, and the levels were skillfully adjusted to facilitate access from the Theater. The southward exposure of the stoa was ideal for both summer and winter. The arrangement proved so satisfactory that when the Odeion of Herodes Attikos came to be built in the second century after Christ it was placed at the other end of the stoa which thereafter served both theaters.

From a passage in Vitruvius (5.9.1) we know that the stoa was a work of Eumenes. Pergamene architects or engineers were probably involved directly. Thus in the back wall of the Athenian building

we find a curious system of arcaded buttresses which is best paralleled in the Temenos of Athena above the Theater at Pergamon. And the palm capitals employed in the stoa in Athens are of a type that was revived from the archaic period and much favored by the architects of Pergamon.

We do not know whether the initiative for the construction of the stoa in Athens came from Athens or from Pergamon. But we may be sure that the project was made possible by this great ruler of Pergamon, Eumenes II, who had inherited an admiration for Athens from his father Attalos I.[48]

Eumenes' attitude toward Athens was shared also by his younger brother and successor on the throne of Pergamon, Attalos II (159-138 B.C.). It is probable that Attalos as a youth had studied in Athens; it is certain that he was made an honorary citizen. The improvement that Eumenes had worked in the facilities in the theater district to the south of the Acropolis was matched by what

Attalos did for the Agora to the north of the Acropolis (Fig. 11). The Agora reached the height of its development in the second century after Christ. But it was in the second century B.C. that the square assumed its basic form (Fig. 12).[49] In this period the old irregular space took on a more regular shape, and the colossal scale of the new buildings gave the square a more monumental appearance. The most telling elements in the new construction were two huge stoas, one, which we call the Middle Stoa, on the south of the main square, the other, the Stoa of Attalos, on the east. Attalos' building was begun c. 150 B.C. and it exhibits a number of the same Pergamene mannerisms as the Stoa of Eumenes. The Middle Stoa is slightly earlier. Its architecture has an exotic flavor which suggests a foreign benefactor. Although the two stoas were carefully related to one another and to the square, it is hard to avoid the impression that Attalos' building with its high marble façade was deliberately de-

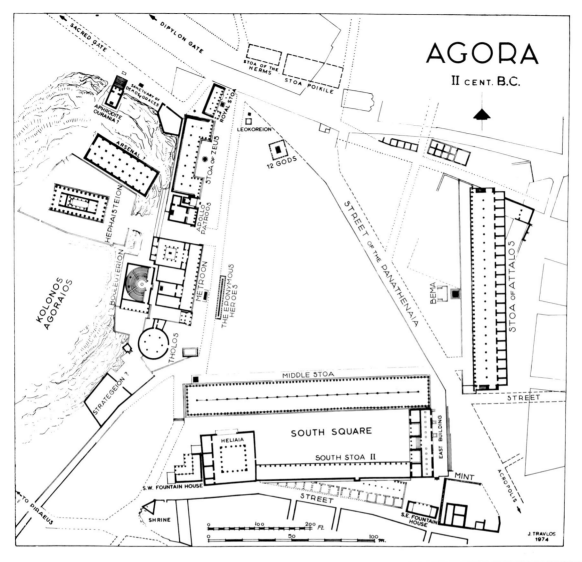

AGORA
II CENT. B.C.

Top: Fig. 11. Athens, the Agora in the late second century B.C. (photo: American School of Classical Studies, Athens).

Bottom: Fig. 12. Athens, model of the Agora c. 150 A.D., from the northwest (photo: American School of Classical Studies, Athens).

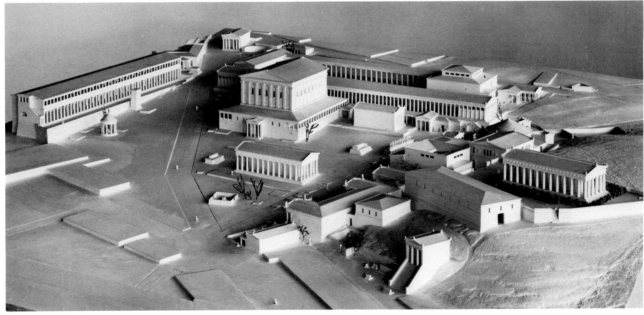

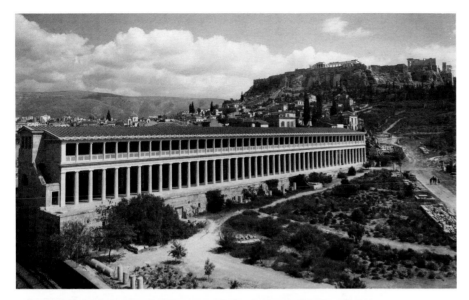

Fig. 13. Athens, Stoa of Attalos II reconstructed, from the northwest (1964) (photo: American School of Classical Studies, Athens).

Fig. 14. Athens, Stoa of Attalos II reconstructed, interior (photo: American School of Classical Studies, Athens).

signed to overshadow the older building with its squat profile and poros construction.

The Stoa of Attalos in the Agora was rebuilt in the 1950s to serve as a museum (Fig. 13).[50] The ancient remains provided ample evidence for a faithful reconstruction. The building was two-aisled and two-storied. One can now visualize how effective the Stoa was in closing one whole side of the square, and what a generous amount of space it provided for sheltered promenading. The forty-two shops that were entered from the colonnades (Fig. 14) must have been among the most fashionable in the city; their rentals were undoubtedly a tidy source of reve- nue. There is no better example of the Greek stoa in its fullest development.

The identification is certain. Athenaios (5.212e,f) mentions a Stoa of Attalos in the Agora, and among the hundreds of marbles found on the site are enough elements of the dedicatory inscription to assure the restoration of the

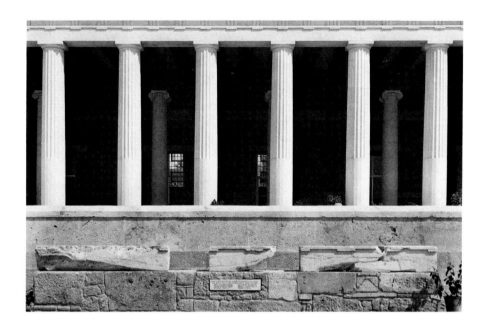

Fig. 15. Athens, Stoa of Attalos II reconstructed; remnants of dedicatory inscription in foreground (photo: American School of Classical Studies, Athens).

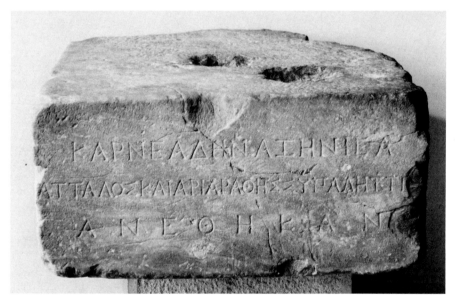

Fig. 16. Base for statue of Karneades dedicated by Attalos and Ariarathes, Agora Museum, Athens (photo: American School of Classical Studies, Athens).

donor's name: King Attalos, son of King Attalos and of Queen Apollonis (Fig. 15). The inscription was carved on the lower architrave in letters 14 centimeters high; they were painted red and were clearly legible from the square.

Among the ruins of the Stoa was found a marble base which once held a seated bronze portrait statue of Karneades, the founder of the New Academy and the leading philosopher in Athens of the second century B.C. (Fig. 16).[51] The dedicators are named in the inscription as Attalos, i.e., the builder of the Stoa, and Ariarathes, Attalos' brother-in-law, King of Cappadocia, 163-130 B.C. There is reason to believe that Attalos in his youth, and perhaps also Ariarathes, had sat at the feet of Karneades, and we may suppose that, in presenting the Stoa, Attalos thought of it as a gesture of gratitude to the city of his alma mater. In the inscription Attalos and Ariarathes are designated as citizens of the Attic deme Sypalletos. The Athenian citizenship, still a much esteemed honor, will represent the Athenians' appreciation of the benefaction.[52]

Notes

1. For a comprehensive treatment of the models, cf. H. Drerup, *Archaeologia Homerica* II O: *Griechische Baukunst in geometrischer Zeit* (Göttingen, 1969), 69-76. The architectural type of a particular model is not always certain. It seems reasonable to assume that the most familiar of the known models, those from the Argive Heraeum and from Perachora, since they were found in sanctuaries and bear some resemblance to actual temples known from excavation, do themselves symbolize temples. One can only speculate as to the occasion for the dedication. Both models date from the eighth century B.C. The models of round buildings with conical roofs found in Attic graves of the ninth and eighth centuries B.C. have been identified, no doubt rightly, as granaries. They presumably symbolize success in farming in an agricultural community. Cf. E. L. Smithson, "The Tomb of a Rich Athenian Lady, ca. 850 B.C.," *Hesperia 37* (1968), 92-97.

2. One thinks especially of the colossal Ionic temples at Samos, Ephesos, and Didyma, all begun within about one generation around the middle of the sixth century, to be followed later in the century by a great Doric temple, the Olympieion, at Athens. For the relationship among these archaic temples, cf. G. Gruben, *Die Tempel der Griechen*[2] (Munich, 1966), 220-228, 309-354.

3. E. N. Gardiner, *Olympia, Its History and Remains* (Oxford, 1925), chap. 13: "The Treasuries"; W. B. Dinsmoor, *The Architecture of Ancient Greece*[3] (London, 1950), 115-117; Gruben (note 2), 57-61

(Olympia), 77-85 (Delphi); A. Mallwitz, *Olympia und seine Bauten* (Munich, 1972), 163-179; P. Bruneau and J. Ducat, *Guide de Délos* (Paris, 1965), 67; Stephen G. Miller, "Excavations at Nemea, 1976," *Hesperia 46* (1977), 20-21; "Excavations at Nemea, 1977," *47* (1978), 67-78 (Nemea). The name "treasury" (*thesauros*) is not attested for Delos or Nemea, but the small buildings of fairly uniform design set within these sanctuaries presumably served much the same purpose as the buildings at Olympia and Delphi which are specifically referred to as treasuries by Pausanias.

4. Curtius et al., *Olympia; Ergebnisse*, II (Berlin, 1892), 128-133; H. Schleif and W. Zschietzschmann, "Das Philippeion," in E. Kunze and H. Schleif, eds., *Olympische Forschungen 1* (Berlin, 1944), 1-52; Mallwitz (note 3), 128-133; Stella G. Miller, "The Philippeion and Macedonian Hellenistic Architecture," *AthMitt 88* (1973), 189-218.

5. Stella G. Miller (note 4), 192-193.

6. C. Habicht, *Gottmenschentum und griechische Städte*[2], *Zetemata, 14* (Munich, 1970), 12-16, 245.

7. Habicht (note 6), 17-25, 245-252.

8. The inclusion of Olympias in the family group as recorded by Pausanias would be remarkable if the group was conceived in the period 338-336 B.C., whereas her inclusion was to be expected if Alexander had been responsible. Furthermore the number five, which is well attested by the actual remains as well as by Pausanias (5. 20. 9-10), calls for a central figure; this position could have been filled most appropriately by Alexander who would then have been flanked by his parents and grandparents. Cf. *Olympische Forschungen 1* (note 4), 2, 21, 51-52.

9. For a detailed study of the divine honors paid to Philip II and to other members of the Macedonian royal family, cf. E. A. Fredricksmeyer, "Divine Honors for Philip II," *TAPA 109* (1979), 39-61; for the Philippeion, cf. especially pp. 52-56. On Philip's personality and for his view of his place in the evolving Greek world, cf. most recently P. Lévêque in *Philip of Macedon*, M. B. Hatzopoulos and L. D. Loukopoulos, eds. (Athens, 1980), 176-187.

10. L. Moretti, *Olympionikai, I Vincitori negli antichi Agoni Olympici* (Rome, 1957), nos. 434, 439, 445; C. M. Kraay and M. Hirmer, *Greek Coins* (London, 1966), figs. 562-568.

11. The placing and the prominence of the treasuries are admirably shown in the restored panorama of the sanctuary in Petros G. Themelis, *Delphi* (Athens, 1980), folding plate at back.

12. "Consécration d'armes galates à Delphes," *BCH 102* (1978), 571-581; J. J. Coulton, *The Architectural Development of the Greek Stoa* (Oxford, 1976), 234 (West Stoa); Themelis (note 11), 16, 24, folding plate at back of book.

13. W. W. Tarn, *Antigonos Gonatas* (Oxford, 1913), ch. 6: "The Coming of the Celts"; M. Segré, "La più antica tradizione sull'invasione Gallica in Macedonia e in Grecia 280/79 a. C.," *Historia* (Studi storici per l'antichita classica), I (Milan, 1927), 18-42; G. Nachtergael, *Les Galates en Grèce et les Soteria de Delphes* (Brussels, 1975), 126-205. For the Athenian involvement, cf. C. Habicht, *Untersuchungen zur politischen Geschichte Athens im. 3. Jahrhundert v. Chr. Vestigia*, 30 (Munich, 1979), 87-94.

14. G. Roux, "La Terrasse d'Attale I à Delphes," *BCH 76* (1952), 141-196; Coulton (note 12), 234; Themelis (note 11), 16, 22, folding plate at back of book; E. V. Hansen, *The Attalids of Pergamon*[2] (Ithaca and London, 1971), 292-295.

15. Hansen (note 14), 46-48, 225.

16. Coulton (note 12), 66-72.

17. Roux (note 14), 149-162; T. D. Boyd, "The Arch and the Vault in Greek Architecture," *AJA 82* (1978), 94-96.

18. W. A. Laidlaw, *A History of Delos* (Oxford, 1933); H. Gallet de Santerre, *Délos primitive et archaique* (Paris, 1958); R. Vallois, *L'architecture hellénique et hellénistique à Délos*, I and II (Paris, 1944, 1966); *Guide de Délos* (note 3); P. Bruneau in *Princeton Encyclopedia of Classical Sites* (Princeton, 1976), 261-264.

19. F. Courby, *Exploration archéologique de Délos* V: *Le Portique d'Antigone* (Paris, 1912); *Guide de Délos* (note 3), 92-93; Coulton (note 12), 231. For the political significance of the stoa, cf. Tarn (note 13), 388-391.

20. R. Vallois, *Exploration archéologique de Délos* VII: *Le Portique de Philippe* (Paris, 1923); *Guide de Délos* (note 3), 75-76; Coulton (note 12), 23-24.

21. H. A. Thompson and R. E. Wycherley, *The Athenian Agora* XIV: *The Agora of Athens* (Princeton, 1972), 96-103; Coulton (note 19), 81-85, 222.

22. Courby (note 19), 37-40; *IG* XI.4, 1095; F. Durrbach, *Choix d'inscriptions de Délos* (Paris, 1921), no. 35. On the standing of the Antigonids in the Aegean in the third century B.C., cf. Habicht (note 6), 58-73, 256-257.

23. Courby (note 19), 74-83; *IG* XI.4, 1096; Durrbach (note 22), no. 36.

24. Vallois (note 20), 154-166; *IG* XI.4, 1099; Durrbach (note 22), no. 57. Neither the archaeological nor the historical evidence has yet permitted a firm dating within the long reign of Philip V: 221-179 B.C.

25. Vallois (note 20); *Guide de Délos* (note 3), 76; Coulton (note 12), 234; Hansen (note 14), 290.

26. A. Conze and others, *Archäologische Untersuchungen auf Samothrake*, I and II (Vienna, 1875 and 1880); K. Lehmann, *Samothrace—A Guide to the Excavations and the Museum*[4] (Locust Valley, N.Y., 1975); P. W. Lehmann in *Princeton Encyclopedia of Classical Sites* (Princeton, 1976), 804-806 (with bibliography). For a historical survey of island and sanctuary, cf. P. M. Fraser, *Samothrace* II i: *The Inscriptions on Stone* (New York, 1960), 3-17.

27. Fraser (note 26), 4-11, has warned against equating royal beneficence toward the Sanctuary with political domination of either the Sanctuary or the city of Samothrace. The same applies, of course, to the other great sanctuaries of Greece through most of their histories. For Delos, cf. C. Habicht (note 6), 70.

28. Conze and others (note 26), 35-45; *Guide*[4] (note 26), 88-89; J. R. McCredie, "Samothrace: Preliminary Report on the Campaigns of 1965-1967," *Hesperia 37* (1968), 212-216; "Samothrace: Supplementary Investigations, 1968-1977," *Hesperia 48* (1979), 2-6. For the dedicatory inscription, cf. Fraser (note 26), no. 11, and, more recently, G. Roux, "Samothrace, le sanc-

tuaire des Grands Dieux et ses mystères," *Bull. de l'Association Guillaume Budé 1* (1981), 2-23.

29. G. M. A. Richter, *Portraits of the Greeks,* III (London, 1965), 261-263, fig. 1781; Kraay and Hirmer (note 10), 382, no. 801, pl. 218. On Arsinoe, cf. Gabriella Lonzega, *Arsinoe* II: *Università degli studi di Padova, Pubblicazioni dell'Istituto di Storia Antica,* VI (Rome, 1968).

30. *Guide*[4] (note 26), 90-92; McCredie, *Hesperia 37* (note 28), 216-234; *48* (note 28), 6-8.

31. Conze and others (note 26), I, 77-85, pls. 29, 53-68; K. Lehmann-Hartleben, "Second Campaign of Excavations in Samothrace," *AJA 44* (1940), 336-352; K. Lehmann, "Samothrace: Third Preliminary Report," *Hesperia 19* (1950), 7-13; K. Lehmann, "Samothrace: Fourth Preliminary Report," *Hesperia 20* (1951), 2-6; McCredie, *Hesperia 48* (note 28), 27-35; *Guide*[4] (note 26), 54-58. For the inscription, cf. Fraser (note 26), no. 10.

32. K. Lehmann and Denys Spittle, *Samothrace 4* ii: *The Altar Court* (New York, 1964); *Guide*[4] (note 26), 75-77. Oscar Broneer, in his review of this book, has shown good reasons for restoring the structure as a roofed building, probably a meeting place: *AJA 71* (1967), 96-98, contra P. W. Lehmann (note 26), 429-432. The discovery of the name of Philip Arrhidaios on the exhedra above the circular paved area strongly supports the restoration of the same, as proposed by the excavators, on the Altar Court rather than the "Adaios" favored by Fraser (note 26), no. 9.

33. T. Wiegand and H. Schrader, *Priene, Ergebnisse der Ausgrabungen* (Berlin, 1904); G. Kleiner, "Priene," *RE, suppl. 9* (1962), cols. 1181-1221; M. Schede, *Die Ruinen von Priene*[2] (Berlin, 1964); *Princeton Encyclopedia of Classical Sites* (note 26), s.v. "Priene" (G. E. Bean).

34. E. L. Hicks, *Ancient Greek Inscriptions in the British Museum,* 3 (Oxford, 1890), 6; M. N. Tod, *Greek Historical Inscriptions* (Oxford, 1948), no. 194.

35. Tod (note 34), no. 185.

36. F. Hiller v. Gaertringen, *Inschriften von Priene* (Berlin, 1906), 108, 75; C. Habicht (note 6), 17-18, 245 ff. Later the cult of the Emperor Augustus was added to that of Athena in the famous old temple: Hiller, *Inschriften*, nos. 157, 158. We are not here concerned with the details of the later building history of the temple which have been the concern of a reexamination of the structure by Otto Bauer, "Beobachtungen am Athenatempel in Priene bei den Bestandsaufnahmen 1965 und 1966," *BonnJbb 169* (1969), 117-129; "Vorläufiger Bericht über die Neuarbeitung des Athenatempels zu Priene in den Jahren 1965/66," *IstMitt 18* (1968), 212-220. Joseph C. Carter is engaged in a detailed study of the remnants of the cult image and ceiling sculptures. See "The Date of the Sculptured Coffer Lids from the Temple of Athena Polias at Priene" in *Studies in Classical Art and Archaeology, A Tribute to P. H. von Blanckenhagen,* G. Kopcke and M. B. Moore, eds. (Locust Valley, N.Y., 1979), 139-151.

37. For the dating of the coins of the pretender Orophernes cf. B. Simonetta, "Notes on the Coinage of the Cappadocian Kings," *NC 1* (1961), 9-50 and O. Mørkholm, "Some Cappadocian Problems," *NC 2* (1962), 407-411. Orophernes' involvement with the temple is to be dated with assurance c. 157 B.C. on the evidence of Polybius 32. 10.

38. Wiegand and Schrader (note 33), 192-203; M. Schede, "Heiligtümer in Priene," *JdI 49* (1934), 97-103; idem (note 33), 48-57; Coulton (note 12), 277-278.

39. Hiller (note 36), no. 204 and p. 311; M. Schede, *JdI 49* (note 38), 106-108.

40. On the attitude of the Hellenistic rulers toward Athens, cf. W. S. Ferguson, *Hellenistic Athens* (London, 1911), 297-311. Cf. also M. Rostovtzeff, *The Social and Economic History of the Hellenistic World* (Oxford, 1941), passim, for commercial and social relations. On Athenian relations with the Ptolemies, cf. M. Thompson, "Ptolemy Philometor and Athens" in *ANSMN 11* (1964), 119-129. Much light has been thrown on the political relations between Athens, the Ptolemies, and the Antigonids in the first half of the third century by honorary decrees praising Kallias and Phaidros, sons of Thymochares of the deme of Sphettos; the decree for Kallias dates from 270-269 B.C., that for Phaidros (*IG* II² 682) from 255-254 B.C. Cf. T. L.

Shear, Jr., *Kallias of Sphettos and the Revolt of Athens in 286 B.C.* (*Hesperia,* suppl. 17., Princeton, 1978). Christian Habicht has dealt recently with many of the city's political and international problems in the third century in *Untersuchungen zur politischen Geschichte Athens im 3. Jahrhundert v. Chr.,* Vestigia Bd. 30 (Munich, 1979).

41. W. Judeich, *Topographie von Athen²* (Munich, 1931), 92, 353-354; J. Delorme, *Gymnasion* (Paris, 1960), 146-147; R. E. Wycherley, *The Athenian Agora* III: *Literary and Epigraphical Testimonia* (Princeton, 1957), 142-144. On the attribution, cf. M. Thompson (note 40) and Christian Habicht in a forthcoming volume of *Hypomnemata.*

42. Judeich (note 41), 78, 96, 17, 306; J. Travlos, *Pictorial Dictionary of Ancient Athens* (London, 1971), 387-391.

43. Judeich (note 41), 65, 94, 99, 101, 382-384; Travlos (note 42), 402-411.

44. For Antiochos' relations with Athens, cf. Ferguson (note 40), 302-305.

45. Judeich (note 41), 306-319; M. Bieber, *The Greek and Roman Theater²* (Princeton, 1961), passim; Travlos (note 42), 537-552.

46. R. Bohn, *Die Altertümer von Pergamon* IV: *Die Theaterterrasse* (Berlin, 1896); Bieber (note 45), 62-63, 120, figs. 243-247, 461-462; E. V. Hansen (note 14), 276-279.

47. Judeich (note 41), 325-326; Travlos (note 42), 523-526; Coulton (note 12), 225; Hansen (note 14), 295.

48. Among the earliest Pergamene gifts to Athens was a garden setting in the Academy constructed by King Attalos and named the Lakydeion after Lakydes who used it as a place for teaching (Diogenes Laertius 4. 60). Since Lakydes was head of the Academy 242-216 B.C. the establishment presumably dates from that period, and so must have been the work of Attalos I (241-197 B.C.). In 200 B.C. Attalos was given a tumultuous welcome by the citizens when he appeared in Athens to join the Romans and the Rhodians in the defense of the city against Philip V (Polybius 16. 25; Ferguson [note 40], 271-277). It was presumably in gratitude for this timely intervention that the new Athenian tribe Attalis was formed, and a bronze statue of the monarch was added to the company of the Eponymous Heroes in the Athenian Agora (Pausanias 1.5.5; T. L. Shear, Jr., "The Monument of the Eponymous Heroes in the Athenian Agora," *Hesperia* 39 [1970], 199f.). It is probably also to Attalos I and to the same occasion that we should attribute the famous groups of sculpture seen by Pausanias (1.25.2) on the Acropolis at Athens: Theseus vs. Amazons, Athenians vs. Persians, Pergamenes vs. Gauls, Gods vs. Giants. Pausanias refers the monument simply to Attalos, and some scholars have preferred to identify the donor with Attalos II (159-138 B.C.). But it is hard to believe that a Pergamene ruler would have chosen to celebrate in such a setting any Pergamene victory other than the decisive triumph won by Attalos I over the Gauls at the Sources of the Kaikos at some time before 230 B.C. (Livy 38.16; Hansen [note 14], 28, 59, 306-314). A date within the reign of Attalos II would remove the monument very far from the event. Cf. the admirable review of the evidence by A. Stewart, *Attika: Studies of Athenian Sculpture of the Hellenistic Age,* Society for the Promotion of Hellenic Studies, suppl. paper no. 14 (London, 1979), 19-23. Thus already within the time of Attalos I Pergamon was represented in three very prominent parts of Athens: the Acropolis, the Agora, and the Academy.

49. Thompson and Wycherley (note 21), 21-33.

50. H. A. Thompson, *Agora Picture Book no. 2: The Stoa of Attalos II in Athens* (Princeton, 1959); Travlos (note 42), 505-522; Thompson and Wycherley (note 21), 103-108; Coulton (note 12), 219; Hansen (note 14), 295-298.

51. IG II² 3731; H. A. Thompson, "Excavations in the Athenian Agora, 1949," *Hesperia* 19 (1950), 318f.; Thompson and Wycherley (note 21), 107; Richter (note 29), II, 250, no. 8.

52. On the extraordinarily close links between Pergamon and the Athenian schools of philosophy, cf. Hansen (note 14), 396-397.

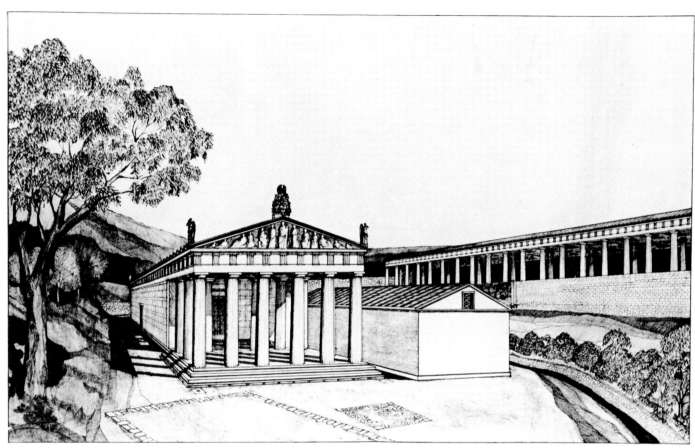

Fig. 9. The Hieron, Samothrace, at left; the Stoa at right, third century B.C.: restored perspective (after *Samothrace*, 3[III], pl. CX).

Macedonia and Samothrace:
Two Architectural Late Bloomers

ALFRED FRAZER

*Department of Art History and Archaeology,
Columbia University*

THE EXHIBITION *The Search for Alexander* focuses on the most brilliant examples of Macedonian material culture during the hundred years from 350 to 250 B.C. It eloquently documents the figural and decorative arts of the culminating century of Macedonian history, a period in which the northward shift of wealth and power brought about a corresponding change in the locus of the most significant center of artistic patronage in the Hellenic peninsula. One would expect a similar move in the realm of architecture, the most capital-intensive of the fine arts. But even were architecture a portable art, it would be difficult if not impossible to document equivalent Macedonian achievements in the art of building.

The reason is simple. With the exception of the ruinous palace at Vergina, for our knowledge of which we owe much to Manolis Andronikos and his colleagues, and the scarcely less well-preserved urban structures of the excavated portions of Pella, made known to us through Photios Petsas' work, our knowledge of Macedonian building of this critical period is restricted to the interred architecture of the Macedonian tombs now being revealed through Professor Andronikos' efforts.[1] Tempting as is the equation "as in death, so in life," it is natural to desire a knowledge of more buildings above ground. This is especially true of monumental religious buildings, the glory of earlier Greek architecture.

The later fourth- and early third-century buildings in the Sanctuary of the Great Gods at Samothrace, a mountainous island some forty kilometers off the Thracian coast and some one hundred forty kilometers east of the Strymon River, taken as a convenient boundary between Macedonia and Thrace, offer perhaps the best conspectus of nearby monumental religious constructions coexistent with the Macedonian nekropoleis. In the context of this symposium they assume an additional importance, in that, on the basis of epigraphical evidence or reasonable inference, the majority of the structures erected in the Samothracian Sanctuary during the period of the chronological focus of the Alexander exhibition were the products of Macedonian royal patronage.[2]

The Samothracian Sanctuary is sufficiently well-known that it is unnecessary to describe the hilly topography which insured that its layout would be that of the episodic scatter-pattern more often found in sanctuaries of the archaic and classical periods than that of the increasing regularity one expects to find in later Hellenistic sanctuaries such as Kos (Fig. 1).

Although excavation has revealed evidence of substantial architecture from the sixth, fifth, and early fourth centuries B.C., the principal Samothracian monuments were erected in the century that most concerns our symposium. It is important to recognize that both Macedonia and Samothrace came to enjoy the architectural fruits of wealth and power at the same time—beginning with the reign of Alexander's father —and having no previous monumental architectural tradition, both faced common problems and enjoyed comparable opportunities to adopt and to exploit the enticing models available to them in the great architectural traditions in the regions to the south and east. I will review a number of Samothracian buildings that exhibit significant similarities and differences to and with contemporary Macedonian work.

The first is an hypaethral enclo-

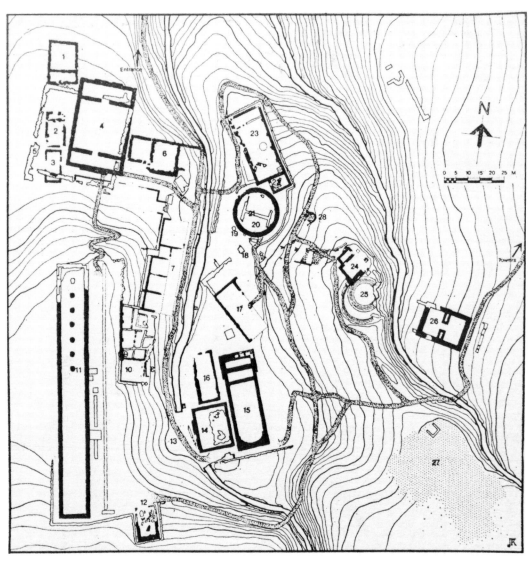

Fig. 1.　Archaeological plan of the Sanctuary of the Great Gods, Samothrace (after *Hesperia 48,* 1 [1979], fig. 1). Monuments mentioned in text: 11. Stoa, 14. Altar Court, 15. Hieron, 17. Temenos, 20. Rotunda of Arsinoe II, 24. hexastyle Doric Dedication of Philip III and Alexander IV, 25. circular platea, 26. Propylon of Ptolemy II, 28. small circular monument.

sure now called the Temenos marked by an asymmetrically placed Ionic, Pi-shaped propylon on its eastern face (Fig. 2).[3] Its origin is placed around 340 B.C. by its excavator, Phyllis Williams Lehmann, and attributed by her to the largesse of Philip II of Macedon, who was an initiate in the Samothracian cult and who first encountered his consort Olympias at the sanctuary. Moreover, she attributes the building's design to Skopas of Paros.

The marble propylon of the Temenos is not an integral part of the structure it abuts, but is affixed to it (Fig. 3). It is not essential to the

Temenos' integrity physically nor to its function, whatever that may have been. Its form recalls Pishaped structures such as the Doric Stoa of Zeus Eleutherios at the northwestern corner of the Athenian Agora which was laid out in the closing years of the Perikleian Age (Fig. 4).[4] The stoa has been characterized by Thompson and Wycherley as "probably the best result which an architect could achieve if he wished to make of a stoa a complete and self-contained unit." Although Thompson and Wycherley disagree, I think the same may be said of the Doric winged stoa in the Agora of Tha-

sos which is dated by Roland Martin to c. 330-320 B.C. (Fig. 5).[6] On neighboring Samothrace, the Temenos and its propylon present the contrary case: the winged propylon is a façade for façade's sake. As Martin has pointed out, the conception of the façade as an element distinct in structure and form from the building of which it forms the face is a fundamental characteristic of Macedonian tombs. He has also called attention to a comparable phenomenon above ground in the late fourth-century decorative façade that Pythippos, the son of Peisistratos, literally applied to the late sixth-

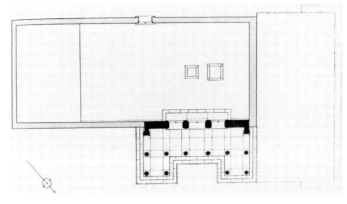

Fig. 2. The Temenos, Samothrace, c. 340 B.C.: restored plan (after P. W. Lehmann, *Skopas in Samothrace,* fig. 8).

Fig. 3. The Propylon of the Temenos, Samothrace, c. 340 B.C.: restored elevation (after P. W. Lehmann, *Skopas in Samothrace,* fig. 15).

Fig. 4. The Stoa of Zeus Eleutherios, Agora, Athens, c. 430 B.C.: restored model.

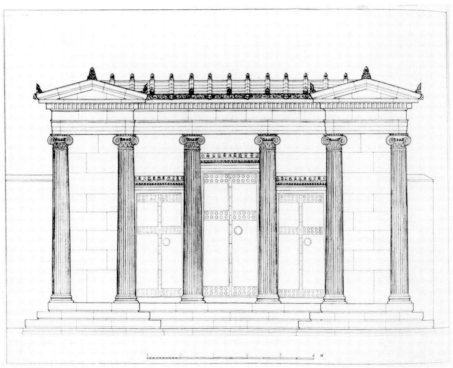

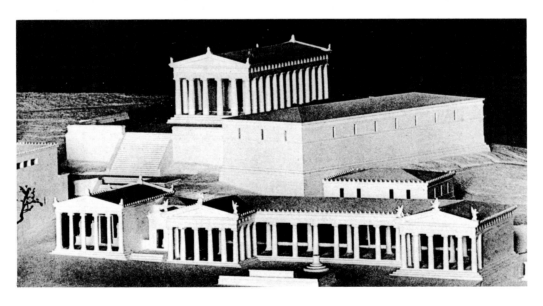

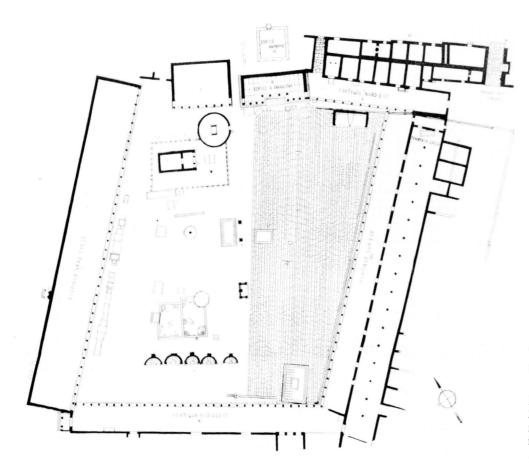

Bottom: Fig. 6. The Gate of Zeus and Hera, late sixth century B.C., and façade of Pythippos, late fourth century B.C., Thasos (after *RA* [1968], 171, fig. 1).

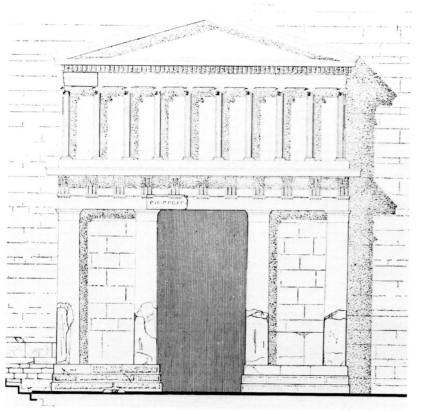

century Gate of Zeus and Hera in the western trace of the wall of Thasos (Fig. 6).[7] Its date falls comfortably within the period of the construction of the Samothracian Temenos and the earlier Macedonian tombs. In an article on façade architecture and vista terraces in Macedonian architecture, Demetrios Pandermalis suggested that we might also view the propylon of the Vergina Palace in a similar context.[8]

The Temenos was followed by three closely related Doric structures, two of which are at the core of the sanctuary. Of the three, two—the monumental altar and its architectural enframement and a prostyle, hexastyle structure on the Eastern Hill near the entrance to the sanctuary—are linked by inscriptions to Philip Arrhidaios, Alexander's older half-brother and

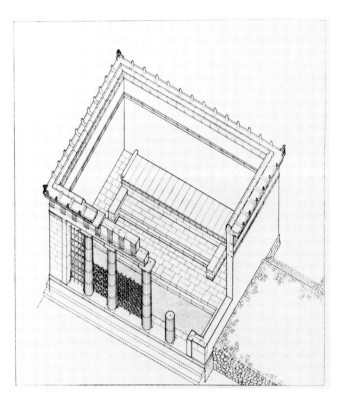

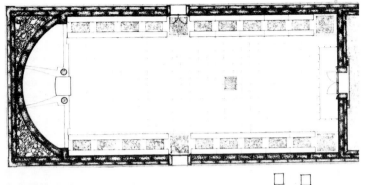

Left: Fig. 7. The Altar and Court, Samothrace, eighth decade of the fourth century B.C.: restored isometric (after *Samothrace,* 4[II], frontispiece).

Right: Fig. 8. The Hieron, Samothrace, beginning of the eighth decade of the fourth century: restored plan (after *Samothrace,* 3[III], pl. CII).

surrogate for religious matters.[9] Within the latter, according to the inscription, Arrhidaios had succeeded to the Macedonian throne in association with Alexander IV Posthumous.[10] The third and largest of these buildings, the principal hall of initiation called the Hieron, cannot yet be attributed to an individual patron, but all physical indications place its beginnings to the 320s. Given its size and its costly Thasian marble superstructure, it is difficult to envisage on that site at that time a patron other than a member of the Macedonian royal house capable of making such a capital investment.

Dedicated by Arrhidaios alone and before 323, the altar—particularly with its enclosure—was a Doric version of the archaic Ionic type of architecturally framed monumental stepped altar more or less of the Samian type (Fig. 7).[11] Stella Miller, in her doctoral dissertation—a work fundamental to any further study of Macedonian architecture—has called attention to the preponderance of Doric in the nascent architecture of Macedon, while giving due weight to the considerable contribution of mainland Ionic.[12] From this point of view, we may suggest that Arrhidaios and his staff, traveling safely in the baggage train of Alexander's army, transformed the vivid impression they gained of Ionic altars in Asia Minor into an equivalent mainland Doric version.

As for the Hieron hard by the Altar, Lehmann, the excavator of this grandiose, internally apsidal structure, finds its stylistic affinities about equally divided between Asia Minor and Macedonia (Figs. 8, 9).[13] Certainly, its elaborately painted plaster interior is related to contemporary work in the latter area (Fig. 10).[14]

The dedication by Arrhidaios and Alexander Posthumous on the sanctuary's Eastern Hill, which abuts an earlier circular platea, recalls in its plan those of the archaic treasuries of Olympia, Delphi, and elsewhere which were then past fashion in Greece proper. Relevant here are Miller's numerous citations of Peloponnesian influence on the formation of monumental architecture in Macedonia.[15] The building is unique in the Samothracian Sanctuary in that, whereas its sides and rear were constructed of the ubiquitous Thasian marble, its façade was of a finer marble—probably Pentelic—perhaps yet another instance of façade architecture.[16] The pavement of this build-

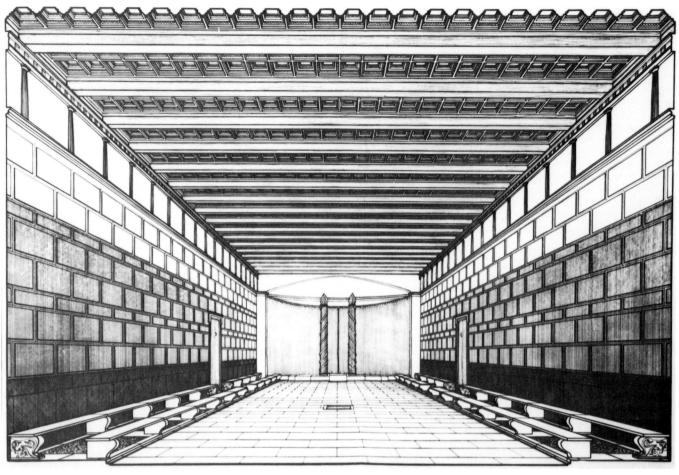

Fig. 10. The Hieron, Samothrace: restored interior perspective (after *Samothrace,* 3[III], pl. CVI).

ing was composed of amorphous bats of smoothed white marble set in a pink-tinted mortar. A similar paving is found in the stately hall M_1 in the Vergina Palace.[17] In each the result is strikingly like an enlarged slice of the fatty Italian sausage called *motardella.* Unattractive as this pavement may be to us, it was evidently admired in Samothrace and Macedonia in the last quarter of the fourth century, and I suspect that we will find additional examples in the future.

The Hieron and the Dedication of Philip III and Alexander IV have yielded abundant evidence of polychromatic wall painting of the so-called First Style, and so has the later stoa on the Western Hill.[18] In its wealth of painted plaster walls, Samothrace shares an affinity with many of the Macedonian works that we know. It is true that they exhibit none of the variety of subject matter that make the decoration of Macedonian tombs so exciting; the Samothracian material is rigorously architectural. But this is understandable in view of their different functions. One would hardly expect illustrative murals on the walls dedicated to a mystery cult. Masonic lodges today are similarly aniconically decorated.

The works begun in the twenties—the Hieron, the Altar, and the Dedication of Philip and Alexan-

der—all adhere to the Doric canon so widely, but by no means exclusively, affirmed in Macedonia. The strength of the Doric conviction then prevailing at Samothrace is especially felt in the enclosure of the Altar where the traditional Ionic rendering of this form was replaced by Doric, although Ionic could as easily have been employed. Is it possible that the three buildings were conceived as parts of a conscious program? If so, we would be faced with a propagandistic manipulation of patronage of whose broader implications Homer Thompson has written in this volume.

Following the furor of activity

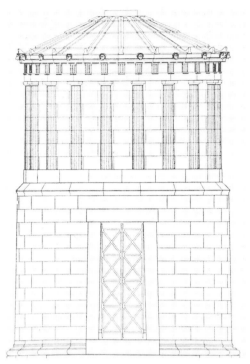

Fig. 11. Round structure, Samothrace, early third century B.C.: restored elevation (after *Hesperia 48*, 1 [1979], 42, fig. 41).

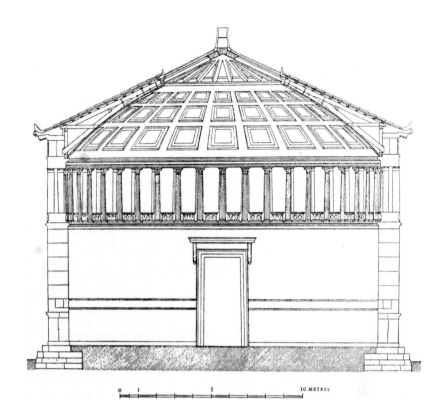

Fig. 13. The Rotunda of Arsinoe II, Samothrace: restored cross-section (after Conze, *Untersuchungen auf Samothrake*, I, pl. LV).

Fig. 12. The Rotunda of Arsinoe II, Samothrace, 289-281 B.C.: restored perspective (after Conze, *Untersuchungen auf Samothrake*, I, pl. LIV).

between 340 B.C. and the end of the century, there followed a fallow period of half a generation, as far as we know marked only by the construction of a miniature round structure to the northwest and downhill from the buildings of Philip and Alexander and of unknown patronage (Fig. 11).[19] This little building exhibits a high cylindrical wall rising from a molded base and punctuated by a door surmounted by a blind Doric order of engaged half-columns. Its function has not been determined but few, I think, would quarrel with the comparison that its excavator, James McCredie, has made with monumental tombs or cenotaphs

of late classical and Hellenistic Asia Minor.[20]

This little round tower, as McCredie has pointed out, seems to have been a paradigm for the next addition to the sanctuary, the monumental rotunda given to Samothrace by Arsinoe II while she was still the consort of Lysimachus, sometime between 289 and 281 B.C. (Figs. 12, 13).[21] With an outer diameter of over twenty meters, the rotunda had neither an external peristyle nor a freestanding interior colonnade; it remains a unicum in the corpus of Greek buildings. Its cylindrical drum was surmounted by a kind of clerestory—partially blind and partially

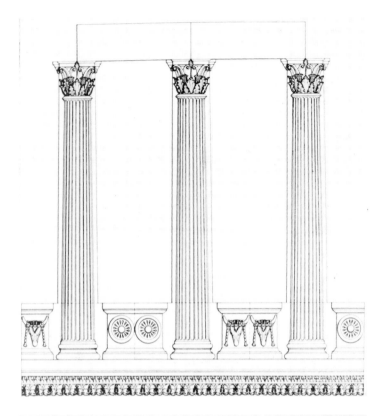

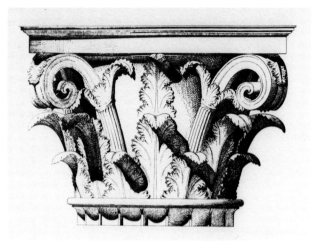

Left to right, top to bottom: Fig. 14. The Rotunda of Arsinoe II, Samothrace: restored interior order (after Oberleitner et al., *Funde aus Ephesos und Samothrake*, 140, fig. 129).

Fig. 15. The Temple of Athena Alea, Tegea, 345-340 B.C.: restored Corinthian pilaster capital (after Hill, *The Temple of Zeus at Nemea*, pl. 21, 2).

Fig. 16. The Propylon of Ptolemy II, Samothrace: restored plan.

open—with external Doric pilasters and internal Corinthian half-columns, whose capitals, in their proportions and general design, suggest a stimulus from Tegea and / or Nemea (Figs. 14, 15).[22] The interior of Arsinoe's Rotunda offers the first known appearance of the Corinthian order on Samothrace, and it is interesting to recognize its probable source in the

context of the contribution of Peloponnesian design to the formation of monumental Macedonian architecture. We will later return to the Corinthian problem. As novel as the rotunda's design, it is even more remarkable for the technical skill of its circular wooden-framed roof, spanning over seventeen meters.

The three circular structures

thus far unearthed in the Samothracian Sanctuary—the open platea, the cenotaphlike structure, and Arsinoe's Rotunda—are unique in the architecture of Greek sanctuaries, but they find interesting resonance in the circular forms found in Macedon or in works of Macedonian patronage beginning with the Philippeion at Olympia, and including circular forms at the Vergina Palace and Pella. Professor Miller has emphasized the apparent predilection for circular forms in Macedonia and has characterized all of them as secular; it may be that the Samothracian structures stand as their counterparts in the religious realm.[23]

The monumental Thasian marble Propylon of Ptolemy II, so ascribed on the basis of its inscribed epistyles, gave access to the sanctuary across the torrent that formed the eastern sacred boundary of the sanctuary (Fig. 16).[24] The formula of these inscriptions permits the amphiprostyle, hexastyle structure

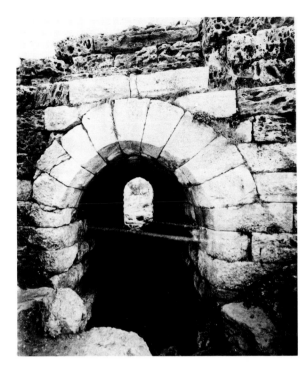

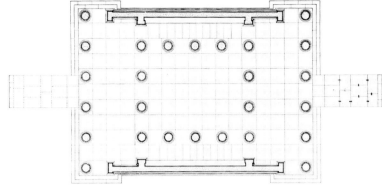

Fig. 18. The North Propylon, Epidauros, late fourth century B.C. (?): restored plan (after Roux, *L'architecture de l'Argolide,* pl. 73).

Fig. 17. The Propylon of Ptolemy II, Samothrace: southern opening of vaulted tunnel through foundations.

to be dated to 285-280 B.C., that is coeval with or, more likely, just after the beginning of Arsinoe's Rotunda. The concurrent dates, similar technical features, and decorative motifs suggest that the two buildings were the work of a common atelier and possibly the same architect, and further, that Arsinoe, still Lysimachus' consort and queen in both Thrace and Macedon, was the effective patron of both buildings.

As the Rotunda displayed its designer's technical virtuosity and courage in its roof, so the Propylon exhibits its designer's engineering skill and hardihood in the vaulted tunnel, two meters wide, that conducted the waters of the boundary torrent diagonally through its substructure (Fig. 17). Built in the late 280s, the tunnel is the first and so far the only example of this form of construction at Samothrace.[25] It had been preceded by the vaults of Macedonian tombs of greater span.[26] Formally, it is comparable

to the vaulted passage in the Nemean stadium recently excavated by Stephen Miller and dated by him to the 320s.[27] Again connections are seen between Macedonia, Samothrace, and the Peloponnese.

Another Peloponnesian aspect of the Ptolemaic Propylon is its plan, reminiscent of that of the North Propylon at Epidauros and the width of which—measured on the centerlines of its outer walls—is identical to that of the Epidaurean gatehouse dated by Heinrich Bauer to the late fourth century (Fig. 18).[28] Epidaurean reflections figure prominently in Stella Miller's analysis of nascent Macedonian architecture.[29] The soaring marble superstructure of the Propylon exhibits a number of interesting peculiarities, most notable of which is the presence of an Ionic eastern façade and a western Corinthian façade; the building was designed by an architectural equivalent of the Andokides Painter.

The Ionic capitals are of the

form distinguished by a canal decorated plastically by a calyx and tendril or a flower and tendril motif (Fig. 19). It is a form that is so far undocumented in Macedonia, but is well represented in northwestern Asia Minor and related areas —Sardis, the Smintheion in the Troad, Pergamon, Aigai, and Kallatis on the Black Sea coast of Romania (Figs. 20, 21).[30] I wonder if other examples were to be seen in Lysmacheia so near to the Smintheion. One wonders also whether the idea of the decorated canal, of which the Samothracian example is one of the earliest representatives, might not be a conscious revival of that type of capital whose canal was centered with a carved rosette as we know it from the early fifth-century B.C. capitals of the temple of the Parthenos, a Thasian dedication at ancient Neapolis (Kavalla) (Fig. 22).[31]

Although the Propylon's Ionic capitals and their corresponding pilaster capitals have their affinities

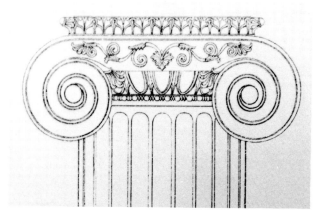

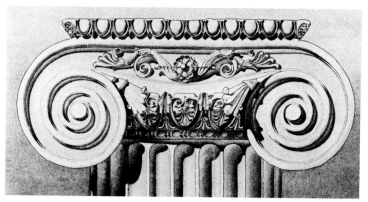

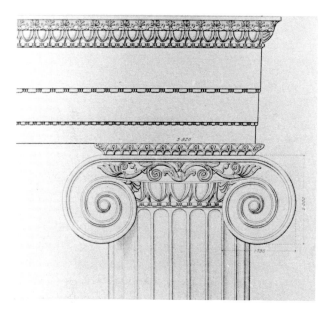

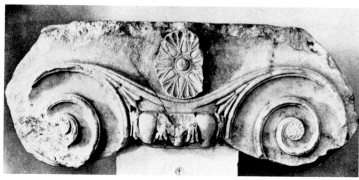

Left to right, top to bottom: Fig. 19. The Propylon of Ptolemy II, Samothrace: restored Ionic capital of east façade (after Conze, Hauser, Benndorf, *Untersuchungen auf Samothrake*, II, pl. xxv).

Fig. 20. The Temple of Artemis, Sardis: restored Ionic capital, early third century B.C. (after Butler, *Sardis*, II, pl. 13).

Fig. 21. The Temple of Apollo Smintheus, Chrysa, c. 200 B.C.: restored Ionic capital (after *Antiquities of Ionia*, IV, pl. xxix).

Fig. 22. The Temple of the Parthenon, Kavalla (Neapolis), early fifth century B.C.: Ionic capital, Archaeological Museum, Kavalla (after Lazarides, *Neapolis—Christoupolis—Kavala*, pl. 33).

with the area immediately to the east of the island, the column bases are plinthless Attic-Ionic, unlike all other known columns of the type, the bases of which are Asiatic of one form or another. The Asiatic base is likewise undocumented in Macedonia.

Turning to the Propylon's Corinthian façade—and it should be noted that in dealing with a large scale version of the Nike Temple with variant façades we again confront the phenomenon of façade architecture—we find that its capitals are related in scheme and certain motifs to those of Arsinoe's Rotunda but are more *soigné* and

designed on different proportions, probably prompted by their greater scale, their exterior placement, and their different viewing angle (Fig. 23). The corresponding anta pilaster capitals are of the sofa type, otherwise undocumented at Samothrace but exhibited in at least four buildings in Macedonia (Fig. 24).[32] Of apparent Peloponnesian origin, the sofa capital seems to have died out in its homeland in the Hellenistic period, but here we have it alive and well in North Greece. It is interesting that at Samothrace it appears in association with a freestanding Corinthian order. Corinthian is not

firmly documented in Macedonia. A possible exception is the well-known fragment from the Vergina Palace published by Heuzey and Daumet and interpreted by them and accepted by Roux as coming from a Corinthian pilaster capital.[33] The identification has legitimately been questioned by Miller.[34] However, the discovery of the connection of a Corinthian capital and a responding sofa capital at Samothrace might suggest that we look at Vergina again. If Heuzey's identification is correct, we have a very early example of the later normal Corinthian pilaster capital, that is, the simple ortho-

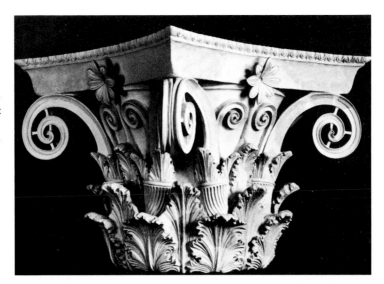

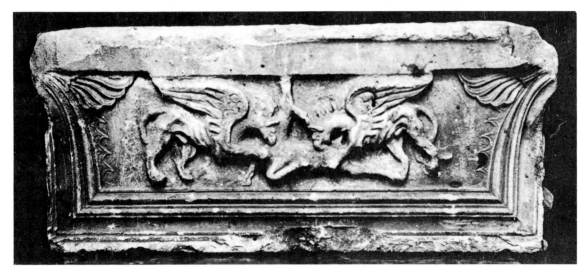

graphic projection of a Corinthian capital in the round onto a flat plane. Such a solution could not have obtained at Samothrace as it would have produced a pilaster capital much higher than the Ionic pilaster capital to which it had to correspond. Time does not permit the interjection of Didyma into this discussion.

The griffin motif on the Samothracian sofa capital requires a note. This predatory hybrid creature is well-known in Greek art, and its Eastern origins are no less well-known. But its form at Samothrace, with the spiked dorsal fin, is of a particular form first docu-

mented in the late archaic coinage of Teos from whence it passed to the coinage of the Tean colony of Abdera, immediately opposite Samothrace on the mainland shore. Subsequently it became widespread in the northern Aegean cultural basin and its northward extension into the Black Sea littoral.[35] I may cite here one example in Scythian gold of the fourth century B.C., and one in a pebble mosaic from a round building at Pella.

We may conclude with one final Samothracian building, the attenuated Doric stoa on the Western Hill of the Sanctuary (Fig. 9), a work

that its excavator, James Mc-Credie, would place in the same half-century as the Rotunda and the Propylon.[36] We do not know its patron, but given the political situation it is difficult to think of a donor beyond the confines of Macedonia, particularly since a column honoring Philip V of Macedon was erected in front of it around 200 B.C.[37] This stoa was so long that an extensive terrace and sustaining wall were required. The result was a building that provided a scenographic background to the principal structures of the Sanctuary in good Hellenistic fashion and which, at the same time, offered

the best possible opportunity to survey the Sanctuary from a dignified distance and from a commanding height. The stoa's role as a viewing platform is of special interest to us in the light of Demetrios Pandermalis' study of such viewing platforms in Hellenistic royal architecture, of which the platform of the Vergina Palace is a notable example.

From the Vergina platform only royal personages and their courtiers viewed the plain below. At Samothrace the view was available to every initiate as well as to at least one king, Philip V, whose brazen image, as we have said, surveyed the Sanctuary below and beyond the terrace—much as the images of Ptolemy Philadelphus and Arsinoe surveyed the Altis at Olympia.

Samothrace offered Macedonian notables an asylum of variable security. Arisinoe sought refuge there from the wrath of Keraunos, so successfully that her next public appearance was in Alexandria at the side of Philadelphus. The image of Philip V was less fortunate, for after the king's death it fell victim to the wrath of Rome, either melted down on the spot or, more likely, carried to the new center of power as an item of triumphal booty. Finally, in the Samothracian-Macedonian story, we encounter Perseus, Macedon's last king, who fled from the disastrous field of Pydna for asylum at Samothrace, where he was captured and taken prisoner to walk in the *pompa triumphalis* in Rome. Thereby, one episode in the history of art following that of wealth and power came to an end, and another began.

Notes

1. Vergina Palace: M. Andronikos, Ch. Makaronas, N. Moutsopoulos, and G. Bakalakis, *To anaktoro tēs Verginas* (Athens, 1961); M. Andronikos, *Vergina, the Prehistoric Necropolis and the Hellenistic Palace,* Studies in Mediterranean Archaeology, 13 (Lund, 1964), 7; idem, *Vergina,* Keramos Guides (Athens, 1972), 11-12; Pella: Ph. Petsas, "Pella," *Princeton Encyclopedia of Classical Sites* (Princeton, 1976), 685 ff. with bibliography through 1971; T. Hadzisteliou Price, "An Enigma in Pella: the Tholos and Herakles Phylakos," *AJA 77,* 1 (1973), 66-71; Vergina Tombs: M. Andronikos, "Vergina: oi Basilikoi Taphoi tēs Megales Toumbas," *AAA 10* (1977), 1-40; idem, "The Royal Graves in the Great Tumulus," *AAA 10* (1977), 40-72.

2. Karl Lehmann, *Samothrace—A Guide to the Excavations and the Museum,* 4th rev. ed. (Locust Valley, N.Y., 1975); James R. McCredie, "Samothrace: Supplementary Investigations, 1968-1977," *Hesperia 48,* 1 (1979), 1-44.

3. Phyllis W. Lehmann, *Skopas in Samothrace* (Northampton, Mass., 1973); Phyllis W. Lehmann and Denys Spittle, *The Temenos, Samothrace,* 5 (Princeton, forthcoming 1981).

4. John Travlos, *Pictorial Dictionary of Ancient Athens* (New York, 1971), 527-533; Homer A. Thompson and R. E. Wycherley, *The Agora of Athens: The History, Shape and Uses of an Ancient City Center,* The Athenian Agora, 14 (Princeton, 1972), 96-103.

5. Thompson and Wycherley (note 4), 100.

6. Roland Martin, *L'Agora, Etudes Thasiennes,* 6 (Paris, 1959), 59-92.

7. Roland Martin, "Sculpture et peinture dans les façades monumentales au IVᵉ siècle av. J.-C.,"*RA* (1968), 180-184.

8. Demetrios Pandermalis, "Beobachtungen zur Fassadenarchitektur und Aussichtsveranda im hellenistischen Makedonien," *Hellenismus in Mittelitalien* (Kolloquium in Göttingen, June 1974), *Abhandlungen der Akademie der Wissenschaften in Göttingen,* Philologisch-Historische Klasse, folio 3, 97 (1976), 387-397.

9. Karl Lehmann and Denys Spittle, *The Altar Court, Samothrace,* 4, II (New York, 1964); James R. McCredie, "Samothrace: Preliminary Report on the Campaigns of 1965-1967," *Hesperia 37,* 2 (1968), 216-234; Lehmann (note 2), 91-92; McCredie (note 2), 6-8.

10. Phyllis W. Lehmann, *The Hieron, Samothrace,* 3 (Princeton, 1969).

11. Mehmet Cetin Sahin, *Die Entwicklung der griechischen Monumentalaltäre* (Bonn, 1972), 44-58.

12. Stella G. Miller, "Hellenistic Macedonian Architecture: Its Style and Painted Ornamentation" (Ph.D. diss., Bryn Mawr College, 1971), 15-89 and 228-229.

13. Lehmann (note 10), III.1, 215-217.

14. Phyllis W. Lehmann, "The Wall Decoration of the Hieron in Samothrace," *Balkan Studies 5* (1964), 284-286; idem (note 10), III.1, 207-208 and 216.

15. Miller (note 12), 15-89.

16. See note 9.

17. Andronikos, Makaronas, Moutsopoulos, and Bakalakis (note 1), pl. XV.2.

18. Hieron: Lehmann (note 14); Dedication: McCredie (note 9), 221-222 and (note 2), 8; West Stoa: McCredie and Lehmann (note 36).

19. McCredie (note 2), 35-43.

20. Ibid., 40.

21. Lehmann (note 2), 54-58.

22. Heinrich Bauer, *Korinthische Kapitelle des 4. und 3. Jahrhunderts v. Chr., Ath Mitt-BH 3* (1973), 111-113.

23. Miller (note 12), 181.

24. Lehmann (note 2), 88-89; McCredie (note 2), 2-6.

25. Thomas D. Boyd, "The Arch and the Vault in Greek Architecture" (Ph.D. diss., Indiana University, 1976), 41-44 and 92-95; idem, "The Arch and the Vault in Greek Architecture," *AJA 82,* 1 (1978), 86.

26. Boyd, Diss. (note 25), 95-96 and 124-125.

27. Stephen G. Miller, "Excavations at Nemea, 1978," *Hesperia 48,* 1 (1979), 96-103; idem, "Excavations at Nemea, 1979," *Hesperia 49,* 2 (1980), 198-200.

28. P. Cavvadias, *Istoria tēs Ellenikēs Technēs* (Athens, 1916-1924), fig. 454; Bauer (note 22), 97 and 109-118; Georges Roux, *L'architecture de l'Argolide aux IVe et IIIe siècles avant J.-C.* (Paris, 1961), 253-274.

29. Miller (note 12), 24, 100, and 105.

30. Sardis: Howard C. Butler, *Temple of Artemis, Sardis,* 2.1 (Leyden, 1925), 63-72 and 125, fig. 135; Gottfried Gruben, "Beobachtungen zum Artemis-Tempel von Sardis," *AthMitt 76* (1961), 171 ff. and 192. Smintheion: Richard Pullan, *Antiquities of Ionia,* IV (London, 1881), 40 ff. and pl. 29; Hans Weber, "Zum Apollon Smintheus-Tempel in der Troas," *IstMitt 16* (1966), 103-106 and pl.13. Pergamon (Exedra in Palestra): Paul Schazmann, *Das Gymnasion; Altertümer von Pergamon,* 6 (Berlin, 1923), 68-69 and pl. 19. Aigai: Richard Bohn, *Altertümer von Aegae, JdI-EH 2* (1889), 21 and pls. 23 and 59.1.

31. G. Bakalakis, "Neapolis—Christoupolis—Kavala," *ArchEph* (1936), 7-19 and figs. 10 and 13; D. Lazarides, *Neapolis — Christoupolis—Kavala* (Athens, 1969), 102, pls. 32-33.

32. Miller (note 12), 30 ff.

33. Léon Heuzey and Honoré Daumet, *Mission archéologique de Macédoine* (Paris, 1876), I, 201; II, pl.13.5; Roux (note 28), 365 and 375.

34. Stella G. Miller, "The Philippeion and Macedonian Hellenistic Architecture," *AthMitt 88* (1973), 212-213; idem (note 12), 32-33.

35. Communicated to me by Oscar Fikar on the basis of his unpublished research. I am indebted to Mr. Fikar for this information.

36. James R. McCredie, "Samothrace. Preliminary Report on the Campaigns of 1962-1964," *Hesperia 34,* 2 (1965), 101-116; Lehmann (note 2), 83-85; McCredie (note 2), 8-12.

37. Lehmann (note 2), 82; James R. McCredie, "Recent Excavations in Samothrace 1965-1974," *Neue Forschungen in griechischen Heiligtümern* (Tübingen, 1976), 96.

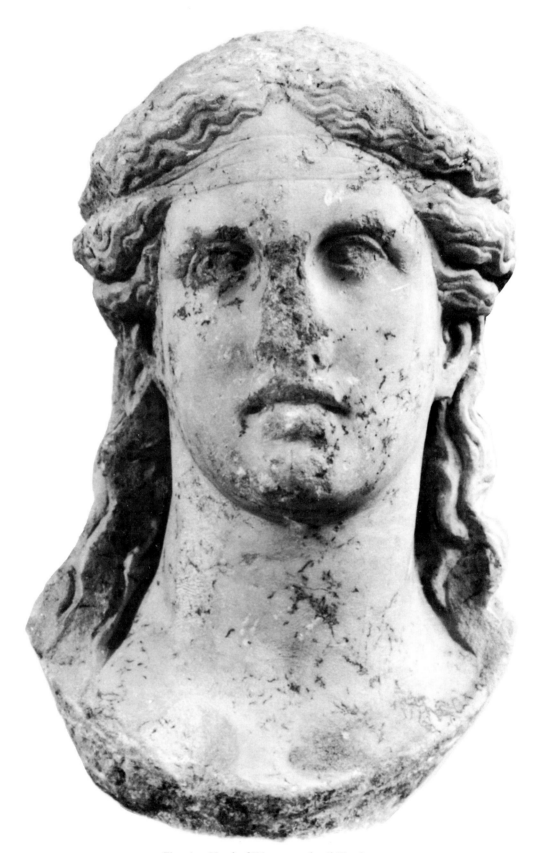

Fig. 4. Head of Dionysos, detail Fig. 3.

Dionysos at Delphi: The Pediments of the Sixth Temple of Apollo and Religious Reform in the Age of Alexander

ANDREW STEWART

Department of Art History,
University of California at Berkeley

IT IS GENERALLY RECOGNIZED that the age of Alexander, and indeed the fourth century in general, was a critical period for the Olympian religion in Greece. Not only had the progress of philosophical thought rendered the Olympian pantheon somewhat quaint in the eyes of the elite, but the events of the Peloponnesian and other wars, let alone the meteoric rise of Philip and Alexander, had tended to expose them to all as capricious at the very least, or maybe simply alienated from the affairs of this world and heedless of its welfare.[1] Yet as far as concerns the average man, there is no evidence of any lasting collapse of faith. To judge from the orators (who would know their audiences), belief in divine aid and divine retribution seems almost as strong as it had ever been.[2] Yet evidence of an increase in mysticism and superstition, the mass popularity of certain new personal divinities such as Asklepios, the steady intrusion of Eastern gods, and a proliferation of hero cults seem to suggest that even in their traditional strongholds the Olympians were tending to be overtaken by the times.[3]

Religious art is, of course, a mirror of religious faith, and I know of no better commentary upon the effect of such changes in belief upon the Olympians themselves than the monuments. The most famous (or most notorious) of all replicas of the classical divinities is the Belvedere Apollo (Fig. 1), today somewhat dethroned from his commanding position in Renaissance and neoclassical aesthetics.[4] Yet however bland and superficial the copy, the original bronze must have been an imposing piece indeed:[5] recent work has shown that the cloak was either exaggerated by the copyist or added entirely by him,[6] and that the bow once held in the left hand was complemented by a right arm raised to pluck an arrow from a quiver on the god's back. The bow would have been shining silver, the quiver, sandals, and arrowheads probably gilded along with the god's own hair, all contrasting with the dark tan of his body.[7]

Here Apollo comes literally out of the blue, stepping lightly across our front and pausing for a split second to loose off an arrow at some unseen foe. Compared with, say, the viewer's relationship to the early classical Apollo from the west pediment of the Temple of Zeus at Olympia (Fig. 2),[8] the rela-

tion between god and spectator is now deeply polarized. The contrapposto pays no attention, as it had done before, to earthly gravity, the muscles remain relaxed and completely free of exertion of any sort, while at no point does any part of the body stop to confront us directly. All axes are diagonally recessive, deflecting the eye away from the statue itself and back into the space from which the god has momentarily appeared. Accentuating the swiftness and unexpectedness of Apollo's arrival, not to mention the imminence of his departure, these devices have the effect of reducing the spectator to passive onlooker, stunned by the suddenness of events in which he can play no part at all. Apollo, in other words, is present to him only to show how little present he really is, only to disappear again at once.

To this sculptor, then, the divine is both ineffably perfect and absolutely self-sufficient *(autárkēs)*. As Gerhart Rodenwaldt saw almost forty years ago, the role of the Olympians is now to "live at ease" on the blissful heights of Olympus, carefree and appearing on earth only intermittently like bolts from the blue to keep in order the affairs of men.[9] The entire statue is

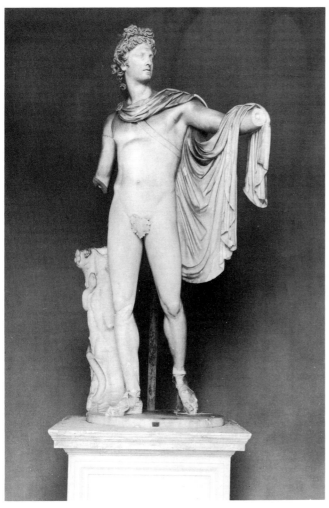

Fig. 1. Apollo Belvedere, Vatican (photo: Deutsches Archäologisches Institut, Rome).

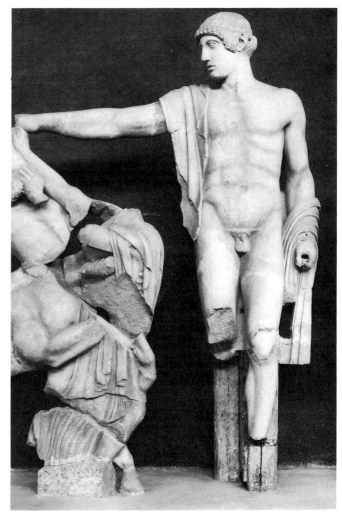

Fig. 2. Apollo from the west pediment of the Temple of Zeus at Olympia (photo: Alinari).

ice-cold condescension personified: no wonder that so many were turning for comfort elsewhere.[10] Yet Apollo was not the god of intelligence for nothing. Even when under pressure, as was clearly the case in the fourth century, when Asklepios was swiftly usurping his medical functions and the ecstatic cults of his brother and rival, Dionysos, were going from strength to strength,[11] he still had a card or two to play. Particularly crucial in this regard was his role as the adjudicator of religious reform, mediated through his mouthpiece, the Pythia of Delphi.

Thus, around 330 the Epidaurians were persuaded to consult Delphi concerning the wisdom of inscribing on stone a paian to Asklepios by one Isyllos, describing the god's lineage and recent epiphany at Sparta to check the invasion of Alexander.[12] Apollo consented, officially acknowledging thereby that Asklepios was indeed his son,[13] and that he could therefore use Apollo's own titular form of address, Paian. Last but not least, however, Apollo was quick to approve processions to himself equal to those offered to Asklepios, and strengthened the practice

whereby suppliants offered sacrifice in the precinct of Apollo Maleatas *before* putting their cases to Asklepios. Here then we see Apollo accepting the inevitable and striking a bargain with the newcomer, trading legitimacy for subservience. By making a limited retreat from intimate contact with this particular area of human concern, he is able to reestablish his own overall authority at a higher level, as it were: a tactical withdrawal leads to a strategic success.[14]

To turn to Delphi itself. Here the late archaic temple of Apollo was destroyed by a landslide in 373. A

new temple, the sixth in the series, was begun almost immediately under the Corinthian architect Spintharos, but as the inscribed accounts tell us, because of war and financial difficulties construction dragged on for almost fifty years.[15] Because of the need to house the oracle itself as quickly as possible, the temple was built in the reverse order to normal: after a long interruption due to the Third Sacred War of 355-346 (when the temple monies were seized by the Phocians for their war chest)[16] the cella seems to have been finished to roof level and the peristyle itself begun by the late 340s. During the Fourth Sacred War of 340-338 work was again broken off, but by 330 the

peristyle was up and the roof near completion.[17] No mention of the pedimental sculpture occurs in the accounts, which become too fragmentary to read at around this date. Since, however, disbursements stop around 320 and are then replaced by an annual payment of thirty minae for upkeep,[18] it would seem reasonable to place them in this final phase of construction, i.e., between 335 and 320.

These sculptures were contracted to an Athenian, Praxias, but as Pausanias tells us in his description of them,[19] he died on the job and another Athenian, Androsthenes, was hired to finish the work. Until recently the groups were thought to have vanished entirely,

but between 1967 and 1975 substantial fragments of them (cf. Figs. 3-4) were rediscovered by Francis Croissant and Jean Marcadé in the museum reserves at Delphi, where they had been carelessly stored by the early excavators and overlooked by subsequent researchers.[20] Their style suggests a date around 330,[21] and as far as one can tell in their incomplete and only semipublished state, they bear out Pausanias' account to the letter.[22] Briefly, an Apollo *kitharōidós* dominated the east pediment, flanked by Artemis, Leto, and the Muses, while on the west stood Dionysos, also with a kithara, surrounded by dancing Thyiads, with Helios setting in one corner (presumably balanced by Selene rising in the other). Each composition measured about sixty feet long (18.5 m.) and seven and one-half feet high (2.3 m.) at the apex.

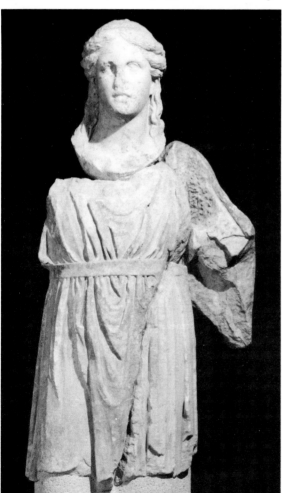

Right: Fig. 4. Head of Dionysos, detail Fig. 3.

Left: Fig. 3. Dionysos from the west pediment of the sixth temple of Apollo at Delphi (photo: Ecole française d'Athènes).

Not enough fragments have yet been located, put together, and identified to discuss either composition as a narrative, though an account of the meaning of the whole is possible, at least in general terms. With its tableau showing Apollo installed at Delphi in glory, the east pediment seems to have been fairly traditional in character, concluding the story of his triumph begun on its archaic predecessor.[23] Yet the west pediment, of which we possess the central figure of Dionysos (Figs. 3-4: attributed by its find spot, technique, scale, and iconography),[24] is wholly unexpected, at least at first sight. What, one may ask, are Dionysos and his raving maenads, considered at least since Nietzsche[25] to be representatives of all that is irrational and un-Apolline in Greek culture, doing here?

The usual answer is that their inclusion is symptomatic of a new universalizing tendency in Greek religion, so that rational and irrational are now united with official sanction in a single all-embracing world view. In such syncretism, as it is called, just as with Alexander's conquests the gods now begin to break loose from their specific connections with particular localities, so their very characters begin to lose their individuality too as they come gradually to fuse into a higher unity.[26] Yet while it would be foolish to deny that in the *long* run something very like this certainly did occur, in any account of origins, which are the issue here, one must not forget that Delphi is Apollo's shrine and that in any shift in Delphic policy the interests of the cult of Apollo must have been paramount.[27]

The question of Dionysos' importance at Delphi in the classical period is a vexed one, and I have no space to do it justice here. Suffice it to say that his grave was in the temple itself,[28] and that apart from his biennial festival, the *trietērís*, two often overlooked facts indeed testify to an early connection with Apollo there. First, both Homer and Stesichoros tell us that it was Dionysos who gave the golden amphora to Thetis in which the bones of Achilles and Patroklos, Apollo's ritual antagonists, were to be interred: this act is also shown on the François vase.[29] Now, according to the twin principles of Greek religion whereby ritual antagonism in myth corresponds to symbiosis in cult, and preservation of bones (especially in gold) signifies ultimate regeneration for the hero,[30] the installation of Achilles' son Neoptolemos as Hero of Delphi after his death at

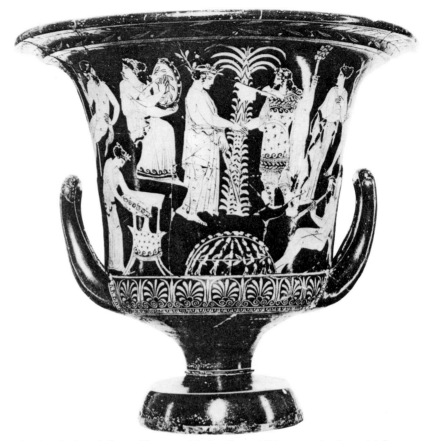

Fig. 5. Attic red-figured krater with Apollo and Dionysos, Leningrad (after Metzger, pl. 25c).

Apollo's hands[31] may be seen to link Dionysos, Achilles/Neoptolemos, and Apollo in close-knit fashion. And second, the fifth-century Delphic inscription of the Labyads provides for a sacrifice to Dionysos *and no other* in Apollo's own month of Apellaios, time of the yearly ephebic festival.[32] To turn to later sources, Pausanias tells us that as Thyiads the maenads were even related to Apollo, for Thyia was Apollo's consort, and became by him the mother of Delphos; ever since, the ecstatic dances of the maenads on Parnassos were conducted in honor of both deities.[33] In the fifth century, all three tragedians associate the two gods, occasionally exchanging their epithets,[34] and by the early fourth cen-

tury an Athenian vase painter could picture these two representatives of opposing yet complementary aspects of the human psyche as conjoined in an indissoluble bond over the omphalos (Fig. 5).[35]

Yet all this is very far from explaining either the prominence given to Dionysos on Apollo's temple itself,[36] or the peculiarities of his statue. As to the first, Parnassos is not the sanctuary of Apollo, and the many sources which testify to Dionysos' preeminence on the mountain tops[37] should not be confused with the few that place him in the abode of the Pythia. Also, as T. B. L. Webster has pointed out, the group of early fourth-century vases that associate the two deities may have more to

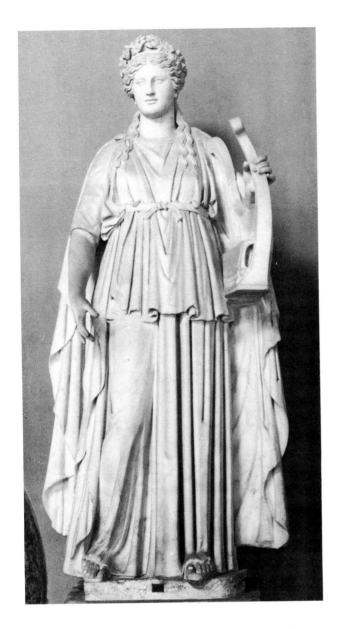

Right: Fig. 7. Apollo, detail of an Attic red-figured krater with the contest of Apollo and Marsyas, Leningrad (after Schefold, *Kertscher Vasen*, pl. 18b).

Left: Fig. 6. Replica of the Apollo Patroos of Euphranor, Vatican (photo: Deutsches Archäologisches Institut, Rome).

do with a need for *homónoia* on the part of the restored Athenian democracy after 403 than with Delphic theology as such.[38]

Concerning the sculpture, Dionysos' face is broad and soft, his hair is voluminous and long-tressed, and his forehead is bound as is normal with a *tainía*, perhaps intended to recall the *mítra*, Eastern-derived symbol of all that is wild and uninhibited in his nature (Figs. 3-4).[39] Yet nevertheless, he stands quite quietly, without a trace of that ecstatic mobility which one might expect in such circumstances.[40] Furthermore, he is clad neither in his own traditional Eastern dress, nor in his long unbelted gown and wraparound himation. Instead, he wears the heavy, high-belted, full-length chiton and back mantle of Apollo *kitharōidós*.[41] Here a newly joined fragment of the left arm and shoulder clinches the matter, by demonstrating beyond all reasonable doubt that he actually held, and was perhaps shown playing, the kithara. The entire composition is one attested for Apollo by a long sequence of fourth-century *kitharōidói*, notably the contemporary Apollo Patroos of Euphranor and its replicas (Fig. 6) and, to choose a piece where the chiton is also worn without the overfold, the Apollo featured on the Marsyas painter's name piece in Leningrad (Fig. 7).[42]

To display the two personalities at opposite ends of the temple is one thing, but to represent Dionysos in such a pseudo-Apolline manner is surely quite another. A remark of Plutarch's, made in the

context of a discussion about the place of Dionysos at Delphi, puts the novelty of this conception of the god in full focus:

> Artists represent Apollo in paintings and sculpture as eternally ageless and young, but Dionysos they depict in many guises and forms. And they attribute in general to Apollo a uniformity, orderliness, and unadulterated seriousness, but to Dionysos a certain variability, combined with playfulness, wantonness, eagerness, and frenzy. They call upon him thus:
> "Hail Bacchus, who incites
> Womankind, Dionysos who inflames
> With honors fraught with frenzy."[43]

Justly troubled by the uniqueness of this statue, Marcadé has suggested that Apollo, not Dionysos, is indeed the subject. Yet this not only directly contradicts Pausanias but does not resolve the problem of the *tainía* or *mítra*.[44] In fact, there is another explanation, and to my mind a more likely one.

To begin with, the almost unearthly stillness of the Delphi Dionysos amidst the frenzied turmoil of his followers does have a certain precedent—but in literature, not in art. Euripides' *Bacchae* of 405 is seminal not only for the worship of Dionysos in the fourth century but also for its thinking in general about the central place of the irrational in the newly reconstituted views of the age.[45] In this play, such tranquillity or *hēsukhía* is the attribute of the soul that has transcended the orgiastic raving awakened by its recognition of the long-repressed forces within it, and has attained a higher peace, a reconciliation of opposites on a more lofty plane, a calm acceptance of the new wisdom, the new *sōphrosūnē*.[46] The chorus in particular constantly yearns to achieve this state, and just as regularly contrasts Dionysos' own *hēsukhía* with the anger and rage of his opponent, Pentheus (whose name, Teiresias reminds us, means "pain"):

> The brash, unbridled tongue,
> The lawless folly of fools, will end in pain.
> But the life of wise content
> Is blest with quietness, escapes the storm,
> And keeps its house secure.
> Though blessed gods dwell in the distant skies
> They watch the ways of men.
> Not with knowledge is wisdom bought.[47]

In this statue, then, one may perhaps recognize Dionysos confronting the viewer with the evidence that it is he who has attained true insight into the real meaning of the ancient Apolline virtues, texts of which were of course prominently displayed on the temple.[48] He both "knows himself" and does "nothing to excess" while his maenads rave as yet uncomprehendingly about him.

Yet what of his kithara and pseudo-Apolline costume? Here a Delphic hymn to Dionysos, written around 340, then inscribed on stone, and rediscovered in the late nineteenth century, may help us further (see appendix).[49] Commissioned from one Philodamos of Skarphea for performance at the Theoxenia of 339 (the city's official invitation to its gods to honor it with their presence), then set up at the Pythia's behest, it not only must reflect official thinking on Dionysos' status at Delphi, but actually seems almost programmatic for this pediment, carved only a few years later, and its concerns. The first indication of this is its form: not a wild dithyramb as hitherto obligatory in Dionysos worship but the stately Apolline paian. Isyllos' paian to Asklepios, mentioned earlier, is suggestive in this context.[50] Thus each of its twelve stanzas is both punctuated and ended by ritual phrases that conjoin the two divinities, as follows:

> Cry "Io Bacchos, Ie Paian!"
> ...
> Come, Lord Paian, come savior
> Gracious, keep our city secure,
> In blissful happiness. (5,11-13)

Meanwhile the narrative itself, expunged of all reference to Dionysos' bloodier and darker exploits, continually invokes his presence, describing in somewhat mawkish language his birth at Thebes and his reception at Delphi, Eleusis, and other panhellenic centers of worship. A brief vignette from stanza II vividly recalls this pediment:

> Then did holy Delphi abound with song,
> The sacred land did dance for joy
> While you, revealing now your starry form
> Stood on high in Parnassos' glens,
> Encircled by maidens of Delphi.
> Come, Lord Paian, come savior. . . . (19-24)

Next he is introduced to the company of the gods at the Temenos of the Muses at Pieria in Thessaly, near Mount Olympos (a sanctuary much frequented and heavily endowed by the Macedonian kings). And who else should be his sponsor but Apollo?

> Then the virgin Muses, ivy-wreathed
> Encircled you about,
> Sang your immortality
> Paian, glorious for ever,
> And Apollo himself led the dance.
> Come, Lord Paian, come savior. . . . (58-63)

This accomplished, Apollo through his oracle then enjoins the Amphiktyons, on pain of retribu-

tion, to complete his own temple as fast as possible, to perform the present hymn at the yearly festival of the Theoxenia, and to make sacrifice as well. Philodamos at this point takes it upon himself to add that the temple should be in gold, with chryselephantine statues. Next, Apollo commands his servants to celebrate a brilliant festival to Dionysos, to honor him with choruses and sacrifices at the Theoxenia and competitions at the Pythia,[51] and to erect an *ágalma* of him in a chariot drawn by golden lions, "equal to the blazing eastern sun," setting it in a holy grotto. The poem then ends with a final call to the faithful to receive Dionysos, "invoke him in your city streets, with ivy-tressed choruses Throughout all the holy land of Hellas in all-night festival. . . ." (145-150).[52]

According to the hymn, then, Dionysos and Apollo at Delphi are henceforth to be as one: Apollo, bowing to the inevitable again, tries once more to strike a bargain. Dionysos not only receives from him his characteristic offerings and titles (spreading Apollo's fame and honors, *tímē* and *kléos*, yet wider)[53] but in return shares the worship paid to Apollo during the nine months when the latter was supreme at Delphi. The pediment is even more explicit. Here Dionysos again receives a half-share in events, but now he is as it were *possessed* by Apollo, as if Apollo were claiming the ultimate promise of Dionysiac tranquillity, *hēsukhía*, as a state of mind that is, in the final analysis, Apolline.[54]

The effects of this move upon the Pythian cult, and upon Apollo and Dionysos themselves, are interesting and in some ways unexpected. To begin with, from about

Right: Fig. 9. Head of Apollo, detail Fig. 8.

Left: Fig. 8. Apollo with Galatian shields, Delos (photo: Ecole française d'Athènes).

this period the Pythia begins to take an interest in Dionysos worship, and in the Hellenistic period we find the oracle heavily engaged in the regulation not only of images, altars, festivals, and sacrifices to Dionysos, but even of such quintessential manifestations of his cult as maenadism and the guild of Dionysiac artists.[55] Indeed, as Parke and Wormell remark, "our authorities preserve more instances of Delphic responses concerning Bacchic worship than concerning all other Olympian deities put together, . . . often . . . advising the first introduction of the cult of Dionysos in places where it was previously not observed. . . . In fact, this position as patron of the Dionysiac cult was one which the Pythian Apollo managed to retain when much of his other activi-

ties had fallen away."[56] Clearly, then, on at least one level, Apollo's tactics appear to have borne fruit.

When one turns to the iconography of Apollo and Dionysos in Hellenistic art, however, the story is a somewhat different one. Marcadé has noted a handful of examples of Apollo wearing the *tainía* or *mítra,* of which the Apollo from the theater quarter at Delos is the most important (Figs. 8-9).[57] A variant of the fourth-century Apollo Lykeios type (Fig. 15), itself Pythian in its iconography, he places his foot on a pile of Galatian shields, a motif with decidedly Delphian overtones.[58] Other than this and a terra cotta or two, however, the monuments assembled by Marcadé are all of the Roman period, and I have not been able to add to them. At first sight, then, it

Left: Fig. 10. Dionysos from the choragic monument of Thrasyllos at Athens, British Museum.

Middle: Fig. 11. Dionysos from the choragic monument of Theodoros, Philemon, Ariston, and Battalos, Thasos (photo: Ecole française d'Athènes).

Right: Fig. 12. Bronze hydria with Dionysos and Ariadne from Chalke (near Rhodes), British Museum (after Walters, *Select Bronzes*, pl. 35).

would seem that generally speaking Apollo retains his integrity, at least for the present.

As for Dionysos, no examples of a Hellenistic or Roman Dionysos *kitharōidós* in the *skhéma* of the Delphi example are known to me. The seated Dionysos from the choragic monument of Thrasyllos at Athens, apparently placed there in 271,[59] could be construed as a seated version of it (Fig. 10), though to my mind its significance lies in a rather different sphere. The identification of this statue as a Dionysos *melpoménos* ("the musician") has long been inferred from a note in Pausanias.[60] In fact, Dionysos' association with Apollo's Muses is hinted at in Aeschylus and made explicit in Plato's *Laws*, Philodamos' hymn, and a number of Hellenistic cults.[61] It would therefore seem that it is to the more limited milieu of the theater and music that one must turn for fresh insights, if any.

In 1957-1958 a large, early third-century choragic monument was discovered in the Dionysion at Thasos, and was very thoroughly published by Paul Bernard and François Salviat in the following year.[62] In a semicircular exedra dedicated by two actors and two flutists stood a statue of Dionysos *kitharōidós* (Fig. 11) flanked by a number of other figures, probably Muses and/or personifications such as Tragedy and Comedy. Al-though there seems little obvious connection between this Dionysos and his predecessor at Delphi, the excavators immediately recognized an intrusive element in the iconography here, namely the himation.[63] This, however, is not a back mantle draped in the Apolline manner but is gathered around the lower body and over the raised left thigh. The motif derives from fourth-century precedents showing Dionysos with Ariadne (Fig. 12),[64] but here the excavators must be right in saying that he uses the entire scheme of long chiton and himation only because he is taking over Apollo's role as leader of the Muses, *mousāgétēs*.[65] In the Hellenistic period this motif of the slip-

Fig. 13. Gold shrine with Dionysos and satyr, National Museum, Athens, Stathatos Collection (photo: Deutsches Archäologisches Institut, Athens).

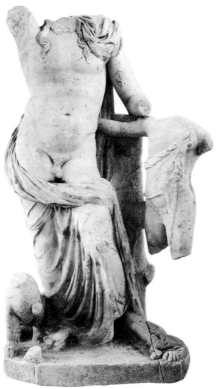

Fig. 14. Dionysos and satyr from Leptis Magna, Tripoli (photo: Deutsches Archäologisches Institut, Rome).

Right: Fig. 15. Replica in statuette form of the Apollo Lykeios, Staatliche Kunstsammlungen, Dresden.

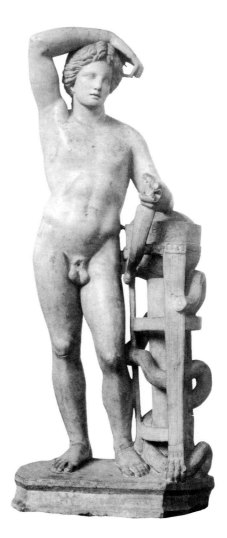

ping himation (with chiton now removed) swiftly became the attribute of the drunken Dionysos, as on the Stathatos shrine (Fig. 13)[66] or the multiple recensions of what one might call the Leptis Magna Dionysos (Fig. 14).[67] In this case it has long been recognized that the god's posture once more owes a great deal to the Apollo Lykeios (Fig. 15); exhaustion after the battle with Python has here shaded into drunken lassitude.[68]

The monument that consolidates anew this increasingly somewhat disorganized tradition of Apolline-Dionysiac interchange (which in essence seems to owe very little to Delphi) is the Cyrene Apollo (Fig. 16). This "colossal,

finely executed and sovereignly unpleasing" statue, as Martin Robertson has described it,[69] is known in about twenty copies and variants from all over the Greco-Roman world.[70] It may possibly copy the Apollo of Timarchides the Elder which in Pliny's day was to be found in the temple of Apollo near the Porticus Octavia, and was perhaps made around 180 B.C.[71]

In this statue, Apollo and Dionysos have become totally fused into one for the first time since the composition on the Delphi temple, a century and a half earlier: yet here, how different is the balance struck by the artist! For the long Apolline chiton and back mantle the sculptor now substitutes the

slipping himation of Dionysos *kitharōidós* and Dionysos the Drunk. When compared with the Basel Dionysos (a work surely of the same general period),[72] the physique, too, shows once again how indistinguishable the two gods have become: each is round-hipped, with soft but not flabby musculature, deep-bellied, and sexually immature (Figs. 17-19). The way in which the right arm lies over the top of the head recalls the Apollo Lykeios, but now (since the snake around the support is unique and must be a copyist's addition) the gesture is severed from its connection with the aftermath of the fight with Python. Yet though it would be tempting to in-

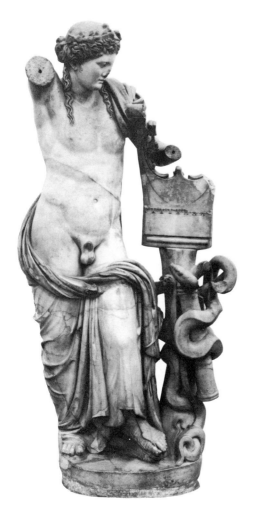

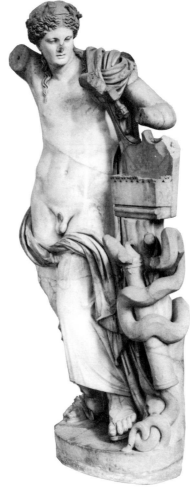

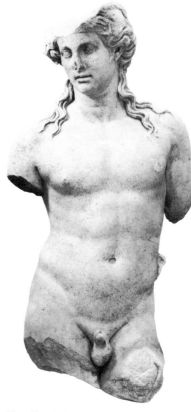

Fig. 17. Dionysos, Antikenmuseum, Basel.

Fig. 16. Apollo from Cyrene, British Museum. Left: frontal view; right: three-quarter view.

fer from this and the sprung rhythms of the pose that Apollo's musical ecstasy has attained almost Dionysiac proportions,[73] the general effect nevertheless remains quite sober, cool, and balanced: the two personalities have become fused, and neither is dominant.

My suggestion is that what we could have here, in this image of the god of the Muses,[74] is a reflection of *manía sōphrōn*. This, variously translated as "temperate madness" or "controlled inspiration," was a commonplace of Hellenistic and Roman thinking about the very sphere of Apollo's activity

at issue here, music and poetry.[75] "For properly understood," as Helen North has remarked, "*manía sōphrōn* concerns not only style but the whole process of poetic composition. Innumerable critics, both ancient and modern, have discovered that the poetry of inspiration, which is the expression of profound emotion, requires not merely emotion but also its control. To take but one example, the first of Ruskin's criteria by which to judge poetry is 'absolute command over all passion, however intense'—in a word, *sōphrosúnē*. . . . So, too, in the *sōphrōn* style there

must be passion, there must be *manía*, as well as the power to control it; only from the union of Dionysos and Apollo is great literature born."[76]

So, then, if I am right, it is the Cyrene Apollo that completes the process of fusion begun with something of a false start at Delphi 150 years before. Now, however, the syncretism is carried out in a far more balanced, less partisan, and less tendentious way: from his most essential being each god contributes to a composite divinity that is both novel and, in its way, not devoid of insight. And so it is

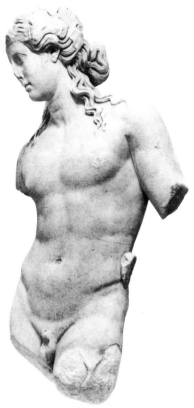

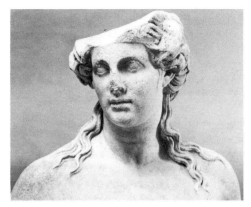

Fig. 19. Head of Dionysos, detail Fig. 17.

Fig. 18. Three-quarter view of
Dionysos, Fig. 17.

not surprising that by the Roman period we find the Rhodians, Spartans, Thracians, and others reportedly worshipping Apollo and Dionysos as one god.[77] Meanwhile, in another context the neo-Platonists and others (following the lead of the Stoics and Orphics) can now declare that the two are but equal and opposite halves of a higher unity, namely the sun itself as it passes through the celestial and infernal regions respectively.[78] To return a final time to Delphi, where by Plutarch's time, as he remarked, Dionysos' share in the sanctuary was no less than that of Apollo, this was even suggested by some in antiquity as a solution to the problem of the letter E suspended between the columns of the temple. As Plutarch and others after him have suggested, it may mean $\epsilon\tilde{\iota}\ \overset{\prime}{\epsilon}\nu$, or Thou Art One.[79]

Appendix:
Philodamos' "Paian to Dionysos"
Text and Translation

Preliminary note: the text published here is as edited by Professor Brain L. Rainer on 260-265 of his 1975 dissertation (note 49, which also refers to the *apparatus criticus*), with only one emendation, that proposed for line 108 by M. Markovich (note 49), 167-168. I am deeply grateful to Professor Rainer for his kind permission to include this previously unpublished text as a part of my paper.

I

[Δεῦρ' ἄνα] Διθύραμβε, Βάκχ',
Ε[ὔιε, Ταῦρε κ]ισσοχαῖ-
τα, Βρόμι', ἠρινα[ῖς ἱκοῦ
ταῖσδ'] ἱεραῖς ἐν ὥραις ·
5 Εὐοῖ ὦ ἰὸ [Βάκχ, ὦ ἰὲ Παιά]ν ·
ὅν Θήβαις ποτ' ἐν εὐίαις
Ζη[νὶ] γείνατ[ο] καλλίπαις Θυώνα
πάντες δ' [ἀθά]νατοι [χ]όρευ-
σαν, πάντες δὲ βροτοὶ χ[άρεν
10 σαῖς, ὦ Β]άχχιε, γένναις.
'Ἰὲ παιάν, ἴθι σωτή]ρ,
εὔφρων τάνδε] πόλιν φύλασσ'
εὐαίωνι σὺν [ὄλβωι].

II

Ἄν τότε βαχχίαζε μὲν
χθὼ[ν μεγαλώνυμός] τε Κάδ-
μου Μινυᾶν τε κόλπ[ος Εὔ-
βο]ιά τε καλλίκαρπος ·
Εὐοῖ ὦ ἰὸ Β[άκχ', ὦ ἰὲ] Παιάν

I

Come hither, Lord Dithyrambos, Bacchos,
Euios, ivy-garlanded Tauros,
Bromios, come
At this sacred springtime season.
5 Cry 'Io Bacchos, Ie Paian!'
Thyona, mother of children fair, to Zeus
Bore you once in Bacchic Thebes;
And all the gods in chorus danced,
All men rejoiced,
10 O Bacchos, at your birth.
 Come, Lord Paian, come savior
Gracious, keep our city secure,
In blissful happiness.

II

Then did Kadmos' far-famed land,
15 The Minyans' vale,
And Euboia, fruitful isle,
Welcome you in Bacchic revel.
 Cry 'Io Bacchos, Ie Paian!'

¹[Δεῦρ' ἄνα] Weil ²Ε[ὔιε] Weil [Ταῦρε
κ]ισσοχαῖτα Vollgraff ³⁻⁴ἠρινα[ῖς
ἱκοῦ ταῖσδ'] Weil ⁶ὅν Weil ⁷Ζη[νὶ] γεί-
νατ[ο] Weil ⁸δ' [ἀθά]νατοι [χ]όρευσαν
Weil ⁹χ[άρεν] Vollgraff ¹⁰[σαῖς, ὦ
Β]άχχιε Diels ¹⁴Ἄν Vollgraff ¹⁵χθὼ[ν
μεγαλώνυμος] Weil ¹⁶⁻¹⁷κόλπ[ος Εὔ-
βο]ια Vollgraff: κόλπ[ος Αὔγε]ια Weil

πᾶσα δ' ὑμνοβρυὴς χόρευ-
20 ε[ν Δελφῶ]ν ἱερὰ μάκαιρα χώρα ·
αὐτὸς δ' ἀστερόεν [δ]έμας
φαίνων Δελφίσιν σὺγ κόραι[ς]
[Παρν]ασσοῦ πτύχας ἔστας.
'Ιὲ Παιάν, ἴθι σω[τή]ρ
25 εὔφρων [τάνδε πόλ]ιν φυλασσ'
εὐαίωνι [σύ]ν ὄλβωι.

Then did holy Delphi abound with song,
20 The sacred land did dance for joy
While you, revealing now your starry form
Stood on high in Parnassos' glens
Encircled by maidens of Delphi.
 Come, Lord Paian, come savior
25 Gracious, keep your city secure,
 In blissful happiness.

III

['Αστρο]φαὲς δὲ χειρὶ πάλ-
λων δ[έρ]ας ἐνθέοις [σὺν οἴσ-]
τροις ἔμολες μυχοὺς ['Ελε]υ-
30 σῖνος ἀν' [ἀνθεμώ]δεις ·
Εὐοῖ ὦ ἰὸ Βάκχ', ὦ ἰ[ὲ Παι]άν ·
[ἔθνος ἔνθ'] ἅπαν 'Ελλάδος
γᾶς ἀ[μφ' ἐ]νναέταις [φίλοις] ἐπ[όπ]ταις
ὀργίων ὁσί[ων 'Ια]κ-
35 χον [κλείει σ]ε, βροτοῖς πόνων
ᾤξ[ας δ' ὅρ]μον [ἄμοχθον].
'Ιὲ Παιάν, ἴθι σωτήρ,
ε[ὔφρων] τάνδε [πόλιν φύλα]σσ'
εὐαίωνι σὺν ὄλ[βωι].

III

Dappled with stars was the fawn-skin
You brandished, when inspired
With frenzy divine
30 You reached Eleusis' flowery glens.
 Cry 'Io Bacchos, Ie Paian!'
There all the people of Hellas' land
Bidden by the Residents
Dear to initiates of the Sacred Mysteries
35 Cried 'Iacchos, Lord!' And to mortals
You revealed a haven from toil and cares.
 Come, Lord Paian, come savior
 Gracious, keep our city secure,
 In blissful happiness.

¹⁹⁻²⁰χόρευε[ν Δελφῶ]ν Weil ²¹ἀστερόεν
[δ]έμας Weil ²²⁻²³κόραι[ς Παρν]ασσοῦ
Weil ²⁷['Αστρο]φαές Vollgraff ²⁸δ[έρ]-
ας Vollgraff ²⁸⁻²⁹[σὺν οἴσ]τροις Weil
²⁹⁻³⁰['Ελε]υσῖνος Weil ³⁰[ἀνθεμώ]δεις
Weil ³²[ἔθνος ἔνθ'] Weil ³³[φίλοις] Weil
fortasse ³⁵[κλείει σ]ε Weil ³⁶[ἄμοχθον]
Vallois: [ἄλυπον:] Weil

[deest stropha IV]

[Strophe IV is mutilated]

V

['Έ]ν[θεν ἄ]π' ὀλβίας χθονὸς
Θεσ[σαλίας] ἔκελσας ἄσ-
55 τη τέμενός τ' 'Ολύμπι[ον]
[Πιερ]ίαν τε κλειτάν·
Εὐοῖ ὦ ἰὸ Βάκχ', [ὦ ἰὲ Παι]άν·
Μοῦσαι [δ'] αὐτίκα παρθένοι
κ[ισσῶι] στε[ψ]άμεναι κύκλωι σε πᾶσαι
60 μ[έλψαν] ἀθάνα[τον] ἐς ἀεὶ
Παιᾶν' Εὐκλέα τ' ὀ[πὶ κλέο]υ-
σαι, [κα]τᾶρξε δ' 'Απόλλων.
'Ιὲ Παιά[ν, ἴθι σ]ωτήρ,
[εὔ]φρων τάνδε πόλιν φύλ[ασσ']
65 [εὐαί]ωνι [σὺν] ὄλβωι.

V

Sailing on from that blest land
You came to Thessaly's towns,
55 Famed Pieria
And Olympos' holy sanctuary.
 Cry 'Io Bacchos, Ie Paian!'
Then the virgin Muses, ivy-wreathed
Encircled you about,
60 Sang your immortality
Paian, glorious for ever,
And Apollo himself led the dance.
 Come, Lord Paian, come savior
 Gracious, keep our city secure,
65 In blissful happiness.

[desunt strophae VI, VII, VIII]

[Strophai VI, VII, and VIII are mutilated]

IX

105 Ἐκτελέσαι δὲ πρ[ᾶ]ξιν Ἀμ-
φιχτύονας θ[εὸς] κελεύ-
ει τάχος, ὡ[ς Ἑ]χαβόλος
μῆν' ἰχέ[τας] χατάσχηι·

⁵³[Ἔ]ν[θεν] Weil [ἀ]π' Vollgraff
⁵⁴Θεσ[σαλίας] Weil ⁵⁵⁻⁵⁶Ὀλύμπι[ον
Πιερ]ίαν Weil ⁵⁸[δ'] Weil ⁵⁹χ[ισσῶι]
Weil ⁶⁰μ[έλψαν] ἀθάνα[τον] Weil
⁶¹⁻⁶²ὀ[πὶ χλέο]υσαι Weil ⁶²[χα]τᾶρξε
Weil ¹⁰⁵πρ[ᾶ]ξιν Weil ¹⁰⁶θ[εός] Weil
¹⁰⁷ὡ[ς Ἑ]χαβόλος Vollgraff ¹⁰⁸μῆν'
ἰχέ[τας] Markovich

Εὐοῖ ὦ [ἰὸ Β]άχχ', ὦ ἰὲ Παιάν ·
110 δε[ῖξαι] δ' ἐγ ξενίοις ἐτεί-
οις θ[ε]ῶν ἱερῶι γένει συναίμωι
τόνδ' ὕμνον, θυ[σ]ίαν τε φαί-
νει[ν] σὺν Ἑλλάδος ὀλβίας
πα[νδ]ήμοις ἰχετε[ί]αις.
115 Ἰὲ Παιάν, ἴθι σωτήρ,
εὔ[φρ]ων τάνδε π[ό]λιν φύλασσ'
εὐαίωνι σὺν ὀλ[β]ωι.

X

ᾦΩ μάκαρ ὀλβία τε κεί-
νων γε[νεὰ] βροτῶν ἀγή-
120 ρων ἀμίαντον ἃ χτίσηι
ναὸ[ν ἄ]ναχ[τι] Φοίβωι,
Εὐοῖ ὦ ἰὸ Βάχχ', ὦ ἰὲ Π[αιάν]·
χρύσεον χρυσέοις τύποις
πα[]ν θεαὶ 'γχυχλοῦ[νται]
125 [αἰω]ρῶ[ντα χλά]δογ, χόμαν
δ' ἀργαίνοντ' ἐλεφαντί[νωι]
[ἐν] δ' αὐτόχθονι χόσμωι.

¹¹⁰δε[ῖξαι] Weil ¹¹¹θ[ε]ῶν Weil ¹¹²θυ[σ]-
ίαν Weil ¹¹²⁻¹¹³φαίνει[ν] Weil ¹¹⁴πα-
[νδ]ήμοις Weil ¹¹⁹γε[νεά] Weil ¹²¹ναὸ-
[ν ἄ]ναχ[τι Weil ¹²³χρύσεον Vollgraff
¹²⁴'γχυχλοῦ[νται] Vollgraff ¹²⁵[αἰω]-
ρῶ[ντα χλά]δογ Vallois ¹²⁶ἐλεφαντί-
[νωι] Diels ¹²⁷[ἐν] Vollgraff: ἐλέφαντι
χ[υδρόν] Weil (fortasse recte)

Ἰὲ Παιάν, ἴθι [σωτήρ,]
εὔφρων τάνδε πόλιν φύλασ[σ']
130 εὐαί[ωνι] σὺν ὄλβωι.

IX

105 To the Amphiktyons Apollo commands:
Swiftly complete this undertaking,
That the Far-Shooter
May withhold his wrath from his suppliants.

Cry 'Io Bacchos, Ie Paian!'
110 And perform in the gods' yearly Theoxenia
This, their sacred kinsman's hymn.
Celebrate, too
A sacrifice garnished
With blessed Hellas' universal prayers.
115 Come, Lord Paian, come savior
Gracious, keep our city secure,
In blissful happiness.

X

O blessed be that generation of mortals
O happy that race of men
120 Which builds an ageless,
Ever-inviolate shrine for Lord Apollo!
Cry 'Io Bacchos, Ie Paian!'
A golden temple with golden statues,
And He, round whom the goddesses dance,
125 Lifting high the olive-branch,
His hair of ivory gleaming
all with his native chaplet bedecked.

Come, Lord Paian, come savior
Gracious, keep our city secure,
130 In blissful happiness.

XI

Πυθιάσιν δὲ πενθετή-
ροις [π]ροπό[λοις] ἔταξε Βάκ-
χου θυσίαν χορῶν τε πο[λ-
λῶν] κυκλίαν ἄμιλλαν.
135 Εὐοῖ ὦ ἰ[ὸ] Βάκχ’, [ὦ ἰὲ Παι]άν·
τεύχειν, ἁλιοφεγγ[έ]σ[ι]ν
δ’ ἀ[ντ]ο[λαῖς] ἴσον ἁβρὸν ἄγαλμα Βάκχο[υ]
ἐν [ζεύγει] χρυσέωλ λεόν-
των στῆσα[ι], ζαθέωι τε τ[εὖ]-
140 ξαι θεῶι πρέπον ἄντρον.
['Ι]ὲ Παιά[ν, ἴθι σω]τήρ,
εὔφρων τάνδε πόλ[ιν φ]ύλασσ’
ε[ὐ]α[ίωνι] σὺν ὄλβωι.

XI

To his servants Apollo commands
For the four-yearly Pythian festival
Prepare sacrifices to Bacchos
And circling contests of many choirs.
135 Cry 'Io Bacchos, Ie Paian!'
Stand, too, in a car
Harnessed with golden lions,
A splendid statue of Bacchos, one
Equal to the blazing eastern sun;
140 Carve, too, a grotto meet for this most holy Lord.
Come, Lord Paian, come savior
Gracious, keep our city secure,
In blissful happiness.

XII

’Αλλὰ δέχεσθε Βακχ[ια]σ-
145 τὰν Δι[ό]νυσ[ον, ἐν δ’ ἀγυι]-

XII

Now, receive your Bacchant leader,
145 Your Dionysos; invoke him

¹³¹⁻¹³²πενθετήροις [π]ροπό[λοις] Soko-
lowski ¹³³⁻¹³⁴τε πο[λλῶν] Weil ¹³⁶ἁλιο-
φεγγ[έ]σ[ι]ν Weil ¹³⁷δ’ ἀ[ντ]ο[λαῖς] Voll-
graff Βάκχο[υ] Weil ¹³⁸[ζεύγει] Voll-
graff ¹³⁹στῆσα[ι] Weil ¹⁴⁰⁻¹⁴¹τ[εὖ]ξαι Weil
¹⁴⁴⁻¹⁴⁵Βακχ[ια]στάν Weil ¹⁴⁵Δι[ό]νυσ[ον
ἐν δ’ ἀγυι]αῖς Weil

αἷς ἄμα συγ [χορ]οῖσι κ[ι-
κλήισκετε] κισσ[οχ]αίταις:
Ε[ὐο]ῖ ὦ ἰὸ Βάκχ’, ὦ ἰὲ [Παιάν] ·
πᾶσαν ['Ελ]λάδ’ ἀν’ ὀ[λβί]αμ
150 παν[νυχίζ]ετ’ ἐ[πὶ] πολ[υθ]ύ[του]ς τ’ ’Α[θά]νας
[desunt duo versus]
.....................................
[Χαῖρ’ ἄ]ναξ ὑγιείας.
’Ιὲ Πα[ι]άν, [ἴ]θι σω[τήρ],
155 [εὔφρων] τάνδε πόλιν φύλασσ’
εὐαίωνι [σὺν ὄλβωι].

In your city streets,
With ivy-tressed choruses.
Cry 'Io Bacchos, Ie Paian!'
Throughout all the holy land of Hellas
150 In all-night festival, and on
To Athens, city of sacrifices
.....................................
O Lord of health, farewell!
Come, Lord Paian, come savior
155 Gracious, keep our city secure,
In blissful happiness.

¹⁴⁶[χορ]οῖσι Weil ¹⁴⁶⁻¹⁴⁷κ[ικλήισκετε]
Weil ¹⁴⁷κισσ[οχ]αίταις Weil ¹⁴⁹['Ελ]-
λάδ’ Weil ὀ[λβί]αμ Sokolowski
¹⁵⁰παν[νυχίζ]ετ’ Sokolowski ἐ[πὶ] πολ-
[υθ]ύ[του]ς τ’ ’Α[θά]νας Vollgraff
¹⁵³[Χαῖρ’ ἄ]ναξ Vollgraff

[Decree]
Θ[ε]ό[ς]
1 Δελφοὶ ἔδωκαν Φιλοδάμ[ωι
Αἰν]ηεσιδάμου Σκαρφεῖ καὶ

[Decree]
The god.
1 The Delphians bestowed upon
Philodamos the son of [Ain]-

τοῖς ἀδελφοῖς Ἐπιγένε[ι

2 Μα]ντίδαι αὐτοῖς καὶ ἐκ[γό-
νοις] προξενίαν προμ[αν]τείαν
προεδρίαν προδικ[ίαν]

3 [ἀτέ]λειαν ἐπι[τιμ]ὰν καθ-
[άπερ Δε]λφοῖς· ἄρχοντος
Ἐτυμόνδα, βουλευόντων

4 Πλ]είσιστωννος Καλλικρ[

vacant versus duo

5 [ἐπεὶ Φιλόδαμος καὶ τοὶ
ἀδελφο]ὶ τὸμ παιᾶνα τὸν ἐς
τὸν Διόνυσον

6 [ἐποίησαν.....¹⁰.....κατὰ
τὰ]ν μαντείαν τοῦ Θεοῦ ἐπαγ-
γείλατ[ο]

7 [...........²⁵.........
χ]ρῆ[σθ]αι, τυχἀγαθᾶι.

Θ[ε]ό[ς] Rainer ²Μα]ντίδαι fortasse
Weil ⁴Πλ]είστωνος Weil ⁵[ἐπεὶ...
ἀδελφο]ὶ Pomtow, *SIG*³ no. 270 ⁶[ἐποίη-
σαν...κατὰ τὰ] ν Sokolowski ἐπαγγεί-
λατ[ο] Pomtow ⁷ χ]ρῆ[σθ]αι Pomtow

esidamos of Skarpheia and upon his brothers Epigenes and [Ma]ntidas and their descendants a proxeny, priority of consultation with the oracle, priority of seating at festivals, priority of trial, immunity from taxes, and all civil rights as Delphians enjoy. (Done) in the archonship of Etymondas, councillors [Pl]eiston and Kallikr[ates? . . .

(2 lines left uninscribed)

[Since Philodamos and his brothers wrote] the paian to Dionysos [. . .] was proclaimed according to the oracle of the god [. . .] to consult, by Good Fortune.

Notes

I would like to thank Anthony Bulloch, Francis Croissant, Joseph Fontenrose, Reynold Higgins, Paula Perlman, Jenny Richardson, Ronald Stroud, Nancy Tersini, and Nicholas Yalouris for their help and advice in preparing this paper; they are, of course, responsible neither for my conclusions nor for my mistakes.

In addition to those abbreviations listed in the front of this journal, I use the following:

Amandry	P. Amandry, "Naiskos en or de la collection Hélène Stathatos," *ASAtene 24-26* (1946-1948), 181-198.
Bieber	M. Bieber, *The Sculpture of the Hellenistic Age,* rev. ed. (New York, 1961).
Burkert	W. Burkert, *Griechische Religion der archaischen und klassischen Epoche* (Stuttgart, 1977).
Deubner	O. Deubner, *Hellenistische Apollogestalten* (Athens, 1936).
Etudes	*Etudes Delphiques, BCH,* supplement 4 (Paris, 1977).
Jeanmaire	H. Jeanmaire, *Dionysos* (Paris, 1951, rpt., 1978).
Lippold	G. Lippold, *Die griechische Plastik, Handbuch der Archäologie,* v. 3.1 (Munich, 1950).
Marcadé	J. Marcadé, *Au Musée de Délos,* Bibliothèque des écoles françaises d'Athènes et de Rome, 215 (Paris, 1970).
Metzger	H. Metzger, *Les représentations dans la céramique attique du IV^e siècle,* Bibliothèque des écoles françaises d'Athènes et de Rome, 172 (Paris, 1951).
Parke-Wormell	H. W. Parke, D. E. W. Wormell, *The Delphic Oracle,* 2 vols. (Oxford, 1965).
Rainer	B. L. Rainer, "Philodamus' Paean to Dionysos: A Literary Expression of Delphic Propaganda" (Ph.D. diss., University of Illinois at Urbana, 1975).
Robertson	M. Robertson, *A History of Greek Art,* 2 vols. (Cambridge, 1975).
Roux	G. Roux, *Delphi: Orakel und Kultstätten* (Munich, 1971).

1. Cf. W. K. C. Guthrie, *The Greeks and Their Gods* (London, 1950), ch. 12; E. R. Dodds, *The Greeks and the Irrational* (Berkeley-Los Angeles, 1951), chs. 6-8; M. P. Nilsson, *Geschichte der griechischen Religion, i, Handbuch der Altertumswissenschaft,* vol. 2.1 (Munich, 1950-1955), 804-815; Burkert, 460-495. The only treatments I know of religious art from this point of view are G. Rodenwaldt, "Θεοὶ ῥεῖα ζῶοντες," *AbhBerl* (1943), 14, and the long but somewhat superficial essay by K. Zimmermann, "Wandlungen des griechischen Götterbildes in der bildenden Kunst der niedergehenden Polis," *Hellenische Poleis,* iii, ed. E. C. Welskopf (Berlin, 1974), 1205-1289.

2. Cf. J. K. Dover, *Greek Popular Morality in the Time of Plato and Aristotle* (Berkeley and Los Angeles, 1974), 129-138; on an increasing belief in the power of *túkhē,* however, see Dover, 140-141, with Menander, *Aspis,* 97-148; Demetrios of Phaleron, fr. 81 Wehrli (Polybius 29.21; Diodorus 31.10).

3. Cf. notes 1 and 2 with Nilsson, *Geschichte der griechischen Religion,* ii, *Handbuch der Altertumswissenschaft,* vol. 2.1 (Munich, 1950-1955), 1-47 and passim. The evidence for ruler cult prior to the period of the Diadochi is too controversial to be discussed here: see C. Habicht, *Gottmenschentum und griechische Städte², Zetemata,* 14 (Munich, 1970), 1-36, 236-252, etc.

4. Lippold, 269-270, pl. 98,3; Robertson, 460-461, pl. 143d.

5. And was recognized as such in antiquity; for Hellenistic versions, see Deubner, 46-57, 66-67.

6. R. Tölle, "Apollon des Leochares," *JdI 81* (1966), 142-172; Deubner, "Der Gott mit dem Bogen. Das Problem des Apollo im Belvedere," *JdI 94* (1979), 223-244. Professor Yalouris has suggested to me that the cloak which Apollo often wears in the red-figure gigantomachies (cf. E. Pfuhl, *Malerei und Zeichnung der Griechen* [Munich, 1923], figs. 584, 587) may be a kind of protective talisman (ἔρυμα, προβολή), which would support its presence on the original of the Belvedere statue.

7. Cf. Pindar *Olympian Odes* 9.32-33, *Pythian Odes* 2.16; but see Callimachus *Hymnus in Apollinem* 32-34 where everything about him has become golden.

8. Lippold, 120-121, pl. 44; Robertson, 276, 280-281, pl. 94b.

9. Rodenwaldt (note 1), passim.

10. Cf. notes 1 and 2. On the predominance of Aphroditian and Dionysian themes in fourth-century vase painting see Metzger, 369-374, with remarks also by T. B. L. Webster, *Art and Literature in Fourth-century Athens* (London, 1956), 38-41, 79, 103-106.

11. Asklepios: see E. J. and L. Edelstein, *Asclepius,* 2 vols. (Baltimore, 1945), especially ii, 108-125, 242-250; Burkert, 327-330. Dionysos: Jeanmaire, 94-97, 351-372, 418-441; A. Henrichs in C. Houser, *Dionysos and His Circle* (Cambridge, Mass., 1979), 7-8; Burkert, 432-440.

12. *IG* IV².1.128: text and translation, Edelstein (note 11), i, T 295-296, 516, 594; cf. Parke-Wormell, no. 279.

13. As he also did to one Apollophanes of Arkadia: Pausanias 2.26.7 (Edelstein [note 11], i, T 36; ii, 68-74; Parke-Wormell, no.

276). Note that the type of Thrasymedes' gold and ivory cult statue of Asklepios, erected in the Epidaurian sanctuary around 380-370, derived from statues of Zeus, not Apollo: Pausanias 2.27.2; Edelstein (note 11), i, T 630, 683, ii, 218-231; B. Krause, "Zum Asklepios-Kultbild des Thrasymedes in Epidauros," *AA 87* (1972), 240-257.

14. Cf. Parke-Wormell, i, 345: "The two cult centres of Epidaurus and Delphi worked as complements to each other. Asclepius healed the sick in conjunction with Apollo, but did not answer general enquiries there, as he did in some other places. Apollo, though a god of healing, contented himself at Delphi with giving general responses, and was rarely concerned with the question of curing sickness." On Asklepios at Delphi see Roux, 177-179.

15. On the temple see F. Courby, *Fouilles de Delphes,* ii.1: *La terrasse du temple* (Paris, 1915), 1-91, 112-117, pls. 1-10. For the accounts, E. Bourguet, *Fouilles de Delphes,* iii.5: *Les comptes du IV siècle* (Paris, 1932), nos. 19-46; Roux, *RA* (1966), 245-296; J. Bousquet, in *Etudes,* 91-101, with important new joins and revisions in chronology.

16. Diodorus 16.28, cf. Isocrates 5.54; Roux (note 15), 247-259.

17. Bousquet (note 15), passim.

18. Archonship of Eukritos, 323/322-312/311: Bourguet (note 15), no. 20, line 64; Roux (note 15), 252.

19. Pausanias 10.19.4: see note 22. On Praxias see Marcadé, *Recueil de signatures de sculpteurs grecs,* ii (Paris, 1957), 110-113. It still seems impossible to resolve the question as to which of the two sculptors named Praxias ([1] son of Lysimachos, active 368 to before 338, [2] son of Praxias, active c. 350-340) was initially responsible for the pediments, though the later chronology for the sculpture given below perhaps tilts the balance in favor of the latter. If so, however, it is strange that Pausanias describes him as a "pupil of Kalamis" (II): why was he not taught by his (presumed) father? Perhaps Praxias I is responsible after all, in which case it is not surprising that he died on the job: a portrait commission at Athens in 368 would make him sixty at the very least in 330.

20. Bibliography: F. Croissant-J. Marcadé, "Rapports sur les travaux de l'Ecole française en 1971/Delphes," *BCH 96* (1972), 887-895; idem, "Rapports sur les travaux de l'Ecole française en 1973/Delphes. II. Sculptures," *BCH 98* (1974), 785-788; idem, "Rapports sur les travaux de l'Ecole française en 1974/Delphes," *BCH 99* (1975), 709-710; Marcadé, *Etudes,* 389-408. On the central figure of the east pediment, P. Themelis, "Κεντριχὴ μορφὴ ἀπὸ τὸ ἀνατολικὸ ἀέτωμα τοῦ ναοῦ τοῦ Ἀπόλλωνος τῶν Δελφῶν," *ArchEph* (1976), *Archaiologika Chronika,* 8-11 and pls. E-H, also "Contribution à l'étude de l'ex-voto delphique de Daochos. I. Fragment d'une statue assise," *BCH 103* (1979), 508-514 and fig. 3; contra, Croissant, "La statue assise de la voie sacrée à Delphes," *BCH 102* (1978), 587-590; and, decisively, "Les frontons du temple du IV siècle à Delphes: Premiers essais de restitution," *RA* (1980), 172-179. On the Dionysos head, known long since, see C. Picard, *Manuel d'archéologie grecque: La sculpture,* iv.2 (Paris, 1963), 1025-1027 and pl. 26.

21. The best comparisons, as one would expect, are with Athenian sculpture of the later fourth century. Dated reliefs are not particularly helpful, though the texture and fall of the cloth of Dionysos' robe, Fig. 3, are paralleled up to a point by that of the peplos of the Athenas on the decree reliefs of 331/330, 333/332, and 318/317 (H. K. Süsserott, *Griechische Plastik des 44. Jahrhunderts vor Christus* [Frankfurt-am-M., 1938], pl. 91; cf. Lippold, pl. 94, 4). An obvious relative is the Apollo Patroos of Euphranor (H. A. Thompson, "The Apollo Patroos of Euphranor," *ArchEph* [1953-1954], iii, 30-44, pls. 1-2; S. Adam, *The Technique of Greek Sculpture* [*BSA,* supplement 3 (London, 1966)], pls. 42-43; Robertson, pl. 125d; cf. fig.6), by common consent a work of the third quarter of the century. I would guess that it is anterior to the Dionysos, however, which simplifies and coarsens many of its drapery motifs, such as the crimped folds above the girdle and the looped ones below it. A more profitable comparison in terms of absolute chronology is the statue of Sisyphos I from the Daochos group at Delphi, dedicated between 336 and 332 (Adam, pls. 47-49; T. Dohrn, *Antike Plastik,* 8 [Berlin, 1968], 33-54, esp. 39-40, pls. 30-32); here, however, the carving is more fluid and the architectonics of the drapery rather less con-

trived, which seems to me to argue for an earlier date. A later phase of the style is given by the grave relief NM 2574 (R. Lullies-M. Hirmer, *Greek Sculpture*[2] [New York, 1960], pls. 240-241; Robertson, pl. 158f), which should belong only a little before such monuments were banned in 317. Finally, the Athena Praetoriana, copied on the decree relief of 318/317, must belong to the same group as the Delphi Dionysos, if it is not by the same hand (cf. G. B. Waywell, "Athena Mattei," *BSA 66* [1971], 373-382, esp. 378, pl. 72a; Bieber, figs. 210-212); compare, once again, the texture and fall of the cloth above and below the girdle and in particular the deep shadow-grooves both between the major folds and in their bifurcations. Here, as with the Dionysos, the surface of the cloth is no longer treated as a unity (contrast the Apollo Patroos) but broken up into contrasting areas of black and white by lavish use of the drill.

22. Τὰ δὲ ἐν τοῖς ἀετοῖς, ἔστιν Ἄρτεμις καὶ Λητὼ καὶ Ἀπόλλων καὶ Μοῦσαι δύσις τε Ἡλίου καὶ Διόνυσός τε καὶ αἱ γυναῖχες αἱ Θυιάδες · τὰ μὲν δὴ πρῶτα αὐτῶν Ἀθηναῖος Πραξίας μαθητὴς Καλάμιδός ἐστιν [ὁ] ἐργασάμενος· χρόνου δὲ ὡς ὁ ναὸς ἐποιεῖτο ἐγγιγνομένου Πραξίαν μὲν ἔμελλεν ἀπάξειν τὸ χρέων, τὰ δὲ ὑπολειπόμενα τοῦ ἐν τοῖς ἀετοῖς κόσμου ἐποίησεν Ἀνδροσθένης, γένος μὲν καὶ οὗτος Ἀθηναῖος, μαθητὴς δὲ Εὐχάδμου. Pausanias 10.19.4.

23. P. de la Coste-Messelière, *Fouilles de Delphes* iv.3: *Art archaïque* (fin); *Sculptures des temples* (Paris, 1931), 15-74, esp. 33-55 and fig. 8, 68; J. Dörig, "Lesefrüchte III: Der Ostgiebel des Apollontempels in Delphi," *Gestalt und Geschichte (Festschrift Karl Schefold), AntK,* Beiheft 4 (Bern, 1967), 106-109; Lippold, pl. 25,1; cf. Aeschylus *Eumenides* 1-19.

24. The torso 1344 was found "in the opisthodomos" of the temple, the head 2380 "between the Treasury of the Athenians and the western limit of the temenos," i.e. downhill to the southwest of the western façade of the temple: *BCH 99* (note 20), 709. For comments on the technique see *BCH 96* (note 20), 887, fig. 1, and Stewart, *Skopas of Paros* (Park Ridge, 1977), 40. With a preserved height of 1.5 m. the piece is over-life-size, and would fit snugly into the 2.3 m. high central part of the pedi-

ment; on the iconography, see below.

25. F. Nietzsche, *Die Geburt der Tragödie aus dem Geist der Musik* (Leipzig, 1872); commentary and discussion, Burkert, 341-343.

26. Cf. A. Fairbanks, *A Study of the Greek Paean,* Cornell Studies in Classical Philology, 12 (New York, 1900), 152-153; W. F. Otto, *Dionysos, Myth and Cult,* trans. R. B. Palmer (Bloomington, 1965), 202-208. For a more hardheaded view see Guthrie (note 1), 198-202, also Burkert, 341-343.

27. Clearly understood by Rainer, 178.

28. The earliest literary evidence for this is Philochoros, *FGrHist* 328 F7; for other references see Parke-Wormell, 15, note 31; Roux, 122-123. On Dionysos at Delphi see, in general, P. Amandry, *La mantique Apollinienne à Delphes,* Bibliothèque des écoles françaises d'Athènes et de Rome, 170 (Paris, 1950), 196-200; Jeanmaire, 187-219, 439-441; J. Defradas, *Les thèmes de la propagande delphique* (Paris, 1954), 89-91, 116-117; J. Fontenrose, *Python* (Berkeley, 1959), 374-394, 468; Parke-Wormell, 11-12; Roux, 34-35, 160-167; Rainer, 145-151. The supposed "priority" of Dionysos at Delphi is a complex problem mercifully irrelevant to my concerns here; at any rate, for what it is worth I agree with Amandry and Fontenrose in rejecting any influence from Dionysiac *manía* on the mantic procedures of the Pythia. In this context see also Fontenrose, *The Delphic Oracle* (Berkeley, 1978), 207. I omit for the moment any consideration of late sources such as Plutarch's *De E apud Delphos* (*Moralia* 384-394, esp. 388E-398C) and *De Iside et Osiride* (*Moralia* 364E-365A), for reasons that will become obvious shortly.

29. *Odyssey* 24. 71-77; Stesichorus fr. 234 Page; cf. G. Nagy, *The Best of the Achaeans* (Baltimore, 1979), 208-210. For the frieze of the François vase see Robertson, pl. 35b; best pictures in P. E. Arias-M. Hirmer, *Greek Vase Painting* (New York, 1961), pls. 40, 44 center; E. Simon, *Die griechischen Vasen* (Munich, 1976), pls. 53, 56 below and p. 70; detail, J. Charbonneaux et al., *Archaic Greek Art* (New York, 1971), fig. 67; *ABV,* 76, no. 1. Of the three other vases with this subject (list, F. Brommer, *Vasenlisten zur griechischen Heldensage*³ [Marburg, 1973], 320) two are so fragmentary that Dionysos, if originally present, has not survived, while on the somewhat idio-

syncratic dinos by Sophilos now in the British Museum (inv. 1971.11-1.1; *Paralipomena,* 19, no. 16 bis; A. Birchall, "A New Acquisition: An Early Attic Bowl with Stand, signed by Sophilos," *BMQ 36* [1972], 107-110, pls. 24-27) he only carries a thyrsos.

30. Antagonism: Burkert, *Homo Necans* (Berlin, 1972), 17, note 41, 68; idem, "Apellai und Apollon," *RhM 118* (1975), 1-21, esp. 19; idem, *Griechische Religion,* 291; Nagy (note 29), 59-65, 118-150, esp. 121; a discussion of the Telephos myth from this point of view by the present author will appear in a forthcoming booklet publishing the de Bry head in the J. Paul Getty Museum. Bones and gold: Nagy (note 29), 179-180, 208-210. Pertinent here is the "heroic" burial of the occupant of the gold ash-chest in Tomb II at Vergina: M. Andronikos, "Vergina: The Royal Graves in the Great Tumulus," *AAA 10* (1977), 1-72; M. E. Caskey, "News Letter from Greece," *AJA 82* (1978), 344-345, fig. 11; N. Yalouris, M. Andronikos, and K. Rhomiopoulou, *The Search for Alexander,* exh. cat. (Boston, 1980), 32, 187, no. 172, and color plate 35.

31. Pindar *Nemean Ode* 7.34-49; *Paean* 6.105-121 etc.; see especially Fontenrose, "The Cult and Myth of Pyrrhos at Delphi," *University of California Publications in Classical Archaeology* 4 (1960), 191-266; Nagy (note 29), 118-141; for the archaeology, Roux, 177, plan at p. 223, no. 52; J. Pouilloux, *Fouilles de Delphes,* ii.10: *La région nord du sanctuaire* (Paris, 1960), 49-60, plan 9, pl. 30, 1.

32. T. Homolle, "Inscriptions de Delphes. Réglements de la phratrie des ΛΑΒΥΑΔΑΙ," *BCH 19* (1895), 5-69, esp. 12, lines 43-45; G. Rougemont, *Corpus des inscriptions de Delphes,* i: *Lois sacrées et réglements religieux* (Paris, 1977), no. 9, lines 43-45; see the archaic original of this inscription, ibid., 86, no. 9 bis (my thanks to Professor Ronald Stroud for this reference). See Burkert, "Apellai und Apollon," *RhM 118* (1975), 1-21, esp. 10; the principle is surely the same as that embodied in Plato's advice to his puritanical disciple, Xenokrates—"Sacrifice to the Graces!" (Diogenes Laertius 4.6). See too the further links between Dionysos and Apollo embodied in the figures of Dionysos' priest Melampous (φίλτατος . . . Ἀπόλλωνι, Hesiod fr. 261 West; *RE* xv. 1,

s.v. col. 394; Parke, *The Oracles of Zeus* [Oxford, 1967], 165-173) and Apollo's priests Anios (*Kypria* fr. 20 Allen: P. Bruneau, *Recherches sur les cultes hellénistiques de Délos,* Bibliothèque des écoles françaises d'Athènes et de Rome, 217 [Paris, 1970], 413-460) and Maron (*Odyssey* 9.197; *RE* XIV. 2, s.v. col. 1911), not to mention Orpheus.

33. Pausanius 10.6.3-4, 32.7.

34. Apollo and Dionysos: Aeschylus fr. 341N² (ὁ κισσεὺς Ἀπόλλων, ὁ Βακχεύς, ὁ μάντις); Euripides fr. 477N² (δέσποτα φιλόδαφνη Βάκχε, παιὰν Ἄπολλον εὔλυρε). Muses and Dionysos: Aeschylus fr. 60 N²; Sophocles *Antigone* 965; Euripides *Bacchae* 410; cf. Solon fr. 26 West. Dionysos on Parnassos: Aeschylus *Eumenides* 22-26; Sophocles *Antigone* 1126-1130; Euripides *Iphigenia Taurica* 1234-1244, *Ion* 550, 715-718, 1122-1131; Aristophanes *Clouds* 602-605, *Frogs* 1211-1213. For the fourth century cf. Plato *Laws* 653D, and for the Hellenistic and Roman periods, notes 61, 77, and 78.

35. Calyx-krater, Leningrad St. 1807: *ARV²* 1185, no. 7; Metzger, 177, no. 32 and pl. 25c (whence my Fig. 5); Roux, pl. 52.

36. Interestingly, he was apparently included, rather unusually, in the gigantomachy of the west pediment of the archaic temple: references note 23, with Euripides *Ion* 216-218. Here the sculptor may have taken his cue from the Siphnian Treasury, where he appears on slab B of the north frieze: V. Lenzen, "The Figure of Dionysos on the Siphnian Frieze," *University of California Publications in Classical Archaeology,* 3.1 (1947).

37. Cf. also Anacreon fr. 357 Page.

38. Webster (note 10), 15-16; Webster, *Athenian Culture and Society* (Berkeley, 1973), 116 and 284, note 21, citing Lysias 2.18, 63; 18.37; 25.20; Andocides *de Mysteriis* 76; Isocrates 7.69; 18.27, 44.

39. On the problem of the *mítra* in art see C. Picard, *Mélanges G. Glotz,* ii (Paris, 1932), 707-721; Marcadé, *Etudes,* 400-401; contra, H. Brandenburg, *Studien zur Mitra* (Münster, 1966), 138-139, 147, note 23; E. Pochmarski, "Ein zweiter Basler Dionysos," *AntK 15* (1972), 73.

40. Cf. Euripides *Ion* 715-718:
ἰὼ δειράδες Παρνασοῦ πέτρας
ἔχουσαι σκόπελον οὐράνιόν θ᾽ ἕδραν,
ἵνα Βάκχιος ἀμφιπύρους ἀνέχων πεύκας
λαιψηρὰ πηδᾷ νυκτιπόλοις ἅμα σὺν
Βάκχαις.

41. According to the combined testimony of Libanius *Oratio* 60.7 and Aeschylus fr. 59N² both Apollo and Dionysos may wear a χιτὼν ποδήρης but the testimony of the vases shows that the latter is always unbelted. On Apollo's back mantle (ἐπιπόρπημα, ἐπιπορπίς or ἐφαπτίς) see Eustathius *ad Iliadem* p. 905, 54. D. Haubner, "Die Tracht des Gottes Dionysos in der griechischen Kunst" (Ph.D. diss., Wien, 1972) was unavailable to me at the time of writing.

42. On the Apollo Patroos see H. Thompson, (note 21), iii, 30-44 and pls. 1-2; details, S. Adam (note 21), pls. 42-43; Lippold, 261; Robertson, 410, pl. 125d; O. Palagia, *Euphranor* (Leiden, 1980), chap. 3, figs. 6-17. On the Vatican copy see G. Lippold, *Die Skulpturen des Vatikanischen Museums*, iii.1 (Berlin-Leipzig, 1936), no. 582 and pl. 51; M. Bieber, *Ancient Copies* (New York, 1977), 96, figs. 484-485. The Marsyas pelike, Leningrad St. 1795, is *ARV²*, 1475, no. 3; Metzger, pl. 21, 3; K. Schefold, *Kertscher Vasen* (Berlin, 1930), pl. 18b (whence Fig. 7). See, in general, Deubner, 5-11, 58-61.

43. Plutarch *de E apud Delphos* 9 (*Moralia* 389B).

44. Marcadé, *Etudes*, 400-401; the late texts cited there on page 400 and the Hellenistic and Roman Apollos with the *"mitra,"* figs. 10-17, are susceptible of another and rather different explanation: see below.

45. Cf. Dodds (note 1), 187; Henrichs (note 11), 7-8.

46. See, in general, H. North, *Sophrosyne* (Ithaca, 1966), 81-84; on ἡ. and σ. in the *Bacchae*, see also Dodds, *Euripides' Bacchae* (Oxford, 1960), xliv, 120-121; J. Roux, *Euripide, Les Bacchantes* (Paris, 1972), 380-381, 421-422, 523-524.

47. Euripides *Bacchae* 386-398. Cf. 353, 453-459, 493-494 on Dionysos' appearance: effeminate of feature and with long curling hair (like that of his maenads, 757). Aeschylus, too, describes him in rather similar terms (*Edonoi* fr. 61N²), and the

type may be implied even in *Iliad* 6.135-137. Yet its greater popularity in the later fifth and fourth centuries and the increasing effeminacy of Apollo (in both character and physique normally his absolute antithesis) in the same period are phenomena which still require explanation. Rather than the stylistic determinism implied by e.g. Robertson, 237, 388-389, one might perhaps look for instance to changes in homosexual fashions among ephebes for an answer: cf. in this context Aristophanes' *Clouds* 961-1008; Plato *Charmides* 154-156 and ff., etc.; J. K. Dover, *Greek Homosexuality* (New York, 1978), 73-81. E. Pochmarski, *Das Bild des Dionysos in der Rundeplastik der klassischen Zeit Griechenlands* (Ph.D. diss., Graz, 1969) was unavailable to me at the time of writing.

48. Parke-Wormell, 387 and note 24 for references; cf. F. Imhoof-Blumer and P. Gardner, *A Numismatic Commentary on Pausanias* (London, 1887, 2nd ed. as *Ancient Coins Illustrating Lost Masterpieces of Greek Art*, Chicago, 1964), 118-119, pl. x, 22-23.

49. Essential bibliography: H. Weil, "Un péan delphique à Dionysos," *BCH 19* (1895), 393-418, 548, and pls. 16-17 (*editio princeps*); idem, "Le péan delphique à Dionysos (supplement)," *BCH 21* (1897), 510-513; Fairbanks (note 26), 139-153; E. Diehl, *Anthologia Lyrica Graeca*, ii (Leipzig, 1925), 252-257; J. U. Powell, *Collectanea Alexandrina* (Oxford, 1925), 165-171; W. Vollgraff, "Le péan delphique à Dionysos," *BCH 48* (1924), 97-208; idem, "Le péan delphique à Dionysos," *BCH 49* (1925), 104-142; idem, "Le péan delphique à Dionysos," *BCH 50* (1926), 263-304; idem, "Le péan delphique à Dionysos," *BCH 51* (1927), 423-468; R. Vallois, "Les strophes mutilées du péan de Philodamos," *BCH 55* (1931), 241-364; F. Sokolowski, "Sur le péan de Philodamos," *BCH 60* (1936), 135-143; E. Diehl, *Anthologia Lyrica Graeca*, ii.b, 2nd ed. (Leipzig, 1940), 119-126; Rainer, passim; M. Markovich, "Philodamus' Delphic Hymn to Dionysus," *ZPE 18* (1975), 167-168; Fontenrose (note 28), 254-255, H 31-32.
Of these studies, Rainer's is by far the most detailed and judicious, but perhaps rather inconclusive on religious matters and apparently unfamiliar with some of the recent archaeological and epigraphical evidence. Thus he does not know of the

discovery of the pedimental sculptures, and is unaware of the article by Claude Vatin, "Pharsaliens à Delphes," *BCH 88* (1964), 446-454, which locates the archonship of Etymondas (when the poem was inscribed) in 334/333 or 339/338. Most recently, P. Marchetti, *Etudes*, 67-89 (followed by J. Bousquet, note 15, 95, note 13), has eliminated the gap in the lists at 344/343 and raised the remaining archons previously attributed to 343/342-337/336 by one year, leaving only 340/339 unfilled (the name, eight letters in the genitive, is missing). This then should be Etymondas' year, for in the genitive his name is ETYMONΔA: the command to finish the work or risk Apollo's wrath, μῆνις, at lines 105-108 (see Markovich, loc. cit.) is then explained by the interruption caused by the Fourth Sacred War, then just beginning.

50. Rainer, 143, perhaps underestimates the significance of this fact. The paian to the Furies (Xenophon *Hell* 4.7.4; Aeschylus *Agamemnon* 644-645) may be explained by these divinities' lack of any proper literary forms of address of their own, as may the paians to Asklepios (who as Apollo's son would in any case merit the honor: cf. notes 12 and 13) by Isyllos and others (cf. Athenaeus 15.720A: to Hygieia). Dionysos, on the other hand, does have his own form of address, a fact that is sharply and no doubt intentionally highlighted by Philodamos' own first line: [Δεῦρ᾽ ἄνα] Διθύραμβε, Βάκχ᾽. . . .

51. At which he would not normally have been present, since his tenure at Delphi covered only the three winter months, when Apollo was away: the Theoxenia, however, was in March and the Pythia in August. Cf. Plutarch *de E apud Delphos* 9 (*Moralia* 388E); Fontenrose, *Python* (note 28), 379-381, also note 52.

52. In stanza xii, where Athens is mentioned at line 150, there is a curious and apparently hitherto unremarked similarity in the vocabulary to that used by the Delphic oracle in addressing the Athenians, quoted in Demosthenes 21.51-52 (Parke-Wormell, no. 282): had the Athenians been backsliding on their commitments, or were they simply the first in a catalogue (lines 151-152 are missing) introduced and expressed in rather conventional language? With re-

gard to this stanza, note also the continual association of Dionysos with Night in this poem: ἀστερόεν δέμας (21), ἀστροφαές (27), παννυχίζετε (150, perhaps also 40). On the pediment, it will be remembered from Pausanias' account (note 22) the sun was setting, as befits a composition that faced west. See, in general, P. Hommel, "Giebel und Himmel," *IstMitt 7* (1956), 11-55, and on Dionysos, maenads, and night, Jeanmaire, ch. 5 passim; an allusion to the "chthonic" Dionysos, whose grave was to be found in the temple itself, is possible but to my mind less likely, since Philodamos rigorously excludes this (together with all other "disturbing" features of the Dionysiac legend) from his poem, even though Thebes is celebrated as his birthplace in lines 6-10 (on this aspect of the god see Jeanmaire, 273-278; Burkert, 308, 438, 442-443; M. Detienne, *Dionysos mise à mort* [Paris, 1977]; see also note 78).

53. Cf. also line 153, where he becomes ἄναξ ὑγιείας. On τιμή, κλέος, cult, and song see Nagy (note 29), 118-119.

54. Note once again the expurgation of all "disturbing" features of the legend from the poem (note 49). Interestingly, Aristonoos' *Hymn to Apollo* (Powell [note 49], 162-164), inscribed only six years later during the archonship of Damochares (334/333: G. Daux, *Fouilles de Delphes*, iii suppl.: *Chronologie delphique* [Paris, 1943], 14; cf. P. de la Coste-Messelière, "Listes amphictioniques du IVᵉ siècle," *BCH 73* [1949], 233-236; Marchetti, *Etudes*, 82), only mentions Dionysos in the context of his biennial appearance at the trietēris (line 37). Presumably he was now considered to be "tamed."

55. See Parke-Wormell, nos. 282, 284, 337, 349, 549, 550; Fontenrose (note 28), H 28, 31-32, 44, 49(?), 51-52, 74; Q 241, 266, 267. Compare too the legendary and fictional responses, almost all apparently invented in this period: Parke-Wormell, nos. 214, 321, 338, 408, 414, 502, 542-548, 551, 556, 557, 570; Fontenrose (note 28), L48, 81, 100, 103, 133-135, 140, 148-149, 150, 159, 171, 173-174; F 14.

56. Parke-Wormell, 330, 338.

57. *Etudes*, 400-408, figs. 10-17; for the Apollo, A 4124, see especially Marcadé, 182-184, 367, and pl. 30.

58. On the Apollo Lykeios see Lucian *Anacharsis 7*; Deubner, 26-29, 62-63; Lippold, 238-239, pl. 84, 1; Bieber, 18 and figs. 17, 19-23. On the motif of the shields see Callimachus *Hymnus in Delum* 171-185, with C. Picard, "Apollon, Bès, et les Galates," *Geneva 5* (1927), 52-63.

59. Dionysos, British Museum 432: Bieber, 66 and fig. 213. On the controversy about its original location on this monument or otherwise see the summary by P. Bernard and F. Salviat, "Nouvelles découvertes au Dionysion de Thasos," *BCH 83* (1959), 330, note 3; cf. 331, note 1, on the rare late classical examples of Dionysos *kitharōidós*.

60. Pausanias 1.2.5.

61. Note 34, with Plato *Leges 2*, 672D; Diodorus 4.5 and 7; Ovid *Ars Amatoria* 3.347, etc.; P. Roussel, M. Launey, *Inscriptions de Délos*, iv (Paris, 1937), no. 1959; *IG* XII. 5. 46 (Naxos); F. Hiller von Gaertringen, *Inschriften von Priene* (Berlin, 1906), no. 174, 5; D. Morelli, "I Culti in Rodi," *Studi Classici e Orientali 8* (1959), 41, 122-123; see also Lysippos' Dionysos on Helicon, Pausanias 9.30.1. In line 58 of Philodamos' paian the Muses become Thyiads, donning ivy wreaths and dancing the dithyramb. For further references and discussion see O. Gruppe, *Griechische Mythologie und Religionsgeschichte, Handbuch der klassischen Altertumswissenschaft*, v. 2.2 (Munich, 1906), 829, note 3.

62. Bernard and Salviat (note 59), 288-335 and pls. 13-21.

63. Note 62, 330; for his more normal costume in monumental sculpture, cf. the so-called Sardanapalus type: Lippold, 242; Robertson, 395-396; E. Pochmarski, "Neue Beobachtungen zum Typus Sardanapal," *JOAI 50* (1972-1973), 41-67.

64. E.g. the Meleager painter's cup BM E 129: *ARV²*, 1414, no. 89; Arias-Hirmer (note 29), pl. 222; Metzger, 115, pl. 11, 2; cf. the pelike NM 1181: *ARV²*, 1475, no. 5; K. Schefold, *Untersuchungen zu den Kertscher Vasen* (Berlin-Leipzig, 1934), pl. 37, 1. Hydria handle appliqués, BM 311 and 312: G. M. A. Richter, "A Fourth-Century Bronze Hydria in New York," *AJA 50* (1946), 364, nos. 12-13 and pls. 26, 14 and 27, 19; cf. H. Speier, *RömMitt 47* (1932), 77 and pl. 22, 4. As Bernard and Salviat point out (note 59) on pp. 318-320 of their article, the motif derives from fifth-century Aph-

rodite types (see most recently Bieber [note 42], 42-47 and pls. 72-74).

In essence, it seems to connote a relaxation of constraints, an emancipation from repressions combined with a certain insouciance: on the mortal plane one imagines a state of mind similar to that described by Homer in his well-known phrase λύτο γούνατα καὶ φίλον ἦτορ (*Odyssey* 34.345 etc.).

65. Bernard and Salviat (note 59), 330-331.

66. National Museum, Athens ΣΤ 232. Amandry passim; idem, *Collection Hélène Stathatos: Les bijoux antiques* (Strasbourg, 1953), no. 232, pl. 35; Stella G. Miller, *Two Groups of Thessalian Gold, University of California Publications in Classical Studies*, 18 (Berkeley, 1979), 10, pl. 19a. Reynold Higgins informs me that he favors a second-century date for this piece, which seems reasonable; as Nancy Tersini has pointed out to me, the starburst and rosettes in the gable recall those on the new gold chest from Vergina (note 30), which could indicate manufacture in Macedonia or for Macedonians.

67. Now in Tripoli: Amandry, 189 and fig. 15; idem, *Collection Stathatos* (note 66), 94-95, fig. 55; Bernard and Salviat (note 59), 320-321, fig. 23.

68. This adaptation was made at least by the later fourth century, as the seated Dionysos on the Derveni krater demonstrates (*BCH 87* [1963], pls. 16-17; Robertson, 483-493 and pl. 141b; *The Search for Alexander* [note 30], no. 127 and color pl. 20); cf. too the Dionysos-Satyr group NM 245: C. Blumel, *Griechische Bildhauerarbeit, JdI-EH 11* (1927), 63, no. 27, and pl. 33; Speier (note 64), 77 and pl. 22, 4; Amandry, 185-186, fig. 2; Pochmarski, "Zum Kopf vom Südabhang," *AM 90* (1975), 156. The earliest example of the gesture in monumental sculpture is to be found on the Berlin-Sciarra-Landsowne Amazon (Lippold, 172 and pl. 61, 3; Robertson, 334-336 and pl. 111b), and in a painting on the krater N.Y. 07.286.84 (*ARV²*, 613, no. 1; Robertson, pl. 88a). The gesture is not discussed by G. Neumann in his *Gesten und Gebärden in der griechischen Kunst* (Berlin, 1965), but it seems a perfect complement to the slipping himation in the sense of languor it conveys: I wonder whether it might not originally have been an intensification of the gesture of ἀθυμία discussed

by Neumann on 151-152 of his book (cf. Xenophon *Cyropaedia* 3.1.24). For neo-Attic and Roman versions of the Dionysos-Ariadne and Dionysos-Satyr groups see, in general, W. Fuchs, *Die Vorbilder der neuattischen Reliefs, JdI-EH 20* (1959), 108-111 and pls. 22-24; cf. A. Bruhl, *Liber Pater,* Bibliothèque des écoles françaises d'Athènes et de Rome, 175 (Paris, 1953), pl. 6; on the interchange of iconographies between Apollo and Dionysos in the Hellenistic period note especially Marcadé, 174-193.

69. Robertson, 550 and pl. 174c; the name piece of the type is BM 1380 (Fig. 16).

70. Deubner, 30-36, 63-64 (K30); list edited by G. Becatti, "Timarchides e l'Apollo qui tenet citharam," *BullComm 63* (1935), 111-131, cf. idem, "Attika—Saggio sulla scultura attica dell'ellenismo," *RivIstArch 7* (1940), 33-36. Arguments over the date of the original are summarized by Bernard and Salviat (note 59), 333, note 1; additions to the lists, E. Paribeni, *Sculture di Cirene* (Rome, 1959), no. 142, pl. 85, plus the statuette Thasos 70 (both signaled by Bernard and Salviat [note 59], 320, note 2, 331, note 5), and also perhaps the statuettes Delos A 1992, A 5176, and Athens, Sisilianos: Marcadé, pl. 31. Recent discussions in W. Helbig, *Führer durch die offentlichen Sammlungen klassischer Altertümer in Rom,*[4] ii (Tübingen, 1966), no. 1383 (H. von Steuben); Bieber, 160 and figs. 678-681; J. Huskinson, *Roman Sculpture from Cyrenaica in the British Museum, CSIR* Great Britain, ii.1 (London, 1975), no. 12 and pl. 5; A. F. Stewart, *Attikà, JHS* supplement 14 (London, 1979), 42-45.

71. This assertion, which is Becatti's (note 70), is based on the reappearance of the type in the triad of Postumius, Herakles, and Apollo that occupies the background of the merchants' panel of Trajan's arch at Beneventum (Becatti, 120, fig. 1, pl. 1). The topographical objections raised by F. J. Hassel, *Der Traiansbogen in Benevent* (Mainz, 1966), 16-17, cf. pls. 7,2 and 11,1, who situated the sanctuaries concerned in Ostia, have been decisively quashed by M. Rotili, *L'Arco di Traiano a Benevento* (Rome, 1972), 102-106, cf. pls. 103, 107-112, and T. Lorenz, *Leben und Regierung Traians auf dem Bogen von Benevent* (Amsterdam, 1973), 20, cf. pl. 5 above. Yet even though it seems

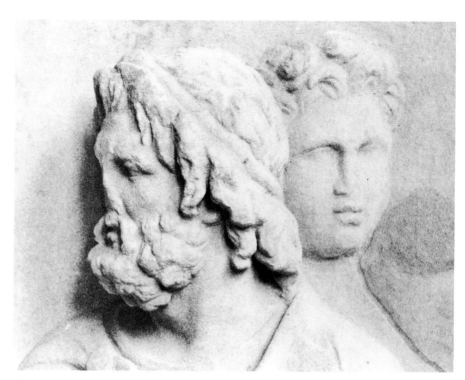

Fig. 20. Heads from the Telephos frieze from the Great Altar of Pergamon, Berlin (after *Altertümer von Pergamon,* iii. 2, pl. 36, 6).

clear that the gods in question are supposed to be on the rocky outcrop of the Capitol overlooking the Forum Boarium, it must be admitted that the attribution itself continues to rest only on Pliny's brief notice in *NH* 36.34 and on general considerations of style. Thus the head is close to that of the snake-legged giant from the north frieze and the physique to that of the Apollo from the east frieze of the Great Altar of Pergamon, carved around 160: cf. H. Winnefeld, *Altertümer von Pergamon,* iii.2 (Berlin, 1910): *Die Friese des Grossen Altars,* pls. 9, 14, and 26 top left; cf. P. J. Callaghan, "On the Date of the Great Altar of Zeus at Pergamon," *BICS 28* (1981), 115-121. As for the connection with Athens and the Polykles family, the arguments are too complex to be summarized here. Cf. Becatti (note 70), passim, with A. Stewart's *Attikà* (note 70), 42-46, and compare a head found near the Hephaisteion in 1924: *ADelt 9* (1923-1924), par. 20 and fig. 7 (NM 3482); Stewart, *Attikà* (note 70), 53, 64, note 101.

A final comparison is the Medusa Rondanini in Munich (E. Buschor, *Medusa Rondanini* [Stuttgart, 1958], pls. 1,3), recently redated to the Hellenistic period by J. D. Belson, "The Medusa Rondanini: A New Look," *AJA 84* (1980), 373-378. Bel-

son suggests that the type may have been copied from the golden aegis dedicated on the Acropolis of Athens by Antiochos IV Epiphanes of Syria, presumably as a result of his visit in 176 (cf. *Attikà* [note 70], 47). A forthcoming article by Peter J. Callaghan will emend this view somewhat, showing that the creation of the type is most likely due to Antiochos III, at the very end of the third century. At any rate, common to both pieces are the ovoid, classically proportioned face, sharply defined features, prominent chin, high cheekbones, open, undulant lips, slightly hooded, large-lidded eyes with their wide-swinging brows, and clearly demarcated locks divided into two or three strands. Whatever the original function of the Medusa may have been, these strong affinities in style suggest that she indeed belongs close within the orbit of the Apollo, and so (perhaps) of Timarchides as well.

72. Pochmarski (note 39), 73-75 and pls. 18-20. Pochmarski dates the type to the second century A.D., but cf. the heads from the Telephos frieze (after Winnefeld [note 71]) illustrated in Figs. 20-21. On the seated Dionysos/Apollo type with the "Lykeios" gesture, cf. note 68 with e.g. Deubner, 37-39, 65 (K32-5); Amandry, 138, note 1;

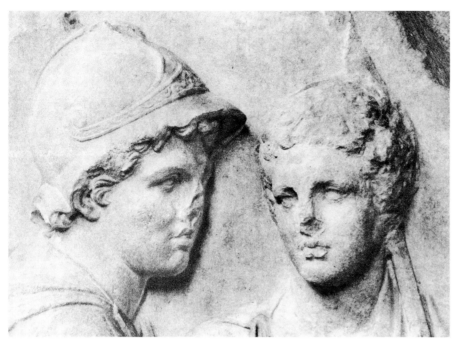

Fig. 21. Heads from the Telephos frieze from the Great Altar of Pergamon, Berlin (after *Altertümer von Pergamon*, iii. 2, pl. 36, 7).

Marcadé, 184-186 and pl. 30 (with a good discussion of theatrical associations).

Apollo's long hair perhaps deserves a note at this point. Until c. 460 he is generally represented as long-haired, presumably after the Homeric hymn to Apollo (3. 450: cf. K.A. Pfeiff, *Apollon* [Frankfurt, 1943], pls. 1-2, 7-9, 12, 14-23, 31-35). From the early classical period, however, his hair is either bound up or (very rarely) cut short (Pfeiff, pls. 13, 14b, 24-30, 40, 43-49) until the second quarter of the fourth century, when there is an increasing tendency to let it hang long and loose, especially in *kitharōidoí* (cf. Fig. 7 with the Apollo Rhamnousios of Skopas, *BullComm 60* (1932), tav.agg. D to p. 60; G. Becatti, "Una nuova copia dell'Apollo Palatino di Scopas trovata a Salviano (Todi)," *BullComm 64*, (1936) 19-25, esp. 25, fig. 2; and the Taranto fragment, Robertson, pl. 133b. The first *kitharōidós* to have long curling locks falling over his breast is apparently Euphranor's Apollo Patroos (Fig. 6: note 21). Dionysos, however, always wears his hair long, often with these same front locks: Apollo's adoption of this coiffure may have been influenced by Dionysiac iconography, but if so, since the exchange took place in the fourth century, one can

no longer really label this feature of the Kyrene type as truly "Dionysiac."

73. So Marcadé, 182.

74. That this Apollo was quite clearly a *Mousāgétēs* is shown by the program of the Faustina baths in Miletos, which featured it as the centerpiece of a group of Muses: cf. A. von Gerkan, F. Krischen, *Milet*, i.9: *Thermen und Palaestren* (Berlin, 1928), 61, 65, fig. 80, 104-118, and pls. 28-34. On the Muses, Lippold, 334, pl. 120, 2-4; Bieber, 128-129, figs. 497-502; D. Pinkwart, *Das Relief des Archelaos von Priene und die "Musen des Philiskos"* (Kallmünz, 1965); A. Linfert, *Kunstzentren hellenistischer Zeit* (Wiesbaden, 1976), 100-101.

75. See especially H. Lewy, *Sobria Ebrietas* (Giessen, 1929); North, "The Concept of *sophrosyne* in Greek Literary Criticism," *CP 43* (1948), 1-17, especially 13-16. Oddly enough, considering its title, the latest study of Hellenistic poetry pays no attention to the concept at all: D. H. Garrison, "Mild Frenzy: A Reading of the Hellenistic Love Epigram," *Hermes*, Einzelschr. 41 (1978).

76. North (note 75), 16.

77. Dio Chrysostomus 31.11 (cf. Morelli [note 61], 102, 122-124, 162-164; Macrobius *Saturnalia* 1.18.1-2, cf. Otto (note 26), 203-206. N.B. that at Delphi a statute of Apollo slaying Python, set up by the Knidians in the fourth century, seems to have undergone the ultimate indignity of conversion to a Dionysos in the first century B.C.: A. Schober in *RE*, supp. v (1931), cols. 138-139, commenting on Pausanias 10.32.1, and E. Bourguet, *Fouilles de Delphes*, iii.1: *Inscriptions de l'entrée du sanctuaire au trésor des Athéniens* (Paris, 1929), no. 137. Schober's remarks are apparently misunderstood by Roux, 161.

78. Kleanthes, *Stoicorum Veterum Fragmenta*, i, fr. 540, 541, 546; Macrobius *Saturnalia* 1.18 (for "Aristoteles" in 18.1 read "Aristokles: cf. *RE* xiv., s.v., cols. 194-196); Menander Rhetor, ed. Spengel, 3, 446; Servius ad Vergil *Eclogues* 5. 66; Proclus *Hymns* 1.40, 3, p. 131, 28; Julian *Oratio* 4, p. 186, 27; 198, 5 ed. Hertlein; *contra*, Arnobius *Adversus Gentes* 3.33; Firmicus Maternus *De errore profanarum religionum* 8.7; see in general, Bruhl (note 68), 172-173, 188, 194, 262-266; E. Simon, "Apollon in Rom," *JdI 93* (1978), 202-227 passim. On the revival of interest in *numina mixta*, specifically Apollo-Bacchos, in Renaissance and baroque literature and art, see especially E. Panofsky, *A Mythological Painting by Poussin in the National Museum Stockholm*, Nationalmusei Skriftserie, NR 5 (Stockholm, 1960), with C. Dempsey, "The Classical Perception of Nature in Poussin's Earlier Works," *JWarb 29* (1966), 219-249, esp. 223ff. My thanks to Professor Svetlana Alpers for drawing my attention to these references.

79. *De E apud Delphos* (*Moralia* 384D-394C); cf. F. Poulsen, *Delphi* (London, 1920), 149; Roux, 194-195; Parke-Wormell, 389, are skeptical—and so, I think, am I. See now A. T. Hodge, "The Mystery of Apollo's *E* at Delphi," *AJA 85* (1981), 83-84.

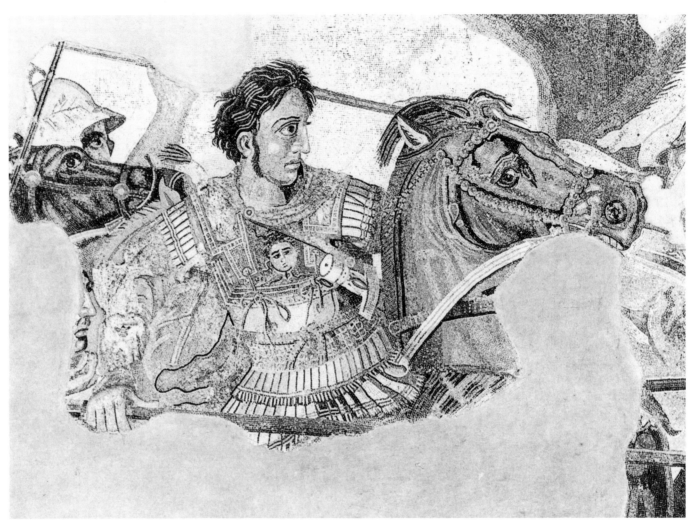

Fig. 8. Detail of Alexander from a mosaic found at Pompeii, Museo Nazionale, Naples.

Alexander's Influence on Greek Sculpture
As Seen in a Portrait in Athens

CAROLINE HOUSER

Department of Art, Smith College

THE DEATH OF Alexander the Great in 323 B.C. is usually accepted as the beginning of the Hellenistic era.[1] Finds from recent excavations indicate, however, that the Hellenistic style in sculpture was established at an earlier date. Although this material can be related to Alexander, it suggests that the new style was not dependent, as is often thought, upon the breakup of his empire nor upon his assimilation of East with West. First evidence of the new characteristics can be found in philhellenic kingdoms on the outskirts of the Greek world, indicating that the Hellenistic style began outside the artistic center of the classical world. This newly discovered art, part of a major monument erected in Athens during the late fourth century, shows a strong mixture of classical elements with Hellenistic tendencies.

Important fourth-century sculptors are named in literature and inscriptions that survive from antiquity, but we know little about their work on a firsthand basis. We do not possess a single monumental statue from the mid- or late fourth century which is universally accepted as an original work that can be securely dated and attributed with certainty to a particular artist.

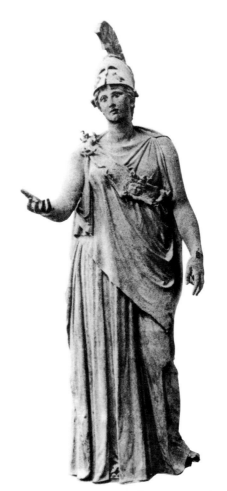

Fig. 1. The Piraeus Athena, National Museum, Athens.

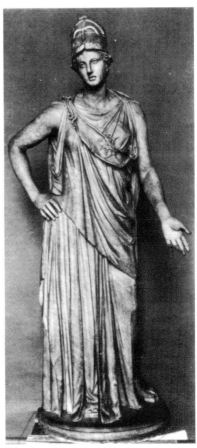

Fig. 2. The Mattei Athena, Louvre.

Literary references and Roman copies have been the primary basis of our knowledge about fourth-century sculpture; only recently have we had good evidence to demonstrate the difference between a Greek original (Fig. 1) and a Roman copy (Fig. 2).[2] Comparison of the Piraeus Athena to the Mattei Athena dramatizes the con-

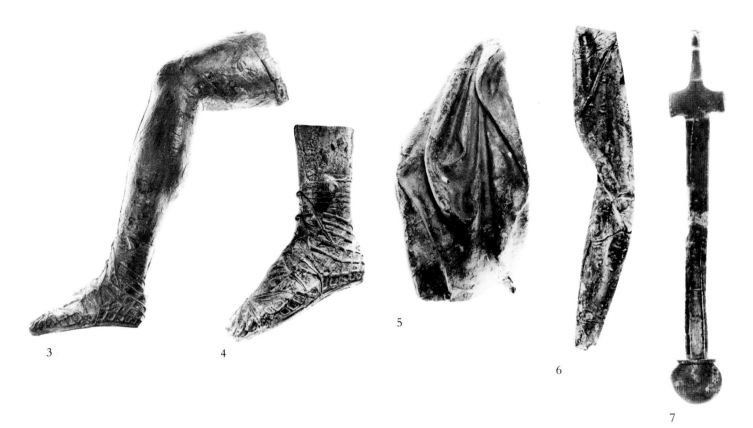

3 4 5 6 7

siderable caution with which we must use copies to discuss style.

Still needed are solid points of reference, original works that can be dated on an objective basis, in order to refine our understanding of freestanding fourth-century sculpture that represents the shift from classical to Hellenistic style. Fragments of a statue excavated in the Athenian Agora provide a starting point. An equestrian figure can be reconstructed from four large sections that survive from a gilded bronze statue, broken in antiquity. The statue can be identified as a portrait of Demetrios Poliorketes and dated 303/302 B.C. by a combination of archaeological and historical evidence.[3] As the only freestanding fourth-century statue from Athens that can be identified and firmly dated, the monument of Demetrios can be used as a reliable reference point.

Demetrios Poliorketes, "Deme-

trios the Besieger," was the son of Antigonos Monophthalmos, "Antigonos the One-Eyed." The fortunes of father and son were even more entwined than were those of Philip II and Alexander the Great, and the mutual dependence of Antigonos and Demetrios was stronger. Antigonos, an officer first for Philip and then for Alexander, acquired command of the royal army in Asia in 321 B.C. That command provided him with an excellent chance of reuniting Alexander's empire under his and Demetrios' control—a goal they pursued together. Their hopes were defeated at Ipsus, where Antigonos was killed when the elephants ran out of control.

Demetrios apparently resembled Alexander. He is said to have been even more handsome and, like Alexander, was a charismatic figure who inspired devotion. He sought to link himself with Alex-

Figs. 3-7. Leg, foot, two drapery fragments, and sword from a portrait of Demetrios Poliorketes, Agora Museum, Athens.

ander in every way, cultivating his Alexander-like appearance and marrying women who had a legitimate link to the Macedonian regency. Whether fighting or relaxing, Demetrios operated with style; when he was in Athens, for example, he set up residence in the Parthenon. (He reasoned that deification made him the brother of Athena, so he stayed in her house.)

The largest portions of the Agora portrait that survive represent the left leg of Demetrios, two sections of drapery from his cloak, and his sword. They are of heroic size; if the statue were complete, the figure would be at least six feet tall. The leg (Fig. 3) is in the posi-

tion of a horseman's, and the upper thigh is cut away on the inside to fit astride a horse. The controlled but easy pose indicates that both horse and man were at rest. Muscular and lean, the leg suggests a mature man in peak physical condition.

The footgear (Fig. 4) consists of a sock, a sandal, and a spur. The sandal simulates one piece of leather that has been perforated by holes cut in a pattern that resembles (but is not) a network of woven separate thongs. A tongue at the back of the sandal is designed to protect the wearer's Achilles tendon. A flat and wide strap laces the sides of the sandal together; the strap is folded through the eyes, then wound around the ankle and knotted in front. This footgear—the sock and openwork sandal—had not been identified as a type before this sculpture was found, but there are many other representations of it.[4] The design incorporates an explicit account of all elements of the footgear.

The artful arrangement of the surviving drapery suggests a naturalism similar in style to that of the Parthenon figures. One section of drapery (Fig. 5) forms soft, heavy folds; it belongs over the left leg at the upper thigh, where it falls quietly with no indication of movement. The other drapery section (Fig. 6), long and narrow, represents a fold of the horseman's cloak; it, too, is motionless. The two extant fragments are enough to establish that Demetrios was portrayed sitting at rest in an erect posture.

The large straight sword (Fig. 7) is not an Athenian type. It is the distinctive shape and size popular in Macedonia and the Greek East at the time of Alexander. The handle

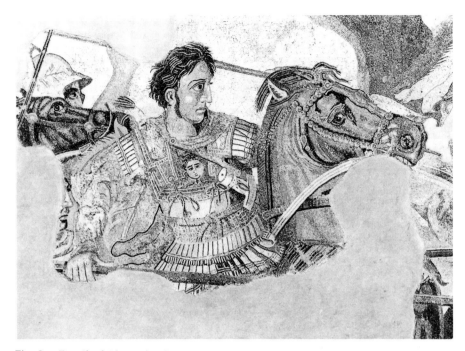

Fig. 8. Detail of Alexander from a mosaic found at Pompeii, Museo Nazionale, Naples.

is similar, for example, to that of Alexander's sword in the so-called "Alexander Mosaic" (Fig. 8), which reflects a late fourth-century design. The weapon is a counterpart in sculpture to several real swords found in Macedonian tombs.[5] Like the elegant and practical footwear, the sword is a faithful representation of the actual paraphernalia of a Macedonian leader.

Of the smaller fragments, the most interesting is a miniature Pegasos (Fig. 9). The flying horse, now disfigured by bronze disease, can be reconstructed on the helmet of Demetrios. The model for an elaborate helmet with a Pegasos on each side is that of the Athena Parthenos (Fig. 10).[6] Demetrios, of course, knew the Phidian chryselephantine cult image well since he lived in the Parthenon.

The statue that can be reconstructed from these pieces is time-

Fig. 9. Pegasos from a portrait of Demetrios Poliorketes, Agora Museum, Athens.

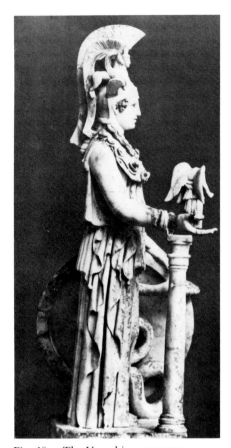

Fig. 10. The Varvakion statuette, a
Roman copy of the Athena Parthenos,
National Museum, Athens.

Fig. 11. Reconstruction drawing of a portrait of Demetrios Poliorketes.

less and serene in pose (Fig. 11). There is no flutter in the quiet drapery; there is neither tension nor torsion in the leg; the sword is sheathed. Comparison with the rhythmic movement of mortal horsemen on the Parthenon frieze (Fig. 12) emphasizes the repose of the powerful portrait. The weight and balance of the statue are similar to those of the figures of gods depicted on the Parthenon, both on the frieze and in the pediments (Fig. 13). Affinity with those high classical fifth-century gods is reinforced by a comparison with the late classical riders carved in the round for one of the great monuments of the fourth century, the

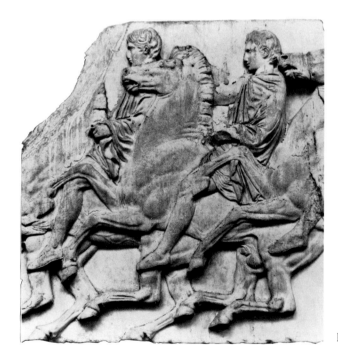

Fig. 12

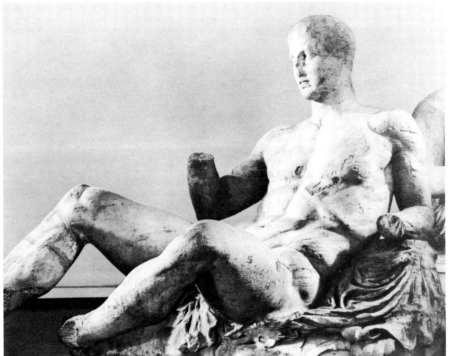

Fig. 14. Amazon from the Temple of Asklepios at Epidauros, National Museum, Athens.

Fig. 13. Herakles from the east pediment of the Parthenon, British Museum.

Fig. 12. Detail of horsemen from the north side of the Ionic frieze on the Parthenon, British Museum.

Temple of Asklepios at Epidauros (Fig. 14). It is, of course, easier to portray action and movement in relief than in statues carved fully in the round; however, the Epidauros figures demonstrate that the design of Demetrios' statue, closer in pose to high classical figures than to other familiar late classical ones, represents the artist's or the patron's choice—not the limitations of freestanding sculpture.

Despite dependence upon high classical form and iconography, Demetrios' monument reveals a shift from classical to Hellenistic style that is subtle and sophisticated, yet strong in its reflection of new ideas. First, the conventional pose used during the classical period for representing a commander-in-chief has been replaced by a new one. The fifth-century *strategos* head-type has already been identified by Poulsen: an erect head, usually turned slightly on its axis, wearing a helmet pushed back off the face to the top of the head.[7] The best-known *strategos* head is probably that of Perikles, reflected in a Roman herm now in the Vatican (Fig. 15). Since we know the *strategoi* portraits mainly through Roman replicas, which usually copied only the head, we have less information about the original bodies.[8] We do know, however, that the conventional

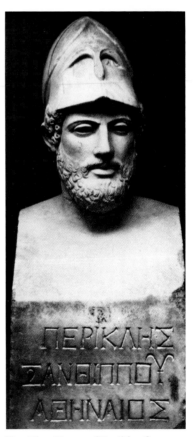

Fig. 15. Herm of Perikles from a villa near Tivoli, Vatican.

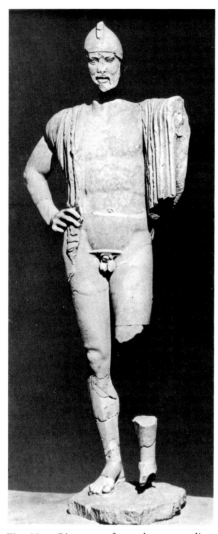

Fig. 16. Oinomaos from the east pediment of the Temple of Zeus at Olympia, Olympia Museum.

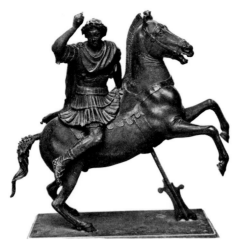

Fig. 17. Statuette from Herculaneum, Museo Nazionale, Naples.

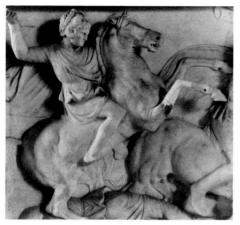

Fig. 18. Detail of Alexander from a sarcophagus found in the royal cemetery at Sidon, Archaeological Museum, Istanbul.

strategos was a standing figure. I believe the convention was used for the pedimental figure of King Oinomaos on the Temple of Zeus at Olympia (Fig. 16) and for the two high classical statues found in 1972 near Riace Marina, one of which certainly wore a helmet.[9]

Second, the Agora statue honors a particular man and was clearly designed to be an easily recognizable image of him. Explicit and extravagant representation of a specific individual is documented by this distinctive monument set up in the last decade of the fourth cen-

tury in the Athenian civic center. In this case, personal glorification of the subject was carried to the extreme by the use of gold to cover the statue; gold implies deification since previously it had been reserved by the Greeks for images of gods. When democracy was strong in classical Athens, there would have been no monumental gilded portrait of a man who accepted the title "savior" and who assumed the title "king." This gilded equestrian monument is an artistic record of the role that Hellenistic divine kingship played in the bastion

of democracy by the end of the fourth century B.C.[10]

These innovations in Demetrios' equestrian monument in the Athenian Agora can be directly related to Alexander the Great. First, the ruler is a horseman. The Agora statue depicted Demetrios mounted on his horse, following a model prevalent among fourth-century portraits of Alexander. Lysippos was commissioned by Alexander to memorialize the king's Companions who fell at Granicus in a group portrait. The monument was composed of bronze statues of the men with Alexander in their midst on horseback. A statuette in Naples (Fig. 17) has long been described as a scaled-down copy of the Granicus portrait of Alexander. Reflecting the composition of a fourth-century painting, the "Alexander Mosaic" (Fig. 8) depicts Alexander on horseback, while the Persian king rides in his chariot. In the late fourth-century image of Alexander on the so-called "Alexander Sarcophagus" from Sidon, the Macedonian commander again appears as a horseman (Fig. 18).

An equestrian pose seems inevitable for Alexander. Stories of his expertise as a horseman are numerous, beginning with his famous taming of Bucephalus. When one considers his campaigns, one realizes that much of his life was spent on horseback. Besides suggesting Alexander's constant movements and conquests, the equestrian pose reflects his Macedonian heritage. Alexander I and Philip II both chose a horseman to be a symbol on their respective coinage; in both cases the horseman may be recognized as a reference to the king himself.[11] The equestrian pose was well established in late archaic and

classical Greek sculpture to indicate young knights, such as Dexileos (Fig. 19) and the Athenian cavalry in procession on the Parthenon frieze (Fig. 12), as well as to memorialize equestrian victors in the Games, one of which the "Rampin Rider" (Fig. 20) must be. However, Alexander's adoption of the pose established it as that of the victorious statesman-general.[12]

Several poses could be suggested to convey the character of Demetrios, whose personal pleasures were as famous as his military conquests on both sea and land. The standing *strategos* type would have been the traditional Athenian one for him to use in a portrait commemorating him as Athenian commander-in-chief. But Demetrios rejected the classical practice in favor of the equestrian form so closely associated with Alexander.[13] That model, spread wide by Alexander's images, became the standard for temporal leaders for the next two thousand years. The portrait of Demetrios from the Athenian Agora is the oldest surviving example in life-size bronze of an equestrian commander-in-chief.

A second innovation in Demetrios' statue is that it is a specific portrait. Greeks had long represented themselves in monumental statues, but the earlier images were generic—stylized or idealized. Specific portraits appear as part of a general trend in the fourth century toward increasingly naturalistic figures. Early dramatic evidence of individualized portraiture appears in sculpture commissioned for two powerful mid-fourth-century courts at the edge of the Greek world: Macedonia and Caria.

The fiercely determined counte-

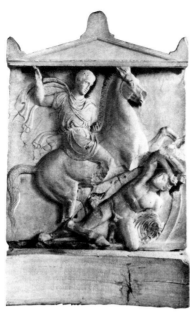

Fig. 19. Stele of Dexileos, Kerameikos Museum, Athens.

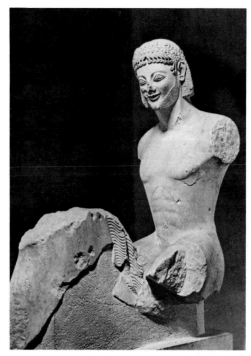

Fig. 20. Rampin Rider: head in the Louvre; body and horse in the Acropolis Museum, Athens.

nance of Philip II, Macedonian king from 359 to 336 B.C., has been identified by Professor Andronikos in an ivory head excavated at Vergina[14] and in a life-size marble copy of Roman date in Copenhagen.[15] Although the practice of stamping a ruler's image on coinage did not spread throughout the Greek world until the end of the fourth century, Philip may have done this in the mid-fourth century;[16] literary references attest to other portraits now lost.[17]

Distinctive features of the large male portrait statue that survives from the Mausoleum (Fig. 21, right) indicates that it is a portrait of a particular person. It might be an image of Mausolos himself. Surely it is the portrait of one of the members of the Carian ruling family, the Hekatomnid dynasty, as is the large female statue from the Mausoleum (Fig. 21, left) often identified as Artemisia.[18]

Patronage from the Carian and the Macedonian courts undoubtedly was a catalyst in the development of specific portrait sculpture. Rulers who held office through their own personalities and power

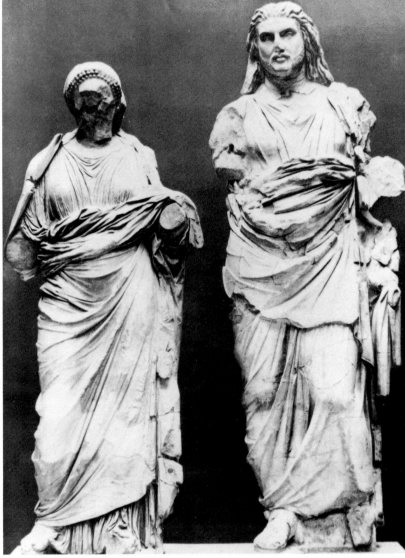

Fig. 21. Two figures from the Mausoleum at Halicarnassus, probably Artemisia at the left and Mausolos at the right, British Museum.

that Alexander commissioned are lost, we know from literary records that often they were portraits of himself, his family, and his loyal friends. There can be little doubt that they were meant to be easily recognizable.

The luxurious gold surface of Demetrios' statue also follows Alexander's precedent in form and concept. Since the classical Greeks used gold for images of the gods, the material was surely the visual sign of Demetrios' deification. The practice of portraying mortals in the material of the immortals can be traced to Alexander and perhaps through him back to Philip. One or both of them commissioned Leochares to make gold and ivory statues of Alexander, his parents (Olympias and Philip), and his paternal grandparents (Amyntas and Eurydike) for the Philippeion at Olympia.[20]

This one dated statue of Demetrios Poliorketes, a major monument when it was made shortly before the end of the fourth century, provides a solid start for refining our understanding of the rich and complex sculpture of the late classical and early Hellenistic time. In it we see that classical elements of both form and iconography still flourished in Athens itself, even in a statue that is Hellenistic in concept and date. The powerful images of Phidias' work were firmly impressed on those who lived in their shadow; classical ideals and forms were deeply rooted in the stronghold of democracy.

The particular innovations in the equestrian statue of Demetrios do not depend upon art that Alexander and his troops met in Persia or in Egypt. Instead, the seeds can be found in philhellenic kingdoms on the edge of the Hel-

had an obvious need to promote themselves. Genuine admiration for Greek art probably played a role in the Macedonian and Carian commissions, but there can be little doubt of the political motives behind the patronage. By recognizing and patronizing the best Greek artists, those philhellenic rulers claimed relationship to the civilized world, the Greek world, in which the Macedonians' membership was insecure and the Carians' ethnic and political membership

nonexistent. By commissioning specific portraits of themselves and their families, they promoted their dynasties and political legitimacy and enhanced their personal glorification.

As son and successor of Philip and also as adopted son of the Carian Hekatomnid,[19] Alexander inherited the practice of commissioning the best Greek artists to make specific portraits—precise descriptions of particular individuals. Although the original statues

lenic world, especially in Alexander's own Macedonia. The birth of Hellenistic style outside the traditional artistic center of the classical world reflects the important role of patronage by powerful politicians in the formation of that style, which suited the needs of kings and satraps for expressions of their personal strength and splendid glorification.

The Hellenistic characteristics in the equestrian portrait of Demetrios—which can be traced directly to Alexander himself—argue for accepting the time previously proposed by Margarete Bieber for the establishment of Hellenistic style —the beginning of the reign of Alexander the Great (336 B.C.).[21] The birth of Hellenistic ideas can be seen even earlier in forms from the mid-fourth century. The number of years in question is small, but the difference is important because it acknowledges the impact made on art by the living Alexander.

Notes

1. The numerous important scholars who accept the death of Alexander as the beginning of Hellenistic art include Christine Havelock, *Hellenistic Art* (Greenwich, Conn., n.d.), 17, and William R. Biers, *The Archaeology of Greece* (Ithaca, 1980), 277. Gisela Richter, in *A Handbook of Greek Art*, 6th ed. (London, 1969), 166, describes the Hellenistic period as beginning "about 330." A good summary of the definition of "Hellenistic," starting with its first use in 1833, is made by Margarete Bieber in *The Sculpture of the Hellenistic Age*, rev. ed. (New York, 1961), 3; Miss Bieber sees "the true beginning of the Hellenistic period" in "the beginning of the reign of Alexander the Great."

2. An image of Athena that was found in the Piraeus in 1959 can be related to a number of Roman copies, especially to one from the Mattei Collection that is now in the Louvre. They are published in a study by G. B. Waywell, "Athena Mattei," *BSA* 66 (1971), 373-382, pls. 66-72. Differences are clear in both form and content; the gentle, quiet strength and nobility expressed in the fourth-century statue is lost in the vacant expression of the marble copy made in Roman times.

3. The excavator's report of the sculpture is by T. Leslie Shear, Jr., "The Athenian Agora: Excavations of 1971," *Hesperia* 42 (1973), 165-168 and pl. 36. Identification and dating of the sculpture are considered by Caroline Houser in "The Agora Horseman: A Portrait of Demetrios Poliorketes" in a forthcoming issue of *Hesperia*.

4. Almost identical sandals are worn by several figures of the Daochos group at Delphi; they are illustrated by Tobias Dohrn in "Marmor-Standbilder des Daochos-Weihgeschenks in Delphi," *Antike Plastik 8* (1968), pls. 26 and 30-31. The sandal type has also been recognized by G. B. Waywell; see *The Free-Standing Sculpture of the Mausoleum at Halicarnassus in the British Museum* (London, 1978), 100, no. 26, and 151, nos. 211 and 213.

5. Two examples are published in *Treasures of Ancient Macedonia*, catalogue of an exhibition at the Archaeological Museum of Thessalonike, 1980: one from Kozani (no. 43, p. 41 and pl. 9) and one from Beroia (no. 68, p. 44 and pl. 13).

6. I am grateful to Nicholas Yalouris for his assistance in recognizing the relationship between the helmet of Demetrios and that of the Athena Parthenos.

7. Frederick Poulsen, "Iconographic Studies in the Ny Carlsberg Glyptothek," *From the Collections of the Ny Carlsberg Glyptothek*, I (Copenhagen, 1931), 16-18.

8. The *strategos* statue of Perikles appears to be copied in a statuette found near Orchomenos, now in the National Museum, Athens (inv. no. 14765). The standing figure holds a spear in his extended left hand. Originally published by Oikonomos (*ArchEph 3* [1937], 896-909), the statuette is catalogued and illustrated by G. M. A. Richter in *Portraits of the Greeks*, I (London, 1965), 104, note "b," and figs. 446-447. I am indebted to G. M. A. Hanfmann for a helpful discussion of the problem.

9. The long and laborious job of cleaning the Riace Marina statues has now been completed, and they await complete publication. In the meantime, a few photographs have been made available to the press and can be seen in *Time*, 26 January 1981, 70.

10. The monument is evidence only that Attic democracy was weak, not that it was dead. To overthrow domination by one Macedonian overlord (Kassander), Athens needed the aid of others (Antigonos and Demetrios). The complexities of Athenian political history during the end of the fourth century and in the first years of the third century B.C. are documented and explained by T. Leslie Shear, Jr., in "Kallias of Sphettos and the Revolt of Athens in 286 B.C.," *Hesperia*, supplement 17 (Princeton, 1978). Although Demetrios was called

"king," the title did not mean that he was actual king *of* Athens or necessarily of any other particular place or people; see R. M. Errington, "Macedonian 'Royal Style' and Its Historical Significance," *JHS 94* (1974), 20–37.

11. Horsemen appear early and often on Macedonian coins; see Martin Price, *Coins of the Macedonians* (London, 1974). The first horsemen appear to be warriors or Ares himself. Horsemen on the regal coinage of Alexander I, who was the first king of Aegae to have his name stamped on his coins, appear to be a reference to the Macedonian monarchy (Price, 10). Such a personal and powerful action is in keeping with the career of that first Macedonian king to be admitted to the Olympic Games and, thereby, the first to be recognized officially as a Hellene; his actions set a pattern reflected in the career of his most famous descendant and namesake, Alexander the Great.

No longer carrying the spears held by their predecessors, the horsemen on Philip II's coins raise their right arms in a victor's salute or to display a victor's palm (Price, 21–22 and nos. 56–57; also in Nicholas Yalouris, Manolis Andronikos, and Katerina Rhomiopoulou, *The Search for Alexander,* exh. cat. [Boston, 1980], 107, no. 16). Philip's salute, a gesture appropriate for a leader addressing a crowd, is reflected in the equestrian statue of Marcus Aurelius, where it can be seen easily in large scale. The victorious pose as an allusion to Philip's successful horse race at the Olympic Games in 356 B.C. surely carried political and cultural connotations since it symbolized Philip's personal powers and the occasion of the recognition of the Macedonian dynasty as Greek.

12. Small bronze statuettes of Alexander, probably reflecting lost monumental statues, suggest that he did not totally reject the classical *strategos* form. Two can be seen in Margarete Bieber, *Alexander the Great in Greek and Roman Art* (Chicago, 1964), pl. x, no. 18, and pl. XXXIII, no. 65.

Although Alexander accepted honors of deification, he did not adopt the pose used most often by Greek artists to represent Zeus: a figure seated on an elaborate armchair. Alexander probably would not have dared to offend the Greeks, especially his Macedonian troops, with such a blatant symbol of deification; furthermore, the connotations linked with an armchair—

those of a sedentary life and the status quo—would not convey an accurate picture of Alexander.

13. The horseman pose was quickly picked up by Alexander's followers; Demetrios Poliorketes was not the only one, nor was he the first. According to Pliny (*NH* 35.96), Apelles portrayed Antigonos as a horseman, once marching with his steed and once mounted on it. Diogenes Laertius recounts that Demetrios of Phaleron, local ruler of Athens for Kassander before being overthrown by Demetrios Poliorketes and Antigonos, adopted the horseman pose for many of the statues that he had erected of himself all over Attica (*Lives* 5.5, "Demetrius" 75).

14. *The Search for Alexander* (note 11), 187, no. 170.

15. In the Ny Carlsberg Glyptothek. For bibliography and photograph see *The Search for Alexander* (note 11), 98, no. 1.

16. Price (note 11), 22, and G. M. A. Richter, *Portraits of the Greeks,* III (London, 1965), 253.

17. Richter (note 16), 253.

18. A complete study of the Mausoleum statues now in London has been made by G. B. Waywell (note 4); for the statues usually identified as Mausolos and Artemisia, see 97–105.

19. Arrian 1.23.8.

20. Pausanias 5.20.9. The Philippeion at Olympia was built after Philip's victory at Chaironea, late in the summer of 338 B.C.; we do not know whether it was completed before his murder in the spring of 336 B.C. Four of the statues commissioned for the tholos represent people whom we could expect Philip to choose (himself, his parents, and Alexander). Adding Olympias' image, however, surely must have been Alexander's act since his parents' marriage floundered long before Philip married Kleopatra in 337 B.C.

21. Bieber (note 1), 3.

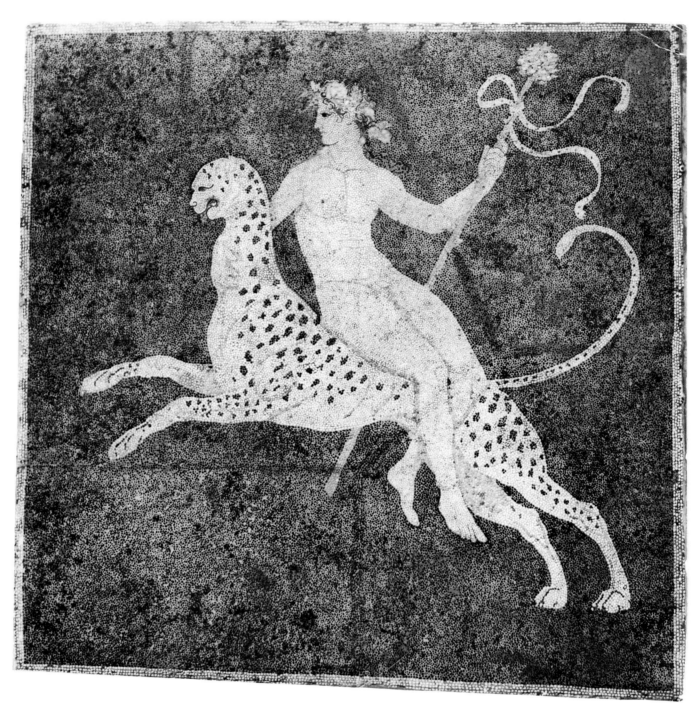

Fig. 1. Dionysus on a panther, Building I, Pella.

Early Greek Mosaic

MARTIN ROBERTSON
Oxford University (Emeritus)

FIFTEEN YEARS AGO I published an article on Greek mosaics.[1] In fifteen years quite a lot of new material has appeared, and a good deal of work has been done on the subject. I have been engaged with other things, and am not as up-to-date as I should be on this. All the same, I have thought a bit about the subject, and am glad of a chance to review it in the general context of the development of Macedonia and the transition from classical to Hellenistic.

It is my impression that new finds of pebble-mosaics do not really affect the picture of the beginnings of the craft in Greece.[2] When I wrote, the only floors in Greek lands with a secure archaeological date before the end of the fifth century were one from Motya in west Sicily and a fragment from Corinth, both of which have only animal decoration.[3] There is now another floor from Corinth, with centaurs.[4] The practice of making floors by laying pebbles in plaster or cement is of course much older, and we know that in Phrygian Gordion they were made the vehicle for pattern-work from the eighth century, but not seemingly in Greece.[5] It may be chance that none of the pieces dated to the fifth

century shows a figure composition, but it could be of some significance. The earliest-looking, technically and stylistically, of the floors treated as pictures (figure scenes with heroic or divine action) remain those at Olynthus.[6] Of these we can be sure only that they date after the city began to be extended when the Chalcidian League was founded in 432 B.C. and before its destruction by Philip II of Macedon in 348. We do know, however, that the city had close, if varying, relations with its great neighbor; and that Archelaus of Macedon, who reigned from 413 to 399, moved his capital from Aegae to Pella and built a great palace there which he had decorated by the painter Zeuxis. There is very little evidence before this time for Greek houses having elaborate painted decoration. The first documented case I know is the story of Alcibiades inviting the painter Agatharchos to dinner and then imprisoning him until he had decorated the house. I have suggested that this may belong to the last phase of Alcibiades' life in Athens, in 407-406, and have been directly inspired by the decoration of the palace at Pella (Agatharchos is described as making his escape

through the guards "as if from a king's house");[7] and that perhaps the idea of figured mosaic floors was likewise initiated at Pella by Archelaus and Zeuxis and imitated thence at neighboring Olynthus and elsewhere in Greece.[8] This is of course pure conjecture; but we are in a field where, if one sticks to proven fact, one gets a very thin harvest. The importance of Pella in the later fourth century in the development of pebble-mosaic into a fine art with a high degree of sophistication helps, I think, to make the idea plausible. I do not attach much importance to the fact that the first female centaur we hear of was in a painting by Zeuxis, and that one of the first we possess is in a mosaic threshold from Pella; but the coincidence does suggest the possibility of some continuity in artistic tradition from Archelaus' palace to the later mosaics.[9]

Decorated floors wherever found are almost confined to the principal suite in a house: the *andron* (dining room), its anteroom, and the threshold between them. We may suppose that the householders of Olynthus could not afford the services of the technicians who laid the hypothetical floors in the palace at Pella, but even al-

lowing for that, the immense difference in technical character between the Olynthus and the Pella floors must be due in part to chronological development. All such floors are constructed in basically the same way: a layer of coarse plaster, and over that a layer of finer plaster into which the pebbles are set. It is very much like the procedure of fresco painting. Here as there, the artist who had to carry out a complex figure design first drew in the outlines on the coarse layer (what the Italian fresco painters called a *sinopia;* traces of such sketches have been found under lifted mosaics at Pella); and then, again like the fresco painter, he laid only so much at a time of the finer plaster as he could use before it hardened.[10] A big, elaborate floor like that at Pella signed by Gnosis, which we shall consider in a moment, could not possibly have been laid all at once. At Olynthus the pebbles, though they do not vary greatly in size, are not matched up or graded. They seem to have been put in as they came to hand, and are set loosely, allowing a lot of the plaster to be seen between them. The figures and designs are in light-colored stones, grayish white or yellowish brown, and the background in darker browns and grays, though in some patterned floors greenish or purplish stones are selected for special use. The light-on-dark effect led me to postulate red-figure vase painting as an inspiration.[11] It may perhaps have played a part, but I feel less sure now. Light figures standing out against a darker ground is a principle favored by Greek artists in other media too, especially relief where the backgrounds were commonly painted red or blue; and Homer Thompson has persua-

sively suggested that the vase painters themselves may have borrowed the idea for red-figure from the relief carvers.[12] No doubt weavers often employed the same principle in their designs (examples are the winged horses in the border of Zeus' mantle on the early fifth-century terracotta *akroterion* at Olympia,[13] and the dancers on the Etruscan Vel Statie's cloak in the François tomb[14]) and the suggestion long ago put forward by Lorentz that textiles were a prime inspiration for the floor designers now seems to me extremely probable.[15]

The light-on-dark principle remains in force on the Pella floors, but in other respects they present an emphatic contrast to those at Olynthus. Variety of color is greater and is used more naturalistically. The range of size in the stones is not much different, but they are packed close to hide the background more completely. This can be achieved only by careful grading before use; and that this was done is made evident in other ways too. Areas where detailed modeling is important are carried out in smaller pebbles, and other materials are introduced for special purposes. Most important is the free use of lead strips to outline important forms. I have compared this to the use of relief line to contour figures in red-figure vase painting, and indeed the effect, and the purpose, are very similar.[16] Whether there is any influence of vase painters' practice on the mosaicists is much less certain. Relief contour is not a significant feature of Attic red-figure in the fourth century, and by the time the Pella floors were laid that was probably coming to an end if it had not already ceased; but the dating of the

floors is highly problematic. I shall return to the question, though very inconclusively. Attic red-figure seems to die out in the twenties of the fourth century. There are, as we shall see, points of stylistic contact between these mosaics and the vase painting of Apulia; but I shall be repeating and amplifying arguments I have used before to suggest that these resemblances are not due to the influence of one art on the other, but to derivation from a common source.

Most of the mosaics at Pella are from two great houses.[17] They differ among themselves considerably, but not in a way which makes it easy to say that all those in one house are earlier than all those in the other. The most primitive in many respects is an Amazonomachy from Building II, but other floors from that house seem more advanced than any from Building I;[18] yet only in Building I are lead strips and other materials introduced. I suppose that the two houses (which are close to one another though not contiguous) are approximately contemporary; and that either the floors in each were not all laid at the same time, or several artists or workshops were employed, some more old-fashioned, some more forward-looking. The floral and animal border of the Amazon floor is very much in the tradition of Olynthus, though it shows the new neatness of laying; but the figure scene, though of rather poor quality, is far more pictorially treated than anything in the Chalcidian city: a good deal of color, some modeling by shading, and a limited suggestion of spatial setting in the ground on which the figures stand. An incomparably finer work, the large Dionysus on a panther from Building I (Fig. 1),

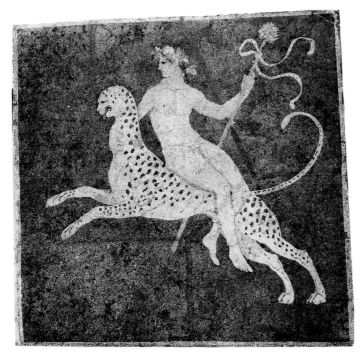

Fig. 1. Dionysus on a panther, Building I, Pella.

has likewise old-fashioned features, but of a different kind.[19] Here there is no indication of setting, and the modeling by shading is very light and linear. The effect, like that of the best red-figure, is achieved by harmony of line and by the balance of the light figures and the dark ground. This seems to me the most beautiful pebble-mosaic we have, but it is rivaled by another from Building II, in a very different style.[20] The stag hunt (Fig. 2), with its over life-size figures powerfully modeled and set in a way which emphasizes, in spite of the dark background unmodulated above the irregular groundline, the space in which they move, is a magnificent tour de

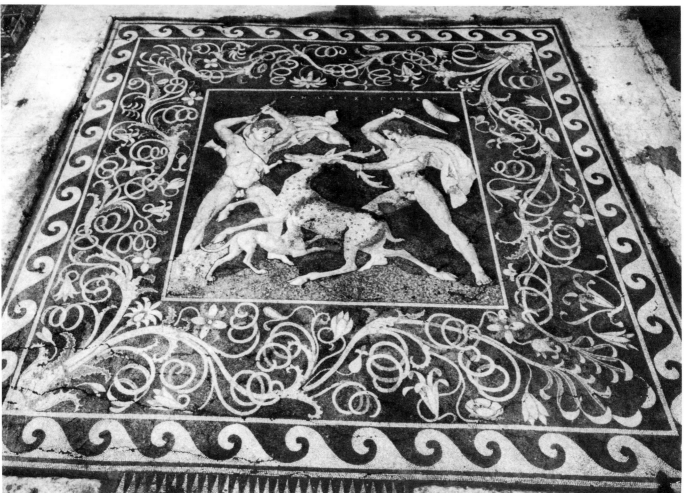

Fig. 2. The stag hunt, Building II, Pella.

force. No wonder the artist, Gnosis, proudly signed it. He shows his quality equally in the border. The frame of the Amazon battle has traditional florals, palmette and lotus; here there is something quite different. From two acanthus calyces at opposite corners spring stems which wind, with spiraling tendrils and a profusion of flowers of many different kinds, to meet at the other two corners in a pattern of leaves teasingly reminiscent of the conventional palmette form. It is, I think, enchanting decoration; but though Gnosis has carried it out with exquisite skill it does not seem to be his invention. This type of scroll is found at this time in all sorts of arts: painted on the geison crowning the Doric order on the façade of the Great Tomb at Lefkadia[21] in goldwork and textiles;[22] and especially on Apulian vases (Fig. 3).[23] This very individual style cannot have sprung into being independently in different arts, and I have suggested that we know where it comes from: the flower-painting of the Sicyonian artist Pausias. I have come back to this in a number of publications, and am sorry to serve up such old cheese again;[24] but the more I think about it the more I think it must be true, and if true of considerable importance: it is perhaps worth going a little more fully into the question and its implications.

Pliny says of Pausias in this connection: "In his youth he loved his townswoman Glycera, the inventor of garlands (coronae), and by striving in imitation with her he brought that art (encaustic painting) to the most numerous variety of flowers. Finally he painted her herself, sitting with a garland, one of the most famous of pictures, known as the stephaneplocos

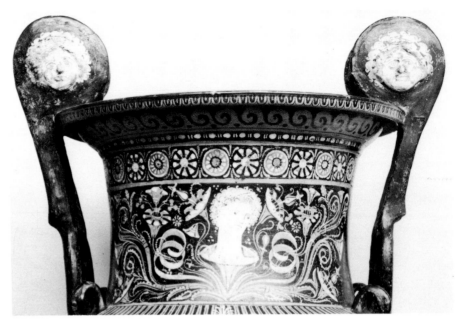

Fig. 3. Apulian volute krater, late fourth century B.C., British Museum, inv. no. F284.

(garland-weaver) or by others as the stephanopolis (garland-seller), since Glycera had supported her poverty by selling garlands"; and in another place: "Later began variation by a particolored mixture of flowers, the alternation strengthening the scents and colors. This was devised at Sicyon by the genius of the painter Pausias and of his sweetheart Glycera, a garland-maker. When he would imitate her works in painting she, to challenge him, would vary them, so that art and nature would vie together. There still exist pictures of his in this manner, the most outstanding the so-called stephaneplocos, in which he painted Glycera herself."[25] The particular character of Pausias' garlands evidently lay in the variety of flowers twined together. Since we have this record of a new floral style introduced in painting in the mid-fourth century, and the sudden appearance of a style which precisely corresponds

to the account in various other crafts of the time, it seems perverse to doubt the connection; and the picture can be filled out a little. I am not sure if one can press an association between the story of Glycera and her portrait and the fact that these "Pausian" scrolls so often are shown surrounding a girl's head, not only on the vases but also on a big floor at Durrës in Albania (Durazzo, Dyrracchium, Epidamnos);[26] perhaps not, though it is tempting.

It is in North Greece that floors of this character are far most commonly found: at Epidamnos in Epirus; in Macedon at Pella and Vergina, now convincingly identified as the old capital Aegae. Besides the elements already noticed, they have in common with each other and with the Apulian vases an emphasis on three-dimensionality in the foreshortening of the flowers and of the corkscrew tendrils. Most floors from other parts

of Greece have nothing like this style; but on one from Sicyon foreshortened flowers are combined with conventional palmettes, and on another from the same site, all the elements are present, though the corkscrews only in a very tentative form.[27] Here the garlanding is not confined to a border nor arranged around a head; it covers the whole floor, round a more formally designed, rosettelike flower in the center. This very attractive design is, though much simpler, exceedingly like that of a splendid great floor from the palace at Vergina, one of the masterpieces of the craft, standing with Gnosis' work and the Dionysus on the panther at Pella.[28] On the Vergina floor corkscrew curls are prominent, and the three-dimensionality is enhanced by tonal modeling.

The city of Sicyon has never been systematically excavated, and it is remarkable what a number of pebble-mosaic floors or fragments of floors has emerged among chance finds there; mostly earlier, or earlier-looking: one would say transitional between Olynthus and Pella.[29] This may of course be chance, but it does look as though the craft flourished there particularly. There is considerable evidence for cultural contact in this period between Sicyon and Macedon. Lysippus, court sculptor to Philip and Alexander, was a Sicyonian and the glory of the Sicyonian school of bronze statuary. Apelles, Alexander's court painter, came from east of the Aegean, but he had been to school in Sicyon, to sit under the great second head of the school of painting there, Pausias' master Pamphilos. Pamphilos himself was not a native Sicyonian but came from Amphipolis, a city captured by Philip in 357; and it is

perhaps significant that Pliny describes him as a Macedonian.[30]

Of Pausias Pliny writes further that "he was the first to introduce the painting of ceiling-coffers (lacunaria), nor was it the practice before him to decorate vaulted ceilings (camarae) in this way."[31] The first statement can hardly be true. We have a marble coffer from the Nereid Monument at Xanthos which shows traces of a painted female head; and though the Nereid Monument is no longer dated in the fifth century but around 380, this should still be before Pausias' time.[32] No doubt, though not the first to do so, Pausias did paint them; but the other assertion is more interesting and more surprising. Whether or not he was the first to paint these (and he may well have been), Pausias evidently did paint vaulted ceilings; so there must have been vaulted ceilings for him to paint. Vaults are not usual in Greek architecture, but there is now one area where we commonly do find them: the Macedonian tombs.[33] I do not suppose that it was tomb vaults that Pausias painted; but this Macedonian tomb architecture, with its elements of fantasy which are so beautifully demonstrated by Stella Miller in this volume, interacted, as she shows us also, with "real," aboveground architecture, and surely especially with the architecture of Macedonian palaces. The façade of the Lefkadia tomb has, for instance, remarkable correspondences with what can be reconstructed of the court façade of the palace at Vergina;[34] and the tomb vaults, introduced for the practical purpose of sustaining the weight of earth, might well have been imitated for their aesthetic possibilities in palaces. Most tomb vaults are

undecorated; but there is one impressive example in another tomb at Lefkadia which is painted; and the painting is an all-over floral design, which seems to reinforce the idea of a connection with Pausias. It is dated by the excavator, Katerina Rhomiopoulou, to the third century.[35] The florals are related in character to "Pausian" scrolls, and seem to be a later derivation from them.

The historical circumstances suggest that Pausias could have had good opportunities for painting palace vaults. In Philip and Alexander's time Sicyon was ruled by a tyrant Aristratos, who, Demosthenes says, was their creature and betrayed the city to the Macedonian interest.[36] He was a patron of the arts: there was a celebrated picture of him standing by his victorious chariot, painted by Melanthios, another of Pamphilos' famous pupils, with the assistance of Apelles and others (the figure of the tyrant afterwards painted out by Nealkes at the order of Aratus).[37] As a friend of Demosthenes, I find the Pella-Sicyon axis an unappealing phenomenon, but on the credit side it evidently had a strong artistic dimension lacking in other axes one has known. It seems to be natural to suppose that Pausias developed vault painting in connection with palace architecture. He could well have been called to the Macedonian court, like Apelles and Lysippus; but Pliny remarks that he spent his life at Sicyon, where it is highly likely that Aristratos would have built himself a palace on the Macedonian model and have had Pausias decorate it.[38] The figure paintings in the little cupola of the tomb at Thracian Kazanlak may be relevant.[39] A much larger circular

room in the palace at Vergina might, on this analogy, have had a painted dome, or at least a painted ceiling; and so could a circular building at Pella, which did have a fine mosaic floor: a frieze of animals surrounding a Pausian floral design.[40] This brings us back to mosaics. If I seem to have moved away from them it is because the evidence does seem to me to suggest that the origin and development of fine figured floor mosaic is bound up with that of Macedonian palace architecture; and that it is one of the most important artistic consequences of the growing involvement of Macedonia throughout the fourth century with the culture of the Greek city-states.

Awareness of an association between mosaic floors and Macedon is implied, I think, in a passage from Duris of Samos quoted by Athenaeus.[41] Duris is attacking Demetrius of Phalerum, Cassander's quisling in late fourth-century Athens. Demetrius was a great one for economic restraint in the public sector, but his private life was different. "And in his expenditure on dinners," says Duris, "he outdid the Macedonians, and in his nicety, the Cypriots and Phoenicians. Showers of myrrh fell upon the ground, and flowery were many of the floors in the dining-rooms, laid in patterns by craftsmen." Flowery floors laid in patterns by craftsmen is surely a reference to our "Pausian" mosaics. We have in fact a fragment of one such floor from Athens, which I should like to think came from Demetrius' house, though there is no evidence whatever that it does.[42] The artist was pleased enough to sign it, though only the end of his name, ". . . on," sur-

vives, but it is weak stuff compared to Gnosis' work; Athens was perhaps beginning to become provincial. Pausian florals are there, however, and another element perhaps likewise derived from Pausias. A circular *emblema* with Heracles and Nessos, which bears the signature and must have occupied the center, is "supported" at its imagined corners by flying birds: a fancy surely not originally conceived for the decoration of a floor but for a painted cupola or ceiling.

A word about subject matter. Heracles and Nessos here, the Amazonomachy and Dionysus at Pella, belong to the old repertory of divine and heroic themes: at Olynthus we have Bellerophon and the Chimaera, the arms of Achilles, a *thiasos*. So also the largest and most elaborate of all the Pella floors, though to me among the least pleasing, which shows Theseus with the girl Helen in his arms, stepping into a chariot driven by Phorbas, while a companion of Helen, named Deianira, protests from behind.[43] Gnosis' stag hunt is different. It cannot be placed as mythology. The composition resembles that of the stag hunt on the Alexander Sarcophagus from Sidon, which is an adjunct of a lion hunt in which Alexander himself takes part on horseback.[44] That lion hunt has often been associated with a famous bronze group by Lysippus and Leochares, dedicated at Delphi by Krateros.[45] The same association has been suggested for another relief, from Messene, and for a mosaic from Building I at Pella, each with two figures on foot attacking a lion.[46] The mosaic has a "Pausian" frame, and is similar but inferior to Gnosis' work. Alexander in the group at Delphi was mounted,

as he is on the sarcophagus, so the relief from Messene and the mosaic cannot be closely derived from it. Nevertheless, I have always supposed that this sudden popularity of lion hunts (absent from Greek art since the orientalizing vase painting of the seventh century[47]) was directly due to Alexander's Eastern conquests and his taking over, in his role of Great King, of this hieratic sport of oriental monarchy. This is now called in question by the appearance of a lion hunt on the façade of the great tomb at Vergina, revealed by Professor Andronikos and conjectured by him to be that of Philip II.[48] The lion hunt is one of a number of teasing points which from the start have made me hesitant to accept the identification. The evidence so far adduced for a date in the third quarter of the century seems to me inconclusive, and I feel happier with the suggestion, put forward independently by Phyllis Lehmann and W. L. Adams, that this is the tomb erected in 316 by Cassander for Philip Arrhidaeus and Eurydice, murdered by Olympias.[49] In saying this, however, I must pay tribute to the generosity and speed with which Professor Andronikos has made this marvelous material generally available, and to the moderate and open-minded way in which he has put forward his case. One eagerly awaits his full publication and argument.

I am, as my friends frequently complain, a loose, imprecise dater; and I cannot put a close date on the mosaic floors. Pausias would seem to have been active around the mid-fourth century, but there are problems and it is hard to date him accurately.[50] "Pausian" scrolls appear on vases in the third quarter of the fourth century but are perhaps

commoner in the last quarter. Craftsmen would have laid floors in Athens for Demetrius Phalereus between 317 and 307. The palace at Vergina used to be dated in the third century but is now brought back into the fourth. As a provisional schema I would suggest that the figured floors at Olynthus belong to the first half of the fourth century, those at Sicyon to the middle decades, those at Pella, Vergina, and Epidamnos to the second half, perhaps mainly the last quarter.

The relation of these mosaics to painting, apart from the special case of the "Pausian scrolls" (and even there, what Pausias actually painted cannot have been quite like anything we actually have), is another hard question. The beautiful Dionysus on the panther, isolated on its dark ground, looks like a sophisticated development of the pure mosaic tradition of Olynthus; but Gnosis, in his figure design no less than in its floral border, was surely closely in touch with the figure painting of his day, though there are no grounds for bringing Pausias' name in here. The battle-scene on the Alexander Sarcophagus seems certainly influenced by the great picture copied in the Alexander Mosaic,[51] and it could well be that in the hunt too the designer, whether or not he had in mind the bronze group at Delphi, took elements from a picture which could also have had an influence on Gnosis. The combination in Gnosis' mosaic of the more or less naturalistic terrain over which the figures move with the unrealistic dark background above looks at first sight like a compromise between pictorial ideas and the decorative tradition of the floor designer. It is used also in the Amazon-

omachy and the Rape of Helen. Something strangely like it, however, is found in the Roman wall paintings from Boscoreale,[52] especially in the panel of the Naples wall, with Macedonia and her companion; and the likeness of these figures to the beautiful Judges of the Dead on the façade of the Lefkadia tomb proves them, I think, faithful copies from early Hellenistic originals. The background at Boscoreale is dark red: the light-on-dark effect again. The figures at Lefkadia are drawn on a light ground.

Another question which I considered fifteen years ago is that of the change from pebble- to tessera-mosaic.[53] The earliest figured mosaic in tesserae we have is one with Ganymede and the eagle from Morgantina in Sicily, archaeologically dated before the middle of the third century; and Kyle Phillips had argued that the development took place in the West and was only later brought from Syracuse to Alexandria. I suggested that the resemblance of the sophisticated pebble floors at Pella to tessera-mosaics in Alexandria which seemed to me early implied the probability that the change took place independently in the courts of the Successors. I still think that something like this is likely, but Katherine Dunbabin has shown that it is to some degree an imaginary question.[54] There are many different techniques of laying floors which can loosely be described as "mosaic": plaster with pieces of other material set into it. The cutting (found in some floors) of natural pebbles to improve their shape or surface, the introduction of different materials (lead for contouring, terra-cotta curls and other substances) in the floors of Build-

ing I at Pella, already lead away from the original limitations of pebble floors;[55] and on the strictly technical side it is not pebble-mosaic which seems to lead most directly to tessera but some of the other flooring methods. Nevertheless it seems to me that artistically the sophisticated pictorial character of the pebble-mosaics from Pella does point straight to the great future of mosaic work in tessera floors, and I would suppose that there was a direct development. Katharine Dunbabin's tentative suggestion that perhaps Gnosis' floor might be down-dated to near the time of Ganymede at Morgantina, so that it might show influence itself from tessera-work, seems to me extremely improbable in view of the close likeness of its "Pausian" border to the scrolls on fourth-century vases.[56]

I was certainly wrong to argue that pebble-mosaic was driven out by the triumph of tessera. Pebble floors with figure scenes no doubt continued to be laid for a long time. This however, is moving away from the area covered in this symposium. What I have wanted to do here is place the beginning and first flourishing of pictorial mosaic in relation to the integration of Macedonian culture with that of old Greece, which formed part of the development of Macedon between Archelaus and Alexander.

1. "Greek Mosaics," *JHS 85* (1965), 72-89, pls. 18-22; "Greek Mosaics: A Postscript," *JHS 87* (1967), 133ff., pls. 23-24; hereafter GMi and GMii.

2. E.g., Rhodes: *ArchRep.* (1968-1969), 38 and cover; "Νέα Σύρήματα ἐκ Ρόδου καί Ἀστυπαλαίας," *AAA 6* (1973), 119ff., fig. 9; Eretria: *ArchRep.* (1971-1972), 7, fig. 11; (1977-1978), 16, fig. 29; Pierre Ducrey and Ingrid R. Metzger, "The House of the Mosaics at Eretria," *Archaeology 32, 6* (1979), 34ff.

3. Motya: GMi (note 1), 76 with note 20, pls. 19.1-2, 22.3; Corinth: GMi (note 1), 84 with note 62; GMii (note 1), pl. 23.5.

4. *ArchRep.* (1975-1976), 6ff., fig. 6.

5. GMi (note 1), 72ff. with note 4; R. Young, "Early Mosaics at Gordium," *Expedition 7, 3* (Spring 1965), 4-13.

6. GMi (note 1), 73ff.; David M. Robinson, *Excavations at Olynthus,* II, V, and VIII (Baltimore, 1930, 1933, and 1938).

7. Martin Robertson, *A History of Greek Art* (Cambridge, 1975), 414ff. with note 146. The story: [Andocides] iv *Alc.* 17; Plutarch *Alc.* 16; Demosthenes *contra Meidian* 147; J. Overbeck *Die antiken Schriftquellen zur Geschichte der bildenden Künste bei den Griechen* (Leipzig, 1868), 1123-1125; see R. Burn, "A Biographical Source on Phaiax and Alkibiades?" *CQ 4* (1954), 138-142.

8. Robertson (note 7), 486ff. with note 104.

9. Zeuxis' centauress: Lucian *Zeuxis* 3-7; Overbeck (note 7), 1663. Pella threshold: *Deltion* (1960), pl. 47 top; see GMi (note 1), 77ff. with notes 28, 31.

10. GMi (note 1), 72; Ph. Petsas, "Mosaics from Pella," *La mosaique gréco-romaine* (Paris, 1965), 44.

11. GMi (note 1), 74.

12. In a lecture.

13. *BerlWinckProg 100* (1940), 45, fig. 8.

14. M. Pallottino, *Etruscan Painting* (Skira, 1952; rpt. 1978), 121.

15. *RömMitt 52* (1937), 165-222.

16. GMi (note 1), 75.

17. Petsas (note 10), 41ff. with plan A and fig. 1 (photograph); Petsas, "Ten Years at Pella," *Archaeology 17* (1964), 74ff. with plan and photograph.

18. Petsas, *Archaeology* (note 17), 80, fig. 10; M. Andronikos, *Pella Museum (The Greek Museums)* (Athens, 1975), fig. 6.

19. Andronikos (note 18), fig. 5; Petsas (note 10), figs. 2 and 18 (detail of underside); also Petsas, *Archaeology* (note 17), fig. 7; GMi (note 1), pl. 20.1; Robertson (note 7), pl. 153, b.

20. Petsas (note 10), figs. 7-10 and a-b (color details); Petsas, *Archaeology* (note 17), fig. 9; GMi (note 1), pl. 20.2; Robertson (note 7), pl. 153, a; Andronikos (note 18), figs. 3-4.

21. Ph. Petsas, *O taphos ton Lefkadion* (Athens, 1966), pls. A and B, 3.

22. Goldwork: e.g., Nicholas Yalouris, Manolis Andronikos, and Katerina Rhomiopoulou, *The Search for Alexander,* exh. cat. (Boston, 1980), no. 114, p. 159 and pl. 11. Textile: the piece from the great tomb at Vergina, ibid., 36, fig. 19; *AAA 10* (1977), pl. 1.

23. E.g., Robertson (note 7), pl. 52, b; A. J. Trendall, *South Italian Vase-painting* (London, 1966), pls. B and 9, a.

24. GMi (note 1), 82ff.; GMii (note 1), 133ff.; Robertson (note 7), 486ff.

25. *NH* 35.125; 21.4

26. Both the vases cited in note 23; Durrës floor: Robertson (note 7), pl. 152, c; *OJhBeibl. 21/22* (1922-1924), 203-214, figs. 122-123.

27. The first floor: Orlandos in *Praktika* (1941), 60, fig. 7; GMii (note 1), 134, no. 2; now reconstructed by D. Salzmann, *AA* (1979), 290-306, figs. 1-13. The second: Orlandos, fig. 6; *BCH 65* (1940-1941), 241, fig. 7; GMii (note 1), 133ff., no. 1, pl. 24. See also note 29.

28. *AJA 61* (1959), pl. 80, figs. 14, 16; M. Andronikos, Ch. Makaronas, N. Moutsopoulos, G. Bakalakis, *To anaktoro tēs Verginas* (Athens, 1961); M. Andronikos, *Vergina,* Studies in Mediterranean Archaeology, 13 (Lund, 1964), fig. 14.

29. Many of the fragments are now shown by Salzmann (note 27) to belong to a single floor.

30. *NH* 35.76.

31. *NH* 35.124.

32. Painted coffer from Nereid Monument: A. H. Smith, *A Catalogue of Sculpture in the Department of Greek and Roman Antiquities, British Museum,* 3 vols. (London, 1892-1904), II, no. 934.3; J. Six, "Pausias," *JdI 20* (1905), 157, fig. 3; "Classical and Post-Classical Greek Painting," *JHS 67* (1949), 12, fig. 1 (Rumpf). Dating of Nereid Monument: P. Coupel and P. Demargne, *Fouilles de Xanthos, III: Le Monument des Néreides: L'architecture* (Paris, 1969); W. A. P. Childs, *The City-Reliefs of Lycia* (Princeton, 1978), 13.

33. See especially Stella Miller in this volume. See also T. D. Boyd, "The Arch and the Vault in Greek Architecture," *AJA 82* (1978), 83-100; and cf. P. W. Lehmann, "The So-called Tomb of Philip II: A Different Interpretation," *AJA 84* (1980), 528ff.

34. Façade of Lefkadia tomb: Petsas (note 21), pl. A; court-façade of Vergina Palace: Andronikos et al. (note 28).

35. "A New Monumental Chamber Tomb with Paintings of the Hellenistic Period Near Lefkadia (West Macedonia)," *AAA 6* (1973), 87ff., with color plate.

36. *De corona* 18.48 and 18.296.

37. Plutarch *Aratus* 13; Overbeck (note 7), 1759.

38. *NH* 35.127.

39. V. Mikov, *Le tombeau antique près de Kazanlak* (Sofia, 1954); A. Vassiliev, *Das*

antike Grabmal bei Kasanlak (Sofia, 1957); L. Zhivkova, Das Grabmal von Kazanlak (Recklinghausen, 1973).

40. Palace-room: "Th" on plan, Andronikos, Vergina (note 28). Building and mosaic at Pella: BCH 90 (1966), 871 and 875, fig. 5; V. Laourdas and Ch. Makaronas, Archaia Makedonia, I (Thessalonike, 1971), pl. 18.

41. 12.542D; Overbeck (note 7), 2161.

42. Athens, Fetiye Djami; found "near the Arch of Hadrian"; GMii (note 1), 134ff., no. 3, pl. 23.1-4.

43. Petsas (note 10), fig. 6; Petsas (note 17), 80, fig. 8; BCH 86 (1962), folding plate 25-26; Deltion (1961-1962), pls. 241-243; (part) Andronikos (note 18), fig. 10; see GMi (note 1), 78ff.

44. V. von Graeve, Der Alexandersarcophag (Berlin, 1970).

45. Pliny NH 34.64; Plutarch Alexander 40; Overbeck (note 7), 1490-1491.

46. Limestone relief on curved surface from Messene: Louvre 858; The Search for Alexander (note 22), 121, no. 44. Lion-hunt mosaic: ibid., 11, fig. 1; Andronikos (note 18), figs. 7-9; Ph. Petsas, "New Discoveries at Pella—Birthplace and Capital of Alexander," Archaeology 11 (1958), fig. on 258 below (in situ, showing border); M. Robertson, Greek Painting (1959, rpt. New York, 1979), 166, 169; Petsas (note 10), figs. 3 and 4 (details), 12-17 (details displaying technical procedures); Scientific American (Dec. 1966), cover (large detail in color of lion's head).

47. The most famous is on the Chigi oinochoe: H. Payne, Protokorinthische Vasenmalerei (Berlin, 1933), pl. 27; K. Friis Johansen, Les vases sicyoniens (Paris and Copenhagen, 1923), pl. 40; and often. A new fragment of the Sacrifice Painter's kotyle, Aegina 296 (W. Kraiker, Aigina [Berlin, 1951], pl. 24) shows that it bore a very similar one. Other examples listed and discussed by Johansen, 149-151.

48. Andronikos,"Vergina, the Royal Graves in the Great Tumulus," AAA 10 (1977), 1-72; also in M. B. Hatzopoulos and L. D. Loukopoulos, eds., Philip of Macedon (Athens, 1980); and elsewhere.

49. P. W. Lehmann (note 33), 527-531; W. L. Adams, "The Royal Macedonian Tomb at Vergina: An Historical Interpretation," The Ancient World 3 (1980), 67-72.

50. Pliny gives no date to Pamphilos or Pausias, but writes of Euphranor (34.128): "Post eum (Pausian) eminuit longe ante omnes Euphranor Isthmius Olympiade CIIII" (After him [Pausias] outstanding before all was Euphranor of the Isthmus, in the 104th Olympiad) (363-360 B.C.). The "after" is generally taken chronologically, but the contrast "post eum . . . ante omnes" surely makes this doubtful. In any case the date, probably based on the Battle of Mantinea (362) which Euphranor painted, seems to come early in Euphranor's career: he made statues of Philip and Alexander in a chariot or chariots. One would think that Pausias too had worked later: his master Pamphilos was also master of Apelles, whom Pliny dates in the 112th Olympiad (331-328 B.C.) and who outlived Alexander.

51. Most recently and best: B. Andreae, Das Alexandermosaik aus Pompeji (Recklinghausen, 1977).

52. P. W. Lehmann, Roman Wall-Painting from Boscoreale (Cambridge, Mass., 1953); M. Robertson, "The Boscoreale Figure-Paintings," JRS 45 (1955), 58ff.; B. Andreae and H. Kyrieleis, eds., Neue Forschungen in Pompeii (Recklinghausen, 1975), 71-100; other references in Robertson (note 7), 729, note 181.

53. GMi (note 1), 85-88, with references.

54. K. Dunbabin, "Technique and Materials of Hellenistic Mosaics," AJA 83 (1979), 265-277.

55. See especially Petsas (note 10).

56. Dunbabin (note 54), 277.

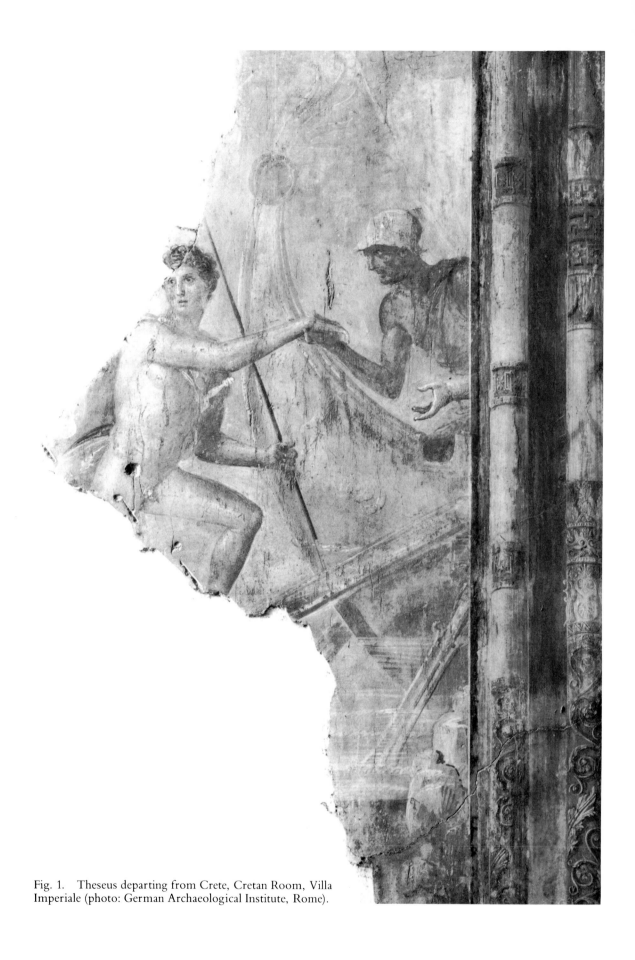

Fig. 1. Theseus departing from Crete, Cretan Room, Villa
Imperiale (photo: German Archaeological Institute, Rome).

Painting in the Time of Alexander and Later

P.H. VON BLANCKENHAGEN

Institute of Fine Arts, New York University

GREEK CLASSICAL WRITERS are almost silent about Greek art. There are some casual references, but essentially all information we have comes from late Greek and Latin authors and thus is of questionable value. The one exception is Xenophon; in *Memorabilia* 3.10, he reports on Socrates' discussions with a painter, a sculptor, and a cuirass-maker. This sequence is not arbitrary; it is in a descending order. There is reason to believe that the ancients had not a very high esteem for artists generally,[1] but that among them painters ranked higher than the others.[2] This may have been so because painting required less physical labor. But Socrates did not have any such prejudices. According to him, the good cuirass-maker serves proper physical demands of men; the good sculptor succeeds in representing man's emotions by imitating bodily actions, ψυχῆς ἔργα; only the painter is capable of representing what seems to have "neither shape nor color," the essence of man, ψυχῆς ἦθος. This is precisely what artists of the fourth century B.C. emphasize; and in all later authors, fourth-century painters receive the highest praise.

While Phidias and Polykleitos, for instance, were as highly regarded as Praxiteles or Lysippos, in the judgment of authors such as Cicero,[3] Diodoros,[4] or Quintilian,[5] painting "came to perfection" not before the fourth century. We know of more painters and paintings of that period than of any other. Greek and Latin authors mention very many names and tell us, often in detail, of a large number of famous masterpieces of all sorts, gods and heroes, representations of legends and of historical events, even of daily life. We are told, as well, that in later times they were copied, and that sometimes copies were sold as originals to ignorant buyers.[6] As early as the second century B.C., collections had been formed in Pergamon, Alexandria, and in many other residences.[7] Not only Hellenistic rulers but Roman generals and governors wanted masterpieces, and soon Rome became richest in those cherished Greek paintings of a glorious past.[8]

They were of course panels, and thus all have perished. But probably toward the end of the Roman Republic, those who could not have these panels began to include adaptations in the decoration of their rooms, where they appeared as parts of different patterns of wall decoration. Pompeii, Herculaneum, and other places have yielded hundreds of walls with such adaptations of famous paintings; many are variations of the same original, obviously reflections of masterpieces. Few, if any, of these adaptations, however, can be called faithful copies. Some may be, but we cannot be sure. In their desire for reconstructing lost masterpieces, earlier historians of ancient art have been more confident than we.[9] Today one is inclined to see Pompeian paintings only as examples of Roman art—and in some respect they are certainly just that—and to forget or push aside their relation to and their dependence on Greek works. Pompeian painters have proven to produce arbitrary alterations too often; and thus it seems senseless to try to gain true knowledge of the originals from their decorative works. Still, there are a few exceptional instances where for some external or internal reasons it seems possible to accept a particular piece as a reasonably trustworthy copy.[10]

The best known and generally accepted case is not a painting but a mosaic: the Battle of Alexander and Darius.[11] A rich man placed it

in his Pompeian house on a spot designed especially for that purpose. When and where the mosaic was made is still a controversial issue, but there is hardly a doubt that it is a copy of a famous painting. Similar historical paintings decorated Alexander's funeral carriage.[12] They all belong to an old established species of Greek painting going back at least to the representation of the Battle of Marathon in the Stoa Poikile in Athens.[13] It may have become especially popular in Alexander's time. Aristotle is said to have counseled Protogenes to paint Alexander's exploits, *propter aeternitatem rerum,* as Pliny puts it (35.106). At least six famous painters have been connected with Alexander: Aristeides, Philoxenos, Protogenes, Aetion, Antiphilos, and, more than others, Apelles, whose portraits of Philip and Alexander were "too numerous to count."[14] We hear not only of long established subject matters, but also of novel ones such as Aetion's representation of Alexander's wedding with Persian Roxanne. Lucian's detailed description argues for its fame, and it seems it sets a pattern.[15] Beatrice Green and I have tried to show that the painting known as the Aldobrandini Wedding is an Augustan copy of a painting of another celebrated wedding, that of Demetrios Poliorketes and Phila in the presence of her two sisters, one of them being the wife of the first Ptolemy.[16] In many points, the composition agrees with the Roxanne painting—and no wonder: both the older bride and the very young groom were descendants of Alexander's Successors who based their claim to rule on their relation to Alexander, imitating him as often as they could. The original of the

Aldobrandini Wedding may well have come to Rome eventually, like the very many Pliny mentions as being in public buildings in Rome. Pliny and others describe some of these, and often the descriptions agree with paintings on Pompeian walls preserved in different variations, but obviously depending on famous Greek works. In each of these cases, however, it is never easy, often impossible, and always speculative to establish the composition of the original. The problematic situation may be illustrated by three examples.

Pliny describes a painting by Athenion thus: "Achilles in the dress of a virgin discovered by Odysseus, a group of six figures in one picture" (*NH* 35.134). Almost fifty representations of this subject in paintings, mosaics, and reliefs have been collected.[17] Is any of them a reasonably truthful copy? Many will think this question unanswerable if not indeed meaningless.[18] It seems significant that even in a case so richly documented the problem has not been solved, and probably never will be solved.[19]

According to Pliny (*NH* 35.132) Nikias painted an "Io" and an "Andromeda." Some paintings in Rome and in Pompeii reflect both, and both are similar compositions. "Andromeda" has been adapted also in mosaics, sculpture, reliefs, gems, and coins.[20] Analysis of the entire evidence has led to the conclusion that the Pompeian paintings represent classicistic versions of a fourth-century work which is best reflected in a mosaic in Antioch. This mosaic may be a faithful copy of Nikias' panel.

According to ancient authors, Theseus must have been one of the

most popular subjects in fourth-century painting. None of the many representations of Theseus on Pompeian walls can be linked to specific Greek works, whether they showed a Theseus "fed on roses" or "on meat."[21] There are, however, two compositions which may be claimed to reflect fourth-century panels. One is Theseus leaving sleeping Ariadne, boarding his ship and turning his head for a last glance.[22] The composition is repeated many times on Pompeian walls as well as on Greek vases and Roman reliefs, the basic elements varying but little. Perhaps the best executed rendering, preserved only fragmentarily, is on a wall in an imperial villa in Pompeii (Fig. 1). It belongs to one of the largest and most elegantly decorated rooms dated to the very end of the first century B.C. (Figs. 2 and 3).[23] The quality of its three panels is high; their subjects are not arbitrarily selected, Crete being the common denominator. On the rear wall is Theseus with the slain Minotauros and the rescued Athenian children (Fig. 4). On the other side wall, opposite the fleeing Theseus, we see Daedalus searching for the corpse of Icarus. Only this painting has been published adequately. I have tried to show that it is a reliable copy of a late Hellenistic painting of which other less reliable versions exist.[24] Are all three panels in this room good copies of famous originals? They are executed with care by accomplished painters for an important large room in a villa of Augustus himself. Other versions exist of both Theseus paintings.[25] The best known version of Theseus and Minotauros is from Herculaneum. It seems to reflect the original of the fourth century more faithfully

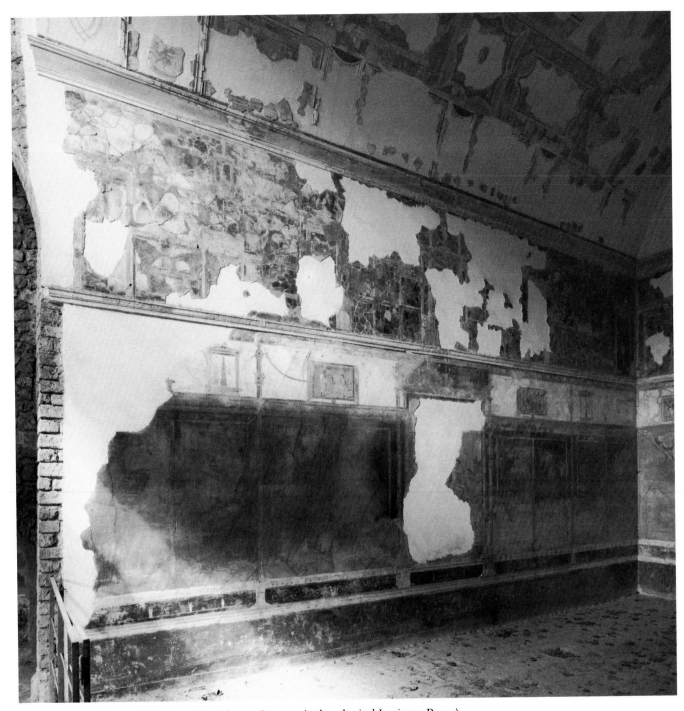

Fig. 2. Cretan Room, Villa Imperiale (photo: German Archaeological Institute, Rome).

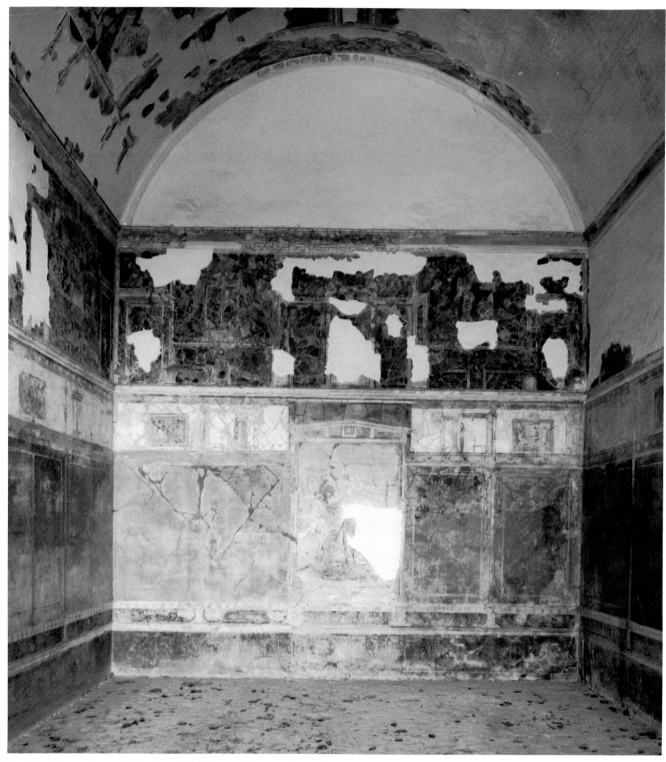

Fig. 3. Cretan Room, Villa Imperiale (photo: German Archaeological Institute, Rome).

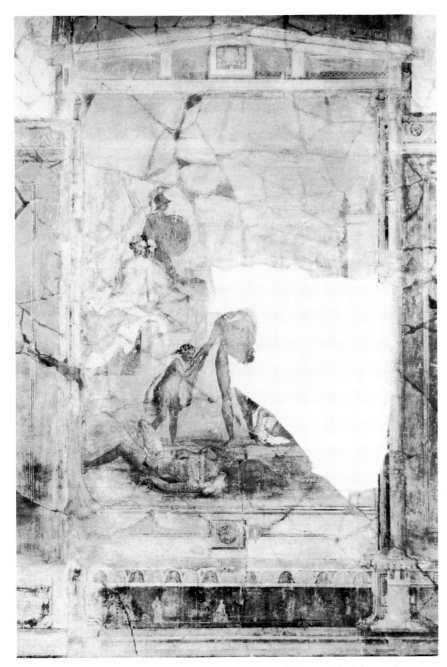

Fig. 4. Theseus and the Minotaur, Cretan Room, Villa Imperiale (photo: German Archaeological Institute, Rome).

than do the others. The rendering in the Villa Imperiale seems to change the original composition according to a late Hellenistic taste, and the same may be true for the fragment of fleeing Theseus.[26] If this is true, we are confronted here with an example of a classical prototype being changed to conform with a faithful copy of a late Hellenistic painting which was, of course, closer to the decorative taste of the later Augustan period. All three panels are carefully selected to make an ensemble: Crete and Athens, the victory of civilization over barbarism, and the prize of that victory. Greek are the models, whether adapted or copied; Roman are the selection, the symbolic use, and the entire concept of the combination.

Copies, even faithful ones, cannot be equal to originals. Up to recent times only modest Greek originals were known, most of them painted grave stelae from Volos.[27] Pausanias mentions a stele painted by a great painter, Nikias, and the description seems to suggest it was somehow similar to stelae we have found.[28] But these are not works of great artists. The motifs are similar to sculpted grave stelae: husband and wife, mother and child, families and servants, warriors, speaking to us in a low and discreet, and often tender voice. There is one stele, however, probably of the early third century, that uses setting for the indication of spatial extension.[29] In the foreground we see dead Hediste on her bed behind which an opening of the wall permits us to look at the room beyond, and at an opened door through which a person is entering the house. No diagonally drawn lines suggest a large space; only parallel straight lines indicate

layers of depth. All the same, this stele lets us speculate about the ways and means of representing pictorial space in the panels of great painters, for instance those of the artist who painted the original "Achilles at Skyros."

Larger and more ambitious paintings became known through the discovery of the tomb at Lefkadia.[30] (For illustrations, see Stella G. Miller's Figs. 3-6 in this publication.) It was and is an astounding discovery. On a two-tier façade the lower part is decorated by four painted figures (Miller, Fig. 3), the likes of which had not yet been seen. But before we turn to these we may look first at the metopes (Miller, Figs. 3, 4, and 6).[31] They pretend to be sculpted in high relief, but in fact are painted. Architectural reliefs were surely always colored, but when exposed to wind and rain, color would soon fade. The Lefkadia metopes are very lightly painted—they are, however, not monochromes—recalling the most famous sculpted metopes with centaurs, those from the Parthenon. Strongly and broadly painted shadows around the contours give the paintings the appearance of high reliefs. As the postament of the upper part of the façade, there is a frieze (Miller, Figs. 3 and 5). It is a sculpted one in fact, but it could easily be taken for a painted frieze. The vivid coloring of figures produces the illusion of a flat painting. Metopes and frieze pretend to be what they are not; illusion counteracts reality in a play of optical tricks. Such manner of representational decoration of buildings came as a surprise, at least to me. I could not help remembering ancient tales about artists who tricked spectators and even beasts by the perfect verisi-

militude of their works.[32] True, these represent a confusion between reality and the representation of reality, and not between sculpture and painting, i.e., three- and two-dimensionality; but the trompe-l'oeil effect is the same. Perhaps we should reinterpret those ancient anecdotes and take them more seriously. Seeming to us radically different from true art, such visual tricks, make-believe, and illusion were for the Greeks apparently intimately linked with art, praised by artists and condemned by Plato, whose severe criticism of all art—based, of course, on his philosophy—may now perhaps appear more comprehensible to us. In this context another tomb may be worth mentioning, although the paintings are decorative rather than representational: the Tomb of Lyson and Kallikles.[33] (For illustrations see Miller, Figs. 25-30 and Pl. 1.) The painted pillars with their shaded sides, and the arms resting on the painted architrave or hanging from it create the illusion of three-dimensionality in a manner familiar to us in much later decoration (Miller, Figs. 27-28). These paintings have very correctly been called predecessors of the Pompeian Second Style.[34]

To return to Lefkadia: more important than the metopes and frieze are the four large figures on the lower tier of the façade (Miller, Fig. 3).[35] A man in a cuirass, the soldier whose tomb it was, is being led by Hermes Psychopompos to the Netherworld. Hermes wears a red chlamys and a blue cloak with a red border. He guides the deceased both toward the door of the actual tomb and to the two figures on the other side of it, the two judges of the Netherworld, Aiakos and

Rhadamanthys. Iconographically, Hermes with the deceased is not new in funereal art, but it was rare, limited to lekythoi in stone and clay;[36] the two judges have no antecedents. The emphasis is on death, no longer on the life of the dead and his or her family and friends; and that may point to a difference between stelae and tombs. When the new Macedonian tombs with their paintings are published, that difference, I believe, will become more obvious. The four figures on the Lefkadia façade were our first examples of larger size original Greek paintings; light and shade, brushstrokes, and many more elements of the manner of Greek painting could now be examined.

Surprisingly, at least to my eyes, contours play a minor rather than a major role on the Lefkadia façade, especially in the representation of the two divine judges. This is all the more astonishing in view of the paintings in a tomb at Kazanlak in Bulgaria.[37] These are smaller, later, and provincial. They can easily be linked to paintings decorating pots found mainly in Sicily[38] which are rather securely dated in the third century B.C., as is Kazanlak. In these vase decorations as well as in the Kazanlak tomb paintings, contour is the decisive structural element. Light and shade play their roles as accents rather than as determining factors. The Lefkadia paintings are essentially different. This difference separated them, on the one hand, from other roughly contemporary paintings known to us up to their discovery, but connected them, on the other hand, with Pompeian frescoes of three centuries later. For the first time they seemed to give us some information about lost originals—no more than that, however. They are,

after all, but decorations of a tomb façade and thus of a different, more modest species than the famous panels mentioned by ancient authors. Their subdued colors, based on brownish-ochre tints with red and blue added, seem to reflect the notorious four-color scheme of earlier painting. Do they in fact?

While the deceased and Hermes remind one of painted grave stelae, the two judges are closer to Pompeian painting. This is especially true of Rhadamanthys who stands and gazes like the "Philosopher" from the villa in Boscoreale, as has been frequently observed. Motifs and pictorial formulae have a long life. Therefore, those who understand the Boscoreale frescoes as originals of the middle of the first century B.C. will interpret the similarity merely as evidence of a long Greek tradition. I am inclined to see the frescoes as an adaptation of a Macedonian cycle, rather good copies with regard to each figure or group, but not with regard to the sequence. There is no reason to believe that the original cycle should have agreed with the decorative requirements for two opposite walls on a Second Style room in a Pompeian villa. The original cycle may have been much longer; it may or may not have come to Rome in its entirety. At any rate, the Pompeian copyist chose what he needed for his central and for his wing sections, thus making it impossible for even the most acute minds to arrive at an interpretation accepted by all of us.[39] I believe that today we can say only that the Boscoreale frescoes are copies of parts of an official Macedonian cycle with a historical and/or legendary theme. Many details of Rhadamanthys and the Philosopher are different, especially their colors, but

others are comparable: light and shading and the treatment of folds, for instance. It is not too difficult to imagine the original of the Philosopher as somewhat similar to Rhadamanthys, and to attribute the difference in coloration as well as in brushstroke to the Pompeian painter.

Other figures from Boscoreale may be compared with one on the east wall of the "chamber grave" at Vergina.[40] A mourning seated woman, "Demeter," is comparable to the "Bride" in Boscoreale as well as to the seated woman in the "Macedonia" group. The manner in which the Boscoreale painter adapted or copied his model may be typical of such adaptations—but then, it may not be. Are the Macedonian tomb paintings different from, or like, contemporary panel paintings by famous artists? Is the sparse palette a reliable example of Pliny's famous four-color palette, and did the great painters use a richer one about which Pliny also tells us quite a bit? Is it, or is it not, an accident that we detect more close parallels of those Macedonian paintings in Boscoreale, which reflects a Macedonian cycle? These and many more questions must be raised—but I cannot answer them.

Among the Vergina paintings there is the representation of Hades' rape of Persephone (Pl. 5),[41] also the subject matter of a picture by the famous painter Nicomachos.[42] Similar abduction scenes are frequent in earlier Greek art. But how much more lively, expressive, and convincing is this painted version, compared with preceding reliefs or vase paintings. We recognize at once that such scenes can best be represented in larger paintings. To judge from

photographs, the painter appears much more dashing, more competent, freer than the one who painted the Lefkadia figures. The hair and beard of Hades, the hair of Persephone, the hands and the bodies are rendered expressively through a few, economically applied brushstrokes. Shading, however, is made by parallel hatching, almost like that in Kazanlak: a less ingenious formula of indicating volume and movement. But similar hatching still does occur quite frequently in Pompeian paintings. The painting in Vergina is the oldest example of the theme in large size. It has, of course, an afterlife for many centuries, especially on Roman sarcophagi. But it is used as well for themes other than Persephone and Hades, for instance for the Dioscuri and the daughters of Leukippos, and even, strangely enough, for the rape of the Sabine women—in the frieze from the Basilica Aemilia in Rome. The most intriguing piece of painting in Vergina is (at least to me) the hunt. Published photographs do not as yet permit any detailed description of the scene that takes place in the woods.[43] Only one telling detail has become sufficiently known to me. It is the nude rider who is seen from the back and turns his horse toward the background.[44] As soon as I saw it I recalled that riderless horse in the center of the historical battle frieze of the Monument of Aemilius Paullus in Delphi.[45] Up to now it was our earliest example of a motif that perhaps more than any other changes the neutral background of a relief into the suggestion of limitless air. The motif appears as well on a relief from Lecce in Budapest,[46] and then later in one of the four reliefs on the tomb of the Julii

in St. Remy.[47]

The Vergina hunt has been compared with the Alexander Mosaic, but only the leafless trees are the same. The Vergina mural goes much further in depicting depth and landscape, even further, it seems, than another comparable piece, the fragmentary mosaic in Palermo, also representing a hunt.[48] Neither mosaic includes another important element of the Vergina composition, an object described as a high stele. It is this element that reminds one of many mythological and sacro-idyllic Pompeian landscape paintings in which a column, a stele, a doorlike monument, or similar pieces of light architecture are typical.[49] It was generally believed that these pictorial elements, often emphasizing the axis of the composition, were characteristically Roman. Now we know that they follow a Greek tradition, even though in altered forms. I myself have always believed and have tried to demonstrate that landscape painting originated in Greek Hellenistic art.[50] It seems to have begun as early as the fourth century B.C.. The Macedonian hunt at Vergina appears to prove it and thus it is a sensational discovery. Among Pompeian mythological landscape paintings, there are three pictures representing the Niobids on horseback.[51] Two of them are almost replicas, one is a variation. The best preserved one[52] appears to me to depend on the fragmentary picture in the Villa Imperiale.[53] In both, all figurative elements are almost identical; in the Villa Imperiale they are placed in a slightly tighter composition, less spread out over the available space, and larger in proportion. The similarity between this painting and the

Vergina hunt appears to me startling. Contrary to what I myself have thought,[54] I am now inclined to believe in the existence of a later fourth-century composition representing the Niobids on horseback of which the painting in the Villa Imperiale is a reasonably good reflection. The original would have shared much with the Macedonian hunt, for instance the architectural motif and even the motif of that horse with the turned head, discussed above.

These preliminary observations are but a few reactions to the new paintings. Future studies of all these splendid Macedonian tomb paintings may have far-reaching consequences. To mention but a few: new examination of Pompeian paintings and their relation to Greek models; new investigation into the origins of Hellenistic art, sculpture as well as painting, and its relation both to classical and to Roman art; and new research in the technique, color, perspective, and composition of ancient painting through the centuries.

Notes

1. Plutarch *Pericles* 2; Lucian *Somnium* 6-9.

2. Painting was taught to freeborn boys in the early fourth century (Pliny *NH* 35. 77).

3. Cicero *Brutus* 70. Of equal rank also: Aetion, Nicomachos, Protogenes, Apelles.

4. Diodorus Siculus 26.1.

5. Quintilian 12.10.1-10.

6. Lucullus bought the copy of a painting by Pausias (Pliny *NH* 35.126); earlier the Attalids had ordered copies of famous pieces.

7. Cf. J. Burckhardt, *Griechische Kulturgeschichte* (Berlin, 1898-1902, Kröner edition), II, section 9, chapter 5, 438 ff.; H. Jucker, *Vom Verhältnis der Römer zur bildenden Kunst der Griechen* (Frankfurt, 1950), 140-149; M. Fränkel, "Gemälde-Sammlung und Gemälde-Forschung in Pergamon," *JdI* (1891), 49 ff.

8. An early witness and a critical one is Polybius 9.10.

9. G. Lippold, *Antike Gemäldekopien* (Munich, 1951) still reflects the desire to recapture as many Greek originals as possible in interpreting later adaptations. In more recent times, and more convincingly, H. Lauter-Bufe, *Zur Stilgeschichte der figürlichen pompejanischen Fresken* (Erlangen, 1967), examines them in close relation to the styles of Roman wall decoration. With respect to mythological landscape painting, I pursued similar aims in "The Odyssey Frieze," *RömMitt 70* (1963), 100-146, and "Daedalus and Icarus on Pompeiian

Walls," *RömMitt* 75 (1968), 106-143. R. Ling appears to be the most recent scholar in this line, "Hylas in Pompeiian Art," *MélRome 91* (1979), 773-816. Generally, Pompeian studies are devoted to research other than this; cf. *Neue Forschungen in Pompeji*, eds. B. Andreae and H. Kyrieleis (Recklinghausen, 1975). In this symposium, not one single paper dealt with "Kopienkritik."

10. Lauter-Bufe (note 9) analyzes ten types of compositions reflected in Pompeian murals. For my analyses of the Icarus paintings and the Odyssey frieze, see note 9.

11. Best reproduced and described by Bernard Andreae in his monograph *Das Alexandermosaik aus Pompeji* (Recklinghausen, 1977).

12. Diodorus Siculus 18.26-27.

13. Pausanias 1.15.1; Pliny *NH* 35.57.

14. Apelles: Pliny *NH* 35.79-97, especially 93; for the others, Pliny *NH* 35.78, 98-100, 101-106, 110, and 114.

15. Lucian, *Herodotos sive Aetion*.

16. Blanckenhagen and Green, "The Aldobrandini Wedding Reconsidered," *RömMitt 82* (1975), 83-98.

17. V. M. Strocka, *Die Wandmalerei der Hanghäuser in Ephesos, Forschungen in Ephesos,* 8 (Vienna, 1977), 107-108, note 380; Ling (note 9), 789 ff.; M. A. Manacorda, *La paideia di Achille* (Rome, 1971). The latest literature appears to be Jürgen Borchhardt in *Taenia. Festschrift für Roland Hampe* (Mainz, 1979), 257-269. This paper seems to me to confuse the issues and to reach unacceptable results without examining the full evidence.

18. Strocka (note 17) obviously thinks so. His radical skepticism and Borchhardt's (note 17) unwarranted confidence in Lycian reliefs as reflections of fourth-century paintings characterize the two opposite poles of research. Cf. also P. G. P. Meyboom, "Some Observations on Narration in Greek Art," *Meded 40* (The Hague, 1978), 65.

19. It seems to me that Strocka's "baroque" version (note 17) does have a certain claim to reflect Athenion's picture.

20. Lauter-Bufe (note 9), 4 ff., 20 ff., with older literature.

21. Pliny *NH* 35.128.

22. Lauter-Bufe (note 9), 44 ff.

23. This date for the decoration of the Villa Imperiale, at least for this room, is now generally accepted: Blanckenhagen, *RömMitt 75* (note 9), 116; Lauter-Bufe (note 9), 170 and 279; A. Allroggen-Bedel, "Zur Datierung der Wandmalereien in der Villa Imperiale in Pompeji," *BABesch* (1975), 225 ff.; F. L. Bastet, *Proposta per una classificazione del terzo stile pompeiano* (The Hague, 1979), 37; cf. F. Zevi, *Studi Miscellani, 5* (Rome, 1960-1961), 29, note 68 (as early as 1960-1961!).

24. Blanckenhagen, *RömMitt 75* (note 9), 106 ff., pls. 27 ff.

25. Lauter-Bufe (note 9), 40 ff.

26. Lauter-Bufe's analysis (note 9, 40 ff. and 70 ff.) contains convincing observations; see esp. p. 75.

27. A. Arvanitopoulos, *Graptai Stelai Demetriados-Pagasou* (Athens, 1928); V. J. Bruno, *Form and Color in Greek Painting* (New York, 1977).

28. Pausanias 7.22.6.

29. J. Engemann, *Architekturdarstellungen der frühen Zweiten Stils, RömMitt,* suppl. 12 (Heidelberg, 1967), fig. 57, 3.

30. Ph. Petsas, *O taphos ton Lefkadion* (Athens, 1966).

31. Recently reexamined by V. J. Bruno, "The Painted Metopes at Lefkadia and the Problem of Color in Doric Sculptured Metopes," *AJA 85* (1981), 3-11.

32. For example, the horse that was neighing at the painted one (Aelian *VH* 2.3) or the birds that flew to painted grapes or Zeuxis trying to remove a painted curtain (Pliny *NH* 35.65-66).

33. For color plates, Ch. Makaronas and S. G. Miller, "The Tomb of Lyson and Kallikles," *Archaeology 27* (1974), 248-259; M. B. Hatzopoulos and L. B. Loukopoulos, eds., *Philip of Macedon* (Athens, 1980), 60-61, figs. 37-39; 63, fig. 39 (detail).

34. P. W. Lehmann, "Lefkadia and the Second Style," *Studies in Classical Art and Archaeology, A Tribute to P. H. von Blanckenhagen,* G. Kopcke and M. B. Moore, eds. (Locust Valley, N.Y., 1979),

225-229; K. Fittschen, "Zur Herkunft und Entstehung des 2. Stils—Probleme und Argumente," *Hellenismus in Mittelitalien,* ed. P. Zanker (Kolloquium in Göttingen, June 1974), *Abhandlungen der Akademie der Wissenschaften in Göttingen,* Philologisch-Historische Klasse, folio 3, 97 (1976), 539 ff.

35. Petsas (note 30), color plates z-1.

36. C. Clairmont, "The Lekythos from Myrrhene," *Studies in Classical Art and Archaeology* (note 34), 103.

37. L. Zhivkova, *Das Grabmal von Kazanlak* (Recklinghausen, 1973); V. Mikov, *Le tombeau antique près de Kazanlak* (Sofia, 1954).

38. U. Wintermeyer, "Die Polychrome Reliefkeramik aus Centuripe," *JdI* (1975), 136-241.

39. Cf. Blanckenhagen and Green (note 16), 93, note 55; one of the most recent extensive interpretations is by K. Fittschen in *Neue Forschungen in Pompeji* (note 9), 93-100, with a survey of earlier literature and excellent plates, 67-71.

40. M. Andronikos, *The Royal Graves at Vergina* (Athens, 1978), 15 and fig. 3 on p. 8.

41. Andronikos (note 40), 15-18 and figs. 4-5 on pp. 9 and 11; *Philip of Macedon* (note 33), 208 and fig. 111 on p. 209; and Nicholas Yalouris, Manolis Andronikos, and Katerina Rhomiopoulou, *The Search for Alexander,* exh. cat. (Boston, 1980), 30, fig. 13.

42. Pliny *NH* 35.109.

43. Described by Andronikos (note 40), 18-21, and see fig. 6 on p. 13. Also, Andronikos in *The Search for Alexander* (note 41), 30-31 and fig. 10, in color, on p. 27.

44. *Philip of Macedon* (note 33), figs. 112 and 113 on pp. 210-211.

45. H. Kähler, *Der Fries vom Reiterdenkmal des Aemilius Paullus in Delphi* (Berlin, 1965), pl. 5.

46. A. Hekler, *Die Sammlung antiker Skulpturen in Budapest* (Vienna, 1929), 100, no. 92. Dated, perhaps correctly, in the second century B.C., but earlier than the frieze in Delphi.

47. Often discussed, most recently by F. Kleiner, "The Glanum Cenotaph Reliefs," *BonnJbb* (1980), 105 ff., esp. 119.

48. Kleiner (note 47), 123, fig. 12.

49. From the Io painting in the Casa di Livia to many Third Style paintings: cf. Blanckenhagen and Alexander, *The Paintings from Boscotrecase, RömMitt,* suppl. 6 (Heidelberg, 1962); also W. J. T. Peters, *Landscape in Romano-Campanian Mural Painting* (Assen, 1963).

50. Blanckenhagen, *RömMitt 70* (note 9), 100 ff.; Blanckenhagen, *RömMitt 75* (note 9), 106 ff.

51. M. C. Dawson, "Romano-Campanian Mythological Landscape Painting," *YCS 9* (1944), nos. 27, 28, pl. 10; Peters (note 49), 74 ff., 95; H. Sichtermann, "Der Niobiden-Sarkophag in Providence," *JdI 83* (1968), 201, fig. 15.

52. Dawson (note 51), no. 27; best reproduced in *EAA 5,* 523, fig. 672.

53. Published only once, by Sichtermann (note 51).

54. Blanckenhagen, *RömMitt 75* (note 9), 141. The painting in the Villa Imperiale may well be of Augustan date like the Icarus painting in that villa. The other two versions follow closely, as do two Icarus paintings: cf. Blanckenhagen, *RömMitt 75* (note 9), 107 ff., nos. 2 and 3.

Painting in the Age of Alexander the Great and the Successors

NICHOLAS YALOURIS

Ministry of Culture, Greece

MANY CHANGES IN THE LATE fifth and fourth centuries B.C. were evident in all areas of Greek life—political, economic, social, religious, and philosophical. These changes also affected literature and the arts. The chief characteristics that developed in the arts between the immediate post-Parthenon period and the age of Alexander the Great and the Successors may be summarized as follows: the study of perspective and three-dimensional space; the study and representation of man's natural environment; the study of the human figure per se and in three-dimensional space; the study of the differences between the male and female body that appeal to the senses; and the treatment of dress as a factor in its own right in the rendering of the human form.

In other words, there was a decisive shift of direction towards naturalism and its younger brother, realism. But the origin of this shift lay much further back, in the generation of artists at work in the late archaic period and at the time of the Persian Wars. It was the bold and innovative spirit of that generation that first laid the foundations of this revolutionary change, which was to reach full bloom at

the end of the fifth century B.C. and to be in its final flowering in the course of the fourth century.

This conclusion is supported by any number of ancient works of art. We may confine ourselves to the monumental paintings and a few other crucial works, works that have not survived but which we know from ancient literary sources:

The painter Agatharchos of Samos flourished around the end of the fifth century and was renowned for his scene-painting for the theater; indeed, he was the author of a book on scene-painting (σκηνογραφία).[1]

Apollodoros the Athenian, another painter, and contemporary of Agatharchos, was believed to have been the first to discover the gradation of shades and to mix colors for tinting. This explains why Apollodoros was remembered chiefly as a *skiagraphos* (shadow painter), a fact that means only, of course, that he was particularly effective at color shading, for the first attempts at shadow painting are met with in the early fifth century.[2]

Zeuxis, another painter and rival of Apollodoros, was born in Herakleia, in Pontos. Having distinguished himself in Athens, he went

to Pella in Macedonia, at the invitation of King Archelaus, where he decorated the royal palace with paintings.[3] His work was daring and pioneering. One of his compositions portrayed a youth holding clusters of grapes, and according to ancient writers the verisimilitude and perfection of the fruit could not have been bettered. It seems Zeuxis was also highly skilled at conveying the delicacy and beauty of the female figure. He was particularly celebrated for his painting of the lovely Helen, a painting which ended up in Rome.

Parrhasios, a contemporary and also a rival of Zeuxis, came from Ephesos and was famous for his perspective drawing and for his penetrating and revealing portraits.[4]

Pliny's statement, in his *Historia Naturalis* (35.65-66), in connection with the rivalry between Parrhasios and Zeuxis, is indicative of Parrhasios' technique and his disposition to naturalism and illusionism: "This last (Parrhasios) it is recorded," says Pliny, "entered into a competition with Zeuxis, who produced a picture of grapes so successfully represented that birds flew up to the stage buildings; whereupon Parrhasios him-

self produced such a realistic picture of a curtain that Zeuxis, proud of the verdict of the birds, requested that the curtain should now be drawn and the picture displayed; and when he realized his mistake, with a modesty that did him honor he yielded up the prize, saying that whereas he had deceived birds Parrhasios had deceived him, an artist."

These attainments of painters at the end of the fifth and the beginning of the fourth centuries (of which only a few are mentioned here by way of example) attracted the attention and admiration of ancient writers, who constantly praised their fascinating works. Such creations caused an upheaval in the art of painting and led to fulfillment of its total potential.

At the same time these naturalistic-illusionistic trends were in vogue, the realistic movement —which later turned to parody and caricature—was launched by another group of artists, both painters and sculptors, the contemporaries of the artists just cited.[5]

During the fourth century the technique of painting became formalized and was made subject to certain clearly established principles, while simultaneously the teaching of painting—which included arithmetic, geometry, and drawing—assumed a definite pattern.

The Sikyonian painter Pamphilos contributed greatly to these developments, yet himself remained loyal to classical, ideally beautiful forms and so earned for himself a nickname meaning the "righteous painter" (χρηστογράφος).[6]

Pausias put the final touches on those directions begun by the Sikyon School and by his teacher Pamphilos. Pausias was well known for the color harmony and foreshortening of his figures. Among them the most famous was a bull, boldly drawn, receding into the background of the picture. He was also praised for a great number of studies of multicolored flowers, which he was the first to introduce into Greek painting. In one of his paintings in the Tholos at Epidauros Pausias portrayed the personification of Methi, that is Drunkenness. He showed Methi drinking from a glass goblet through the transparent sides of which her features could be plainly seen.[7]

The work of yet another pupil of Pamphilos, Apelles, acquired lasting fame in antiquity.[8] One of his best known paintings was Aphrodite emerging from the sea, the lower half of her body clearly visible through the water. An equally striking work by Apelles was one in which he portrayed Alexander the Great. The young king—fathered, so legend has it, by Zeus— seemed on the point of hurling the god's thunderbolt which he held in one hand from out of the very depths of the picture, deliberately painted in dark tones in order to highlight the flashes and flames playing around the thunderbolt.

In the same vein Antiphilos of Egypt in one of his genre paintings showed a boy blowing on a fire the reflection of which illuminated his face and the objects in the space around him.[9] What painters were endeavoring was no longer merely the rendering of perspective by linear means, but also the study of light which reveals the form and mass of objects.

Works by the artists just mentioned were scattered throughout the length and breadth of the Greek world, but it was the hospitable land of Macedonia, where artists had been particularly welcome from as early as the fifth century, that was the chief meeting point of new artistic directions. It was the Macedonian state, with its unlimited wealth and vitality, and the thirst for letters and the arts which possessed it as the New World of antiquity, which offered the most fertile ground for the formulation and assimilation of new horizons. Leading artists, painters, and sculptors worked for a time in Macedonia or settled permanently there. Two of them, the painter Apelles and the sculptor Lysippos, became Alexander's favorite artists.

Native artistic activity had, of course, a character of its own, and was not without merit. This is born out by all kinds of sixth- and fifth-century works of art found in Macedonia and in the regions bordering it: Thessaly, Epiros, and Thrace. Such works clearly bear the stamp of local production. This is valid for architecture, metalwork, ceramics, and sculpture, and probably also for painting.

But in fourth-century Macedonia it was painting that dominated over every other kind of figurative art. This is ascertained by the fact that paintings (frescoes, painted stelae, etc.) are much more numerous and of higher quality than the sculpture found in Macedonia. We may therefore conclude that monumental painting—together with metalwork—was the most favored art, the art *par excellence* in Macedonia.

The new social conditions and the rise of a new aristocracy, consisting of Macedonian officers and state officials, provided a welcome for painting, which by that time was no longer inspired only by he-

roic themes, but also by incidents in everyday life. As a result, monumental painting—previously limited to the decoration of a few temples and public buildings—acquired a much wider range of application, including the decoration of villas and monumental Macedonian tombs. The artistic world of the time was so dominated by the attainments of painting that even sculpture proved sensitive to its influence. Sculptors began to express themselves in the painter's idiom, and sculptural works became permeated by the art of painting. One consequence of painting's dominance of the whole field of representative art was the incident in which the sculptor Praxiteles sought the cooperation of the painter Nikias when he reached the last stage of touching in with paint the figures he had made.[10]

Excavations over the past decades, in those beautiful regions of Macedonia that have produced such rich finds, have thrown new light on later classical and Hellenistic art. They illuminate many problems connected with the art of those periods, which until lately have been the subject among specialists of endless discussion and conflicting opinion. The most important contribution these new discoveries have made concerns the identity of the original sources of Roman art. It seems certain now that Macedonia was the meeting point of all movements in Greek art at the end of the fifth and the beginning of the fourth centuries. It was there that the arts assumed their new forms and thence that they were transmitted by Alexander and the Successors to the East and to India. In the West, Rome and the whole of Italy (particularly Campania) received all these

movements through the medium of the Greek colonies in Magna Graecia and Sicily as well as through the Etruscans. Finally, in Hellenistic times new channels for these movements were provided by the empires of the Successors (especially Alexandria), which the Roman empire eventually annexed one at a time.

Moreover, many of the most famous works had earlier been carried off to Rome to adorn public buildings and villas of Roman citizens. Also, a large number of artists of Greek descent were at work in Italy, a fact attested by inscriptions on many works of art.

The writer was therefore justified who stated: "In the realm of the arts and the intellect, Rome and Italy were but provinces of the Hellenistic world, at least until the beginning of the Roman empire."[11] To revert to the Greek sources which Romans also zealously studied, it is significant that leading Latin authors should have dedicated substantial portions of their writings to Greek art as if it had been something of their own creation. Indeed, two of the weightiest of them became profound students of the subject. Pliny, who lived in the first century A.D., dedicated an entire book to Greek artists in his invaluable work *Historia Naturalis*, and Vitruvius, who lived a century earlier, wrote *De Architectura*, an important source book for Greek architecture.

A few comparisons plead in favor of Macedonia as the fountainhead of all this artistic activity during the years of the Roman Empire. The new kind of monumental private house discovered in Macedonia, which served to shelter its owner from an inquisitive society, is quite similar to those first-

century B.C. villas unearthed in Italy. They are luxurious private villas, little short of being palaces, which share the same architectural plan and interior arrangement.

There can be no doubt that the first style of Pompeian wall decoration, long ago recognized as deriving from the Hellenistic *koinē,* can now be more precisely located in Macedonia. The architectural arrangement of wall surfaces is exactly the same in the villas of Pella, the tombs of Macedonia built between the fourth and second centuries B.C. and recently excavated, and the Roman villas of the first century B.C., the wall decoration of which is known as the First Style.[12]

Furthermore the Second, Third, and Fourth Styles of Pompeian wall painting, considered until now an Italo-Roman creation, seems also to be of Greek provenience. This has been convincingly shown by Professor Fittschen.[13] But now the provenience can be more precisely located in Macedonia, where the different tendencies and achievements blended together eventually to form the Hellenistic *koinē.*

The following group of paintings are pertinent to this:

1. Abduction of Persephone by Pluto, a fresco of the small Tomb I at Vergina (Pl. 5).[14] With his left arm Pluto has seized Persephone around the waist and is mounting the chariot that will take them to his underworld kingdom. In its violent movement and foreshortening and in the dramatic agitation of the garments, the bold contrapostal composition of the group reflects the great strides made by Greek painting at the time, the fourth century B.C. These advances were complemented by

color alternations (deep violet, yellow, and azure blue) and linear and chromatic painting.

2. The painted grave stele of Hediste from a tomb of Pagasae, now in the Volos Museum.[15] This dates to the middle of the third century B.C. and represents a dead woman reclining in her chamber. There is a strong sense of three-dimensional space, a sense emphasized by the several planes reminiscent of a stage setting and the achievement of Agatharchos,[16] and by the positioning of two figures —one appears in the doorway in the background, and the other leans against a wall projection behind the dead woman.

3. Medea plotting the murder of her children, a mural from Pompeii now in the Naples National Museum, dated to the early first century A.D.[17] Here again, as in the previous work, the three-dimensional scene is divided into various planes. The upper part of a figure can be seen at the left-hand window. This mural may have been inspired by a work of Aristolaos from Sicyon, a pupil of Pausias (in the late fourth century B.C.), or by a work of the Hellenistic painter Timomachos of Byzantium, following the style of Aristolaos.[18] It is in this work that we come across elements occurring in the previously mentioned painted stele from Pagasai. But the setting within which the figures are portrayed is more audacious than the conventional one; large bright surfaces have been added above the wall, and an open door provides a link with the exterior. The subject of the composition is Medea, torn between the love she feels as a mother and the hatred as a deceived wife. The desperation and suffering arising out of her inner struggle is tacitly expressed in another mural, from Herculaneum, now on display in the Naples Museum.[19] It echoes the concern of Parrhasios to render the inner emotions of his subjects.

4. A picture of a dead man in a mural designed as a metope in the tomb of Lefkadia.[20] The deceased, in the background of the metope made of white plaster, is wearing a white leather breastplate over a purple-red chiton. Other details are depicted in blue, violet, and yellow. Shadings around the outline of the figure give it a molded appearance. This metope, and three others, concerns the judgment of the dead man, who is under examination by the mythical judges of the underworld, Aiakos and Rhadamanthys, in the presence of Hermes.

We come across this arrangement of figures on metopes again in Pompeian painting in the Villa Fanius Sinister at Boscoreale. Also portrayed there on metopes are men and women of a noble class wearing Macedonian attire.[21] The figures probably represent Queen Phila and on her left her son King Antigonus the Third (or both are members of the princely house of Ptolemy of Egypt). The third figure, a dignified old man with a penetrating stare, seems ready for a battle of words with the nobles opposite him; he is most likely a philosopher. His superior bearing, reminding one of the figure of Rhadamanthys in the Lefkadia tomb, may be compared with the finest portraits of the Hellenistic era. There is no doubt that the artist was of Greek descent and familiar with the achievements in Macedonia.

5. Four murals removed from the walls of villas at Stabia are now in the Naples Museum.[22] They represent Artemis the Huntress, a youthful maiden (Primavera), Leda and the Swan, and Medea, each against an aquamarine or greenish-blue background. They remind one the metope-figures of the Lefkadia tomb. These figures show the influence of the neo-Attic style. They are painted in light and delicate yellow and white shades and are reminiscent of figures on painted stelae from Thessaly, Macedonia, and Alexandria.

The erect and thoughtful figure of Artemis personifies the moral character of late fifth- and fourth-century figures. On the other hand, the ethereal figure of Primavera gathering flowers, with her contrapostal stance—her back to the viewer—brings to mind similar fourth-century figures moving through three-dimensional space. This charming apparition of a youthful maiden suggests allegorical personifications and has been rightly named Primavera.

6. The Tomb of Lyson and Kallikles (Pl. 1) of Lefkadia in Macedonia is to be dated to the first half of the second century B.C., that is, before Macedonia came under Roman dominion.[23] Apart from the monumental weapons which decorate the upper part of the small walls of the chamber, the pictorial decoration on the interior of the tomb consists of painted patterns by means of which the walls are articulated and organized as an axial symmetric unit. Therefore it is clear that that kind of decoration cannot be considered a typical Roman invention, as suggested in the past.

Among the fine arts, it was mosaic that made a sudden and spectacular advance in the fourth century. If we judge from those re-

mains known today, it would seem that mosaic art reached its peak in Macedonia. The unrivaled pebble mosaic scenes at Pella are of the highest order this art could attain. No contemporary mosaic elsewhere in Greece comes near the perfection of the Macedonian ones. These are the following:

a. Mosaic at Pella showing Dionysos on a panther,[24] dated to the end of the fourth century B.C. The outlines of the figures are accentuated by the use of dark lines. This work was widely copied both in Greece and elsewhere.

b. Another mosaic at Pella: the Abduction of Helen by Theseus,[25] of the late fourth century B.C. Despite the neutral background, all the figures, drawn three-quarter face, seem to move in lively fashion over the rocky ground, represented with great naturalness rather than schematically.

c. Another mosaic at Pella, illustrating a deer hunt, dated to the end of fourth century B.C.[26] The artist is known from the preserved inscription; his name was Gnosis. Even with all the limitations inherent in the use of pebbles instead of pigments, this amazing work achieves both foreshortening and shading; it directly reflects the significant achievements of monumental painting in that period.

d. The previous scene has a counterpart in a mosaic at Alexandria.[27] But in place of the two Macedonian hunters, there are two Eros figures, who nevertheless possess the same stance as the hunters. The deer moves in the same way as the deer in the Pella mosaic, and further, the representation of the ground is identical in the two mosaics. A second scene, an animal frieze, closely resembles one in a mosaic at Olynthos in the House of the Comics. The leafless tree in the Alexandria frieze is the same as the one featured in the mosaic of the battle of Issos, and also in the mural on the façade of Tomb II at Vergina. The ivy tendril that separates the two scenes in the Alexandria mosaic is to be found also in a mosaic at the Kalē Tychē villa at Olynthos.[28]

Alexandria's role as a stepping-stone between Greece and Italy is acknowledged. It is quite apparent that the great achievements of Macedonia found their way to Italy through Alexandria.[29] The one work of art which confirms the Macedonian origins of Roman painting was only recently discovered. It is the frieze on the façade of Tomb II at Vergina depicting a hunting scene. The composition consists of many figures moving in all directions and even towards the background; of trees, of which some are in leaf and some leafless—doubtless an indication of the season in which the hunt is taking place; and of a massive mountain at the right-hand edge of the picture. We come across all these elements again in Roman painting starting with the Odyssey landscapes of the first century B.C. now in the Vatican, and continuing with the Second, Third, and Fourth Style paintings of the first century A.D.

e. Mosaic of Issos from the House of the Faun at Pompeii,[30] dated to the first century B.C. This is a copy of the mural painting by Philoxenos of Eretria, who lived at the end of the fourth century B.C.[31] The tumultuous noise of battle is almost audible as one looks on this composition. The movement of the innumerable warriors engaged in battle both toward and away from the viewer creates the illusion of three-dimensional space, especially Darius' chariot preceded by the horse which has turned toward the back of the composition in a daring foreshortening in the same manner as Pausias' bull.[32] The subtle play of shading has a lot to do with the effect of this picture on the senses. The leafless tree, which we find in many fourth-century mosaics and frescoes, is the only concession—as it is in the other works—to the natural landscape.

We have considered only a few works (paintings and mosaics). Of course many more exist in Macedonia, as well as in the rest of the Hellenistic world: Thrace,[33] Delos,[34] Athens,[35] Pergamon, Kos, Cyprus, Palestine (Massasa, Herodion), South Russia, and Libya.[36] Some of these are characterized by the axial symmetry of their composition, others by the illusionistic rendering of space and the extension of the perspective outdoors through a door or a window. These elements have been supposed to be achievements of Italo-Roman painting. Yet they all occur in Greek works of art, especially those of Macedonia, at a much earlier period than the Roman ones.

Several problems and theories must now be reexamined in light of the recent excavations in Macedonia. The many fascinating finds and monuments discovered there open up new horizons. It will soon be necessary to rewrite at least in part the history of late classical and Hellenistic art.

Notes

1. Vitruvius 7. *Praeftio* 10. See *EAA*, s.v.

2. Plutarch *De glor. Ath.* 2; Pliny *NH* 35.60. See *EAA*, s.v.

3. Pliny *NH* 35.61; Plato *Prt.* 318b; Xenophon *Mem.* 1.4.3; Plato *Symp.* 4.63; Plato *Grg.* 453.c. See *EAA*, s.v.

4. Pliny *NH* 35.60, 35.67-69. See *EAA*, s.v.

5. Tendencies for realism already appear in late archaic and classical periods, but they are sparse; artists representing those tendencies in monumental art were few and without great success.

6. Pliny *NH* 35.76 and 35.123; Plutarch *Arat.* 12.

7. Pliny *NH* 21.4 and 35.123-126; Pausanias 2.27.3 (Tholos at Epidauros, paintings). See *EAA*, s.v.

8. See *EAA*, s.v.

9. Pliny *NH* 35.114

10. Pliny *NH* 35.133.

11. J. Charbonneaux, R. Martin, F. Villard, *Grèce hellénistique* (Paris, 1970), 167.

12. G. E. Rizzo, *La Pittura Ellenistico-Romana* (Milano, 1929), 5-6, pls. I-II.

13. K. Fittschen, "Zur Herkunft und Entstehung des 2. Stils-Probleme und Argumente," *Hellenismus in Mittelitalien* (Kolloquium in Göttingen, June 1974), *Abhandlungen der Akademie der Wissenschaften in Göttingen,* Philologisch-Historische Klasse, folio 3, 97 (1976), 539-559. See also Ingeborg Scheibler, *Zum Koloritstil der Griechischen Malerei* (1978), IV,229 ff.

14. M. Andronikos, *The Royal Graves at Vergina* (Athens, 1978), 17-18, figs. 4-5.

15. A. Arvanitopoulos, *Graptai Stèlai Dèmètriados-Pagason* (Athens, 1928), 147-149, figs. 170-173, pl. II. See also Charbonneaux (note 11), 130, fig. 127.

16. See note I.

17. Charbonneaux (note 11), p.118 and fig. 118 on p. 119.

18. Charbonneaux (note 11), 118.

19. Rizzo (note 12), pl. LXXV.

20. Ph. Petsas, *O taphos ton Lefkadion* (Athens, 1966), 114-124, pls. VI, X, 2.

21. Charbonneaux (note 11), 134-136, figs. 132, 134.

22. A. Maiuri, *La peinture romaine* (Geneva, 1953), pls. 82-83; O. Elia, *Pitture di Stabia* (Naples, 1957).

23. Ch. Makaronas, "Λευχάδια," *Makedonika* 2 (1941-1952), 634-636, pls. 18-19; S. Miller, "The Philippeion and Macedonian Hellenistic Architecture," *AthMitt* 88 (1973), 216, pl. 88,3; Ch. Makaronas and S. G. Miller, "The Tomb of Lyson and Kallikles: A Painted Hellenistic Tomb," *Archaeology* 27 (1974), 249-259 (with color plates).

24. D. Papakonstantinou-Diamantourou, *Pella,* I (Athens, 1971), pl. 12.

25. Ph. Petsas, "Ten Years at Pella," *Archaeology* 17, 2 (1964), fig. 8; Papakonstantinou-Diamantourou (note 24), pl. 14. *History of the Greek Nation,* 5 (Athens, 1974), 461 (color plate).

26. Petsas (note 25), fig. 9. *History of the Greek Nation* (note 25).

27. N. A. Daszewsky, "Some Problems of Early Mosaics from Egypt," *Das Ptolemaische Aegypten: Akten des Internationalen Symposiums,* Berlin, 27-28 September 1976 (Mainz-am-Rhein, 1978), 123-136, figs. 116-121. See also Picard, *RA* (1936), 205-209, where some other works of art indicative of Macedonian influence on art of Alexandria are discussed.

28. D. Robinson, *Excavations at Olynthus,* 12 (Baltimore, 1946), pl. I. The information on the Alexandria and Olynthos mosaics I owe to René Ginouvez, Director of CNRS, France; I am most grateful to him.

29. Two other centers represent links between Greece and Italy. One is Centuripe in Sicily and the other is the Lipari islands. Both centers were flourishing during the Hellenistic age (third century B.C.), producing painted vases following the Greek-Macedonian tradition; even their "Koloritstyle" is the same, adopted later in Italy. See G. Libertini, *Centuripe* (Catania, 1926), 145-186; G. M. A. Richter, "Polychrome Vases from Centuripe in the Metropolitan Museum," *Metropolitan Museum Studies* 11 (1930), 187-205. For Lipari vase painting see A. D. Trendall, "Lipari Vases and Their Place in the History of Sicilian Red-Figure" in L. Bernabo-Brea, M. Cavalier, *Meligunis-Lipara,* 2 (Palermo, 1965), 271-289. Also see Schuchhardt, "Das 'badende Mädchen' im Münchener Antiquarium," *Die Antike* 12 (1936), 84-106.

30. B. Andreae, *Das Alexandermosaik aus Pompeji* (Recklinghausen, 1977), with color plates and full bibliography.

31. Pliny *NH* 35.110.

32. Pliny *NH* 21.4.

33. The frescoes of the tomb of Kazanlak: Charbonneaux (note 11), 112 ff.

34. J. Chamonard, *Le quartier du théâtre, Exploration archéologique de Délos,* 8 (Paris, 1922-1924), 127-134, fig. 59.

35. W. Hopfner, *Das Pompeion* (1971), 12, fig. 9.

36. Fittschen (note 13), 540 ff.